THE ABBY ALDRICH ROCKEFELLER FOLK ART CENTER SERIES · I

BEATRIX T. RUMFORD, GENERAL EDITOR

AMERICAN FOLK PORTRAITS

Paintings and Drawings from the Abby Aldrich Rockefeller

Folk Art Center

PUBLISHED BY NEW YORK GRAPHIC SOCIETY · BOSTON

IN ASSOCIATION WITH THE COLONIAL WILLIAMSBURG FOUNDATION

This catalog was published with the aid of a grant
from the National Endowment for the Arts in Washington, D.C., a federal agency.

FIRST EDITION

New York Graphic Society books are published by Little, Brown and Company.
Published simultaneously in Canada by Little, Brown and Company (Canada) Limited.
Printed in the United States of America.

LIBRARY OF CONGRESS CATALOGING IN PUBLICATION DATA

Abby Aldrich Rockefeller Folk Art Center.
American folk portraits.

(Abby Aldrich Rockefeller Folk Art Center series; 1)
Includes bibliographical references and index.
1. Portraits, American—Catalogs. 2. Primitivism in art—United States—Catalogs.
3. Abby Aldrich Rockefeller Folk Art Center—Catalogs.
I. Title. II. Series.
N7593.A23 1981 757'.0973'07401554252 81-4990
ISBN 0-8212-1100-5 AACR2

CONTENTS

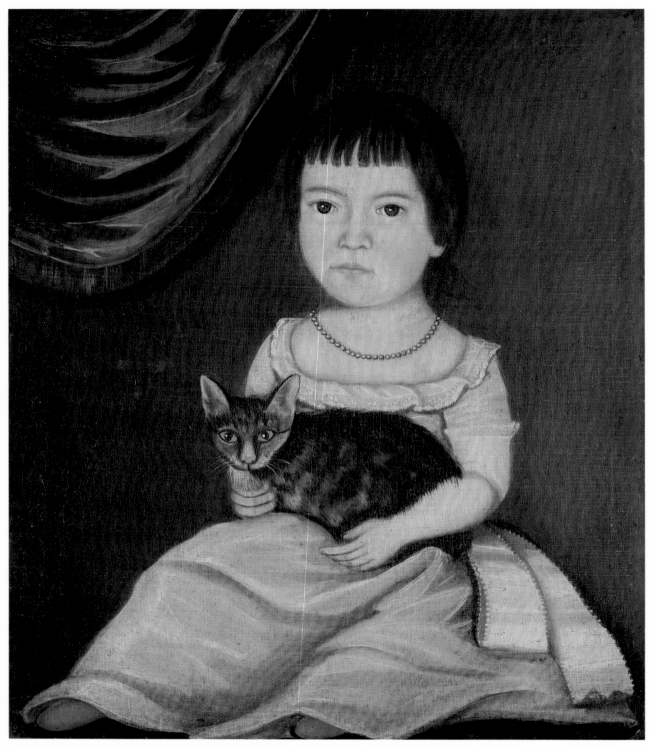

Attributed to the Beardsley Limner, *Child Posing with Cat* (cat. no. 20)

TO NINA FLETCHER LITTLE

whose appreciation of American folk art and careful scholarship

have been our inspiration

AMERICAN
FOLK PORTRAITS

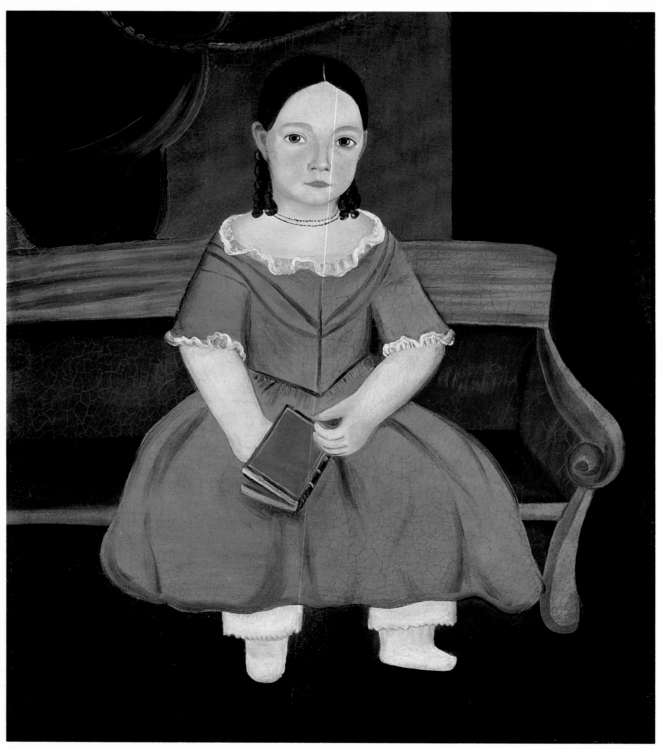

Figure 1 Style of William Matthew Prior, *Girl Seated on Bench* (cat. no. 153)

FOREWORD

The reappraisal of American folk portraiture as an art form can be traced to an exhibition of locally owned pictures held in Kent, Connecticut, in the summer of 1924. Among the paintings shown were a striking group of likenesses, now recognized as the work of Ammi Phillips, which attracted the attention of the critical press. Writing about this exhibit for *International Studio,* Mrs. H. G. Nelson commented, "These quaint souvenirs of a bygone time have a distinct artistic worth of their own. It is interesting to observe how much in common this art has with certain phases of the 'modern movement' in art today."[1] Mrs. Nelson was referring to the work of an adventurous group of American artists who deliberately organized colors and forms in unexpected ways to express openly their personal feelings and ideas about aspects of everyday life.

Avant-garde artists who traveled abroad early in this century were exposed to and influenced by their European counterparts' interest in primitive art forms. There was, in fact, a direct relationship between the development of non-naturalistic American art and the rediscovery of folk art. As early as 1916, Bernard Karfiol, Robert Laurent, and other young artists affiliated with Hamilton Easter Field's School of Painting and Sculpture at Ogunquit, Maine, had begun acquiring old weathervanes, carvings, and paintings similar to those Field used to decorate the fishing shacks that served them as studios. These post-Armory Show[2] modernists recognized in the directness and simplicity of the best of the old-fashioned handmade objects they collected some of the same abstract qualities with which they were experimenting themselves, and they astutely realized that the products of previous generations of American artisan-craftsmen provided a precedent and thus a means of legitimizing their own use of simplified shapes, arbitrary perspective, and unmixed colors.

As the summers passed, Karfiol's and Laurent's enthusiasm for folk art forms prompted other artists like William Zorach, Elie Nadelman, Yasuo Kuniyoshi, and Henry Schnackenberg to collect. In February 1924, several months before the exhibit in Kent, Schnackenberg organized a show of what he titled "Early American Art" for the Whitney Studio Club in New York City.[3] Most of the forty-five objects included were borrowed from his artist associates and would today be classified as folk, or popular, art. It was the first exhibition of its kind.

Abby Aldrich Rockefeller's interest in folk art was a direct result of her appreciation of contemporary art. A founder and active supporter of the Museum of Modern Art, she knew and patronized many of the artists who exhibited there. She took particular pleasure in discovering and acquiring the work of unrecognized talent. In 1928 this search brought her to the Downtown Gallery in Greenwich Village, where for two years Edith Gregor Halpert had been representing living American artists, including members of the Ogunquit Colony. Mrs. Halpert had become familiar with American primitives in the summer of 1925, when her husband, the painter Sam Halpert, rented a studio on the Maine coast from Robert Laurent. Edith Halpert was so intrigued by the contemporary look of the old-fashioned objects Field and Laurent had collected that she decided to expand the scope of her gallery. Soon she was selling nineteenth-century pictures and weathervanes gathered on her subsequent forays around New England. The timing of Mrs. Rockefeller's visit to the Downtown Gallery was propitious. She and her husband, John D. Rockefeller, Jr., were becoming increasingly absorbed in the restoration of Williamsburg, the colonial capital of Virginia. On being introduced to nineteenth-century primitives by Edith Halpert, Mrs. Rockefeller recognized that here was another aspect of American cultural history worth preserving, one that would provide a logical background for her sizable collection of modern American art.[4]

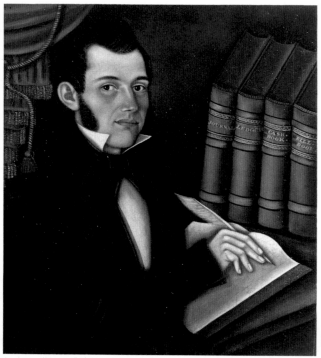

Figure 2 R. B. Crafft, *The Merchant* (cat. no. 45; reproduced in color on p. 76)

Guided and assisted by Edith Halpert, Holger Cahill,[5] and others, Mrs. Rockefeller devoted nearly ten years to building a wide-ranging collection of distinctive, aesthetically pleasing objects fashioned by craftspeople, amateurs, and students who had little, if any, training in the principles of academic art but were motivated by a desire for artistic expression whether they were creating for pay, personal pleasure, or to fulfill a school assignment. Abby Aldrich Rockefeller's interest in folk art was primarily aesthetic rather than antiquarian. She was especially fond of student art, such as calligraphy, memorials, and theorems, and of children's portraits and acquired many examples of varying quality in each category.

Although Mrs. Rockefeller made a number of independent purchases, Halpert and Cahill were responsible for some of her most memorable acquisitions. Mrs. Halpert discovered the appealing portrait by an unidentified artist titled *Baby in Red Chair* (fig. 3), and Holger Cahill found R. B. Crafft's *The Merchant* (fig. 2) in 1934, when Mrs. Rockefeller sent him to search for folk art in the South. Cahill felt that *The Merchant* was an unusually interesting example of the professional portrait painter's technique and demonstrated why contemporary artists who were experimenting with multi-

ple perspectives were attracted to certain folk paintings. A few years earlier, Mrs. Rockefeller had personally approached Robert Laurent about the possibility of purchasing *Girl Seated on Bench* (fig. 1) after she saw it during a visit to his home in Brooklyn. But Laurent, who had purchased the portrait at a Maine auction in 1924, wanted to keep it. Some years later, Mrs. Rockefeller got Edith Gregor Halpert to persuade him to sell her the picture.

Other pioneer collectors in the folk art field included Clara Endicott Sears of Harvard, Massachusetts, who was so intrigued by the New England primitive portraits she acquired that she published the first book on the subject in 1940; Isabel Carleton Wilde, a Boston dealer; and the artist Elie Nadelman. Early in the 1930s, financial pressures forced the sale of much of the material in both collections, and Mrs. Rockefeller quietly bought some of the best Wilde and Nadelman pieces (see cat. nos. 181 and 282).

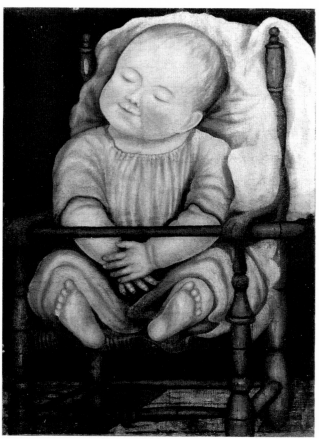

Figure 3 Unidentified artist, *Baby in Red Chair* (cat. no. 207; reproduced in color on p. 225)

Since she always shied from publicity, few people realized the scope and nature of Mrs. Rockefeller's involvement in the arts. Yet she was willing to share her folk art with the widest possible audience, provided that her ownership was not revealed. Some of the paintings and a number of the sculptures were shown anonymously at the Newark Museum in 1930 and 1931 in exhibitions assembled by Holger Cahill. The following year the Museum of Modern Art featured 174 pieces from Mrs. Rockefeller's growing collection, again anonymously, in a comprehensive exhibition titled "American Folk Art—The Art of the Common Man in America, 1750-1900."[6] After its New York debut, the enormously popular show traveled to six cities and served to focus the attention of collectors and critics on the artistic merits of nonacademic art (fig. 4). Some of the impact of the show, which was again organized by Holger Cahill, must be credited to the fully illustrated 225-page exhibition catalog he prepared with the assistance of Dorothy Miller and Elinor Robinson. Cahill's introduction is still being quoted, and curators and collectors continue to regard the 1932 catalog as a useful reference.

In 1935 Mrs. Rockefeller lent a portion of her folk art collection for public exhibition in Williamsburg, and for twenty years a number of paintings and carvings were shown in the Ludwell-Paradise House, a former Colonial Williamsburg exhibition building (fig. 5). Cahill prepared a fifty-page interpretive manual that incorporated his 1932 essay and was supplemented by inventories and advertisements of Williamsburg artists and craftsmen. He pointed out that "as it is defined by the objects in this exhibition, folk art is the work of people with little book learning in art techniques, and no academic training." While observing that this kind of work had been occasionally produced by Tidewater Virginia craftspeople, gifted amateurs, and students enrolled in local boarding schools, he stressed the importance of aesthetics over provenance or documentary interest. In his words, an object had to have "art quality" to be classified as "folk art."[7]

In 1939 a major part of this important collection was presented to Colonial Williamsburg. At the same time, Mrs. Rockefeller gave fifty-four pieces of folk art to the Museum of Modern Art, which later shared the gift with the Metropolitan Museum of Art. Through the cooperation of these two museums and the generosity of David Rockefeller, 424 examples of nonacademic art collected by Abby Aldrich Rockefeller between 1929 and 1942 were reassembled in Williamsburg and were housed in a modern building bearing her name that was opened to the public in 1957, through the generosity of John D. Rockefeller, Jr. Folk art scholar Nina Fletcher Little researched and wrote a catalog of the collection for the opening of the new museum, which she had also helped to design (fig. 6).

Even after Mrs. Rockefeller had placed the best of her collection on view in Williamsburg, her enthusiasm for folk art was undiminished and she continued to collect with a keen eye for strong design, color, and fine

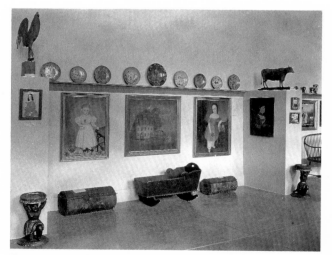

Figure 4 View of the 1932 "Art of the Common Man" exhibition as shown at the Philadelphia Museum of Art

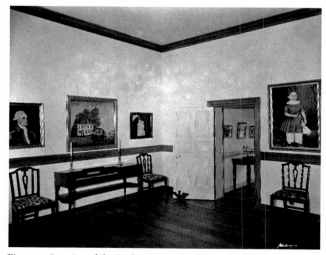

Figure 5 Interior of the Ludwell-Paradise House in Williamsburg with Mrs. Rockefeller's folk art on view, about 1937

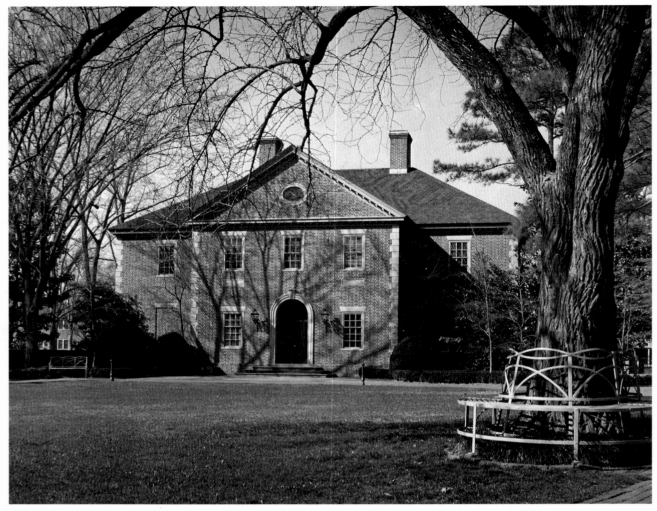

Figure 6 Exterior of the Abby Aldrich Rockefeller Folk Art Center building, which opened in May 1957

workmanship. During the late 1930s, she purchased a wide variety of folk art subjects – chiefly chalkware, weathervanes, children's portraits, theorems, and memorials – to use as furnishings at Bassett Hall, the Rockefellers' Williamsburg home (fig. 7). Among her most delightful discoveries was a portrait of a small girl with a cat that dates about 1800 and has recently been attributed to the Beardsley Limner (see p. 6). Mrs. Rockefeller ceased actively collecting folk art by 1942, and thereafter no significant additions were made to the exhibits at the Ludwell-Paradise House or to the furnishings of Bassett Hall before her death in 1948.

Today Mrs. Rockefeller's folk art is the core of a major collection that continues to develop along the lines she established. Many objects of great rarity and quality have been added and weaker areas of the collection have been, and continue to be, enriched. In all, it currently contains over 1,800 objects, dating from colonial times to the present. Since 1957 staff efforts to further Mrs. Rockefeller's pioneering achievements by expanding her collection and by using folk art to serve a broad educational purpose have been enthusiastically endorsed by Carlisle H. Humelsine, first as President and now as Chairman of the Board of the Colonial Williamsburg Foundation. His support and vision have enabled the museum housing Abby Aldrich Rockefeller's collection to emerge as a progressive and vital institution, one that is preeminent in the field of Ameri-

can folk art. A small group of dedicated and talented directors have been responsible for judiciously building the collection and for furthering folk art studies through the production of exhibitions, films, and catalogs. Those who have been instrumental in guiding the museum's growth include Mitchell A. Wilder (1958), Lucius D. Battle (1958-1961), Mary C. Black (1961-1964), Bruce Etchison (1964-1966), Peter A. G. Brown (1966-1971), and Graham Hood (1971-1973). To emphasize that the museum's concern with folk art is continually developing and involves an ongoing research program as well as innovative exhibits, its title was changed from "Collection" to "Center" in 1977.

In exhibiting American folk art, Williamsburg's Folk Art Center strives to present as inclusive and varied a selection of quality objects as that represented in Abby Aldrich Rockefeller's collection when it made its anonymous debut in 1932 as "The Art of the Common Man." The museum displays its holdings as art, and, insofar as the documentation on each object permits, the accompanying label describes who made the piece and why, and discusses the cultural context in which it was created (fig. 8).

Potential additions to the collection, whether by gift or by purchase, are reviewed by Colonial Williamsburg's curatorial staff and its President, Charles R. Longsworth. Since Mrs. Rockefeller collected the work of unschooled artists with vastly different social and professional backgrounds, the museum continues to

subscribe to a broad definition of folk or popular art and has no cutoff date. Originality, workmanship, and condition are basic criteria used in evaluating potential acquisitions. But the decisive element in any object considered for the Center is its genuine aesthetic quality, rather than historical associations or documentary interest. Because accession funds and storage space are limited, the material purchased since 1957 is periodically reviewed and culled of duplicate, heavily conserved, or mediocre examples. However, all of Mrs. Rockefeller's collection has been deliberately kept intact as a reflection of her taste and the understanding and appreciation of folk art prevalent in the 1930s. Thus, although a number of portraits acquired by Mrs. Rockefeller would not be categorized as folk art by today's standards, they remain in the collection and are included in this catalog.[8]

Research on the collection has always been emphasized. The tradition of scholarship initiated by Holger Cahill and fostered by Elinor Robinson[9] and Edith Halpert served as the basis for interpretation at the Ludwell-Paradise House as well as for the catalogs of the collection published in 1940 and 1947. Subsequent investigative studies have been made by Nina Fletcher Little, Mary C. Black, and Tom Armstrong, and, more recently, by Barbara Luck, Ann Barton Brown, Donald R. Walters, and Carolyn J. Weekley. Because the museum staff has taken a leadership role in folk art research, many once-anonymous painters are

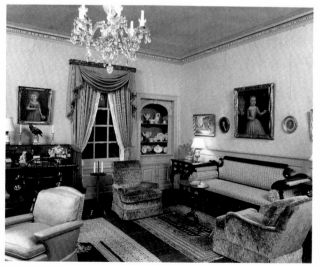

Figure 7 View of the Morning Room at Bassett Hall featuring portraits by Michele Felice Cornè (cat. no. 41) and James Peale (cat. no. 120)

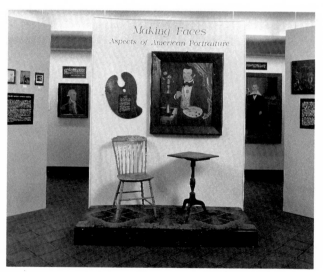

Figure 8 An interpretive exhibit of American portraiture installed in the Folk Art Center lobby in 1978

now identified and much more is known about who these unschooled American artists were, their sources of inspiration, the techniques they used, their methods of work, and the demands and expectations of their clientele. But even after considerable searching, the names of those responsible for over one third of the portraits in this catalog remain unknown, a fact that indicates the formidable amount of sleuthing yet to be done.

Because the 1957 catalog of the nucleus of 424 objects collected by Mrs. Rockefeller is out of print, and in view of the Center's growth and the substantive research of the last two decades, the bulk of our considerable resources is not easily accessible to many who might wish to use them. This volume is the first in a projected series of four catalogs that will detail the Abby Aldrich Rockefeller Folk Art Center's present holdings. It is earnestly hoped that by publishing a thorough assessment of the Folk Art Center's portraits, information about related examples will be brought to the attention of our curatorial staff with the result that now-anonymous artists will be identified and biographical information on others will be expanded. Subsequent volumes will feature paintings other than portraits, sculpture, and decorative usefulwares.

This catalog represents sustained effort on the part of Folk Art Center staff over a five-year period. The descriptive entries for the portraits and biographical sketches of the identified artists have been compiled and written by Barbara Luck, Beatrix T. Rumford, Donald R. Walters, and Carolyn J. Weekley; the introductory essay, "Aspects of American Folk Portraiture," was drafted by Donald R. Walters and expanded by Carolyn J. Weekley. Much credit is also due Ann Barton Brown, Catherine Gibbons Mapp, Elizabeth Mankin Kornhauser, and Cynthia Seibels for their preliminary research on many of the paintings discussed herein. Editorial assistance has been skillfully supplied by Donna Sheppard of Colonial Williamsburg's Publications Department, Betty Childs of New York Graphic Society, and Betsy Pitha of Little, Brown. The excellent photographs were provided by Frank Davis, Hans Lorenz, and Delmore Wenzel of Colonial Williamsburg's Audiovisual Department and checked for clarity and color accuracy by Patricia A. Hurdle. The tedious task of typing the manuscript in various stages and the countless other organizational details related to its preparation have been competently handled by Connie P. Cheatham, Elizabeth A. Sanders, and Joyce S. Slepin.

The Folk Art Center is immensely grateful to the National Endowment for the Arts for the financial assistance that has enabled the Center to publish this volume. We also wish to express our gratitude to the late William P. Murdoch and his wife, Phyllis Murdoch Schoettle, whose generous gift has made it possible to illustrate one third of the portraits in color.

It must also be noted that the production of this catalog would not have been possible without the cooperation of private collectors and dealers as well as professional colleagues at many museums, libraries, and historical societies who have graciously responded to numerous queries by providing photographs, documentation, and other valuable information. We are especially indebted to Mary Allis, Dr. J. G. Bogle, Mrs. Charles M. Burdick, Jr., Mrs. Samuel E. Chamberlain, Wayne Craven, James B. Dorr, Bruce Etchison, Mr. and Mrs. Howard A. Feldman, Mr. and Mrs. Austin Fine, Milton E. Flower, Thomas L. Gravell, Herbert W. Hemphill, Jr., Elizabeth C. Hollyday, Louis C. and Agnes H. Jones, Mrs. Jacob M. Kaplan, Caroline Keck, Mrs. Steven Kellogg, Dr. Arthur B. Kern, Nina Fletcher Little, Elizabeth Lyon, Dorothy C. Miller, Lucy B. Mitchell, Jacquelyn Oak, Charles H. Olin, Eleanor Quandt, Norbert and Gail Savage, Christine Skeeles Schloss, Mr. and Mrs. Samuel S. Schwartz, Linda C. Simmons, Robert G. Steele, Peter H. Tillou, Robert C. Vose, Jr., Faye Walters, William Lamson Warren, and Mr. and Mrs. William E. Wiltshire III.

We would also like to extend thanks to the following individuals and institutions: Robert Bishop, Museum of American Folk Art; Mary C. Black, New-York Historical Society, New York, N.Y.; Roderic H. Blackburn, Albany Institute of History and Art; Bland Blackford, Archivist, Colonial Williamsburg Foundation; Georgia B. Bumgardner, American Antiquarian Society, Worcester, Mass.; John S. Carter, Peabody Museum, Salem, Mass.; Stiles T. Colwill, Maryland Historical Society, Baltimore, Md.; Henry Grunder, Earl Gregg Swem Library, College of William and Mary, Williamsburg; William H. Harrison, Fruitlands Museum, Harvard, Mass.; Graham Hood and staff of the Department of Collections at Colonial Williamsburg, in particular John C. Austin, Linda B. Baumgarten, John D. Davis, Joan D. Dolmetsch, Mrs. Harold B. Gill, Mildred B. Lanier, and Susan Shames; Frank Horton, Museum of Early Southern Decorative Arts, Winston-Salem, N.C.; Shelby A. Kriele, Greene County Historical Society, Coxsackie, N.Y.; Laura C. Luckey, Museum of Fine Arts, Boston, Mass.; Nancy Muller, Shelburne Museum, Shelburne, Vt.; Richard Nylander, Society for the Preservation of New England Antiquities, Boston,

Mass.; Ruth Piwonka, Columbia County Historical Society, Kinderhook, N.Y.; Emily A. Ross, Poultney, Vt., Historical Society; M. Patricia Schaap, Livingston County Historian, Geneseo, N.Y.; Clifford W. Schaefer, curator of the collection of Edgar William and Bernice Chrysler Garbisch, New York, N.Y.; Karol Schmiegel, Henry Francis du Pont Winterthur Museum, Winterthur, Del.; Richard E. Slavin III, New York State Historical Association, Cooperstown, N.Y.; Kenneth M. Wilson, Greenfield Village and Henry Ford Museum, Dearborn, Mich.

The portraits in the collection of the Abby Aldrich Rockefeller Folk Art Center represent the work of painters from different professional and social backgrounds with varying degrees of technical ability. Individual likenesses range from highly original abstract stylizations to compositions that were clearly influenced by academic traditions. In the essay and entries which follow we have endeavored to evaluate the special qualities of each image clearly and honestly.

BEATRIX T. RUMFORD
Director

NOTES

[1] Mrs. H. G. Nelson, "Early American Primitives," *International Studio*, LXXX (March 1925), p. 456.

[2] "The Armory Show" quickly became the popular name for the controversial and enormously influential International Exhibition of Modern Art held in New York City's 69th Regiment Armory in 1913. Organized by a group of liberal American artists, the show introduced European post-impressionism and cubism and other contemporary styles to the general public.

[3] The Whitney Studio Club, directed by Juliana Force and underwritten by Gertrude Vanderbilt Whitney, was the progenitor of the Whitney Museum that was founded in 1930.

[4] For a more detailed discussion of the history of folk art collecting in the United States and Mrs. Rockefeller's activity in this area, see Beatrix T. Rumford, "Uncommon Art of the Common People: A Review of Trends in the Collecting and Exhibiting of American Folk Art," *Perspectives on American Folk Art* (New York, 1980).

[5] When introduced to Mrs. Rockefeller, Holger Cahill was on the staff of the Newark Museum, building a collection of contemporary art. He had previously spent a summer in Norway, Sweden, and Germany, where he had visited provincial museums and had become interested in European peasant art.

[6] There were 175 objects in this landmark exhibition; the additional item was a carved horse belonging to Cahill that was added to the Williamsburg collection in 1957.

[7] Holger Cahill to Miss Bullock, January 7, 1935, AARFAC archives.

[8] See cat. nos. 9, 13, 14, 41, 42, 83, 94, 162, 226, 245, 246, and 247.

[9] After eight years on the staff of the Newark Museum, Elinor Robinson served as Mrs. Rockefeller's art secretary from 1934 to 1941.

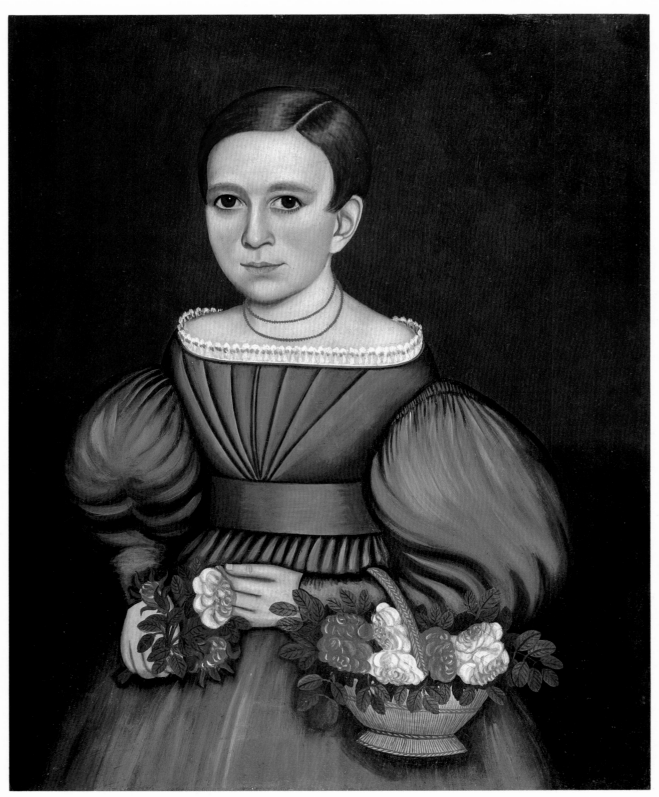

Figure 9 Attributed to Noah North, *Girl with Flower Basket* (cat. no. 114)

INTRODUCTION

Aspects of American Folk Portraiture

We have certainly, either by nature, . . . or by accident, something that appears like a decided predisposition for painting in this country. . . . painters, if not too numerous to mention, are much too numerous to particularize. They are . . . more than we know what to do with. If you cannot believe this, you have but to look at the multitude of portraits, wretched as they generally are, that may be found in every village of our country. You can hardly open the door of a best-room any where, without surprizing or being surprized by, the picture of somebody, plastered to the wall and staring at you with both eyes and a bunch of flowers.[1]

These observations were made in 1829 by John Neal, a Maine journalist, penmanship teacher, and miniature painter who fancied himself a leading connoisseur of the arts and was one of the first to write on the subject in America. Neal's comments clearly demonstrate the enormous popularity portraiture enjoyed among all segments of early nineteenth-century society, and most particularly among the prosperous middle class, which frequently supported the efforts of untrained and minimally trained painters. The 1820s and 1830s were extraordinarily productive years for American portraitists of these levels; their methods of work and readiness to serve an eager public were an extension and expansion of traditions firmly established during the colonial era.

Yet Neal, whose opinions were considered controversial even in his own period,[2] lacked the perspective of time that enables us to evaluate better and understand some of the interactions that linked not only the colonial era with the early nineteenth century, but the work of the folk, or nonacademic, painter with that of his academic peer. In his apparent haste to condemn certain portraits as "wretched," quite likely those by the self-taught and semitrained, Neal unknowingly discounted the value these images would have for later generations

as well as their importance in the broader history of American painting.

It is also true that Neal's assessments and perceptions were more the exception than the rule; few Americans shared his learned art background and exposure to European paintings or the intellectual pretensions that nurtured it. Even as late as 1829 most American artists and their patrons viewed paintings as primarily useful and decorative objects within the context of household furnishings but rarely as vehicles for portraying those ennobling qualities of dignity and commitment to heroic ideals championed by the Maine connoisseur. Thus Neal's assessment of the naive artistic endeavors that he saw around him should be interpreted as an elitist statement criticizing a society whose aesthetic awareness and ability to distinguish between good and inferior art were still immature.

The reasons why early Americans failed to exercise the principles of fine arts connoisseurship as they applied to English and European academic painting are not entirely clear. Scholars continue to offer interpretations based on the insularity inherent in a colonial society and on the complex hierarchy of values that dominated life in that time.[3] The prevalence of portraiture in early America as opposed to landscape, genre, and historical painting is indicative of these values and reflects a conscious choice and attitude on the part of the people. The fact that so much of the surviving portraiture stylistically falls outside the academic mainstream and bridges on and into folk, or nonacademic, painting indicates that these pictures were acceptable to the society for which they were created and demonstrates the important role such images played in American painting from its inception.

Two central questions are prerequisites for assessing these likenesses: why was portraiture the favored painting format until almost the end of the nineteenth

century; and what was its function and value? The rare period documents that comment on the subject and the rich variety of extant likenesses suggest a rationale dependent on varying socioeconomic conditions, needs, and aspirations. Most people, then as now, were interested in pictures of themselves and of their loved ones. Mortality rates ran high, and the concept of a tightly structured family unit was more vital to social and economic survival than it is today. Family portraits, particularly in rural areas, were often commissioned *en suite,* recording in single or group likenesses every member of a household. Regarded as family icons, portraits were often considered utilitarian because they fulfilled visually the need for a genealogical record in addition to providing decorative embellishment, which concurrently became a functional expression of worldly status. The portraits of members of the Russell Dorr family by Ammi Phillips (see cat. nos. 121-126) are among the many known examples of this custom.

In this respect portraits served both as permanent records and as sentimental remembrances. So strong

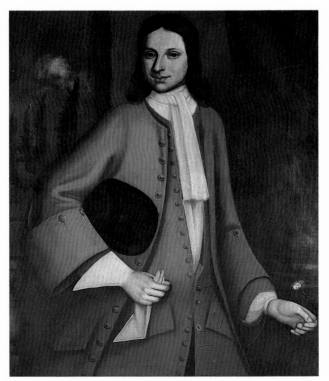

Figure 10 Attributed to the Schuyler Limner, *Robert Sanders* (cat. no. 174)

was the desire for a visual record of an individual that artists were sometimes summoned to take likenesses from corpses. Perhaps the earliest known allusion to the practice in America is associated with Thomas Child, a limner and house painter working in Boston. On November 10, 1706, Samuel Sewall recorded in his diary that "this morning Tom Child, the Painter died." Sewall added, in rather sarcastic verse:

> Tom Child had often painted Death
> But never to the Life before;
> Doing it now, he's out of Breath;
> He paints it once, and paints no more.[4]

References like Sewall's, while pertinent, are rare and document only one reason for portrait commissions in the colonial years.[5] America's earliest patrons of portrait art, mainly families with official status and wealth, more often commissioned likenesses to express and record their sense of self-worth. In attempting to emulate the artistic standards of the Old World, they understandably wished their likenesses to reflect affluence in the best English and European manner. Early portraits like those of John and Robert Sanders (see cat. nos. 173, 174 and fig. 10) and Pieter Waldron (see cat. no. 172), by an anonymous and possibly self-taught New York artist, exhibit considerable knowledge of English academic style. The compositions and poses were probably derived from the English mezzotints of royalty or other notables that proliferated in colonial homes and public buildings (fig. 11). Artists of similar ability—and with similar training—were consistently patronized throughout the eighteenth and nineteenth centuries by rural and urban Americans alike, evidently because their patrons found their work satisfactory.

Although we may assume that the Sanders brothers considered their portraits adequate likenesses, our knowledge of the sitter's response to such pictures is incomplete and will probably remain so in view of the limited documentation that exists for folk painters and their clientele. Generalizations are therefore risky in the absence of more revealing specifics, but it is nonetheless important to consider the question of the client's attitude.

One case in point discussed later in this essay is the work of William Matthew Prior, who advertised his least expensive portraits as being in a "flat" style "without shade or shadow" as opposed to "finished." The modern viewer of Prior's work is quick to sense what meaning these terms had for the artist (see p. 176), but one can only wonder how his patrons distinguished the

differences between these techniques. How typical was the work Prior and those who are associated with him and how prevalent was this intentionally watered-down style among American portrait painters whom we now term "folk"? Finally, one wonders if the popularity of Prior's "flat" style does not illuminate further John Neal's comments and John Vanderlyn's lament that the "mass of folk can't judge of the merits of a well finished picture."[6]

The subtleties of these questions are also related to the prevailing, and documented, view that most early American portrait painters were ranked by their contemporaries as craftsmen or artisans and not as ingenious or gifted creators[7]— as is illustrated by the careers of numerous folk artists who began as house and/or sign painters and eventually added portraiture to their repertoire. This observation has particular significance for the way in which folk portraiture and more generally folk paintings are assessed today as cultural and artistic statements. Where known or suspected, the craft background and training of a folk painter are usually evident in a naive handling of perspective, foreshortening, compositional balance, proportion, modeling, and the like. Sometimes, as observed in the most successful folk pictures, these deficiencies in, or—in the case of the Prior school—disregard of, academic technique were resolved through experimentation and innovation, ultimately producing inventive, colorful, and aesthetically pleasing images that give visual enjoyment and provide decorative interest. These are the artistic qualities that we value today and they represent the criteria by which portraits are discussed in this catalog.

Currently there is no precise way of measuring the relationship between the basically craft-oriented folk portrait painter and his academic counterpart. There were no firm lines of distinction between academic and nonacademic, or folk, painting during the early years, and consequently the ever-shifting relationships that existed among painters with different levels of skill has not been adequately defined. Folk painters pursued their professions as best they could, often limited by the lack of readily accessible materials. Yet, the accounts of portraitists like James Guild and Chester Harding indicate that unschooled painters usually sought out opportunities for artistic advancement and new sources of inspiration in an effort to improve their work and compete with their fellow artists in satisfying public demand.

Prints were an important source for broadening the largely self-taught painters' knowledge. In addition,

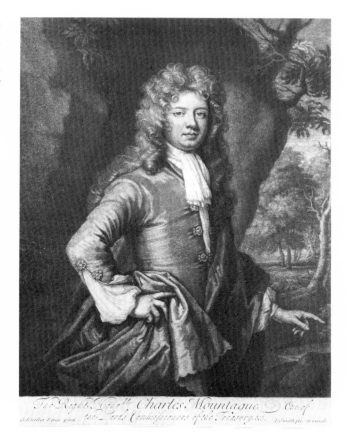

Figure 11 Mezzotint by Smith after Kneller, *Charles Montagu.* The Henry Francis du Pont Winterthur Museum

paintings brought from Europe by settlers or commissioned by Americans visiting abroad or made by foreign artists working in America were also crucial in communicating new art trends. The flow of information about styles and techniques had become well established by the second half of the eighteenth century as American painters returning from academic studio training abroad began to influence local limners. Itinerancy by artists of all ranks, common in colonial times, became still more prevalent after the Revolution and contributed greatly to the development of personal contacts and the informal exchange of ideas among painters.

Given the complexity of relationships that existed among all ranks of artists, their training and sources of inspiration, and, more specifically, our limited knowledge of the careers of folk artists, one begins to sense something of the formidable challenge every scholar

faces in interpreting their work intelligently and drawing succinct conclusions from it. In the following pages we have attempted to provide a general, yet necessarily incomplete, summary of some of the aspects of training, production, and aesthetic qualities observed in folk portraiture that seem the most typical and tenable vis-à-vis the material in this collection.

For the colonial period, the career of Joseph Badger (1708-1765) illustrates some of the general concepts just discussed and represents the typical artisan-craftsman tradition out of which many self-taught American limners emerged. A native of Massachusetts and a long-time resident of Boston, Badger consistently de-

scribed himself as a glazier or painter (meaning sign or house painter) and on rare occasions as a limner.[8] Where or by what means Badger learned to paint portraits is unknown, but he must have been largely self-taught, with possibly some basic instruction from the English immigrant academic painter John Smibert.[9]

Badger's surviving portraits, like *Two Children* (fig. 12), show how earnest were his attempts to create fashionable pictures. His knowledge of academic poses and compositions is more obvious in the small likeness of Elizabeth Greenleaf (see cat. no. 7), undoubtedly based on a mezzotint or influenced by the artist's contact with academics like Smibert or with their work. What Bad-

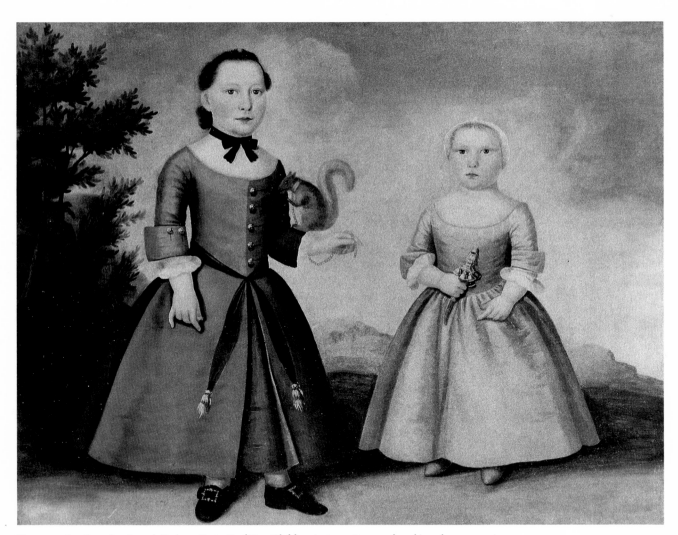

Figure 12 Attributed to Joseph Badger, *Portrait of Two Children* (cat. no. 8; reproduced in color on p. 42)

ger's portrait lacks in anatomical correctness and polished modeling it compensates for in color design, a technical skill that he had probably acquired from his other occupations. Badger's successful combination of portrait painting with sign and house painting is typical of many American artists who can best be described as semitrained or folk. Portrait painting was a natural and lucrative recourse for these artisan-craftsmen, adding a widely sought service to their often related trades.

Another example of the multifaceted careers of America's eighteenth-century folk painters is found in the dual occupations of Rufus Hathaway (1770-1822) of Duxbury, Massachusetts. According to family tradition, Hathaway first supported himself by painting portraits in the early 1790s.[10] Four years later he married the daughter of a wealthy Duxbury merchant and soon after was apparently urged by his in-laws to take up the more acceptable practice of medicine, although he also continued to paint portraits, miniatures, and works in other formats.[11] Hathaway's portraits of some of the members of the Weston family (fig. 13; see also cat. nos. 89-91) are typical of the strong, often compelling, likenesses that he produced. Like those of so many small-town artists who did not travel extensively, Hathaway's painting commissions were proportionate to the local population.

In contrast to the sophisticated developments in portraiture initiated by superb technicians like John Singleton Copley and later fulfilled by artists with a new vision like Gilbert Stuart, the craft skills on which many nineteenth-century professional nonacademic portrait painters relied in part continued the well-established eighteenth-century practice. Such artists advertised an extensive repertoire of skills, as indicated in the following excerpt from an 1806 newspaper notice by a New Hampshire artisan-painter:

GEORGE DAME, . . . *intends to carry on the Painting Business, in its various branches, Varnishing, Gilding, &c. Coaches, Chaises, Signs, Firebuckets, fancy Chairs, Standards, &c. painted in the neatest manner, Looking-Glass, and Picture frames painted and gilded, gilding on Glass, &c. painting in Water Colors, and Gilding on Paper, Vellum, Silks, &c. &c.*

<div align="center">

ALSO,

PORTRAIT & MINIATURE
</div>

painting, warranted likenesses — Specimens may be seen at his shop.[12]

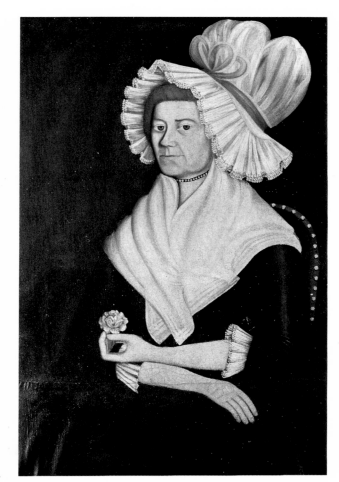

Figure 13 Attributed to Rufus Hathaway, *Mrs. Ezra Weston* (cat. no. 88)

Dame's comprehensive advertisement reveals the variety of skills needed by a successful ornamental painter. In fact, portrait painting was often only one aspect of a commercial or ornamental painter's profession. Many portraits created by such craftsmen are technically sound, but they seldom exhibit an understanding of the fine points of academic portraiture, whose time-honored artistic conventions were not generally a part of craft training. The crude portrait of 1844 presidential and vice-presidential candidates James K. Polk and George M. Dallas (fig. 14) exemplifies a type of ornamental painting that merges the craft of the professional commercial artist with the art of the amateur portraitist. It probably served as a campaign banner or

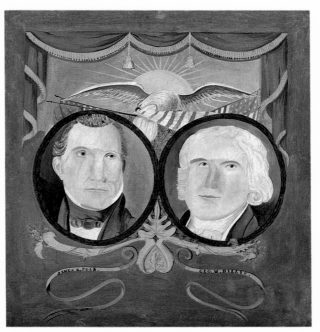

Figure 14 Unidentified artist, *Polk-Dallas Campaign Banner,* ca. 1844, oil on canvas, 33¼″ x 31⅛″ (84.5 cm. x 79.1 cm.), accession no. 58.100.52

may appear unsophisticated to modern eyes, the demand for their work grew steadily as an increasingly affluent and status-conscious middle class emerged in the decades after the Revolution. Growing industrialization, improved road and canal systems, westward expansion and development, and all the other factors that contributed to middle-class prosperity also resulted in a new sense of national and self-identity. Portraiture was no longer prohibitive in cost and thus restricted solely to the wealthy. It was perhaps inevitable that the middle class adopted what had formerly been a primarily elitist tradition of expressing pride in its accomplishments through such media as watercolors or oils. But like their predecessors these new patrons of art were not always able to distinguish between good and inferior portraiture and were often satisfied with an unremarkable painting, provided it was a recognizable likeness.

James Guild, a peddler, tinker, schoolmaster, and portrait painter, has left a fascinating journal that traces his early development as a completely self-taught portrait painter. Guild described his first attempt to paint a portrait:

I put up at a tavern and told a Young Lady if she would wash my shirt, I would draw her likeness. The poor Girl sat niped up so prim and look so smileing it makes me smile when I think of while I was daubing on paint on a piece of paper, it would not be cal[l]ed painting, for it looked more like a strangled cat than it did like her. However I told her it looked like her and she believed it, but I cut her profile and she had a profile if not a likeness. [13]

Guild's account of his initial attempt at portraiture might also describe the reader's reaction to the contorted likeness of Hepzibah Carpenter (fig. 16), painted by an unidentified artist. Confessions of struggling artists like Guild and contemporary accounts of how the subjects of such portraits reacted to their completed likenesses are, as noted previously, quite scarce. It is evident, however, that some nineteenth-century nonacademic portraitists sensed that their clients could not tell the difference between good and bad art. This was also obviously the opinion of John Vanderlyn (1775-1852), a well-known nineteenth-century academic painter: "Were I to begin life again, I should not hesitate to follow this plan, that is, to paint portraits cheap and slight, for the mass of folks can't judge of the merits of a well finished picture, I am more and more persuaded of this." [14]

standard, another type of painting listed in George Dame's advertisement.

Self-portraits by America's folk artists are rare. None so thoroughly documents the nonacademic portrait painter's vocation as the one by Jonathan Adams Bartlett (1817-1902) of Rumford, Maine (see frontispiece). Proudly brandishing palette and brushes, Bartlett also displays many of the tools he used to grind and mix pigments. *The Artist's Studio* (fig. 15) by an unidentified artist is another informative document, revealing much about the common props, methods of working, and attitudes of a professional portrait painter. The artist's equipment is shown in the window seat; his interest in music, sculpture, and literature is indicated by some of the props shown in the room. Symbolic rays of enlightenment stream through the window and across the artist's brow and the canvas before him. The painter's elegant figured-velvet smock and his well-furnished studio suggest that he aspired to a high level of artistic expertise, an aspiration contradicted by the mediocre execution of this presumed self-portrait.

Although the efforts of America's folk portraitists

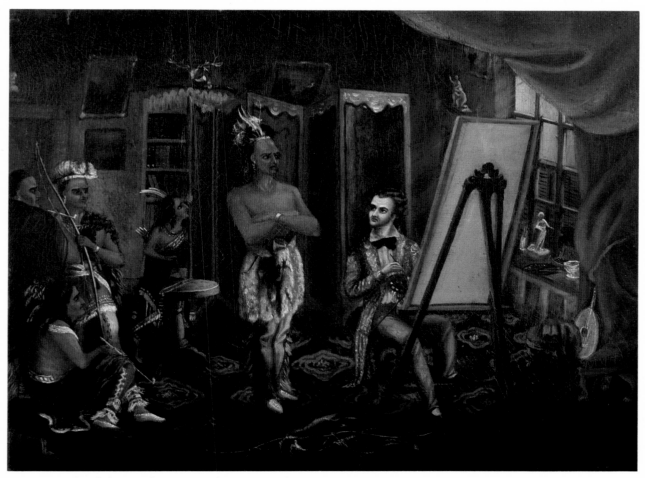

Figure 15 Unidentified artist, *The Artist's Studio*, ca. 1860, oil on canvas, 18¼" x 24¼" (46.0 cm. x 61.6 cm.), accession no. 77.101.1

Vanderlyn's cynical comments are from a rare contemporary reference to a painter well represented in this collection, Ammi Phillips. Judging from the large and diverse body of portraiture left by Phillips, he is an excellent example of a presumably self-taught painter who continued to experiment and develop fresh solutions to problems as his work progressed (see cat. nos. 121-134). Phillips's creations, however, never approached the academic sophistication of those of his critic, Vanderlyn, who by the time he became familiar with Phillips's likenesses had already spent twelve years painting in Europe.

Like Bartlett and Phillips, Joseph Whiting Stock (1815-1855) of Springfield, Massachusetts, generally rose above the level of routine formula work, particu-larly in his portraits of children (see cat. nos. 160 and 161). Stock's detailed diary and journal survive as useful written records of a nineteenth-century nonacademic professional artist.[15] Interspersed with account listings are statements revealing where he obtained his supplies, how he spent his time, and, just as important, his at-titude toward his work and his clients.[16] Stock sincerely considered himself a "fine artist," yet his journal and his paintings show him to have been a popular painter for the middle class.

Regardless of their level of competence, non-academic professional artists, like their academic peers, sought to exhibit worthy portraits and other works in juried showings at prestigious institutions. In 1835 Horace Rockwell, whose unique trade sign advertising

his portrait work is in this collection (fig. 17), exhibited at the well-known Artists' Fund Society in Philadelphia. In later life it is said that Rockwell "would quietly steal away" from his Indiana residence and travel to Cincinnati or New York City, where he won numerous prizes in art competitions and where he could sell his oil paintings at good prices.[17] Like other artists of his period and earlier, Rockwell probably also relied on impromptu, self-promoting hotel lobby exhibitions to advertise and promote his work. Typical of the practice is the following notice, excerpted from an 1800 issue of the *Connecticut Courant*:

The Ladies and Gentlemen of Hartford are respectfully informed that the exhibition of Mr. Steele's Ball room, including one of the best likenesses of General Washington &c. &c. Will continue until Saturday the 31st. It may be seen through Optical Glasses provided for that purpose.
N.B. *When there is a selected company, a beautiful Bird will sing while an Organ plays.*[18]

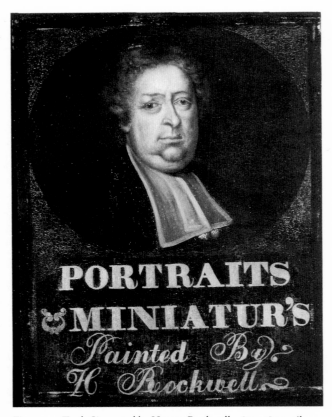

Figure 17 *Trade Sign*, used by Horace Rockwell, 1835-1850, oil on poplar panel, accession no. 79.707.2. Gift of Mr. William E. Wiltshire III. 30" x 23¾" (76.2 cm x 60.3 cm)

Figure 16 Unidentified artist, *Hepzibah Carpenter* (cat. no. 257; reproduced in color on p. 260)

Images of national leaders and military heroes were popular among all segments of society (see cat. nos. 152, 199, 209, 210, and 282). Scenic views and literary and historical themes, subjects referred to as "fancy pieces," were often treated by amateur and professional artists alike.[19] After 1840, painters encountered increasing competition from photographic portraiture, which certainly encouraged the growing importance of "fancy pieces" in the output of the nonacademic, yet professional, artist.

Such was the case with William Matthew Prior (1806-1873), a versatile artist who developed into one of the more productive painters of his time. Although portraiture remained part of Prior's trade throughout a long career, photography made increasing inroads on his commissions and necessitated a shift in emphasis; in the 1850s, he began to paint popular romantic landscape subjects and, in the 1860s, a series of inexpensive portraits on glass that depicted famous historical figures.

Prior's career began in Bath and Portland, Maine, where he first advertised as an ornamental painter.[20] Yet from the age of seventeen he was also capable of painting portraits in a fairly accomplished manner, as exemplified by the portrait of Abraham Hammatt exhibited in 1831 at the Boston Athenaeum, alongside works by such well-known artists as Gilbert Stuart (who was Prior's idol), Asher B. Durand, Thomas Cole, Washington Allston, and Thomas Sully.[21]

At the same time Prior developed an economical, simpler "flat style" of portraiture (see cat. no. 150) that enabled him eventually to compete with the booming photography business. In 1831, the year that Prior exhibited at the Boston Athenaeum, he ran this revealing advertisement in the *Maine Inquirer:* "Persons wishing for a flat picture can have a likeness without shade or shadow at one quarter price."[22] A rare printed label attached to the back of one of Prior's cut-rate likenesses also shows his response to competition from other artists and from the daguerreotype studios: "POR-TRAITS/PAINTED IN THIS STYLE!/ Done in about an hour's sitting./Price $2,92, including Frame, Glass, &c./Please call at Trenton Street/East Boston/WM. M. PRIOR."[23]

Although Prior is credited with having conceived this style of rendering portraits, in actuality two relatives, Sturtevant J. Hamblin (fig. 18) and George Hartwell, carried his stylistic innovations to their logical conclusion. They attained a level of abstraction and pure decoration rarely achieved by Prior. His keen sense of business and economic need caused Prior to merchandise his art at the expense of fully developing his artistic abilities.

The price scale of portraiture, its direct relationship to the amount of time invested by an artist to complete a portrait, and the consequent effect of price on the "look" of what is termed "folk" portraiture is nowhere better illustrated than in small-scale or miniature portraits painted by nonacademic artists who are often best known for their large-scale canvases and panels.[24] During the first forty years of the nineteenth century, cut or painted profiles and other forms of miniature portraits had mass appeal because they tended to be the least expensive kind of portrait available, were portable, and could serve as an intimate remembrance of a loved one. The popularity of small-scale portraits in the period 1800-1840 is witnessed by the case of J. H. Gillespie (see cat. nos. 76-80). A miniaturist who recently emerged from anonymity, Gillespie claimed to have painted over thirty thousand likenesses during his career![25]

John James Trumbull Arnold, whose large-scale portraits in oil have likewise only recently been identified, created a rare, perhaps unique, self-portrait with advertisement in watercolor and ink on paper on which he calls himself a "Professor of Penmanship/Portrait and Miniature painter, etc., etc." (fig. 19). The inscription suggests a multifaceted career, a significant part of which he evidently spent in painting miniatures.

Advertisements published by artists in eighteenth- and nineteenth-century newspapers further document four basic categories of miniatures. In ascending order of expense and relative complexity, they included cut profiles, or "silhouettes" (for example, see cat. nos. 95, 235, 236, 252, 253, 255, and 266); profiles painted in watercolor on paper (for example, see cat. nos. 136, 142, 143, 221, 222, and 267); full-face portraits painted in watercolor on paper (for example, see cat. nos. 146, 147, 158, 167, and 251); and miniatures painted on ivory (see cat. nos. 117 and 281).

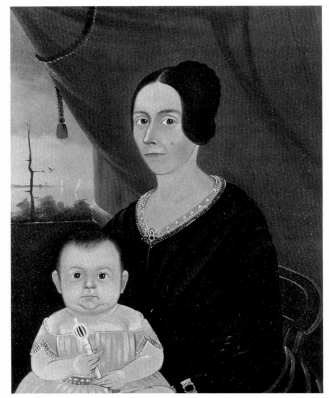

Figure 18 Signed by Sturtevant J. Hamblin, *Woman and Child by a Window,* dated 1848. National Gallery of Art, Washington, D.C.

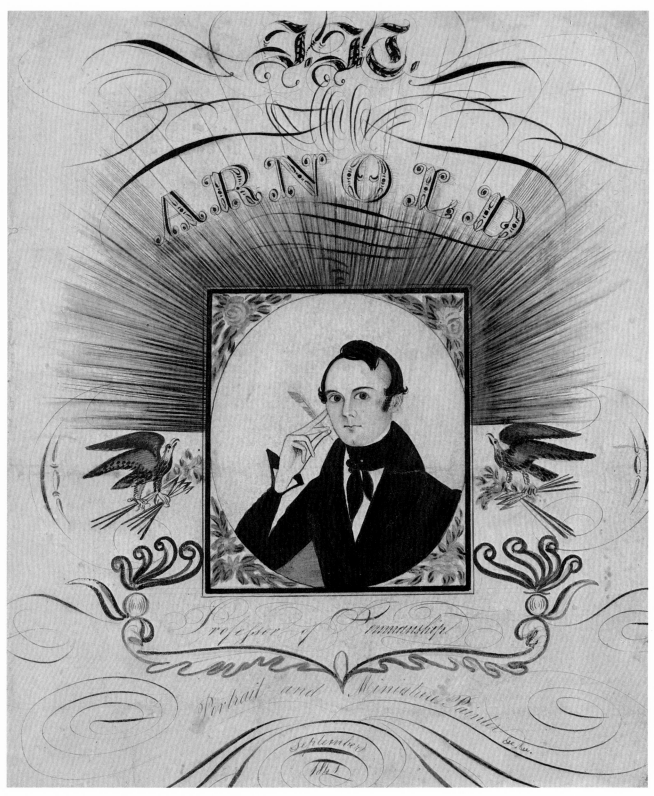

Figure 19 John James Trumbull Arnold, *Self-Portrait* (cat. no. 4)

The least expensive type of portrait available in the first half of the nineteenth century was the common cut profile, or silhouette, as the form is known now. Since they were produced quickly they were cheap, and by folding a piece of paper in half first, two profiles could be cut at the same time. The two basic types of cut profiles include the hollow-cut sort, in which the area that the figure occupies is cut away from a piece of paper, usually white, and then backed by black paper, fabric, or reverse-painted glass; and the cut-and-paste variety, where the profile of the subject is cut out of a piece of paper and adhered to a background of contrasting color. The fine details of the head, including hair and hair ribbons, were usually added to the finished profile with black ink, watercolor, or pencil rather than being cut, and gilt was sometimes used for interior accents.

Professional artists often developed shortcuts in style and technique that further speeded their production of likenesses and created a formula look. In fact, the notion that individual heads were added to previously prepared stock bodies can be much better documented in miniatures than in full-scale portraits.[26] Although the sitter's individuality obviously suffered, subjects were sometimes given more or less the same body by use of techniques that involved press printing by woodblock (fig. 20), engraving, or lithography (fig. 21).

Side views in which the head was painted or drawn rather than cut in silhouette required more skill and time than common cut profiles and cost more. The price

CORRECT LIKENESSES.
TAKEN WITH ELEGANCE AND DESPATCH BY
RUFUS PORTER.

Prices as follows—
Common Profile's cut double, - - $.0 20
Side views painted in full colours, - - 00
Front views, - - - - - - - 3 00
Miniatures painted on Ivory, - - 8 00
☞ *Those who request it will be waited on, at their respective places of residence.*

Figure 22 *Handbill for Rufus Porter*, 1815-1820, engraving on paper. Courtesy of the American Antiquarian Society, Worcester, Massachusetts

Figure 20 Unidentified artist, *Profile of a Woman* (cat. no. 235)

Figure 21 Unidentified artist, lithographed "stock" body, 1830-1835 (see cat. no. 266)

scale in the handbill of the New England artist Rufus Porter (fig. 22) indicates graduated prices.[27] Although the cost for side views has been obliterated in Porter's advertisement, he probably charged one dollar.[28] A designation for this category of profile portraiture may be attributed to Justus Dalee, a New York state artist (see cat. nos. 46-48), who aptly described himself in a business directory as a "Side Portrait Painter." Ruby Devol

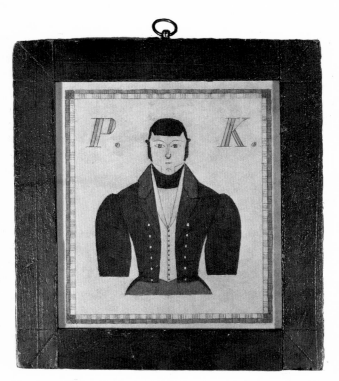

Figure 23 Unidentified artist, *Mr. P. K.* (cat. no. 251; reproduced in color on p. 256)

eliminating the need for accurate draftsmanship and ignoring the real features of the sitter (fig. 23).

Small likenesses executed on ivory rather than on paper commanded the highest prices in miniature portraiture, often twice those of full-face miniature portraits on paper, the next most expensive alternative. Painting on ivory required a familiarity with the support material and special techniques that were quite different from those used in painting on paper.[29] *Miniature Portrait of a Man* (see cat. no. 117), attributed to Abraham Parsell, a New York City miniaturist who worked primarily on ivory, exhibits two interesting techniques. First, the ivory has been lightly scored with closely spaced parallel lines to facilitate the adherence of paint; second, the artist applied paint on the back of the ivory so that soft tints are transmitted through the translucent support and become a part of the portrait.

Technique, particularly the shortcut methods used by many nineteenth-century portrait painters who catered to the widespread demands for cheaply and quickly produced likenesses, was usually related to price. Frequently—and often regardless of an artist's potential for producing more accomplished, finished work—a client got just as much "art" as he was willing to pay for. Some of the more conventional labor- and cost-saving devices included the physiognotrace, pantograph, camera obscura, collage elements, and printed stock bodies.

In 1794 the Reverend John Caspar Lavater published his *Essays on Physiognomy,* in which one engraved plate illustrates an elaborate technique for taking profiles on translucent oiled paper by using a mechanical device that in the process also steadied the pose of the sitter.[30] It is interesting to note that the 1854 will and inventory of personal property belonging to Joseph Whiting Stock shows under a listing of "Paintings" one "lot (50 or 60) of Crayon Heads on oiled paper," which may reflect his use of such a device.

In 1826 Rufus Porter published the third edition of a self-instruction manual for amateur and professional artists entitled *A Select Collection of Valuable and Curious Arts and Interesting Experiments.*[31] One entry gives instructions for "the construction and use of a copying machine." This instrument, better known as a pantograph, consists of bars forming a parallelogram with a fixed fulcrum or foot. It was used by artists to reduce, enlarge, or simply copy linear images in the same scale. For example, an image of a life-size profile could be reproduced in miniature by using a pantograph.

Finch, a talented female amateur artist, painted portraits of her neighbors only in profile (see cat. nos. 72 and 73), while Jacob Maentel, a professional, worked in profile (see cat. nos. 107-110) until the mid-1820s, when he began to paint his subjects full face (see cat. nos. 111-113). The collection's portrait of Miss Rebecca Freese (see cat. no. 267) by an unidentified artist is noteworthy because it illustrates the subtlety of draftsmanship and precision of detail that such artists sometimes attained.

"Front Views," which included three-quarter and full-face positions of the head, were more expensive because they required much more professional experience and artistic skill. The three-quarter likeness of the Williams child (see cat. no. 258) seems to reveal the anonymous creator's awkward struggle to define the facial structure and suggests that profile portraiture was a much safer medium for the less skilled artist. Some amateurs and professionals avoided the complexities of full- and three-quarter-face portraiture by simply reducing the portrait to a decorative abstraction, thereby

Portable Camera obscura

Figure 24 *Camera Obscura*, from *The Artist's Repository and Drawing Magazine*, III (London, 1785-1794). Collection of Earl Gregg Swem Library, College of William and Mary, Virginia

portunity; *the Ladies are particularly informed that he takes their Profiles without their faces being scraped with the Machine, or their being "under the disagreeable necessity of retiring into a dark room or having the shadow varied by the flare of a candle," as he makes use of neither.*[34]

Various decorative, time-saving methods recur in the work of folk portrait painters. In respect to collage techniques, the names of Ruth Henshaw Bascom (see cat. no. 15), who worked primarily in Massachusetts, and R. W. and S. A. Shute, a team who worked in New England and upper New York state, are perhaps the best known. For example, the jewelry in the miniature portrait *Lady in Blue* (see cat. no. 158) is fashioned with gilt foil to give a three-dimensional effect. Another well-documented miniature portrait painter, James Sanford Ellsworth, utilized embossed papers or envelopes used for valentines to frame some of his profile likenesses (see artist's biography, p. 90). The portrait of Abigail Parsons and its companion, which have been attributed to A. D. Parsons (see cat. nos. 118 and 119), illustrate how

In addition to those for the pantograph, Porter supplied specific instructions for constructing a somewhat more complex mechanical aid for obtaining miniaturized portraits, the camera obscura, a rather simple device that enabled the operator to draw accurately the outlines of objects or scenes viewed in front of it.[32] Simply put, in a camera obscura (fig. 24) an image of the subject is reflected, rebounded, and drastically reduced in size onto a piece of paper by employing a darkened box or chamber usually fitted with two mirrors and a simple convex lens. Figure 25 shows the reverse of a miniature watercolor portrait by Edwin Plummer, an early nineteenth-century Boston artist. The backs of other Plummer miniature portraits bear similar trial or preliminary pencil profiles characteristic of those obtained by the use of a camera obscura or other optical or mechanical aid.

A certain mystique surrounded the unusual mechanical or optical contraptions, and when properly promoted, they served as effective advertising.[33] But some artists who did not rely on such devices stressed their unpleasant aspects, as did William King in a broadside describing his own technique:

The correctness of his Profiles is so well known, he presumes that those who want will not neglect the op-

Figure 25 Reverse of miniature by Edwin Plummer (cat. no. 135)

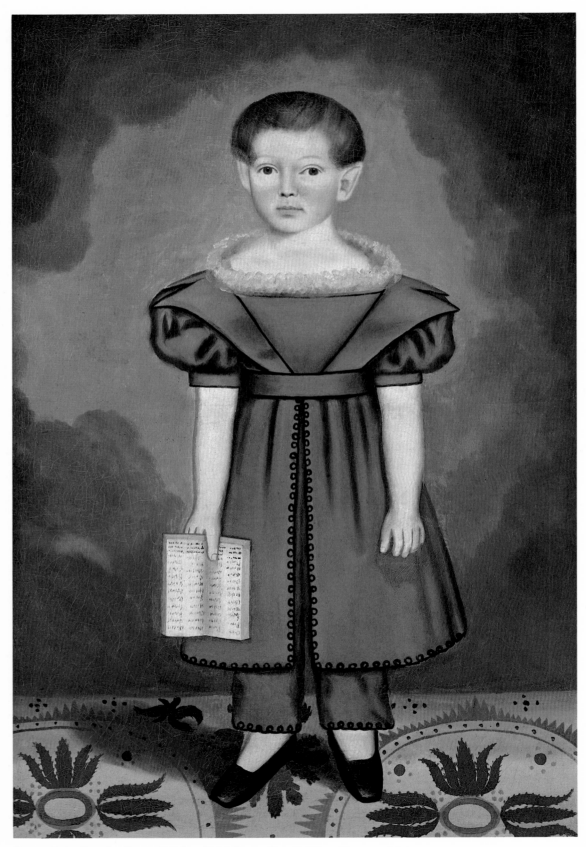

Figure 26 Attributed to Erastus Salisbury Field, *Boy on Stenciled Carpet* (cat. no. 69)

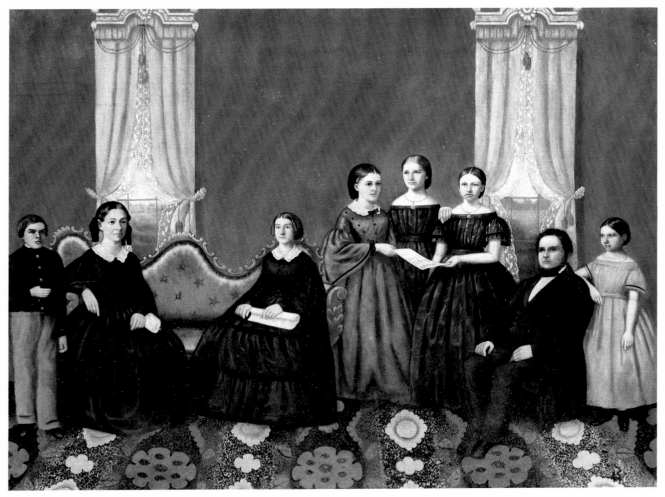

Figure 27 Attributed to Erastus Salisbury Field, *The Smith Family* (cat. no. 71)

a printer's stock ornamental border could be used to provide a decorative frame for an otherwise rather conventional profile.

While the development of mechanical aids and decorative techniques provided either greater realism or ornamental charm, the introduction of photography in the 1840s, offering a way to obtain cheap, lasting images of family and friends, jeopardized the careers of numerous portrait painters who could not compete with the acute accuracy of the camera.[35] The craze for portrait photography at mid-century is expressed well in an excerpt from an article by T. S. Arthur in *Godey's Lady's Book* in 1849:

If our children and children's children to the third and fourth generation are not in possession of portraits of their ancestors, it will be no fault of the Daguerreotypists of the present day; for, verily, they are limning faces at a rate that promises soon to make every man's house a Daguerrean Gallery. From little Bess, the baby, up to great great-grandpa', all must now have their likenesses; and even the sober Friend, who heretofore rejected all the vanities of portrait-taking, is tempted to sit in the operator's chair, and quick as thought, his features are caught and fixed by a sunbeam.[36]

The portrait painter countered this unexpected competition from the camera by various means and

with varying degrees of success. Miniaturists, who were the artists most threatened by the process, often trimmed their painted portraits to fit the fancy new daguerreotype cases equipped with embossed brass mats (see cat. nos. 297 and 298). Some self-taught painters, recognizing the limitations of their skill and lured by the money-making potential of the new invention, abandoned the brush and became camera operators. Other well-established folk artists, like the handicapped itinerant Joseph Whiting Stock, took photographers as partners and set up daguerreotype studios where they offered both photographic and painted images. Many portrait commissions were based on daguerreotypes rather than on long sittings.

The use of the photograph as a technical aid was endorsed in an essay entitled "The Daguerreotype" that appeared in *The Bulletin of the American Art-Union* for November 1850 (p. 131):

Art has nothing to fear from this invention. On the contrary, she has everything to gain; for she can verify by it her imitations of lines and masses, and her nice gradations of lights and shadows.

Despite his appreciation of the photographic image, the writer was quick to point out that mechanized picture making was an inadequate substitute for a carefully painted portrait:

When we think, however, that the Daguerreotype can only give us the aspect of a face as it appears during a mere moment of time, and that our ideas of that face are formed from the combination of a great number of its appearances at various times, and that its characteristic expression comes and goes . . . we shall cease to wonder that a photograph is so often unsatisfactory, and the artist's portrait so much more life-like. It is he only who can catch this fleeting peculiarity, which distinguishes his sitter from all other people; – this looking of the soul out of the features, which, after all, is what we observe and remember.

Perhaps the most obvious effect of the camera's influence was the tedious similarity of pose and composition that permeated second-rate academic and much folk portraiture by mid-century. The late portraits by Erastus Salisbury Field are a case in point. A comparison of *Boy on Stenciled Carpet* (fig. 26) with *The Smith Family* (fig. 27) emphasizes the startling changes in composition and palette that resulted from Field's attempt to approximate the realism of the daguerreotype. Zedekiah Belknap, Aaron Dean Fletcher, James Herring, and Asahel Powers are other artists represented in this collection who responded to the introduction of photography by shifting to a more realistic painting style that obscured or eliminated the interesting nonrepresentational elements for which folk portraiture is admired today – simplification, decorative patterning, and vivid contrasting color. By 1870 the accuracy and immediacy of the inexpensive photograph had diminished the demand for portraits by semiskilled painters. Thereafter, the painted likeness, once the most prevalent form of folk art, was only occasionally commissioned from studio-trained academic artists and was rarely attempted by others.

The twentieth-century enthusiasm for and appreciation of folk portraits reflects both a revival of interest in the lives and culture of ordinary people and an awareness and acceptance of contemporary art. Many of the aesthetic qualities that we find exciting in folk portraits, such as distortion, abstraction, and multipoint perspective, were simply intuitive solutions to technical artistic problems involved in rendering anatomy, light, and space. Ironically, the best naive portraits – those that reveal an inherent sense of design and present interesting visual effects – are appreciated today for the very omissions and simplifications which, in their own time, surely caused them to be considered merely adequate substitutes for the more fashionable – and more expensive – academic likenesses.

DONALD R. WALTERS AND CAROLYN J. WEEKLEY

NOTES

[1]*The Yankee; and Boston Literary Gazette,* N.S., I (1829), p. 48, quoted in Harold Edward Dickson, ed., "Observations on American Art: Selections from the Writings of John Neal (1793-1876)," *Pennsylvania State College Bulletin,* XXXVII (February 5, 1943), p. 42.

[2]*Ibid.,* pp. ix, xi, and xxi. In 1829 Neal was referred to by young Edgar Allan Poe as one "who now and then hitting, thro' sheer impudence, upon a correct judgement in matters of authorship, is most enviably ridiculous whenever he touches the fine arts –." Later,

C. Edward Lester in *The Artists of America* (New York, 1846) remarked, "The opinions of a man like John Neal, which ought to outweigh in such a matter the criticisms of a regiment of politicians, are unheeded...his opinion about art would be treated by many persons as worth just exactly as much as John Smith's."

[3]For general discussion of these matters, two sources are recommended: Neil Harris, *The Artist in American Society: The Formative Years, 1790-1860* (New York, 1966), pp. 2-88; and Joshua C. Taylor, *The Fine Arts in America* (Chicago, 1979), pp. xiv-45.

[4]Frederick W. Coburn, "Thomas Child, Limner," *American Magazine of Art*, XXI (June 1930), p. 327. The true meaning of Sewall's poem may never be known, but at least one art historian, the late William Sawitzky, disagreed with Coburn's interpretation and felt that the verse referred to Child as a painter of hatchments on coffins. See Groce and Wallace, p. 124.

[5]A few other American portrait painters, including John Wesley Jarvis and William S. Gookin, occasionally advertised that they did posthumous likenesses. Two of Joseph Whiting Stock's best-known children's portraits were painted posthumously, *Jane Henrietta Russell*, in the Shelburne Museum, and *The Young Hammerer*, New York Historical Association, Cooperstown.

[6]Holdridge and Holdridge, *Ammi Phillips*, p. 14.

[7]There are various contemporary comments on this subject, but perhaps those scholars most often quote are John Singleton Copley's, who noted that Americans regarded art as "no more than any other useful trade...like that of a carpenter, tailor, or shoe maker, not as one of the most noble arts in the world." Harris, *The Artist in American Society*, p. 8.

[8]Richard C. Nylander, "Joseph Badger, American Portrait Painter" (M.A. thesis, State University of New York College at Oneonta, 1972), p. 15.

[9]*Ibid.*, pp. 18-19.

[10]Little, Hathaway, p. 95.

[11]*Ibid.* In addition to portraits and miniatures, a genre scene derived from a print and an overmantel panel are also attributed to Hathaway.

[12]As quoted in Nina Fletcher Little, *Country Art in New England, 1790-1840* (Sturbridge, Mass., 1965), p. 4.

[13]"From Tunbridge, Vermont to London, England—The Journal of James Guild, Peddler, Tinker, Schoolmaster, Portrait Painter, From 1818-1824," Vermont Historical Society, *Proceedings*, N.S., V (1937), p. 268, hereafter cited as "Guild's Journal."

[14]Holdridge and Holdridge, *Ammi Phillips*, p. 14.

[15]For additional information on Stock's life and career, see Tomlinson.

[16]*Ibid.*, p. 27. In an entry concerning a particularly bleak stay in New Bedford, Mass., in 1842, Stock wrote, "Business was very dull during the time I spent in the place which together with the political troubles in the State, diverted the mind of the public from patronizing the Fine Arts."

[17]Peat, p. 111.

[18]*Connecticut Courant* (Hartford), May 26, 1800.

[19]*Ibid.* Among the typical nonportrait work listed in Stock's *Journal* are the painting of two full-sized skeletons for Dr. Swan, two transparent window shades, George Washington on an engine, signs, landscapes, and a selection of "fancy pieces" that were variously titled "The Twins," "The Sisters," "My Dove," "My Dog," "Morning Walk," and so forth.

[20]Little, Prior, pp. 44-45.

[21]*Catalog of the Fifth Exhibition of Paintings in the Athenaeum Gallery* (Boston, 1831), no. 213.

[22]Little, Prior, p. 45.

[23]*Ibid.* See also Selina F. Little, "Phases of American Primitive Painting," *Art in America*, XXXIX (February 1951), pp. 6-24.

[24]The popularity of miniature portraits and small-scale likenesses in America was the result in great part of the influx of foreign, chiefly French, painters throughout the 1790s and particularly during the years of the French revolution. The immigrant artists traveled everywhere and executed an extraordinary number of images. Men like Charles Balthazar Julien Fevret de Saint-Mémin, Pierre Henri, and Joseph-Pierre Picot de Limoëlan de Clorivère produced small, inexpensive portraits for a large clientele, and no doubt their success prompted local American artists to try their skills. The early miniature portraits and profiles made by various members of the Peale family also contributed to the popularity of small portraits in America.

[25]*Baltimore Sun*, December 9, 1837.

[26]In the 1930s the formula poses and prodigious output of artists like Erastus Salisbury Field, Ammi Phillips, and Joseph Whiting Stock engendered among scholars a theory that itinerant portraitists spent their winters preparing a supply of canvases with body and backgrounds prepainted so that only the customer's head was needed to complete the composition. To date, no large-scale headless likenesses by nonacademic artists have appeared to support this hypothesis, which is now generally discounted.

[27]Porter's original printed handbill, reproduced as fig. 22, is in the American Antiquarian Society, Worcester, Mass.

[28]"Rufus Porter, Founder of the Scientific American," *Scientific American* (September 6, 1884), p. 144.

[29]"Guild's Journal," p. 295. The following quotation from the journal illustrates perfectly the apprehension novices had about painting on ivory: "I been in the habit of painting on paper and a Gentleman says, cant you paint on Ivory? Oh yes but I am out of Ivory [Guild's standard reply]. Very well I have a piece and you may paint my miniature, so for the first time I attempted Ivory painting and went so much beyond my expectations that I thought I soon would be a dabster."

[30]Rev. John Caspar Lavater, *Essays on Physiognomy* (1794), as discussed in Mrs. E. Nevill Jackson, *Silhouette: Notes and Dictionary* (New York, 1938), pp. 123-124, illus. as pl. 63 opposite p. 68.

[31]Third ed. (Concord, N.H., 1826), pp. 53-57.

[32]The camera obscura was known in ancient times and was accurately diagramed and used by Leonardo da Vinci in the fifteenth century. More recently it was employed by artists in the nineteenth century as an aid in profile taking, perspective drawing, and the projection of outdoor scenes.

[33]In various advertisements the profilist J. H. Gillespie invited public inspection of "his very curious and elegant apparatus" and his "curious optical and mechanical instruments." See the *New Brunswick Courier*, November 6, 1830, and the Baltimore *Sun*, December 9, 1837.

[34]The original broadside is in the American Antiquarian Society and is quoted in Carrick, pp. 49-50.

[35]A surviving 1841 broadside by A. & E. H. Clark of West Stockbridge, Mass., emphasizes the significant effect photography had on portrait painting: "The value of a portrait depends upon its accuracy, and when taken by this process it must be accurate from necessity, for it is produced by the unerring operating of physical laws—human judgement and skill have no connection with the perfection of the picture...it is evident that the expression[s] of the face may be fixed in the picture which are too fleeting to be caught by the painter." The broadside is reproduced in Edna Bailey Garnett, *West Stockbridge, Massachusetts, 1774-1974...* (Great Barrington, Mass., 1974), p. 109.

[36]T. S. Arthur, "American Characteristics, No. V—The Daguerreotypist," *Godey's Lady's Book* (May 1849), p. 352.

Notes on the Catalog

The portraits are organized in two groups: those by or attributed to known artists, and those by individuals whose identity is undetermined. The first section, known artists, is organized alphabetically by surname. For multiple entries by the same artist, the artist's name is cited at the beginning of the series and works are listed chronologically by date of execution; identified sitters painted in the same year appear in alphabetical order. When a work is signed, or other period documentation exists, the title is cited without further qualification as to authorship. Otherwise, "attributed to" implies acceptance of authorship on the basis of style; "probably" and "possibly" denote diminishing degrees of certainty; "style of" indicates an apparent stylistic influence by that artist, not an attribution to him.

In the second section, likenesses by unidentified artists are arranged chronologically by date of execution. When dates of execution coincide, portraits of known sitters, arranged alphabetically, precede those unidentified.

A circa date indicates the compiler's approximation of the time of execution, and spans as much as five years on either side of the year given. The medium used is noted, and where wood supports are used, species are identified only if the wood was microscopically analyzed. Actual measurements—i.e., support size—are cited with height preceding width. Separate measurements are provided for companion portraits only where differences register ¼ inch or more; where differences are less, the measurements of the largest painting only are given.

Any signature, date, or inscription found on a painting is recorded exactly as it appears and the location is noted as precisely as possible. Where examination of watermarks on paper supports was possible, these marks are cited and identified as to manufacturer when known. All documented information detailing the conservation history of a particular portrait is summarized under *Condition*.

The provenance is given in chronological sequence, starting with the earliest known owner. The last name cited may be assumed to be the source from which the Folk Art Center acquired the portrait. The first two digits in museum accession numbers indicate the year of the acquisition.

Where and when the portrait has been on public view is given under *Exhibited*. The short titles of exhibitions and institutions used in this section are listed alphabetically and spelled out in the exhibitions list on page 291.

Similarly, if the portrait has been discussed or reproduced in the literature, the pertinent publications are given under *Published*. The short titles used in this section are spelled out in the publications list on page 293, and this list, along with occasionally cited sources in the notes, functions as the catalog's bibliography.

Generally, the use of color for, and the size of, an illustration represent curatorial judgment concerning a portrait's quality and relative importance to the Williamsburg collection. Miniatures, however, are consistently pictured actual size or smaller.

KNOWN ARTISTS

2

Aldridge (or Oldridge)
(active 1808)

1	**William Bell**	1978-139
2	**Sarah Bell**	1978-140
3	**Woman of the Bell Family**	1978-141

Aldridge or Oldridge
Fauquier County, Virginia, 1808
Pastel on paper
23″ x 18¾″ (58.4 cm. x 47.6 cm.)

The three Bell family likenesses represent a new discovery in Virginia portraiture. They are stylistically related to two Fauquier County charcoal sketches of Mr. and Mrs. William Edmonds, assigned to "Oldridge" in Linda Crocker Simmons's catalog on Jacob Frymire and his contemporaries.[1] The Edmonds sketches presumably were studies for oil paintings and they are inscribed "Oldidge – pinter" and "taken by Mr. Oldridge."[2] The writing style of the inscriptions differs from the Bell markings and the inconsistent spelling of the artist's name suggests that they were written by someone other than the artist. For this reason and because the name "Oldridge" is uncommon in early Virginia, the preferred spelling is thought to be "Aldridge," a surname that appears regularly both in state records and in Fauquier County.[3] Unfortunately, no artist named Aldridge has been identified, although another privately owned pastel in Berryville, Virginia, has been attributed to him.[4]

The Bell portraits are capably drawn and exhibit some knowledge of academic techniques. The coloration of the two women's likenesses is especially appealing. The skin tones are soft and modeling is held to a minimum. Sarah Bell wears a medium blue dress with a sheer white lace collar and holds two pink roses in her right hand. Various tones of the same blue were used for her eyes and to lighten the background nearest her face. The miniature portrait case she wears on a gold chain is reversed to show the back with the letter "C" in hairwork. The older Bell woman wears a similar dress with a white fichu and a bonnet trimmed with a pink ribbon.

Stylistic peculiarities in these likenesses, which include the elongated heads, long, thin-bridged noses, almond-shaped eyes with the pupil placed abnormally high in the iris, and the full lips separated by a long line and set off by heavy shadow below the lower lip, should be helpful in identifying other works by Aldridge.

Inscriptions/Marks: Inscribed in ink on the original wood panel backing of no. 1 is "Wm. Bell's likeness/1808/by Aldridge." An inscription by the same hand on the original wood panel backing of no. 2 reads "S Bell's Likeness/Sarah Bell/1808/By Aldridge Fauquier County, Virginia."

Condition: Conservation treatment for no. 2 only by E. Holly-day in 1978 included surface cleaning the front and back, reducing buckles in the support, and mending and filling small tears and losses. Number 1 exhibits no evidence of previous conservation and is badly water stained around all the edges, with considerable flaking and loss throughout. Number 3 has never been treated and also has some water stains around all the edges and minor losses throughout. All three portraits retain their original 1½-inch molded frames, painted black.

Provenance: Georgia Luthy, Alexandria, Va.

[1]See the exhibition catalog, Frymire, pp. 46-48, illus. as nos. 38 and 39 on p. 50.
[2]*Ibid.,* p. 48.
[3]Research files, Museum of Early Southern Decorative Arts, Winston-Salem, N.C., list a John Aldridge and Joseph W. Aldridge in northern Virginia during the approximate period of the portraits; the 1810 Virginia census includes a Dr. James Aldridge in Fauquier County.
[4]Linda Simmons to AARFAC, November 9, 1978.

John James Trumbull Arnold
(1812-ca. 1865)

John James Trumbull Arnold's mid-century portraiture is only beginning to emerge from obscurity, and although several examples of his distinctive style have now been identified, many facts of his life remain unknown. Born September 29, 1812, he was one of eight children of Dr. John B. Arnold and his wife, Rachel Weakley Arnold, of Latimore Township, York County, Pennsylvania.[1] Evidence that Arnold was active at least

1 3

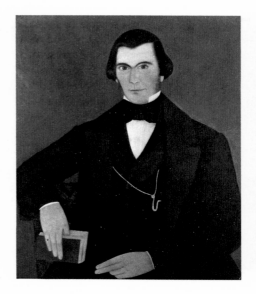

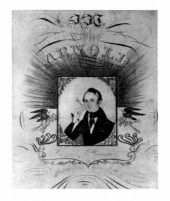

4 John James Trumbull Arnold, *Self-Portrait*, above

5 Attributed to Arnold, *County Squire*, far left

6 Attributed to Arnold, *Squire's Wife*, left

as early as 1841 is offered by no. 4, a combination self-portrait and advertisement for the artist's capabilities in penmanship, portraiture, and miniature painting. Arnold reportedly worked until shortly after the Civil War, when he is said to have "drunk himself into an early grave."[2] The exact place, date, and circumstances of his death have not yet been determined.

Although itinerant portraitists were generally diminishing in number by mid-century, Arnold was an exception. In addition to several likenesses with York County, Pennsylvania, histories, Arnold is said to have worked in Washington, D.C. He also painted in northwestern Virginia (now West Virginia), as indicated by five 1849 portraits of members of the Withers family of Summit Point, Jefferson County. A likeness of a man inscribed "C K M–s/By J J T Ar–t(?)/Romney Va/April 1853" has been recorded.[3] Probably works executed in western Maryland will eventually be found.

At a time when many portrait painters began assimilating techniques that would allow them to compete visually with the photographic processes beginning to encroach on their business, Arnold's work remains refreshingly original and personal. Some twenty likenesses are recorded to date, and they show many characteristics that make his style immediately identifiable, among them extremely soft gray brown shading above – and sometimes below – the eyes. Eyelashes are individually painted, and eyebrows are usually smooth sweeping arcs of paint with little trace of the feathering

that might more realistically suggest hairs. Arnold's skill with a pen may have predisposed him to a heavy reliance on linear definition of hands and facial features; creases and wrinkles of flesh appear as barely modeled lines, giving sitters frail or pinched appearances. The elongated fingers seen in his self-portrait crop up in later oils, the hand either held flatly or bent in a droopy, rubbery fashion. Most sitters are shown seated, half-length, their right arms frequently jutting stiffly out from the body and propped on a table or chair arm.

[1] Dr. Milton Flower to AARFAC, July 10, 1979.

[2] Groce and Wallace, p. 13.

[3] The Withers portraits were ascribed to "J. J. G. Arnold" in Patty Willis, "Jefferson County Portraits and Portrait Painters," *Magazine of the Jefferson County Historical Society,* VI (December 1940), p. 24. The inscribed likeness of Mr. "C K M" is in the collection of Dan Wagoner. Romney, Va., is now a part of Hampshire County, W.Va.

4 Self-Portrait 77.300.4

John James Trumbull Arnold
Probably Pennsylvania, Maryland,
or Virginia, 1841
Watercolor, pencil, and ink on wove paper
9⅞" x 7⅞" (24.8 cm. x 20.0 cm.)
(Reproduced in color on p. 28)

This miniature self-portrait, which may have doubled as an advertisement of sorts, is an extremely rare survival.

As Arnold's most elaborate work discovered to date, it offers us ample evidence of not only his facility with a pen but also his ability as a portraitist, which interestingly – and perhaps understandably in an advertisement – conveys a rather boastful and pretentious image of the man.

Most of Arnold's large-scale oil portraits date from about ten years after this piece, which is the only example of his work in miniature yet identified.

Inscriptions/Marks: On the recto, above the likeness, handwritten in two types of ornate printing in brown ink, is "J.J.T./ARNOLD," and below the image, handwritten in script in brown ink is "Professor of Penmanship/Portrait and Miniature Painter &c, &c./September/1841." No watermark found.
Condition: Restoration prior to acquisition included backing the primary support with Japanese mulberry paper and slight inpainting in a small area at mid-right leading into an old tear. Judging by the interrupted pen strokes, it would appear that all four edges of the primary support were trimmed at some time. Probably period replacement 1¼-inch pine frame with rounded face, set-in flat corner blocks, and applied strips forming the outer edges.
Provenance: Edgar William and Bernice Chrysler Garbisch, New York, N.Y.; Edward B. Stvan, Chagrin Falls, Ohio; gift of the Antique Collectors' Guild.
Published: Sotheby Parke Bernet, Inc., *Important Frakturs, Embroidered Pictures, Theorem Paintings, and Other American Folk Art from the Collection of Edgar William and Bernice Chrysler Garbisch – Part II,* catalog for sale no. 3637, May 8-9, 1974, and illus. as lot no. 163 (titled *Rare Specimen of Penmanship*); Walters, Pt. 2, p. 1C, illus. as fig. 2.

5 **County Squire** 37.100.2

6 **Squire's Wife** 37.100.3

Attributed to John James Trumbull Arnold
Probably Pennsylvania, Maryland, Virginia, or West Virginia, ca. 1850
Oil on canvas
34⅛″ x 28″ (86.7 cm. x 71.1 cm.)

As in companion likenesses of John and Agnes Dunbar painted in York County, Pennsylvania, in 1853-1854,[1] Arnold has not bothered to adhere to the convention of posing these two sitters slightly turned toward each other, although there is little doubt they form a pair. Many hallmarks of Arnold's style are evident, including soft gray brown shading of the eyelids and tiny dark eyelashes that sprout from them one by one. Their hands demonstrate Arnold's typical treatment, consisting of linear definition, minimal modeling, crisply outlined nails, and depiction within a flat plane. Fingers are held together, and even if they are separated, as the man's are by his book, they appear unconvincing and two-dimensional. The woman's left hand provides an amusing glimpse of Arnold's attempt to produce a more naturalistic bend in the fingers; since they are still positioned together and are flatly depicted, they cannot assume the required configuration with any semblance of realism and droop like soft wax candles.

Both sitters' costumes are enlivened by touches of jewelry, and the sweeping curves of their gold watch chains add graceful lines that stand out sharply against the black of waistcoat and dress. The man wears a ruby ring surrounded by pearls; his companion is unusually bedecked by almost any standard, being adorned in dangling pearl and filigree earrings, a hair bracelet, two brooches, a watch chain, five rings, and a head ornament! The title of "squire" was undoubtedly an early twentieth-century tongue-in-cheek reference to the couple's profusion of finery.

Condition: In 1953 Hans E. Gassman cleaned and lined the paintings and inpainted scattered areas of loss. Modern replacement 3-inch molded white pine frames, painted black, with gilt liners.
Provenance: Found in New Jersey and purchased from Edith Gregor Halpert, Downtown Gallery, New York, N.Y.
Published: AARFAC, 1940, p. 20, nos. 25 and 26 (titled *New Jersey Squire* and *The Squire's Wife*); AARFAC, 1957, p. 350, nos. 181 and 182.

[1]The Dunbars' portraits, as well as those of two of their children, Mary and James, are privately owned by a descendant.

Joseph Badger
(1708-1765)

Joseph Badger, the son of Stephen and Mary Kettell Badger, was born in Charlestown, Massachusetts, on March 14, 1707/08. Nothing is known about his childhood or early training as a glazier and house painter, the profession he claimed throughout his lifetime. On June 2, 1731, he married Katharine Felch in nearby Cambridge. Two of their children, Joseph and William, followed their father's trade and moved to Charleston, South Carolina. They were probably joining their uncle, Daniel Badger, a house and ship painter who had been in Charleston since 1735. A grandson of the artist, James Badger, and a cousin named Jonathan Badger also pursued these family enterprises in South Carolina. Thus it appears that the elder Joseph founded a small

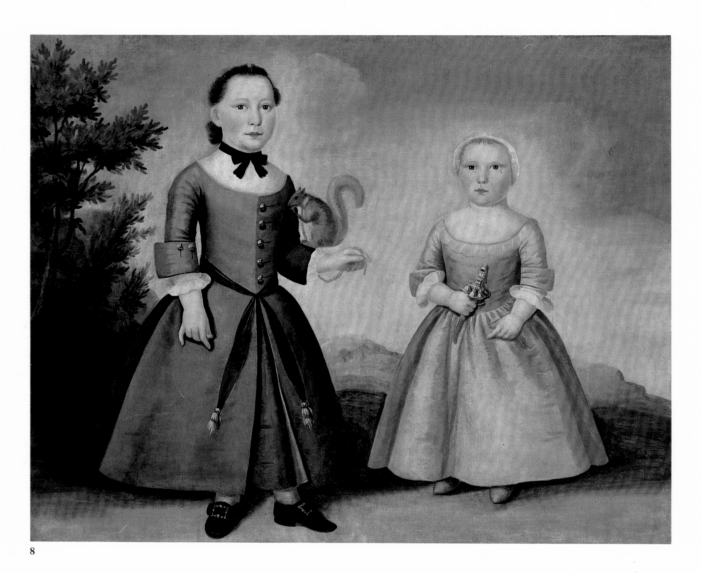

8

dynasty of craftsmen in allied painting trades, although he was the only one of the group associated with portrait painting.

The artist and his wife apparently moved to Boston in 1733, making their home near Brattle Church Square until 1763. It was probably there that Badger's abilities and interests in portrait painting were developed through contact with artists like John Smibert and Peter Pelham, who lived in the same general area, or Thomas Johnston, the early teacher of John Greenwood. Badger seems to have spent his entire career in this area of Boston, moving just two years before his death to a house and lot he purchased on Temple Street.

None of Badger's portraits is signed, and attributions to him are therefore based on several surviving portraits documented through eighteenth-century family records. The artist's biographer, Richard Nylander, notes that many of Badger's sitters were related, and thus his reputation seems to have been based on verbal recommendations; this probably accounts in some way for the lack of newspaper advertisements by Badger. Also, the fact that he was rarely listed in eighteenth-century documents as a limner may indicate that portraiture was a minor part of his business.

Badger's style and development as an artist have received little attention in published studies, although

nearly 150 of his paintings are known. Most art historians have dismissed his images as wooden and stiff and his style as amateurish, erratic, and limited. These assessments are essentially true, particularly in light of John Singleton Copley's early Boston work, which by the mid-1750s had surpassed Badger's in quality and popularity. Yet the best of Badger's portraits exhibit both charm and decorative interest, qualities that were important to aspiring eighteenth-century Americans. His use of color and the patterned effect sometimes created by the range and intensity of hues reinforce the visual impact of his work. Badger's shortcomings and his self-made solutions to techniques like linear and color perspective may appear humorous, but they are wonderfully inventive and express a kind of fresh vitality often lacking in academic portraiture produced during these same years.[1]

[1]All biographical information in this entry has been summarized from Richard C. Nylander's M.A. thesis on the artist, "Joseph Badger, American Portrait Painter" (State University of New York College at Oneonta), pp. 1-42.

7

7 Elizabeth Greenleaf 37.100.4

Attributed to Joseph Badger
Boston, Massachusetts, ca. 1751
Oil on canvas
21¾" x 17¾" (55.2 cm. x 45.1 cm.)

Although heavily restored, this likeness of Elizabeth Greenleaf still exhibits many characteristics of Badger's work. The shape of the child's head and the short, stocky neck and hands are similar to those seen in the collection's double portrait by the artist (no. 8). The pink color of the dress, the pear Elizabeth holds, and the flowers on her hat are also typical of Badger's tendency to create areas of decorative interest.

This likeness of Elizabeth closely resembles a companion portrait of her sister, Priscilla, now in a private collection. They were the daughters of Dr. John and Priscilla Brown Greenleaf of Boston. Priscilla was born on December 29, 1746, and Elizabeth on July 11, 1748. Both girls died suddenly from an undetermined illness in 1752.[1]

Condition: The portrait was heavily overpainted circa 1800. David Rosen cleaned the painting in 1937. In 1953 Sheldon Keck recleaned, lined, and replaced extensive inpainting in the face, dress, and background. Mid-nineteenth-century 2-inch concave molded frame with gilt carved inner molding.
Provenance: Frank Buckingham, Plymouth, Mass.; Katrina Kipper, Accord, Mass.
Published: AARFAC, 1957, p. 102, no. 54, illus. on p. 103.

[1]Alfred Frankenstein, "American Paintings by John Singleton Copley, Exhibition Review," *American Art Review,* II (September-October 1975), pp. 146-147.

8 Portrait of Two Children 57.100.15

Attributed to Joseph Badger
Probably Boston, Massachusetts, ca. 1760
Oil on canvas
41⅛" x 49¾" (104.5 cm. x 126.4 cm.)

This painting was found in an antique store in London in the 1950s and was subsequently identified as Badger's work through an illustration and query published in *Country Life.*[1] The identities of the sitters have never been adequately established, although there is some evidence that they are the children of Captain and Mrs. Stephen Brown of Hamilton, Massachusetts, a town just north of Boston. The association with that family is

based on the English ownership of Badger's portraits of Captain and Mrs. Brown in 1920.[2]

The details of the costumes, the pet squirrel held by the little boy, and the other child's silver and coral whistle and bells are seen in several children's portraits by Badger; however, this is the only double portrait of children attributed to him. The effect produced is impressive and ambitious, but the composition is unbalanced since the greatest decorative interest and weight is concentrated in the left half of the picture. The child on the right seems isolated, and the overall canvas reads as two separate compositions or portraits, perhaps reflecting the artist's unfamiliarity with double and group portrait formats.

Badger's method of painting and his lively sense of color are well represented in this portrait. The vibrant blues and yellows of the costumes and the pink tones of the faces are carefully handled with the simplicity and directness of one accustomed to more conventional craft practice. This tendency is especially noticeable in Badger's juxtaposition of darks, middle tones, and highlights, which creates a series of diagonal elements in the costumes. The artist was fond of deep shadows, particularly around hands and in the folds of costumes.

Condition: Russell J. Quandt lined, cleaned, replaced the stretchers, and inpainted scattered areas of paint loss, particularly in the sky, in 1957. Possibly original 3-inch molded frame, painted black.
Provenance: Found in England and purchased from the Hon. Claud Phillimore.
Exhibited: "Inaugural Exhibition: Art Across America," Munson-Williams-Proctor Institute, Utica, N.Y., October 15-December 31, 1960.
Published: Black and Lipman, p. 3, no. 16, illus. on p. 14; *Country Life,* CXXI (June 13, 1957), illus. on p. 1202.

[1]*Country Life,* CXXI (June 13, 1957), p. 1202.
[2]Lawrence Park, *Joseph Badger and a Descriptive List of his Works* (Boston, 1918), p. 10, illus. on p. 11.

Louis Joseph Bahin
(1813-1857)

Born in Armentières, France, on October 6, 1813, Louis Joseph Bahin served in the French artillery and later studied art under M. Aubert. He exhibited his paintings in Marseilles from 1832 to 1845 and was awarded a first prize by the Society of Arts in Paris for a self-portrait. Bahin married Josephine Fanny Carementrand of Man-

tua, Italy, and in 1848 the couple sailed for America with their two sons, Gustave J. and Alphonse. They landed first at New Orleans and then moved on to Natchez, where they eventually made their home. Bahin traveled up and down the Mississippi painting portraits of plantation owners and their families. He is also known to have painted genre scenes, landscapes, and illustrations from French history. On April 6, 1854, he filed a declaration of intention for naturalization in Adams County, Mississippi. He died on June 27, 1857, and was buried in Natchez.[1] Some twenty paintings by Bahin have been recorded, many of them privately owned.[2]

[1]Mrs. Louis Joseph Bahin to AARFAC, May 19, 1969.
[2]Published examples of Bahin's work include an 1853 portrait of a steamboat captain advertised by Kennedy Galleries in *Antiques,* LXXIII (April 1958), p. 324, and the 1859 portraits of John Ford Harper and Mrs. Miles Harper in Mrs. Thomas Nelson Carter Bruns, comp., *Louisiana Portraits* (New Orleans, 1975), p. 283.

9 Truman Holmes, Jr. 36.100.9

Louis Joseph Bahin
Possibly New Orleans, Louisiana, 1854
Oil on canvas
35⅝" x 25" (90.5 cm. x 63.5 cm.)

Tonal transitions in the boy's face are handled easily and convincingly, but they are too heavily weighted with gray. The resulting pallor, particularly inappropriate in a young child's face, was actually a widespread phenomenon of Victorian portraiture and probably reflects the daguerreotype's influence.

The folds in the boy's dress show the assurance of Bahin's studio training, but the artist's difficulties with anatomical passages demonstrate that the demands of full-length portraiture exceeded his capabilities. Vivid color and the busyness of the foreground foliage distract the viewer's attention from these inadequacies. An intensely blue sky, red dress, yellow straw hat, and bright green vegetation all vie for attention, while the steamboat plying the Mississippi adds a note of interest. If the subtle handling of this river vignette is any indication, considerable talent may be reflected in Bahin's landscapes,[1] although his fame rests chiefly on his portraiture.

This portrait was titled *Truman Holmes, Jr. of New Orleans* when acquired, but efforts to verify the boy's

identification have been unsuccessful. A Captain Truman Holmes, possibly the subject's father, is listed in the 1860 and 1861 New Orleans city directories; otherwise, no person with the name has been located there.[2]

Inscriptions/Marks: "Bahin/1854" was painted on the rock at lower left but the inscription is barely visible. Early records indicate that "Bahin" once appeared on the reverse of the canvas, but the lining now obscures any such inscription.

Condition: In 1936 Sidney S. Kopp cleaned the painting, lined it, and extensively inpainted the edges of the canvas and the dog's legs. William Young recleaned and further retouched the painting in 1951. Modern replacement 3⅛-inch cove-molded frame, painted gold.

Provenance: Katrina Kipper, Accord, Mass.

Exhibited: "American Folk Art, 1730-1968," Anglo-American Art Museum, Louisiana State University, Baton Rouge, March 1-April 15, 1968, and exhibition catalog, no. 4, and illus. as no. 4 in "Folk Art of the South"; Philbrook Art Center.

Published: AARFAC, 1957, p. 351, no. 186; Helen Comstock, ed., *The Concise Encyclopedia of American Antiques,* II (New York, 1958), illus. as pl. 209c opposite p. 336.

[1]Several Bahin landscapes are privately owned. Mrs. Louis Joseph Bahin to AARFAC, May 19, 1969.

[2]Collin B. Hamer, Jr., New Orleans Public Library, to AARFAC, October 11, 1976.

9 Louis Joseph Bahin, *Truman Holmes, Jr.*

Lucius Barnes
(1819-1836)

10 Mrs. Martha Atkins Barnes 35.300.2

Lucius Barnes
Probably Middletown, Connecticut, probably 1834
Watercolor and ink on heavy wove paper
7½" x 6½" (19.1 cm. x 16.5 cm.)

Martha Atkins Barnes, second daughter of Martha and Thomas Atkins, was born in Middletown, Connecticut, on June 17, 1739. In 1758 she married Jabez Barnes, a seafaring man, and the couple had ten children, eight of whom were living at the time of Jabez's death in 1782. The subject died in Middletown at the age of ninety-five on October 10, 1834, presumably the same year in which this portrait and at least seven others of her were created by her fifteen-year-old grandson, Lucius Barnes.

In the year of Martha's death, her pastor, John Cookson, wrote and locally published her memoir, which provides insight into her character.[1] As Martha matured, she became deeply religious and affiliated her-self with the Strict Congregationalists, later joining the Baptist Church in 1805. Her husband did not sympathize with her beliefs and often forbade her to attend services. Once when he threatened to take her life if she disobeyed him, Martha asked her minister whether she should seek refuge at her sister's house. He replied: "No, go right home, and if he shoots you, you will be in heaven before morning."[2]

One of the recorded portraits of Martha Atkins Barnes is tipped into a copy of Cookson's *Memoir.* Perhaps the others were also meant to illustrate copies of the book. According to an undated verso inscription, at least one likeness was supposedly "made from life."

The artist, Lucius Barnes, was the son of Martha Barnes's youngest son, Elizur. He had been crippled at an undetermined time during his short life and died at the age of seventeen. His eight recorded profile drawings of his grandmother, which show her either walking with a cane while sometimes smoking a clay pipe or seated in

a chair reading the Bible, inspired at least two other versions of this well-remembered Middletown personality by other family amateur artists.[3]

Inscriptions/Marks: In ink on the reverse are doodles and partial sketches of two heads, various initials ("H," "D," "L"), and the name "Martha." No watermark found.

Condition: At an unspecified time, probably before 1935, the entire figure, chair, and floor areas were cut out and adhered to a modern piece of paper. Restoration between 1954 and 1956, probably by Christa Gaehde, included removal from a pulpboard mounting and inpainting small areas of loss. Restoration by E. Hollyday in 1974 involved flattening, repair of nail holes in the edges of the primary support, and dry surface cleaning of unpainted areas. Possibly original 3⅛-inch rosewood-veneered cyma reversa frame with gilt liner and trim.

Provenance: Stephen Van Rensselaer, Williamsburg, Va.

Exhibited: "The Inner Circle," Milwaukee Art Center, September 15-October 13, 1966; Smithsonian, American Primitive Watercolors, and exhibition catalog, p. 4, no. 7.

Published: AARFAC, 1940, p. 26, no. 56; AARFAC, 1947, p. 24, no. 56; AARFAC, 1957, p. 218, no. 112, illus. on p. 219.

[1]A copy of the *Memoir of Mrs. Martha Barnes,* published in Middletown by Edwin Hunt, is in the Connecticut State Library, Hartford.

[2]*Ibid.*

[3]The two portraits are undated. One is by Thomas Atkins, a nephew of the subject; the other is attributed to Culmer Barnes, Martha Barnes's great-grandson.

10

Jonathan Adams Bartlett (1817-1902)

Bartlett was largely unknown except by family descendants before 1976, when J. E. Martin published an extensive investigation of the artist's life and work prior to the public auction of Bartlett's self-portrait and the companion likeness of his fiancée, Harriet Glines (nos. 12 and 11).

Although several other paintings have been ascribed to Bartlett by family tradition, Harriet's is the only signed example currently recorded, and the full extent and nature of his activity, whether professional or amateur, await further research. He was a farmer and house carpenter by trade, but he seems to have tried his hand at a number of other skills, including music, cabinetmaking and ornamental painting, photography, and teaching.[1]

Bartlett was born August 18, 1817, in what is now South Rumford, Maine. He died October 8, 1902, and he and Harriet Glines Bartlett were buried just across the Androscoggin River in Rumford Center. They had eight children: Florus Hogarth, Iverness, Burneretta, Fredolin Fitzobin, Florin Isadora, Everard Lyford, Loretta Sophrinella, and Rosabelle.

[1]J. E. Martin, *Jonathan Adams Bartlett (1817-1902): Folk Artist From Rumford Center, Maine* (Rumford, Me., 1976), and conversations with the artist's grandson, William Adams Bartlett, and his wife, Marie Barker Bartlett.

| 11 | **Harriet A. Glines** | 76.100.3 |
| 12 | **Self-Portrait** | 76.100.2 |

Jonathan Adams Bartlett
Probably South Rumford, Maine, probably 1841
Oil on canvas
31⅞" x 27" (81.0 cm. x 68.6 cm.)
33" x 27" (83.8 cm. x 68.6 cm.)
(No. 12 is reproduced in color, frontispiece)

Bartlett probably executed his self-portrait at the same time that he painted the signed companion likeness of his fiancée, Harriet A. Glines (1818-1893), whom he wed in May 1842.

Both portraits incorporate a great wealth of detail and express exuberant delight in recording the form and color of favorite and familiar objects, such as Harriet's

11

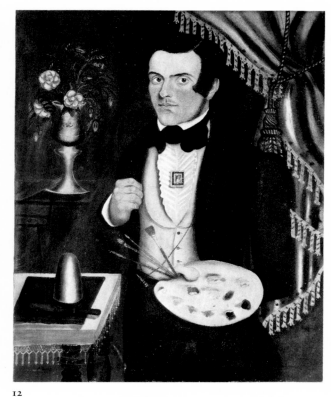

12

Inscriptions/Marks: Painted in period script on the verso of no. 11 is "H, A, Glines. Ae. 23/Painted – 1841 – By J, A, Bartlett." No markings on companion portrait.

Condition: These paintings were cleaned before Charles Olin's restoration in 1976, when they were lined, the original lapped stretchers were replaced, and minor areas of loss were inpainted. Original 4¾-inch splayed mahogany-veneered frames with ⅜-inch rounded black inner lips and ornamental brass hangers at center tops.

Provenance: Everard Lyford Bartlett, South Rumford, Me.; William A. Bartlett, Rumford Center, Me.; J. E. Martin, Mexico, Me.; Peter H. Tillou, Litchfield, Conn.

Published: Eleanor H. Gustafson, "Museum accessions," *Antiques,* CXIII (June 1978), p. 1256; J. E. Martin, *Jonathan Adams Bartlett (1817-1902): Folk Artist From Rumford Center, Maine* (Rumford, Me., 1976), pp. 64-71, illus. on pp. xii, 58, and 59.

pet bird, the vases of roses, and articles of clothing and personal adornment. Especially enchanting is the artist's stickpin, in actuality a miniature portrait that presumably represents Harriet.

Bartlett's naive self-portrait provides a rare and important glimpse into the folk artist's attitudes about himself and his vocation, just as it documents the tools of his trade. Bartlett's artistic pride is clearly evident in the prominent display of his brushes, palette, palette knife, grinding slab, and muller.

William Thompson Bartoll
(1817-1859)

William Thompson Bartoll was the son of John and Rebecca Thompson Bartoll of Marblehead, Massachusetts, where he was baptized with his twin brother, John, at the First Church on June 22, 1817. William

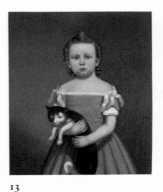

13 14

married Sally Lindsey Silman on April 21, 1835, and the couple had six children.[1]

The scant documentation available about Bartoll's life, which he evidently spent in Marblehead, dying there of "lung fever" on February 14, 1859, makes it especially difficult to comment on his training and artistic development over the years.[2] Tradition holds that he began as a sign and house painter, turning at some unknown date to portrait, mural, and landscape painting.[3] One reliable source noted that the interior walls of his house (still standing in Marblehead in 1955) were painted with murals and portraits of his children.[4] It is also known that he exhibited on a regular basis at the Boston Athenaeum from 1834 to 1855.[5]

Numerous unsigned portraits that share genealogical histories and/or stylistic similarities with his few signed examples have been attributed to Bartoll. Included among them are twenty-six portraits at the Marblehead Historical Society and others in public and private collections.[6]

One characteristic of the two portraits by Bartoll illustrated in this catalog is the sullen facial expression of the sitters. Both subjects appear to be pouting, their eyes fixed in a rather mistrusting gaze toward the viewer. This pose is not especially representative of other portraits assigned to Bartoll, a fact that indicates that additional study of his artistic development is required. Bartoll obviously was familiar with and primarily worked in an academic tradition and had some understanding of anatomy, modeling, and composition.

[1]Agnes M. Dods, "The Editor's Attic," *Antiques*, LVI (November 1949), p. 372; Ruth E. Walton to AARFAC, February 16, 1975.
[2]Gretchen L. Girdler to Nina Fletcher Little, June 13, 1955, AARFAC files.
[3]Dods, "The Editor's Attic," p. 372.
[4]Girdler to Little, June 13, 1955, AARFAC files.
[5]Lipman and Winchester, p. 280.
[6]Dods, "The Editor's Attic," p. 372.

13 Girl with Cat 39.100.3

William Thompson Bartoll
Probably Marblehead, Massachusetts, ca. 1840
Oil on canvas
27⅛" x 22⅛" (68.9 cm. x 56.2 cm.)

The neutral green background used here is seen in a number of Bartoll's extant signed or attributed portraits. The painting of the dress, in a rich medium orange set off by shiny blue satin sleeve ribbons and white eyelet lace undersleeves, is a tribute to Bartoll's understanding of complementary coloration. The effective shading of the plain background and the sensitive modeling of the child's face and hair further attest to Bartoll's knowledge of formal studio conventions, although the awkward drawing of the hands and the delightfully naive rendering of the cat's forelegs betray his earlier work as a house and sign painter.

Inscriptions/Marks: Inscribed in paint on the verso of the original canvas support, now lined, is "W. Bartoll, Pinxt."
Condition: Russell J. Quandt lined and cleaned the canvas in 1956. Period replacement 2½-inch molded gold leaf frame.
Provenance: Found in Marblehead, Mass., and purchased from Bessie J. Howard, Boston, Mass.
Exhibited: "American Cat-alogue, The Cat in American Folk Art," Museum of American Folk Art, New York, N.Y., January 12-March 26, 1976, and exhibition catalog, illus. as no. 40; Philbrook Art Center.
Published: AARFAC, 1957, p. 84, no. 44, illus. on p. 85; Agnes M. Dods, "The Editor's Attic," *Antiques*, LVI (November 1949), p. 372; Mabel Munson Swan, *The Athenaeum Gallery, 1827-1873* (Boston, 1940), p. 200.

14 Lydia Bessom 37.100.5

Attributed to William Thompson Bartoll
Probably Marblehead, Massachusetts, ca. 1845
Oil on canvas
12" x 9¼" (30.5 cm. x 23.5 cm.)

This portrait has been assigned to Bartoll on the basis of its stylistic relationship to no. 13 and because the sitter's last name, Bessom, is associated indirectly with families living in nineteenth-century Marblehead, where the artist also lived and worked. A signed Bartoll portrait, *Mr. Bessom of Marblehead*, in the Fruitlands Museum at Harvard, Massachusetts, may represent Lydia's father, although no records have been found to document such a relationship.[1]

The sitter wears a royal blue dress with white undersleeves and a small lace collar fastened with a cameo. The picture's small size heightens the precise quality of

details throughout while its overall sophistication indicates that by the mid-1840s Bartoll had mastered many of the difficult techniques associated with high-style portrait painting.

Condition: The original canvas has never been lined; unspecified cleaning was done at an unknown date. Original 2½-inch molded gold leaf frame.
Provenance: Bessie J. Howard, Boston, Mass.

[1]Clara Endicott Sears, *Some American Primitives: A Study of New England Faces and Folk Portraits* (Boston, 1941), pp. 223-224.

Ruth Henshaw Bascom
(1772-1848)

Ruth Henshaw Bascom was born on December 15, 1772, the daughter of William and Phoebe Swan Henshaw of Leicester, Massachusetts.[1] She attended Leicester Academy, and beginning at age seventeen and continuing through her early seventies she kept a rather complete diary that records in detail the day-by-day involvements of her family. She married her first husband, Dr. Asa Miles, in 1804. After his death in 1806 she married Reverend Ezekiel Lysander Bascom, with whom she spent most of her life in the vicinity of Gill, Massachusetts, although the couple traveled widely through New England and south to Savannah, Charleston, and Norfolk. Most of the large number of surviving profile portraits by Bascom have been discovered in or near Franklin County, Massachusetts. She died in the town of Ashby in 1848.

Portraiture was apparently an avocation that Mrs. Bascom pursued more for pleasure and self-satisfaction than for monetary gain. Undoubtedly she had learned something of drawing and the use of crayons during her school days, and perhaps that experience helped her develop her particular style and method of producing pastel likenesses that often incorporated tiny bits of tinfoil or other materials for jewelry, buttons, or the like. In most of her portraits Bascom posed the sitter against a paper background and traced the profile shadow on the paper. She then finished the picture in crayons and sometimes also cut out the finished profile and mounted it on the background. Bascom's work is valued today for its simplicity and directness.

[1]Agnes M. Dods, "Ruth Henshaw Bascom," in Lipman and Winchester, Primitive Painters, pp. 31-38.

15 Profile of a Boy 31.200.1

Attributed to Ruth Henshaw Bascom
Probably New England, ca. 1820
Pastel on paper
19 5/16″ x 15 1/8″ (49.1 cm. x 38.4 cm.)

This life-size pastel portrait of a small boy facing left is typical of the numerous profiles Ruth Henshaw Bascom made during her lifetime. The child's very stylized head and upper torso are placed against the light blue background; he wears a darker blue coat with small brass-colored buttons. Except for the precise delineation of the boy's ear, eye, and the outline of his face, the colors were applied and modeled to give an overall soft effect. Like most of Bascom's work, this likeness illustrates the modest yet successful achievements of an artist who either reduced or ignored the many technical com-

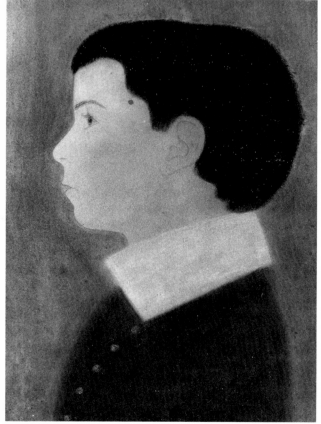

15

plexities of grander portrait formats and developed an abstract, simple form that undoubtedly suited her abilities and ambitions.

Condition: The surface was cleaned, severe water stains were reduced, and the portrait was fumigated by Christa Gaehde in 1955. Possibly original 2-inch lap-joined frame, stained brown.
Provenance: Found in Bridgeport, Conn., and purchased from Edith Gregor Halpert, Downtown Gallery, New York, N.Y.
Exhibited: AARFAC, American Museum in Britain; AARFAC, June 4, 1962-April 17, 1963; AARFAC, June 4, 1962-November 20, 1965; American Folk Art.
Published: Cahill, p. 34, no. 33; Walters, Pt. 3, illus. as fig. 1 on p. 1C.

The Beardsley Limner
(active 1785-1805)

The Beardsley Limner, a yet-to-be-identified post-Revolutionary New England portrait painter, was active between 1785 and 1805 in Connecticut and Massachusetts towns along the old Boston Post Road, where he painted newly prosperous, self-assured Federalists and their families. His name is derived from the handsome portraits of Elizabeth and Hezekiah Beardsley of New Haven, now in the Yale University Art Gallery, which were among a group of six portraits originally attributed to his hand. Subsequent research and exposure has led to the discovery of ten more canvases by this artist, but to date no signatures or notations in sitters' records have been found to reveal who he was.[1]

His surviving paintings indicate that the Beardsley Limner was not trained in the principles of studio art, but like many self-taught portraitists he worked out his own solutions to the problems of reproducing a three-dimensional form on a two-dimensional canvas by experimenting, by observing the work of more accomplished artists like Ralph Earl, and by consulting engravings or art instruction books then in circulation. Characteristics of the artist's style include symmetrical, almond-shaped eyes, excessively long and indented lips, and a minimum of facial shadowing. The head is shown in a three-quarter view, thus allowing the outline of cheek and nose to suggest the shape of the head and depth of the features.

The Beardsley Limner primed his canvases with a coat of either red or white paint; x-radiography shows that he drew with assurance and seldom altered the initial placement of sitters or accessories. The harmonious use of bright colors is a consistently important

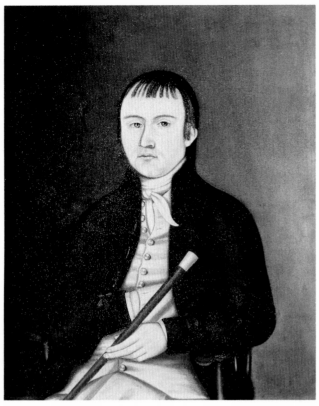

16

element in the growing number of unusually interesting and attractive likenesses ascribed to this hand.

[1]Nina Fletcher Little first identified a group of six portraits that were exhibited in Little-Known Connecticut Artists and discussed in Little, pp. 99-100, illus. on pp. 114-117. In 1972 Christine Skeeles Schloss prepared the AARFAC, Beardsley Limner exhibition and accompanying catalog in which she attributed eight more portraits to the artist. Subsequent discoveries include *Child Posing with Cat,* AARFAC, no. 19, and the portrait of Major Andrew Billings of Poughkeepsie, N.Y., "Collectors' Notes," *Antiques,* CXIII (June 1978), pp. 1244-1246.

16 James Steele 60.100.1

Attributed to the Beardsley Limner
Probably Ellington, Connecticut, 1785-1805
Oil on canvas
32" x 26" (81.3 cm. x 66.0 cm.)

Born on October 30, 1756, in Tolland, Connecticut, the son of James and Abigail Huntington Steele, James Steele settled in Ellington, Connecticut, in 1782, where

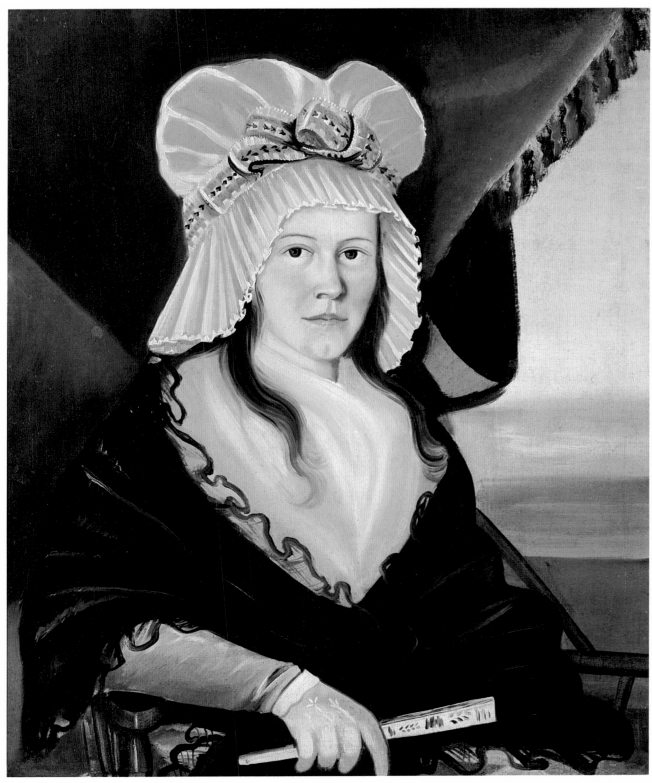

17

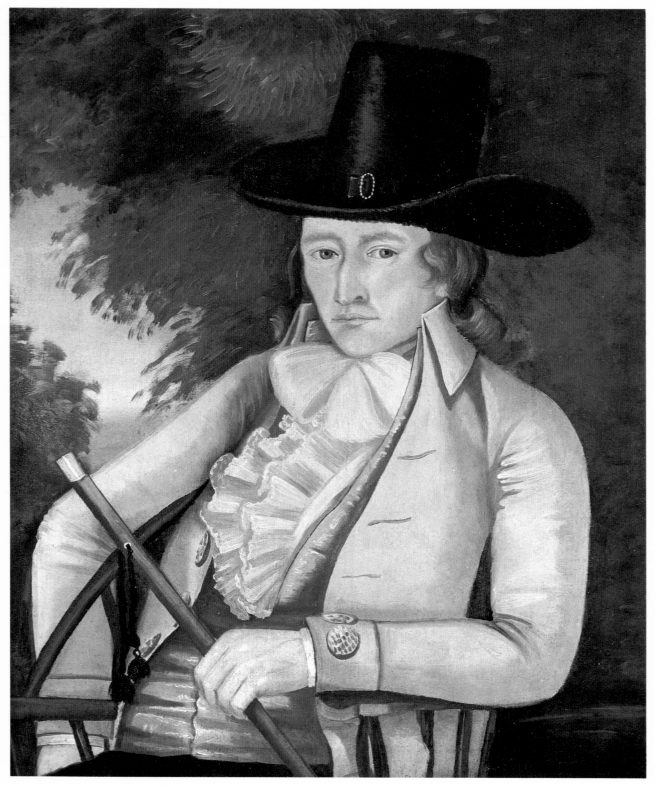

18

he met and married Jemima Wolcott. Examination of 1819 probate papers in the Connecticut State Library reveals that Steele had been a successful merchant, because at his death on January 5, 1819, he left an estate valued at $5,510.72.

Steele, who appears to be in his late thirties, is seated in a green Windsor armchair against a plain background. Thin black bangs frame his oval face and he is attired in a rich dark blue jacket and peach colored vest and pants.

The portrait includes many of the same formulas found in other paintings attributed to the Beardsley Limner: almond-shaped eyes, three-quarter view of the face, ill-formed shoulders, gracefully proportioned hands, and fingers rendered as a unit with lines used to differentiate each digit. (See nos. 17, 18, 19, and 20.) The Limner generally placed his subjects within a shallow space close to the picture plane and painted a window or curtain behind the figure to further define the spatial limits. Although there are no background props in Steele's portrait, the dark shadows cast by the cane create an illusion of a strong light source in front of the sitter and add a feeling of depth to the painting.

Condition: The painting was cleaned and lined prior to acquisition. Original 3-inch molded frame, painted black.
Provenance: Mrs. Joseph E. Davis, Worcester, Mass.; Copley Gallery, Boston, Mass.; unidentified dealer, Newburyport, Mass.; The Old Print Shop, New York, N.Y.
Exhibited: AARFAC, Beardsley Limner, and exhibition catalog, pp. 12 and 27, illus. as fig. 9 on p. 29.

17 Mrs. Oliver Wight (Harmony Child) 57.100.10

18 Oliver Wight 57.100.9

Attributed to the Beardsley Limner
Probably Sturbridge, Massachusetts, 1786-1793
Oil on canvas
31¼" x 25½" (79.4 cm. x 64.8 cm.)

The portraits of Oliver and Harmony Wight are two of the Beardsley Limner's strongest and most effective pictures. The artist used a series of triangles to structure both compositions. He emphasized the carefully painted faces and attempted to individualize the features, especially the arch of Wight's nose. The hair, the beribboned and ruffled bonnet, and the modish beaver hat were also handled rather precisely in contrast to the sketchy painting of the shawl, shirt, and coat buttons.

The curtains and bushes behind the Wights are not merely decorative but define the heads and serve to link and to balance the compositions in terms of color and design when they are hung as a pair.

Oliver Wight was born in Sturbridge, Massachusetts, on September 27, 1765, and lived there intermittently most of his life. When he was twenty-one, he married Harmony Child, who is thought to have been born in 1765 in Woodstock, Connecticut. For the next seven years, Wight worked as a cabinetmaker and built a substantial house and barn on land given him by his father, an early settler. This house still stands on its original location and is now owned by Old Sturbridge Village.

Plagued by financial difficulties, the Wights were forced to sell their home and leave Sturbridge in 1793. Four of their twelve children were born before their departure, two while they were living elsewhere, and six after their eventual return. Oliver died in Sturbridge on October 27, 1837, leaving as estate of $56.40. Harmony died May 20, 1861, at the age of ninety-six.

Condition: In 1959 Russell J. Quandt lined and cleaned both canvases and inpainted minor losses. Probably period replacement 2-inch molded gilt frames.
Provenance: Isabel Carleton Wilde, Cambridge, Mass.; Edith Gregor Halpert, Downtown Gallery, New York, N.Y.; Boris Mirski Art Gallery, Boston, Mass.; M. Knoedler & Co., New York, N.Y.
Exhibited: AARFAC, Beardsley Limner, and exhibition catalog, pp. 25 and 27, illus. as figs. 7 and 8 on pp. 24 and 26; "New England Provincial Artists 1775-1800," Museum of Fine Arts, Boston, July 21-October 17, 1976, and exhibition catalog, pp. 46 and 48, illus. on pp. 47 and 49.
Published: Black and Lipman, p. 20, no. 18 only, illus. on p. 26; Christine Skeeles Schloss, "The Beardsley limner," *Antiques,* CIII (March 1973), p. 534, illus. as figs. 7 and 8 on pp. 535 and 537.

19 Young Boy in Green Suit 64.100.4

Attributed to the Beardsley Limner
Probably New England, possibly 1790
Oil on canvas
35½" x 27⅜" (90.2 cm. x 69.6 cm.)

This painting was one of the six originally attributed to the Beardsley Limner on the basis of style by Nina Fletcher Little in 1957. Subsequent research has revealed ten more portraits and indicates that *Young Boy in Green Suit* marks a transition between the tight, decorative compositions done early in the Limner's career and the more loosely painted, illusionistic images he created

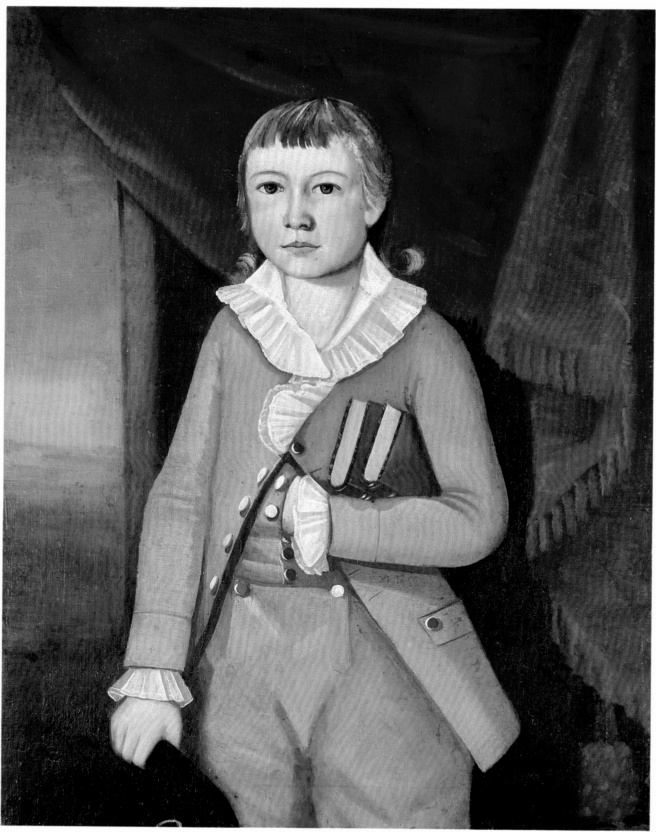

20

Attributed to the Beardsley Limner
New England, ca. 1790
Oil on canvas
20⅜" x 17½" (51.8 cm. x 44.5 cm.)
(Reproduced in color on p. 6)

This engaging likeness is the sixteenth portrait to be attributed to the Beardsley Limner. On the basis of costume and technique, it appears to be an early example of his work. The small seated figure is compressed onto the picture plane with a shadowless olive brown ground immediately behind and a swag of fringed green drapery filling the void in the upper left corner. The artist's lack of understanding of foreshortening and anatomy is evident in the positioning of the girl's arms and in the rendering of her overlarge head with its flat, unmodeled features. Fabric folds are highlighted with broad unblended streaks of thinly applied paint to create decorative surface patterns enlivening the tight composition. The large-eared tabby cat is more convincingly drawn and competes with the child's solemn face for the viewer's attention.

Condition: The painting was lined and mounted on new stretchers by David Rosen prior to purchase. In 1980 David C. Goist attached a layer of fiberglass and infused the reverse with microcrystalline wax; he also cleaned the painting and inpainted numerous small losses throughout and mounted the picture on a new expansion bold stretcher. Mid-nineteenth-century replacement 2-inch gilded splayed frame with half-round convex outer molding and concave inner molding.

Provenance: Found in Connecticut and purchased November 18, 1938, from Edith Gregor Halpert, American Folk Art Gallery, New York, N.Y., for use at Bassett Hall, Mr. and Mrs. John D. Rockefeller, Jr.'s Williamsburg home.

Exhibited: Previously unrecorded.
Published: Previously unrecorded.

later. Here the conventional red-tasseled curtain becomes more than the colorful decorative device it is in no. 20. As in the portrait of Harmony Wight (no. 17), it is used to create a circular space behind the sitter that is deepened by the suggestion of a misty landscape beyond. The child's features and hair are carefully painted, but the brushwork in other areas is sketchy. Light from a single source creates consistent shadows that outline and define the left side of the boy's face and his bent arm.[1]

Condition: The painting was acquired with the canvas affixed to compressed fiberboard and trimmed flush with the edges of the board. Modern replacement 2½-inch molded frame, painted black, with gilded inside edge.

Provenance: Mrs. Foster Stearns, Exeter, N.H.; Mr. and Mrs. Bertram K. Little, Brookline, Mass.; Miss Mary Allis, Fairfield, Conn.

Exhibited: AARFAC, Beardsley Limner, and exhibition catalog, p. 27, illus. as fig. 10 on p. 30; AARFAC, September 15, 1974-July 25, 1976; Little-Known Connecticut Artists.

Published: AARFAC, 1974, p. 31, illus. as fig. 23; Little, p. 106, illus. on p. 117; Christine Skeeles Schloss, "The Beardsley limner," *Antiques*, CIII (March 1973), illus. on p. 536.

[1]Details of costume and composition suggest a stylistic and, possibly, a family relationship with three portraits of sons of Dorothy Lynde and Elijah Dix of Worcester, Massachusetts, which the Beardsley Limner painted in the early 1790s (exhibition catalog, AARFAC, Beardsley Limner, pp. 27-28, illus. as figs. 11, 12, and 13, pp. 30-31).

Prudence Bedell
(b. 1829)

21	**Ann Beedell [sic]**	59.300.1
22	**Stephen Bedell**	59.300.2
23	**Martha T. Bedell**	59.300.3

Possibly Prudence Bedell
New Baltimore, New York, probably 1840-1845
Watercolor and pencil on wove paper
12⅛" x 7⅝" (30.8 cm. x 19.5 cm.)

Numbers 21, 22, and 23 represent three of the five children of John W. Bedell (1798-1877) and his first wife, Martha Titus Bedell (1798-1835), of New Baltimore, Greene County, New York. Birth dates for the children, provided by an unpublished Bedell-Powell family genealogy, are as follows: Charles T., 1821; J. Anna, 1826; Stephen, 1828; Prudence, 1829; and Martha T., 1832.[1] A note on file at AARFAC indicates that the portraits were painted by Prudence,[2] an assertion which – although possible – may prove difficult to substantiate through surviving documentary evidence. To date, no other paintings or drawings by Prudence Bedell have been found, nor have any conclusive references to her artistic efforts been recorded. Furthermore, the costumes and hairstyles depicted in the portraits indicate an execution date closer to 1840 than to 1845, making Prudence, if indeed she was the artist, a rather precocious draftswoman at eleven or so years of age.

All three of the Bedell sisters attended Troy Female Seminary (since renamed the Emma Willard School) in Troy, New York, intermittently between 1848 and 1850.[3] Oil painting, watercolor painting, and drawing were taught at the seminary during those years, so it is quite likely that they were exposed to some formal art instruction.

If Prudence was the artist, she may not have attempted a self-portrait. The omission of a portrait of Charles may be explained by the possibility that he had married and left home by this time.[4] Anna, Stephen, and Prudence were all unmarried and still residing with their father (and, by then, his second wife, Elizabeth Coonley Bedell) in 1865.

Inscriptions/Marks: Printed in pencil and ink or watercolor in open block letters at the tops are "ANN BEEDELL," "STEPHEN BEDELL," and "MARTHA T BEDELL." Penciled horizontal guidelines and some additional roughed-in letters are also visible in these areas. On the verso of no. 21 appears the pale and incomplete sketching of a head. A blind stamp in the lower right corner of no. 22 shows an oval containing a coat of arms with the words "LONDON/ABRADED DR . . . BOARD." The embossing of an oval blind stamp in the upper right corner of no. 23 is too weak to read, but is presumed to duplicate that found on the stamp on no. 22. Watermarks in the primary supports of nos. 21, 22, and 23 read "J. WHATMAN/TURKEY MILL/1839" for the Maidstone, Kent, England firm operated by the Hollingworth brothers between 1806 and 1859.

Condition: Treatment by E. Hollyday in 1974 included removal of acidic secondary supports, repair of an edge tear in no. 23, and dry surface cleaning of unpainted areas. Period replacement 1¼-inch splayed frames, painted black.

Provenance: J. Stuart Halladay and Herrel George Thomas, Sheffield, Mass.;[5] an unidentified Connecticut owner;[6] The Old Print Shop, New York, N.Y.

Published: The Old Print Shop Portfolio, XVIII (March 1959), illus. as no. 25 on p. 161.

21

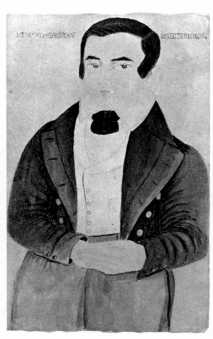

22

23

[1] This information, as well as that contained in several U. S. Census reports, was transcribed and made available through the assistance of Shelby A. Kriele, Greene County Historical Society, Coxsackie, N.Y.

[2] The handwritten note stated: "Stanton Hill Quakers family – Iron bound chest in Albany Institute History and Art. Prudence B. did these – Medway New York. Children of John T. [sic] Bedell. Stephen went to school in Washington. Prudence and Martha pupils of Emma Willard. All three painted by Prudence."

Although records for Coeymans Monthly Meeting are fragmentary, it appears that John W. Bedell, the children's father, was raised as a Quaker; about 1840 he contributed to the establishment of a Hicksite meetinghouse, and by 1848 the records show that he had joined the Hicksite movement. However, Martha and their children may not have joined the Society of Friends. "Stanton Hill" was the local name for the neighborhood around Coeymans Meeting, according to the 1824 edition of Horatio Gates Spafford's *Gazetteer of the State of New York* (Albany and Troy; 2nd ed.). The Albany Institute of History and Art has no iron-bound chest such as the note describes.

[3] According to Mrs. Russell Sage, *Emma Willard and her Pupils; or, Fifty Years of Troy Female Seminary* (New York, 1898), p. 805, Anna and Prudence attended in 1848, Martha in 1850. However, school records show that the three girls were enrolled in the seminary, usually for periods of less than four months at a time, for several years.

[4] The 1850 census indicates that Charles occupied a separate household in New Baltimore by that year, had married, and had three daughters aged two, five, and eight. Quite likely he had married by 1841.

[5] Although Halladay and Thomas's past ownership of the Bedell portraits remains uncertain, the note cited in n. 2 was written on a 1940s bank slip from Great Barrington, Mass.; Great Barrington is quite close to Halladay and Thomas's Sheffield, Mass., home; and the handwriting bears a strong resemblance to Thomas's. Also, at some unspecified date, Thomas corresponded with a Glenn S. Bedell of Coxsackie, N.Y., regarding "a portrait," although whether the correspondence related to the three Bedell watercolors cannot be positively determined.

[6] The Old Print Shop stated that nos. 21-23 "came to us from Connecticut" in its *Portfolio*, XVIII (March 1959), p. 161.

Zedekiah Belknap
(1781-1858)

Recent research has established that Zedekiah Belknap was born in Auburn (formerly Ward), Massachusetts, in 1781.[1] After his graduation in 1807 from Dartmouth College, where he studied divinity, Belknap became an itinerant artist and supported himself by painting portraits of middle-class residents of towns and villages in Massachusetts, New Hampshire, and Vermont. There is no evidence that Belknap ever received any professional art training, but he evolved a formula method of taking likenesses that proved popular with his clientele.

To date, more than 170 portraits have been confidently ascribed to Belknap's hand and others will undoubtedly be recorded as his work becomes better known. Signed and dated Belknap portraits range in date from 1807 to 1848.[2] Zedekiah Belknap died ten years later at the age of seventy-seven and is buried with his parents, two sisters, and brother in the Aldrich graveyard at Weathersfield, Vermont.

Although Belknap's first portraits reflect his efforts to paint in an academic manner, he soon developed a style that was more efficient for a traveling limner and enabled him to paint rapidly. He used bright colors and lavished attention on personalizing details of costume, hairstyle, and small accessories.

Belknap's sitters are boldly outlined, but there is little modeling. He consistently depicted only one side of the nose, outlining its profile with a heavy reddish shadow. Other prominently rendered facial features include full mouths, sharply outlined round eyes, and flat, red ears.

Belknap seems to have specialized in full-size oil portraits, most of which are painted on wood panels that are usually scored with diagonal lines that simulate a canvas twill and help the paint adhere to the surface, and then are covered with a gray green wash. Occasionally he used a canvas support with a heavy twill weave. Late in his career, Belknap's likenesses became less decorative as he attempted to depict the sitters more realistically, which may be interpreted as his reaction to the growing popularity of the daguerreotype.

[1] The biographical information on Zedekiah Belknap was researched by Elizabeth Mankin while she was a museum intern at AARFAC in 1975. See Mankin, pp. 1056-1066.

[2] Three 1807 portraits of John, Xperience, and Sarah Carpenter, all members of a New Hampshire family, were described and illustrated in the *Newtown Bee* (Conn.), July 29, 1977, p. 42. The latest portrait known is inscribed on the back "Portrait of Rufus Holman/at 71 yrs. Aug. 13th 1848/Z. Belknap pinxt/Nov. 1848," and is illustrated in Mankin, p. 1066.

| 24 | **Mrs. Thomas Harrison** | 31.100.16 |
| 25 | **Captain Thomas Harrison** | 31.100.15 |

Attributed to Zedekiah Belknap
Probably Boston, Massachusetts, probably 1815
Oil on basswood panel
33¾" x 23¾" (85.7 cm. x 60.3 cm.)
33½" x 25½" (85.1 cm. x 64.8 cm.)

The striking likeness of Mrs. Thomas Harrison is an early example of Belknap's work and is one of his most successful pictures. The curtain and column indicate an

24

25

time of his death in 1855.[1] No biographical data have been found on his first wife, who is pictured here.

Condition: Both panels were prepared in two sections and are supported by a pair of horizontal braces screwed to the reverse; the panel faces were diagonally scored with a toothing plane. Borwin Anthon cleaned both panels and did minor inpainting in 1935. In 1956 Russell J. Quandt recleaned them. Modern replacement 2¾-inch molded gilt frames.
 Provenance: Edith Gregor Halpert, Downtown Gallery, New York, N.Y.
 Exhibited: AARFAC, Belknap; American Folk Art.
 Published: AARFAC, 1957, p. 94, nos. 49 and 50, illus. on p. 95; Cahill, p. 30, nos. 15 and 14, illus. on pp. 63 and 62; John and Katherine Ebert, *American Folk Painters* (New York, 1975), no. 24 only, illus. on p. 51; Mankin, p. 1058, illus. as pls. I and II.

[1]Mankin, p. 1058.

26 Lady with White Shawl and Lace Cap
31.100.18

27 Man with Jabot
31.100.17

Attributed to Zedekiah Belknap
New England, ca. 1820
Oil on basswood panel
27¼" x 22½" (69.1 cm. x 57.6 cm.)
27" x 22¼" (68.6 cm. x 56.5 cm.)

This somber pair of portraits exhibits many of the techniques characteristic of Zedekiah Belknap's work, such as prominent depiction of facial features, a heavy reddish shadow outlining the nose, and a diagonal scoring of the panel. Both sitters are viewed against a solid green background wearing dark clothes accented with white accessories.

Condition: Both panels are composed of two pieces mortised together with a tongue and groove joint. The faces of the panels have

awareness of academic conventions, but they are merely suggested and add to the design of the composition rather than define space. The elegant young matron is described with an economy of lively brushwork, yet the exaggerated curls, proliferation of paste jewels, rakish feather headpiece, and linear dress ruffles combine to give Mrs. Harrison an extraordinarily decorative appearance.

The companion portrait of the massive Captain Harrison is less interesting, although Belknap paid careful attention to particular details of his military uniform, such as the eagle buttons and sword handle. Captain Harrison was a native of Boston. He joined the U.S. Army in May 1812 as a captain in the infantry and raised a company of men with which he marched to the Canadian frontier. After losing a leg in the Battle of Chippewa, he was brevetted major for his distinguished service. In 1815, the year the two portraits were probably executed, Thomas Harrison resigned his commission. He was inspector for the Boston Customs House at the

26

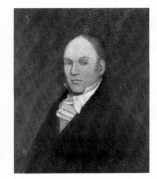

27

been diagonally scored with a toothing plane. David Rosen cleaned these paintings prior to 1935, when Borwin Anthon consolidated the crazed surfaces. Possibly original 2¾-inch molded gilt frames.

Provenance: Found in Bridgeport, Conn., and purchased from Edith Gregor Halpert, Downtown Gallery, New York, N.Y.

Exhibited: American Folk Art.

Published: AARFAC, 1940, pp. 19 and 20, nos. 21 and 22; AARFAC, 1947, p. 15, nos. 21 and 22; AARFAC, 1957, p. 349, nos. 168 and 169; Cahill, p. 31, nos. 17 and 16; Mankin, p. 1069.

28 Girl with Gold Beads 59.100.1

Attributed to Zedekiah Belknap
New England, ca. 1820
Oil on basswood panel
26¾" x 22" (67.9 cm. x 55.9 cm.)

The sharp contrast created by placing the pale figure against a drab ground is softened by a pleasing (and perhaps unconscious) repetition of curved forms: corkscrew curls, round face, arched brows, sloping shoulder, enveloping shawl, and scrolled sofa arm. The paint is applied with quick, fluid brushstrokes and

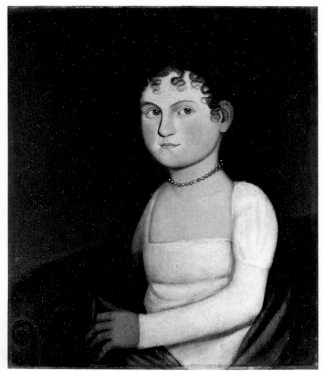

28

Belknap relied on his usual mannerisms to define the young girl's pretty face. Her gold beads are built up in gilt impasto, which gives them a three-dimensional quality.

Condition: No evidence of previous conservation. The face of the panel has been diagonally scored with a toothing plane. Original 1¼-inch molded frame, painted yellow.

Provenance: George Abraham and Gilbert May, West Granville, Mass.

Exhibited: AARFAC, Belknap.

Published: Antiques, LXXIII (April 1958), p. 335, illus. in advertisement; Mankin, p. 1068.

John S. Blunt
(1798-1835)

29 The Navigator's Wife 36.100.11

30 The Navigator 36.100.10

Possibly John S. Blunt
New England, ca. 1830
Oil on canvas
33½" x 28¼" (85.1 cm. x 71.8 cm.)

Clearly the work of a professional portraitist, these handsome companion portraits are unified by the vibrant red upholstery and the strong diagonals created by the placement of the sitters' arms on curiously foreshortened bolsters. Compared with the rapidly painted, generalized structure of the stiffly posed bodies, the facial features are individualized and convincingly modeled despite a slight greenish cast to the flesh tones. The lady's fashionably looped and plaited hairstyle seems to repeat the exaggerated fullness of her leg-of-mutton sleeves. The artist's pleasure in creating decorative patterns is also evident in his depiction of lace, jewelry, rows of upholstery tacks, and the surface of the globe. Both figures are shown against a thinly painted brown ground, which, in the woman's portrait, does not completely cover the coat of dull red paint used to prime the canvas.

More than thirty stylistically related portraits have been recorded, many of which are known to have been painted in coastal New England towns between Providence, Rhode Island, and Portsmouth, New Hampshire.[1] Circumstantial evidence supports Robert

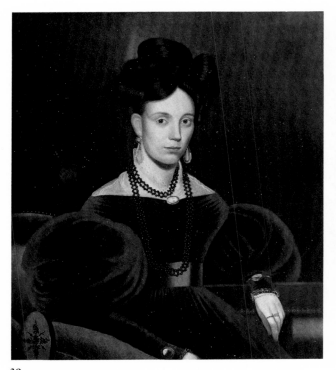

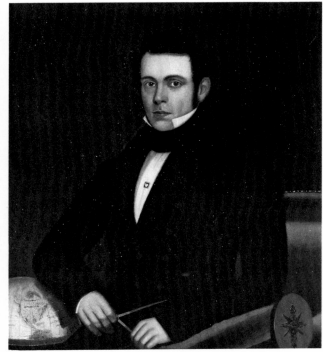

29

30

Bishop's thesis that the artist was John S. Blunt (1798-1835), an ornamental and portrait painter based in Portsmouth. While a signed portrait by Blunt has not yet been found, there is documentary evidence that Leonard Cotton, the subject of a related portrait, commissioned Blunt to decorate three fire buckets for him. Two of the leather fire buckets as well as Cotton's portrait survive, and the style of lettering used on the buckets is very similar to that on the globe under the Navigator's right elbow.[2]

Inscriptions/Marks: Lettering on the globe in the man's portrait includes "NORTH ATLANTIC OCEAN," "NORTH AMERICA," and "SOUTH"; a crayon inscription along the left side of the reverse of no. 30's frame reads "B, M, Simms Milton Mills N. H."
Condition: In 1956 Russell J. Quandt lined both canvases and mounted them on modern supports, cleaned both portraits, and did minor inpainting. Original 3½-inch cove-molded gilt frames with sanded inner surfaces and plaster leaf applied at each corner.
Provenance: Found in New Hampshire and purchased from Katrina Kipper, Accord, Mass.
Exhibited: Borden Limner, and exhibition catalog, pp. 44 and 45, illus. as nos. 22 and 21.
Published: Robert Bishop, "John S. Blunt," *Antiques,* CXII (November 1977), p. 965, illus. as nos. 4 and 3.

[1]A related portrait of Gilbert Chace Dean of Assonet, Mass., done about 1833, has been ascribed by family tradition to "Plummer of

Boston" (see nos. 135 and 136), although this attribution has not been substantiated. See "American Art Treasures Discovered: A Community Adventure," Morris Museum of Arts and Sciences, Morristown, N.J., April 17-May 29, 1977, and exhibition catalog, illus. as no. 13.
[2]See the exhibition catalog, Borden Limner, pp. 12-17.

J. Bradley
(active 1831-1847)

Despite the astonishing number of inscribed portraits left by J. Bradley, a good deal of mystery still surrounds his life. Jean Lipman initiated research on this artist as early as 1945,[1] but only in 1966 did Mary Black and Stuart Feld establish the solid core of twenty-two signed works that so cogently illustrate the characteristics of his style.[2] Since that time, six additional signed portraits have been added to the checklist of Bradley's work,[3] and at present no paintings attributable solely on a stylistic basis are known.

That Bradley immigrated to America is known from inscriptions on five 1834 portraits of the Totten

family of Staten Island, which read in part, "Drawn by I. Bradley./From Great Britton."[4] Black and Feld have found only two immigrants recorded as John, J., or I. Bradley who entered the United States via New York City between 1820 and 1831, the date of Bradley's earliest recorded work. One was a twenty-six-year-old Liverpool manufacturer arriving September 6, 1827; the other—a somewhat more likely candidate in view of the former's occupation—was a John Bradley who arrived from Ireland on August 7, 1826, aboard the *Carolina Ann*, occupation unlisted.

Before 1848, New York City directories show that Bradley worked as a portrait painter—and sometimes as a miniature painter as well—at 56 Hammersley Street in 1836-1837, at 128 Spring Street in 1837-1844, and at 134 Spring Street in 1844-1847, all addresses that are in the present-day area of Houston Street. Nothing is known of Bradley following his disappearance from the New York City directories in 1848.

An 1831 portrait of an unidentified woman and an 1832 portrait of a cellist are Bradley's earliest known paintings.[5] Their small sizes (19½ inches x 16½ inches and 17¾ inches x 16¾ inches respectively) and their depictions of adults at full length are factors that distinguish them from the main body of the artist's work. Because of the profusion of personal and specific objects included in them, one readily associates them with the conversation pieces that had been so popular in Britain but that were rarely painted in America. However, it is evident that Bradley quickly adapted his services to the demands of a new public, for he painted Asher Audrovette in 1832 in the larger-scale, half-length seated pose that he used for adults thereafter.[6] Children were different, of course. Their small size and still unformed features made them prime candidates for full-length portraiture, and nearly all of Bradley's young subjects recorded to date are shown in such a pose.[7]

Black and Feld have pointed out one of the most intriguing characteristics of Bradley's work: faces, hands, and sometimes costumes are frequently outlined in white or lighter tones, reversing the more generally accepted procedure of contouring figures by shadowing the edges, a technique that—in simplest form—resulted in dark outlining. Posed against dark backgrounds, Bradley's figures thus achieve the "crisp silhouettes" and the "strangely luminous quality" described by commentators on his style.[8]

Another characteristic that distinguishes Bradley's work is his attention to detail, which might be considered a general trait of the self-taught artist. Bradley, however, was extraordinarily precise, leaving no small feature of accessory or background to the imagination. Every inch of eyelet embroidery worn by a sitter is depicted in exacting detail, and even the shadows cast by tiny strands of coral beads are shown on children's necks. Black and Feld note that the sheet music depicted in the portrait of Margaretta Bowne Crawford could be played from the painting, so clearly is it rendered.[9]

Bradley's paintings are also made appealing by his use of bright, clear colors. Reds, greens, blues, and golds are rich and deep, and even the somber hues that increased in popularity toward the end of his career achieve a jewel-like quality by their clarity. Finally, in addition to keen observation, there is often an element of humor in Bradley's work. Two of his male subjects hold lighted cigars, the perfect way to while away the hours of a dull sitting. And two little girls share canvas space with kittens in pursuit of eminently feline activities: one bats a fallen rose across the floor, while the other has abandoned the flower and climbs vigorously to the top of a potted rosebush![10]

[1]Lipman, Bradley, pp. 154-166.

[2]Black and Feld, pp. 502-509. They also note on p. 508 of their article, but do not include in their checklist, an unlocated pastel of a vase of flowers supposedly signed "Drawn by J. Bradley—N. Y. 1846." Since the painting has not been examined, it has not been included in the updated inventory of Bradley's work.

[3]Portraits added to the checklist include one of an unidentified boy signed "J. Bradley 128 Spring Street" now in the collection of Gerald Kornblau; a portrait of Asher Audrovette signed "I. Bradley Del[n] 1832" in the collection of Peter H. Tillou; a privately owned portrait of Amanda Campbell signed "By J. Bradley 128 Spring St."; a portrait of an unidentified *Child in a Green Dress* signed "J. Bradley, 128 Spring Street, New York" and published as lot no. 253 in Sotheby Parke Bernet, *Important American Folk Art and Furniture: The Distinguished Collection of the Late Stewart E. Gregory, Wilton, Connecticut*, catalog for sale no. 4209, January 27, 1979; a portrait of M. J. Fox signed "By J. Bradley, 13[4?] Spring Street, New York, December 1845," which was illustrated in a flyer for an auction of the estate of Florence A. Sammis, Maison Auction Company, Wallingford, Conn., March 7, 1970; and a portrait of an unidentified woman signed "I. Bradley Deli[n] 1831," which is in the collection of Hirschl & Adler Galleries, and was illustrated in *Antiques*, CXVIII (August 1980), p. 176.

[4]As of 1966, the portraits of Mr. and Mrs. John Totten were in the Staten Island Historical Society, Staten Island, N.Y.; Edgar William and Bernice Chrysler Garbisch owned the portrait of John Totten, the son; and Stuart P. Feld owned the portraits of Mr. and Mrs. Abraham Cole Totten. "I" was an older form of writing "J," and Bradley seems to have switched to the more modern lettering in 1836. See Black and Feld, p. 507, nos. 14-15.

[5]*The Cellist* is in the Phillips Collection, Washington, D.C.

[6]The portrait of Asher Audrovette is illustrated in Tillou, no. 62.

[7]The unidentified boy in Gerald Kornblau's collection (see n. 3) is shown to the knees.

[8]Lipman, Bradley, p. 155; Black and Feld, p. 505.

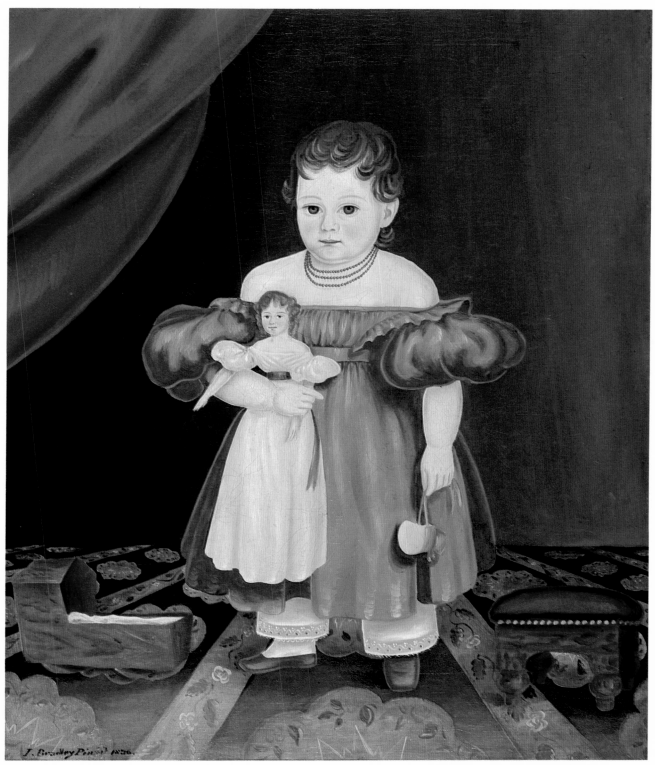

31

[9]Black and Feld, p. 508. The portrait is in the Monmouth County Historical Society, Freehold, N.J.

[10]The cigar-smoking men are John Totten, the son (see n. 4), and Abraham Ellis, whose portrait is in the Staten Island Historical Society. The kitten cuffing a rose appears in *Little Girl in Lavender* in the National Gallery of Art, Washington, D.C., the gift of Edgar William and Bernice Chrysler Garbisch. The climbing kitten appears in a portrait of Emma Homan in the Garbisches' collection.

31 Girl with Doll 57.100.4

J. Bradley
Probably New York City or immediate area, 1836
Oil on canvas
34¼" x 28¼" (87.0 cm. x 71.8 cm.)

Seldom in folk portraiture has the special relationship between a girl and her doll been so sympathetically portrayed. The small child's tight grasp of the doll, her wary glance, and her defiant stance lead one to wonder if she would have posed at all without the beloved object. Other details suggest that the doll was a special plaything: the doll's hair and eye color are the same as the girl's, the shapes of her balloon sleeves echo those of her owner's dress, and she is large, more than half the child's height.

Bradley is well known for his careful depiction of specific costumes and props. Although the grain-painted cradle shown at lower left is obviously too small for the doll, it must have been a favorite possession of the girl's, which undoubtedly was also true of the tiny painted acorn-footed stool at lower right, both of which are somewhat lost in the confusing pattern of the carpet. But by exaggerating the convergence of the carpet's stripes the viewer's eye is immediately drawn to the central figure, and the child is presented in a rather grand and dramatic manner. This impression is heightened by the use of the vibrant red drapery, which has not been employed in the usual fashion, as a backdrop. Instead, it appears to have been momentarily pulled aside from in front of the girl, revealing her as a figure on a stage.

Bradley's peculiar technique of highlighting the figure's outlines is readily apparent along the child's shoulders and lower arms, and his use of deep, rich color is also superbly illustrated by the jewel-like tones of blue dress, red drape, and green and amber carpet.

Inscriptions/Marks: Painted in the lower left corner is "I. Bradley Pinxit 1836."
Condition: Unspecified treatment prior to acquisition included patching two tears at upper left and upper right and repainting small areas of the drape, girl's dress, and doll's hair. In 1958 Russell J. Quandt cleaned the canvas, lined it, replaced the auxiliary support, removed old repainting, and inpainted minor areas of loss. Modern replacement 2-inch cove-molded gilded frame with quarter-round outer edge.
Provenance: Unidentified owner(s) in Kutztown, Pa., and St. Petersburg, Fla.;[1] found in California and purchased from Edith Gregor Halpert, Downtown Gallery, New York, N.Y.
Exhibited: AARFAC, New York, and exhibition catalog, no. 11; "Masterpieces of American Folk Art," Downtown Gallery, New York, N.Y., June 1-30, 1951.
Published: Black and Feld, pp. 505 and 507, no. 14, illus. as no. 14 on p. 506; McClinton, illus. on p. 296.

[1]Edith Gregor Halpert's notes read "found in California, this painting has been traced through St. Petersburg, Florida, to Kutztown, Pa., but no actual data or provenance has thus far been found." AARFAC files.

32 Boy on Empire Sofa 58.100.22

J. Bradley
Probably New York City or immediate area,
1837-1844
Oil on canvas
34½" x 27" (87.6 cm. x 68.6 cm.)

Bradley's depiction of this unidentified lad possesses great charm. The young fellow's stare is cool, level, and fearless, yet his stiff posture and precarious perch on the edge of a sofa imply a restless eagerness to jump down and run away. His actual size and age are difficult to judge since Bradley may well have exaggerated the size of the scrolled arm and leg of the Empire sofa. The vivid red and green swagged carpet pattern leaps up to the eye, and both of the boy's feet would appear to be firmly planted on it except that the placement of the scrolled foot of the sofa indicates that the child's legs dangle well off the floor.

One simultaneously views the center of the sofa frontally and the arm from an extreme angle in a visually impossible dual perspective. But consistency of viewpoint was not a concern; rather, Bradley's purpose was to emphasize the decorative quality afforded by the sofa's graining, and he was undeniably successful. The graining's flamboyance and electric movement are particularly important in view of the child's somber maroon colored coat. The elaborate soutache trim at lapels and lower front corners would have added more decorative appeal against a bright color, but here one looks twice to see the black configurations. Bradley lightened the edges of the coat to retain its outline against the dark sofa. The crisp pleating of the boy's shirt frill and collar is typical of the artist's careful attention to detail, as is

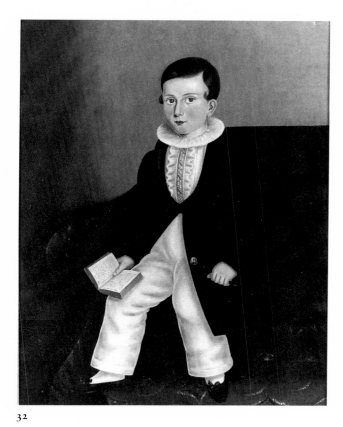

32

carpet. Amanda's brother would have been Charles C. Campbell, born in New York City in November 1834, and the twins are believed to have been painted in 1843 when they were about nine years old.[2]

Inscriptions/Marks: Painted in the lower right corner is "by J. Bradley/128 Spring S$^{\text{tr}}$."; painted on the pages of the book in the subject's hand is "The History of Robin Hood."

Condition: The canvas may have been removed from its auxiliary support and rolled up at some point. Unspecified treatment prior to acquisition included inpainting horizontal cracking overall and patching a tear at the lower center between the boy's feet. In 1970 Bruce Etchison lined the canvas, cleaned it, removed old retouches, and inpainted scattered areas of loss, mostly along horizontal cracking lines. Period replacement 3-inch cove-molded gilded frame with splayed outer edge.

Provenance: J. Stuart Halladay and Herrel George Thomas, Sheffield, Mass.

Exhibited: Halladay-Thomas, New Britain, and exhibition catalog, no. 1; Halladay-Thomas, Pittsburgh, and exhibition catalog, no. 6; Halladay-Thomas, Whitney, and exhibition catalog, p. 29, no. 6.

Published: Black and Feld, pp. 506-507, no. 18, illus. as no. 18 on p. 509; Lipman, Bradley, pp. 155 and 165, no. 4, illus. as fig. 5 on p. 159.

[1]Black and Feld suggest this may have been a short title for *The noble birth and gallant achievements of the remarkable outlaw Robin Hood, from a manuscript in the British Museum,* published in London in 1827. Black and Feld, p. 506.

[2]Private owner to AARFAC, November 19, 1978.

John Brewster, Jr.
(1766-1854)

John Brewster, Jr., was born a deaf-mute on May 30/31, 1766, in Hampton, Connecticut, the son of a respected and cultured doctor, John Brewster, and his first wife, Mary Durkee Brewster. One of seven children, young Brewster was encouraged to cope with his affliction from an early age. He learned to read and write and his aptitude for painting was nurtured under the tutelage of the Reverend Joseph Steward (1753-1822), a local portraitist.

Brewster began painting full-length likenesses of his family and neighbors in the early 1790s. He had moved to Maine by 1796 and between painting assignments he presumably lived with the family of his younger brother, Royal, who had married and settled in Buxton. For the rest of his life John Brewster managed to support himself entirely by painting portraits and miniatures as he traveled about Maine, Massachusetts, Connecticut, and eastern New York.

the readable title of the book: *The History of Robin Hood.*[1] The boy's little black bamboo-turned cane has a silver head in the shape of a fist.

Although the child's identity has not been established, the private owner of a Bradley portrait of Amanda Campbell states that family tradition claims the existence of a companion portrait of Amanda's twin brother, painted seated on a sofa. The sizes and signatures of the two portraits match, although Amanda stands by a vase of flowers on a completely different

When the first permanent American school for the deaf and dumb was founded in Hartford, Connecticut, in 1817, Brewster was fifty-one years old and had been an independent and successful artist for many years. School records indicate that he was one of the seven pupils who registered for the first session. He remained at the school three years, learning new ways to communicate and paying his own tuition. In 1820 he returned to Maine and continued his professional career, dying on August 13, 1854, at the age of eighty-eight.[1]

[1]Much of the biographical information about Brewster is from Little, Brewster, pp. 97-129.

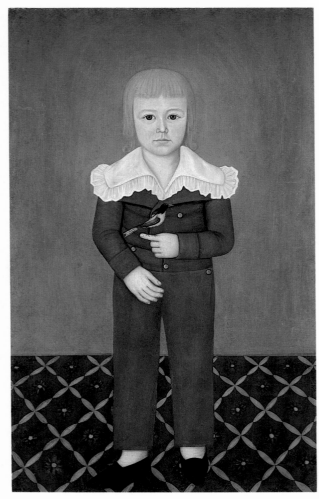

33

| 33 | Boy with Finch | 39.100.5 |
| 34 | Girl in Green | 39.100.6 |

Attributed to John Brewster, Jr.
New England or New York state, ca. 1800
Oil on canvas
39″ x 24″ (99.1 cm. x 61.0 cm.)

These sensitive portraits of an unidentified brother and sister are attributed to the itinerant portraitist John Brewster, Jr., on the basis of their stylistic relationship to his signed portraits.[1] The good draftsmanship and clarity of detail are typical of Brewster's hand, as are the cool, quiet colors, the sharply defined and delicately modeled features, and the directness of the children's gazes.

Posed against slate blue backgrounds, both children are dressed in a deep shade of emerald green accented with white. A black and yellow finch is perched on the little boy's forefinger and he stands on a boldly patterned stenciled floor. The young girl's high-waisted gown has a scoop neck and elbow-length sleeves trimmed with delicate lace that contrasts well with the heavy dress fabric. The distinctive white braid defining the bodice is casually tied in a half bow with long dangling tassels. The girl holds an open book in one hand, and looks toward the viewer as though calmly glancing up from her reading. Perhaps Brewster's own muteness caused him to emphasize the eyes of his sitters, thereby stressing the features of his subjects that were most important in his own life.

Condition: David Rosen lined and cleaned both portraits in 1939. In 1955 Russell J. Quandt relined the paintings, cleaned them,

Brewster's vigorous characterizations have long been recognized as some of the strongest likenesses produced by an itinerant New England artist. Serene expressions, clearly delineated features, and delicate flesh tones distinguish his work. As his career progressed, his modeling of facial features and hands became rounder and more pronounced. After 1805 Brewster often penciled his name and the date on the stretchers of his portraits, and about this time he gave up producing large compositions and concentrated on bust-length or half-length figures painted on canvases measuring 30 inches by 25 inches. Brewster usually primed his canvases with a coat of gray paint.

removed discolored overpaint applied by a previous conservator, and did some inpainting. Modern replacement 2⅞-inch cove-molded frames, painted black, with gilt inner and outer quarter-round moldings.

Provenance: Found in Beacon, N.Y., and purchased from a Mr. Johnson by Mrs. Mark W. Henderson, University, Va.; Parke-Bernet Galleries, Inc., New York, N.Y.; Edith Gregor Halpert, Downtown Gallery, New York, N.Y.

Exhibited: AARFAC, American Museum in Britain; AARFAC, March 9, 1961-March 20, 1966; AARFAC, September 15, 1974-July 25, 1976, no. 34 only; Flowering of American Folk Art; "John Brewster, Jr.," Connecticut Historical Society, Hartford, November 6-December 31, 1960.

Published: AARFAC, 1940, p. 16, nos. 1 and 2; AARFAC, 1947, p. 12, nos. 1 and 2, no. 34 illus. as frontispiece; AARFAC, 1957, pp. 78 and 80, nos. 41 and 42, illus. on pp. 79 and 81; AARFAC, 1974, no. 34 only, p. 21, no. 6, illus. on p. 20; Black and Lipman, p. 21, nos. 34 and 35, illus. on pp. 29 and 38; Ford, illus. on p. 61; Lipman and Winchester, no. 33 only, illus. as fig. 49 on p. 44; Little, Brewster, p. 107, nos. 18 and 19, illus. on p. 122; Parke-Bernet Galleries, Inc., *Furnishings of*

Historic Gadsby's Tavern at Alexandria, Virginia ... Property of Mrs. Mark M. Henderson, University, Virginia, catalog for sale no. 32, lot no. 92, April 23, 1938, no. 34 only, illus. on p. 43; Rodris Roth, "Floor Coverings in Eighteenth Century America," *U.S. National Museum Bulletin* 250: *Contributions from the Museum of History and Technology* (Washington, D.C., 1967), no. 33 only, p. 20, no. 12.

[1]Both portraits were acquired from an unidentified Beacon, N.Y., family with the tradition that the children's father was a popular physician who made his rounds on horseback. John Brewster's brother Royal was a doctor in Buxton, Maine, and Nina Fletcher Little has established that Royal's son, John W. A. Brewster, resided in Goshen, N.Y., in the mid-nineteenth century. It is possible that these portraits are of John W. A. Brewster and one of his sisters. For an example of a related signed portrait, see *One Shoe Off* in the New York State Historical Association, Cooperstown, in Little, Brewster, p. 108, no. 25, illus. on p. 125.

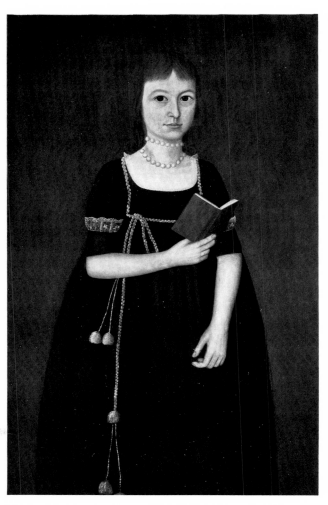

34

Doctor Samuel Broadbent
(1759-1828)

Other than the fact that he was born in London in 1759, nothing is known about Samuel Broadbent before 1798, when he advertised his skills as physician, surgeon, and midwife in a Hartford paper and announced he was establishing a practice in nearby Wethersfield. Apparently not enough local patients availed themselves of his services, since Broadbent became a traveling doctor. In 1808 he married a Wethersfield widow, Abigail Griswold, by whom he had a son and a daughter. Twenty years later he succumbed to dropsy and high living and died in Wethersfield at the age of sixty-nine.[1]

Although Broadbent never seems to have advertised that he painted portraits, he was recording the faces of neighbors and medical associates at least as early as 1808.[2] The artist was at his best with watercolors, and it is likely he received some training in the use of that difficult medium before leaving England. He also worked in oils and in pastels. Approximately thirty portraits in all three media, which either depict or are in some way related to Wethersfield area residents, have been attributed to Broadbent.[3]

[1]Warren, Broadbent, p. 99.

[2]The earliest signed and dated portrait by Samuel Broadbent is an 1808 watercolor portrait of Samuel Blin, a Wethersfield architect, which is in the Connecticut Historical Society, Hartford.

[3]For an illustrated checklist of twenty-six portraits, see Warren, Broadbent, pp. 113-128.

35 Mrs. Asa Willey 71.100.5
(Roxalana Thompson)

36 Asa Willey 71.100.4

Attributed to Dr. Samuel Broadbent
Connecticut, 1807-1815
Oil on canvas
32¼″ x 27¼″ (81.9 cm. x 69.2 cm.)

Although unsigned, these flat, linear likenesses are attributed to Dr. Samuel Broadbent because of Roxalana Thompson Willey's strong stylistic resemblance to Broadbent's portraits of Mrs. John Churchill (Laura Welles) and Mrs. Romanta Woodruff (Hannah Robbins), both of which are in the Connecticut Historical Society.

The paired portraits of Mr. and Mrs. Willey are well balanced in terms of color and design and include a surprising amount of background detail for an artist who was usually restrained in his use of props and accessories. Both of the Willeys are seated in identical green hoop-back Windsor armchairs beside small red tables. The shelves of books behind Asa Willey were probably an allusion to his legal training.

These compositions are not executed in Broadbent's usual careful manner, however; the paint was applied quickly and, in several areas, too thinly. The embroidered net worn by Mrs. Willey is convincingly rendered but elsewhere the brushwork is sketchy and somewhat coarse. There was an attempt to soften the sharply outlined features with shaded flesh tones, but the colors were poorly blended and the effect is blotchy. The sitters' tense poses and intent, sidelong stares give both subjects a wary look.

Born in East Haddam, Connecticut, on February 22, 1774, Asa Willey practiced law in Hebron and El-

lington, Connecticut, and served as the first probate judge in Tolland County. He married Roxalana Thompson (1785-1851), his second wife, on May 10, 1807. These portraits appear to date from the first eight years of their marriage. The Willeys died within ten months of each other in 1851.

Inscriptions/Marks: "Sir," is written on the sheet of paper shown under Asa Willey's right hand, and lettered on the spines of the books behind him are SPIRIT OF LAW, SPIRIT OF LAW, GRANGE REPORTS, and three numbered volumes of DURNFORD & EASTIS REPORTS.
Condition: In 1972 Robert Scott Wiles backed both canvases with fiberglass and remounted them on modern expandable stretchers. Small canvas tears were repaired and both portraits were cleaned and inpainted. Both were acquired unframed with hanging rings attached to the center top stretchers.
Provenance: Abbott B. Thompson, Melrose, Conn.
Exhibited: "Paintings by Doctor Samuel Broadbent," Connecticut Historical Society, Hartford, November 4, 1973-January 31, 1974.
Published: Warren, Broadbent, pp. 108 and 116, illus. as nos. 23 and 24 on p. 127.

37 Mrs. Eleazer Bullard 73.100.5
(Hannah Wilson)

Attributed to Dr. Samuel Broadbent
Massachusetts or Connecticut, ca. 1815
Oil on canvas
28″ x 25″ (71.1 cm. x 63.5 cm.)

The stiffly posed half-length figure, green Windsor chair, meticulously painted lace, taut cupid's-bow mouth, and tiny tendrils of curled hair falling over the forehead are among the elements this likeness shares with other portraits attributed to Dr. Samuel Broadbent. While not flattering, this rather severe depiction of a poised, plain-faced young woman was probably an honest likeness of Mrs. Eleazer Bullard. The composition is simple and uncomplicated. The smooth oval face is framed and softened by a sheer lace ruffled collar secured by a simple gold and onyx brooch. The facial features are well drawn and slightly modeled but the rigid fingers are poorly rendered and awkwardly placed.

Hannah Wilson Bullard (1789-1830) of Berlin, Connecticut, was the first wife of Eleazer Bullard (no. 63) of New Marlborough, Massachusetts, whom she married in September 1812. The couple lived in New Marlborough and were the parents of three children. After Hannah's death at the age of forty-one, Eleazer Bullard married Emily Sheldon (no. 62) and moved to Lee, Massachusetts.[1]

35

36

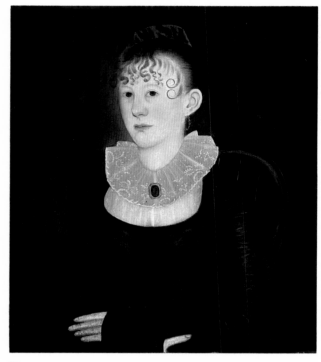

37

Brown's use of painted oval spandrels and the lifelike modeling of faces suggest that he may also have been influenced by the work of William Jennys (active 1795-1806). Brown had a flair for combining fresh, clear colors, and like many nonacademic artists he was exacting and specific in depicting his subjects' clothing and furniture. While J. Brown's surviving portraits vary in size, format, and complexity of composition, his literal likenesses always project the personalities of real people.

[1]The documented portraits are: Clarissa Taylor Ingersoll, shown half-length within an oval, 29½" x 25" (74.9 cm. x 63.5 cm.), inscribed on the reverse "Nov. 1803 Aged 31/Painted by J. Brown," formerly in the collection of Stewart E. Gregory; General Samuel Sloan and Mrs. Sloan of Williamstown, Mass., shown half-length, the man's portrait inscribed on the reverse "Gen^l Sloan AE 65/A.D. 1806/J. Brown/ Pinx^t," present whereabouts unknown; Laura Hall (Mrs. Ambrose Kasson) of Cheshire, Mass., shown standing full-length, 6 feet x 3 feet (182.9 cm. x 91.4 cm.), New York State Historical Association, Cooperstown; Mr. and Mrs. Calvin Hall of Cheshire, Mass., Laura's parents, the reverse of Mrs. Hall's portrait inscribed "J. Brown, Pinx^t. Jan 2 [?], 1808," AARFAC, nos. 39 and 40; Erastus Emmons and Williams Emmons of Medway, Mass., each shown half-length within an oval, each inscribed on the reverse "J. Brown, March, 1808," collection of Bertram K. and Nina Fletcher Little.

Condition: The portrait was lined and mounted on wood backing with new strainers by an unidentified conservator about 1955. In 1976 Bruce Etchison cleaned the surface and did minor inpainting. Circa 1835 replacement 2-inch split turned baluster frame, painted red with black sponging.[2]

Provenance: Mrs. James Stagliano, Lee, Mass.

[1]Connecticut Historical Society to AARFAC, September 10, 1979.

[2]The frame is identical to those on portraits of four other members of the Bullard family believed to have been painted by Erastus Salisbury Field in 1835 (see nos. 62 and 63), which is presumably when this portrait was framed to match the later likenesses.

J. Brown
(active 1803-1808)

At the present time there are no data on an elusive and skilled New England artist who signed himself "J. Brown" other than the inscriptions on the reverse of five portraits of Massachusetts subjects, all painted between 1803 and 1808.[1] His stylish poses and sketchy landscape vistas indicate that he was familiar with the informal portrait style that Ralph Earl (1751-1801) was utilizing in Connecticut after he returned from England in 1785.

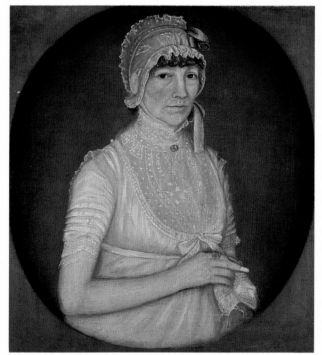

38

38 Mrs. Asa Childs (Clarissa Partridge Ide)

58.100.1

Attributed to J. Brown
Probably Medway, Massachusetts, ca. 1808
Oil on fine linen
27¼" x 23½" (69.2 cm. x 59.7 cm.)
(Reproduced in color on p. 69)

On the basis of technical and stylistic evidence, this portrait of Clarissa Partridge Ide Childs of Medway, Massachusetts, has long been attributed to the "J. Brown" who signed the portrait of Mercy Barnes Hall (no. 39). Similarities between the portraits include Holland linen supports primed with brownish red and gray base coats, a corresponding handling of paint in the treatment of facial planes, and the use of impasto to simulate lace.

The attribution to Brown has been further substantiated by Nina Fletcher Little's discovery of portraits of Erastus and Williams Emmons, also of Medway, Massachusetts, both of which are inscribed on the reverse "J. Brown, March, 1808,"[1] and are painted within pale brown ovals identical to the one that surrounds Mrs. Childs. She was related to the Emmons family through her first husband, and it seems likely that all three portraits were painted during Brown's 1808 visit to Medway.[2]

Clarissa Childs has paused in her sewing and gazes straightforwardly at the viewer, the shadows beneath her eyes hinting at weariness. The simplicity of the composition and the muted palette of soft shades of brown, blue, gray, and white emphasize the sharply modeled features of Mrs. Child's thin face, which is effectively framed by sheer white lace.

The daughter of Moses and Rachel Partridge, Clarissa was born on June 14, 1775. Her first husband, Gregory Ide, died three years after their wedding in 1795, and Clarissa married Lieutenant Asa Childs of Upton, Massachusetts, in 1799. In 1813 the family traveled by flatboat to Pittsburgh, Pennsylvania, where Asa Childs became a manufacturer of shoes. Clarissa Childs died in Pittsburgh on November 4, 1849.

Condition: In 1958 Russell J. Quandt lined, cleaned, and mounted the painting on new stretchers, repaired old tears in the upper right corner and near the right elbow, and did minor inpainting. Probably original 2-inch cove-molded gilt frame with beading along the inner and outer edges.
Provenance: Rockwell Gardiner, Richfield, N.Y.; J. Stuart Halladay and Herrel George Thomas, Sheffield, Mass.
Exhibited: AARFAC, April 22, 1959-December 31, 1961; AARFAC, September 15, 1974-July 25, 1976; Halladay-Thomas,

Pittsburgh, and exhibition catalog, no. 63, illus. as frontispiece; "What is American in American Art?" M. Knoedler & Co., New York, N.Y., February 9-March 6, 1971.
Published: AARFAC, 1959, p. 20, no. 9, illus. on p. 21; AARFAC, 1974, p. 23, no. 10, illus. on p. 22; Black and Lipman, p. 23, no. 46, illus. on p. 47.

[1]Nina Fletcher Little to AARFAC, August 23, 1974.
[2]Little to AARFAC, November 25, 1974.

39 Mrs. Calvin Hall (Mercy Barnes)

57.100.2

40 Calvin Hall

57.100.1

J. Brown
Probably Cheshire, Massachusetts, January 1808
Oil on fine linen
34½" x 30½" (87.6 cm. x 77.5 cm.)
34" x 30" (86.4 cm. x 76.2 cm.)

Calvin and Mercy Hall are seated in a vaguely defined interior with their expressive faces silhouetted against rich folds of red drapery. Twilight views of the local Cheshire landscape create an illusion of space behind them, and Mr. Hall's tavern is visible in the distance to his left.

J. Brown usually concentrated his efforts on reproducing facial structure as accurately as possible, and in depicting the Halls' features, his hard-edged technique resulted in startlingly realistic characterizations. Other parts of his sitters' bodies and the backgrounds received less attention and were more loosely painted, and shrewd-looking Mr. Hall appears to be sliding out of his Windsor armchair. Although the artist obviously intended the portraits to be companion pieces, he did not attempt to create a continuous scenic background and the proportions of the two settings do not correspond.[1]

Calvin Hall served with a New York state regiment during the American Revolution. In 1804 he built a house in Cheshire, Massachusetts, where he and John D. Leeland kept a tavern. Hall and Leeland built a store adjacent to their tavern in 1808 and four years later they incorporated a glass factory. The Halls moved to Deerfield, New York (now North Utica), in 1816 and established a new glass factory.[2]

Inscriptions/Marks: Mrs. Hall's canvas is signed on the reverse "J. Brown, Pinxt. Jan. 2 [?], 1808."
Condition: In 1957 Russell J. Quandt lined both paintings and mounted them on new stretchers. He repaired old tears in the upper right corner of Mrs. Hall's portrait, cleaned the surfaces of both, and did minor inpainting. Probably period replacement 2-inch cove-molded gilt frames with beaded inner and gadrooned outer borders.

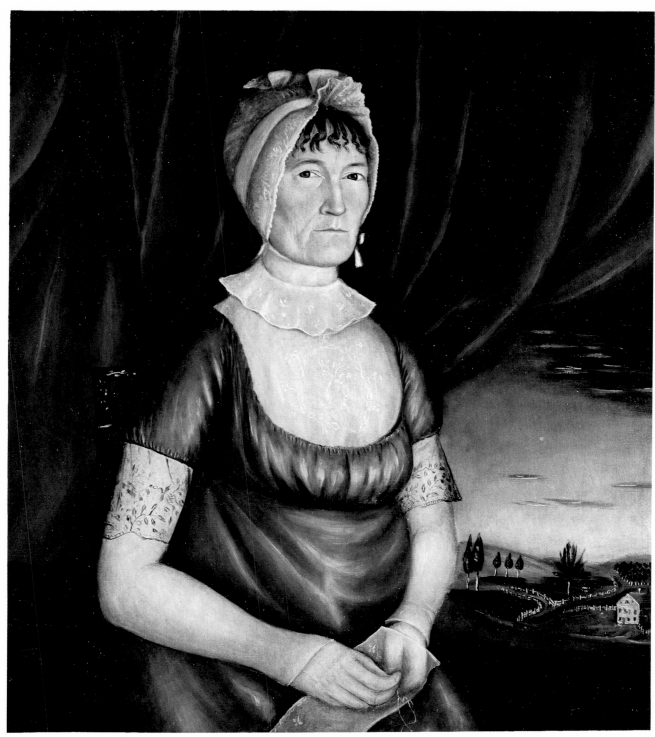

39

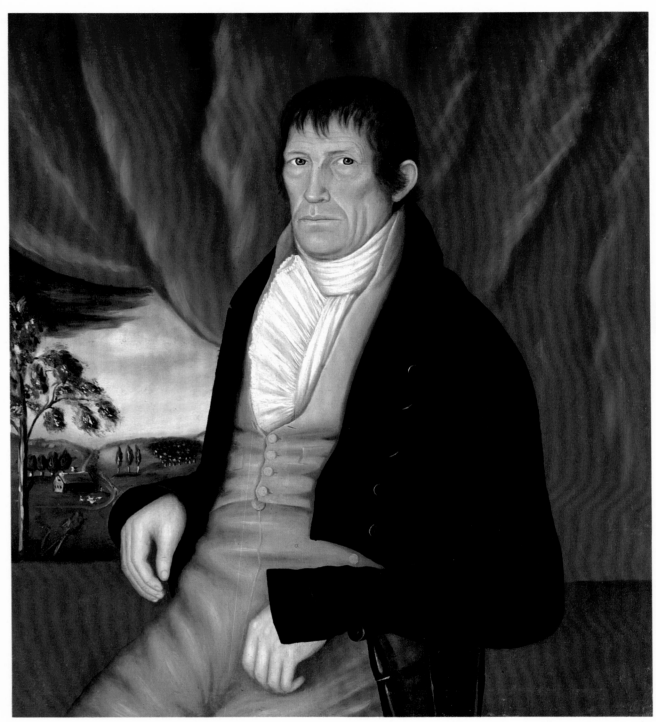

40

Provenance: Both portraits were found in Saratoga, N.Y., and purchased from the Old Print Shop, New York, N.Y.

Exhibited: AARFAC, American Museum in Britain; AARFAC, March 9, 1961-March 20, 1966; "Rediscovered Painters of Upstate New York," traveling exhibition organized by the New York Historical Association, June 14, 1958-February 28, 1959, and exhibition catalog, pp. 28-29, nos. 21 and 22, illus. on p. 28.

Published: Black and Lipman, p. 23, nos. 43 and 44, illus. on p. 45.

[1]At the same time he painted Mr. and Mrs. Hall, J. Brown also did a striking six-foot standing likeness of their twenty-one-year-old daughter, Laura. She is posed against a neutral background, her hand resting on the crest rail of a spindle-back Windsor side chair similar to the one in which her mother is seated. Laura Hall's portrait is in the New York State Historical Association, Cooperstown.

[2]Biographical information was provided by Agnes Halsey Jones in September 1958.

Michele Felice Cornè
(ca. 1752-1845)

A commercial artist of considerable ability, Michele Felice Cornè was about forty-eight years old when he sailed from Naples to Salem, Massachusetts, aboard the ship *Mount Vernon.* Cornè arrived in Salem in July 1800, and during the next six years he undertook all types of ornamental painting, including murals, panoramas, overmantel panels, and fireboards in addition to marine scenes, landscapes, and portraits. Many of these projects, as well as Cornè's ability as an art teacher and his enthusiasm for tomatoes, are noted in the *Diary* of that inveterate recorder of Salem life, the Reverend William Bentley.[1] Cornè painted in Boston between 1807 and 1822; he then moved to Newport, Rhode Island, where he died in 1845 at the age of ninety-three.

While Cornè's technique is more accomplished than that of the portraitists represented in this catalog, it should be noted that immigrant foreign artists often competed with and influenced those self-taught native American painters with whom they came in contact.[2]

[1]*The Diary of William Bentley, D.D.,* I-IV (Gloucester, Mass., 1962), *passim.*

[2]See the exhibition catalog, Cornè, pp. ix-xiv; also Barry Arthur Greenlaw, "Michele Felice Cornè," unpublished M.A. thesis, Winterthur Program and University of Delaware (Newark, Del., 1962).

41	Sara Wellman	79.100.3

Attributed to Michele Felice Cornè
Salem, Massachusetts, possibly 1802
Oil on panel
21¾" x 16⅞" (55.2 cm. x 42.9 cm.)

This winsome likeness has a sprightly, spontaneous quality seldom found in portraits of small children. According to a biographical label pasted to the back of the panel, Sara Wellman was painted when she was seventeen months old, but her long neck, sensitively modeled heart-shaped face, and thick wavy blond hair make the child appear older.

The quick, confident brushwork and sure treatment of color reflect the hand of an experienced artist.

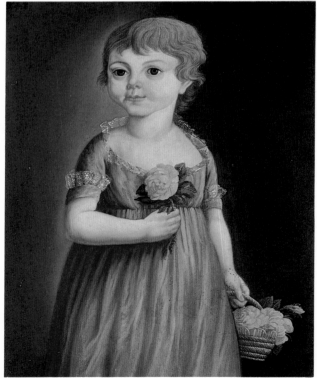

41

The portrait is attributed to Michele Felice Cornè on the basis of its stylistic relationship to signed and dated examples of his work that were painted in Salem between 1801 and 1804.[1] The gracefully attenuated figure, overlarge limpid brown eyes, and slightly lumpy structuring of the face are characteristic of Cornè, as are the delicate handling of the full-blown roses Sara carries and the lace trim on her simple gold dress.

Born in Salem April 15, 1801, Sara was the daughter of Timothy and Sally Wellman. She married William Homans of nearby Marblehead in 1828, and the couple had two children. Sara Wellman Homans died at Lynn, Massachusetts, in 1872.

Condition: In 1971 an unidentified conservator at Hirschl & Adler Galleries stabilized three small vertical splits in the panel and cleaned the portrait. Modern replacement 2-inch cove-molded gilt frame with cast plaster acanthus ornament in each corner.
Provenance: Purchased from Katrina Kipper, Accord, Mass., in January 1940 for use at Bassett Hall, Mr. and Mrs. John D. Rockefeller, Jr.'s Williamsburg home.

[1]For illustrations of related paintings by Cornè, see the following in the exhibition catalog, Cornè: portrait of Miss Lydia Robinson, no. 52, illus. on p. 25; portrait of Sarah Prince Osgood, no. 56, illus. on p. 28; portrait of Captain James Cook, no. 58, illus. on p. 29; fireboard from the Ferncroft Inn, no. 77, illus. on p. 38.

42 Portrait of Thomas West 79.300.1

Michele Felice Cornè
Salem, Massachusetts, 1803
Watercolor on laid paper
10⅞" x 8⅞" (27.6 cm. x 22.5 cm.)

Cornè's literal approach to the bust-length portrait format proves to be surprisingly effective in this meticulously painted likeness of Captain Thomas West. Cornè bathed the man's face in light and then defined his strong features with the minute precision of an engraver. West's stock, pink and blue striped white silk vest, and navy coat were more quickly painted, with broad highlights to suggest form and texture. The subject's curved and truncated torso is positioned on a pedestal of blue gray stone with brown veining, and the striated background is painted a soft shade of gray.

Except when he was at sea, Captain Thomas West resided in Salem, Massachusetts, where he was born in 1778 and died seventy-one years later. West served as master of the *George*, the fastest of Salem's merchant fleet, on several of her early voyages between 1816 and 1820.[1] He was a member of the East India Marine Society, founded in Salem in 1799, for which Cornè executed a number of commissions. Among the items included in an 1803 bill from Cornè to the society was a charge for two busts at $6 each. Since Cornè's watercolor of Captain West is signed and dated 1803, it seems likely that it is one of the two bust portraits noted on the bill.[2]

Inscriptions/Marks: Signed in white at lower right, "M. Cornè fecit 1803." No watermark found.
Condition: No evidence of previous conservation. There are several small water stains on the background. Original 2-inch molded gilt frame.
Provenance: Purchased from Katrina Kipper, Accord, Mass., in February 1935 for use at Bassett Hall, Mr. and Mrs. John D. Rockefeller, Jr.'s Williamsburg home.

[1]George Granville Putnam, *Salem Vessels and Their Voyages* (Salem, Mass., 1924), pp. 1-8.
[2]See the exhibition catalog, Cornè, p. xiv.

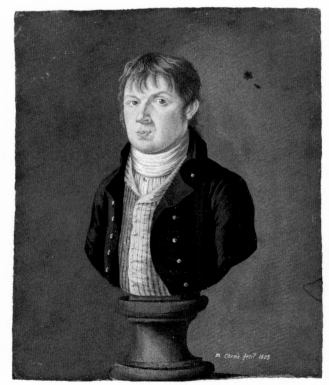

42

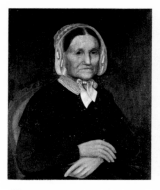
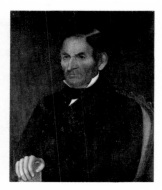

43 44

Salmon W. Corwin
(1829-1855)

43 **Mary T. Ketcham** 63.100.8

44 **Joseph Ketcham** 63.100.7

Salmon W. Corwin
Probably near Otisville, New York, 1854
Oil on canvas
30″ x 25″ (76.2 cm. x 63.5 cm.)

These hard-edged portraits of Mr. and Mrs. Joseph Ketcham were completed within a two-day period and illustrate how the realism of the camera had formularized a young portrait painter's approach to composition and design. Salmon W. Corwin is remembered chiefly for his association with Joseph Whiting Stock (see nos. 160-161) when the latter was working in Orange County, New York, during 1853-1854. A native

of Orange County, Corwin was born in Mount Hope in 1829 and died in New Vernon twenty-six years later.

Corwin apparently painted these portraits of the Ketchams[1] shortly before going into business with Stock in Port Jervis, New York, in the spring of 1854. The partnership was brief; only one print, a lithograph of Port Jervis signed "Published by Stock & Corwin Portrait Painters" in the New-York Historical Society, is known. Their partnership was dissolved by January 1855. Salmon Corwin died that same year, shortly after Stock's death.[2]

Inscriptions/Marks: The portraits are signed, respectively, in the lower right corner, "Mary T. Ketcham/Born June 2 1783/Painted January 19, 1854/by S. W. Corwin," and "Joseph Ketcham/born June 21, 1782/painted Jan. 17, 1854/by S. W. Corwin."
Condition: No evidence of previous conservation. Original 4½-inch gilded cove-molded frames with molded inner edge and applied plaster ornaments at the center and corner of each member.
Provenance: Descended in the family; gift of C. Fremont Kuykendall.

[1]"These paintings were painted at their [the Ketchams'] farm house three miles from Otisville, New York." Fremont Kuykendall to Lucius Battle, November 20, 1959.
[2]"Joseph Whiting Stock," Smith College Museum of Art, Northampton, Mass., February 4-March 20, 1977, and exhibition catalog, pp. 6, 49, 58, and 59.

R. B. Crafft
(active 1836-1866)

45 **The Merchant** 35.100.1

R. B. Crafft
Probably Indiana, Kentucky, or Tennessee, 1836
Oil on canvas
25⅛″ x 30″ (63.8 cm. x 76.2 cm.)

What little is known about the career of R. B. Crafft has been gleaned from one Indiana newspaper advertisement and from the inscriptions on a dozen recorded signed portraits that date from 1836 to 1866. *The Merchant* is the earliest as well as the most ambitious and innovative of these portraits. While the swagged drapery and realistic modeling of the face indicate a degree of familiarity with artistic conventions, the aberrations in perspective seen in the fingers, the relationship of ledger and desk, and the row of tilted account books suggest the experimental hand of an untutored artist struggling

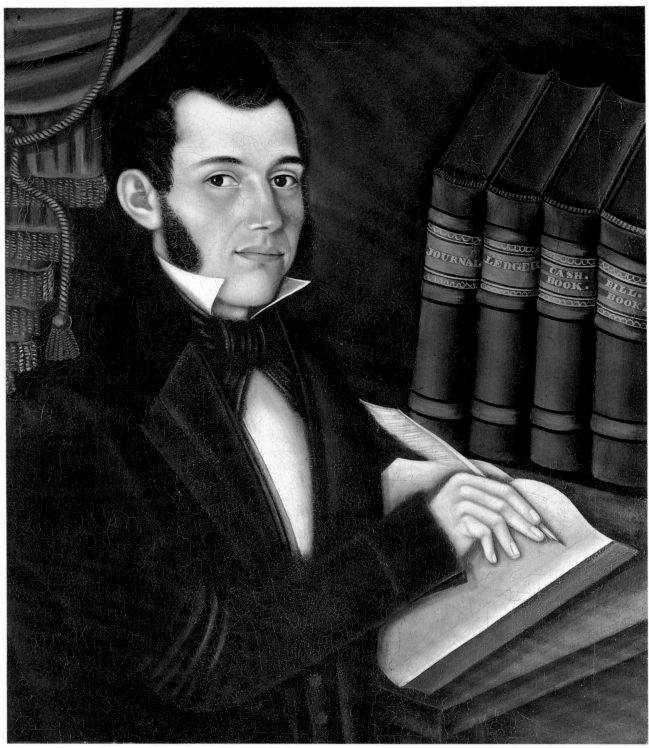

45

to solve technical problems in his own way. Crafft cleverly signed and dated the open ledger but neglected to note the identity of his subject, where the likeness was taken, or how much he was paid.

Although the provenance of *The Merchant* is undetermined, in 1839, three years after it was painted, Crafft was in Clinton, Vermillion County, Indiana, where he painted Mr. and Mrs. Robert Filson.[1] On February 3, 1844, he was sufficiently confident of his ability to advertise in the *Fort Wayne Sentinel* that "all Likenesses are warranted correct and satisfactory or no charge will be made."[2] About the same time he did portraits of the Indian chief Francis La Fontaine and three members of his family. Crafft is said to have painted in Louisville and Madison County, Kentucky, in 1845, and in Jefferson County, Kentucky, in 1853.[3] A pair of signed portraits of a Lexington, Mississippi, couple is dated 1854, and by 1865 Crafft had executed at least one very accomplished academic portrait in Danville, Kentucky. The latest signed portrait by Crafft is dated 1866.[4]

Like a number of other nineteenth-century itinerant artists, Crafft sought to improve his art by emulating the methods of more accomplished contemporaries whose work he doubtless saw in the course of his travels. As he gained experience, the intriguing arrangements of personalizing accessories were gradually replaced by solid backgrounds, while the figures became rounder and more modeled and finally assumed a photographic appearance. In terms of color and design, these polished portraits are aesthetically inferior to the arresting likeness of *The Merchant*.

Inscriptions/Marks: Written across the top of the open ledger is "August 16 th,1836/R. B. Crafft Dr/for cash pain[t]"; the books are titled JOURNAL, LEDGER, CASH BOOK, and BILL BOOK.
Condition: In 1955 Russell J. Quandt lined and cleaned the portrait. Possibly original 3¼-inch cove-molded gilt frame.
Provenance: Found by Holger Cahill and purchased from George S. Baker, Atlanta, Ga., with a history of having come from Tennessee by way of Zebulon, Ga.
Exhibited: "The Arts and Crafts of the Old Northwest Territory," Henry Ford Museum, Dearborn, Mich., October 8-November 29, 1964; Philbrook Art Center.
Published: AARFAC, 1940, p. 20, no. 22; AARFAC, 1947, p. 16, no. 32; AARFAC, 1957, p. 36, no. 16, illus. on p. 37.

[1] The Filson portraits are in the Allen County-Fort Wayne Historical Society.
[2] Peat, p. 111.
[3] Edna Talbott Whitley, *Kentucky Ante-Bellum Portraiture* (Lexington, 1956), p. 647.
[4] Except for the Filson likenesses, the portraits signed by Crafft are privately owned, usually by descendants of the subjects.

Justus Dalee
(active 1826-1847)

The earliest dated record of Justus Dalee's activity is a fifty-two-page sketchbook entitled "EMBLEMATIC FIGURES, REPRESENTATIONS, &, TO PLEASE THE EYE."[1] This homemade, hand-sewn volume with a Palmyra, New York, history contains twenty-two pages showing finished watercolor and ink compositions, pencil or watercolor and ink renderings, and unfinished or preliminary sketches in pencil. The illuminated title page is dated "May 19th, 1826," and the latest dated drawing in the book is inscribed "February 12th, 1827." Several of Dalee's drawings are signed in full, and on one page he titled himself "Professor of Penmanship." Inscriptions in the sketchbook do indeed show Dalee to have been an accomplished penman at that date, although his drawings are generally naive in composition and awkward in rendering. "Professor" Dalee, still, practically speaking, an art student himself, copied at least four drawings from printed plates in an early edition of an art instruction manual, *The Oxford Drawing Book*.

By the mid-1830s Justus Dalee was working in the Albany, New York, area; six family records drawn and signed by him at nearby West Troy and Cambridge, New York, locations have survived, one of which is dated September 26, 1834.[2] Dalee used a partially

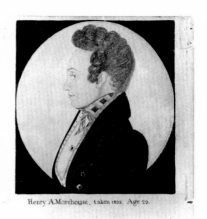

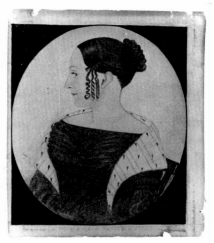

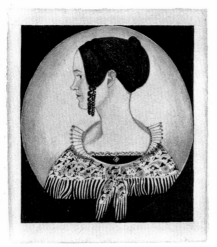

Henry A.Morehouse, taken 1839. Age 22.

46 47 48

printed, engraved stock register, which he subsequently colored by hand, filling in the births, marriages, and deaths of the client's family members, combining ornamented block letters with his graceful cursive script.

About the same time Dalee began focusing as a professional artist on painting miniature watercolor portraits. Although dated portraits do not survive before 1839, hairstyles and costumes depicted in some uninscribed examples indicate he had started painting portraits regularly by about 1835. The works that fall into this category generally combine a half-length, full-frontal body with the head described in profile. It is obvious that when he began to paint watercolor miniatures, Dalee took the least troublesome analytic approach to rendering these two parts of the anatomy. The solid black-painted spandrels that frame all of Dalee's fifty recorded later works in full profile are found on only one of the ten recorded "frontal" body portraits.[3]

Dated portraits encompass the period from May 1839 to 1845. By 1840 Dalee was working in Rochester, New York, where he executed at least two known portraits in that year. In 1841 he is listed in *King's Rochester City Directory and Register* at 17 Adams Street as a "Side Portrait Painter," an apt description of his use of profile portraiture at that time. In July 1842 Dalee had worked his way across New York and appeared in Cabotville (now Chicopee), Massachusetts, just north of Springfield. By 1843 he was back in Rochester, and in 1847 he was listed as a "portrait painter" in the *Commercial Advertiser Directory for the City of Buffalo.* The 1848-1849 directory listed him as a "grocer," a change of occupation that would explain the lack of

later examples of his work.[4] Portraits that are either inscribed by Dalee or have fairly reliable histories indicate that he was an active itinerant artist who produced portraits and family records as he moved along the main routes across upper New York state into western Massachusetts and down into central Connecticut. He may have painted as far south as New York City. Although numerous works by Dalee have been recorded, many questions concerning his life and his whereabouts at certain times remain to be answered.

[1]This sketchbook is in the Walters Art Gallery, Baltimore.
[2]Two family records by Dalee, Brust Family Record, acc. no. 39.305.2, and Potter Family Record, acc. no. 58.305.2, are at AARFAC.
[3]See *Profile Portrait of a Young Woman*, no. 48.
[4]Research by Jack T. Ericson uncovered these two references to Dalee in the *Commercial Advertiser Directory for the City of Buffalo*, published by Jewett, Thomas & Co. and T. S. Cutting. The 1847 directory reference appears on p. 38, the 1848-1849 one on p. 137.

46 Henry A. Morehouse 31.300.5

Attributed to Justus Dalee
Probably New York state, 1839
Watercolor, pencil, and ink on wove paper
3¼" x 2⅞" (8.3 cm. x 7.3 cm.)

Twelve of the sixty recorded portraits by Justus Dalee bear brown ink recto inscriptions in his characteristic lettering style; six, including the portrait of Henry A. Morehouse, are dated 1839.

An analysis of Dalee's extant works shows that he was in the habit of posing all single subjects facing left. With only one exception, subjects painted as companion portraits and framed together as a pair are posed facing each other with the man on the left. Although the portraits of Henry A. Morehouse and Belene Ann Park (see no. 47) were purchased together, their poses and the different manner in which they are inscribed suggest that they were not intended as a pair and perhaps have no association with each other.

Morehouse's portrait exhibits the black framing spandrels and pale blue background shading characteristic of one of Dalee's two general categories of portraiture. Aside from this stock format and certain anatomical clichés, such as his drawing of ears, Dalee's portraits tend to be nonstylized renderings of individual personalities whose features, hairstyles, costumes, and jewelry are treated in an unusually comprehensive manner. Details such as Morehouse's sporty plaid collar and kerchief and curly hair illustrate the artist's attempt to personalize his portraits.

Inscriptions/Marks: Hand-lettered in ink in the margin beneath the portrait is "Henry A. Morehouse, taken 1839. Age 23." The same inscription appears very faintly on the verso in pencil, apparently in the artist's script. No watermark found.
Condition: No evidence of previous conservation. Period replacement 1-inch gilt frame with applied bead molding.
Provenance: Edith Gregor Halpert, Downtown Gallery, New York, N.Y.
Exhibited: Washington County Museum.
Published: AARFAC, 1940, p. 26, no. 69; AARFAC, 1947, p. 24, no. 69; AARFAC, 1957, p. 142, no. 71, illus. on p. 143.

47 Belene Ann Park 31.300.6

Attributed to Justus Dalee
Probably New York state, Massachusetts, or Connecticut, ca. 1840
Watercolor, pencil, and ink on wove paper
3 3/8″ x 2 3/4″ (8.6 cm. x 6.9 cm.)

Although Dalee's seated subjects always seem somewhat awkwardly positioned in their chairs, he did make an attempt to depict a variety of Windsor, "fancy," and slat-backed chair forms, although certainly in stylized fashion.

Whereas Dalee's portraits of men generally show the bodies of the subjects in profile, his spandreled likenesses of women are divided between those with bodies in profile and those with bodies turned slightly to a frontal position. Without exception, the artist avoided

drawing his adult subjects' hands. Another artistic idiosyncrasy particularly well illustrated here is Dalee's stylized drawing of ears.

Inscriptions/Marks: On the verso of the primary support in penciled script is "Belene Ann Park." No watermark found.
Condition: No evidence of previous conservation. Period replacement 1-inch gilt frame with applied bead molding. Evidently the same type of frame was cut down for this piece and for nos. 46, 135, and 136.
Provenance: Edith Gregor Halpert, Downtown Gallery, New York, N.Y.
Published: AARFAC, 1940, p. 26, no. 70 (titled *Mrs. Henry A. Morehouse*); AARFAC, 1947, p. 24, no. 70 (titled *Mrs. Henry A. Morehouse*); AARFAC, 1957, p. 360, no. 245.

48 Profile Portrait of a Young Woman 58.300.23

Attributed to Justus Dalee
Probably New York state, Massachusetts, or Connecticut, ca. 1840
Watercolor, pencil, and ink on wove paper
3 11/16″ x 2 3/16″ (8.1 cm. x 6.6 cm.)

The long-necked, humpbacked appearance of this unidentified young woman illustrates well the problems that Justus Dalee sometimes encountered when he combined profile and frontal poses. Of the ten recorded specimens that utilize the combination pose, no. 48 is the only one with the black-painted spandrels that characterize the majority of Dalee's other surviving works.

Condition: Restoration by Christa Gaehde in 1958 included cleaning, unspecified repairs, and mounting on Japanese mulberry paper. Original 3/4-inch molded gold leaf frame.
Provenance: J. Stuart Halladay and Herrel George Thomas, Sheffield, Mass.
Published: Walters, Pt. 2, p. 2C, illus. as fig. 13 on p. 3C.

J. A. Davis
(active 1832-1854)

Although more than fifty-five works showing definite stylistic relationships have now been attributed to J. A. Davis, surprisingly little is known about the artist or his life. Part of this difficulty stems from the fact that his full name remains unknown;[1] his signed portraits that have been identified are inscribed only "J. A. Davis" or "J. A. D." and the surname was a common one in many parts

of New England, where Davis worked. The suggestion that one Joshua A. Davis, listed as a portrait painter in Providence, Rhode Island, city directories between 1854 and 1856, may be the artist in question has not yet been proved or disproved.[2]

Davis's travels can be reconstructed by examining the names, locales, and dates associated with a number of his sitters. His earliest work is a privately owned, previously unrecorded hollow-cut profile of an unidentified man with watercolor-painted body that is signed and dated October 20, 1832. It is the only silhouette as yet recorded for Davis, but undoubtedly many others exist. At a slightly later date, white opaque watercolor in the painting of the faces also represents a deviation from the characteristic technical approach indicated by recorded examples of Davis's work. In general, Davis's earliest pieces appear to have been done in New Hampshire, but throughout the 1840s eastern Connecticut and Rhode Island subjects predominate.[3] Davis's latest dated inscribed portrait is 1854.[4]

Many of Davis's figures assume leaning postures. His sitters rarely seem convincingly seated in their chairs, and in terms of composition, curious relationships are formed by inscription panels, border devices, or landscape elements that often cut off the figures at half- or three-quarter length. If two unfinished portraits can be considered typical of Davis's method, they show that the artist first drew his entire composition in pencil, next concentrated on the fully painted development of the subject's head (and landscape details, where they appear), and finally painted the body.[5] Davis primarily used pencil to render facial features, and many portraits also bear signs of a pale blue watercolor wash around the eyes or mouth. Black-costumed figures and a pale, thin watercolor palette characterize many of this artist's works, although bright touches of color are found in some recorded portraits.

[1]Sybil Kern is actively researching J. A. Davis's identity and, in unpublished manuscript material, has proposed that the artist was Jane Anthony Davis (1821-1855) of Warwick, R.I. Additional information will be needed to substantiate this theory.

[2]Savage and Savage, p. 875; see also the exhibition catalog, Three New England Watercolor Painters, p. 42.

[3]See the exhibition catalog, Three New England Watercolor Painters, p. 42.

[4]Ibid., p. 49, no. 11.

[5]Slides of these two privately owned drawings are on file at AARFAC.

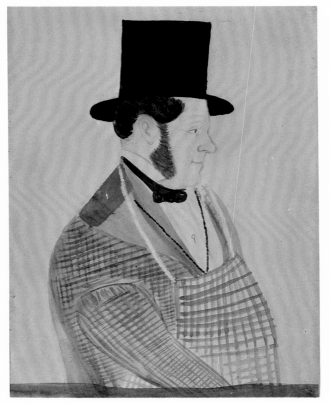

49

49 Shopkeeper 77.300.1

Attributed to J. A. Davis
Probably Connecticut or Rhode Island, ca. 1845
Watercolor and pencil on wove paper
6″ x 4½″ (15.2 cm. x 11.4 cm.)

In addition to the cut silhouette cited previously (see the biographical entry for J. A. Davis), only three watercolor profiles by Davis have been recorded thus far, one of which is the latest dated work credited to him.[1] The *Shopkeeper* is attributed to the artist on the basis of characteristic touches of pale blue on the face, pencil drawing of facial features, the palette, the use of a wide border line cutting off the figure at the bottom, and the irregular manner of depicting plaid fabric, which can be found in other works by the artist. Checked aprons of the type shown here were commonly used by small merchants who engaged in a variety of trades; a previously unrecorded portrait by Davis of a cobbler shows a similarly aproned figure.[2]

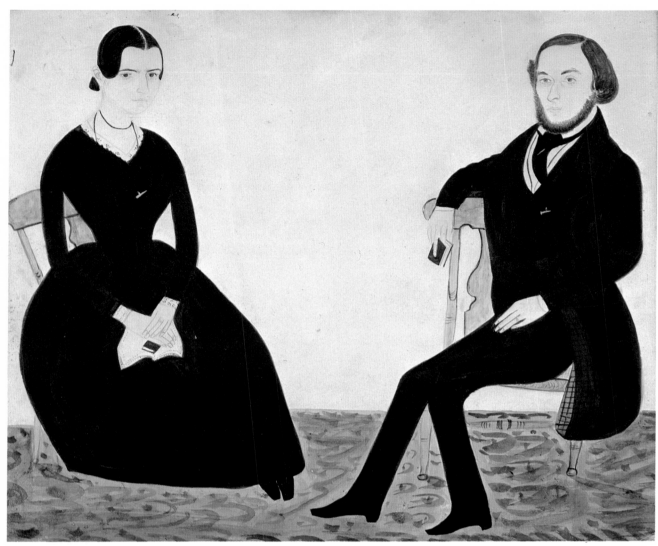

50

Condition: Unspecified restoration prior to its acquisition included backing the primary support with Japanese mulberry paper. Probably period replacement 1-inch molded gilt frame.

Provenance: Found in Rhode Island;[3] Edgar William and Bernice Chrysler Garbisch, New York, N.Y.; gift of Mr. and Mrs. Howard A. Feldman.

Published: Sotheby Parke Bernet, Fine Americana, lot no. 576 (titled *The Butcher*).

[1]This is the portrait of Luella P. Hodges, dated August 1854. See the exhibition catalog, Three New England Watercolor Painters, p. 49, no. 11, illus. as fig. 11 on p. 48.

[2]See *The Shoemaker, Elijah G. Chase,* in *101 American Primitive Water Colors and Pastels from the Collection of Edgar William and Bernice Chrysler Garbisch* (Washington, D.C., 1966), p. 104, no. 89.

[3]Sotheby Parke Bernet, Fine Americana, lot no. 576 and illus.

50 Mr. and Mrs. Eben Davis 32.300.1

Attributed to J. A. Davis
Possibly Newbury, Massachusetts, or Plainfield, Connecticut, possibly 1844
Watercolor and pencil on heavy wove paper
13½" x 15¾" (34.3 cm. x 40.0 cm.)

Before the location of signed works by J. A. Davis, this portrait was misattributed to one of the sitters, Eben Davis, based on an interpretation of the inscription on its frame backing cited below. It had been assumed erroneously that Mr. Davis, the portrait painter, and

Eben Davis, the subject, were one and the same, and a genre watercolor in the Folk Art Center's collection signed by "E. P. Davis" provided circumstantial reinforcement for this mistaken attribution.[1] The genre signature matches that of Eben Pearson Davis of Byfield Parish, Newbury, Massachusetts, indicating that the male subject in this double portrait was indeed an artist responsible for at least one composition. There is no stylistic connection between the portrait and the genre subject, however, and the discovery of signed portraits by J. A. Davis quickly clarified the identity of the artist credited with the likenesses of Eben P. Davis and his wife.[2] No relationship between J. A. Davis and Eben P. Davis has yet been determined.

Eben Pearson Davis was born on April 9, 1818. He was a carpenter and, at one point at least, a shoemaker by trade and was known to have been an accomplished penman.[3] Rhoda Ann Thatcher, his wife, was born in Canterbury, Connecticut, on September 18, 1819. She married Eben Davis in Plainfield, Connecticut, on September 17, 1844.[4] The Davises spent their married life in Byfield, where their three children were born and where Rhoda Ann died on September 6, 1877. Some years after her death, Eben moved to Worcester, where he died on April 4, 1902.

This portrait of Eben P. and Rhoda Ann Thatcher Davis is the largest recorded work by J. A. Davis; two other full-length standing subjects shown in interior settings employ the same loosely painted, dappled effect as a floor treatment.[5]

Inscriptions/Marks: Penciled in script on the verso of the primary support is "Eben Davis/He and wife." Printed in pencil on a fragment of the wood backing of the frame is the later inscription "MR & MRS EBEN DAVIS OF BYFIELD/MASS/PAINTED BY MR DAVIS BEFORE/THEIR MARRIAGE/ABOUT. . . [1860]" (the fragment has been broken, losing the date, which has been taken here from a transcription in earlier records). Penciled in script on the verso of the same wood fragment is "From Sarah Lizzie Stickney/June 1899." The primary support bears the watermark "J WHATMAN/1844" in three places for the Maidstone, Kent, England firm operated by the Hollingworth brothers between 1806 and 1859.
Condition: Restoration between 1954 and 1956, probably by Christa Gaehde, included reduction of water stains along the edge and minor inpainting in the floor; at that time or later, the primary support was glued to a rag-content, slightly larger paper, the lower sides and bottom margin of which were watercolored to simulate the floor design of the original painting. Dry surface cleaning by E. Hollyday in 1974. Period replacement 1-inch gilt frame.
Provenance: Found in Boston, Mass., and purchased from Edith Gregor Halpert, Downtown Gallery, New York, N.Y.
Exhibited: American Folk Art; Goethean Gallery; "The Inner Circle," Milwaukee Art Center, September 15-October 23, 1966; "Social and Cultural Aspects of American Life," Pine Manor Junior College, Wellesley, Mass., January 13-February 28, 1963; Three New

England Watercolor Painters, and exhibition catalog, p. 47, no. 9, p. 66, no. 11, illus. as no. 9 on p. 47.
Published: AARFAC, 1940, p. 27, no. 76, illus. on p. 25; AARFAC, 1947, p. 25, no. 76, illus. on p. 22; AARFAC, 1957, p. 160, no. 80, illus. on p. 161; Cahill, p. 35, no. 41; Nina Fletcher Little, "New Light on Joseph H. Davis, 'Left Hand Painter,'" *Antiques,* XCVIII (November 1970), illus. as fig. 5 on p. 756; Savage and Savage, p. 872, illus. as fig. 4 on p. 874.

[1] The genre composition is *Eben P. Davis's Horse,* AARFAC, acc. no. 31.301.4.
[2] Savage and Savage, pp. 872-875.
[3] Although family notes indicate that Davis was a carpenter "all his life," Newbury marriage records list his occupation as a shoemaker. He could easily have pursued both trades.
[4] This information was obtained from family records. Newbury, Mass., vital records, however, give contradictory marriage statistics, indicating that the couple was married in Newbury August 31, 1844.
[5] See the exhibition catalog, Three New England Watercolor Painters, illus. as no. 6 on p. 46, and as no. 26 on p. 54.

51 Girl with Gold Beads 32.300.2

Attributed to J. A. Davis
Probably New England, ca. 1845
Watercolor and pencil on heavy wove paper
4⅞" x 4⅛" (12.4 cm. x 10.5 cm.)

Although it was nearly a compositional cliché of portraiture in the period, the swagged drapery framing this unidentified subject was a departure for J. A. Davis since he used it in only one other recorded portrait.[1] The related example is essentially identical except that it lacks the stippled background seen through the openings created by the placement of the subject's arms, a background technique that relates to the painting of the floor area in the portrait of Mr. and Mrs. Eben Davis (see no. 50).

Condition: Restoration between 1954 and 1971, probably by Christa Gaehde, included minor inpainting at a tear along the upper left arm and shoulder, in two small areas in the drape, and in one small area in the left sleeve balloon. Treatment by E. Hollyday in 1974 included setting down an area of paint to the right of the hand. Period replacement 1-inch flat mahogany-veneered frame.
Provenance: Found in Boston, Mass., and purchased from Edith Gregor Halpert, Downtown Gallery, New York, N.Y.
Exhibited: Three New England Watercolor Painters, and exhibition catalog, p. 51, no. 16, p. 66, no. 22, illus. as no. 16 on p. 50; Washington County Museum.
Published: AARFAC, 1940, p. 26, no. 66 (titled *Girl with Necklace*); AARFAC, 1947, p. 24, no. 66 (titled *Girl with Necklace*); AARFAC, 1957, p. 360, no. 243.

[1] See the portrait of Eunice A. Buss in the exhibition catalog, Three New England Watercolor Painters, illus. as no. 8 on p. 46.

51 Attributed to J. A. Davis, *Girl with Gold Beads*

Joseph H. Davis
(active 1832-1837)

Although more than 130 watercolor portraits attributable to this itinerant artist have been recorded since his first works were identified by style and name over thirty-five years ago, indisputable facts and records concerning the life of the person named Joseph H. Davis have eluded researchers. Several theories have been proposed and some discarded, but the large body of Davis's work has consistently remained the most revealing source of information about him, his period of artistic activity, and the chronology of his travels.[1] In a decorative script as characteristic of his portraits as the images themselves, Davis inscribed most of his pictures with the names of his subjects, their ages, various dates, and also sometimes where they were painted.[2] Through inscribed portraits and further research into the residences of his sitters, it can be shown that between 1832 and 1837 Joseph H. Davis, the "Left Hand Painter,"

traveled an area on the Maine–New Hampshire border extending from Wakefield, New Hampshire, at the northernmost point, southward to Epping, New Hampshire.[3] Other localities that he visited include Lebanon and Berwick in Maine, and Farmington, Strafford, Barrington, Northwood, Deerfield, Durham, and Lee in New Hampshire.

All of Davis's recorded portraits portray his subjects in profile, with bodies slightly turned to reveal more of their costumes. Single figures generally face right, although couples or family members were posed confronting each other, whether painted individually or grouped. Davis is undoubtedly best known for his full-length subjects placed on highly stylized, brightly colored carpets or imaginary floor treatments and shown either standing or seated in freely grained, decorated chairs. In a comparatively small group of portraits, Davis placed figures, all children, in outdoor surroundings. To date, only five half-length miniature portraits attributable to J. H. Davis have been recorded, although others probably await recognition and identification. In addition, a still life has recently been attributed to this artist, thereby broadening the known range of his subject matter.[4]

Davis's style represents in general a blend of ornamental writing and drawing and includes an attempt to render facial features realistically; an array of personal accessories that are as emblematic and symbolic as they are "real"; and largely artificial formula settings. Some of the stylistic details of his work are discussed in more detail in the entries for individual objects (see nos. 52-55).

[1]The evolution of theories regarding the identity of Joseph H. Davis is discussed in Spinney, pp. 177-180; Frank O. Spinney, "Joseph H. Davis," in Lipman and Winchester, Primitive Painters, pp. 97-105; and in the research conducted by Gail and Norbert H. Savage and Esther Sparks, which is summarized in the exhibition catalog, Three New England Watercolor Painters.

[2]The dates Davis provides vary, but most often they follow sitters' ages and indicate either the date of the sitter's next birthday or of the one just past, for example, "Thomas York. [who was] Aged 50. March 29th 1837." or "Nicholas D. Hill. [who will be] Aged 36 June 1836." Marriage, birth, and death dates may also be given, as well as the date when the painting was executed.

[3]Repeated published references to Davis's portrait of Bartholomew Van Dame, which is inscribed "JOSEPH H. DAVIS/LEFT HAND/ PAINTER . . . ," have made this personal characteristic fairly common knowledge, an irony in view of the few facts that are known about his life. Van Dame also used his left hand, a fact that probably prompted a discussion of the idiosyncrasy between the two men and led to the allusion in the inscription.

[4]Nina Fletcher Little, "New Light on Joseph H. Davis, 'Left Hand Painter,'" Antiques, XCVIII (November 1970), pp. 756-757, illus. as fig. 7.

52

Exhibited: AARFAC, April 22, 1959-December 31, 1961; Three New England Watercolor Painters, and exhibition catalog, p. 65, no. 113 (titled *Woman in an Interior,* or *The Frugal Housewife*); Washington County Museum.

Published: AARFAC, 1940, p. 26, no. 67 (titled *Woman in Interior*); AARFAC, 1947, p. 24, no. 67 (titled *Woman in Interior*); AARFAC, 1957, p. 204, no. 104, illus. on p. 205 (titled *Frugal Housewife*); AARFAC, 1959, p. 32, no. 28 (titled *Frugal Housewife*); Spinney, p. 180, no. 8 (titled *Woman in an Interior*).

53 Interior: Man Facing Woman 58.300.9

Attributed to Joseph H. Davis
Probably Maine or New Hampshire, ca. 1835
Watercolor and pencil on wove paper
10⅝" x 16½" (27.0 cm. x 41.9 cm.)

Although Davis's profiles, particularly his later works, bear crisp, hard, but sensitively drawn pencil outlines, some of his unfinished or trial sketches reveal that he often arrived at precision through deliberate reworkings.[1] The features of the two unidentified subjects in this uninscribed double portrait were heavily retraced at some point; the heavy retracing and the generally immature, hesitant quality of the entire composition and its elements suggest that the portrait is one of the artist's earliest, perhaps even abandoned, efforts. The handling of the cat, the subjects' faces, the woman's dress, the man's hat, and the rough brushwork of the carpet seem particularly awkward and inept when compared with more confidently executed later works.

Technically this portrait deviates from most of Davis's other likenesses in the use of a pale blue painted background, although a pair of half-length miniatures attributed to him employ the same device.

Inscriptions/Marks: Watermark in the primary support, "[?] MAN W BALSTON & CO/1814," probably for William Balston of the Springfield Mill, the present J. Whatman Ltd. mill, Maidstone, Kent England.

Condition: Restoration by Christa Gaehde in 1958 included mending small marginal tears and backing with Japanese mulberry paper. Possibly original 1¾-inch grained splayed frame.

Provenance: J. Stuart Halladay and Herrel George Thomas, Sheffield, Mass.

Exhibited: Halladay-Thomas, Albany, and exhibition catalog, no. 95 (titled *Conversation Piece*); Halladay-Thomas, Hudson Park; Halladay-Thomas, New Britain, and exhibition catalog, no. 59 (titled *Conversation Piece*); Three New England Watercolor Painters, and exhibition catalog, p. 40, no. 28, p. 64, no. 105, illus. as no. 28 on p. 41.

Published: Peterson, illus. as pl. 44.

[1]Spinney, p. 73.

52 Woman in Profile on 35.300.1
Patterned Floor

Attributed to Joseph H. Davis
Probably Maine or New Hampshire, ca. 1835
Watercolor and pencil on wove paper
8⁵/₁₆" x 6¼" (21.1 cm. x 15.9 cm.)

This uninscribed portrait of a woman in profile is a fairly modest and somewhat coarsely drawn example of Davis's formula for single figure subjects. It is difficult to determine whether or not an inscription line was trimmed from the bottom of this piece because several uninscribed portraits by Davis that retain full blank margins do survive.

Condition: Restoration by an unidentified conservator between 1954 and 1956 included reduction of water stains across the upper margin, removal of surface dirt, and inpainting of minor losses over the body. Period replacement 1¹⁵/₁₆-inch grain-painted splayed frame.

Provenance: Found in Boston, Mass., and purchased from Edith Gregor Halpert, Downtown Gallery, New York, N.Y.

55 Attributed to Joseph H. Davis, *The York Family at Home*

54 The Tilton Family 36.300.6

Attributed to Joseph H. Davis
Probably Deerfield, New Hampshire,
January 1837
Watercolor, pencil, and ink on wove paper
10″ x 15 1/16″ (25.4 cm. x 38.3 cm.)

Perhaps the most striking feature of this interior scene is the patterned floor covering on which the artist has placed his subjects. Whether such abstract designs were inspired by stenciled patterns, painted floorcloths, or woven carpets, it seems probable that the artist developed them primarily as a decorative stage for his figures.

A few of Davis's portraits bear a date of execution; for example, no. 54 is dated January 1837 in a festooned foliate wreath behind the figures, a framing device used frequently by the artist. Usually, however, an approximate date of execution must be derived by comparing the birth or age dates characteristically recorded by Davis in ornamental script below the subjects, as he did in no. 55.

On October 19, 1830, John T. Tilton of Deerfield, New Hampshire, married Hannah B. Barstow of East Kingston. An 1857 map of Deerfield shows two houses listed under the name of J. T. Tilton. In addition, three single portraits of children bearing the Tilton surname and apparently done in the same month and year by Joseph H. Davis have been recorded. According to their inscriptions, however, two of the subjects would have been born before John and Hannah Tilton's marriage.[1] The relationship between the various Tilton subjects painted by Davis awaits further clarification.

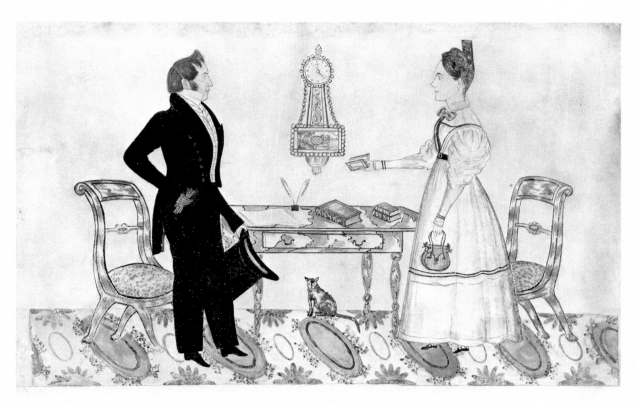

53 Attributed to Joseph H. Davis, *Interior: Man Facing Woman*

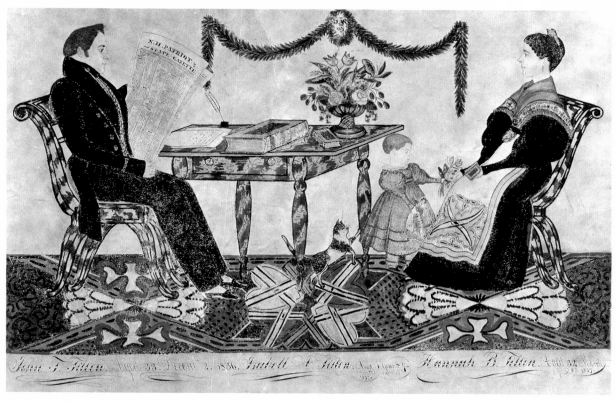

54 Attributed to Joseph H. Davis, *The Tilton Family*

Inscriptions/Marks: Printed in ink in the swagged medallion at the top is "JAN/1837." In ink in script in the bottom margin is "John T. Tilton. Aged 33. Decem^br 2^d. 1836. Isabell A. Tilton. Aged 1 Year. & 7-/months June 13^th/1837./Hannah B. Tilton. Aged 32 March/8^th 1837." Printed in ink at the top of the newspaper is "N.H. PATRIOT. &/STATE-GAZETTE." No watermark found.

Condition: Backed by Sidney Kopp in 1939. Restoration by Christa Gaehde in 1954 included removal from a pulpboard mounting, probably mending tears, and inpainting in the sitters' costumes and in other small scattered areas. Dry surface cleaning of unpainted areas by E. Hollyday in 1974. Period replacement 2-inch mahogany-veneered splayed frame.

Provenance: Found in Cambridge, Mass., or in Maine and purchased from Katrina Kipper, Accord, Mass.

Exhibited: AARFAC, April 22, 1959-December 31, 1961; Smithsonian, American Primitive Watercolors, and exhibition catalog, p. 5, no. 9; Three New England Watercolor Painters, and exhibition catalog, p. 35, no. 23, p. 63, no. 84, illus. on p. 35; William Penn Museum.

Published: AARFAC, 1940, p. 26, no. 68; AARFAC, 1957, p. 148, no. 74, illus. on p. 149; AARFAC, 1959, p. 32, no. 29; AARFAC, 1965, illus. as pl. 6; Spinney, p. 180, no. 7.

[1]See nos. 81-83 in the checklist of Joseph H. Davis's work in the exhibition catalog, Three New England Watercolor Painters, pp. 62-63.

55 The York Family at Home 31.300.13

Attributed to Joseph H. Davis
Probably Lee, New Hampshire, probably
August 1837
Watercolor, pencil, and ink on wove paper
11 1/16" x 14 7/8" (28.1 cm. x 37.8 cm.)
(Reproduced in color on p. 85)

Thomas York of Lee, New Hampshire, was born on March 29, 1787. He married three times, his third wife being Harriet Bartlett of Brentwood, who was born August 23, 1811 or 1812, and died December 17, 1840. Julia Ann York, born on April 22, 1837, was the second child of this marriage. A neighbor of Mr. York's, Bartholomew Van Dame, who was teaching school in Lee in 1857, wrote in a diary entry dated September 23, "I then cut across the pasture and called at Mr. Tho. York's who is very low from consumption. I shaved myself here. I also sung and prayed at his request." On November 15 he recorded, "Mr. Thomas York was buried to-day." Thomas York is depicted reading the *Morning Star,* a Free Will Baptist newspaper to which Van Dame, an itinerant schoolmaster, preacher, and reformer, was a frequent contributor. Two portraits of children bearing the York surname and also done in 1837 have been recorded, but their relationship to Thomas York has not yet been determined.[1]

The swagged and garlanded framed picture of a square hip-roofed house with four outside chimneys

and pedimented doorway shown behind the figures may represent the York home; this specific reference and the identified newspaper in Mr. York's hands typify the details by which Davis personalized his formula portraits.

The lines written below the subjects of this portrait and those below the Tilton family portrait (see no. 54) are characteristic of Davis's approach to inscription organization and calligraphy. The script is a flourished "Italian Hand" that was popularized by several writing manuals of the period.[2] Davis characteristically divided the information provided in his inscriptions into alternating right- and left-slanting sections.

Inscriptions/Marks: In ink in script in the margin at the bottom is "Thomas York. Aged 50. March 29^th 1837. Julia Ann, F. York. 4 months Aug^st 22/1837/ Harriet York. Aged 26 August 23^d 1837." Printed in ink at the top of Mr. York's newspaper is "MORNING STAR." No watermark found.

Condition: Unspecified restoration between 1954 and 1971, probably by Christa Gaehde, included backing with Japanese mulberry paper, mending two tears in the margin at lower right, reducing a water stain in the upper left corner, and some inpainting, particularly in the woman's sleeve, in the back of her head, in the man's coat near the elbow, and in the central carpet medallion. Dry surface cleaning of unpainted areas by E. Hollyday in 1974. Period replacement 1 5/8-inch flat frame, painted red.

Provenance: Found in New York state and purchased from Edith Gregor Halpert, Downtown Gallery, New York, N.Y.; given to the Museum of Modern Art in 1939 by Abby Aldrich Rockefeller; turned over to Colonial Williamsburg in June 1954.

Exhibited: AARFAC, American Museum in Britain; AARFAC, June 4, 1962-November 20, 1965; American Ancestors, and exhibition catalog, no. 20; American Folk Art; American Folk Painters; Three New England Watercolor Painters, and exhibition catalog, p. 40, no. 27, p. 64, no. 101, illus. as no. 27 on p. 41.

Published: AARFAC, 1957, p. 359, no. 242; *Antiques,* XL (September 1941), p. 141 and illus. on cover; Cahill, p. 35, no. 40, illus. on p. 78; Lipman, p. 20, illus. as fig. 30; Spinney, pp. 177-180, illus. as fig. 2 on p. 178; Warren S. Tryon, comp. and ed., *A Mirror for Americans: Life and Manners in the United States 1790-1870 as Recorded by American Travelers, I: Life in the East* (Chicago, 1952), illus. as frontispiece.

[1]See nos. 99 and 100 in the exhibition catalog, Three New England Watercolor Painters, p. 64.

[2]Davis was not the only artist who used this letter form. See also a special section on calligraphy by Esther Sparks, *ibid.,* pp. 68-69.

William Dering
(active 1735-1751)

William Dering is not well known in the published histories of American colonial painting or American folk art. This collection's portrait of Mrs. Drury Stith

was for many years the only identified portrait by his hand, and as Dering's only signed work it still remains a vital link in all attributions to him.[1] The most recent scholarship on the artist was published by Graham Hood in 1978 and provides the most complete account of Dering's life and career.[2]

The earliest reference to Dering is found in a 1735 *Pennsylvania Gazette* notice in which he advertised as a dancing master and listed the various hours and classes of his dancing school. Almost a year later the same Philadelphia newspaper carried an announcement that indicated that Dering and possibly his wife were teaching French, "Reading, Writing, Dancing, Plain Work, Marking, Embroidery, and several other works" at a house on Mulberry Street. Whether he was painting at the time is unknown, but it seems possible that Dering may have had a passing interest in drawing and may also have taught such rudimentary skills at his school before coming to the Williamsburg area of Virginia in 1737.

Virginians had patronized several artists before Dering's arrival, the most talented being the English painter Charles Bridges, who executed portraits for an impressive number of the colony's leading citizens from 1735 to about 1745. Dering probably had ample opportunity to view Bridges's work and he may also have met the older painter before Bridges's departure for England. As Hood suggests in his book on the two artists, it seems plausible that "1 large hair trunk with about 200 prints" and "1 paint box," which Dering owned between May 1744 and May 1745, may have formerly belonged to Bridges. While the possible contact between the two may never be documented, the discovery of more Virginia paintings by Dering may very well indicate a stylistic relationship between their paintings that is not obvious now.

By 1739 Dering had moved to Williamsburg and purchased two lots and a dwelling now known as the Brush-Everard House. During the next eight years he was identified in local public records as a dancing master, and there is no mention of portrait painting or similar pursuits. The only other specific reference to his portraiture comes from the ledger book of John Mercer, a merchant of Stafford County, Virginia, which states that he supplied the artist with paints in return for Dering's taking his likeness. Mercer had lodged with Dering during general court sessions held in Williamsburg from 1748 to 1750.

By the mid-1740s Dering was in financial difficulty and he had to mortgage much of his Williamsburg property. He had evidently left the Virginia area for

South Carolina by 1750, the year he and a Mr. Scanlan advertised a ball in Charleston. The Dering surname is found throughout South Carolina records prior to and following 1750, making it entirely possible that the artist had relatives in that area. It is perhaps only coincidental, but interesting, that the early Charleston pastellist, Henrietta Johnston, was first married to Robert Dering, an Irish aristocrat. Although no direct family connection between the two artists has been established, it is a research query now being investigated.

Documented references to William Dering in Charleston extend only to 1751. No paintings from South Carolina by him are known, and his career and whereabouts thereafter are equally obscure.

Although Dering's few identified portraits indicate modest ability and talent, they are as forthright and decoratively pretentious as any likenesses of their era. His style and approach were decisive and crisp, and his paints were applied quickly for costumes and perhaps a bit more carefully for faces; there was little attempt to personalize features or delve into character. His colors are deep and often rich, following the tradition of formal baroque portraiture that was in vogue during the period. The attitudes and expressions of his sitters are pleasant and self-assured, leaving the viewer no doubt of their opinion of their own worth and pride.

[1]The first important article on Dering, which includes a discussion of Mrs. Stith's portrait, was Pleasants, pp. 56-63. The attribution of the portraits of George Booth and his mother, Mrs. Mordecai Booth (in a private collection), to Dering was made in Weekley, pp. 21-28.

[2]All biographical information in this entry is from Hood, pp. 99-122, Pleasants, pp. 56-63, and AARFAC files.

56 George Booth 1975-242

Attributed to William Dering
Possibly Gloucester, Virginia, 1748-1750
Oil on canvas
50¼" x 39½" (127.6 cm. x 100.3 cm.)

George Booth's likeness may be considered the most impressive and appealing of the group of eight portraits now ascribed to Dering as well as one of the most visually intriguing and unique mid-eighteenth-century pictures executed in Virginia. Booth's engaging full-length pose with bow and arrows and the elaborate setting were most likely inspired by mezzotint sources, although certain details suggest the artist's own inven-

tiveness and the wishes of his patron. The garden vista with various buildings beyond may represent a settlement in Virginia, perhaps the early fortifications on the York River at Tindall's Point (now Gloucester Point) or a view of a family estate.

Even more fascinating are the two busts that dramatically flank the subject. Architectural plinths, similar to those supporting the busts, were commonly used with urns, masks, drapery, or small classical figures in American colonial portraiture, but seldom were such features given the prominence they have in Booth's likeness. The quickly drawn little dog, bearing his master's kill between exaggerated teeth, and the bold, basically linear quality of execution throughout are additional evidence of Dering's naive disregard of the subtleties of his trade as well as the limitations of his talent. Despite his errors and ambitious inclination to mimic academic styles, Dering's work is not totally imitative or repetitive. George Booth's likeness is decoratively charming

and vigorous in an inventive way that is more pleasing than many of the sophisticated portraits of the same period.

George Booth was the son of Mordecai Booth (1703-ca. 1774) and Joyce Armistead Booth of Belleville in Gloucester County, Virginia. The date of his marriage to Mary Mason Wythe (1751-1814), also of Gloucester, is undetermined. The subject died in 1777.[1]

Condition: Theodor Siegl lined and initiated cleaning of the portrait in 1976. This work was completed by Louis Sloan, who also filled and inpainted losses in 1977. Probably original 3⅞-inch molded frame, painted black.

Provenance: Mr. and Mrs. William B. Taliaferro, Norfolk, Va., descendants of the subject.

Published: Hood, illus. as fig. 64 opposite p. 97 and on pp. 105, 106, and 107; Graham Hood, "Charles Bridges and William Dering; Two Virginia Painters, 1735-1750: William Dering, Williamsburg painter 1745-1750," *Antiques,* CXII (November 1977), illus. on cover; Weekley, illus. as fig. 2 on p. 26.

[1]All information in this entry is from Hood, pp. 103-109, and from AARFAC archives.

57

57 Mrs. Drury Stith (Elizabeth Buckner)

1951-577

William Dering
Williamsburg, Virginia, 1748-1750
Oil on canvas
30″ x 22″ (76.2 cm. x 55.9 cm.)

Elizabeth was born about 1695-1700, the daughter of Major William Buckner, a justice, high sheriff, and burgess of York County, Virginia. She married Colonel Drury Stith, a justice and burgess from Brunswick County, about 1717 and they had seven children. The portrait was probably executed during a visit to Williamsburg or to her parents' home in nearby York County.[1] The "AEtatis Suae" notation found at the lower left of the picture is a curious throwback to portrait inscriptions commonly observed on Hudson Valley patroon paintings dating from 1710 to 1735.

This lady's picture is much more conservative in pose and format than *George Booth,* and it probably was based on either a mezzotint source or inspired by one of Charles Bridges's bust-length portraits that Dering may have seen. The effect is still formidable in terms of strong delineation of the face and in the exuberant folds and whorls of fabric. The manner in which Mrs. Stith's hair, eyes, and eyebrows are drawn, the modeling

of her face, and her affable expression are close to Dering's treatment of Booth's features. Although heavily restored, the blue gray dress with its red lining at the bodice and sleeve and the rosy flesh tones are noteworthy and contribute to the painting's visual interest.

Inscriptions/Marks: A painted inscription at the lower left of the painting reads "AEtatis Suae 50" (in the fiftieth year of her life); at the lower right corner is the painted signature "W. Dering 17 – ."

Condition: The painting was lined and paint losses were touched up by Mrs. J. G. Hopkins and Henry C. Hopkins at an undetermined date before its acquisition. In 1951-1952 Sheldon Keck relined and remounted the canvas on new stretchers, cleaned it, and inpainted numerous old losses throughout. Period replacement 3½-inch molded frame, painted black, with carved gilt inner border cut down to fit the painting.

Provenance: Descended in the family from the sitter to Griffin Stith; to Mrs. Christopher Johnston I (Susanna Stith); to Christopher Johnston II; to Christopher Johnston III; to Christopher Johnston IV; to Mrs. Pinckney W. Snelling (Sarah C. S. Johnston).

Published: Hood, illus. as fig. 62 on p. 102; Graham Hood, "Charles Bridges and William Dering; Two Virginia Painters, 1735-1750: William Dering, Williamsburg painter 1745-1750," *Antiques,* CXII (November 1977), illus. as fig. 1 on p. 934; Pleasants, illus. on p. 59; *The Williamsburg Collection of Antique Furnishings* (Williamsburg, Va., 1973), illus. on p. 57; Weekley, illus. as fig. 3 on p. 27.

[1]All information in this entry is from Hood, pp. 101-103, and Pleasants, pp. 61-62.

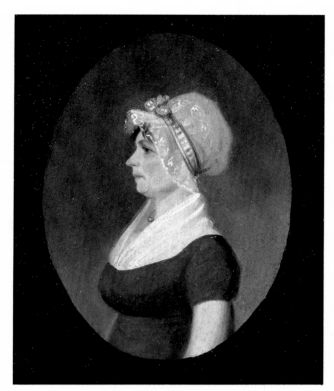

58

Jacob Eichholtz
(1776-1842)

Jacob Eichholtz was born November 2, 1776, the son of Leonard and Catherine Mayer Eichholtz of Lancaster, Pennsylvania.[1] He apparently received his first drawing lessons from a sign painter in the late 1780s. During that time Eichholtz also attended the English School of Franklin College (now Franklin and Marshall College). Little is recorded about his activities before 1801, when he was hired as a journeyman by George Steinman, a Lancaster coppersmith. The next year Eichholtz joined his brother George as a "tin-plate worker" in the family's business in Lancaster.

Although he is known to have produced likenesses as early as 1806, Eichholtz's first advertisements offering portrait painting and profiles appeared in the February 23, 1808, issue of the *Intelligencer and Weekly Advertiser,* published in Lancaster. In 1808 Eichholtz met the painter Thomas Sully, from whom he undoubt-

edly received valuable advice. At the urging of a friend, Eichholtz journeyed briefly to Boston in 1811 to seek further instruction from Gilbert Stuart; during this and the next three years the aspiring Lancaster artist exhibited at the Pennsylvania Academy of the Fine Arts and executed several portraits in the Philadelphia area. He continued to travel between Philadelphia and Lancaster on a regular basis during his career and visited other Pennsylvania cities as far west as Pittsburgh. Additional painting trips were made to towns in Maryland and Delaware until his death in 1842.

Eichholtz's paintings have been described as simple, direct, and competent. He used traditional portrait formats and his figures are usually precisely drawn, but conservative in coloration. Eichholtz's early profile portraits, like the one in this collection, are less polished than his full-face likenesses of the 1820s and 1830s.

[1]All biographical information in this entry is from Rebecca J. Beal, *Jacob Eichholtz 1776-1842, Portrait Painter of Pennsylvania* (Philadelphia, 1969), pp. xix-xxxi.

58 Woman in Profile 63.100.6

Attributed to Jacob Eichholtz
Possibly Philadelphia, Pennsylvania, ca. 1810
Oil on yellow poplar panel
9″ x 6½″ (22.9 cm. x 16.5 cm.)

This simple, yet sensitive, portrait of an unidentified woman illustrates several aspects of Eichholtz's early style, including the use of a profile pose, soft and rather indistinct modeling of the face and costume, and colors restricted to muted shades of gray and tan for the dress and background. Even at this early date in his career, Eichholtz was able to draw faces in convincing three-dimensional form. The oval format is seen in other small likenesses by the artist of about the same period.

Condition: Unspecified treatment by Russell J. Quandt in 1963 probably included cleaning and some minor inpainting and possibly reduction of warp in the primary support. Period replacement 1½-inch gilt frame.
Provenance: Descended in the Hammerslee and McClure families of Philadelphia, Pa.; Helen Yerkes, New York, N.Y.

James Sanford Ellsworth
(1802/3-1874?)

James Sanford Ellsworth is one of a mere handful of nonacademic miniature portrait painters whose works have been seriously considered and closely studied over a long period of time.[1] Over 265 likenesses by him have been recorded, primarily watercolor profiles but also several miniature full-face subjects and a small group of full-scale portraits in oil on canvas;[2] together they offer an unusual opportunity for an in-depth inspection of one artist's accomplishments in American folk portraiture.

In spite of a trail of works left by this extensive traveler, few fully substantiated facts concerning his life have been unearthed. From a letter written by Ellsworth later in life, it is known that he was born somewhere in Connecticut in 1802 or 1803.[3] He was baptized in West Hartland, Connecticut, on July 26, 1807, and on May 23, 1830, he married Mary Ann Driggs of Hartford. The short-lived marriage produced one child and ended in divorce in 1839, his wife alleging that he had deserted his family in 1833. Most of his documented portraits come from Connecticut and western Massachusetts, but in an 1861 letter he mentioned being "in Pennsyl-

vania," "at the edge of Ohio," and "in New York State." Ellsworth's death has not been documented, although one unvalidated account claims that he died in an almshouse in Pittsburgh in 1874.

Ellsworth's style is an interesting blend of the real and the unreal: his frank, representational, presumably realistic renderings of individualized subjects are, at the same time, characterized by distinctive conventions — gray tinted, scallop-edged, cloudlike aureoles that frame the heads of his sitters, related, cloudlike bases on which his half-length figures seem to be borne aloft, and curious, fanciful, upholstered chairs upon which more than half of his known subjects are enthroned. Although these devices predominate in the works produced throughout his career (ca. 1835-ca.1855), columns, drapery, other furniture forms, or a landscape view were occasionally introduced, and Ellsworth sometimes employed cut embossed papers or envelopes as framing elements for his small portraits. Such decorative details, formula stylizations, and careful attention to costume detail and facial modeling make this itinerant artist an especially intriguing personality. Moreover, judging by the volume and date of his work, Ellsworth was one of the few professional folk portraitists who, at least temporarily, seems to have thwarted the initial threat that the age of photography posed for such painters.

[1]H. S. French, a contemporary of Ellsworth's who supposedly knew or contacted him personally, discussed the artist in his book, *Art and Artists in Connecticut* (Boston, 1879); Frederic Fairchild Sherman published a monograph, *James Sanford Ellsworth* (New York, 1926), in addition to several articles on him in *Antiques* and *Art in America* in the 1920s; and Lucy B. Mitchell has produced the most thorough studies of the artist, first published in Mitchell, pp. 151-184, and updated and expanded in the exhibition catalog, AARFAC, Ellsworth, which includes an excellent bibliography of other writings dealing with the artist.

[2]As recorded by Lucy B. Mitchell. See also Lucy B. Mitchell to AARFAC, September 16, 1978.

[3]These facts and other biographical data are from the exhibition catalog, AARFAC, Ellsworth, pp. 4-5 and 14.

59 Louisa Avery Herrick 63.300.3

James Sanford Ellsworth
Probably Montgomery, Massachusetts, ca. 1840
Watercolor on wove paper
3⅜″ x 2⅝″ (8.6 cm. x 6.7 cm.)

See also nos. 60 and 61. William Herrick (1781-1866), his wife, Louisa Avery Herrick (1785-1866), and her nephew, William Herrick Avery (1820-1887), were all

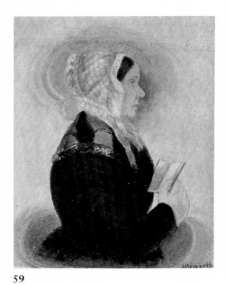
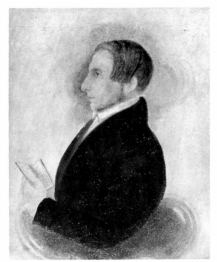
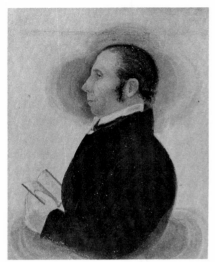

59 60 61

residents of Montgomery, Massachusetts, and presumably sat for Ellsworth there. These miniature profiles illustrate the care with which Ellsworth depicted individual facial features and the scallop-edged, cloudlike devices that characterize most of his works in watercolor.

Inscriptions/Marks: Printed in black watercolor in the lower right corner of the primary support is "Ellsworth,/Painter." No watermark found.

Condition: Restoration by Christa Gaehde in 1963 included removal from a blue paper mounting, cleaning, backing with Japanese mulberry paper, and probably inpainting areas of support loss ½ inch from the top edge where the support appears to have once been folded. Probably twentieth-century replacement ³/₁₆-inch engraved brass frame.

Provenance: Mrs. Florence M. Emery, Westfield, Mass. (a descendant of the sitter); Robert Carlen, Philadelphia, Pa.

Exhibited: AARFAC, Ellsworth, and exhibition catalog, p. 26, no. 25, illus. as fig. 25 on p. 27; "James S. Ellsworth: American Miniature Painter," Connecticut Valley Historical Museum, Springfield, Mass., October 9–November 13, 1953.

Published: Mitchell, p. 175, no. 25.

| 60 | **William Herrick Avery** | 63.300.4 |
| 61 | **William Herrick** | 63.300.5 |

James Sanford Ellsworth
Probably Montgomery, Massachusetts, ca. 1840
Watercolor on wove paper
3 ¼″ x 2 ⁹/₁₆″ (8.3 cm. x 6.5 cm.)
3 ⁵/₁₆″ x 2 ⁵/₈″ (8.4 cm. x 6.7 cm.)

For *Commentary* and *Provenance,* see no. 59.

Inscriptions/Marks: Printed in black watercolor in the lower margin below the sitter's forearm on no. 60 is "Ell." Printed on no. 61 is "E" followed by what is probably an "L." No watermark found.

Condition: Most of the original signatures were apparently trimmed from these portraits, probably when they were reframed sometime before 1953. Restoration by Christa Gaehde in 1963 included removing both watercolors from a blue paper mounting, cleaning, backing with Japanese mulberry paper, and probably repairing areas of support loss along a horizontal line near each top edge where the supports appear to have been folded. Probably twentieth-century replacement ³/₁₆-inch engraved brass frames.

Exhibited: AARFAC, Ellsworth, and exhibition catalog, p. 26, nos. 24 and 26, illus. as nos. 24 and 26 on p. 27.

Published: Mitchell, p. 175, nos. 24 and 26.

Erastus Salisbury Field
(1805–1900)

Erastus Salisbury Field lived most of his ninety-five years in Leverett, the small western Massachusetts town where he was born in 1805. On June 9, 1900, several weeks before Field's death, the *Greenfield Gazette and Courier* carried an article titled "Old Folks of the County" in which an unidentified reporter commented on the significance of his art:

Although Mr. Field was an all-around painter of the old school, his work which has been most highly appreciated is that of portrait painting; his likenesses of people of past generations are as nearly correct as can

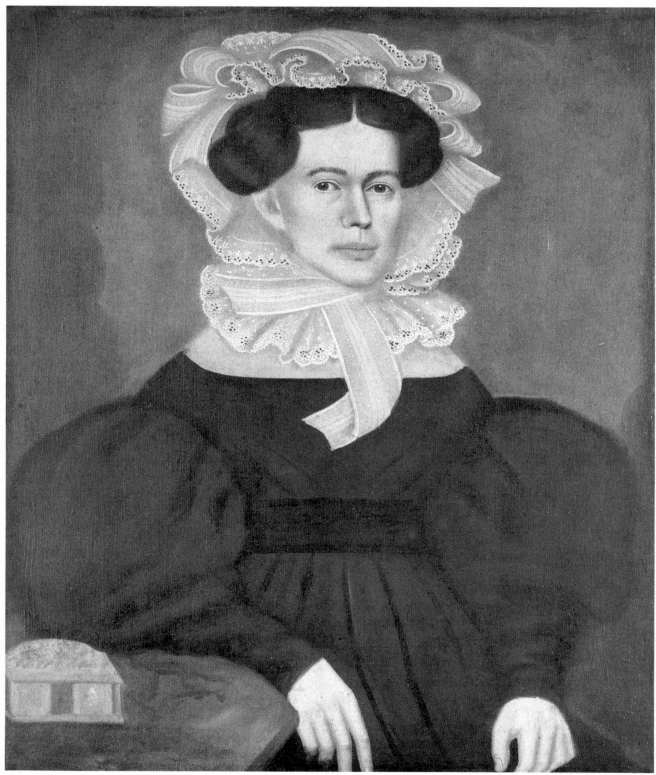

62

well be made in oil, and give to posterity faithful ideas of the personal appearance of their ancestors. [1]

To modern eyes, Field's most original and effective likenesses were painted between 1825 and 1845 because thereafter his attempts to imitate the realism of the camera supplanted the uniquely personal sense of design and composition that distinguishes his best work.

Erastus and his twin sister, Salome, were the third and fourth of nine children born to their parents, for whom they were named. Field's early talent for drawing and painting was recognized by his family, and in 1824, at age nineteen, he was sent to New York City to study with Samuel F. B. Morse (1791-1872). His apprenticeship was ended after only three months when the studio was closed because of the sudden death of Morse's young wife. Field returned to Leverett in the spring of 1825 and painted the first of his known works, a tightly drawn, smoothly painted likeness of his maternal grandmother, Elizabeth Ashley. [2] The portrait indicates that at the outset of his career Field had already developed the assured brushwork and curious cloudlike backgrounds of gray highlights that characterize much of his portraiture. At about the same time, Field began his travels up and down the Connecticut Valley in search of commissions. Late in 1831 he married Phoebe Gilmer of Ware, Massachusetts, and their only child, Henrietta, was born the next year. The decade following his marriage was an extraordinarily productive and prosperous time for Field. Nine portraits from the period 1831-1841 are included in the collection at Williamsburg.

To meet the demands of patrons eager for his services, by 1835 Field had evolved an efficient shorthand technique that enabled him to complete a half-length portrait in a day, for which he charged four dollars in 1838. [3] Among the mannerisms most often observed in his quickly painted likenesses are stiff frontal poses, square shortened hands, pointed ears, stippled flesh tones, and the use of black dots to describe lace patterns. Many of Field's early portraits are enlivened by strong, gay colors, but his palette became more restrained as his style grew increasingly photographic.

Field probably learned to use the camera during the period 1841-1848, when he was living and painting at various addresses in New York's Greenwich Village. Although he painted relatively few portraits after he returned to Massachusetts in 1849 to manage his ailing father's farm, Field found it convenient to base his later compositions on photographs of his subjects rather than painting from life. His lifeless group portrait of the Smith family (no. 71) illustrates the unhappy result of this practice. Undaunted by the dwindling demand for painted likenesses, Field became increasingly absorbed in portraying biblical and historical themes, often deriving his ideas from prints. In 1876 he created his masterpiece in this genre, a complex architectural fantasy titled *The Historical Monument of the American Republic.* [4]

[1] Quoted in Black, Field, p. 36.
[2] Field's ca. 1825 portrait of Elizabeth Virtue Billings Ashley is in the Museum of Fine Arts, Springfield, Mass.
[3] Manuscript receipt signed by Erastus Salisbury Field to Ashley Hubbard, February 10, 1838, AARFAC archives.
[4] In the Museum of Fine Arts, Springfield.

62	**Mrs. Eleazer Bullard (Emily Sheldon)**	73.100.2
63	**Eleazer Bullard**	73.100.1
64	**Mrs. Squire Brewer (Emeline Bullard)**	73.100.4
65	**Squire Brewer**	73.100.3

Attributed to Erastus Salisbury Field
Probably Lee, Massachusetts, ca. 1835
Oil on canvas
34½" x 28" (87.6 cm. x 71.7 cm.)

Erastus Salisbury Field's ability to support himself as a portrait painter was based on volume and low prices. To meet the demand for inexpensive likenesses, he found it expedient to standardize several basic formats that could easily be modified to suit the tastes and requirements of different clients. This efficient, businesslike approach is well illustrated in his somber portraits of four members of the Bullard and Brewer families that appear to have been commissioned by Eleazer Bullard to hang as a group.

The two men and the two women were posed identically and wear similar clothes, but Field made a concerted effort to individualize their features, which is evident in the firm delineation of Mrs. Brewer's long nose, the way her pallid husband's eyebrows grow together, and in Mr. Bullard's ruddy complexion and unshaven cheeks. The subjects' hands were more quickly painted, but they were gracefully positioned despite blunt fingers. Knuckles were suggested with dots of pink and flesh-colored pigment, and the same stippling technique was used to model the faces. The short

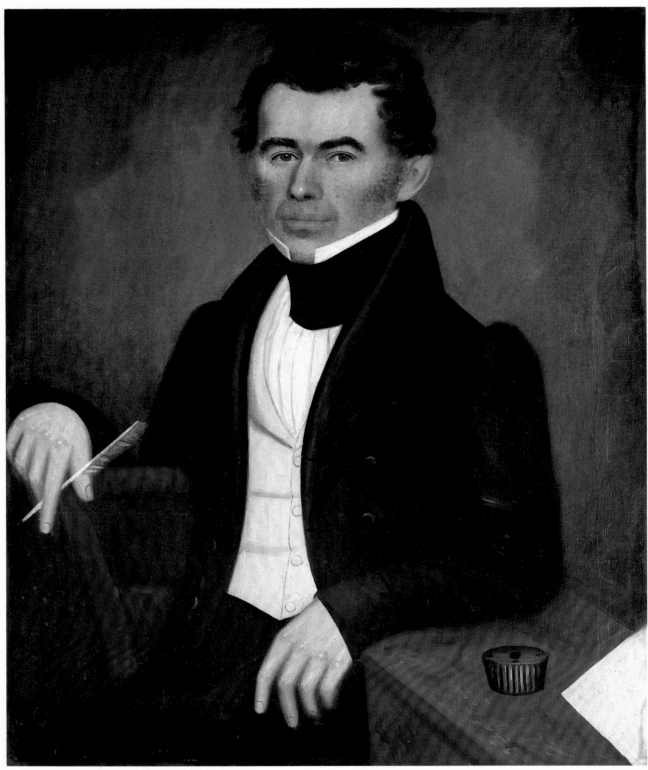

63

waists, narrow shoulders, and elongated arms are physical distortions characteristic of Field's style. The women's dresses and hairstyles indicate a date of about 1835, which corresponds with the two-year period when Field is known to have worked in Lee.

To further personalize and vary the compositions, Field provided the Bullards with tables, a pincushion, and writing equipment. The props, the dramatic juxtaposition of light and dark tones, and the lady's intricately ruffled cap and collar become decorative devices that make the Bullard portraits stronger and more interesting pictures than the companion likenesses of the Brewers.

The son of Joel and Mary Holcomb Bullard, Eleazer Bullard was born on October 25, 1787, in New Marlborough, Massachusetts, where he lived until his first wife's death in 1830. Soon thereafter, he moved to Lee, Massachusetts, where he died in 1858. He married Hannah Wilson of Berlin, Connecticut, on September 20, 1812 (see no. 37 for her portrait, attributed to Samuel Broadbent) and they had three children, among them Emeline Bullard (1815-1876), who became the

wife of Squire Brewer (1805-1900). Eleazer Bullard's second wife was Emily Sheldon Bullard (1798-1849).

Condition: The paintings were cleaned and lined by an unidentified conservator about 1955, at which time all of the canvases were mounted on composition board. Original 2-inch split turned baluster frames, painted red with with black sponging.

Provenance: Mrs. James Stagliano, Lee, Mass.

Published: Karen M. Jones, "Museum accessions," *Antiques,* CV (February 1974), p. 284; Walters, Pt. 2, no. 63 only, illus. as fig. 14 on p. 4C.

66	**Possibly Mrs. Pearce**	39.100.8
67	**Possibly Mr. Pearce**	39.100.7

Attributed to Erastus Salisbury Field
Possibly Hadley, Massachusetts, ca. 1835
Oil on canvas
30" x 26" (76.2 cm. x 66.0 cm.)

When acquired, these crisp likenesses were believed to be marriage portraits of a Mr. and Mrs. Pearce of Hadley, Massachusetts. Although the identities of the

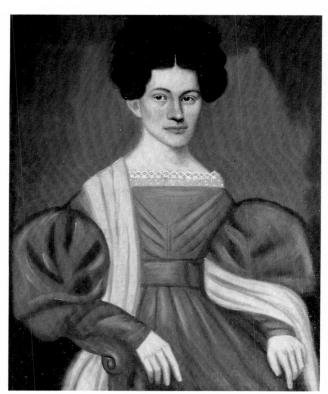

64 Attributed to Erastus Salisbury Field, *Mrs. Squire Brewer*

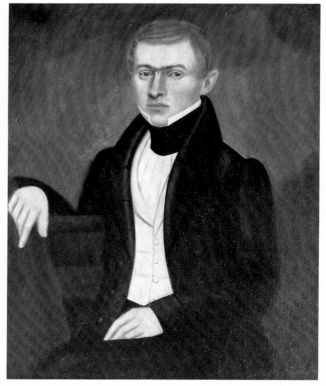

65 Attributed to Erastus Salisbury Field, *Squire Brewer*

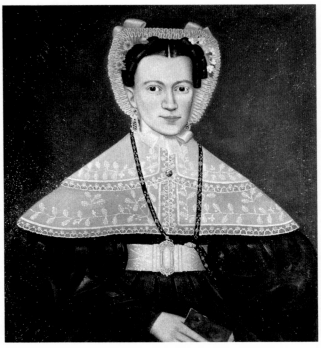

66

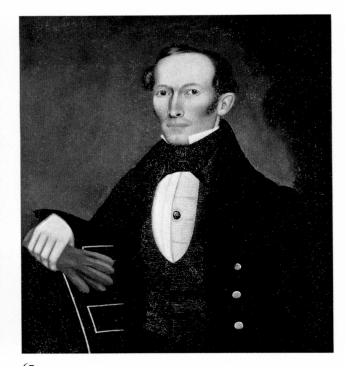

67

subjects remain unverified, the poses, coloration, and painting technique exhibit the formula approach to portraiture that Erastus Salisbury Field practiced with considerable success after 1835.

Both half-length subjects are silhouetted against a shaded gray background of cloudlike forms. Their narrow, sloping shoulders contribute to the triangular design of the compositions, which focuses the viewer's attention on the faces. The features are neatly outlined in thin brown lines and the cheekbones are described with touches of pink coloring.

Mr. Pearce is posed seated sideways in a Hitchcock-type grain-painted side chair. He grasps a brown glove in his right hand. His fingers and body are blocky in appearance and are painted in short, broad brushstrokes. Mrs. Pearce faces front and is represented as a serene young woman with a fixed gaze. Her pleated bonnet is trimmed with colorful silk flowers and her short-waisted brown dress has fashionable leg-of-mutton sleeves. Her black and gold jewelry, including an oval onyx pin that matches one worn by her husband, suggests that she was a woman of some means and social standing. The black dots and heavy impasto

Field often used to simulate lace are particularly effective in the woman's portrait because the rows of embroidery forming the stiffly starched collar create rhythmic decorative patterns.

Condition: In 1943 M. Knoedler & Co. lined and cleaned both paintings; in April 1955 Russell J. Quandt also cleaned them and did minor inpainting. Modern replacement 2¾-inch flat board frames with raised corner blocks and quarter-round molding around the outer edges, painted black and stenciled with a leaf design.[1]

Provenance: Found in Hadley, Mass., and purchased from Edith Gregor Halpert, Downtown Gallery, New York, N.Y.

Exhibited: AARFAC, Field, and exhibition catalog, nos. 69 and 70, no. 66 only, illus. as pl. II; AARFAC, April 22, 1959-December 31, 1961; AARFAC, September 15, 1974-July 25, 1976; "American Art, Four Exhibitions," Brussels Universal and International Exhibition, April 17-October 18, 1958, and exhibition catalog, illus. as nos. 79 and 80 on p. 45; "Somebody's Ancestors," Springfield Museum of Fine Arts, Springfield, Mass., February 7-March 8, 1942, and exhibition catalog, nos. 1 and 2, no. 66 only, illus. as pl. II.

Published: AARFAC, 1940, p. 20, nos. 23 and 24, illus. on pp. 16 and 17; AARFAC, 1947, p. 16, nos. 23 and 24, illus. on pp. 12 and 13; AARFAC, 1957, pp. 48 and 50, nos. 22 and 23, illus. on pp. 49 and 51; AARFAC, 1959, p. 36, nos. 36 and 37; AARFAC, 1974, p. 22, nos. 7 and 8, illus. on pp. 2 and 21; Mary C. Black, "Erastus Salisbury Field and the sources of his inspiration," *Antiques,* LXXXIII (February 1963), no. 66 only, illus. as no. 5 on p. 206; Agnes M. Dods, "A Checklist of Portraits and Paintings by Erastus Salisbury Field," *Art in America,* XXXII (January 1944), p. 36; Ford, p. 75; French, p. 120, nos. 160

and 161; Oliver W. Larkin, *Art and Life in America* (New York, 1949), no. 66 only, illus. on p. 226; Frederick B. Robinson, "Erastus Salisbury Field," *Art in America*, XXX (October 1942), p. 248, no. 66 only, illus. as fig. 3 on p. 252.

[1]The reproductions were copied from original frames on portraits painted by Field that are now privately owned. See the exhibition catalog for AARFAC, Field, Pt. VII, figs. 44 and 45.

68 Portrait of a Baby Girl 67.100.1

Attributed to Erastus Salisbury Field
Probably Massachusetts, ca. 1835
Oil on canvas
27" x 21" (68.6 cm. x 53.3 cm.)
(Reproduced in color on p. 100)

In this quickly painted portrait of a baby seated on a plank floor, the cloud background, enlarged head, slightly pointed ears, black dots to depict lace, and short, stubby fingers are as indicative of Erastus Salisbury Field's hand as a signature would be.[1] The faulty rendering of anatomy and perspective create an image that is both amusing and appealing, since the short, formless legs and tiny feet could not possibly support such a chunky body. The unidentified child's coral necklace adds compositional interest by providing a line of color that is repeated in the rose she holds.

Condition: In 1967 Russell J. Quandt lined the canvas, mounted it on modern stretchers, and cleaned it. Possibly original 2½-inch molded gilt frame.
Provenance: Mrs. Frances Holden, Linn, Ill.; Thomas and Constance Williams, Litchfield, Conn.
Exhibited: AARFAC, September 15, 1974-July 25, 1976.
Published: AARFAC, 1974, pp. 31 and 32, illus. as no. 24 on p. 32.

[1]Field painted several similar portraits of very young children, including *Infant with Cat* in the Balken Collection, Princeton University Art Museum, Princeton, N.J.

69 Boy on Stenciled Carpet 31.100.3

70 Girl Holding Rattle 31.100.4

Attributed to Erastus Salisbury Field
Probably Lee, Massachusetts, ca. 1838
Oil on canvas
43¾" x 29¼" (111.1 cm. x 74.3 cm.)
34¾" x 25½" (88.2 cm. x 64.8 cm.)
(No. 69 is reproduced in color on p. 32;
no. 70 is reproduced in color on p. 101)

These beguiling portraits are thought to represent an unidentified brother and sister, and they are attributed to Erastus Salisbury Field on the basis of their obvious stylistic relationship to a full-length portrait of Field's niece, done in 1838, and to other paintings by the artist.[1] The portraits incorporate several devices typical of his early work—elfin ears, a peculiar cloudlike background, square, shortened hands, and stippled pink and gray tones to suggest facial modeling.

Characteristically, Field made no attempt to foreshorten the boldly stylized red, green, and yellow figured floor covering. It appears to run uphill in both portraits and provides decorative splashes of color that contrast effectively with the swirling gray backgrounds. The boy's slippered feet seem to hover just above the carpet and his attenuated arms accentuate the vertical thrust of the composition. Field was apparently dissatisfied with his original positioning of the boy's left hand and repainted it; the initial design is now faintly

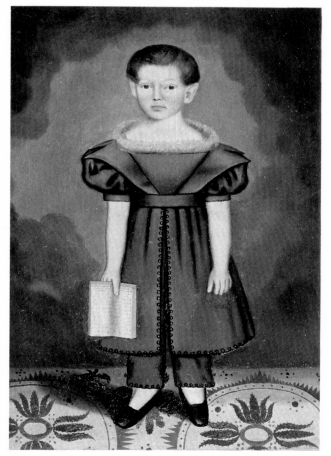

69

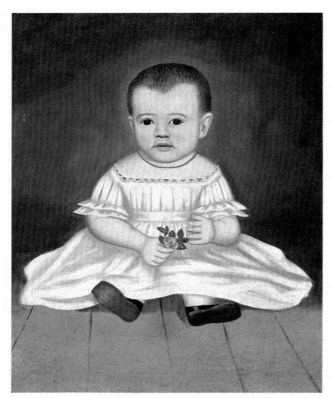

68 Attributed to Erastus Salisbury Field, *Portrait of a Baby Girl*

Thomas Flexner, "New Bottles for Old Wine: American Artisan, Amateur, and Folk Paintings," *Antiques*, XLI (April 1942), no. 69 only, illus. on p. 247; French, p. 125, nos. 217 and 218; McClinton, illus. on p. 29.

¹The portrait of Ellen Virtue Field is privately owned; it is illustrated in Black and Lipman as fig. 63 on p. 69.

71 The Smith Family 71.100.6

Attributed to Erastus Salisbury Field
Probably North Amherst, Massachusetts,
ca. 1865
Oil on canvas
36" x 47" (91.4 cm. x 119.4 cm.)

When the camera was first introduced to America in 1839 by Field's former teacher, Samuel F. B. Morse, some portrait painters attempted to stay in business by using daguerreotypes as the basis for their compositions. While patrons found this method a welcome alternative to tedious sittings, to modern eyes the results were seldom satisfactory. The distressing effect that painting from photographs had on Erastus Salisbury Field's style is best appreciated by comparing his mechanical rendering of the family of William Smith with the truly masterful life-sized portrait of the family of Joseph Moore, done twenty years earlier.[1] In the Smith picture the colorful parlor furnishings document middle-class Victorian taste, but the slickly painted fro-

visible through blue paint that has become translucent with age. Wearing a full-skirted white dress with a pink sash and clutching a yellow straw rattle, the small girl seems to be more securely anchored to her surroundings than her brother is. Here the addition of a decorated fancy chair with a rush seat and a crouching cat softens the rigid frontality that characterizes many of Field's full-length subjects.

Condition: David Rosen lined and cleaned both portraits prior to 1940. In 1955 Russell J. Quandt relined the canvases, mounted them on modern stretchers, cleaned both portraits, and did minor inpainting. Period replacement 4-inch and 3¼-inch mahogany- and rosewood-veneered cyma reversa frames with gilt liners.
Provenance: Both portraits were found in Bridgeport, Conn., and purchased from Edith Gregor Halpert, Downtown Gallery, New York, N.Y.
Exhibited: AARFAC, Field, and exhibition catalog, nos. 62 and 63, no. 69 only, illus. as pl. I; American Ancestors; American Folk Art.
Published: AARFAC, 1940, p. 17, nos. 7 and 8; AARFAC, 1947, no. 70 only, p. 14, no. 8; AARFAC, 1957, pp. 88 and 349, nos. 46 and 166, no. 69 illus. on p. 89; AARFAC, 1975, no. 70 only, illus. on p. 22; Black, Field, no. 69 only, illus. on p. 53; Cahill, p. 29, nos. 3 and 4, illus. on pp. 55 and 56; Cahill, Early Folk Art, illus. on pp. 262 and 263; James

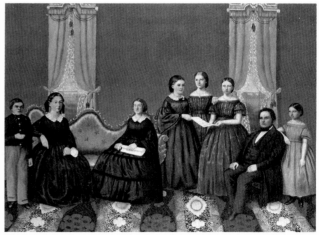

71

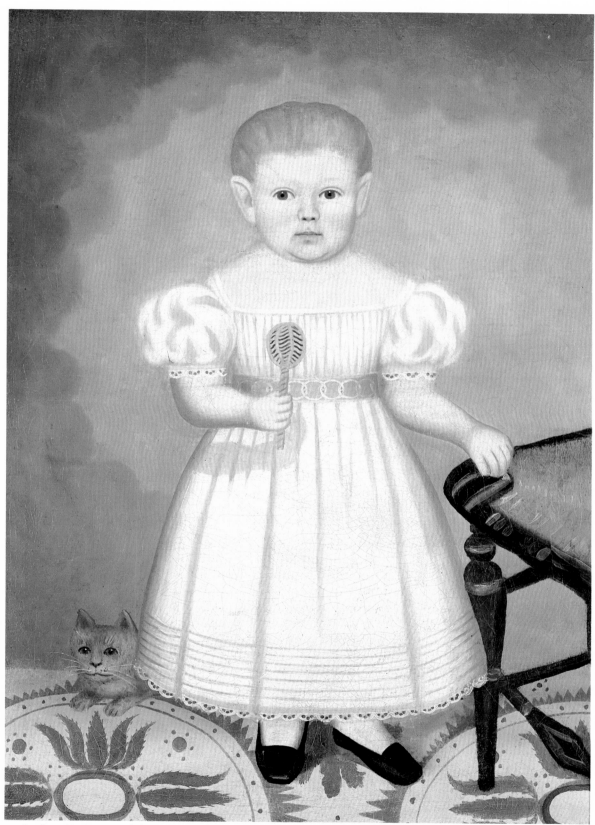

70 Attributed to Erastus Salisbury Field, *Girl Holding Rattle*

zen figures are incorrectly proportioned, poorly integrated, and characterless.

Field was an old acquaintance of the Smith family, since he had painted portraits of William Henry and his wife fifteen years earlier.[2] He lived with the family for several months in 1865, and the group portrait was probably painted during that time. The sitters are, from left to right, Seth (1857-1928), Catherine (Mrs. William Henry Smith) (1810-1899), Mary Jane (grandmother of the donor) (1833-1890), Maria Frances (1836-1917), Sarah (1844-1912), Delia (1842-1916), William Henry Smith (1809-1899), and Harriet (1849-1928).

Condition: The history of treatment before 1963 is unknown; at that time, the Finlayson brothers lined the canvas, mounted it on new stretchers, and did minor inpainting. Modern replacement 2⅛-inch molded gilt frame.
Provenance: Descended in the family to the donor, Mrs. Carl C. Mullen, great-granddaughter of Mr. and Mrs. William Henry Smith.
Exhibited: AARFAC, Field, and exhibition catalog, listed as no. 82.
Published: Black, Field, p. 54; French, p. 122, no. 177.

[1]*The Family of Joseph Moore*, painted about 1845, is in the M. and M. Karolik Collection, Museum of Fine Arts, Boston.
[2]French, p. 121, nos. 175 and 176.

Ruby Devol Finch
(1804-1866)

Aruba (Ruby) Brownell Devol was born in Westport, Massachusetts, on November 20, 1804, the second of seven offspring of Benjamin Devol, Jr., and Elizabeth Rounds Devol.[1] On November 8, 1832, Ruby Devol married William T. Finch of New Bedford. One child, a daughter, Judith, who eventually settled in New Bedford herself, was born to the couple. Ruby Finch died in New Bedford on July 7, 1866, aged sixty-one, her death being attributed to a tumor. The city's vital statistics indicate that Ruby was a widow and that she had resided in New Bedford for an unspecified period of time. However, except for a land transaction she made late in life, the remaining details of her life are now obscure; nothing has been ascertained concerning her husband's occupation, vital statistics, probate record, or how long the couple lived in Westport, where Ruby seems to have drawn and painted most of the artworks she created for her friends and neighbors.[2]

Where Ruby Devol was first introduced to watercolor painting and how and by whom she was encouraged to go beyond any rudimentary art exercises she might have been exposed to at school are undetermined. The earliest dated recorded work, a decorated family register inscribed at the bottom, "Drawn by Ruby Devol of Westport November 19th 1831 Silas Kirbys Family Record Forever,"[3] is her only signed creation. Finch's other recorded works, which date from circa 1830 to 1843, include two versions of the story of the prodigal son and seven profile portraits of friends and neighbors in the Westport/Westport Point community.[4]

By constantly varying the combination of elements in her design vocabulary, this imaginative artist managed to avoid a predictable formula in her overall compositions. Costume details, such as women's jewelry or men's vests, personalize the sitters. The subjects' faces show an attempt not only to describe particular features but also to capture a sense of individual personalities. Poetic verses accompany all of Finch's portraits, and while they typically consist of devout messages or morals, they occasionally contain specific references to events in the sitters' lives. In general, one might characterize her artwork as amateurish and her poetry as charming and quaint—and sometimes abominable. But her portraits possess a degree of truthfulness that evidently made them acceptable to—if not admired by—her Westport neighbors; this quality is also balanced by a visually playful decorativeness that makes them especially appealing to contemporary collectors. Unlike many other women who dabbled in watercolor and ink at this period in the nineteenth century, Ruby Devol Finch shows no dependence on prints or other prescribed sources of inspiration; instead, her works are truly inventive pieces that convey a strong sense of personal involvement. Although the facts of Ruby Devol Finch's life itself are indeed slight, her surviving artwork perhaps tells us more about her than the written record, while simultaneously unfolding a unique personal visual record that helps to plot the network of relationships among members of a small New England village society.

[1]Details of the artist's life and a discussion of all recorded works are given in Walters, Finch, pp. 1C-4C.
[2]The small central village of Westport, Mass., and the nearby whaling port just south at Westport Point are both only a few miles from Newport via the Rhode Island Sound.
[3]AARFAC acc. no. 58.305.25.
[4]One version of *The Prodigal Son* is at AARFAC, acc. no. 36.301.1, and the other is privately owned; three portraits are at AARFAC, nos. 72 and 73 (one is a double portrait), and two are in the collection of Bertram K. and Nina Fletcher Little; the remaining two are privately owned.

72 Hannah and Elijah Robinson 66.300.1

Attributed to Ruby Devol Finch
Vicinity of Westport Point, Massachusetts,
ca. 1830-1835
Watercolor, gouache, brown ink, pencil, and cut
wove paper on wove paper
7″ x 9″ (17.8 cm. x 22.6 cm.)
(Reproduced in color on p. 104)

The portraits of Elijah Robinson (1786-1861) and his
wife, Hannah Castino Robinson (1788-1849), nicely
combine several of the elements that can be found in
other works by Ruby Devol Finch. The eagle is a slight
variation of one employed at the top of a signed family
record by the artist;[1] the treatment of Hannah Robin-
son's cap and Elijah Robinson's cauliflower ear, and an
opaque quality to the faces, can also be seen in single
portraits attributed to Finch of Susannah Tripp and her
husband,[2] and the curtain rendering and floral sprigs in
the spandrels are repeated with little variation in Susan-
nah Tripp's portrait.

The artist apparently made a mistake in the initial
execution of Mrs. Robinson's portrait because the exist-
ing version was painted on a second piece of paper that
was then placed behind the open "window" created by
cutting around the inside of the drapery and oval border
of the main sheet. The verses below the portraits were
probably intended as general admonitions concerning
the importance of Christian values of charity and sym-
pathy toward those in need. The Robinsons, who lived
near the Tripps, owned a dwelling and a small lot on the
east branch of the Westport River adjoining land that
belonged to Raimon Castino, Elijah's father-in-law.

Inscriptions/Marks: Handwritten in script in brown ink above
the sitters' images is "Hannah Robinson June 1st/1788" and "Elijah
Robinson was born May 28 1786." Handwritten in the same script in
brown ink on the left below Mrs. Robinson's image is "Her kindly
melting heart/to every want and every/woe to quitt itself when in/
distress the balm of pity would impart/and all relief that bounty could
bestow." Handwritten in the same script in brown ink on the right
below Mr. Robinson's image is "Teach me to soothe the/the [sic]
helpless orphans grief/With timely aid the widows woes assuage/To
miseries moveing tears to yield relief/And be the sure resource of
drooping age." Handwritten in the same script in black ink or
watercolor across the banner in the eagle's mouth above the sitters is
"Plubius Uniun." Handwritten in a different script in pencil on a
separate sheet initially placed behind the portraits within their frame is
"Captain Elijah Robinson/Stone in Westport Point/Cemetery." No
watermark found.
Condition: Restoration by E. Hollyday in 1974 included filling
in and tinting three areas of support loss in the top sheet and two areas
in the bottom sheet (see *Commentary*) and backing both sheets with
Japanese mulberry paper. Original ½-inch molded mahogany frame
with hanging wire at center top.

Provenance: "An heir of . . . [the Robinson] family";[3] Mrs.
Sydney B. Johnson, Westport Point, Mass.
Published: Walters, Finch, pp. 2C-3C, illus. as fig. 4 on p. 2C;
Walters, Pt. 2, p. 2C, illus. as fig. 14 on p. 3C.

[1] AARFAC acc. no. 58.305.25.
[2] Susannah Tripp's portrait is at AARFAC (see no. 73); that of her
husband, Tillinghast Tripp, is privately owned.
[3] Mrs. Sydney Johnson to AARFAC, February 4, 1966.

73 Susannah Tripp 66.300.2

Attributed to Ruby Devol Finch
Vicinity of Westport Point, Massachusetts,
ca. 1836
Watercolor, gouache, pencil, and ink
on wove paper
8¼″ x 6¼″ (21.0 cm. x 15.9 cm.)

In 1836 Ruby Devol Finch painted a memorial portrait
of Westport master shipbuilder "Captain" Tillinghast

73

72 Attributed to Ruby Devol Finch, *Hannah and Elijah Robinson*

Tripp, who died July 24, 1836. This companion portrait of his widow, Susannah, was presumably completed at the same time.[1] It is impossible to ascertain whether Susannah Tripp personally commissioned Finch to do these portraits and their accompanying verses after her husband's death, or whether the artist simply offered them in sympathy to a friend. It is worth noting that Tillinghast Tripp was a distant relation of Finch's, his maternal grandmother being a Devol.

The tidy cap and prim plain fichu worn by Susannah Tripp might suggest a connection with the Quakers in Westport, where there were two Friends meeting-houses as early as 1837. In any event, three years after her husband's death, Susannah Tripp's name appeared on a list of individuals who met in Westport to organize a congregation called the Third Christian Church. Evidently she was an anxious believer because later church records reveal that a business meeting was called "to labour with certain disobedient members," among them Susannah Tripp, who, it seems, had forsaken her new-found faith for a new Adventist movement prophesying that the second coming of Christ and the end of the world would occur between 1843 and 1844.

Inscriptions/Marks: Handwritten in script in brown ink below the portrait is "Of late I,ve met with a great loss,/A pardner and a friend,/No one is left but children dear/On whom I can depend/Many the years we had lived in peace,/Although in natures paths we trod/Yet previous to his death I trust/Were redeemed by Christs own blood/ Portrait of Susannah Tripp Born April 18/1775 Joined in marriage Jan,, 21 1798." No watermark found.

Condition: Restoration by E. Hollyday in 1974 included filling

in the missing lower right corner with a paper insert and backing the whole with Japanese mulberry paper. Original 1-inch molded gilt frame.

Provenance: "An heir of . . . [the Robinson] family";[2] Mrs. Sydney B. Johnson, Westport Point, Mass.

Published: Walters, Finch, pp. 2C-3C, illus. as fig. 3 on p. 2C.

[1]Tillinghast Tripp's portrait is in the collection of Bertram K. and Nina Fletcher Little. About 1830-1835 Ruby Devol Finch also painted a portrait of Susannah Tripp's sister, Betsy Allen Davis, and one of her husband, Abner Davis, both of which are now privately owned.

[2]Mrs. Sydney Johnson to AARFAC, February 4, 1966.

Aaron Dean Fletcher
(1817-1902)

Aaron Dean Fletcher was born September 15, 1817, in Springfield, Vermont, the youngest of David and Sally Lovell Fletcher's ten children. He is said to have taught himself painting at an early age, and portraits of relatives and neighbors in Springfield and nearby towns that date from about 1835 to 1840 have been recorded. Three likenesses of members of the Chase family, who lived as far east as Newton, New Hampshire, are also from this period.

By 1840 he had moved to Keeseville, New York, a village in Chesterfield Township located on the line between Clinton and Essex counties. Although it was a prosperous area, only twenty-eight paintings from the next fourteen years have been recorded. Fletcher's ill health may explain such sparse productivity. About 1854 he satisfied a long-standing desire to "see the West" by spending a year with his brother Peter and his family in La Porte, Indiana, where he painted several portraits as well as a genre scene of the Jacob Replogle farm.

By 1857 Fletcher was back in Keeseville, painting not only portraits but also an increasing number of landscapes, such as scenic Ausable Chasm. In 1862 he signed and dated a portrait of six-year-old Mary Broadwell. Although Fletcher was then only forty-five years old, lived another forty years, and was listed in the Plattsburg, New York, directory as a Keeseville portrait painter as late as 1886-1887, no works postdating 1862 have been recorded, leaving the last years of the artist's career shrouded in mystery. He died December 27, 1902; the cause of death was given as "infirmities of age" and his occupation as "none."

Illness may have hampered the final refinement of Fletcher's evolving style, but it is also probable that daguerreotype studios provided increasingly stiff competition by mid-century. High-contrast, overemphasized modeling of facial structure had characterized Fletcher's likenesses from the beginning, a development that is still clearly evident around 1850 in his *Portrait of a Man from Willsboro, New York.* The contours of later sitters' faces seldom carry the heavy black outlines that contributed to the graphic quality of his first attempts at portraiture, however, and increased care in rendering the complexities of hands and bodies diverts attention from the faces. By 1862 his acknowledgment of photography's popularity is reflected in the softened modeling and drab coloration of Mary Broadwell's sober face, and his portraiture appears more realistic but also less penetrating.[1]

[1]Biographical information for this entry has been excerpted from Burdick and Muller, pp. 184-193. Portraits of members of the Chase family, all from the collection of Bertram K. and Nina Fletcher Little, are illustrated as figs. 2, 3, and 4 on pp. 185 and 188. Mary Broadwell's portrait is in the collection of Mr. and Mrs. Andrew S. Broadwell and is illustrated as pl. IX on p. 192. Mr. and Mrs. Philip J. Gordon's *Portrait of a Man from Willsboro, New York* is illustrated as fig. 8 on p. 189. A signed view of Ausable Chasm was deaccessioned from AARFAC in 1977; its present ownership is not known.

| 74 | **Lady with Long Gold Earrings** | 31.100.20 |
| 75 | **Gentleman with Sideburns** | 31.100.19 |

Attributed to Aaron Dean Fletcher
Probably Vermont, probably 1835-1840
Oil on canvas
26" x 23⅝" (66.0 cm. x 60.0 cm.)
26¼" x 23½" (66.7 cm. x 59.7 cm.)

Although found in New York state, the style of this pair of portraits relates most directly to Fletcher's work between 1835 and 1840, when he was painting in the areas of Springfield, Rockingham, and Saxtons River, Vermont. The exaggerated articulation of facial structures is characteristic of Fletcher's hand. Individual features are particularly chiseled in appearance, with sharply ridged upper lips, oddly puffed chins, and heavy-lidded eyes. Shadows beneath the eyes create the illusion of bags, and the mouths are fleshy and sensual. Such emphasis probably resulted from Fletcher's intense concentration on these areas, often at the expense of other aspects of the portrait. Similarly, the woman's

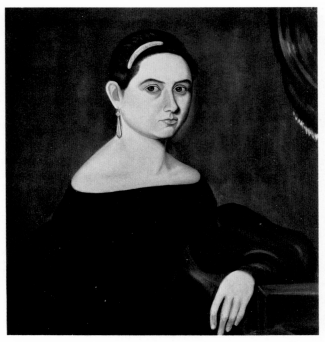

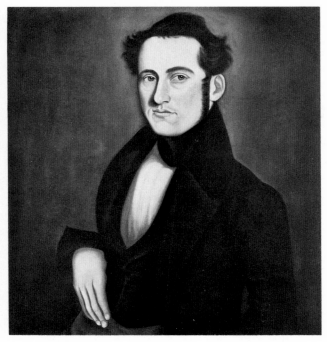

74 Attributed to Aaron Dean Fletcher, *Lady with Long Gold Earrings* 75 Attributed to Aaron Dean Fletcher, *Gentleman with Sideburns*

thick neck and impossibly angled upper arm illustrate the artist's inattention to the sitter's overall anatomy.

Coloration in the two likenesses is subdued, with skin tones distinctly grayed in hue, costumes rendered basically in blacks and whites, and the backgrounds painted a medium brown. Even the drape in the woman's portrait, a prop that is conventionally painted red, appears here in the same muted brown tones of the background.

In at least one other pair of portraits, Fletcher backlighted the male subject's head but not the female's.[1] Lightening of the background to the right of the woman's cheek in no. 74 may represent an abandoned attempt to emphasize the entire head, but more likely Fletcher started the edge of the face here, then moved it back. Another change was made in the position of the woman's arm; old outlines showing through the black dress indicate that Fletcher first posed his sitter with her left hand held up over her chest.

Condition: Before their acquisition both canvases were cleaned and glued to pressed wood panels by an unidentified conservator, the primary supports being trimmed flush with the panel edges. Modern replacement 2½-inch molded gilt frames.

Provenance: Found in New York state and purchased from Edith Gregor Halpert, Downtown Gallery, New York, N.Y.

Published: AARFAC, 1957, p. 353, nos. 199 and 200; Burdick and Muller, no. 74 illus. as pl. VI on p. 191, and no. 75 illus. as pl. VII on p. 191.

[1]The portraits are of the Reverend and Mrs. Moses Chase, illustrated in Burdick and Muller as figs. 2 and 3 on p. 185. Both are in the collection of Bertram K. and Nina Fletcher Little.

J. H. Gillespie
(active in North America 1828-1838)

What little is known of the miniature portrait painter J. H. Gillespie has been gleaned primarily from a handful of newspaper advertisements documenting at least a ten-year period of this artist's activity on the North American continent. In an announcement dated November 8, 1828, and recorded in the Halifax, Nova Scotia, *Acadian Recorder* of February 28, 1829, Gillespie, then "Late of London, Edinburgh, and Liverpool,"

claimed a "patronage entirely unprecedented to this place";[1] indeed, in a subsequent Saint John, New Brunswick, advertisement he states that he had painted "upwards of 1400" miniature portraits in Halifax alone.[2] Because of the demand for likenesses in Halifax, Gillespie adopted the practice of taking the outlines of his subjects in the morning hours and reserving the remainder of the day for the completion.[3]

Another 1829 Halifax advertisement increases our knowledge of his working methods and includes his price scale. Gillespie charged twenty-five cents for plain black profiles or silhouettes, fifty cents for those shaded in black, one dollar if finished in bronze, and two dollars for "features neatly painted in colours."[4] The various types of outlines were evidently achieved by means of "several mechanical and optical instruments."

When Gillespie moved on to Saint John in 1830, he took a "Painting Room" in a house opposite Trinity Church where he invited the public to examine his "very curious and elegant apparatus" by which he claimed to have taken upwards of 30,000 likenesses over a period of "above twenty years."[5] Gillespie was also admitted as "Freeman, Portrait Painter" in the 1830 minute books of the Saint John Common Council.[6]

By 1835 Gillespie had commissions in Maine, as indicated by the profile watercolor portaits of William and Ruth Amelia Greenough of Eastport, Maine, taken in that year; each is individually backed with one of Gillespie's printed label or trade card advertisements that reads "Likenesses Taken By J. H. Gillespie, Profile Miniature Painter."[7] At least two recorded silhouettes by Gillespie bear similarly printed labels that state "Likenesses Drawn In One Minute by J. H. Gillespie."[8]

By December 1837, when Gillespie was advertising in Baltimore, he had increased his charge for profiles painted in colors to four dollars each.[9] In December 1838 Gillespie, "late of London and New York," was offering his services in Philadelphia.[10] His further travels in this country have not been documented beyond 1838 although it has been suggested that he worked in Kentucky at a later date.[11]

Gillespie's profiles are generally crisply delineated, with subtleties in modeling often enhanced by white gouache in the depiction of lace and other finery of female subjects' costumes. When the background is developed, it is simply through a stippled mixture of brown and blue modeling that shades to the edges of the portrait, which is often oval in format; this may be the stylization of "drapery" he refers to in two of his advertisements.[12]

[1]C. Bruce Fergusson, Public Archives, Nova Scotia, to AARFAC, August 2, 1977, gives a transcription of the entire advertisement.

[2]The advertisement in the *New Brunswick Courier*, November 6, 1830, is illustrated in J. Russell Harper, *Painting in Canada, A History* (Toronto, 1966), p. 117.

[3]*Ibid.*; *Acadian Recorder*, February 28, 1829.

[4]The advertisement is quoted in Harry Piers, "Artists in Nova Scotia," *Nova Scotia Historical Society Collections*, XVIII (1914), p. 123.

[5]*Ibid.*; *New Brunswick Courier*, November 6, 1830.

[6]Donald MacKay to AARFAC, August 3, 1977.

[7]The Greenough portraits are privately owned.

[8]One label is illustrated in "The Editor's Attic," *Antiques*, XVII (June 1930), p. 514, fig. 3.

[9]The advertisement in the Baltimore *Sun*, December 9, 1837, is transcribed in J. Hall Pleasants's Biographical File of Artists, J. Hall Pleasants's Studies in Maryland Painting, Maryland Historical Society, Baltimore.

[10]The advertisement in the Philadelphia *Public Ledger*, December 11, 1838, is quoted in Harrold E. Gillingham, "Notes on Philadelphia Profilists," *Antiques*, XVII (June 1930), p. 516.

[11]"Collectors' Notes," *Antiques*, LXVI (September 1954), p. 218.

[12]*New Brunswick Courier*, November 6, 1830; Baltimore *Sun*, December 9, 1837.

76 Profile of Man in Black Coat 74.300.3

Attributed to J. H. Gillespie
Probably New England or Middle Atlantic states, ca. 1835
Watercolor, gouache, and pencil on wove paper
3 1/16 " x 2½" (7.8 cm. x 6.4 cm.)

The five miniature portraits illustrated as nos. 76-80 and mounted as a group in one large frame illustrate well J. H. Gillespie's ability to capture in profile the characters and features of subjects of varying ages. Although Gillespie's advertisements testify that the outlines of his subjects were obtained through the assistance of various optical and mechanical aids, his miniature likenesses generally show a sensitive understanding of and talent for modeling. The distinctive method of shading the background around the perimeter and at the base of the oval surround with light blue and stippled brown was used in many of the prolific artist's works.

Condition: Restoration by E. Hollyday in 1975 included removing an acidic secondary support, removing excess glue from the verso, setting down flaking paint, inpainting small losses in the periphery, and spot-gluing acid-free tissue to the verso. Probably original 3-inch gilt plaster-molded frame with replaced velvet covering the mat, fitted for five oval miniatures. Number 76 is framed with nos. 77-80.
Provenance: Bequest of Grace H. Westerfield.

77	Profile of Woman in Pink-Ribboned Cap	74.300.4
78	Profile of Boy with Light Brown Hair	74.300.5
79	Profile of Boy with Dark Brown Hair	74.300.6
80	Profile of Little Girl Wearing Coral Beads	74.300.7

Attributed to J. H. Gillespie
Probably New England or Middle Atlantic
states, ca. 1835
Watercolor, gouache, and pencil on wove paper
3^1/$_{16}$ " x 2½" (7.8 cm. x 6.4 cm.)
2^{11}/$_{16}$ " x 2^3/$_{16}$ " (6.8 cm. x 5.6 cm.)
2^5/$_8$" x 2^3/$_{16}$ " (6.7 cm. x 5.6 cm.)
2^{11}/$_{16}$ " x 2^3/$_{16}$ " (6.8 cm. x 5.6 cm.)

For *Commentary, Condition,* and *Provenance,* see no. 76.

76

77 78

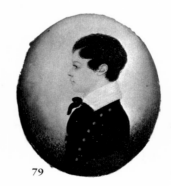

79

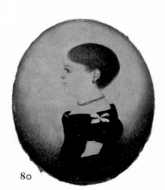

80

Deborah Goldsmith
(1808-1836)

A small collection of family letters, two friendship albums covering a six-year period, a small group of watercolor and oil portraits, and the artist's paint box provide clues to the life of this itinerant professional portrait painter.[1] Deborah Goldsmith was born in Brookfield, New York, on August 14, 1808. Nothing is known of her artistic training, but numerous watercolor, pencil, and ink vignettes that accompany verses entered in two albums which she kept between 1826 and 1832 show her familiarity with the decorative idioms and pictorial clichés popular among schoolgirls and other amateur artists of the period. The printed compositional sources for several romantic subjects in her albums have been identified, thus indicating another source of inspiration. Perhaps encouraged by friends' and relatives' appreciation of her natural talents or creative urge, Deborah Goldsmith began what her fiancé called her painting "business" at some point before 1830. Her travels in search of painting commissions took her to Brookfield, Hamilton, Lebanon, Toddsville, Hartwick, Cooperstown, and Hubbardsville, New York, during the few years before her marriage in 1832 to George Addison Throop, whom she met through a portrait commission.[2]

Although only a handful of her works survive or have been identified to date, correspondence reveals that Goldsmith sought employment in the true sense of a professional itinerant artist. She painted at least six oil portraits on panel, five of them of close relatives and one of George Washington, two miniature portraits on ivo-

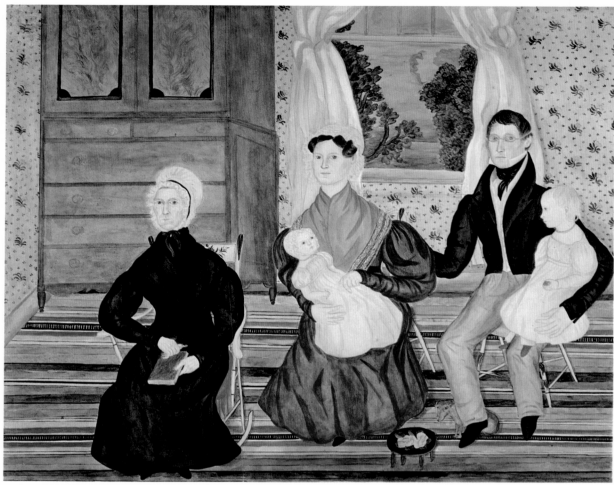

81

ry, including a self-portrait, one watercolor mourning picture, and at least ten watercolor portraits that include two group portraits and interiors, of which *The Talcott Family* is illustrated in this catalog.[3]

Deborah Goldsmith seems to have abandoned her profession after she married. A Baptist with strong religious convictions, she died at age twenty-seven on March 16, 1836, in Hubbardsville, New York, leaving a young daughter and son.

[1]For further discussion of this artist and her work, see Jean Lipman, "Deborah Goldsmith: Itinerant Portrait Painter," *Antiques*, XLIV (November 1943), pp. 227-229; and Shaffer.

[2]A surviving press-printed label suggests that she may also have been a professional milliner in Hamilton at some point before her marriage. Shaffer, pp. 15-16.

[3]See Shaffer, pp. 53-58, for a checklist of recorded works.

81 The Talcott Family 57.300.2

Deborah Goldsmith
Probably Hamilton, New York, area, 1832
Watercolor, pencil, and gold paint on wove paper
14¼" x 17¾" (36.2 cm. x 45.1 cm.)

The painting of the Talcott Family is perhaps Deborah Goldsmith's most ambitious work in watercolor portraiture and is prized for its pictorial documentation of costumes and furnishings as well as for its naive charm. Goldsmith's attention to detail is evident in her attempts to render accurately the decoration on ornamented chair backs, the figured edging on Betsey Talcott's fichu, the coloring and pattern of so-called Venetian carpeting, and the graining on the cupboard in the corner of the

room, its brass hardware simulated with gold paint. Samuel Talcott and his family were probably from the vicinity of Hamilton, New York, because entries in Deborah's second autograph album reveal her presence there between March 7 and March 25, 1832.[1]

Only one other group portrait by Goldsmith has been recorded to date, a watercolor depiction of Mr. and Mrs. Lyman Day with their daughter Cornelia, believed to have been done about 1823. Like *The Talcott Family*, the privately owned Day family painting illustrates decorative floor and wall treatment of the period, and its windows are similarly festooned with billowing white curtains.

Inscriptions/Marks: On the verso at the center bottom in ink in script is "Painted by D Goldsmith March 16th 1832/Mary Talcott age 70 Saml Talcott 38 Betsey Talcott 30 C[h?] Talcott 3 Emily 3 months." No watermark found.

Condition: Cleaned, tears repaired, and mounted on Japanese mulberry paper by Christa Gaehde in 1958. Period replacement 2-inch flat pine frame, painted black, with raised corner blocks.

Provenance: Mr. and Mrs. John Law Robertson, Scranton and Montrose, Pa.; M. Knoedler & Co., New York, N.Y.

Exhibited: AARFAC, Minneapolis; AARFAC, April 22, 1959-December 31, 1961; AARFAC, September 1968-May 1970; "The American Woman as Artist, 1820-1965," Pollock Galleries, Owen Fine Arts Center, Southern Methodist University, Dallas, January 23-February 1, 1966, and exhibition catalog, no. 4 and illus.; Flowering of American Folk Art; Smithsonian, American Primitive Watercolors, and exhibition catalog, p. 4, no. 6; Willian Penn Museum.

Published: AARFAC, 1959, p. 22, no. 14, illus. on p. 23; AARFAC, 1975, illus. on p. 12; Ruth Andrews, ed., *How to Know American Folk Art: Eleven Experts Discuss Many Aspects of the Field* (New York, 1977), pp. 114-115, illus. as pl. 24; Black and Lipman, p. 102, illus. as fig. 113 on p. 129; Marshall B. Davidson et al., eds., *The American Heritage History of American Antiques from the Revolution to the Civil War* (New York, 1968), p. 345, illus. as fig. 452; Dean A. Fales, Jr., *American Painted Furniture, 1660-1880* (New York, 1972), p. 243, illus. as no. 417; Lipman, p. 152, illus. as no. 28; Jean Lipman, "Deborah Goldsmith: Itinerant Portrait Painter," *Antiques,* XLIV (November 1943), illus. as fig. 5 on p. 228; Lipman and Winchester, p. 43, illus. as fig. 47; Lipman and Winchester, *Primitive Painters,* illus. on p. 95; Nina Fletcher Little, *Country Arts in Early American Homes* (New York, 1975), p. 201, illus. as no. 179 on p. 202; Nina Fletcher Little, *Floor Coverings in New England before 1850* (Sturbridge, Mass., 1967), pp. 28-29, illus. as fig. 28 on p. 65 and on front cover; Margaret Perry, "The Flowering of American Folk Art, 1776-1876," *Early American Life,* V (February 1974), pp. 50-54, illus. on p. 51; Karen Petersen and J. J. Wilson, *Women Artists: Recognition and Reappraisal from the Early Middle Ages to the Twentieth Century* (New York, 1976), p. 69, illus. as fig. V, 18 on p. 72; Peterson, illus. as pl. 40; Beatrix T. Rumford, "Williamsburg's Folk Art Center: An Illustrated Summary of Its Growth," *The Clarion* (Winter 1978), p.62 and illus.; Shaffer, pp. 20-21, p. 58, no. 57; Frederic Fairchild Sherman, "Unrecorded Early American Painters," *Art in America,* XXII (October 1934), p. 145; Theodore E. Stebbins, Jr., *American Master Drawings and Watercolors: A History of Works on Paper from Colonial Times to the Present* (New York, 1976), p. 98, illus. as fig. 67.

[1]Shaffer, p. 34.

Ira Chaffee Goodell
(1800-ca. 1875)

Ira Chaffee Goodell was born July 3, 1800, the first child of Moses and Susannah Pettengill Goodell of Belchertown, Massachusetts.[1] Little is known of his early life, but surviving works indicate that he began his career as an itinerant portraitist in the Upper Hudson Valley and western New England in the 1820s. On May 31, 1832, he married Delia Cronin and established residence in Hudson, Columbia County, New York, but the couple had moved to New York City by 1834. Goodell appears continuously in New York City directories as a "portrait painter" and "artist" from 1834 through 1861, although the federal census states that he was residing at Vestal, near Binghamton in Broome County, New York, in 1840, suggesting that perhaps a dearth of commissions in the city temporarily forced him into the countryside in search of work. Goodell remained in New York City until 1871, finally returning to Belchertown, where he had died by 1875.

Fifty-three works signed by and attributed to Goodell have been recorded, the majority of them executed on wood panels. Characteristically, these supports are—or appear to have been originally—capped by wood strips at top and bottom, and probably they were hung unframed.

In spite of the gradual changes in his stylistic development that might be expected of an artist who remained active over a long span of time, Goodell's work as a whole remains easily identifiable. His bust- and waist-length likenesses all appear extraordinarily stiff.[2] Sitters are turned very slightly, and almost invariably one shoulder—generally the one nearer the viewer—is dropped considerably below the other. Goodell's companion portraits of the William Tellers reveal that he had adopted another striking characteristic by 1826: heavy, soft shadows around noses, chins, and particularly eyes.[3] Many of his sitters appear to have blackened eyes, an effect that probably resulted from Goodell's effort to imitate the gauzy look of academic romantic portraiture. In the majority of his likenesses, most backgrounds are devoid of props and are painted in either flat or highlighted neutral tones. Even costumes are usually basically black and white, again possibly reflecting an academic influence. Such a color scheme was thought to lend dignity and formality to the subject; extant examples of portraiture indicate it was popular from about 1825 to the 1850s.

[1]Information in this entry has been adapted from the research conducted by Ruth Piwonka and Cynthia Seibels and summarized in the exhibition catalog, Goodell.

[2]A notable exception to Goodell's general portrait format is the full-length oil on canvas of his son, Angelo Newton Franklin Goodell, painted in New York City in 1849 and now in the collection of Mr. and Mrs. John Whitlock. This unusual portrait commemorates Angelo's skill in shorthand writing, and it is extensively inscribed. Goodell, p. 26, no. 44.

[3]The privately owned portraits of the Tellers are illustrated *ibid.*, p. 9, nos. 6 and 7.

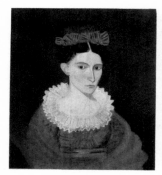
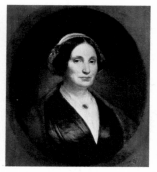

82 Ira Chaffee Goodell, *Mary Ann*

83 George Henry Hall, *Lady with Red Shawl*

82 Mary Ann 36.100.15

Ira Chaffee Goodell
Probably New England, probably 1826
Oil on tulipwood panel
26½" x 23⅝" (67.3 cm. x 60.0 cm.)

Although the last digit of the year inscription on the reverse of the panel is difficult to decipher, an 1826 date of execution seems more likely than an 1820 one in view of the stylistic similarities between no. 82 and three paintings by Goodell of the Johnson family of Dana, Massachusetts, two of which are inscribed "May 1826."[1]

These early portraits by Goodell exhibit a strong linear rendering of the subjects' faces, with shadowing heavily weighted by red tones. The painter's lack of experience in describing textures and in realistically modeling form is expressed by the stiff, unyielding shape of Mary Ann's broadly painted shawl and the heavy-handed treatment of her sheer lace collar. A complete lack of modeling and the bright red color make her hair bows project strongly. Her shawl and the bows and belt on her dress are the same color, but cracking and discoloration of the varnish layer over these areas has dulled their hue so that they no longer stand out as forcefully as they originally must have done.

Inscriptions/Marks: Painted in red script on the reverse of the panel is "–/Mary Ann Y–/Aged 19/ Drawn by I. C. G.–/May 1826 [or possibly 1820]."
Condition: Russell J. Quandt cleaned the panel in 1955. Probably period replacement 3-inch splayed gilded frame with quarter-round outer edge.
Provenance: Katrina Kipper, Accord, Mass.
Published: AARFAC, 1957, p. 355, no. 218; see also exhibition catalog, Goodell, p. 7, no. 1.

[1]These three portraits, all in the American Heritage Collection, Colby College, Waterville, Me., are illustrated in the exhibition catalog, Goodell, pp. 7-8, nos. 2-4.

George Henry Hall
(1825-1913)

83 Lady with Red Shawl 37.100.1

George Henry Hall
Boston, Massachusetts, 1849
Oil on canvas
27" x 22⅛" (68.6 cm. x 56.2 cm.)

George Henry Hall was born in Manchester, New Hampshire, on September 21, 1825, and grew up in Boston, where he developed an early interest in art. His self-portrait, executed at age nineteen, is in the Brooklyn Museum. By 1847 Hall began to exhibit his work at the prestigious Boston Athenaeum, and soon after painting *Lady with Red Shawl* in 1849 he left America for seven years of study in Düsseldorf and Paris. After his return he exhibited in Boston, Philadelphia, and New York, where he died on February 17, 1913.[1]

Hall's early skill and ambitious inclination toward academic painting are clearly visible in his selection of a feigned oval format and in the painterly treatment of this woman's face.

Inscriptions/Marks: Painted above the lady's right shoulder is the inscription "G. H. Hall/Boston, 1849."
Condition: Hans E. Gassman cleaned and lined the painting in 1959. Original 3-inch molded gold leaf frame with gold leaf oval insert.
Provenance: Katrina Kipper, Accord, Mass.
Published: AARFAC, 1957, p. 353, no. 202.

[1]All biographical information about Hall is from Groce and Wallace, p. 284.

Sturtevant J. Hamblin
(active 1837-1856)

Sturtevant J. Hamblin has frequently been grouped with a number of other painters working in a stylistically similar manner who are collectively, and perhaps misleadingly, categorized as the "Prior-Hamblin School."[1] While the term "school" implies direct influence or communication among stylistically linked artists, in this instance little documentation for such interrelationships exists beyond an indisputable connection between Hamblin and his brother-in-law, William Matthew Prior. Signed Hamblin works were first published and discussed by Nina Fletcher Little in 1948, thereby providing a basis for the difficult process of distinguishing Hamblin's hand from those of the "school" painters.[2] The subsequent discovery and analysis of additional documented Hamblin works have further clarified the confusing issue of correctly attributing paintings of this type.[3]

The Hamblins were a family of long-standing artisan traditions in the Portland, Maine, area. Sturtevant's grandfather, George Hamblin, had been apprenticed as a painter and glazier in Barnstable, Massachusetts, and he continued to follow those trades after moving to Gorham, Maine, in 1763. Sturtevant's father, Almery Hamblin, was associated with his four sons, Joseph G., Nathaniel, Eli, and Sturtevant J., in a house, sign, and ornamental painting business in Portland, and the sons' names appear irregularly in that city's directories from 1823 until 1841.

William Matthew Prior married Rosamond Hamblin in 1828, and by 1834 he and his family were residing with Rosamond's brother Nathaniel on Green Street in Portland. By 1837 Prior had established a separate residence on Danforth Street in the "Hamblin Block" of Portland,[4] and Rosamond's brothers Joseph G. and Sturtevant J. were also listed as living there. Three of the Hamblin brothers bought a large farm in Scarborough in 1838, and Eli died there suddenly in 1839. Shortly thereafter, Prior, his family, and his remaining brothers-in-law moved to Boston, where they lived together for a year (1841) at 12 Chambers Street.

Sturtevant was the only Hamblin brother who specifically advertised as a "portrait" painter, and the fact that he had embarked on that stage of his career by 1841 is indicated by four signed likenesses that bear the Chambers Street address.[5] By 1842 Prior and the Hamblins had relocated on Marion Street; two years later, they separated and established other East Boston addresses. Two signed portraits by Sturtevant include "East Boston" in their inscriptions and are dated 1848.[6] Directory listings, however, indicate that by 1856 Sturtevant had joined his brother Joseph in the "gent's furnishings" business. He followed this livelihood for at least ten years, perhaps having been discouraged from a portraitist's career by the growing popularity of photography.

A signed double portrait of an unidentified *Woman and Child by a Window* in the collection of the National Gallery of Art illustrates many of the characteristics of Sturtevant Hamblin's style.[7] Particularly noteworthy are the glistening quality achieved in the rendering of flesh modeling and highlights and the dark, cartoonlike outlining of hands. Hamblin's approach is also typified by the backdrop format that combines drapery, a column, and a window view encompassing a bird perched on a barren tree. However, Hamblin attributions, especially the simpler compositions ascribed to him, are generally based on the recognition of his modeling techniques and idiosyncrasies of anatomical rendering, which emerges only by comparing his works with those of other artists in the Prior-Hamblin group.

Like Prior, Hamblin evidently adjusted the amount of time expended on a portrait's execution according to the price his client was willing to pay. Hamblin never seemed to achieve Prior's capability of producing an "academic" finish, however, and instead of employing the broad range in quality or degree of modeling that his brother-in-law used for this purpose, Hamblin relied more heavily on adjustments of support size and the addition or deletion of details in a composition. His talent reveals itself in fresh, immediate, and clearly conceived likenesses with considerable decorative appeal.

[1]These include William Matthew Prior, William W. Kennedy, George Hartwell, and E. W. Blake.

[2]See Little, Prior, pp. 44-48. Much of the biographical information in this entry is based on Mrs. Little's article. Figure 6 therein illustrates Hamblin's portraits of Mr. and Mrs. Aaron Jewett; the wooden backboard of Mr. Jewett's portrait is inscribed in pencil, evidently a retracing of the original made by a relative of the sitter, "A. J. Aged 44 years/Painted by S. J. Hamblin / No 12 Chambers St/ Boston 1841." This pair of portraits is now in the collection of Edgar William and Bernice Chrysler Garbisch.

[3]In addition to the portraits of Mr. and Mrs. Aaron Jewett, signed Hamblin likenesses include those of Hannah M. Jewett and Phoebe Lorrue Jewett in the collection of Mr. and Mrs. Howard A. Feldman (the former portrait is illustrated in Howard A. Feldman, "A Collection of American Folk Painting," *Antiques,* CVIII [October 1975], p. 765); the *Portrait of Ellen* in the collection of Bertram K. and Nina Fletcher Little, illustrated in AARFAC, 1969, p. 42, no. 83; the National Gallery of Art's *Woman and Child by a Window,* which is inscribed on the reverse "February 9th 1848/Hamblin/East Boston/

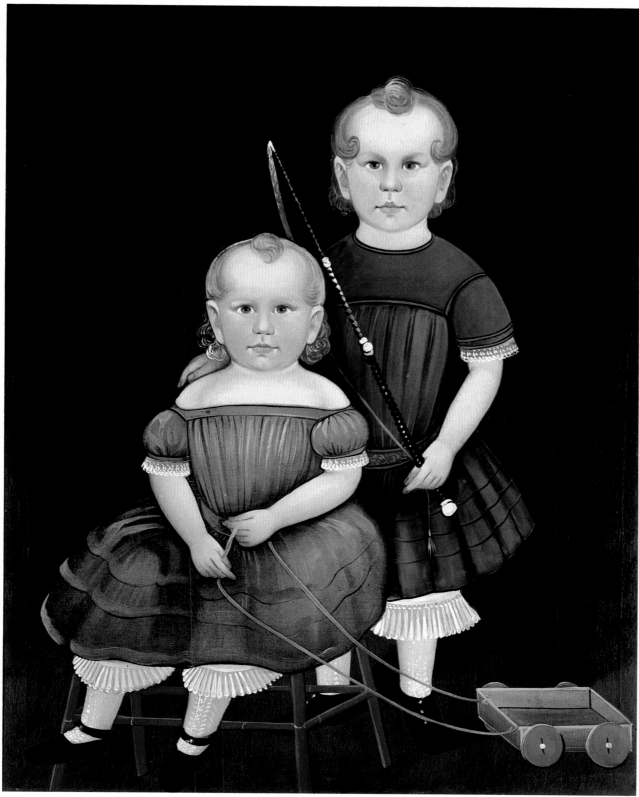

86

1848"; a portrait of Asa Jewett in the collection of Stoney Fields Antiques, inscribed on the reverse "Painted by/S. J. Hamblin/E. Boston/Aug 1848," and illustrated in *Antiques*, CXVI (November 1979), p. 1044; and *General Israel Putnam*, no. 87 in this catalog.

[4]The "Hamblin Block" is a block of four brick row houses located on the southwest corner of the intersection of Danforth and Brackett streets in Portland, Maine.

[5]These are the portraits of Mr. and Mrs. Aaron Jewett cited in n. 2 and of Hannah M. Jewett and Phoebe Lorrue Jewett cited in n. 3.

[6]See n. 3.

[7]*Woman and Child by a Window* is illustrated as fig. 18 in the Introduction.

84 Child in High White Collar 39.100.10

Attributed to Sturtevant J. Hamblin
Probably Massachusetts, ca. 1845
Oil on academy board
14″ x 10⅛″ (35.6 cm. x 25.7 cm.)

One artistic convention or cliché that Sturtevant J. Hamblin frequently repeated in his variously scaled portraits was to pose the subject holding a small open book in one hand. William M. Prior and others used the device on occasion, but Hamblin drew the book and particularly the hand grasping it in a distinctive way.[1] The tooled bindings are described with characteristic dotted line striping and decoration; the fingers and hands taper toward the extended index finger, as in this straightforward little portrait, which is quite typical of Hamblin's simplest, most direct efforts. Number 85 is also a small academy board likeness of a child.

Inscriptions/Marks: A modern inked inscription on the wood backboard reading "R. Phillip Clark/ Braintree Mass." could refer either to the subject or to one of the painting's owners.
Condition: No evidence of previous conservation. Possibly original 2-inch cove-molded and gilded frame with cove-molded inner edge and quarter-round outer edge.
Provenance: Undetermined.
Published: AARFAC, 1957, p. 354, no. 210.

[1]For other examples incorporating this detail, see Tillou, nos. 95, 107, and 108.

85 Baby with Doll 54.100.1

Attributed to Sturtevant J. Hamblin
Probably Massachusetts, ca. 1845
Oil on academy board
15¾″ x 12¼″ (40.0 cm. x 31.1 cm.)

This delightful portrait is attributed to Sturtevant J. Hamblin because of its close stylistic relationship to the

figure of a youngster in the signed portrait *Woman and Child by a Window* in the National Gallery of Art.[1] The shape of the child's ears, the glistening quality of facial modeling, and particularly the configuration and sketchy outlining of the child's hands are all characteristic Hamblin details shared by this portrait and the baby depicted in the signed example. The charm of the best Prior-Hamblin paintings often lies in the inclusion of interesting accessories and personalizing props; in this respect, *Baby with Doll* is one of Hamblin's more successful portraits of the small academy board variety.

Condition: Treatment, presumably by Russell J. Quandt in 1955, included lining the board with a secondary support of Masonite, cleaning, and inpainting scattered areas, particularly along the perimeter. Possibly original 3⅛-inch cyma recta mahogany-veneered frame with gilt liner.
Provenance: Given to the Museum of Modern Art in 1939 by Abby Aldrich Rockefeller; turned over to Colonial Williamsburg in June 1954.

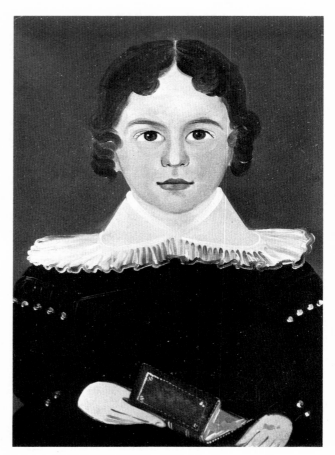

84

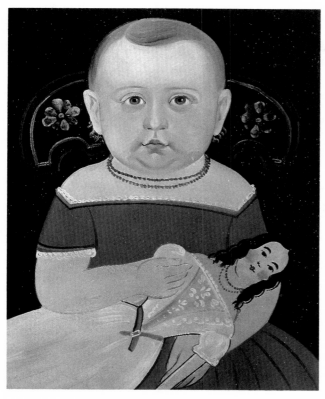

85

to that painting which are recorded in the Folk Art Center's research files.[1] The facial modeling is also clearly like that in no. 85. While the hands of the two children in this portrait reveal the outlining characteristic of Hamblin's approach to rendering hands, the modeling here is more developed than the artist's usual effort. An examination of certain other portraits attributed to him show that, like William M. Prior, Hamblin was capable of painting in a more polished manner when the occasion demanded.[2]

Condition: No evidence of previous conservation. Modern replacement 2½-inch cove-molded gilded frame with quarter-round outer edge.
Provenance: Found in Concord, Mass., and purchased from Edith Gregor Halpert, Downtown Gallery, New York, N.Y.
Exhibited: Houston Museum of Fine Arts, January 1956; "Masterpieces of American Folk Art," Downtown Gallery, New York, N.Y., June 1951; "Toys and Tots," Gunston Hall, Lorton, Va., March 7-31, 1971.

[1]Portrait of Ellen is illustrated in AARFAC, 1969, p. 42, no. 83. The portrait is in the collection of Bertram K. and Nina Fletcher Little.
[2]For an example of Hamblin's more polished style, see the Portrait of a Fireman, New York State Historical Association, Cooperstown.

Exhibited: American Folk Art; Chicago Public School Art Society, November 29-December 15, 1937; "Children in American Folk Art, 1725 to 1865," Downtown Gallery, New York, N.Y., April 13-May 1, 1937, and exhibition catalog, p. 14, no. 67; Goethean Gallery.
Published: AARFAC, 1957, p. 14, no. 5, illus. on p. 15; Robert Bishop, Centuries and Styles of the American Chair, 1640-1970 (New York, 1972), illus. as fig. 795 on p. 443; Cahill, p. 30, no. 12, illus. on p. 61.

[1]See the biography of Hamblin for more detailed commentary on the National Gallery's portrait.

86 Children with Toys 57.100.5

Attributed to Sturtevant J. Hamblin
Probably Massachusetts, ca. 1845
Oil on canvas
36¼" x 29⅛" (92.1 cm. x 74.0 cm.)
(Reproduced in color on p. 113)

The attribution for this wonderful double portrait is based on a similarity to the signed *Portrait of Ellen* and to a relatively large group of full-length portraits related

87 General Israel Putnam 78.100.2

Sturtevant J. Hamblin
Probably Boston, Massachusetts, ca. 1845
Oil on canvas
27⅝" x 19⅝" (70.2 cm. x 49.8 cm.)

This likeness of Israel Putnam and seven other signed or documented works by Sturtevant J. Hamblin form a diverse body of material that has been of considerable aid in correctly attributing other paintings to the artist. The pose and composition appear to have been taken from a rare and little-known eighteenth-century mezzotint of Putnam attributed to Samuel Blyth of Salem, Massachusetts.[1] Hamblin's version is a curious translation of the print source in terms of commercial art techniques. His shortcut methods and vivid coloration give the painting a harshness that seems inappropriate in view of the customary dignity of official or historical portraiture. The configuration of bark on the trees in the landscape is casually achieved with a tool akin to a graining comb, a time-saving device used by an ornamental or house painter. Slapdash copies of historical figures are uncommon in Hamblin's surviving output, but such subjects play a prominent role in the last works of William M. Prior. Although the latter evidently exe-

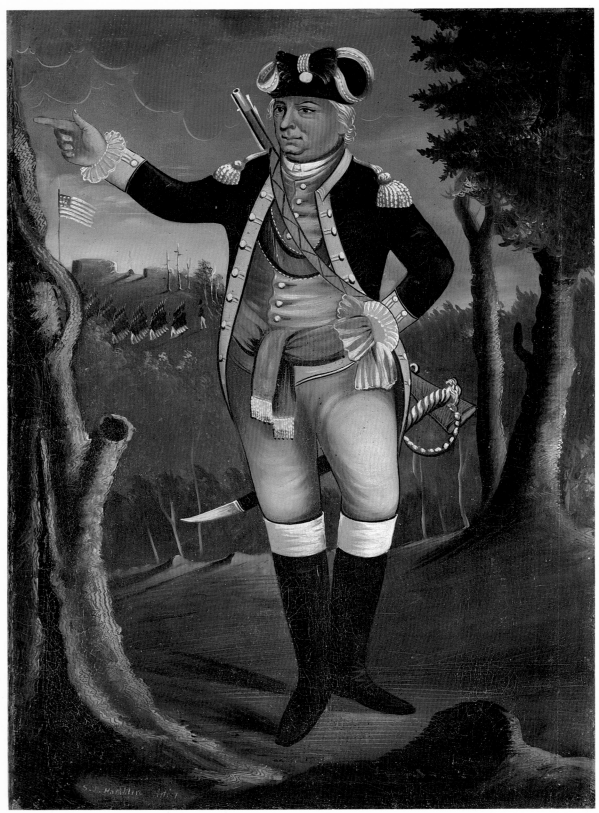

cuted them with equal speed, he used an academically more accomplished or appropriate technique. See also the *Commentary* for no. 152.

Israel Putnam (1718-1790) was a veteran of the French and Indian War, served in the Connecticut General Assembly (1766-1767), and in October 1774 became lieutenant colonel of the 11th Regiment of the Connecticut militia. In 1775 he left to join the Revolutionary forces, was later promoted to major general of the Continental Army, and played a prominent part in the Battle of Bunker Hill.

Inscriptions/Marks: Signed in paint at lower left "S. J. Hamblin Artist."

Condition: In 1973 Paul Schwartzbaum replaced the auxiliary support, lined the canvas, and inpainted scattered areas of loss, primarily along the upper edge. Period replacement 2¼-inch gilded cove-molded frame with applied bead molding along the inner edge and a projecting gadrooned quarter-round outer edge.

Provenance: Robert Fridenberg, New York, N.Y.; Henry Francis du Pont Winterthur Museum, Winterthur, Del.

Published: Sotheby Parke Bernet, Inc., *Property from the Collection of the Henry Francis du Pont Winterthur Museum, Winterthur, Delaware,* catalog for sale no. 4115, lot no. 10, April 28, 1978, illus. as lot no. 10.

[1]One impression of this mezzotint, titled "THE HONBLE ISRAEL PUTNAM ESQR," is discussed and illustrated in *The Month at Goodspeed's,* XXXVIII (October 1966), pp. 9-11, illus. on p. 10. It is suggested therein that the print may be by Benjamin Blyth of Salem. Engravings by Samuel Blyth, including the source for the Hamblin copy, are the subject of ongoing research by Nina Fletcher Little, who was also responsible for bringing the print to the attention of the Folk Art Center.

Rufus Hathaway
(1770-1822)

Rufus Hathaway ranks today among America's most acclaimed folk artists, a position that may seem ironic in light of his small production and only part-time pursuit of painting. Yet the visual appeal of his paintings and the known particulars of his life and small-town patronage offer important and revealing commentary on those concepts so fundamental to folk art and its popular appreciation. What is known of Hathaway was carefully researched and published by Nina Fletcher Little in 1953.[1]

Rufus was the son of Asa and Mary Phillips Hathaway, and it is thought that he was born in Freetown, Rhode Island, on May 2, 1770. The family seems to have moved to several other Rhode Island towns during the ensuing years; his father died in Bristol, Rhode Island, in 1816. Rufus had evidently left home long before, probably in pursuit of commissions for his chosen profession of portrait painting. Among his earliest known likenesses are the 1790 portrait *Lady with Her Pets* and the companion portraits, *The Reverend Caleb Turner* and *Mrs. Phebe (King) Turner,* signed and dated by the artist in 1791.[2] Hathaway had traveled to Duxbury, Massachusetts, sometime before December 1795, when he married Judith Winsor, the daughter of a leading Duxbury merchant, Joshua Winsor. According to family tradition, Rufus fell in love with Judith at the time he was commissioned to paint portraits of her and her sister Lucy. Family history also indicates that the young husband-artist was convinced of his need to pursue a more socially acceptable and lucrative profession, and so he decided to study medicine, apparently with Dr. Isaac Winslow of Marshfield. Hathaway then returned to the small town of Duxbury, where he was a practicing physician until his death in 1822. In subsequent records Hathaway is always referred to as a doctor and never as an artist, although various signed and attributed works prove that he continued to paint.

Hathaway seems to have led a simple, uncomplicated life in Duxbury, going about his duties as a country doctor and offering his talents as an artist when local occasion or need presented itself. In addition to portraits, he is known to have painted miniatures. One landscape, a genre scene inspired by an English print, and a still life are also attributed to him. The naive quality of his work suggests that he was largely self-taught and seems to have been accepting, if not unconscious, of the errors he continually committed in perspective, anatomical drawing, and modeling, and in mixing pigments. One can only wonder, despite the charm they hold for today's viewer, how his stiff, wooden images were received by the original sitters.

Hathaway's technique differs from the quick, economical technique observed in likenesses by other folk painters who sought a wider clientele and financial base for their work. He approached his canvases with genuine concern for depicting the sitter's face and costume as realistically as his talents would allow. His

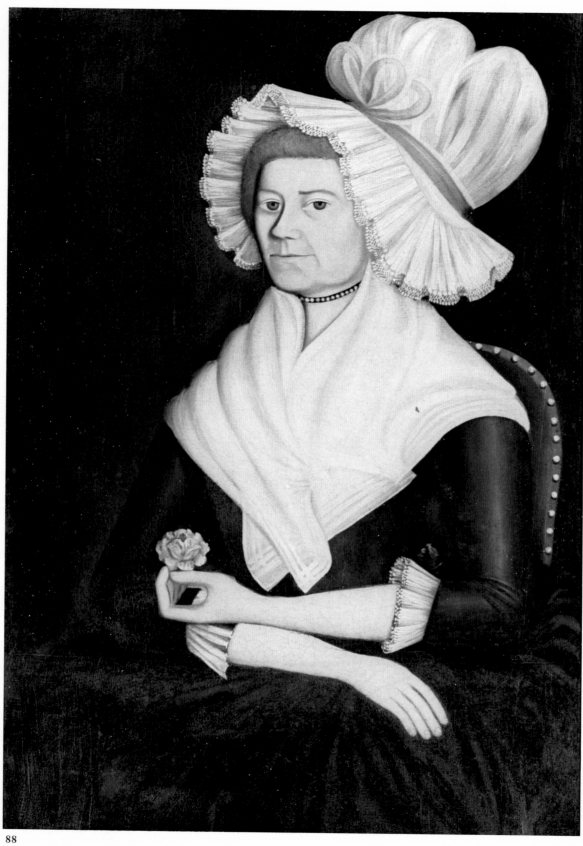

88

picture surfaces are unified in terms of modeling and refinement, and the backgrounds have been developed just as carefully in wider brushstrokes. Within the limitations of this conservative style, Hathaway managed to capture not only appealing likenesses but much of the character and self-pride of his modestly wealthy townspeople.

[1]Except where further noted, all biographical information on the artist included here is from Little, Hathaway, pp. 95-139.
[2]*Lady with Her Pets* is in the Metropolitan Museum of Art, New York, N.Y. The portraits of the Reverend and Mrs. Caleb Turner are in the Old Colony Historical Society, Taunton, Mass.

88 Mrs. Ezra Weston (Salumith Wadsworth) 71.100.3

Attributed to Rufus Hathaway
Probably Duxbury, Massachusetts, probably 1793
Oil on canvas
38" x 25¾" (96.5 cm. x 65.4 cm.)

Numbers 88, 89, 90, and 91 represent three generations of the Weston family of Duxbury. They also serve as superior examples of Rufus Hathaway's style and approach to portrait painting. The smallest and least pretentious of the group (no. 91) represents Maria Weston in a most unusual format, since it has spandrels only in the lower corners. Maria's face and hair are drawn with the same evenness of brushwork that Hathaway devoted to the likenesses of her parents and grandmother. The only visually discomforting feature is her long, streaming bangs, which one wishes had been brushed aside before the artist committed them to canvas.

The portraits of the adults in the Weston family group are far more impressive and provide a full repertoire of characteristics associated with Hathaway's work. The artist tended to see and draw his figures in very confined space and used strong lines and the juxtaposition of contrasting lights and darks to define form. His modeling was sufficient to suggest three-dimensionality, but the illusion of spatial relationships was achieved through crisp delineation and overlapping. The tightly drawn mouths, elongated arms, and awkwardly drawn hands are typical of his inability to depict the human body accurately. Hathaway was also prone to repeat passages, such as the fold in a dress or shawl or the pleats and gathers in a bonnet, a mannerism seen in Jerusha Weston's curled hair and dress skirt, and at the bend in her arm, and again in Salumith

Weston's shawl, cuffs, and bonnet. Hathaway's delight in this kind of decorative patterning contributes greatly to the charm and appeal of his best works.

A number of genealogical facts are known about the sitters, most of which were related in Nina Fletcher Little's article on the artist.[1] Salumith Wadsworth (no. 88) was born in Duxbury, Massachusetts, on March 10, 1742, the daughter of John and Mary Alden Wadsworth. She married Ezra Weston on October 25, 1770, and their only child, Ezra Weston, Jr., was born on November 30, 1771. Salumith died on July 20, 1815, and is buried in the Weston family lot in Duxbury's Mayflower cemetery.

Ezra, Jr., joined his father's prosperous shipbuilding enterprise, which by 1833 was listed by Lloyd's of London as owning over one hundred vessels, the largest business of its type in America. On June 9, 1793, young Ezra married Jerusha Bradford (1770-1833), daughter of Colonel Gamaliel and Sarah Alden Bradford. The couple had six children; the eldest was Maria Weston, who was born on December 3, 1794, and died at nine years of age on February 2, 1804. It is entirely possible that Maria's portrait was done posthumously, which would explain its comparative simplicity and small size. The 1793 date assigned to the other family likenesses, however, is based on the extant bill of sale between Captain Ezra Weston, Sr., and the artist.[2]

Inscriptions/Marks: Painted on the reverse of the original canvas ca. 1845, at the time a duplicate painting of her husband was made, "Salumith Wadsworth/daughter of Doctr John – wife of/Ezra Weston/Born/Died."
Condition: Some inpainting and a canvas patch repairing a small tear were done by Roger Dennis prior to acquisition. Theodor Siegl lined the painting, placed it on new stretchers, cleaned it, and did extensive inpainting in the area of the left arm in 1972. At some unknown date before 1971 an 8-inch piece of canvas was added to the bottom of the original canvas. Original 3-inch molded white pine frame, painted black, with gold borders.
Provenance: Numbers 88, 89, 90, and 91 descended as a group from Ezra Weston, Jr., of Duxbury, Mass., to Mrs. Margaret S. Carter of Waltham, Mass.; Mr. and Mrs. Howard Lipman, New York, N.Y.; Miss Mary Allis, Southport, Conn.
Exhibited: "Loan Exhibition," Museum of Early American Folk Art, New York, N.Y., October 5-November 18, 1962, and exhibition catalog, no. 88 only, no. 70, illus. on p. 6; "Paintings by New England Provincial Artists, 1775-1800," Museum of Fine Arts, Boston, July 21-October 7, 1976, and exhibition catalog, no. 89 only, p. 120, no. 50, illus. on p. 121; "What is American in American Art?" M. Knoedler & Co., New York, N.Y., February 9-March 6, 1971, and exhibition catalog, no. 90, p. 23, no. 12.
Published: Black and Lipman, no. 90 only, p. 23, no. 47, illus. on p. 48; Ruth Davidson, "Museum accessions," *Antiques*, CII (November 1972), all four paintings, illus. on p. 783; Wendell D. Garrett, "Living with Antiques: The Connecticut home of Mary Allis," *Antiques*, XCVI (November 1969), all four paintings, illus. on pp. 760-761; Little, all four paintings, pp. 117-125, illus. on pp. 116, 119, 120, and 124.

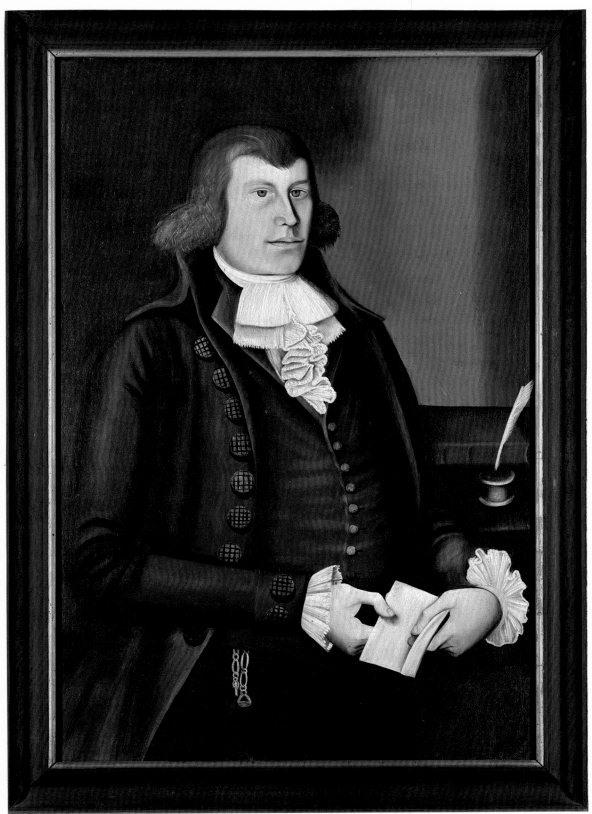

89

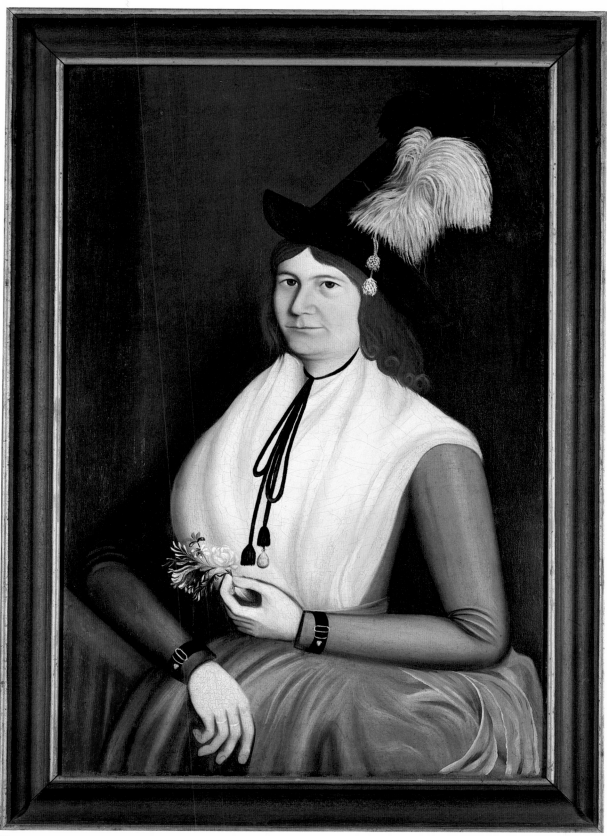

90

[1]Little, Hathaway, pp. 117-125.
[2]Nina Fletcher Little to AARFAC, January 19, 1975. Mrs. Little owns the bill of sale, dated January 5, 1793, which documents the fact that Weston paid Hathaway one pound, ten shillings each for six portraits. The bill of sale was acquired with Hathaway's portraits of Ezra Weston, Sr., and his grandson Church Sampson. Weston also paid six shillings apiece for frames made by the artist.

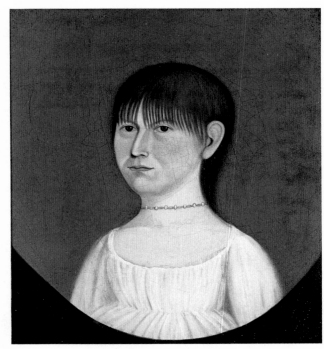

91

89 Ezra Weston, Jr. 72.100.2

Attributed to Rufus Hathaway
Probably Duxbury, Massachusetts,
probably 1793
Oil on canvas
37¾" x 25" (95.9 cm. x 63.5 cm.)
(Reproduced in color on p. 120)

For *Commentary, Provenance, Exhibited,* and *Published,* see no. 88.

Inscriptions/Marks: Painted on the back of the original canvas ca. 1845, at the time a duplicate portrait of Ezra Weston, Sr., was made, "Ezra Weston/son of/Ezra & Salumith/Born Novr 30, 1772 –/Died Augst 15th 1842 –/Mard/June 2, 1793/Jerusha Bradford."

Condition: Theodor Siegl lined the canvas, placed it on new stretchers, cleaned the painting, and inpainted minor losses throughout in 1972. Original 3-inch molded white pine frame, painted black, with gold borders.

90 Mrs. Ezra Weston, Jr. 73.100.7
 (Jerusha Bradford)

Attributed to Rufus Hathaway
Probably Duxbury, Massachusetts,
probably 1793
Oil on canvas
38¼" x 25⅛" (97.2 cm. x 63.8 cm.)
(Reproduced in color on p. 121)

For *Commentary, Provenance, Exhibited,* and *Published,* see no. 88.

Inscriptions/Marks: Painted on the back of the original canvas ca. 1845, at the time a duplicate portrait of Ezra Weston, Sr., was made, "Jerusha Bradford/daughter of/Col. Gamabriel [*sic*]/and his wife – Alden –/Born Jany. 30th 1770/Died – Octr 11th 1833 –/Mard Ezra/Jan. 2, 1793."

Condition: The painting was cleaned and a small tear in the upper left background was repaired by an unidentified conservator prior to 1972. Theodor Siegl lined the canvas and placed it on new stretchers and inpainted small losses throughout in 1972. Original 3-inch molded white pine frame, painted black, with gold borders.

91 Maria Weston 74.100.2

Attributed to Rufus Hathaway
Probably Duxbury, Massachusetts,
probably 1800-1804
Oil on canvas
18" x 16" (45.7 cm. x 40.6 cm.)

For *Commentary, Provenance, Exhibited,* and *Published,* see no. 88.

Inscriptions/Marks: Painted on the reverse of the original canvas ca. 1845, when a duplicate portrait of Ezra Weston, Sr., was made, "Maria Weston – daughter/Ezra & Jerusha – his wife/Born Decr 3rd 1794 –/Died Febry 2d 1804."

Condition: The painting was cleaned and some minor inpainting was done by Roger Dennis before its acquisition. Theodor Siegl cleaned and lined the painting in 1972. He also did minor inpainting and noted that the canvas of this picture was prepared differently from those of the other family portraits by Hathaway. Maria's portrait was painted over a blue gray ground while those of her parents and grandmother have a red ground paint. X-radiography revealed that a profile portrait of a girl facing left was underneath Maria's image and the blue gray ground. Original 2⅛-inch cove molded frame painted black with inner and outer gilt quarter-round moldings.

James Herring
(1794-1867)

James Herring spent his early childhood in England, having been born in London on January 12, 1794, the only offspring of James and Mary Holland Herring.[1] The small family settled in New York City in 1805, and by 1807 young James was enrolled in Erasmus Hall Academy at Flatbush, Long Island, where he reportedly excelled in drawing. About 1813 he married Ann Golden (b. 1797),[2] and in 1814 he gave up teaching and business to pursue a career in the arts.[3]

Herring advertised as a portrait painter in New York City in 1816 and 1817 but was also active in New Jersey during these and succeeding years. He reappeared in New York City directories in 1821, advertising that he did portrait painting, first at Grand and Sullivan streets, then in 1825 at Chatham Square. He was apparently successful enough to have taken on an apprentice in 1825,[4] although by about 1830 declining income forced him to open a circulating library in his new studio at 389 Broadway. This highly successful venture enabled Herring to turn his attention to the projects promoting American art for which he is chiefly remembered today — the creation of *The National Portrait Gallery of Distinguished Americans* and the founding of the Apollo Gallery.

Herring opened the Apollo Gallery at 410 Broadway in 1838 at great personal expense. He intended it as a place to exhibit and sell works by American artists, with the revenue from such sales being applied to the purchase of works for a planned national gallery. As early as 1831 Herring proposed that the American Academy of Fine Arts sponsor a national gallery. Financial difficulties plagued the operation from the start, and by 1840 Herring could no longer afford to underwrite the gallery's rent. The organization found a new home at 322 Broadway in 1842, simultaneously changing its name to the American Art Union, and it continued there until it was dissolved in 1852.

The National Portrait Gallery of Distinguished Americans was a periodical composed of portrait engravings and brief biographies of important persons produced under the supervision of the American Academy of Fine Arts's Board of Directors. Four volumes of the *National Portrait Gallery* appeared between 1834 and 1839. They incorporated works by twenty-four engravers after paintings or drawings by fifty artists, including Herring. Only eight of Herring's twenty works for the periodical are known today; some were done from life, but others were copied from existing portraits by John Vanderlyn, Thomas Sully, John Wesley Jarvis, Gilbert Stuart, and others.

Herring's portrait of Alexander Macomb after Sully shows how well he could emulate the romanticized academic likenesses that were so fashionable then,[5] but the evolution of his own personal style evidences a much steadier progression toward photographic realism. Throughout his life Herring seemed to prefer the careful rendering of specific details to looser, more suggestive treatments of his subjects, a common inclination among self-taught artists. To some degree, his work would always be marked by the sharp contrasts that characterize his earliest endeavors, such as nos. 92 and 93, but years of observation and exposure to more accomplished techniques increasingly developed the subtlety of his modeling. Bright, clear colors were typical of his palette and added much to the decorative appeal of his work. Herring never achieved the psychological insights of some of his better-known colleagues in portraiture, but in their ultimate development, his convincing and aesthetically pleasing likenesses reflect a mastery of many academic techniques.

[1] Information about Herring's life is from Cynthia Seibels, "James Herring: His Life and Works" (B.A. thesis, College of William and Mary in Virginia, 1976).

[2] Ann Golden Herring died in 1829; a second wife, Emily, is known only from a brief mention in a letter of 1835.

[3] From 1808 to 1814 Herring worked as a bill collector in an importing firm, a bookkeeper in a brewery, a teacher, and a distiller.

[4] William Page, later a prominent portrait painter in his own right, remained with Herring no longer than a year.

[5] The portrait is owned by the New-York Historical Society.

92	**Mrs. Jacob Kirkpatrick** **(Mary Burroughs Howell Sutfin)**	58.100.12
93	**Reverend Dr. Jacob Kirkpatrick**	58.100.13

James Herring
New Jersey, 1817
Oil on eastern white pine panel
30" x 25¼" (76.2 cm. x 64.1 cm.)
30" x 25" (76.2 cm. x 63.5 cm.)

The portraits of the Reverend and Mrs. Jacob Kirkpatrick are the earliest dated Herring portraits recorded. Several of the identifying characteristics of the artist's overall œuvre are apparent: bright, clear colors, an ex-

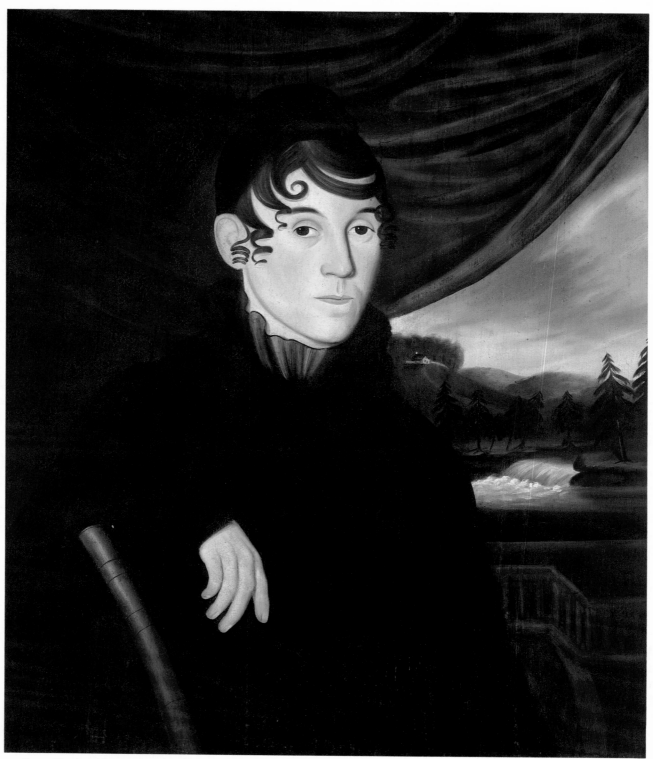

92 James Herring, *Mrs. Jacob Kirkpatrick*

treme contrast range, sharply defined eyes, and a thin, dark line separating the lips. Reverend Kirkpatrick's head, which is much more carefully rounded and modeled than his wife's, shows more of the promise that Herring fulfilled in his later plastic descriptions of form.[1]

The Kirkpatricks' black hair and clothing have been painted against such dark backgrounds that they melt into the space behind them, but the sitters' brightly lit faces and hands rescue the paintings from an atmosphere of gloom. Vivid backgrounds painted along the facing edges of the pair of panels also enliven the compositions. A scenic window view appears beyond Mrs. Kirkpatrick, while the red and tan leather bindings of Reverend Kirkpatrick's books add an especially pleasing note of rhythm and color to his likeness.

These companion portraits probably cost Kirkpatrick thirty dollars. About the same time they were commissioned, Herring painted young Jacob Merseles of Hudson County, New Jersey, depicting him with a quill pen in his hand, in a waist-length, three-quarter pose similar to Reverend Kirkpatrick's. On the paper under Merseles's hand is "Portraits painted in/this style at $15 by/Jas. Herring."[2]

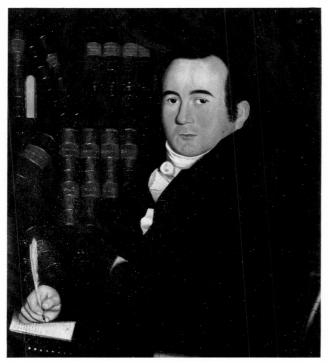

93 James Herring, *Reverend Dr. Jacob Kirkpatrick*

Jacob Kirkpatrick was born on August 8, 1785, at Mine Brook, Somerset County, New Jersey, the third of thirteen children born to Alexander and Sarah Carle Kirkpatrick. The second of eight children, Mary Burroughs Howell Sutfin was born on August 30, 1791, at Freehold, Monmouth County, New Jersey. Her parents were John and Lydia Baker Sutfin.[3] Jacob married Mary on December 13, 1809, and they had fourteen children. Of Scottish descent, Reverend Kirkpatrick was ordained a pastor in the Presbyterian church in 1810 and served a large district in west central New Jersey for many years.[4] He died on May 2, 1866, his wife on November 30, 1874, and both were buried in the Larison's Corner cemetery near Ringoes.[5]

Inscriptions/Marks: "1817," "By Hering," and "Mary Kirkpatrick/Wife Dr Kirkpatrick/A.D./1817" all appear in script on the reverse of her panel. On the reverse of his panel appears "Rev[d] Dr J Kirkpatrick/Painted/A.D. 1817," and below in penciled script, partially covered by a bunch of grapes and three leaves painted black, is "E H Schan–/Lambertv–/N J." Other period writing along the back of one member of his frame is indecipherable. The books on the shelves beyond Reverend Kirkpatrick are titled CAMPBELL'S FOUR GOSPELS, JOSEPHUS, BELLAMY'S WORKS, LIFE OF CALVIN, CHRISTIAN OBSERVER, SAINTS REST, YOUNG, C–'S LIVES, and another that is illegible.
Condition: In 1959 Russell J. Quandt glued small splits in the supports, cleaned the surfaces, and inpainted minor paint losses. Possibly original 2-inch molded and gilded frames.
Provenance: J. Stuart Halladay and Herrel George Thomas, Sheffield, Mass.
Exhibited: AARFAC, New York, and exhibiton catalog, nos. 13 and 14; Halladay-Thomas, New Britain, and exhibition catalog, nos. 50 and 47; Halladay-Thomas, Pittsburgh, and exhibition catalog, nos. 16 and 15; Halladay-Thomas, Syracuse, and exhibition catalog, nos. 23 and 22; Halladay-Thomas, Whitney, and exhibition catalog, p. 30, nos. 16 and 15.

[1]A more complete stylistic analysis of Herring's work is in Cynthia Seibels, "James Herring: His Life and Works" (B.A. thesis, College of William and Mary in Virginia, 1976).
[2]The portrait of Jacob Merseles is privately owned by a descendant.
[3]Mrs. George E. Carkhuff to AARFAC, November 16, 1976.
[4]Rev. Charles S. Converse, *History of the United First Presbyterian Church of Amwell, N.J.* (Trenton, 1881), pp. 14-15.
[5]Mrs. Carkhuff to AARFAC, November 16, 1976.

William Hillyer, Jr.
(active 1832-1864)

William Hillyer, Jr., exhibited three portraits at the American Academy in 1833 and a portrait of a lady at the National Academy of Design in 1835 and 1836. By 1846 Hillyer and William H. Miller had become

partners in a miniature and portrait studio in New York City; in that year they exhibited seventeen pictures at the American Institute of the City of New York Fair, one of which won a diploma as the second best portrait painting in oil. Stephen Krauss joined the partnership sometime after 1859, and by 1862 the trio had turned from portrait painting to photography.[1]

[1]Groce and Wallace, pp. 317, 377, and 445.

94 Mother Holding Baby 39.100.4

William Hillyer, Jr.
Probably New York City, 1835
Oil on canvas
33¼" x 29¼" (84.5 cm. x 74.3 cm.)

The esteem that Hillyer evidently enjoyed in his own day seems hardly justified by this rigid double likeness of a mother and her baby. The woman's oval-shaped face gives the appearance of a textbook study rather than a careful observation from life, and the baby's arms

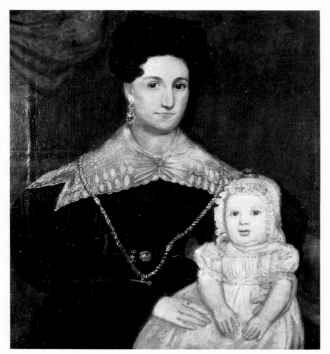

94

are flat and formless instead of being convincingly rounded. As a result, this basically linear design makes the subjects seem inanimate and graceless. In skilled hands, impasto can effectively convey an impression of varying textures, but here it primarily accentuates the composition's clumsy lines, and the woman's collar looks leaden and immobile. Her gold neck chain might have assumed a decorative, sinuous line with admirable effect, but instead it is stiff and heavy. Judging by the few examples of Hillyer's work that have been recorded,[1] this woodenness does not seem to be typical, and in all fairness, at least some of the portrait's crude appearance may be attributed to numerous losses in its surface.

Inscriptions/Marks: According to a label on an old photograph, "William Hillyer, 1835" was originally inscribed on the reverse of the canvas, but if so it is now obscured by the painting's lining.[2]
 Condition: David Rosen cleaned the painting, inpainted areas of loss, and lined it before it was acquired in 1939. Possibly original 4-inch molded and gilded frame.
 Provenance: Edith Gregor Halpert, Downtown Gallery, New York, N.Y.
 Published: AARFAC, 1940, p. 18, no. 18; AARFAC, 1957, p. 349, no. 170.

[1]These include portraits of three members of the Carpenter family in the collection of Jane and Henry Eckert as advertised in the *Ohio Antique Review* (April 1979), p. 24, and a portrait of Rachel Golden (Dean) Christian in the New York State Historical Association, Cooperstown. The New-York Historical Society, New York, N.Y., also owns a portrait of an unidentified gentleman signed "Painted by Miller & Hillyer/New York/1846."

[2]A photograph taken when Halpert owned the portrait bears a label stating that it was "by William Hillyer, 1835, signed and dated." Since no markings can now be located, it is assumed that the inscription appeared on the reverse of the primary support and is now covered by the lining.

Martha Ann Honeywell (1787-after 1847)

Martha Ann Honeywell, born in Lempster, New Hampshire, was quite celebrated in her day, not so much for the artistic quality of her cut profiles and embroideries as for the fact that she was able to create them at all. She was born without hands or lower arms and with just one foot, which had only three toes.

 The best account of her mode of operation is provided by an eyewitness, William Bentley, who recorded in his diary for January 27, 1809:

I visited Miss Hunnewell who is exhibited in this town [Salem, Mass.] as an example of uncommon attainments, in her imperfect form. She has only the first joints of both arms & one foot with three toes & in my presence wrought at embroidery, entering the needle with her toes & receiving it by the mouth, & putting the thread into her needle by her mouth & toes. She cut papers into various fancy forms, using her scissors with her mouth & the short stump of her arm & she wrote a good letter with her toes. Some pious verses she composed were exhibited in needle work wrought by herself. She is about 17 years of age and is attended by her mother from New York. Her head is well formed, her look intelligent, & her understanding clear, & her conversation & accent very pleasing & inspiring respect. [1]

Although not mentioned specifically by Bentley, the cutting of watchpapers and profiles was also an important part of Honeywell's repertoire, and both feats were often mentioned in advertisements.

Honeywell traveled widely in pursuit of a living. The first known reference to her professional work is a *Columbian Centinel* announcement for June 21, 1806, advertising her work in Boston.[2] Documentation exists for her appearances in Salem, Massachusetts, in 1806 and 1809, in Hartford, Connecticut, in 1806, in Charleston, South Carolina, in 1808, 1834, and 1835, and in Louisville, Kentucky, in 1830.[3] An undated broadside also indicates that "she has travelled through Europe, where her work has been universally admired."[4] Her last known activity dates from 1848, but the year of her death has not been determined.[5]

Martha Ann Honeywell's profiles are usually signed "Cut with the Mouth" or "Cut without Hands," and one inscribed "Cut with the lips" is said to exist.[6] Although the majority carry only the initials "M." or "M. A.," representing her forenames, other, more complex creations are signed "Martha A. Honeywell" or "Miss Martha Ann Honeywell."[7] One of her published profiles is described as hollow-cut, but most appear to have been cut-and-pasted examples like no. 95.[8]

Her career was not unique. Other nineteenth-century profile cutters exhibited as curiosities included William James Hubard (1807-1862), who was celebrated initially for his youthful precocity; Sanders K. G. Nellis (active 1836-1862), who was born without arms and performed cutting and other feats with his toes; and a Miss Rogers, who appeared with Honeywell in Charleston in 1808 and performed writing, scissors-cutting, and painting "without the natural use of her hands or arms."[9] Such displays have been compared to

95

"circus freak shows,"[10] and undoubtedly some in the audiences were drawn by curiosity. But how morbid the onlookers' attitudes were might be questioned, since many must have evidenced the admiring and respectful sentiments expressed by Bentley, viewing these astonishing persons as "example[s] of uncommon attainments."[11]

[1] Carrick, p. 108. Bentley erred in her age, of course.

[2] She was advertised in 1806 as being deprived of the use of hands and feet, but in fact she used her toes a good deal. The advertisement is reproduced *ibid.*, pp. 105-106.

[3] *Ibid.*, p. 106; Groce and Wallace, p. 324.

[4] The broadside is in the collection of Patricia Coblentz, according to the exhibition catalog, Borden Limner, p. 74.

[5] The date ascribed to Honeywell's profile of Mrs. Wentworth Winchester in the Essex Institute, Salem, Mass., is 1848. Carrick, pp. 104-105.

[6] *Ibid.*, p. 107.

[7] A cutout Lord's Prayer in the collection of Edward and Elizabeth Stvan is inscribed "Martha A. Honeywell"; another in the collection of Mrs. M. L. Blumenthal is inscribed "Miss Martha Ann Honeywell." C. Kurt Dewhurst, Betty MacDowell, and Marsha MacDowell, *Art-*

ists in Aprons: Folk Art by American Women (New York, 1979), p. 85, fig. 70; M. L. Blumenthal, "Martha Ann Honeywell Cut-Outs," Antiques, XIX (May 1931), p. 379, fig. 2.

[8] The hollow-cut Honeywell profile is illustrated in Alice Van Leer Carrick, "Silhouettes: The Hollow-Cut Type," Antiques, VIII (August 1925), as fig. 1 on p. 85.

[9] Anna Wells Rutledge, Artists in the Life of Charleston, through Colony and State from Restoration to Reconstruction, American Philosophical Society, Transactions, XXXIX, Pt. 2 (1949), pp. 150-151.

[10] Dewhurst, MacDowell, and MacDowell, Artists in Aprons, p. 83.

[11] Carrick, p. 108.

95 Mary M. Arendell 76.306.5

Martha Ann Honeywell
America, 1832
Cut wove paper, ink, watercolor, thread,
and gold paint
4 1/16″ x 3 1/16″ (10.3 cm. x 7.8 cm.)

The discoloration pattern of the primary support indicates that Mary Arendell's profile has been behind its present decorative paper mat for some time. Because of this and the similar color of the two obverse inscriptions, it has been supposed that Honeywell herself made the little "frame," even though it crops the first word of her upper inscription and no recorded writing of hers seems to match the lower lettering. To date, no mats of this type have been noted on other published Honeywell pieces, although if it is the artist's work, framing devices like this would have provided logical and attractive finishing touches to her cut profiles.[1]

Alice Carrick described gilded Honeywell profiles such as Mary Arendell's as being "very rare," and she recorded only two in 1928.[2] No additional examples have been noted, but as yet no thorough studies have been devoted to the artist's extant work.

Nothing is known of Mary Arendell beyond her name, but a further accumulation of Honeywell's advertisements may indicate where she was working in September 1832, thereby providing a locale for the sitter. Honeywell was in Louisville, Kentucky, in 1830 and in Charleston, South Carolina, in December 1834, the dates closest to 1832 yet documented.[3] The fact that Mary Arendell's profile was found in North Carolina strengthens the possibility that it was cut in the South, probably when Honeywell was on a tour of the southern states.

Inscriptions/Marks: In ink in script beneath the profile is "Cut by M, Honeywell with the Mouth,"[4] and below, hand-lettered in ink on the lower edge of the mat, is "Mary. M. Arendell: Sept 20 [or 25?]. 1832." In ink in script on the frame's wood backing is "Mary arendell." Also, in ink script on a separate piece of paper originally folded and used as backing in the frame is a sixteen-line poem titled "Lines written on a retrospective view of my native Home" that is signed "David M Rogers." There is no apparent association between the context of the poem and the profile. No watermark found.

Condition: No evidence of previous conservation. The frame's wood backing has been replaced by a nonacidic one. Original 11/16-inch molded frame, painted yellow, with a hanging loop of wool at center top.

Provenance: Paul Elam, Louisburg, N.C.

Published: Walters, Pt. 2, p. 1C, illus. as fig. 4 on p. 2C.

[1] The mat consists of a separate piece of paper considerably larger than the primary support. It is folded under along the outer edges of the pink painted border on all four sides and is sewn to the primary support by a single long horizontal stitch at center top.

[2] These were an unidentified profile in Mrs. Hampton Carson's collection and an unidentified woman's profile in Henry Erving's collection. Carrick, pp. 107-108.

[3] Groce and Wallace, p. 324; Anna Wells Rutledge, Artists in the Life of Charleston, through Colony and State from Restoration to Reconstruction, American Philosophical Society, Transactions, XXXIX, Pt. 2 (1949), p. 151.

[4] The word "Cut" is obscured by the paper mat when it is placed in normal position. See also the biographical entry for the artist.

William Jennys
(active 1793-1807)

Although William Jennys advertised in the *Norwich* (Connecticut) *Packet* in 1793,[1] his earliest-known works appear to have been painted in and around the area of New Milford, Connecticut, in the mid-1790s, a time and place concurrent with a period of acknowledged activity by Richard Jennys, another portrait painter who was probably related to him and whose work has frequently been confused with William's in the past.[2] Both artists are well known for penetrating, accomplished, predominantly waist-length likenesses set in painted spandrels, the similarities between their styles lending support to the theory that the two worked together, at least for a time.[3]

William Jennys is listed in New York City directories for 1797-1798, but after 1800 sitters' residences and fragmentary documentary evidence indicate that he traveled northward along the Connecticut Valley into central Massachusetts and Vermont and eastward to Portsmouth, New Hampshire, and Newburyport, Massachusetts.[4] His April 30, 1807, receipt for a portrait of James Clarkson,[5] made out in Newburyport, is the last documented reference to Jennys that is now known.

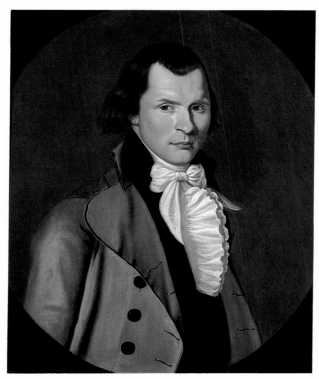

96 William Jennys, *Asahel Bacon*

compelling likenesses demonstrate the psychological insight most frequently associated with extremely skilled portraitists. Although some scholars have detected a softness in his early work,[8] time and practice honed his inherent proficiency to sharp precision. Jennys painted what he saw, and what he saw – bulbous noses, birthmarks, wrinkles, and sneers – was not often "pretty" by conventionally accepted standards. His depictions of stern New Englanders have been described as "brutally frank," his characterizations "stark and unflattering,"[9] and one wonders how acceptable his clients found their images. The large body of Jennys's work (more than one hundred portraits have been recorded) would indicate that they eagerly embraced these forthright revelations of themselves.

Technical characteristics of Jennys's style include readily apparent brushstrokes, indicative here of speed, and thinness of paint. Pigments that have become translucent with age reveal a greenish underpainting that colors sitters' faces today in a manner not originally intended. Backgrounds are frequently olive green to brown. Often a single light source is directed from one side, casting such strong shadows as to create a slightly

Large (47¼ inches by 39 inches) companion likenesses of Mr. and Mrs. Cephas Smith, Jr., show that Jennys was fully capable of treating complex and ambitious compositions.[6] These three-quarter-length seated portraits – hers a double one, including a baby – incorporate tasseled background drapery, and Mr. Smith is depicted writing at a desk. However, Jennys usually chose smaller (30 inches by 25 inches) canvases on which he painted sitters to the waist, their arms hanging down and their hands cropped. Such a format, particularly when coupled with the use of painted spandrels, is directly traceable to that used in mezzotint portraiture and in turn probably reflects the influence of Richard, who is known to have tried his hand at mezzotint likenesses.[7]

William Jennys's portraits exhibit such skill that they are seldom categorized as "folk painting" without reservation. Certainly he erred occasionally, particularly in the rendering of bodies, but on the whole his figures are proportioned with considerable accuracy, his paint is handled with astonishing dexterity, varying textures are superbly distinguished, and his best, most

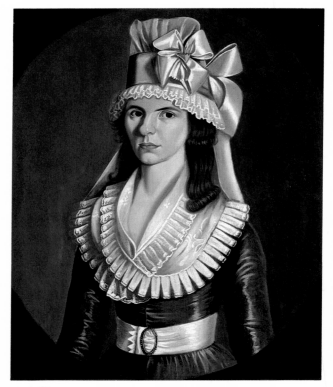

97 William Jennys, *Mrs. Asahel Bacon*

surreal atmosphere and thus contributing to the haunting appeal of Jennys's work.

[1] William Lamson Warren, "Captain Simon Fitch of Lebanon (1758-1835), Portrait Painter," *Connecticut Historical Society Bulletin*, XXVI (October 1961), p. 112.

[2] Two articles summarize much of William Lamson Warren's fundamental research on the artist and resolve much of the confusion between Richard and William. See Warren, Checklist, pp. 33-64, and Warren, Jennys, pp. 97-128. The reader may find other, earlier works on Jennys listed in Groce and Wallace, p. 349.

[3] AARFAC files contain a reference, as yet unverified, to a portrait signed by both Richard and William Jennys.

[4] Jennys may also have traveled as far west as Kingston, Ulster County, N.Y. A *Portrait of a Gentleman of the Livingston Family* attributed to him is described as possibly having been painted there in the exhibition catalog, "The Folk Spirit of Albany," Albany Institute of History and Art, February 26-June 5, 1978, p. 7. The painting is in the Albany Institute of History and Art.

[5] Both the receipt and the portrait are illustrated in Warren, Jennys, as fig. 1 on p. 97 and fig. 2 on p. 99. In 1955 the portrait was privately owned.

[6] The portraits of the Cephas Smiths are in the collection of the Museum of Fine Arts, Boston. Both are illustrated in Warren, Jennys, as figs. 28-29 on pp. 120-121.

[7] *Ibid.*, p. 100, and fig. 33 on p. 125.

[8] Warren, Checklist, p. 39.

[9] Warren, Jennys, p. 117, and Checklist, p. 39.

96	**Asahel Bacon**	63.100.1
97	**Mrs. Asahel Bacon (Hannah French)**	63.100.2
98	**Charles Bacon**	63.100.3
99	**Mary Ann Bacon**	63.100.4

William Jennys
Probably Roxbury or Woodbury, Connecticut, 1795
Oil on canvas
30″ x 25″ (76.2 cm. x 63.5 cm.)
30⅛″ x 25⅝″ (76.5 cm. x 65.1 cm.)
30¼″ x 25⅜″ (76.8 cm. x 64.5 cm.)
30½″ x 24½″ (77.5 cm. x 62.2 cm.)

The dark brown painted spandrels and warm lighter brown backgrounds in these portraits set off the frequently brilliant coloration of the sitters' costumes to advantage. Only the hues of young Mary Ann's likeness are somewhat subdued, her sheer white lace-trimmed overdress allowing faint traces of pink to show through. Five pink bows, her rosy lips, and her shiny brown hair constitute the strongest color notes in the painting. Her

brother, Charles, however, wears a rich turquoise coat over a golden yellow waistcoat, the complementary colors enhancing one another and the latter echoing the soft reddish gold glow of his hair. Asahel's coat is a medium slightly greenish blue which, like Charles's, provides a fine foil for his dark auburn hair. Hannah wears a dress of a lustrous fabric, probably "changeable" taffeta, its emerald green shimmering surface appearing iridescent and orange-tinted in highlights.

Jennys's consummate skill is also evident in his individualistic and convincing depiction of the textures of the widely varying fabrics, which range from delicate embroidered lace to shiny satin and silk. Even hair textures are captured. Hannah's and Mary Ann's hair appears to be of a similar medium coarseness, while Charles's is depicted as much finer, like his father's. It falls over the side of his head like a sheer curtain, exposing the outline of the ear beneath.

Hannah's portrait best illustrates the strong side lighting Jennys used so frequently. The large, rounded tip of her nose achieves even greater emphasis by the dark, elongated shadow it casts.

In both Woodbury and Roxbury, Asahel Bacon (1764-1838) continued the successful commercial tradition established by his father, Jabez (d. 1806), a wealthy self-made merchant of Woodbury. He married Hannah French (1765-1833), the daughter of William and Ann French of Southbury, in 1786, and they lived in the white frame house, still standing, which had been built for him in Roxbury in 1784. Their daughter, Mary Ann (1787-1869), also called Polly, attended Miss Pierce's School in Litchfield. As a student she kept a journal and painted several pleasing watercolors that still survive.[1] Mary Ann married Chauncey Whittlesey of Roxbury on November 15, 1815; her younger brother, Charles (1789-184?), married Betsey Tomlinson in 1811.

Inscriptions/Marks: The inscription "W Jennys pinx! 1795" was painted in black on the reverse of no. 97 and is now covered by a lining canvas.

Condition: In 1939 Fred Hoffman lined and varnished all four canvases. In 1963 Russell J. Quandt relined the canvases, cleaned them, inpainted scattered areas of loss, and repaired several small tears and holes. Mid-nineteenth-century replacement 2¼-inch flat frames, painted black, with raised inner lips.

Provenance: All four portraits descended in the family of Mrs. Chauncey Whittlesey (Mary Ann Bacon); Mrs. Bennett Sheldon Preston (Elizabeth Whittlesey); Edward Whittlesey Preston; Bennett Preston, Bridgeport, Conn.; Mary Allis, Fairfield, Conn.

Exhibited: "The Jennys Portraits," Connecticut Historical Society, Hartford, November 1955-January 1956.

Published: Black and Lipman, no. 97 only, p. 22, illus. as fig. 39 on p. 42; Alfred Frankenstein et al., eds., *The World of Copley (1738-1815)* (New York, 1970), no. 97 only, illus. on p. 97; Daniel R. Hull, *Bewitched Mine Hill: The Silver-Lead-Iron Mine of Roxbury,*

Connecticut (Stonington, Conn., 1966), no. 96 only, pp. 15-16, 25-26, illus. on p. 18; Warren, Checklist, pp. 47-48; Warren, Jennys, pp. 114-115, 122-123, illus. as figs. 3-6 on pp. 100-101.

[1]Mary Ann Bacon's journal and watercolors are in the Litchfield Historical Society, Litchfield, Conn.

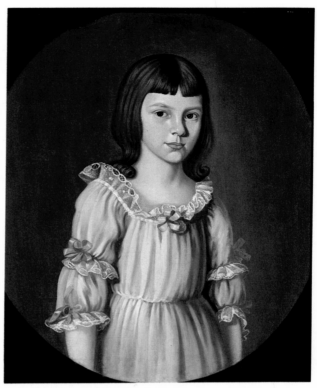

99 William Jennys, *Mary Ann Bacon*

100 Jeremiah Todd 58.100.41

Attributed to William Jennys
Possibly Newburyport, Massachusetts, ca. 1805
Oil on canvas
30¼" x 25¾" (76.8 cm. x 65.4 cm.)

Jeremiah Todd's craggy face must have presented quite a challenge to Jennys. The artist's capability and close observation are evident in the asymmetry of Mr. Todd's eyes, his realistically rendered thick head of hair, and in the generally convincing modeling of a multitude of facial wrinkles. One wonders, however, if the subject's crooked nose had quite so jagged an outline as Jennys gave it. The heavy brown shadow beneath the far eye-

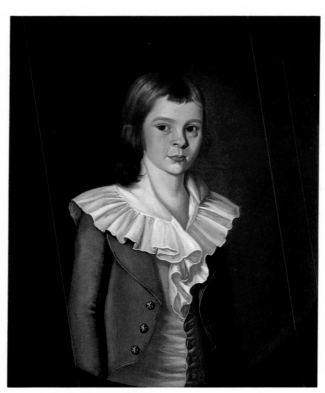

98 William Jennys, *Charles Bacon*

brow is also overly simplified and too sharply delineated to fit comfortably with the other, more softly defined, modeling in the face. Jennys's shadowing of the portrait's painted spandrels is directly related to the high contrast modeling of engraved or painted "frames" that were often an integral part of eighteenth-century mezzotint and oil portraiture.

Jeremiah Todd married Mary Atkin on June 30, 1768, and eight children are said to have been born to the couple. Todd owned a house on Market Square in Newburyport, Massachusetts, which he sold in 1810. His wife died August 21, 1803, aged fifty-nine; Todd died at Atkinson, New Hampshire, August 12, 1812, aged sixty-seven, and both were buried in Newburyport.[1] Along with this portrait, a likeness titled *Woman Holding a Rose,* identified as Todd's daughter, Mary Todd Stanwood (1768-1800), was advertised by Snow and Mills in 1958.[2] However, when Snow and Mills later sold the pair to The Old Print Shop, they apparently identified her as Todd's wife.[3] The present whereabouts of the woman's portrait is unknown.

Although Jennys's travels have not yet been

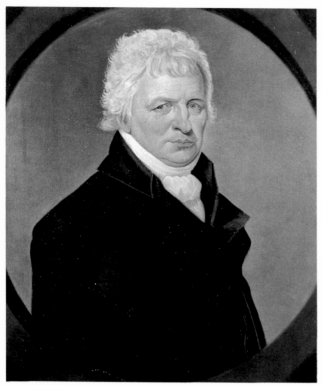

100

[1] Nancy H. Stone, Historical Society of Old Newbury, to AARFAC, October 14, 1963.

[2] *Antiques,* LXXIII (January 1958), p. 37.

[3] The Old Print Shop to AARFAC, May 29, 1963.

[4] James Clarkson's portrait was published as being privately owned in October 1955. Both it and the receipt for it are illustrated in Warren, *Jennys,* as figs. 1 and 2 on pp. 97 and 99.

[5] The transcription of this label is taken from Russell Quandt's notes dated April-May 1959. The label itself is now missing.

[6] The Old Print Shop to AARFAC, May 29, 1963.

Joshua Johnson
(active ca. 1800-ca. 1824)

Joshua Johnson is another of America's folk artists whose works are widely acclaimed, but whose life history remains exceedingly obscure. Many scholars still ponder over the source of his training and national and ethnic origin as well as his ability to maintain a successful career in the competitive urban atmosphere of Baltimore, where Johnson apparently spent most of his adult life.

No provable facts are known about Johnson's early life and training. When J. Hall Pleasants published the first scholarly essay on the artist, he noted several Maryland family traditions that indicated that Johnson was a free black and had been a slave in several different households. This evidence, while conflicting in some details, seemed to corroborate Pleasants's discovery of a Joshua Johnson, portrait painter, listed under the section "Free Householders of Colour" in the 1817-1818 Baltimore city directory.[1] Nothing has been found to refute Pleasants's early theory or any aspect of his research except for the preferred spelling of the artist's surname. Neither the portrait of Sarah Ogden Gustin signed by the artist nor the will of Mrs. Thomas Everette, one of Johnson's sitters, was known to Pleasants.[2] The signature on the Gustin portrait reads "Joshua Johnson," while Mrs. Everette called the painter "J Johnson" in her will. An analysis of various Baltimore directory listings also shows that the name was spelled without the "t" most of the time.

The city records and two newspaper advertisements by the artist constitute all that is known about where he lived and worked. It seems clear that most refer to one artist listed variously as a "portrait painter," "painter," and "limner." It is not known whether

documented extensively enough to provide evidence for conclusive dating of no. 100, the artist's 1807 receipt for James Clarkson's likeness establishes the fact that Jennys was in Newburyport in 1807.[4] Possibly Todd's portrait was painted at the same time and cost the $25 known to have been paid for Clarkson's.

Inscriptions/Marks: A handwritten label attached to one of the stretchers at the time of acquisition is recorded as having read "Jeremiah Todd, born in Rowley, Mass./1745 died in Atkinson, Mass. or N. H. Aug. 29th 1812. Father to Mary J./Stanwood, mother of Mary Stanwood/Morrill, he is great-grandfather to/Annie J. Morrill Rumney."[5]

Condition: In 1959 Russell J. Quandt lined the canvas, cleaned it, replaced the auxiliary support, inpainted minor areas of loss, and repaired two holes in the upper edge and a C-shaped tear in the lapel. Probably period replacement 3½-inch lap-joined frame with mitered, molded, veneered face and gilt liner.

Provenance: Descended in the sitter's family;[6] Kenneth E. Snow and Richard L. Mills, Newburyport, Mass.; The Old Print Shop, New York, N.Y.

Exhibited: "First Flowers of Our Wilderness," Santa Barbara Museum of Art, January 11-February 15, 1976, and University of Arizona Museum of Art, Tucson, February 29-March 28, 1976.

Published: Antiques, LXXIII (January 1958), p. 37; *First Flowers of Our Wilderness* (Tucson, 1975), p. 129, no. 27, illus. as pl. 27 on p. 59.

Johnson's trade was restricted solely to portrait painting, but it seems a curious coincidence that many of the addresses given for him are within the area of Baltimore then populated by fancy- and painted-chair makers. It would not have been unusual for Johnson to have supplemented his income as a furniture decorator since other portraitists of similar ability are known to have done so. Such an arrangement would further explain how Johnson, an artist of only modest talent, could survive financially in a city that patronized successful academic painters such as James Peale, Philip Tilyard, and John Wesley Jarvis, in addition to a steady stream of other proficient itinerants.

Johnson's two advertisements are perhaps the most revealing surviving records. In 1798 he advertised his portrait painting and noted that he was "a self-taught genius, deriving from nature and industry his knowledge of the *Art*" and that he had "experienced many insuperable obstacles in the pursuit of his studies."[3] How much we may rely on these self-pronouncements is unknown since artists frequently exaggerated both their skills and the circumstances of their training in newspaper advertisements. The character of his work certainly suggests that his training, if any, was limited to the rudimentary and basic aspects of his trade.

Most of the numerous paintings now attributed to Johnson share stylistic similarities, but many of them lack the genealogical information needed for specific dating. This factor, plus the absence of information on his training, makes any analysis of Johnson's stylistic development very incomplete and premature. The portraits identified by Pleasants and the documented pictures of Sarah Ogden Gustin and Mrs. Thomas Everette and her children are sources upon which stylistic assessments are currently made. They exhibit a surprising variety of poses and canvas sizes, indicating that Johnson could handle bust-length and both three-quarter and full-length seated and standing figures with equal assurance. His drawing and modeling techniques were sound and consistent, but they were also hard-edged and sometimes rather superficial. Even though he had a set formula for painting hands, costumes, eyes, and mouths, other facial features were often carefully studied and individualized. Johnson was also adept at rendering small toys, fruit, flowers, jewelry, lace, and other elements that give his best paintings decorative charm and color.

[1]J. Hall Pleasants, "Joshua Johnston, the First American Negro Portrait Painter," *Maryland Historical Magazine,* XXXVII (June 1942), pp. 122-125.

[2]The portrait of Sarah Ogden Gustin is in the National Gallery of Art, Washington, D.C.; the group portrait of Mrs. Thomas Everette and her children is in the Maryland Historical Society, Baltimore. An excerpt from the transcript of Mrs. Everette's 1831 will in the library files at the Maryland Historical Society reads: "To my eldest daughter Mary Augusta E. Clarke I bequith the large Family painting of my self and 5 children painted by J Johnson in 1818."

[3]As quoted in the *Baltimore Intelligencer,* December 19, 1798, research files, Museum of Early Southern Decorative Arts, Winston-Salem, N.C.

101　Margaret Moore　　　　　　　　73.100.6

Possibly Joshua Johnson
Probably Baltimore, Maryland, ca. 1812
Oil on canvas
22½" x 18½" (57.2 cm. x 47.0 cm.)

The subject is thought to be Margaret Moore of Pungoteague, a small town on the Eastern Shore of Virginia accessible to Baltimore via the bayside town of Harborton. The little girl is said by previous owners to have been born in 1810 and to have married George Rogers of the area in 1830.

The attribution of this likeness to Johnson is still very tentative and is based on certain stylistic similarities to the large body of work assigned to him. There is at least one other picture (privately owned) probably by Johnson that comes from the Eastern Shore area, but there is no documentation of the artist's visit to the Eastern Shore.

Margaret is shown in a frontal position very like that of Henry McCausland (no. 102), and she holds a sprig of cherries in one hand, a motif seen in other children's likenesses by Johnson. The drawing of the face, arms, and hands, and the little girl's cap is also close to that of similar passages in other Johnson portraits. Like the McCausland child, Margaret is depicted just under life-size.

If this portrait is by Johnson, the image of Margaret on the front and the unfinished woman's likeness on the verso should be very valuable in any future assessment of the artist's approach and technique, and they may possibly represent the most conservative, inexpensive formats he offered. In terms of modeling and brushwork throughout, *Margaret Moore* stands up well against Johnson's more elaborate pictures.

Condition: This portrait was in poor condition when it was acquired, with severe cracking throughout the design surface and numerous small tears and nail holes caused by tacking of the canvas to a homemade stretcher. Of particular concern in the consequent conservation treatment by Theodor Siegl in 1974 was the preservation of an apparently discarded portrait sketch of a woman on the reverse of

the canvas. To enable future examination of this, the verso was cleaned, coated with microcrystalline wax, and mounted on a 3/16-inch sheet of Plexiglas. The old stretcher was mounted to the Plexiglas support and then the front of the canvas showing Margaret Moore was cleaned, tears and punctures were filled, and scattered abrasion and losses were inpainted. Original 1½-inch molded frame, painted black.

Provenance: Miss Estelle Battaile, Pungoteague, Va.; Dr. Robert Hiden, Pungoteague, Va.; Eastern Shore Historical Society, Belle Haven, Va.

Published: Karen M. Jones, *From A to Z: A Folk Art Alphabet* (New York, 1978), illus. opposite p. "B."

102 Laura Winship McCausland and her son, Henry

59.100.3

Attributed to Joshua Johnson
Probably Baltimore, Maryland, probably 1815
Oil on canvas
25 3/8" x 22 1/8" (69.5 cm. x 56.2 cm.)

It is believed that this picture was executed about 1815, a year after Henry's birth in Baltimore on November 14, 1814. The sitters' poses and the brass-tacked upholstered sofa on which they are seated are features seen in numerous paintings by the artist. Henry holds what appear to be two cherries, the kind of small decorative embellishment Johnson used frequently in children's portraits.

The McCausland portrait is not as crisp in modeling and detail as most of Johnson's work is. Some effort was made to capture the intricate patterns of lace in the mother's cap and fichu, but the quality of these areas is less successful than it might have been. Johnson was fully capable of precision work since other portraits by him include jewel-like passages of lace, buttons, flowers, and fruit.

Characteristics of Johnson's style in this painting include the position and curve of the fingers of the child's left hand and the shape of Mrs. McCausland's eyes and eyelids. Both figures are rigid in their poses and are represented slightly smaller than life-size. Skin tones are too pink but correspond with different intensities of the same color in the cherries and the ribbon on the mother's cap. Viewed as a whole, the McCausland portrait is uniformly modest in concept, design, and execution, qualities that make it a forthright picture of enduring pleasantness.

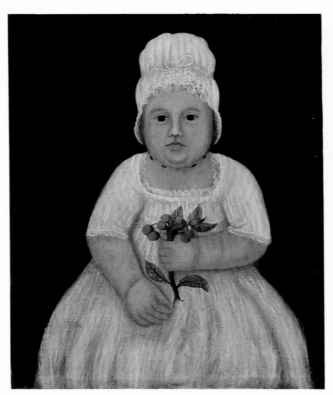

101 Attributed to Joshua Johnson, *Margaret Moore*

101 (reverse) *Unfinished Portrait*

102

"Samuel Jordan of Boston."[1] Interestingly, all are signed and dated 1831.

Stubby, curving fingers with pointed nails and small pursed cupid's-bow mouths appear to be characteristic of Jordan's work. A bold decorative pattern is created by the stenciling of the chair and the buttons and buttonholes on the yellow vest. In this portrait the young man's arm has been diminished to a stump by unconvincing foreshortening.

Inscriptions/Marks: Below the chair back in the lower left corner appears "S. Jordan/Pinxit/1831." The inscription on the book spine in the sitter's hand appears to read *Wats.*

103

Condition: The painting was lined and cleaned and minor losses were inpainted by Russell J. Quandt in 1960. Possibly original 3¼-inch molded and gilt-decorated frame.

Provenance: Descended in the family to Bradley A. McCausland, Orlando, Fla.

Exhibited: AARFAC, September 15, 1974-July 25, 1976.

Published: AARFAC, 1974, illus. as no. 20 on p. 28.

Samuel Jordan
(1803/4-after 1831)

103 Young Man Seated 58.100.38

Samuel Jordan
Probably New York state or
New England, 1831
Oil on canvas
28¾″ x 19¾″ (60.3 cm. x 50.2 cm.)

This portrait of a tousle-haired young man seated sideways in a yellow side chair is one of only four paintings known to have been executed by the mysterious

Condition: The canvas was cleaned and lined by Morton Bradley, Jr., in 1973. Modern replacement 3-inch cyma reversa frame with gilt liner.

Provenance: J. Stuart Halladay and Herrel George Thomas, Sheffield, Mass.

Exhibited: Halladay-Thomas, Pittsburgh, and exhibition catalog, no. 52; Halladay-Thomas, Whitney, and exhibition catalog, p. 33, no. 52.

[1] The New York State Historical Association, Cooperstown, owns two unidentified double portraits by Jordan, each of which is signed and dated to the left of the female sitter's nose. The *Eaton Family Memorial* in the National Gallery of Art, Washington, D.C., is inscribed on the reverse "Painted AD 1831 in Plaistow, N, Hamshire [*sic*]/by Samuel Jordan –." Below, in pseudo-Greek, is "Samuel Jordan of Boston/painter AD 1831/Aged 27/in God's Name/Adieu." At left on the reverse is a shooting star above a half-fallen cross, and below it are the words "Christ our Trust."

William W. Kennedy
(1818-after 1870)

William W. Kenedy [*sic*], aged thirty-two years, appears in the 1850 Maryland census as a portrait painter and a native of New Hampshire. The records also reveal that his wife, Julia, then aged thirty, was born in Massachusetts, as were their children Fred W., Walter, and Julia, aged four, two, and one respectively. An accompanying listing for Elizabeth Kennedy, a sixty-six-year-old New Hampshire native, may refer to the artist's mother.[1]

Signed or inscribed portraits indicate that Kennedy was in New Bedford, Massachusetts, in 1845, in Ledyard, Connecticut, in 1846, and in Berwick, Maine, in 1847. Census data coupled with his daughter Julia's date and place of birth imply that the family moved from Massachusetts to Maryland during the winter of 1849-1850. The artist was first listed in the Baltimore City Directory in 1851, his address being given as 229 Light Street, as it was in 1853-1854. From 1856 to 1859 he was at 227 East Monument Street, in 1860 and 1864 at 82 West Baltimore Street, in 1867-1868 at 75 Chew Street, and in 1870-1871 at 257 West Fayette Street.[2] Two signed portraits that survive from Kennedy's Baltimore period indicate that his technique became somewhat more academic as he matured.

Kennedy is perhaps the least well known of the portraitists referred to as "Prior-Hamblin" artists. To date no contact between him and any other member of this stylistically linked group of painters has been documented. The opportunity for exposure to William Matthew Prior's work certainly existed, however, as is

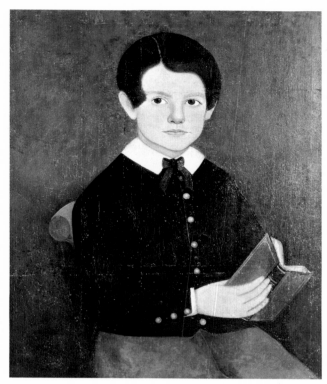

104

readily apparent upon comparing recorded dates and locations of activity for the two artists in both New England and Maryland. Especially noteworthy is the fact that Prior's signed Baltimore works bear an East Monument Street address only a few doors from where Kennedy worked from 1856 to 1859.

Recent research by the Folk Art Center has revealed fourteen signed examples of Kennedy's work, which provide the stylistic basis for an additional thirty-nine attributions. Peculiarities of his anatomical descriptions include exaggerated shading around the nose, a U-shaped configuration connecting the eyebrows and nose of the subject, a dark line between the lips – often with T formations at each corner of the mouth – and a particularly distinctive curvature of the extended fingers of the subject's hands. Occasionally Kennedy's portraits incorporate devices like a landscape view through a window or door, or objects such as a rattle, flute, stick and hoop, drumsticks, or a basket of flowers. But the props he used most frequently were a rose in the outstretched hands of female subjects, and a book in the hands of male sitters. Although he sometimes depicted children full length, either seated or standing, his por-

traits on canvas generally show a half-length subject seated in a side chair against a background that is either draped or shaded half light and half dark. Kennedy painted likenesses on canvases of standard sizes and of the small academy board variety frequently associated with artists of the Prior-Hamblin group.

[1]Census data is from the Maryland Historical Society, Baltimore, to AARFAC, October 2, 1975.
[2]Directory listings for Kennedy are from S. E. Lafferty's unpublished manuscript, "Artists Who Have Worked in Baltimore, 1796-1880, compiled by S. E. Lafferty from City Directories," which is in the collection of the Maryland Historical Society.

104 Boy with Eton Collar 36.100.7

Attributed to William W. Kennedy
Probably New England, probably 1845-1850
Oil on canvas
24¼" x 20" (61.6 cm. x 50.8 cm.)

Although somewhat uninspired in composition and heavily restored, this portrait serves well as an illustra-

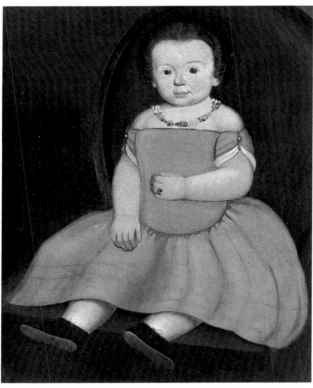

105

tion of the characteristically pronounced hand and finger curvature that is the most easily recognized detail in many of William Kennedy's portraits. Most Kennedy likenesses show heavy shading on either side of the subject's nose, but it is less noticeable here. Other details, however, further substantiate the attribution. The same scrolled chair back projecting from behind the subject's shoulder can be found in a privately owned signed and dated 1847 portrait of Mrs. E. Peace, and the boy's costume is nearly identical to those worn by twin boys, John and William Dolliver, in an unsigned double portrait by Kennedy that is also in a private collection.

Condition: Treatment by an unidentified conservator, probably in the 1930s, included lining and cleaning the canvas, and extensive inpainting of areas of loss, particularly along horizontal and vertical lines where the canvas was once folded. Period replacement 2½-inch molded and gilded frame and liner with quarter-round outer edge.
Provenance: Katrina Kipper, Accord, Mass.
Exhibited: "American Folk Art," Hollins College and the Roanoke Valley Historical Society, Roanoke, Va., May 1-31, 1974, and exhibition catalog, no. 18, illus. on front cover; Goethean Gallery.
Published: AARFAC, 1957, p. 353, no. 205.

105 Baby in Rose Dress 31.100.7

Attributed to William W. Kennedy
Probably Baltimore, Maryland,
probably 1850-1855
Oil on canvas
27" x 23⅛" (68.6 cm. x 58.7 cm.)

The exaggerated shading around the nose and the depiction of the curvature of the fingers provide a tentative basis for attributing this portrait to William W. Kennedy. However, the credibility of such an ascription is vastly strengthened by a nearly identical, privately owned portrait that—although unsigned—displays a treatment of the outstretched hand that is indubitably Kennedy's. The child in the privately owned portrait also holds a rose drawn in characteristic Kennedy fashion.[1] Further support for the attribution lies in the fact that *Baby in Rose Dress* was found in Baltimore, where Kennedy settled and worked as a portrait painter for at least twenty years after 1850.

Condition: David Rosen cleaned the painting prior to 1937, removing a large cap overpainted on the child's head in the process; he also lined the canvas, remounted it, and inpainted scattered areas of paint loss. Unspecified treatment by Sheldon Keck in 1952-1953. Modern replacement 2½-inch cove-molded gilded frame with quarter-round outer edge.

Provenance: Found in Baltimore, Md., and purchased from Edith Gregor Halpert, Downtown Gallery, New York, N.Y.

Exhibited: American Folk Art; Goethean Gallery.

Published: AARFAC, 1940, p. 18, no. 13; AARFAC, 1947, p. 14, no. 13; AARFAC, 1957, p. 352, no. 194; Cahill, p. 30, no. 8.

[1]The portrait is illustrated in June Johnson Jeffcott, "We Are Collecting Our Home," *Antiques,* XLV (May 1944), as figs. 2 and 8 on pp. 253 and 255.

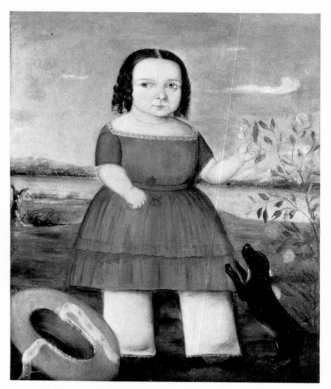

L. G. Lawrence
(active ca. 1845)

106 Girl with Rose Bush
41.100.6

L. G. Lawrence
Amherst, New Hampshire, ca. 1845
Oil on canvas
33¾" x 26" (85.7 cm. x 66.0 cm.)

106 L. G. Lawrence, *Girl with Rose Bush*

L. G. Lawrence remains elusive in terms of specific identification and association with other paintings, although it is probable that this artist was one of two women living in Amherst, New Hampshire, circa 1850.[1]

There is an uneven quality in this picture that is sometimes associated with folk portraiture. Lawrence undoubtedly recognized that the fundamental concern in portrait painting was the rendering of an acceptable likeness of the face, and the artist seems to have directed all of his or her energy toward the little girl's face, which reflects care in drawing and modeling, regardless of the technical errors committed in the process. In contrast, the rest of the canvas seems hastily painted, the result of either an economy of effort or lack of ability.

Inscriptions/Marks: Signed in ink on the sitter's left pantalette "L. G. Lawrence/[A]mherst/N. H."

Condition: Hans E. Gassman cleaned, lined, and inpainted minor portions of the rose bush and lower right edge in 1954. Bruce Etchison relined, cleaned, and inpainted minor losses in 1978. Period replacement 3½-inch molded gold leaf frame.

Provenance: Found in Sutton, N.H.; gift of James Chester Flagg.

Exhibited: Arkansas Artmobile.

Published: AARFAC, 1957, p. 355, no. 216 (the artist's signature was recorded incorrectly as "S. Lawrence").

[1]According to Daniel F. Secomb, *History of the Town of Amherst, New Hampshire* (Concord, N.H., 1883), pp. 669 and 175-176, there were only two L. G. Lawrences living in Amherst circa 1850— Elizabeth Greeley Lawrence, born November 9, 1831, and Lizzie G. Lawrence, who was a member of the Amherst Musical Association.

107 Attributed to Jacob Maentel, *Profile Portrait of a Woman*

Jacob Maentel
(1763-1863)

Jacob Maentel was born in Kassel, Germany, and died a full hundred years later in New Harmony, Indiana.[1] He married Catherine Gutt, an Alsatian. According to descendants of the artist, Maentel was educated as a physician and served under Napoleon either as his secretary or simply as a soldier. It is not known when Maentel immigrated to this country, but certainly by 1810 he had settled in Pennsylvania. Based in Lancaster and its surrounding counties, he created dozens of profile and full-face portraits of his contemporaries in half- and full-length poses.[2]

Maentel's subjects were usually painted in profile until the mid-1820s, when frontal poses began to predominate. His portraits are thought to be fairly accurate representations of the subjects, although he was basically a formula artist who developed and often repeated stock compositional devices. For example, Maentel's full-length figures are often posed on grassy knolls bearing small, distinctive, stippled shrubbery, or they appear in stylized landscapes of rolling hillsides dotted with similarly stippled foliage and stylized architectural elements. Female subjects sometimes hold a rose painted in a characteristic manner, but the array of personalizing accessories used by the artist was broad and included hats, purses, umbrellas, fans, books, songbooks, cats, dogs, parrots, roosters and other birds, and military devices. Interior furnishings included several types of chairs, desks, mirrors, floor coverings, and other objects.[3] The particularly distinctive method and palette the artist employed in modeling facial features and hands were often somewhat harsh in his earliest work and remained generally consistent throughout his career. The diverse likenesses by Maentel represented in this collection amply illustrate the development of the artist's style over a long span of years.

According to one source, Maentel first appeared in the New Harmony, Posey County, Indiana, area in 1836. The illness of some of the members of his family interrupted their move to Texas and evidently caused Maentel to remain in Indiana.[4] He was known during

108 Attributed to Jacob Maentel, *Mrs. Joseph Gardner and Her Daughter*

109 Attributed to Jacob Maentel, *Joseph Gardner and His Son, Tempest Tucker*

his lifetime as a farmer who was fond of painting, and he produced several remarkable full-length portraits of local residents.

[1]For a more detailed account of Jacob Maentel's life and for a discussion of the facts that led to the assignment to him of works previously incorrectly attributed to Samuel Endredi Stettinius, see Black, pp. 96-105.
[2]The theory that Maentel may have spent some time in Baltimore early in his career needs further research. *Ibid.*, p. 96.
[3]Subjects are sometimes also posed in or with chairs in exterior settings.
[4]Black, pp. 96 and 99.

107 Profile Portrait of a Woman 58.300.12

Attributed to Jacob Maentel
Probably Pennsylvania, ca. 1810
Watercolor and gouache on wove paper
6¾″ x 6″ (17.1 cm. x 15.2 cm.)

This watercolor profile is one of six recorded half-length portraits of men and women by Maentel that utilize oval formats with the figures placed behind simulated

110 Attributed to Jacob Maentel, *Woman in Blue Dress*

marbleized partitions. One of them retains what appears to be its original scalloped and cutwork paper mat with elaborate fraktur-style floral painted designs.[1] Although many of Maentel's full-length portraits can be dated by costume to this same period of activity, three of the six known half-length subjects with marbleizing are dated 1809, making them his earliest documented portraits recorded to date. While Maentel continued to produce half-length and bust-length profile and full-face portraits in watercolor in later years, his stylish full-length figures are more abundant and more typical of the personal style by which he is best known today.

Condition: Unspecified restoration by Christa Gaehde in 1958. Modern replacement ¾-inch oval frame, painted black, with gilt inner liner.
Provenance: Robert Carlen, Philadelphia, Pa.
Exhibited: Washington County Museum.
Published: Walters, Pt. 2, p. 2C, illus. as fig. 15 on p. 4C.

[1]*Woman Holding a Rose,* National Gallery of Art, Washington, D.C., acc. no. B-25, 539, gift of Edgar William and Bernice Chrysler Garbisch.

108 Mrs. Joseph Gardner (Margaret 58.300.34
Arehart) and Her Daughter

109 Joseph Gardner and His Son, 58.300.33
Tempest Tucker

Attributed to Jacob Maentel
Pennsylvania, ca. 1815
Watercolor on wove paper
11⅞″ x 9⁵/₁₆″ (30.2 cm. x 23.7 cm.)
12⅛″ x 10″ (30.8 cm. x 25.4 cm.)
(Reproduced in color on p. 139)

Twentieth-century labels once on the backings of this pair of portraits indicate that Joseph Gardner was born November 23, 1783, and died April 14, 1866; Tempest Tucker Gardner was born November 9, 1811, and died June 25, 1896; and Margaret Arehart Gardner was born February 1, 1782, and died December 11, 1869. The Gardners' baby daughter is unidentified.

With their elaborate blue shaded backgrounds and characteristic stippled foliage, these companion double portraits illustrate Maentel's fully developed style at a relatively early date. Although the artist obviously concerned himself with individual details, particularly of costumes, the repetitive landscape elements and the general placement and scale of the figures in the compo-

sition were part of a formula that he followed with few deviations throughout his career in Pennsylvania and later in Indiana.

Inscriptions/Marks: Watermark in the primary support of no. 109, "T G & C°."[1] See also *Commentary* above.
Condition: Restoration by Christa Gaehde in 1959 included cleaning and mounting on Japanese mulberry paper. In 1978 E. Hollyday removed masking tape hinges, dry-cleaned unpainted areas, set down flaking paint, and reduced discoloration of the supports. Modern replacement 1¼-inch splayed frames, painted red, with flat outer edges.
Provenance: C. E. Bilheimer, Harrisburg, Pa.;[2] Arthur J. Sussel, Philadelphia, Pa.
Exhibited: AARFAC, American Museum in Britain; AARFAC, June 4, 1962-March 31, 1965; Historical Society of York County, York, Pa. (before 1959).[3]
Published: Black, no. 109 only, p. 103, illus. on p. 96; Black and Lipman, no. 109 only, p. 52, illus. as fig. 53 on p. 61; Parke-Bernet, Sussel, p. 109, no. 520; *The Vincent Price Treasury of American Art* (Waukesha, Wis., 1972), p. 50, illus. on p. 51.

[1]The initials stand for Thomas Gilpin, who operated a paper mill with his brother Joshua on the Brandywine River two miles above Wilmington, Del., between 1787 and 1838. (Weeks, pp. 92, 157, and 175.) Thomas's initials were used in the mill's watermarks only after 1800. Thomas L. Gravell to AARFAC, September 18, 1978.
[2]Parke-Bernet, Sussel, p. 109, no. 520.
[3]*Ibid.*

110 Woman in Blue Dress 63.300.7

Attributed to Jacob Maentel
Pennsylvania, ca. 1815-1820
Watercolor on wove paper
10¾" x 9" (27.3 cm. x 22.9 cm.)

This profile portrait dates from early in Maentel's period of activity in Pennsylvania and perhaps represents his most elementary and conventional pose for a female subject: a full-length, strict profile of a figure holding a rose and standing on a slightly arched mound from which sprout isolated blades of grass and a small stippled bush. Maentel painted such individual likenesses far more frequently than group compositions. It is interesting to note that the woman's fingers and hand are outlined in dark blue, a technique sometimes used on other works by the artist.

Inscriptions/Marks: No watermark found. Printed on a paper label glued to a piece of laminated paperboard backing in the frame, "LONDON:/G.P.MCQUEEN, 37, Great Marlborough Street, Regent Street./Elliot, Blakeslee & Noyes, Boston, U.S."
Condition: No evidence of previous conservation. Modern replacement 2⅞-inch flat reeded frame with applied convex inner molding, painted black.

Provenance: Robert Carlen, Philadelphia, Pa.
Exhibited: AARFAC, September 15, 1974-July 25, 1976; Washington County Museum.
Published: AARFAC, 1974, p. 32, no. 25, illus. as no. 25 on p. 33.

111 Woman Holding Songbook 63.300.6

Attributed to Jacob Maentel
Pennsylvania, ca. 1830
Watercolor on wove paper
11⅛" x 8¾" (28.3 cm. x 22.2 cm.)

Costume details date this simple portrait to about 1830, making it an early departure from the profile pose so characteristic of Maentel's first known Pennsylvania works.

Condition: Unspecified restoration prior to acquisition included backing the primary support with laid paper. Restoration by E. Hollyday in 1974 included dry-cleaning verso and unpainted recto areas, reducing oil and some foxing stains, re-adhering several edge tears to the backing paper, and flattening scattered creases as much as possible. Probably original 1⅛-inch molded gilt frame.
Provenance: Robert Carlen, Philadelphia, Pa.
Exhibited: AARFAC, New Jersey.

112 Mr. Jonathan Jaquess 59.300.6
113 Mrs. Jonathan Jaquess 59.300.7
 (Rebeckah Fraser Rankin)

Jacob Maentel
Posey County, Indiana, 1841
Watercolor and ink on wove paper
17⅝" x 11¼" (44.8 cm. x 28.6 cm.)
17¾" x 11⅜" (45.2 cm. x 28.9 cm.)

These two portraits were painted in 1841 by seventy-eight-year-old Jacob Maentel about five years after he had moved with his family from Pennsylvania to New Harmony, Indiana. The likenesses represent two elderly Posey County, Indiana, residents: Jonathan Jaquess, Jr. (1753-1843), and his third wife, Rebeckah Fraser Rankin Jaquess (1762-1849).[1] They are only two of several full-face, full-length, large-scale, complex portraits of subjects in interior settings or detailed landscape backgrounds that are representative of the height of Maentel's style and imagination.

Jonathan Jaquess's portrait incorporates a full-rigged ship, which seems not only to symbolize his

religious beliefs, as spelled out in the inscription below, but also to commemorate his service at sea during the American Revolution. The companion portrait of Rebeckah Jaquess is a rich visual document of a midwestern interior with its stenciled walls, woven carpet, and pin-striped writing-arm Windsor chair. Mr. Jaquess's portrait is one of only three known signed examples by Maentel,[2] and the initial publication of this pair in 1954 eventually led to the proper identification of dozens of other works created by the artist during his earlier period of activity in Pennsylvania.

Inscriptions/Marks: Handwritten in ink or watercolor in fraktur-style lettering in the lower margin of the primary support of no. 112 is "There all the ships company meet. Who sailed with their savior beneath. With shouting each other they greet. And triumph oer sorrow and death./Jonathan Jaques Aged 88 Years. painted in Year 1841." In ink or watercolor in conventional script at the lower right corner of the primary support is "Jacob Maentel fecid." Handwritten in ink or watercolor in fraktur-style lettering in the lower margin of the primary support of no. 113 is "Rebecca Jaquis Aged 79 Years, painted in the Year 1841." Hand-lettered in ink or watercolor on the pages of the open book near the subject's hand are what appear to be the following words: "1. For we know, that is/our earthly house of/this [his?] tabernacle were/dissolved, we have a/building of God, an/house

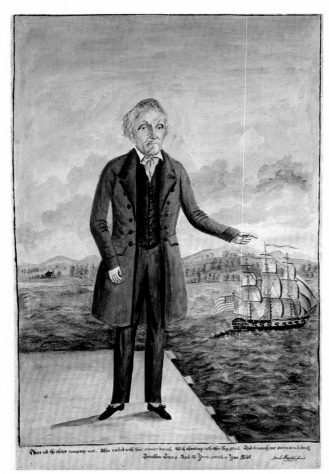

112 Attributed to Jacob Maentel, *Mr. Jonathan Jaquess*

not made with/hands, eternal in the / . . . [obscured by the subject's arm] heavens./2. For in this we groan/earnestly desiring/to be cloathed upon/with our house which/is from heaven./3. If so be that being/ cloathed, we shall/not be found naked." No watermark found.

Condition: Restoration by Christa Gaehde in 1961 included cleaning, reduction of stains, filling in and inpainting thin horizontal lines of paint loss through no. 112's left forearm, coat, and legs, and small areas of paint and support loss in the dress of no. 113, and backing with Japanese mulberry paper. Probably original 1⅝-inch lap-joined flat walnut frames.

Provenance: Arthur E. Jaquess, Poseyville, Ind.; Robert Carlen, Philadelphia, Pa.

Exhibited: AARFAC, American Museum in Britain; AARFAC, June 4, 1962-April 17, 1963; "Currents of Expansion: Painting in the Midwest, 1820-1940," St. Louis Museum of Art, February 18-April 10, 1977; Smithsonian, American Primitive Watercolors, and exhibition catalog, p. 5 no. 11.

Published: Judith A. Barter and Lynn E. Springer, *Currents of Expansion: Painting in the Midwest, 1820-1940* (St. Louis, 1977), p. 65, illus. as nos. 23 and 24 on p. 64; Black, p. 99, illus. on p. 98; Peat, p. 37, both illus. as no. 17 on p. 28; Peterson, no. 113 only, illus. as pl. 60.

111 Attributed to Jacob Maentel, *Woman Holding Songbook*

[1]Although spelled both "Jaques" and "Jaquis" on these portraits, the

113 Attributed to Jacob Maentel, *Mrs. Jonathan Jaquess*

couple's tombstones indicate that their surname was "Jaquess," which agrees with the spelling used by current descendants. Based on the same tombstone inscriptions, Mrs. Jaquess's first name has been spelled "Rebeckah" here, further contradicting Maentel's spelling.

[2]A signed portrait of Johannes Zartmann was published in Black, illustrated on p. 100, and credited therein to the collection of Edgar William and Bernice Chrysler Garbisch. A signed portrait of an unidentified woman was published in *Art in America* (December-January 1965-1966), p. 138, and, at that time, was owned by Mr. and Mrs. Richard H. Wood.

Noah North
(1809-1880)

Although his paintings had been exhibited and admired for many years, Noah North remained relatively unknown until Nancy Muller and Jacquelyn Oak pub-

lished their comprehensive research on him in 1977. Many of North's works had previously been ascribed to an unidentified hand or misattributed to other, less obscure painters like J. Bradley.[1]

North was born on June 27, 1809, the son of Noah and Olive Hungerford North of Alexander, Genesee County, New York. While little is known of the early years of North's life and speculation surrounds the inception of his career in portraiture, a posthumous portrait of Dewitt Clinton Fargo inscribed "N. 11" and dated 1833 makes it probable he had already completed ten commissions by July 7 of that year.[2] Six other portraits, including a second posthumous one and another inscribed "No. 15," are thought to date from 1833. From 1834 through early 1837, North painted residents of Holley, Chili, and Churchville, New York, all in counties neighboring Genesee, but in 1837 he traveled west, probably lured by the favorable economic prospects generated by booming growth along the Ohio and Erie Canal. He was listed as a "portrait painter" in the 1837-1838 directory for Cleveland and Ohio City and is then thought to have gone south and to have advertised in newspapers in Cincinnati and Kentucky.[3] However,

114 Attributed to Noah North, *Girl with Flowerbasket*

no portraits from any of these western areas have been identified as North's work to date.

By 1841 North had returned to New York state, where he married Ann C. Williams in Darien; the couple had moved to Mount Morris, Livingston County, New York, by April 1842. No signed likenesses from this period have been recorded, but those attributed to him on the basis of style show North's markedly increased skill in the handling of paint and the correct proportioning of his figures.[4]

It appears that difficulties beset North in his later years. An 1850-1851 directory listing a "North and M'Lane" under "Painters – House, Sign, and Fancy" suggests that diminishing portrait commissions may have forced him to seek other means of income. The Norths returned to Darien in the late 1850s and to nearby Attica in 1869. An illegitimate daughter born in 1855 to Ann's niece, Caroline Williams, was presumably adopted by the Norths, since she took their surname and lived with them. North's wife and their two natural children, Volney and Mary Ann, aged twenty-eight and thirty-two, died between 1873 and 1875. Records show that North gradually sold most of his Attica property during the years 1872-1880, probably in an attempt to ward off financial difficulties. No portraits from the last decade of North's life have been identified, although an 1880 Wyoming County history does include "painter" among his professions. North died on June 15, 1880.

Characteristics of North's style include sharp delineation and gray-toned modeling of facial features, oversized ears with C-shaped inner curves, long, narrow fingers with blunt nails, and bright touches of color in faces and clothing contrasted with gray and brown backgrounds. Perhaps more important, however, is the unusual sympathy with which his subjects appear to have been portrayed. They gaze directly at the viewer, most smiling engagingly, and project a degree of warmth and immediacy rarely found in folk portraiture.

[1] Muller and Oak, pp. 939-945. The article is the source of the biographical information presented here.

[2] The full inscription on the reverse of this portrait, which is owned by Mr. and Mrs. William E. Wiltshire III, reads "N. 11 By Noah North/ Mr. Dewitt Clinton Fargo/Who died July 7th, 1833/AE 12 years."

[3] As Muller and Oak state, a documented basis for North's travels to Cincinnati and Kentucky has not yet been found. The assertion is currently based on notes of Mrs. Rhea Mansfield Knittle that were published in "Queries and Opinions," Antiques, XXI (March 1932), p. 152. See Muller and Oak, p. 945, n. 20.

[4] Of the three portraits believed to have been painted in Mount Morris, Muller and Oak illustrate a Girl with Coral Necklace, p. 945, fig. 8. The locations of all three are now unknown.

114 Girl with Flower Basket 34.100.1

Attributed to Noah North
Probably New York state, ca. 1835
Oil on yellow poplar panel
27" x 21" (68.6 cm. x 53.3 cm.)
(Reproduced in color on p. 18)

North preserved a great deal of the color value in the girl's medium blue dress by depicting most of the darker shadow areas with base pigment instead of muddying them with black or an earth hue; coupled with minimized modeling, this makes the dress almost as strong a color statement as the girl's similarly treated red and pink roses or her flatly painted double strand of coral beads.

The shape of the inner ear – which here resembles a curving D more than a C – is characteristic of the artist,[1] as is his depiction of the blunt thumb with an upturned nail. North evidently painted the young girl just as he saw her from an elevated viewpoint, for one looks slightly down on her head while her large dark brown eyes are turned upward in an endearing expression of innocent trust.

The Munson-Williams-Proctor Institute in Utica, New York, owns a painting so similar to *Girl with Flower Basket* that a family relationship between the two sitters has been suggested. Their dresses, beads, hairstyles, and coloring are virtually identical, but instead of flowers the Institute's child holds a Bible inscribed "H. M. Cox," probably her name. Another painting attributed to North, *Girl with a Cat*, features a girl in an identically styled dress and the same flower basket seen here, but the unidentified subject of that privately owned portrait has long curls, the dress is a different color, and a cat perches on a window ledge in the background. All three likenesses were probably painted about the same time.

Condition: In 1955 Russell J. Quandt cleaned the panel and inpainted minor areas of loss, including a 3½-inch vertical scratch below the right eye. Battens originally placed along the upper and lower edges on the reverse of the panel were removed at an undetermined time. Period replacement 3½-inch cyma recta frame with flat inner and outer edges and raised corner blocks. The frame was repainted in the twentieth century and a ½-inch liner was added to accommodate the painting's smaller size.

Provenance: Found in Miami, Fla.

Exhibited: AARFAC, New Canaan.

Published: AARFAC, 1957, p. 42, no. 19, illus. on p. 43 (attributed to J. Bradley); Black and Feld, p. 502; Muller and Oak, p. 941, illus. as pl. V on p. 944.

[1] North's C-shaped ears are described in Muller and Oak, p. 943.

115

seems to have attempted to soften this boy's blunt hairline with a few individual brushstrokes over the forehead. As in no. 114, the background has been painted a dark neutral color. Strokes applied with a dry brush occasionally allow the light ground coat to show through and break up the flat space. The boy's background is a cool gray, the girl's a warmer brown.

Although the child's diminutive body and attenuated arm strike present-day viewers as amusing, unquestionably the bug-eyed, stumpy-legged dog steals the show. The dog may have been a product of North's imagination; a cat in another attributed portrait is depicted in a similar stylized fashion.[1] However, prints of similarly pop-eyed puppies are known to have existed from about 1830 to 1860, and it is conceivable that North was influenced by a popular illustration.[2]

> Condition: In 1955 Russell J. Quandt cleaned the panel and inpainted minor areas of loss, including the lower edge of the nose. Possibly original 2¾-inch splayed frame, painted black, with raised gilded corner blocks.
> Provenance: M. Knoedler & Co., New York, N.Y.
> Exhibited: American Folk Painters; Goethean Gallery; "Social and Cultural Aspects of American Life," Pine Manor Junior College, Wellesley, Mass., January 13-February 28, 1963.
> Published: AARFAC, 1957, p. 44, no. 20, illus. on p. 45 (attributed to J. Bradley); Black and Feld, p. 502; Jean Lipman, "The Abby Aldrich Rockefeller Folk Art Collection," Saturday Review, XL (March 16, 1957), illus. on cover; Lipman, Bradley, p. 165, no. 7, illus. as fig. 4 on p. 159 (attributed to J. Bradley); Lipman and Armstrong, p. 130, illus. on p. 132; Muller and Oak, p. 941, illus. as pl. VI on p. 944.

[1]Girl with a Cat is described in the Commentary for no. 114.

[2]The Smithsonian Institution, Washington, D.C., owns one such print, an untitled lithograph that bears the inscription "Drawn by I. Herring/Published by M. Bancroft 403 Broadway/Printed by P. Maverick."

115 Boy Holding Dog 41.100.1

Attributed to Noah North
Probably New York state, ca. 1835
Oil on yellow poplar panel
20¾" x 17½" (52.7 cm. x 44.5 cm.)

The degree of anatomical distortion evident in the child's body is not typical of North's work and may possibly indicate that the artist positioned the boy's very characteristically painted little head on the panel before he decided to include the dog and as much of the lower body as he did. Typical of North's rendering of heads and facial features are the shaping of the inner ear, the brightly colored smiling lips, the broad arching of the eyebrows, the slightly indented temples, and the soft modeling of the eye socket, which runs into the eyebrows, and the shading of the side of the nose. North never seemed to root the hair to the head convincingly; it invariably sits in a mass on top of the head and looks more like a toupee than real hair, although the artist

Ch. B. R. Palmer
(active 1826)

116 Mother and Child 33.100.4

Ch. B. R. Palmer
America, 1826
Oil on canvas
30" x 23⅞" (76.2 cm. x 60.6 cm.)

The difficulties that some folk artists encountered in rendering forms receding in space are particularly well documented in this example, where the child is drawn full-face and the mother's head is seen in three-quarter

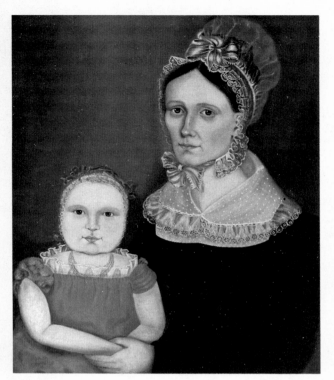

116

Abraham Parsell
(1792-?)

117 Miniature Portrait of a Man 63.100.5

Attributed to Abraham Parsell
Probably New York City, ca. 1835
Watercolor on ivory
2⅝" x 2⅛" (6.7 cm. x 5.4 cm.)

This unidentified miniature portrait is attributed to Abraham Parsell on the basis of stylistic similarities to signed examples of the artist's work.[1] Parsell was born in New Jersey about 1792. New York City directories reveal he was working there as a miniature painter between 1820 and 1856. Presumably John H. Parsell, a miniaturist listed at the same address from 1844 to 1848, was Abraham's son.[2]

All of the recorded miniatures by Abraham Parsell are executed on ivory, suggesting that he preferred this medium. Here the tiny panel has been neatly scored with a series of shallow horizontal lines so the paint would adhere more easily. Parsell also knew how to use the translucent support to give depth and color to flesh tones and background. He painted areas of brown, pink, and orange pigments on the back of the ivory so that soft tints were transmitted to the front with minimum effort.

This unidentified subject illustrates Parsell's characteristic use of a rounded head with broad, arched brows

view. The mother's head and features are more convincingly and sensitively painted because the artist was familiar with the elementary precepts of using outlines of overlapping features and modeling of adjacent shadows to give form. This technique was not entirely feasible in the child's full-face likeness, where subtle foreshortening was crucial to success. Palmer evidently had little experience in this technique, which accounts for the child's flat, masklike face as well as the peculiar distortions of the arms.

Virtually no information about "Ch. B. R. Palmer" has been found to date.[1]

Inscriptions/Marks: An inscription on the original canvas verso was recorded in 1955 before relining as "Ch. B. R. Palmer, Pinxt./Dec.ʳ 1826."
Condition: Unspecified restoration included lining by William Suhr in the 1930s. Russell J. Quandt relined, cleaned, and inpainted small losses in the background in 1955. Period replacement 2½-inch molded gold leaf frame.
Provenance: Edith Gregor Halpert, Downtown Gallery, New York, N.Y.
Published: AARFAC, 1940, p. 18, illus. as no. 17 on p. 15; AARFAC, 1957, p. 40, no. 18, illus. on p. 41.

[1]In 1940 the picture was published with a probable Pennsylvania origin, a designation that cannot be verified in any known source. AARFAC, 1940, p. 18.

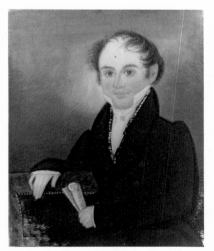

117

and piercing eyes, and a glossy line to define and accent the black waistcoat. Features were rapidly drawn in brown paint with only a slight bit of shading along one side of the nose. Seated on a mahogany sofa upholstered in deep blue and trimmed with brass nailheads, the figure is posed against a shaded brown and gray background.

Condition: No evidence of previous conservation. Some flaking of black paint on the vest and blue paint on the sofa. Temporary replacement frame.
Provenance: Robert Carlen, Philadelphia, Pa.
Published: Walters, Pt. 2, illus. as fig. 22 on p. 4C.

[1]See Sotheby Parke Bernet, Fine Americana, lots 453, 469, and 481.
[2]Groce and Wallace, p.489. A trade card backing a privately owned miniature portrait reads "A. Parsell, MINIATURE PAINTER No. 46, McDougal Street, New York." E. Grosvenor Paine to AARFAC, June 27, 1975.

in Halladay-Thomas papers; however, such evidence can no longer be located, and the basis for these assertions remains unverified.

The uncommon but practical and imaginative use of a printed border for the two portraits, the unusual weblike spandrels drawn in the upper corners of no. 119, and the distinctive way in which the landscape backgrounds are loosely rendered should someday help to identify other works by this otherwise unknown artist.

Condition: Restoration by Christa Gaehde in 1958 included cleaning; probably the primary supports were backed with Japanese mulberry paper at that time. Probably original ½-inch pine frames with traces of black paint.
Provenance: J. Stuart Halladay and Herrel George Thomas, Sheffield, Mass.
Exhibited: Washington County Museum.
Published: Walters, Pt. 3, pp. 2C-3C, illus. as fig. 11 on p. 4C.

118 119

A. D. Parsons
(active ca. 1825)

118 **Abigail Parsons** 58.300.24

119 **Profile Portrait of Mrs. Davis** 58.300.32

Attributed to A. D. Parsons
Probably New England, ca. 1825
Watercolor, gouache, and printer's ink
on wove paper
4″ x 2¹⁵/₁₆″ (10.2 cm. x 7.5 cm.)

The names of the subjects and that of the artist presumably were obtained from information originally found

James Peale
(1749-1831)

James Peale was the fifth child and the third son born to Charles and Margaret Triggs Peale of Chestertown, Maryland. His father died in 1750, just a year after he was born, and it was natural that he turned to his eight-year-older brother, Charles Willson, for advice during his formative years. The two brothers maintained a close relationship throughout their lifetimes, James looking to Charles for artistic guidance as early as the 1770s.[1]

James was twenty years old when Charles returned from his studies in England in 1769, about the time that the younger man made his first attempts in painting. Previously James had worked briefly on the Eastern Shore of Maryland as a carpenter and cabinetmaker, developing useful skills that well prepared him to act as Charles's framer and general studio assistant by 1769. The earliest record of James's painting is documented in a 1771 family letter: James "copies well and has painted a little from life."[2] Presumably during these years he painted the portrait of an unknown little girl in this collection. The style and quality of the portrait, like one other known signed and dated example, bear no resemblance to James's mature style,[3] yet it documents in a very important way the vision and struggles of the minimally trained artist, in this case a beginner who

would have a lifetime of opportunities to develop his talents in the studio of a leading American painter.

James's career was interrupted by the Revolutionary War. In 1776 he joined a Maryland regiment as an ensign and was promoted to first lieutenant about a year later. Disputes over a subsequent promotion to captain caused James to submit his resignation in June 1779, but it has been suggested that he remained in the army as a volunteer for some time afterward. He then settled in Philadelphia near his brother and other members of the large Peale family.[4]

James married Mary Claypoole, sister of James Claypoole, a Philadelphia portrait painter, on November 14, 1782. During the same year he probably began to paint miniature portraits, a format he continued to offer in addition to full-size oil likenesses until about 1818, when his failing eyesight forced him to give it up.

The close ties between the two Peale brothers always provided stimulating explorations of new ideas and means of artistic expression that ranged from their involvement in the family museums in Philadelphia and Baltimore to devising mechanical aids for profile and silhouette production and refining the techniques required for landscape and still-life painting. James was also blessed with talented children. His daughters Anna and Sarah not only were helpful assistants in his work, but also were recognized for their achievements in portraiture and still life. In later life James devoted most of his energies to still-life and landscape painting, leaving the portrait business to younger members of the family. He died on May 24, 1831.[5]

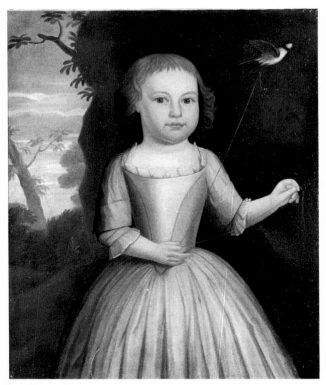

120

[1]Sellers, II, p. 413.
[2]Charles Coleman Sellers, "James Peale: A Light in Shadow 1749-1831," *Four Generations of Commissions: The Peale Collection of the Maryland Historical Society* (Baltimore, 1975), p. 29.
[3]"18th & 19th Century Naive Art," *Kennedy Quarterly*, XVI (January 1978), p. 58, no. 16, illus. as no. 16 on p. 19.
[4]*Ibid.*
[5]*Ibid.*, pp. 30, 32, and 33.

120 Unidentified Child 79.100.2

Attributed to James Peale
Possibly Chestertown, Maryland, 1770-1775
Oil on canvas
30″ x 25″ (76.2 cm. x 63.5 cm.)

Early acquisition records identify the child as Anna Peale, presumably a relative of the artist; the source of the information is unknown, however, and there were no girls of that name in the painter's family until well after 1775. The 1770-1775 date span is based on the close relationship between this picture and another child's portrait signed and dated 1771 by the artist in Chestertown, Maryland.[1] Similarities observed between the two include pastel coloration, nearly identical poses, and similar details in the costumes and the drawing of the faces.

By the time James Peale painted this likeness he had already learned some of the basic techniques of portraiture from his brother. He knew about the effective compositional use of landscape vistas and how to achieve atmospheric depth by mixing certain muted colors. Peale placed the figure precisely in the center of the picture space in an acceptable but simple pose against a conventional dark background to emphasize the face and upper torso. In fact, the child's eyes are at the exact midpoint of the picture's upper half, a device commonly used in eighteenth-century academic likenesses. Peale's modeling of the child's face was also precise, yet it seems abbreviated, as if he hesitated to experiment beyond the

few essential shadows and highlights. The artist's lack of experience in anatomical drawing is evident in the distorted fingers of the sitter's right hand.

This is a pleasant picture, but its significance rests in its documentation of James Peale's little-known early work, not in its decorative appeal. It lacks the bright, often inventive and colorful spontaneity of folk portraiture and has the studied and labored look achieved by an artist who knew correct academic procedure and would strive to perfect his discipline without resorting to experimentation or innovation, methods that often produced the most original and successful examples of folk painting.

Condition: Lined and mounted on new stretchers, cleaned, and minor areas of loss inpainted at an unspecified date before its acquisition. Late-nineteenth-century gesso and gilt decorated frame.

Provenance: Purchased from Edith Gregor Halpert, Downtown Gallery, New York, N.Y., December 28, 1935, for use at Bassett Hall, Mr. and Mrs. John D. Rockefeller, Jr.'s Williamsburg home.

[1]"18th & 19th Century Naive Art," *Kennedy Quarterly,* XVI (January 1978), p. 58, no. 16, illus. as no. 16 on p. 19.

Ammi Phillips
(1788-1865)

Few folk artists have been studied as exhaustively as Ammi Phillips. Collectors, researchers, and others have contributed to the still-growing body of knowledge concerning his life and career. Barbara and Lawrence Holdridge and Mary Black provided the most extensive published information in *Ammi Phillips: Portrait Painter 1788-1865.*[1] The Holdridges identified 309 Phillips paintings in 1969, and since that time many more have been located. Stylistic changes and a scarcity of factual biographical data have presented formidable obstacles to an accurate study of Phillips, and the fact that no one has attempted to deal with the entire range of his work since the 1960s is probably due to the care with which the Holdridges treated their huge project.

Ammi Phillips was born August 24, 1788, the son of Samuel Phillips, Jr., and Milla Kellogg Phillips of Coalbrook, Connecticut. By 1811 he had launched a lifelong career as a portraitist,[2] working predominantly in western Connecticut and Massachusetts and in the several neighboring counties of upstate New York. By

1862, the year of his latest known commissions, Phillips's style had undergone a series of astonishing metamorphoses that ultimately convinced many students that his oeuvre was not the work of one man, but of two – or more.

In the introduction to the Holdridges' checklist, Mary Black conveniently labeled these stylistic evolutions and discussed some of their characteristics and possible causes. The fourteen Phillips portraits in this collection, which range in date from about 1815 to 1850, offer an exceptional opportunity to compare the development of the artist's style over time.

Only two portraits that predate 1812 have been located,[3] but paintings of the following so-called Border Period of circa 1812-1819 amply illustrate Phillips's early approach to portraiture. In general terms, the canvases of this phase show his preoccupation with the depiction of volumetric mass, a studied attempt at soft rounding of forms combined with pastel coloration, particularly pale backgrounds, to create a mood that has long been described as "dreamlike." Unrealistic handling of anatomy and perspective can be expected in a young, untutored artist, but the repetition of Phillips's powerful formal abstractions in his first endeavors reflects originality and self-confidence.

By about 1820 Phillips's closer observance and more skillful depiction of the effects and appearance of light and shadow gave his work a new realism that is evident in likenesses such as those of William Harder (no. 129), John Gebhard, and Winslow Paige. At the same time, he was capable of producing much more rapidly painted and stylized portraits, such as Catherine Philip's, and in fact, both trends are evident in his portraits dating from the later 1820s.[4]

The Kent Period portraits of about 1829-1838 show that Phillips was developing compositional and technical formulas that probably speeded production and, judging by their repetition, must have satisfied both artist and clients. He now painted the usual black jacket or dress very quickly and flatly, strategically placing minimal highlights to suggest detail and to separate figures from very dark backgrounds. Women often lean forward in a fashionable, languid posture, while men frequently appear in Border Period poses, that is, with one hand draped over the crest rail of a stenciled chair in easy self-assurance. Form here is described in shorthand by dropping the subtle gradation of middle tones to create high-contrast likenesses of great impact.

A more straightforward style characterizes the years after about 1840. Dramatic poses and the more

elaborate costume details of earlier years largely disappear, and mid-century clients are depicted as somber, gentle, and unpretentious. Technically, large areas of canvas are rapidly defined with loaded, loose brushstrokes that utilize the skill of years of experience. Faces may be fluid surface delineations or take on a sculptured, chiseled quality reminiscent of the hard-edged tonal contrasts of the 1830s. A curious diagonal distortion occasionally seen in these late portraits often turns textbook oval head shapes into eggs, and causes sitters to slide off the canvas at lower right – whether this is the result of infirmity or idiosyncrasy is unknown (see no. 133).

Phillips's last dated paintings were done at age seventy-four, just three years before his death on July 11, 1865, in Curtisville, Berkshire County, Massachusetts. In many ways, his life provides a classic study of the nineteenth-century itinerant folk artist. Whether he ever received instruction from an established painter has not been determined, but clearly Phillips began his career by

applying many distinctive and novel solutions to the artistic problems that confronted him, and during the subsequent years of his development he absorbed academic influences into a constantly evolving, personal style of his own. The large body of his work and the long span of his productive years are evidence of Phillips's success in creating portraits that pleased the eye.

[1](New York , 1969). More recent research on Phillips's work, specifically that done in Columbia County, N.Y., has been conducted by Ruth Piwonka and Roderic H. Blackburn; see the exhibition catalog, Ammi Phillips in Columbia County.

[2]Nineteenth-century sources specifically mention two nonportrait commissions given to Phillips: a tavern sign and a political campaign banner. They have not been located or identified as his work, however, and the vast majority of Phillips's output must have been portraits. Holdridge and Holdridge, Ammi Phillips, pp. 48 and 51, nos. 104 and 236.

[3]Two pairs of portraits are thought to date 1811 and are recorded as such ibid., p. 45. However, one of each of these pairs is unlocated.

[4]The portraits of John Gebhard, Winslow Paige, and Catherine Philip are all privately owned. They are illustrated ibid., pp. 24 and 32.

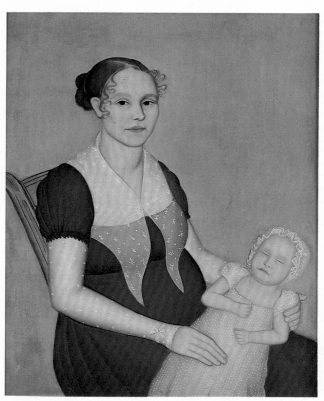

121

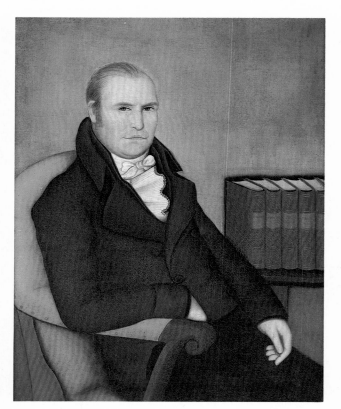

122

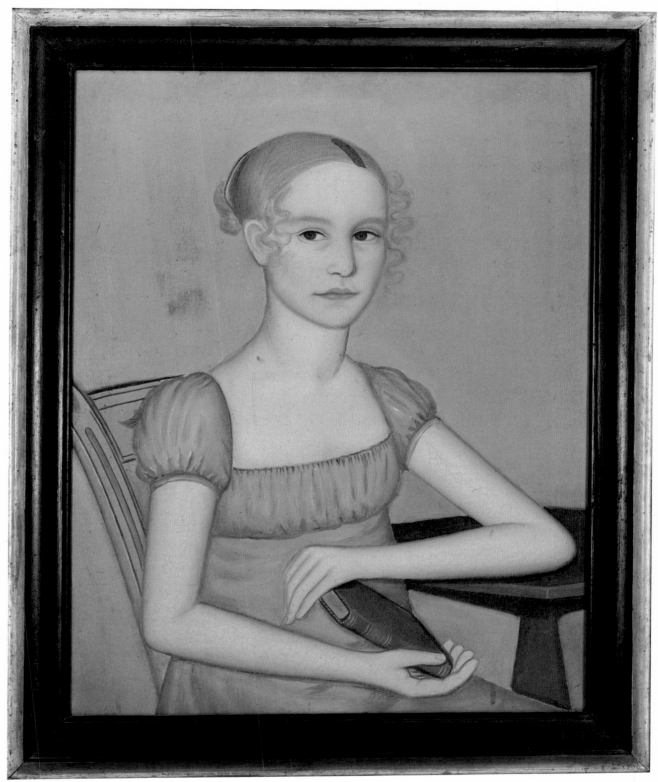

123

121 Mrs. Russell Dorr (Polsapianna 58.100.15
Bull) and Maria Esther Dorr

122 Dr. Russell Dorr 58.100.16

Attributed to Ammi Phillips
Chatham Center, Columbia County, New York,
probably 1814-1815
Oil on canvas
38″ x 29⅞″ (96.5 cm. x 75.9 cm.)
(Reproduced in color on p. 150)

The depiction of Maria Esther, born April 16, 1814, as an infant, the costumes, and other general characteristics have contributed to the establishment of 1814-1815 as a probable date for these companion portraits and for those of the subjects' other children (see nos. 123-126). Perhaps stimulated by a personal interest in painting,[1] Russell commissioned his own likeness and a double portrait of his wife and youngest child, as well as individual portraits of his six older children: Paulina (1802-1844), Catherine Van Slyck (1803-1892), Joseph Priestly (1805-1879), Russell Griffin (1807-1860), Henrietta (1808-1853), and Robert Lottridge (1812-1880).[2] Canvas sizes and sitters' poses indicate that these eight likenesses were executed as four pendants, decreasing in paired sizes according to sitters' ages. Russell's brother and sister-in-law, Colonel Joseph Dorr and Sarah Bull Dorr, and their son Milton are also known to have been painted about this time.[3]

Russell was born in Lyme, Connecticut, April 20, 1771, the last of ten children born to Matthew (1725-1801) and Elizabeth Palmer Dorr (?-ca. 1775). Shortly after his mother's death, his father moved to East Haddam and married Mrs. Lydia Wood McLean, by whom five more children were born. As the older children grew up and left home, Russell was left in the care of a father "distracted by Law" and a stepmother who "remained abusive and Cloathed . . . [him] in Raggs," factors that undoubtedly influenced his decision to move to the homes of two older brothers, one of whom, Jonathan, was a doctor.[4] Russell studied medicine with Jonathan, with Dr. John Stevens of Canaan, New York, and possibly with other area physicians.

In an attempt to recover from an illness, Russell resided temporarily with his brother Joseph in Hoosick Falls, and it may have been then that he became acquainted with Joseph's sister-in-law, Polsapianna Bull (1783-1869) of Hoosick. She was the eighth of nine children born to Amy Chase Bull and Isaac Bull, Jr., a miller and innkeeper. Russell and Polsapianna were married March 21, 1801. Three more children were

born after Phillips undertook the Dorr family commission: Angeline Reed (1817-1906), Seneca Milo (1820-1884), and Harriet D. (1822-1908).

Russell Dorr became a respected and prosperous physician in Chatham Center, New York.[5] His death from "typhus fever" in March 1824 left Polsapianna with ten children aged one to twenty-one. That all of these offspring were well raised and educated may be due as much to Polsapianna's sensible management as to her husband's providence. A biographical sketch of one of her sons-in-law, written in 1894, describes her as "a very practical and able woman, [who] collected her husband's accounts, paid for their homestead, and educated her children."[6] She died at the age of eighty-six on April 6, 1869, and is buried with her husband in the Chatham Center cemetery. Maria Esther married John Henry Newman on August 16, 1841. She died after 1895.

Inscriptions/Marks: The titles painted on the book spines to the left of Dr. Dorr read, from the viewer's left to right, RUSH, DARWIN, BELL, HUNTER, and WILSON.[7] No other original marks found.

Condition: In 1958 Russell J. Quandt replaced the auxiliary supports,[8] lined the paintings, and inpainted scattered areas of paint loss. Original 2½-inch scoop-molded frames, painted black, with quarter-round moldings, painted gold.

Provenance: Rev. Nathaniel Goodell Spalding and Harriet Dorr Spalding, Schodack Landing, N.Y.; Nathaniel Bull Spalding and Cora Boyce Spalding, Schenectady and Schodack Landing, N.Y.; J. Stuart Halladay and Herrel George Thomas, Sheffield, Mass.[9]

Exhibited: AARFAC, New York; Ammi Phillips Portrait Painter; Ammi Phillips 1788-1865; Halladay-Thomas, Albany.

Published: Holdridge and Holdridge, *Ammi Phillips,* p. 45, nos. 11 and 10, no. 121 illus. on p. 26, and no. 122 illus. on p. 29; Holdridge and Holdridge, "Ammi Phillips," p. 109, nos. 47 and 46, illus. on p. 127; Barbara and Larry Holdridge, "Ammi Phillips," *Art in America,* XLVIII (Summer 1960), no. 121 only, illus. on p. 98. See also the exhibition catalog, Ammi Phillips in Columbia County, p. 7, illus. as nos. 2 and 1 on pp. 9 and 8.

[1] In a letter, Russell asserted that "I never had Epilepsy only when stimulated too much and that on the optic nerve in painting: and to[o] closely observing lights & shades." Russell Dorr to Jonathan Dorr, November [?] 1806, Albany Institute of History and Art.

[2] The portrait believed to represent Catherine Van Slyck was owned by Hirschl & Adler Galleries in 1974 and is now privately owned; Henrietta's portrait is in the Balken Collection, Princeton University Art Museum, Princeton, N.J.; and AARFAC owns the portraits of Paulina, Joseph Priestly, Russell Griffin, and Robert Lottridge (nos. 123-126).

[3] The portraits of Colonel and Mrs. Joseph Dorr are in the collection of Bertram K. and Nina Fletcher Little; that of Milton Dorr is privately owned.

[4] Biographical information and quotations are from Russell Dorr's letter cited in n.1.

[5] An inventory of Russell Dorr's estate taken on October 25, 1824, lists several items indicative of modest affluence, such as two silver candlesticks, a coach, a mahogany secretary valued at $50, and five damask tablecloths. His medical books, supplies, and instruments also reflected a significant investment; "8 likenesses & frames" valued at $80

were included in the inventory as well. Columbia County Courthouse, Hudson, N.Y.

[6]"Columbia County Biographies Compiled in 1894," biographical sketch of Dr. Oliver Jasper Peck, unidentified newspaper clipping (June 1939?) in AARFAC files.

[7]The 1824 inventory of Russell Dorr's estate lists over 100 medical references, including titles by four of these authors. Columbia County Courthouse.

[8]The original auxiliary supports for these and nos. 125 and 126 no longer exist, but photographs taken of a detail from each in 1960 indicate that all were strainers that were secured by a single wood dowel at each corner.

[9]The daughter of Mr. and Mrs. Nathaniel Bull Spalding inherited these portraits, which descended in the family. She recalls that the portraits hung in her grandparents' home at Schodack Landing, N.Y., and that Halladay and Thomas purchased them there about 1925. Miss Marcia Spalding to AARFAC, August 15, 1978, March 25, 1979.

123 Paulina Dorr 79.100.7

Attributed to Ammi Phillips
Chatham Center, Columbia County, New York, probably 1814-1815
Oil on canvas
28″ x 21⅞″ (71.1 cm. x 55.6 cm.)
(Reproduced in color on p. 151)

Phillips's pastel coloration seems particularly suited to capturing the fragile and delicate beauty of this adolescent girl. The mauve gray backgrounds of the Dorr family portraits (see nos. 121-126) vary slightly in hue, with Paulina's perhaps being the closest to a pale lavender. Subtle interplay between the background coloration, the light green base coat of the stenciled chair, and the pale blue dress superbly complements the young girl's fair skin and thinly painted hair. It also emphasizes the depths of her dark brown almond-shaped eyes.

Phillips used Paulina's pose frequently throughout his career but perhaps most consistently during the Border Period.[1] In fact, the zigzag arrangement of her arms and book nearly mirrors that seen in a companion portrait of her next younger sister, Catherine Van Slyck Dorr (1803-1892).[2]

Paulina, the eldest child of Russell and Polsapianna Bull Dorr, was born July 15, 1802,[3] and on October 14, 1828, married Martin Harder (1783-1843), a wealthy Ghent, New York, farmer. (Numbers 128-129 are portraits of Martin's parents, painted by Phillips five to ten years after the Dorr likenesses were executed.) Paulina died on May 21, 1844, within five months of her husband. Their only child, Henrietta P. (1835-1842), is believed by a family genealogist to have been adopted.[4] All three are buried in the Chatham Center cemetery, where they share a common marker with Henrietta

Dorr Phelps, Paulina's younger sister who died in 1853.

Condition: The painting appears to be untouched and retains its original mortise-and-tenon jointed strainers, reinforced at each corner by a single wood dowel. Original 2½-inch scoop-molded frame, painted black, with quarter-round outer molding, painted gold.

Provenance: Acquired with no. 124 from the estate of Mrs. Neilson T. Parker (Zulma Steele) of Woodstock, N.Y.

Published: Holdridge and Holdridge, *Ammi Phillips,* p. 45, no. 12; Holdridge and Holdridge, "Ammi Phillips," p. 109, no. 43. See also the exhibition catalog, Ammi Phillips in Columbia County, p. 9, no. 3.

[1]Alsa Slade holds sewing rather than a book but is similarly posed. Other subjects posed similarly include Mrs. Crane and an unidentified woman. These paintings are, respectively, in the National Gallery of Art, Washington, D.C., the gift of Edgar William and Bernice Chrysler Garbisch; privately owned; and formerly in the Halladay-Thomas collection.

[2]Catherine's portrait was illustrated as no. 38 in Hirschl & Adler Galleries, *Quality: An Experience in Collecting,* catalog for exhibition, November 12-December 7, 1974; it is now privately owned. Her portrait is an oval but is presumed to have been cut down from a rectangular format that originally matched Paulina's in size.

[3]Two family Bibles give conflicting years for Paulina's and Catherine's births. Both agree on months and days but one gives 1803 and 1804 as the respective birth years, the other 1802 and 1803. The latter also records the times of day the births occurred, and thus the entries must have been recorded close to the actual events or else they were taken from such a source. For this reason and because period correspondence (Jonathan Dorr to Russell Dorr, August 14, 1804, Albany Institute of History and Art) seems to corroborate Catherine's existence by August 14, 1804, the earlier dates have been chosen here.

[4]James B. Dorr to AARFAC, May 4, 1979.

124 Joseph Priestly Dorr 79.100.8
125 Russell Griffin Dorr 58.100.25

Attributed to Ammi Phillips
Chatham Center, Columbia County, New York, probably 1814-1815
Oil on canvas
24⅜″ x 20″ (61.9 cm. x 50.8 cm.)
24⅝″ x 20″ (62.5 cm. x 50.8 cm.)

Joseph would have been about ten years old and Russell about eight at the time Phillips painted portraits of them, their parents, and their five siblings (see also nos. 121-123 and 126). Elements of the artist's typical pose for adult male subjects of the period appear in these pendant likenesses of the family's two eldest boys. In each instance, an arm has been casually draped over the slat crest of a prominently placed stenciled chair, although the more commonly seen sideways-seated posture was rejected in favor of a standing pose, probably in deference to the lads' shorter arms. Characteristically, Phillips simplified the form of the arm arching over the

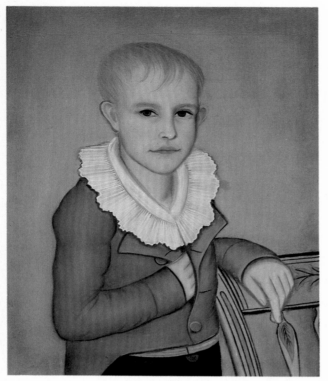

124

was admitted to the bar in 1829 and maintained an active law practice until his death on August 1, 1860.

Inscriptions/Marks: None found on no. 124. Upside down in penciled script on the verso of the lower member of the frame for no. 125 is "Jos[e]ph P Dr. (?) . . . p."[1]

Condition: In 1979-1980 Christine M. Daulton cleaned no. 124, replaced the original pegged mortise-and-tenon jointed strainers, lined the canvas, and inpainted small areas of paint loss. Presumably in 1958-1959 Russell J. Quandt lined no. 125, replaced the strainers,[2] and inpainted small scattered areas of paint loss. Original 2¼-inch scoop-molded frames, painted black, with quarter-round outer molding, painted gold.[3]

Provenance: Number 124 descended in the family to Mrs. Neilson T. Parker (Zulma Steele) of Woodstock, N.Y., from whose estate it was purchased with no. 123. Number 125 descended to Mrs. Russell Griffin Dorr (Harriet Park), Hillsdale, N.Y.; Mrs. Harriet Paulina Dorr Starkweather, Hillsdale, N.Y., and Lake Helen, Fla.; Miss Bessie Peck, North Chatham, N.Y.;[4] J. Stuart Halladay and Herrel George Thomas, Sheffield, Mass.

Exhibited: AARFAC, New York, no. 125 only; Ammi Phillips Portrait Painter, no. 125 only; Ammi Phillips 1788-1865, no. 125 only.

Published: Holdridge and Holdridge, *Ammi Phillips*, p. 45, nos. 13 and 14, no. 125 illus. on p. 23; Holdridge and Holdridge, "Ammi Phillips," p. 109, nos. 42 and 45, no. 125 illus. on p. 128; Barbara and Larry Holdridge, "Ammi Phillips, limner extraordinary," *Antiques*, LXXX (December 1961), no. 125 only, p. 562, illus. on p. 563; Ruth Piwonka and Roderic H. Blackburn, *A Visible Heritage: Columbia*

chair crest into a rubbery tube terminating in an oversized hand, with fingers folded into a rough triangle.

Phillips initially blocked in large areas of the head in a pale flesh tone, experimented with contours, and finally defined those that seemed most satisfactory with a reddish brown line. Frequently he saw no necessity for obliterating the abandoned outlines, leaving clear evidence of his search for correct shape in, for instance, the double image of Joseph's earlobe and the contours of his far cheek. At this stage of Phillips's career, modeling consisted almost solely of uniformly softening the inside edges of his defining outlines, a technique that achieved convincing, albeit optically unrealistic, solidity of form.

Joseph Priestly was born July 9, 1805, married Julia A. Pixley October 8, 1835, and settled in Hillsdale, Columbia County, New York. Like his father, he practiced medicine. He died January 14, 1879, and was buried in the Dorr family plot in Chatham Center cemetery. Russell, born on February 8, 1807, also lived in Hillsdale. He married Harriet Park (1814-1907) of Burlington, New York, on September 19, 1832. He

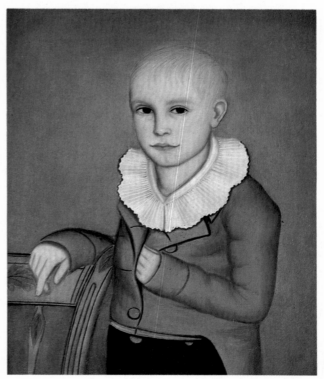

125

County, New York, A History in Art and Architecture (Kinderhook, N.Y., 1977), no. 125 only, p. 121. See also the exhibition catalog, Ammi Phillips in Columbia County, no. 124, p. 10, no. 5, and no. 125, p. 11, no. 6, illus. as no. 6 on p. 11.

[1]The largely illegible inscription is difficult to explain unless frames for Russell's and Joseph's portraits were switched or confused at some point. The identifications as given are substantiated by the children's having been painted, or at least posed, in order by age.

[2]AARFAC file photos indicate that the original auxiliary support for no. 125 was virtually identical to that for no. 124.

[3]The lower member of Russell's frame has had a filler strip added at the bottom; the gold-painted outer molding has been recently painted and may also be a replacement.

[4]Mrs. Parker was a granddaughter of the two boys' younger brother, Seneca Milo Dorr (1820-1884). Mrs. Harriet Paulina Dorr Starkweather was Russell Griffin Dorr's only daughter; according to a family descendant, she owned his portrait until her death in 1936. That Miss Peck may have inherited Russell's likeness after Mrs. Starkweather's death is presumed from information supplied by Mrs. Roswell Park Collin May. (Mrs. May to AARFAC, n.d., but before February 16, 1959.) Although Bessie Peck's mother, Angeline Reed Dorr Peck, was a younger sister of both boys, Miss Peck was also distantly related to the elder Dr. Russell Dorr on her father's side.

126

126 Robert Lottridge Dorr 58.100.8

Attributed to Ammi Phillips
Chatham Center, Columbia County, New York, probably 1814-1815
Oil on canvas
22¼" x 18" (56.5 cm. x 45.6 cm.)

Of the six Dorr family portraits illustrated herein (see also nos. 121-125), this likeness of young Robert hints most strongly at the characteristic style developed by Phillips in later years and typified by his Kent Period paintings. Particularly notable are the boy's triangular-shaped thumb and blunt fingertips, which anticipate the shorthand techniques Phillips later employed so successfully. The brilliant red of the cherries and dress pattern also denote a sharp break with the dreamy pastels more typical of this phase of his career. Dark reddish definition of the contours of the child's skin contrasts vividly with the wispy treatment and pale coloration of his hair. His likeness is paired in size and pose with Phillips's portrait of his next older sister, Henrietta, which is in the Balken Collection, Princeton University Art Museum.

Robert was born August 7, 1812, the sixth child of Dr. Russell and Polsapianna Bull Dorr. He studied law, was admitted to the Columbia County Bar in 1835, and served as town clerk of Chatham in 1836.[1] In June 1837 he joined the U.S. Patent Office in Washington, D.C.,

and shortly afterward received an appointment to the General Land Office, a job that eventually precipitated Robert's 1839 "Unpublished Chapters," basically an aggrieved recollection of his ill treatment by Land Office colleagues and a bitter defense against what he considered petty and self-motivated accusations.[2]

About 1842 Robert moved to Dansville in Livingston County.[3] Although he practiced law there continuously, he was later also listed as a farmer.[4] In 1852 Robert married Mary Tompkins (1832?-1875) of Steuben County, New York, and they had three sons. He died on February 24, 1880.

Condition: In 1958-1959 Russell J. Quandt lined the painting, replaced the auxiliary support,[5] and inpainted scattered areas of paint loss. Original 2-inch scoop-molded frame, painted black, with quarter-round moldings, painted gold.

Provenance: J. Stuart Halladay and Herrel George Thomas, Sheffield, Mass.[6]

Exhibited: AARFAC, New York, and exhibition catalog, no. 6; Ammi Phillips Portrait Painter; Ammi Phillips 1788-1865; Halladay-Thomas, Albany, and exhibition catalog, no. 19; Halladay-Thomas, New Britain, and exhibition catalog, no. 79; Halladay-Thomas, Pittsburgh, and exhibition catalog, no. 9, illus. opposite nos. 32-35;

Halladay-Thomas, Syracuse, and exhibition catalog, no. 34; Halladay-Thomas, Whitney, and exhibition catalog, p. 29, no. 9.

Published: Holdridge and Holdridge, *Ammi Phillips,* p. 45, no. 16, illus. on p. 29; Holdridge and Holdridge, "Ammi Phillips," p. 109, no. 44, illus. on p. 128. See also the exhibition catalog, Ammi Phillips in Columbia County, p. 7, illus. as no. 8 on p. 11.

[1] Mrs. Roswell Park Collin May to AARFAC, March 26, 1959.

[2] The original manuscript copy of "Unpublished Chapters" is owned by the Albany Institute of History and Art. Robert's obituary states that "he was somewhat eccentric and this misfortune was the cause of his often being misjudged and misunderstood." *Dansville Advertiser,* February 26, 1880.

[3] His sister and brother-in-law, Henrietta and Orrin Phelps, had settled in adjoining Genesee County several years earlier and may have encouraged Robert to relocate by reporting favorable prospects.

[4] The 1850 U.S. Census indicates that Robert may have owned a hotel in Dansville; his occupation was listed as both lawyer and farmer in the 1870 report.

[5] The original auxiliary support consisted of strainers secured by a single wood dowel at each corner. See n. 8 for nos. 121 and 122.

[6] AARFAC files contain a rare note in Thomas's handwriting about this sitter: "Robert Lockridge [*sic*] Dorr born at Chatham Center, New York. He was a lawyer. Born August 7th 1812, married in 1852. Was very peculiar . . . Robert married Miss Mary Tompkins." Thomas's information is basically accurate. He may have obtained it from the preceding owner, who was most likely a descendant, but such a provenance remains unverified.

127 Probably Mrs. Jenkins 58.100.11

Attributed to Ammi Phillips
Probably Albany, Rensselaer, or Columbia County, New York, ca. 1815
Oil on canvas
30¼" x 23¾" (76.8 cm. x 60.3 cm.)

Phillips rarely used a half-length pose that cropped the lower arms; when used, it was most often reserved for male subjects. Companion portraits occasionally confirm this, with the men posed like Mrs. Jenkins and the women shown with their hands.[1] Certainly the inclusion of hands offered possibilities for a more graceful as well as a more complex composition, although Mrs. Jenkins's particularly noteworthy awkwardness might more reasonably be ascribed to the omission of all reference to her far arm.

While undoubtedly exaggerated by Phillips, Mrs. Jenkins's pronounced cheeks and jawbone must have been a personal feature because the unusual chin line is not one of his typical facial stylizations. The coarsely woven canvas, mauve gray background, reddish outlining of the figure, dark, harshly defined upper eyelids, heavy impasto simulation of lace, and wispy definition

of curls are all common characteristics of Phillips's approach to portraiture in his Border Period.

Halladay and Thomas identified this sitter as "Mrs. Jenkins of Albany" throughout the 1940s, and the 1941 catalog of Halladay-Thomas, Pittsburgh, included a notation that she was the aunt of Dr. Jenkins Welles of Albany. Unfortunately, efforts to locate his name in Albany records have been unsuccessful.

Condition: Before it was acquired by AARFAC, this painting suffered considerable damage and an inexpert attempt at restoration that included cutting down the width of the canvas. In 1965 Russell J. Quandt began to restore the painting, lining it, placing it on temporary stretchers, and test-cleaning selected patches. In 1974 Theodor Siegl completed treatment, replacing the stretchers, cleaning the painting, removing old retouches, and filling and inpainting extensive areas of damage. Modern replacement 2½-inch molded frame, painted gold.

Provenance: J. Stuart Halladay and Herrel George Thomas, Sheffield, Mass.

Exhibited: Halladay-Thomas, Albany, and exhibition catalog, no. 37; Halladay-Thomas, New Britain, and exhibition catalog, no. 7; Halladay-Thomas, Pittsburgh, and exhibition catalog, no. 47; Halladay-Thomas, Syracuse, and exhibition catalog, no. 32; Halladay-Thomas, Whitney, and exhibition catalog, p. 33, no. 47.

Published: Holdridge and Holdridge, *Ammi Phillips,* p. 45, no. 25; Holdridge and Holdridge, "Ammi Phillips," p. 113, no. 83. See also the exhibition catalog, Ammi Phillips in Columbia County, p. 7, illus. as no. 9 on p. 12.

[1] Examples include Judge and Mrs. James Vanderpoel in the collection of the Albany Institute of History and Art, and Mr. and Mrs. Alexander Thompson and the Reverend and Mrs. John Gabriel Gebhard, privately owned.

128 Mrs. William G. Harder 58.100.29

129 William G. Harder 58.100.28

Attributed to Ammi Phillips
Ghent, Columbia County, New York, probably 1820-1825
Oil on canvas
30⁹⁄₁₆" x 24¾" (77.6 cm. x 62.9 cm.)

Although Ghent and Chatham Center are only a few miles apart, Phillips seems to have painted Mr. and Mrs. Harder five to ten years after he created the Dorr family likenesses (nos. 121-126). The elderly couple's plain dress offers only vague dating clues, although the address on William's letter helps to narrow the range: Ghent was created in 1818, being formerly known as Squampamock. Composition and stylistic considerations, however, suggest that the portraits were painted in the early 1820s. Phillips's 1818 portrait of Philip Slade

shows a continued strong reliance on his early Border Period conventions, while his signed and dated 1820 portraits of the Reverend and Mrs. John Gabriel Gebhard of Claverack illustrate the radical change that some researchers have partially and speculatively attributed to exposure to Ezra Ames's academic style.[1]

The Harders also illustrate Phillips's new approach and are very similar to the Gebhards in handling as well as in composition and proportions. The large scale of most Border Period portraits of adults has been reduced to more manageable dimensions that better accommodate the tighter waist-length format evidently regarded as more fashionable by 1820. The two men are similarly posed, the two women identically so—albeit reversed—and all four portraits illustrate a greater facility in the modeling of facial features than Phillips attained in the Border Period.

Very little is known of the lives of Mr. and Mrs. William Harder. William died intestate, leaving an estate valued at nearly $10,000, and subsequent descriptions of his son Martin as a "wealthy Ghent farmer" probably reflect a substantial inheritance from his father.[2] Gertrude Snyder Harder's 1848 will bequeathed only cash and no property.[3]

Inscriptions/Marks: Painted on the letter in the man's hand are "Mr. William Harder/Ghent,"[4] an "Albany" postmark, and "10" postage.

Condition: In 1958-1959 Russell J. Quandt lined these paintings, replaced their strainers, and inpainted a few areas of loss.[5] Modern replacement 3½-inch scoop-molded splayed frames, painted black, with gold liners.

Provenance: Rev. Nathaniel Goodell Spalding and Harriet Dorr Spalding, Schodack Landing, N.Y.; Nathaniel Bull Spalding and Cora Boyce Spalding, Schenectady and Schodack Landing, N.Y.; J. Stuart Halladay and Herrel George Thomas, Sheffield, Mass.[6]

Exhibited: AARFAC, New York, and exhibition catalog, nos. 9 and 10; AARFAC, September 15, 1974-July 25, 1976; Ammi Phillips Portrait Painter; Halladay-Thomas, Albany, and exhibition catalog, nos. 15 and 16; Halladay-Thomas, Hudson Park; Halladay-Thomas, New Britain, and exhibition catalog, nos. 33 and 35; Halladay-Thomas, Pittsburgh, and exhibition catalog, nos. 19 and 20; Halladay-Thomas, Syracuse, and exhibition catalog, nos. 47 and 48; Halladay-Thomas, Whitney, and exhibition catalog, p. 30, nos.19 and 20; "Third Annual Exhibition: American Furniture and Portraits, Etc.," Columbia County Historical Society, Kinderhook, N.Y., 1939, and exhibition catalog, no. 24.

Published: AARFAC, 1974, p. 27, nos. 18 and 19, illus. on p. 27; Holdridge and Holdridge, *Ammi Phillips*, p. 46, nos. 54 and 55, illus. as no. 54 on p. 40 and no. 55 on p. 30; Holdridge and Holdridge, "Ammi Phillips," p. 111, nos. 66 and 67. See also the exhibition catalog, Ammi Phillips in Columbia County, p. 17, illus. as no. 14 on p.19 and no. 15 on p. 20.

[1]Philip Slade's portrait is in the collection of the Metropolitan Museum of Art, New York, N.Y., the gift of Edgar William and Bernice Chrysler Garbisch. Regarding Ames, see Holdridge and Holdridge, *Ammi Phillips*, pp. 13-14. The privately owned Gebhard portraits are illustrated *ibid.*, pp. 24 and 30.

[2]Martin was so described in "Columbia County Biographies Compiled in 1894," biographical sketch of Dr. Oliver Jasper Peck, unidentified newspaper clipping (June 1939?) in AARFAC files.

[3]See the exhibition catalog, Ammi Phillips in Columbia County, p. 17.

[4]Halladay-Thomas exhibition catalogs give William's middle initial as "G," but the source of their information is unidentified. Contrary to Holdridge and Holdridge, *Ammi Phillips*, p. 46, the initial is not part of the inscription.

[5]Mrs. Russell J. Quandt noted that "the Harder strainers are also put together with two wooden dowels or pegs in each corner, a feature of every Border Limner picture Russell has worked on. . . . The wood of these strainers is different from the others, however—the artist must

127

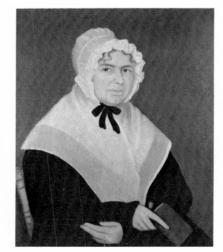

128

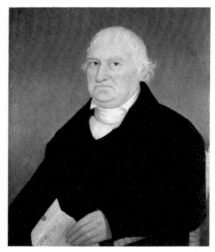

129

have been experimenting." Eleanor Quandt to AARFAC, December 16, 1968. Mrs. Quandt also enclosed a sample of a twill binding tape that they removed, stating that "this is a new one to us. It seems likely that it was put on by the artist, judging by the tacks, etc."

[6]The William Harders were connected to the Russell Dorr family (see nos. 121-126) by marriage, their son Martin having married the Dorrs' oldest child, Paulina, in 1828. These companion likenesses of Martin's parents thus descended to Paulina's youngest sister, Harriet, along with portraits of her own mother and father. The Nathaniel Bull Spaldings' daughter recalls that the portraits hung in her grandparents' home at Schodack Landing, N.Y., and that Halladay and Thomas purchased them there about 1925. Miss Marcia Spalding to AARFAC, August 15, 1978, March 25, 1979.

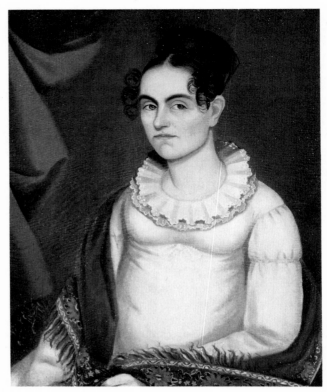

130

130 Possibly Mrs. Henry Peter Van Rensselaer (Jane A. Fort)

58.100.36

Attributed to Ammi Phillips
Claverack, Columbia County, New York,
probably 1820-1825
Oil on canvas
29⅞″ x 23¾″ (75.9 cm. x 60.3 cm.)

Mrs. Van Rensselaer's portrait is most similar to an attributed group that includes Mrs. Henry G. Philip of Claverack, Mrs. James Vanderpoel of Kinderhook, Mrs. John Haskell of Troy, and several unidentified women, all probably painted in the early 1820s in either Columbia or adjoining Rensselaer County.[1]

Halladay and Thomas believed that this portrait represented "Mrs. H. B. Van Rensselaer of Kinderhook, 1820,"[2] an erroneous assumption on two acounts: there were no Van Rensselaers in Kinderhook about 1820,[3] and the only Mrs. H. B. Van Rensselaer found in genealogical research has been Mrs. Henry Bell Van Rensselaer, née Elizabeth Ray King. Born on Long Island in 1815, she would have been much too young for the circa 1820 date that costume and hairstyle ascribe to this portrait.[4]

Although later published as an "unidentified woman,"[5] the possibility that the sitter was some other member of the Van Rensselaer family remained plausible, and the recent discovery that the painting had been owned by Van Rensselaer Trimper supported this theory. But which Van Rensselaer was she? Her true identity may never be established, although a Van Rensselaer genealogy offers persuasive facts that link the portrait with Mrs. Henry Peter Van Rensselaer.[6]

Jane A. Fort was born in Hoosick, New York, on January 18, 1797, the daughter of Jacob and Angelica Vrooman Fort. The date of her marriage to Henry Peter

Van Rensselaer (1794-1874) is unknown, but their first child, Peter, was most likely born in 1818 since he and a second son, Jacob Fort, were baptized at the Dutch Reformed Church in Claverack in 1818 and 1819 respectively. Four other children were born to the couple. Jane died at Claverack on November 25, 1869.[7]

Inscriptions/Marks: None found.[8] The painting's four cast iron stretcher keys are each marked "Pat^d./Feb. 13/1883/Jun. 18/1885/A.D.S."[9]

Condition: A framer's label indicates that this painting was cleaned and restretched late in the nineteenth or early in the twentieth century, when the original auxiliary support and frame were probably replaced and the Shattuck keys were added. In 1971 Bruce Etchison lined the canvas, cleaned it, and inpainted numerous losses throughout its lower half. Modern replacement 2½-inch gilt and gold-painted frame with bead molding along the inner lip.

Provenance: Peter Van Rensselaer; Mrs. Cantine Trumper (Eveline Van Rensselaer); Van Rensselaer Trimper, Albany, N.Y.; Charlotte Paddock, East Greenbush, N.Y.; J. Stuart Halladay and Herrel George Thomas, Sheffield, Mass.[10]

Exhibited: Halladay-Thomas, New Britain, and exhibition catalog, no. 13 (titled *Mrs. Henry Bell Van Rensellaer* [sic] *of Kinderhook, New York*).

Published: Holdridge and Holdridge, *Ammi Phillips*, p. 46, no. 56; Holdridge and Holdridge, "Ammi Phillips 1788-1865," p. 123, no.

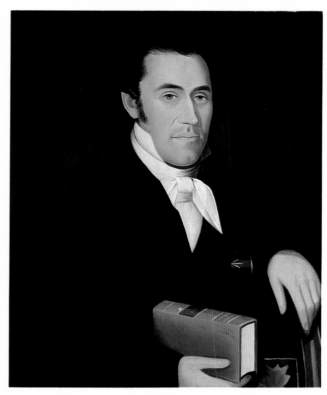

131

was the suggested sitter's granddaughter, the third child of Jane and Henry Peter Van Rensselaer's first son, Peter (1818?-1904) and his wife, Ann Truax Van Rensselaer. The portrait's history prior to its ownership by Halladay and Thomas has been provided through the efforts of Ruth Piwonka, who related Mrs. Paddock's memory of buying the portrait from Van Rensselaer Trimper and selling it to Halladay and Thomas. Piwonka to AARFAC, July 28, 1977.

[7]Piwonka to AARFAC, December 27, 1976.

[8]Barbara and Lawrence Holdridge stated that "the date 1820, probably a later addition, appears on the stretcher" of this piece, but such a marking is no longer visible. If their assertion is correct, the date must have been obscured by the edges of the lining canvas in 1971. Holdridge and Holdridge, *Ammi Phillips,* p. 46.

[9]The initials stand for the keys' inventor, Aaron Draper Shattuck.

[10]See n. 6.

131 **Young Physician** 58.100.42

Attributed to Ammi Phillips
Probably Dutchess County, New York, ca. 1830
Oil on canvas
31" x 25" (78.7 cm. x 63.5 cm.)

Unfortunately, the identity of this sitter may never be learned without more clues than the *Cooper's Surgery* he holds. Phillips was responsible for numerous portraits of men in virtually identical poses at this period, and many of them, like the *Young Physician,* are now unknown by name. However, most of the sitters who can be identified lived in Dutchess County, New York, thus reinforcing the likelihood that this man did also.

By the point in his career when he painted the *Young Physician,* Phillips had evolved a striking, highly stylized formula for turning out portraits, which he doubtless did very quickly if his crisp, sure lines and fluid brushstrokes are any indication. Typically for his work at this time, many parts of the painting have been abbreviated to suggestions: the black jacket is defined by minimal modeling, the hand holding the book is equally flat, and the swipe of a brushstroke over the sitter's raised wrist merely hints at the shadow of his sleeve. It might be argued that because Phillips combined artistic shortcuts with stock poses during this period, his sitters lack individuality, but nothing could be further from the truth. A comparison of "look-alike" paintings reveals that Phillips applied his paint discriminatingly where it counted in a portrait – in the face. That he could observe and record individual characteristics – a heavy-lidded eye, hooked nose, or long face – is merely emphasized by the readily apparent similarities of composition and brushwork.

205. See also the exhibition catalog, Ammi Phillips in Columbia County, p. 25, no. 20, illus. on p. 26.

[1]The portraits of Mrs. Philip and Mrs. Haskell are privately owned. Mrs. Vanderpoel's portrait is in the collection of the Albany Institute of History and Art.

[2]Most Halladay-Thomas notes refer to the painting as "Mrs. H. B. Van Rensselaer"; a few identify her fully as "Mrs. Henry Bell Van Rensselaer." Possibly Halladay and Thomas purchased the portrait under the initialed titled only, later deducing that "Henry Bell" was the only name that matched the initials "H. B." in Van Rensselaer records. "H. B." may easily have been confused for the more likely "H. P." (for Henry Peter) during the course of prior ownership.

[3]Ruth Piwonka to AARFAC, March 4, 1977.

[4]*Ibid.*

[5]Possibly this portrait is the *Unknown Woman* listed as no. 205 in Holdridge and Holdridge, "Ammi Phillips," p. 123, and listed as no. 56, *Woman from Rensselaer County,* in Holdridge and Holdridge, *Ammi Phillips,* p. 46. It is not known why she was thought to be a Rensselaer County resident when the latter was published.

[6]The two earliest owners of this portrait are conjectural and are based on the sitter's probable identity, on the logical line of descent suggested by Florence Van Rensselaer, *The Van Rensselaers in Holland and in America* (New York, 1956), pp. 46, 47, and 65, and, most of all, on a presumed link between Eveline Van Rensselaer Trumper and Van Rensselaer Trimper ("Trumper" and "Trimper" seem too close to be coincidental). Eveline Van Rensselaer Trumper (born 1859)

Phillips often failed to utilize the most basic concepts of anatomy; here, for instance, the physician's head is too large for his body. However, such disproportions neither contradict nor negate the artist's minute observance of distinguishing details, which probably encouraged sitters to accept his portraits as "good likenesses." Additional individualizing touches in this type of portrait are provided by endlessly varied stenciling patterns on chair rails and stiles and by specific book or newspaper titles, the later occasionally bearing dates as well.

Inscriptions/Marks: Painted on book spine in sitter's hand is COOPER'S/SURGERY./VOL./I.[1]

Condition: This painting shows no evidence of previous conservation and retains its original exposed mortise-and-tenon strainers.[2] Original 3½-inch flat frame, painted black, with gold-painted scoop-molded inner lip and gold-painted half-round outer edge.

*Provenance:*5 J. Stuart Halladay and Herrel George Thomas, Sheffield, Mass.

Published: Holdridge and Holdridge, *Ammi Phillips*, p. 48, no. 133 (titled *Man Holding Cooper's Surgery*); Holdridge and Holdridge, "Ammi Phillips," p. 121, no. 175 (titled *Man Holding Cooper's Surgery*).

[1]This may have been a volume of *The First Lines of the Practice of Surgery* . . . (London, 1807) or *A Dictionary of Practical Surgery* . . . (London, 1809), both widely circulated medical references by Samuel Cooper (1780-1849). The first was reprinted many times between 1807 and 1844, the second between 1809 and 1868.

[2]The joints are glued and reinforced by a few nails, not doweled in the more distinctive manner described by Mary Black in Holdridge and Holdridge, *Ammi Phillips*, pp. 11-12.

132 Elderly Lady in White Cap 64.100.5

Attributed to Ammi Phillips
Probably New York-Connecticut border area,
ca. 1835
Oil on canvas
33½" x 27¾" (85.1 cm. x 70.5 cm.)

Phillips frequently used a forward-leaning pose in women's portraits of the Kent Period, 1829-1838, but some of his variations were more successful than others. Poses that combined the torso's forward inclination with an arm resting on a table or sofa to help distribute upper body weight seem more logical—and certainly more graceful—than those that cross the sitter's hands at the waist, resulting in a tight, pinched look. The artist probably employed the latter posture more frequently in his portraits of elderly women because he deemed it more appropriate to their age and status in society. In this instance, the title of the book the sitter holds and the

black ribbon on her bonnet emphasize the suitability of Phillips's conservative choice of pose.

The tonal simplification that Phillips used with dramatic effect in his Kent Period portraits was probably least suited to the complex faces of the elderly, such as this woman, because their deep wrinkles were rendered artificial by hasty surface treatment. Reduced to lines painted on the skin, these marks of time and age lost their essential role in character definition.

Inscriptions/Marks: Painted on the book spine in the sitter's hand is RELIGION/OF THE/HEART/AND/LIFE/VOL. V./CONSOLATIONS/FOR THE/AFFLICTED.[1]

Condition: This painting was lined and the original support was trimmed flush with the strainers' outside edges at an unspecified date prior to acquisition. Scattered, relatively minor, areas of loss were inpainted and a 1¾-inch diagonal tear in the background on the left side was mended. The auxiliary support, possibly original, consists of strainers secured at each corner by two diagonally placed nails. Modern replacement 2⅛-inch frame, painted black, with red liner.

Provenance: An unidentified Connecticut dealer;[2] The Old Print Shop, New York, N.Y.

[1]*The National Union Catalog of Pre-1956 Imprints* includes no title that corresponds exactly; the closest is *Consolation for the Afflicted: Containing The Silent Comforter and The Attractions of Heaven* (Boston, 1848), possibly a later edition of the book that the sitter holds.

[2]The Old Print Shop to AARFAC, November 13, 1964.

133 Man with Book 48.100.1
134 Lady on Red Sofa 48.100.2

Attributed to Ammi Phillips
New York-Massachusetts-Connecticut border
area, ca. 1850
Oil on canvas
33½" x 27½" (85.1 cm. x 69.9 cm.)
33¾" x 27½" (85.7 cm. x 69.9 cm.)

Fluidly and rapidly executed, these paintings bear no trace of the labored appearance and dry, soft shading of Phillips's work during the early 1820s. A lifetime devoted to the skillful handling of his brush is evident in the precision maintained in most critical passages of these likenesses, while the less important areas of the canvas—for example, the chair and sofa arms—are suggested by loose, impressionistic touches of paint. In no. 134, however, the broken rendering of parts of the woman's face reflects haste and perhaps carelessness. The rather crude, wetly painted blue veining of the hands and the use of pinkish red brushstrokes to outline the knuckles are characteristic touches that Phillips em-

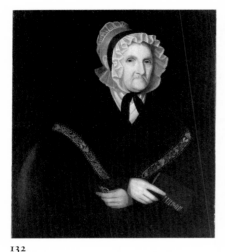

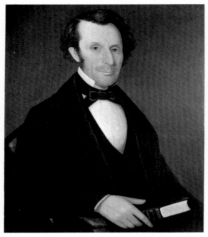

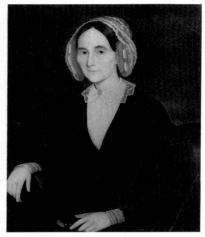

132 133 134

ployed throughout the latter part of his career; the woman's gilded plaster collar fastening is unusual and may represent a whimsical fancy of the sitter's.

The extreme forward-leaning pose utilized in many of Phillips's 1830s portraits of women had largely been replaced by the 1840s by the more natural upright position assumed by this woman. The slight diagonal distortion of the man's likeness is puzzling; the illusion of a canvas pulled taut between the upper left and lower right corners appears sporadically in Phillips's work after about 1840.

Victorian dress proved extremely compatible with many aspects of Phillips's later style. Sober black garb accented by touches of white provided the stark, graphic settings that advantageously exhibited his sure control of hard edges and crisp facial delineation. Even the women's smoothly combed hairstyles seem more suited to these flat, high-contrast depictions than the wispy tendrils or clustered curls of earlier periods.

Edward Duff Balken appears to have donated the portraits to an auction sale organized in 1944 for the benefit of the Berkshire Museum in Pittsfield, Massachusetts, which is where Mrs. Rockefeller purchased them. No written history that might have accompanied the pair survives, but Balken acquired many of his folk art paintings in the Berkshires, where he had a summer home, and in the adjoining area of New York state. Although possibly painted in Columbia or Dutchess counties, New York, a western Massachusetts or western Connecticut origin seems more likely in view of the preponderance of works executed in these areas during the later years of Phillips's life, the period in which costume details place this pair.[1]

Inscriptions/Marks: Painted on the spine of the book in the sitter's hand is *AGRICULT——*.
Condition: In 1955 Russell J. Quandt lined these paintings, replaced the auxiliary supports, repaired a 4-inch horizontal tear through the man's left arm and coat just above the elbow and a 2½-inch vertical tear through the lady's dress placket, and inpainted scattered areas of minor paint loss. Probably twentieth-century replacement 3-inch gilded and gold-painted frames with applied plaster decoration.
Provenance: Edward Duff Balken, Pittsburgh, Pa., and Egremont, Mass.[2]
Exhibited: AARFAC, New Canaan; AARFAC, September 15, 1974-July 25, 1976; Ammi Phillips Portrait Painter.
Published: AARFAC, 1957, p. 353, nos. 203 and 204; Holdridge and Holdridge, *Ammi Phillips*, p. 52, nos. 258 and 259; Holdridge and Holdridge, "Ammi Phillips," p. 122, nos. 191 and 192; Barbara and Larry Holdridge, "Ammi Phillips, limner extraordinary," *Antiques,* LXXX (December 1961), p. 562; Barbara and Larry Holdridge, "Ammi Phillips," *Art in America,* XLVIII (Summer 1960), no. 134 only, illus. on p. 103.

[1]In June 1959 a Colonial Williamsburg Foundation employee claimed to have been told by Mrs. Rockefeller that the sitters were Dutch descendants living in Kinderhook, Columbia County, N.Y. AARFAC to Barbara Cohen, June 18, 1959. It is not known why the portraits were published shortly thereafter as "presumed to be a Rhinebeck, N.Y., husband and wife," or why 1960s museum memoranda state that they had been "found in Dutchess County." In 1965 Holdridge and Holdridge, "Ammi Phillips," p. 106, suggested that nos. 133 and 134 might be Mr. and Mrs. Andrew Bartholomew, based on a close resemblance between the man's likeness and Phillips's painting of John Morse Bartholomew, Andrew's brother. If no. 133 is a Bartholomew, he probably is Hiram, another brother, since Phillips's portraits of the Andrew Bartholomews are said to have burned in a fire in Sheffield, Mass., many years ago. Mrs. Gurdon Pickertt to AARFAC, June 21, 1979.
[2]Ruth Piwonka to AARFAC, May 22, 1977.

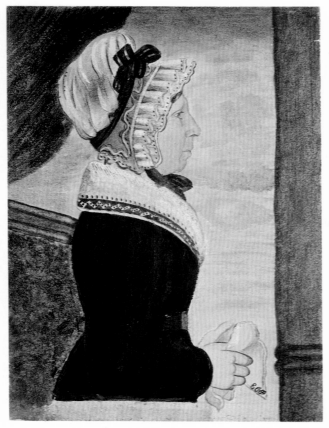

136

By 1825 Edwin had created the miniature portraits of his grandparents illustrated in this catalog, and in the summer of 1828 he advertised himself as a portrait painter in Salem, Massachusetts, offering for public inspection "eight or ten Portrait Likenesses in the Room immediately over Mr. James R. Buffam's store, forming a corner of Essex and Central streets."[4] In 1830 he married Anna Penfield of Portland, and he seems to have spent some time pursuing portrait commissions in Maine because examples of his work have been found in Alfred and Berwick.[5] From 1839 through 1846-1847 he was listed as a portrait painter in Boston city directories, perhaps attracted to the area by his first cousin's success there. No further mention of his painting career has yet been noted, and he died, childless, on July 27, 1880.[6]

At least three of Edwin's recorded watercolor portraits show trial pencil outlines of his subjects on the reverse. The type of delineation suggests that he used a camera obscura or other mechanical aid to record profiles that he afterward developed more fully in watercolor; one such pencil profile has the artist's own color notations inscribed over it.[7] Characteristics of Edwin's

Edwin Plummer
(1802-1880)

Several portraits by Edwin Plummer have been recorded since the initial publication of the inscribed portrait of his grandfather, which helped to identify him as an artist.[1] Edwin was the first of nine children born to Nancy Sawyer and Daniel Farnham Plummer of Haverhill, Massachusetts.[2] His mother died in 1831, and three years later his father married Abigail Richardson Ballard, by whom he had three more children. Birthplaces of Edwin's siblings listed in a Plummer genealogy indicate that by September 1807 the family had left Haverhill for Beverly, and that by May 1814 they had left Beverly for Lancaster, where, according to another source, they "resided many years."[3]

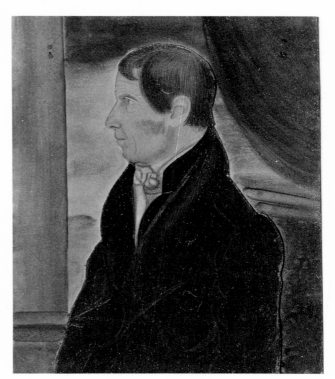

135

watercolor portrait style include hard, precise outlines to his profiles, delicate drawing of the details of face and hair, and the occasional use of corner ornamentation, harsh bright blue and orange backgrounds suggesting sky and landscape, or a formula backdrop incorporating a column, drapery, and stylized upholstered sofa.

[1]AARFAC, 1957, p. 362. The portraits of Edwin's paternal grandparents, Thomas and Elizabeth Chandler Plummer, are illustrated as nos. 135 and 136.

[2]Sidney Perley, *The Plumer Genealogy* (Salem, Mass., 1914), p. 184, and Haverhill, Mass., public records both list Edwin's father's name as Farnham Plummer (or Plumer), but George Chandler, *The Chandler Family . . .* (Boston, 1872), p. 217, gives his father's full name as Daniel Farnham Plummer. Because Chandler also identifies him as "Mr. D. Farnham Plummer," it seems most likely that he did indeed have two Christian names but dropped the first in common usage.

[3]Perley, *Plumer Genealogy*, p. 184; Chandler, *Chandler Family*, p. 217.

[4]*Salem Gazette*, July 11, 1828.

[5]A portrait of an unidentified woman is privately owned, and separate profiles of the Goodwin twins of Berwick, Maine, are in the Karolik Collection, Museum of Fine Arts, Boston, acc. nos. 52.1556 and 52.1557.

[6]Harrison Lorenzo Plummer (1814-1894) was the first child born to Farnham's brother, John Chandler Plummer, and his first wife, Sally Johnson. He became a painter of some renown, exhibiting at the Boston Athenaeum in 1837 and at the Royal Academy in London. One Adrian Plummer, who also exhibited at the Boston Athenaeum in 1837, has not yet been positively identified or firmly linked to the family, although probably some connection exists. Other painting Plummers whose relationships, if any, to Edwin require clarification are the William Plummer included in Frederic Fairchild Sherman, "American Miniatures by Minor Artists," *Antiques*, XVII (May 1930), pp. 422-423 and figs. 2-3, and the William K. Plummer taken on as a pupil by Joseph Whiting Stock in Westfield, Mass., in 1844 (Tomlinson, p. 43). The Plummer portraits illustrated in Sherman, "American Miniatures," appear stylistically attributable to Edwin, and the basis for Sherman's ascription is unknown.

[7]*Goodwin Twin of Berwick, Maine*, Karolik Collection, Museum of Fine Arts, Boston, acc. no. 52.1556.

Plummer's portrait; although dissatisfied with the initial background for some reason, he was able to save the completely worked figure by cutting it out and placing it on a redrawn background.

This portrait of his grandfather is Edwin Plummer's only signed work recorded to date. Thomas was born in Haverhill, Massachusetts, on March 10, 1756; he married Elizabeth Chandler of Billerica, who was born August 6, 1760. She is said to have been a talented woman with a particular interest in literary matters. She died in Haverhill on January 11, 1839.[2]

Inscriptions/Marks: On the verso of the primary support in penciled script at the top is "Aged 71 years"; in inked script at the bottom of the primary support is "Thomas Plummer, Haverhill Ms/by Edwin Plummer his/grandson 1825"; an outline of a woman in profile appears in pencil in the lower half of the support, upside down and facing left with relation to the script (see Introduction, fig. 25). No watermark found.

Condition: Unspecified restoration between 1954 and 1971, probably by Christa Gaehde, included inpainting areas in the coat, particularly over the right shoulder, right collar, and along the lower painted margin. The sitter's figure has been cut out and pasted to a second support, the background then being painted around the figure. Period replacement 1-inch gilt frame with applied bead molding and plain brass hanger at center top.

Provenance: Found in New York state and purchased from Edith Gregor Halpert, Downtown Gallery, New York, N.Y.

Exhibited: American Folk Art; Washington County Museum.

Published: AARFAC, 1940, p. 26, nos. 57 and 58 (titled *Man in Profile* and *Woman in Profile*); AARFAC, 1947, p. 24, nos. 57 and 58 (titled *Man in Profile* and *Woman in Profile*); AARFAC, 1957, no. 135, p. 300, no. 102, illus. on p. 201, and no. 136, p. 362, no. 263; Cahill, p. 35, nos. 42 and 43 (titled *Woman in Profile* and *Man in Profile*); Walters, Pt. 3, no. 135 only, pp. 1C-2C, reverse illus. as fig. 6 on p. 2C.

[1]See the *Goodwin Twins of Berwick, Maine*, Karolik Collection, Museum of Fine Arts, Boston, acc. nos. 52.1556 and 52.1557.

[2]George Chandler, *The Chandler Family . . .* (Boston, 1872), p. 217.

135 Thomas Plummer 31.300.3

Edwin Plummer
Probably Haverhill, Massachusetts, 1825
Watercolor, pencil, and cut wove paper
on wove paper
4¹¹/₁₆″ x 3⅝″ (11.9 cm. x 9.2 cm.)

Edwin Plummer used the formula-style backdrops found in his grandparents' portraits in at least two other examples of his work.[1] A fragment of a painted portrait by Plummer showing the arm of a gentleman holding a book was used as backing in Mrs. Plummer's frame. Further evidence of the artist's attempt to salvage discarded or botched efforts is documented in Thomas

136 Mrs. Thomas Plummer (Elizabeth Chandler) 31.300.4

Edwin Plummer
Probably Haverhill, Massachusetts, 1825
Watercolor, pencil, and gouache on wove paper
4¹⁵/₁₆″ x 3⅝″ (12.5 cm. x 9.0 cm.)

For *Commentary, Provenance, Exhibited,* and *Published,* see no. 135.

Inscriptions/Marks: The initials of the sitter, "ECP," are lettered in ink on her handkerchief at lower right; the secondary support, which is presumed to be original, bears the partial watermark "J WHA[TMAN]/TURKE[Y MILL]/18—" for the Maidstone, Kent, England firm operated by the Hollingworth brothers between 1806 and 1859.

Condition: A sharp 1¾-inch cut along the sitter's back probably indicates an initial attempt to cut out the figure and paste it to a secondary support, as was done in the case of its companion portrait (see no. 135). However, only a ¹³/₁₆-inch-long irregularly shaped piece of the primary support is missing along the sitter's lower back. The primary and secondary supports have been spot-glued together, the latter being watercolored to match the former where the gap occurs. The primary support is considerably thinner than that used in the companion portrait. Period replacement 1-inch gilt frame with applied bead molding and plain brass hanger at center top.

Charles Peale Polk
(1765-1822)

The name of Charles Peale Polk immediately brings to mind the family dynasty of painters who owed their training and much of their artistic success to Charles Willson Peale (1741-1827), a man acknowledged in his own time for gentle wisdom and remarkable energy as an American patriot and leading painter. Polk's association with the Peale family was close. The nephew of Charles Willson Peale, the nine-year-old boy joined the noted painter's household after the death of his mother in 1776;[1] there he learned to paint portraits, although his paintings were never as celebrated or academically successful as those of his uncle and many cousins. The particulars of Polk's career are now being reassessed in a major study of the artist by Linda Crocker Simmons of the Corcoran Gallery of Art.

The beginning of Polk's career as a professional portrait painter is documented by his first advertisements, in Baltimore newspapers of 1785. Stating that he was prepared to paint oil portraits, Polk judiciously noted that he had just "finished his studies under the celebrated Mr. Peale of Philadelphia."[2] A similiar notice was published in an Alexandria, Virginia, paper about three months later.[3] In the same year, Polk is thought to have married his first wife, Ruth Ellison of New Jersey.[4]

The results of Polk's early efforts to establish an appreciative clientele in Baltimore and northern Virginia were apparently unsuccessful, and by 1787 he had returned to Philadelphia and was advertising as a ship, house, and sign painter.[5] His sojourn in Philadelphia enabled him to renew his ties with the Peale family and to acquaint himself with the artistic involvements of its various members. Four years later, in 1791, Polk seems to have accrued enough money and examples of his portrait work to establish a residence and gallery room in Baltimore. There he advertised that he was "fitting up

an exhibition room" in Commerce Street and that he also had "Portraits of the President of the United States" for sale.[6] Polk remained in Baltimore at the above address and later at Frederick and Calvert Street locations until 1796 or 1797. He painted some portraits during that time and opened a drawing school, but it appears that he devoted as much energy to a general dry goods business.[7] He may have maintained a partial interest in the business until 1804, but his intention to leave Baltimore was apparent as early as 1795, when he offered property for sale.[8]

Polk probably moved to Frederick, Maryland, sometime during 1797 or 1798, the year he advertised there that he had "resumed his profession of portrait painter" and noted hopefully that his "moderate prices will again recommend him to the public."[9] During 1798 and ensuing years he advertised his portrait work in Hagerstown, Maryland, and Richmond, Virginia; he also painted in the Shenandoah Valley area of Virginia and West Virginia.[10] The portraits in this collection were executed during this period.

Polk's artistic production just after the turn of the century is largely unknown. In an 1806 Richmond newspaper advertisement he offered "PROFILE LIKENESSES, Engraved in Gold." Several of these small, inexpensive portraits survive and bear Polk's signature.[11] The rest of his career as an artist is obscure. He married a second and third time after the deaths of his previous wives.[12] By 1818 he was working as a government clerk in Washington, D.C., and at the time of his death in 1822 he was living in Richmond County, Virginia.[13]

[1] Sellers, I, pp. 6, 91, 178, and 179.

[2] Research files, Museum of Early Southern Decorative Arts, Winston-Salem, N.C. This advertisement originally appeared in the *Maryland Journal, and the Baltimore Advertiser,* March 25, 1785.

[3] Research files, MESDA. This advertisement originally appeared in the *Virginia Journal, and Alexandria Advertiser,* June 30, 1785.

[4] Sellers, II, p. 422.

[5] Sellers, I, p. 264.

[6] Research files, MESDA. The advertisements appeared in the *Maryland Gazette; or, the Baltimore Advertiser,* May 24, 1791, and in the *Maryland Journal, and the Baltimore Advertiser,* July 22, 1791. Polk's portraits of the President were probably copies made after Charles Willson Peale's likeness of George Washington, done in 1787. See Sellers, I, p. 258.

[7] Research files, MESDA. The *Baltimore Daily Repository,* May 30, 1793, locates Polk at Frederick and Water streets; the *Baltimore Daily Intelligencer,* April 24, 1794, gives the same address; the *Federal Intelligencer, and Baltimore Daily Gazette,* April 27 and September 21, 1795, lists Polk at the corner of Calvert and Water streets.

[8] Research files, MESDA. Polk's real estate sale notices appeared in the *Federal Intelligencer, and Baltimore Daily Gazette,* April 27 and October 5, 1795. On August 16, 1797, the paper noted that a letter to

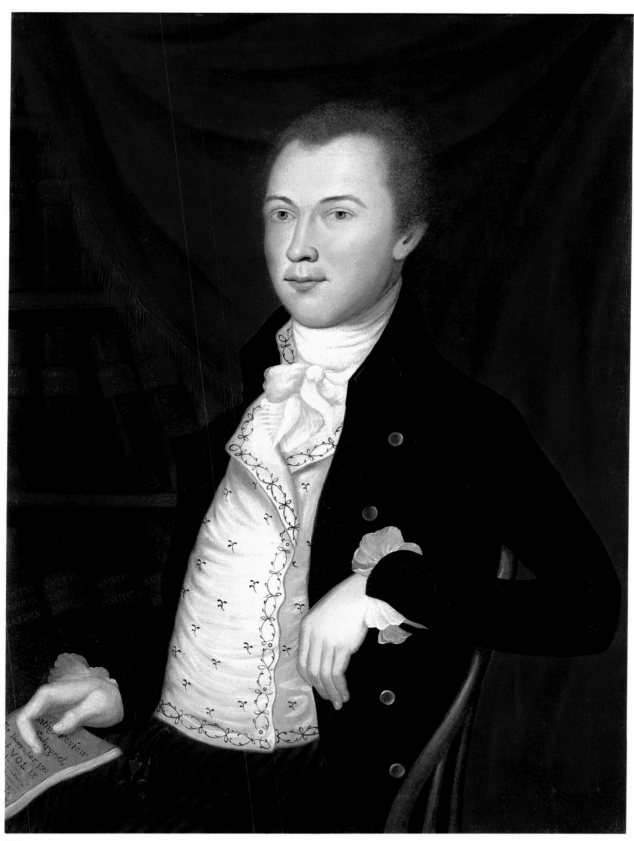

Polk was retained at the Baltimore Post Office, a further indication that the artist had left town. A "Polk & M'Henry" mercantile firm is listed in the Baltimore city directories for 1802, 1803, and 1804 at "14 County Wharf" on South Calvert Street.

[9] Research files, MESDA, quoted from the original in *Bartgis's Federal Gazette, or the Frederick County Weekly Advertiser* (Fredericktown, Md.), January 3, 1798.

[10] Research files, MESDA. Advertisements appeared in the *Maryland Herald and Elizabeth (Hager's) Town Advertiser*, August 23, 1798, and in the *Virginia Gazette and General Advertiser* (Richmond), November 22, 1799. Various Winchester, Virginia, portraits signed and dated by Polk were published in the exhibition catalog, Frymire, pp. 38-43.

[11] Whaley Batson, "Charles Peale Polk: Gold Profiles on Glass," *Journal of Early Southern Decorative Arts*, III (November 1977), pp. 51-57.

[12] Sellers, II, p. 422.

[13] Linda Crocker Simmons to AARFAC, August 21, 1976.

137 Adam Stephen Dandridge, Sr. G1975-147

Attributed to Charles Peale Polk
Probably Jefferson County, Virginia
(now West Virginia), ca. 1800
Oil on canvas
35" x 26" (88.9 cm. x 66.0 cm.)
(Reproduced in color on p. 165)

This portrait was painted by Polk about 1800 along with three other likenesses of Dandridge's young half brothers and sister—David, Moses, and Anne Evelina Hunter.[1] As noted in the entries for the Morrow family pictures (nos. 138-141), the artist visited the northern area of Virginia in 1799 and presumably made other painting trips to nearby communities in 1800. Like the Morrow portraits, this example illustrates Polk's fondness for detail and his ability to render pleasing as well as strong likenesses. The familiar curtain is used here to set off Dandridge's head and further serves as a functional device subtly to reveal the gentleman's impressive library. Dandridge had attended Princeton and no doubt his educated literary tastes were a source of personal pride.

Adam Stephen Dandridge evidently lived most of his life in the valley area. He was the son of Alexander Spotswood Dandridge (1753-1785) and his first wife, Ann Stephen, of Berkeley County, Virginia (now West Virginia).[2] The parents had moved to Jefferson County before Adam's birth in 1782. Adam married Sarah Pendleton of the same area on January 1, 1805, and built his home, The Bower, on a large tract of land inherited from his father. The couple had six children. Dandridge was

active in local politics and served for a number of years as an elder in the local Presbyterian church. He died on March 20, 1821.[3] This portrait eventually went to Adam's mother, who bequeathed it in her will "to my grandson Stephen Dandridge," presumably the sitter's son.[4]

Inscriptions/Marks: Below the sitter's right hand is a pamphlet that reads in part "–onthly Review/Enlarged/For November, 1792/of Vol. IX." The titles, in full and in part, of the books behind the sitter are as follows: top shelf, TORY/STATE, and JEFFERSON/NOTES; second shelf, –ALEY/–OPHY, ROUSSEAU/ON/POLITICS, WEALTH/OF /NATIONS/2, and WEALTH/OF/NATIONS/3; bottom shelf, WINS /–TANICAL/GARDEN, VATTEL'S/LAW OF/NATIONS, RUTHERFORD'S/INSTITUTES, and –RUT/IN–.

Condition: The painting was lined and placed on new stretchers, and cleaning was initiated, by Theodor Siegl in 1976; cleaning and minor inpainting of losses were completed by Siegl's colleagues in 1977. Modern replacement 2-inch molded frame, painted black.

Provenance: Gift of Mr. and Mrs. Edmund P. Dandridge.

[1] The Hunter portraits are in the Corcoran Gallery of Art, Washington, D.C.

[2] All biographical information except where cited elsewhere is from Danske Dandridge, *Historic Shepherdstown* (Charlottesville, 1910), pp. 312-313, and the *Virginia Magazine of History and Biography*, XI (October 1903), pp. 215-217.

[3] Francis Silver V to AARFAC, May 24, 1975.

[4] Linda Crocker Simmons to AARFAC, July 16, 1975.

138 Amos Morrow 57.100.11
139 Mrs. Amos Morrow 57.100.12
140 Thryphone Morrow 57.100.13
141 Thrypose Morrow 57.100.14

Attributed to Charles Peale Polk
Probably Jefferson County, Virginia
(now West Virginia), ca. 1800
Oil on canvas
28⅛" x 25⅛" (71.4 cm. x 63.8 cm.)

The training that Polk received from his famous uncle, Charles Willson Peale, is easily discerned in these four portraits of the Morrow family. The swagged red curtain used as a backdrop and compositional framing device appears in many of Polk's pictures and was also employed on a few occasions by his uncle. The strong lighting on the subjects' faces, the oval shapes of their heads, and their very alert, expressive eyes are also typical of both Polk's and his relative's style. The younger painter's fascination with detail is evident in his

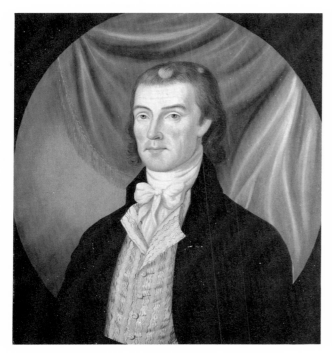

138

meticulous rendering of hair, lace, and jewelry. Polk's effort to produce faithful, realistic likenesses was carried to the extreme here by the inclusion of Mr. Morrow's scalp tumors.

Polk ambitiously attempted to develop his career and a sophisticated style, but he continually labored under certain artistic misunderstandings or inabilities, some of which may be observed in the Morrow likenesses. He was never completely adept in anatomical drawing and foreshortening, flaws that are obvious in the arms and torsos of the Morrow women. Mrs. Morrow appears hunched forward while her daughters' far arms are awkwardly placed and advance rather than recede in space. Some of this stiffness is also caused by Polk's struggle to capture the soft, flowing folds of their gathered dresses. The artist has also been criticized for his bright palette, but to modern eyes the lively reds, yellows, and blues in these portraits are fresh and very appealing.

Little is known about Amos Morrow except that he lived with his family in Jefferson County, Virginia (now West Virginia). According to family tradition, the

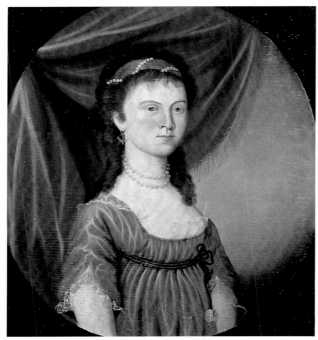

140

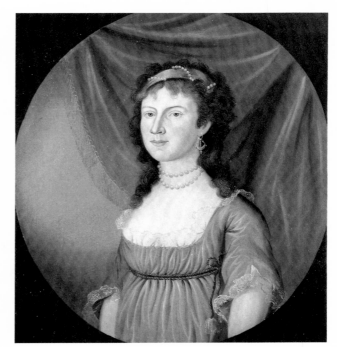

141

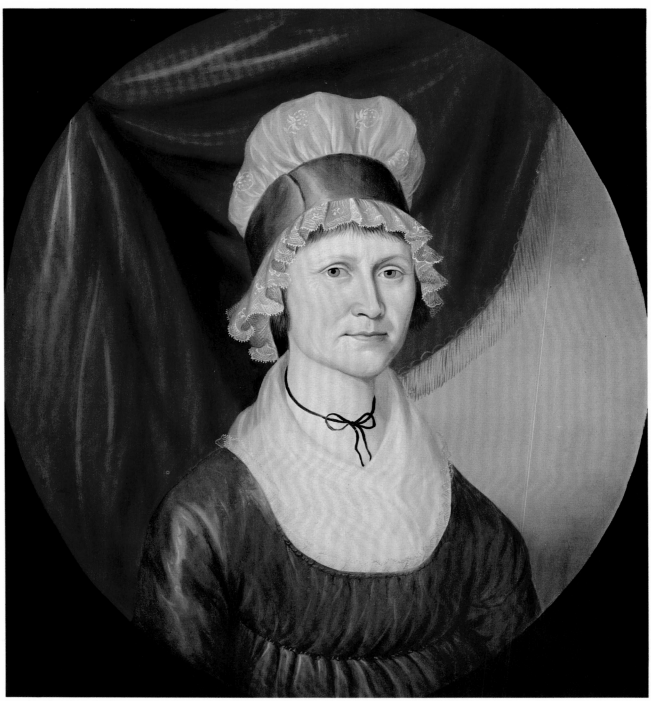

139 Attributed to Charles Peale Polk, *Mrs. Amos Morrow*

Morrows moved there from southeast Virginia. The two daughters were probably twins, as suggested by their identical costumes, poses, and their names, which apparently were inspired by a biblical verse.[1] The four paintings were executed about the time Polk was working in the vicinity of Winchester, Virginia. His 1799 signed and dated portrait of Juliet White in the Winchester-Frederick County Historical Society closely resembles these likenesses of the Morrow twins.[2]

Condition: The paintings were lined and cleaned by an unidentified conservator before their acquisition. Possibly original 2⅛-inch molded frames, painted black, with gilt inner border.
Provenance: Mrs. Arthur Worthington Hawks, Ruxton, Md., a descendant of the Morrows; Robert Carlen, Philadelphia, Pa.; M. Knoedler & Co., New York, N.Y.
Exhibited: "A Southern Sampler: American Paintings in Southern Museums," Hunter Museum of Art, Chattanooga, September 21-October 31, 1975, and exhibition catalog, p. 23, nos. 82-85.

[1] Romans 16:12, "Greet those workers in the Lord, Tryphaena and Tryphosa."
[2] See the exhibition catalog, Frymire, p. 40, no. 31, illus. on p. 41.

Rufus Porter
(1792-1884)

The many interesting details of the life of Rufus Porter, an itinerant painter, inventor, and journalist, were first outlined in an informative, lengthy obituary and biographical sketch in the September 6, 1884, issue of *Scientific American,* a publication that he founded. However, these facts were not thoroughly reviewed and investigated until the publication of Jean Lipman's *Rufus Porter, Yankee Pioneer* more than three-quarters of a century later.[1]

Porter was first introduced to the painting trade in 1810 at age eighteen, when he was apprenticed to a house painter, an experience that exposed him to sign painting and other allied skills. During the War of 1812 he painted gunboats, and in 1813 he is said to have decorated and painted sleighs in Denmark, Maine.[2] Although it seems certain that Porter began his career as a miniature portrait painter during the next few years, no examples of such work survive prior to his return to the Boston area from a sea voyage about 1819. The attribution to Porter of over fifty stylistically related watercolor portraits is based on the validity of the histories of two 1819 likenesses of distant cousins, John

and Mehitable Tyler of West Boxford, Massachusetts; although unsigned, the portraits have always been identified in the family as Rufus Porter's work.[3]

Although no signed portraits by Porter have yet been recorded, an outline of his career as a portrait painter can be developed from additional evidence and biographical data. About the time the Tyler portraits were painted, Porter issued an undated printed handbill that included a woodblock illustration of a typical example of his profile portraiture together with the prices he charged for four types of portraits: cut profiles, watercolor profiles, watercolor full-face portraits, and miniatures on ivory.[4] He painted "Correct Likenesses" throughout New England, traveling from Boston through New York and New Jersey to Baltimore and Alexandria, Virginia, where he built a camera obscura in 1820. This optical aid enabled him to obtain the outlines of his subjects and, it is said, to produce a satisfactory one-dollar portrait in fifteen minutes. Having mounted the camera obscura on a brightly decorated handcart, Porter proceeded to travel as far south as Harrisonburg, Virginia, before winding his way north again.[5]

It would be a misstatement to suggest that Porter concentrated on the portrait painting business at any one time in his life, for his restless, fertile mind continually drew him into new, although sometimes short-lived, pursuits in his roles as an inventor, writer and publisher, and mural painter. Datable portraits, however, suggest that he returned to miniature portraiture throughout his career until about 1835. Porter's design for a camera obscura, presumably the same type he used in his own work, is described in his recipe-style art instruction manual entitled *Curious Arts,* which first appeared in 1825. He detailed his techniques and methods of "Miniature Painting" in an article in the January 22, 1846, issue of *Scientific American:* notes that shed further light on the characteristics of his style in profile and full-face portraiture. Typical examples are discussed in some detail in the individual entries.

[1] Jean Lipman, *Rufus Porter, Yankee Pioneer* (New York, 1968). The first issue of *Scientific American* appeared August 28, 1845.
[2] Lipman, *Rufus Porter,* p. 19.
[3] Illustration of the Tyler portraits *ibid.,* p. 65, fig. no. 38.
[4] *Ibid.,* p. 66.
[5] *Ibid.,* p. 69.

142

143

Condition: Restoration of no. 143 between 1954 and 1970, possibly by Christa Gaehde, included reduction of a large water stain along the right side. Period replacement ⅝-inch molded frames, painted black.

Provenance: Found in Newburyport, Mass., and purchased from Katrina Kipper, Accord, Mass.

Exhibited: Washington County Museum.

Published: AARFAC, 1957, p. 361, nos. 252 and 253; Walters, Pt. 2, p. 2C, illus. as fig. 12 on p. 3C and as fig. 17 on p. 4C.

[1]Rufus Porter, "The Art of Painting – Miniature Painting," *Scientific American,* January 22, 1846.

142 Profile of Lady with Ruff 36.300.4

143 Profile of a Gentleman 36.300.5

Attributed to Rufus Porter
Probably New England, ca. 1820
Watercolor, ink, and gouache on wove paper
4⅝" x 3⁹/₁₆" (11.7 cm. x 9.1 cm.)
4⅜" x 3¹³/₁₆" (11.1 cm. x 9.7 cm.)

This pair of portraits exhibits nicely the general characteristics of Porter's "Side views painted in full colours," which he advertised and illustrated on his printed handbill. The construction of the ears and eyes and the distinctive manner in which he rendered women's lace ruffs and men's stocks is consistent in the group of profile works on paper, for which he is said to have charged one dollar apiece. Another practice observed in the execution of these two portraits and several other Porter miniatures was his use of the borders of the paper (which were covered in the framing) as a test palette.

In the artist's instructions for painting miniature portraits, published about twenty-five years after these likenesses were taken, Porter followed, or at least advocated, set procedures for developing and coloring such portraits. "In finishing the face and hair, the light parts must be preserved," he warned, "for white paint must not be used, except to produce some small specs representing the reflection of light from the eyes, or from jewellery."[1] That the lesson was evidently learned from experience is proved by the portrait *Profile of Lady with Ruff,* in which Porter has unsuccessfully used white gouache to conceal coloring errors below the ear and on the jaw.

Inscriptions/Marks: Primary support of no. 142 bears the partial watermark "[?]RESWICK/1818," probably for the English papermaker Ann Creswick. None found on no. 143.

144 Girl in Green Dress 63.300.1

Attributed to Rufus Porter
Probably New England, probably 1820-1825
Watercolor, ink, and gouache on laminated laid papers
4³/₁₆" x 2¹⁵/₁₆" (10.6 cm. x 7.5 cm.)

Girl in Green Dress exhibits the rendering of eye and ear characteristic of Rufus Porter's work. Also typical of

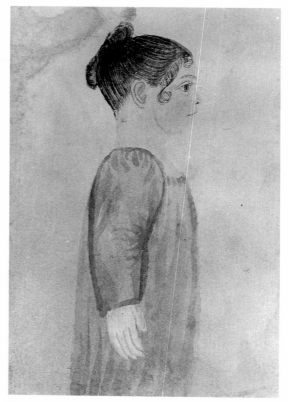

144

Porter's style is the loosely painted, monochromatic modeling apparent on the shoulder of the dress. Chronologically, the likeness is the earliest of three recorded portraits of children by Porter, and it is the only portrait attributed to him in which the artist has attempted to depict hands. Porter rarely deviated from half-length poses, perhaps in an attempt to avoid the very problems encountered here. The hand is painted in white gouache, which gives the impression that the girl is wearing a glove.

Inscriptions/Marks: None found.[1]
Condition: Restoration by E. Hollyday in 1976 included cleaning, reducing water staining, and re-adhering loosened layers of the primary support. Probably original ¾-inch mahogany-veneered flat frame.
Provenance: Mary Allis, Fairfield, Conn.

[1]The primary support actually consists of five separate layers of paper bonded together; although no watermark or other inscriptions are presently discernible, separating the layers might reveal some markings hitherto obscured.

145

145 Eli Ensign Root 58.300.11

Attributed to Rufus Porter
Probably Massachusetts, ca. 1825
Watercolor and ink on wove paper
4⅛" x 3¼" (10.5 cm. x 8.3 cm.)

Several earlier catalogs (see *Exhibited*) identify the sitter as Eli Ensign Root and locate him in Sheffield, Massachusetts, assertions that have not yet been verified.

Under magnification, a delicate stippled modeling technique can be observed in the rendering of this subject's face, which adds a degree of subtlety and sensitivity to what would appear to be the simplest variety of profile watercolor portrait offered by Porter at this point in his career.

Inscriptions/Marks: Incised in block letters in the lower front frame edge is "EER." Transcriptions in AARFAC records indicate that the frame backing or a secondary support bore the later penciled inscription "Eli Ensign Root, born Jan. 1800," but this backing or support is now missing. No watermark found.
Condition: Unspecified restoration by Christa Gaehde in 1958. Original 3-inch oval frame, painted black.
Provenance: J. Stuart Halladay and Herrel George Thomas, Sheffield, Mass.
Exhibited: Halladay-Thomas, Albany, and exhibition catalog, no. 60 (titled *Eli Ensign Root of Sheffield, Massachusetts*); Halladay-Thomas, Hudson Park; Halladay-Thomas, New Britain, and exhibition catalog, no. 151 (titled *Eli Ensign Root of Sheffield, Massachusetts*); Halladay-Thomas, Syracuse, and exhibition catalog, included in nos. 66-97.

146 Portrait of a Woman 58.300.15

147 Portrait of a Man 58.300.14

Attributed to Rufus Porter
Probably New England, probably 1830-1835
Watercolor and ink on wove paper
4" x 3" (10.2 cm. x 7.6 cm.)

Portrait of a Woman and its companion *Portrait of a Man* are representative of the later phase of Porter's work insofar as the modeling technique he used generally exhibits more pronounced stippling and crosshatching compared with that used in some of his earliest profiles.

Porter seems to have been offering full-face likenesses as early as 1820-1825, but in more than fifty recorded examples of his portraiture, the pose appears infrequently before 1830-1835. Full-face poses such as these presented more challenges to the artist and were thus more time-consuming and more expensive for the client; Porter charged three times as much for them as

146 Attributed to Rufus Porter, *Portrait of a Woman*

147 Attributed to Rufus Porter, *Portrait of a Man*

for side views. Although these two unidentified subjects are fairly convincingly rendered, Porter betrays a reliance on habit and formula in the drawing of their ears, which are still depicted in full profile, a fault commonly seen in his attempts at full-face portraiture.

Condition: Unspecified restoration by Christa Gaehde in 1958. Probably original 2-inch molded walnut frames with gilt inner liners.
Provenance: J. Stuart Halladay and Herrel George Thomas, Sheffield, Mass.
Published: Walters, Pt. 2, no. 146 only, p. 2C, illus. as fig. 18 on p. 4C.

Asahel Lynde Powers
(1813-1843)

An exhibition at the Springfield (Vermont) Art and Historical Society Museum in 1958 provided the nucleus of stylistically related portraits with which Nina Fletcher Little began her research for the Folk Art Center's 1973 showing of Asahel Powers's work,[1] by which time fifty-four signed or attributable portraits had been located. Since then, more than twenty more likenesses have been recorded.

Asahel Lynde Powers was born February 28, 1813, the first of the seven children of Asahel Powers, Jr., and Sophia Lynde Powers of Springfield, Vermont.[2] By age eighteen young Asahel had begun his career as a portraitist, depicting nearby residents in half- to full-length seated poses with considerable originality. His works from the early 1830s frequently incorporate a novel background device that most closely resembles sheer drapery hanging from decorative rods that curve inward over the sitter's head and focus attention on it. The treatment is so stylized that in some instances one perceives only swirling lines that seem to radiate outward from the figure.[3] Such handling undoubtedly contributes to the sense of nervous energy that permeates Powers's portraits of this period. Furthermore, an uneasy jumble of conflicting planes and impossible angles puts sitters' chairs and other props into a visual state of upheaval,[4] and the painter's tireless devotion to minute linear detail makes these likenesses unusually busy.

Several portraits signed by "Powers & Rice" indicate that by 1835 a partnership of relatively brief duration had been formed. "Rice" may have been Daniel Rice of Springfield, a bookseller and later a writer and publisher, but exactly what the men's respective roles in

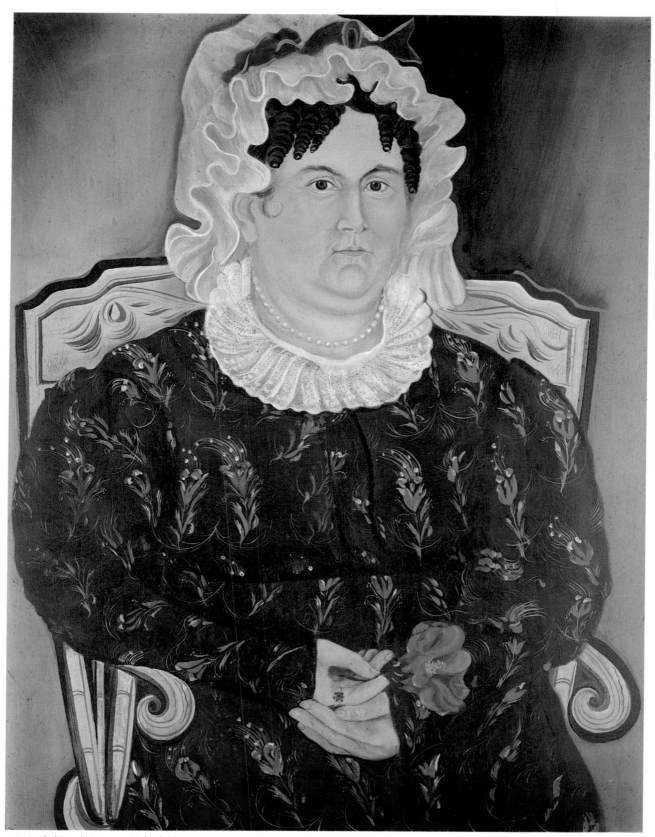

148 Asahel Lynde Powers, *Debrah Martin*

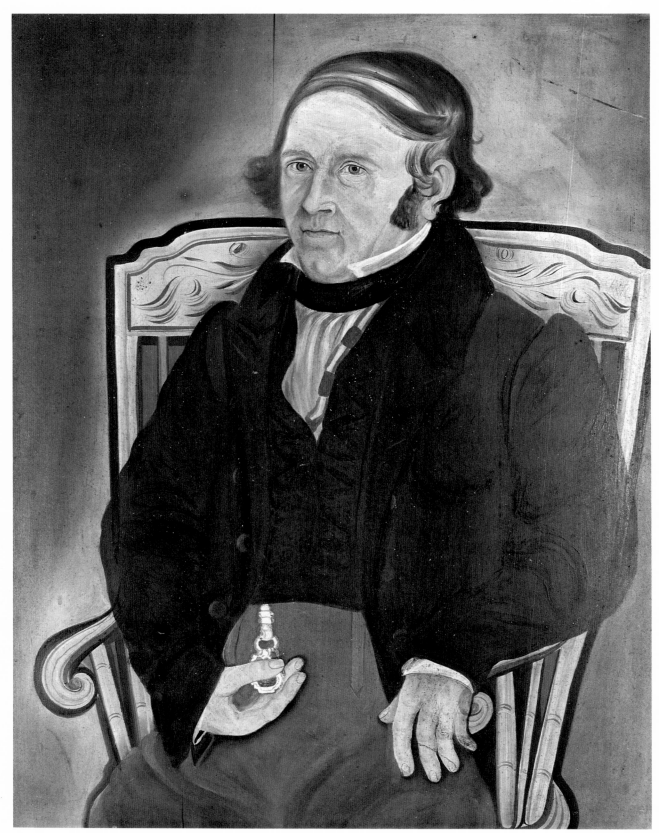

149

the partnership were has not yet been determined. By June 1836 Powers was again signing paintings with his name alone.[5]

During 1839-1841 Powers worked in Clinton and Franklin counties in upstate New York, in many instances painting Vermont citizens who had moved west. An allusion to a wife, Elizabeth M., is found in Clinton County records, but she appears not to have accompanied him when he left New York for Olney, Richland County, Illinois, where his parents had settled by 1841. Powers died there on August 20, 1843, leaving a meager estate and no heirs. No portraits from his last years in Illinois have been recorded as yet.

Works dating from the late 1830s and early 1840s evidence Powers's preoccupation with and growing mastery of academic principles, an expected evolution of style for the self-taught artist who kept his eyes open and acknowledged an increasing public demand for "realism" in portraiture. His latest paintings exhibit considerable technical proficiency, but one detects in them little of the earlier originality and vitality for which he is so well known today.

[1]This research is summarized in the exhibition catalog that accompanied AARFAC, Powers. The Springfield Art and Historical Society Museum was known as the Miller Art Center at the time of the exhibition.

[2]A privately owned double portrait of John and Mary Ann Creighton signed "A. Lynde Po—— [illeg.]" confirms Nina Fletcher Little's suspicion that he had been given his mother's maiden name. Ibid., p. 7.

[3]See, for example, the privately owned portrait of Daniel Cobb III, ibid., p. 21, no. 11, illus. as no. 11 on p. 20.

[4]A good example is the portrait of Charles Mortimer French at the New York State Historical Association, Cooperstown, ibid., p. 16, no. 5, illus. as no. 5 on p. 17.

[5]However, one of three recently discovered portraits of members of the Griswold-Field family of Springfield, Vt., is reputedly dated "June 23/1837," and a modern, typed label on its reverse describes it as the work of "Powers & Rice." If the joint ascription and date given are both correct, Powers's and Rice's partnership must have been intermittent in 1836-1837. See acc. nos. 65.893, 65.894, and 65.895 in the Eleanor and Mabel Van Alstyne American Folk Art Collection, Smithsonian Institution.

148 Debrah Martin — 75.100.2

149 John Martin — 75.100.1

Asahel Powers
Probably Vermont or Connecticut, 1833
Oil on wood panel
33½" x 25" (85.1 cm. x 63.5 cm.)
33½" x 25½" (85.1 cm. x 64.7 cm.)
(No. 148 is reproduced in color on p. 173)

These expressive portraits exhibit many of the characteristics of Asahel Powers's early work, including heavy gray shadowing, strong black outlines, and boldly painted, loose, swirling depictions of fabrics. The folk artist's typical fastidious attention to details of costumes and accessories is evidenced in the elegant black embroidery of John Martin's vest and the colorful floral design of Debrah's dress. Powers used gold leaf to depict John's watch fob instead of the usual yellow paint.

The Martins' precise identities have not yet been determined. Three men with this surname, all grandsons of the English immigrant George Martin (?-ca. 1686), settled in Windham, Connecticut, before 1710, and other descendants eventually located in Williamstown, Vermont. The names John and Deborah occur frequently in the Connecticut-Vermont branch of the family, and probably these sitters belonged to it.[1] Debrah's relationship to John is also unclear. At age thirty-one, she could have been either a young wife or a daughter of—or even more distantly related to—fifty-three-year-old John.

Inscriptions/Marks: On the verso of no. 149 is "John Martin/AE 53 Painted by/A Powers"; in painted script on the verso of no. 148 is "Debrah Martin/AE 31 1833/A Powers." In both instances, the initials "A" and "P" of the signature are combined.

Condition: No evidence of previous conservation. Original 1½-inch molded frames, painted black, with gold-painted edges.

Provenance: Mr. and Mrs. Donald H. Ladd, Hampton, Conn.; Maze Pottinger Antiques, Bloomfield Hills, Mich.

Exhibited: AARFAC, Powers, and exhibition catalog, no. 149, p. 25, illus. as no. 18, and no. 148, p. 26, no. 19, illus. as no. 19 on p. 27.

Published: AARFAC, 1975, illus. on p. 10; Karen M. Jones, "Museum accessions," Antiques, CX (November 1976), p. 914, no. 149 only, illus. on p. 914; Nina Fletcher Little, "Asahel Powers, painter of Vermont faces," Antiques, CIV (November 1973), p. 851, no. 148 only, illus. as fig. 4 on p. 847.

[1]See the exhibition catalog for AARFAC, Powers, p. 25.

William Matthew Prior
(1806-1873)

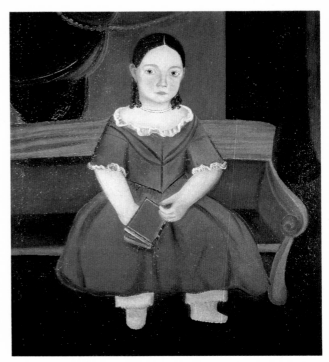

153

William Matthew Prior was born May 16, 1806, in Bath, Maine, the son of sea captain Matthew Prior.[1] Little information survives concerning his childhood and youth except for the family legend that, as a small boy, he drew a chalk portrait of his father or grandfather on a barn door, thereby eliciting the admiration of neighbors.[2] Prior's self-acknowledged "first portrait" was executed at age seventeen, but the panel was subsequently cut into smaller sections and overpainted by Prior with landscape scenes that survive, bearing the original inscription fragmented on the versos.[3]

Until recently there has been no evidence of where or from whom Prior might have received his early training; however, the inscription on an 1824 portrait offers a tantalizing tidbit of information: "W. M. Prior, Painter/Formerly of Bath/1824/3 piece on cloth/Painted in C. Codman's Shop/Portland, Maine."[4] Charles Codman was a portrait, landscape, marine, and sign painter who worked in Portland as early as 1823. He may have offered Prior an informal apprenticeship, or he may simply have provided him studio space, as the inscription indicates he did on at least one occasion.

In 1825 young Prior posed with palette and brush in hand for his first self-portrait, rendering it confidently and sensitively in the "academic" style.[5] Although he evidently began painting portraits in 1823, an advertisement in the *Maine Inquirer* dated June 5, 1827, describes only his skills as a fancy, sign, and ornamental painter and decorator. The first recorded mention of Prior as a portrait artist occurs in a *Maine Inquirer* advertisement that appeared February 28, 1828, and ran for some months thereafter. "Portrait painter, Wm. M. Prior, offers his services to the public. Those who wish for a likeness at a reasonable price are invited to call soon. Side views and profiles of children at reduced prices."[6] Prior's earliest portraits prove that he was capable of painting in a very realistic, polished manner before 1828, and the advertisement offers a preliminary hint of the practice for which he is best remembered today — price adjustment according to the type of work requested by the client. An 1830 notice indicates that his portraits ranged in price from ten to twenty-five dollars, further demonstrating his flexibility in satisfying his customers' needs and simultaneously accommodating their financial limitations. The closing sentence of an April 5, 1831, *Maine Inquirer* advertisement succinctly summarizes his pricing philosophy and describes the works that are perhaps most commonly associated with Prior and other artists who painted in a similar style: "Persons wishing for a flat picture can have a likeness without shade or shadow at one quarter price."[7] Such "flat" portraits are so strongly and popularly linked with Prior's hand that his academic proficiency should be noted in order to keep his abilities in the proper perspective. In the same year that he advertised unshaded likenesses, Prior exhibited a rather accomplished portrait of Abraham Hammatt at the Boston Athenaeum alongside works by some of the most highly respected artists of the day.[8]

Prior seems to have traveled between Bath and Portland in the 1820s. He married Rosamond Clark Hamblin in Bath in 1828, and their first two children were born there in 1829 and 1831. Prior's brothers-in-law were also painters, and his acquaintance with them developed into an enduring relationship in Portland, where he settled sometime between 1831 and 1834.[9] By 1841 Prior, his family, and his Hamblin in-laws had moved to Boston, and there the artist established him-

self on a popular level as one of the most versatile and locally influential painters of his day. Prior was listed continuously in Boston business directories from 1841 until he died in 1873, except for the years 1844-1845, an omission that suggests a period of itinerancy. Later dated and inscribed works show that he traveled and worked in locations as far south as Baltimore on more than one occasion.[10] By 1852 he had established himself at 36 Trenton Street, a location he called the "Painting Garret."[11]

As photography continued to encroach on the commissions of many portrait painters, Prior persisted in publicizing his cut-rate category of portraiture as evidenced by a rare printed and partially handwritten label affixed to the back of one of his unshaded likenesses executed about 1848: "PORTRAITS/PAINTED IN THIS STYLE!/Done in about an hour's sitting./Price $2,92, including Frame, Glass, &c./Please call at Trenton Street/East Boston/WM. M. PRIOR."[12] At about the same time he began to devote more time to other types of painting. His "fancy pieces," which include historical, imaginary, topographical, and foreign landscape subjects, date from the 1850s.[13] By the 1860s Prior initiated a series of portraits of famous personages reverse-painted on glass.[14]

The artist also wrote two books as a result of his involvement in the beliefs of William Miller, a chronologist who originated the Adventist movement and prophesied that the second coming of Christ and the end of the world would occur between March 21, 1843, and March 21, 1844. Prior's visionary beliefs enabled him to paint posthumous portraits "by spirit effect," such as the 1865 likeness of his brother Barker, who had been lost at sea with their father in 1815.[15] It is interesting to note that after the artist's death in Boston on January 21, 1873, his second wife, Hannah Frances Walworth Prior, was described as a clairvoyant in the city directory.

Prior's versatility, productivity, commercial practices, and the influence he exerted on other artists make him one of the most interesting subjects in a study of American folk portraitists. Facets of his style and oeuvre are discussed in the following entries, and his relationships with other artists represented in this collection are examined in the commentaries for Sturtevant J. Hamblin and William W. Kennedy.

[1]Much of the biographical information in this entry, including uncited references to advertisements placed by the artist in early newspapers, is from Little, Prior.

[2]Information from an interview with Marion G. Prior, William Matthew Prior's granddaughter, 1975.

[3] The portrait/landscape panels are privately owned.

[4]The privately owned portrait was listed in Sotheby Parke Bernet, Americana, catalog for sale no. 3134, lot no. 116, December 11-12, 1970.

[5]The self-portrait is privately owned and is illustrated in Lyman as fig. 1 on p. 180.

[6]As quoted in Little, Prior, p. 44. Prior's only recorded profile portrait (and only recorded work in watercolor, for that matter) is of a young man, dating to about 1830. It is privately owned.

[7]Prior and the price scale concept are discussed in some detail in the Introduction to this catalog.

[8]The portrait of Abraham Hammatt is privately owned. See the Introduction, p. 27 and n. 21.

[9]Details of this relationship are provided in the Commentary for Sturtevant J. Hamblin.

[10]Baltimore works by Prior include a portrait of an unidentified man dated 1852 and a landscape dated 1855, both privately owned.

[11]Prior often used a stenciled or stamped notation on the back of his work at this time; it reads "Painting Garret/No. 36 Trenton Street/East Boston/W. M. Prior."

[12]Little, Prior, p. 45. The label and the portrait of Nathaniel Todd to which it is affixed are illustrated in Selina F. Little, "Phases of American Primitive Painting," Art in America, XXIX (February 1951), as fig. 2 on p. 8.

[13]Prior's oldest son, Gilbert Stuart Prior, is listed in the Boston directory for 1856 as a landscape painter; he may have collaborated with his father at this point, but ultimately he pursued a career as an engineer, not as a painter.

[14]See no. 152 for a discussion of Prior's reverse paintings on glass.

[15]Barker Prior's portrait is privately owned. It is illustrated in Lyman as fig. 2 on p. 180.

150 **Portrait of a Man** 58.100.56

Attributed to William Matthew Prior
Probably New England, ca. 1845
Oil on academy board
17⅜" x 14¼" (44.1 cm. x 36.2 cm.)

This relatively simple but direct likeness is thoroughly representative of Prior's least expensive portraiture. The type of support, its dimensions, and especially the economical rendering of facial features are factors that relate the painting to a group of "flat" style likenesses safely attributed to Prior on the basis of a labeled and signed portrait of Nathaniel Todd in a private collection.[1] This likeness of Nathaniel Todd and that of his wife offer reliable means of distinguishing stylistically between Prior's pared-down portraiture and works by others who painted in a related style.

Condition: No evidence of previous conservation. Probably original 3½-inch cyma reversa mahogany-veneered frame with gilt liner.
Provenance: J. Stuart Halladay and Herrel George Thomas, Sheffield, Mass.

[1]The portrait of Nathaniel Todd and a companion portrait of his wife are illustrated in Little, *Prior*, p. 45, fig. 3. The label is illustrated in Selina F. Little, "Phases of American Primitive Painting," *Art in America*, XXXIX (February 1951), p. 8, fig. 2.

the auxiliary support, and inpainted numerous areas of paint loss in the background and face, primarily the nose, forehead, and cheeks. Possibly original 2½-inch gilded cyma recta frame with applied plaster decoration.

Provenance: Bessie J. Howard, Melrose, Mass.
Published: AARFAC, 1957, p. 352, no. 196.

151 Mrs. M. G. Trow 36.100.13

Attributed to William Matthew Prior
Possibly Lynn or Danvers, Massachusetts,
possibly 1852
Oil on canvas
24″ x 19¾″ (61.0 cm. x 50.2 cm.)

Early records on this portrait imply that it is signed and dated on the back of the original canvas and that the sitter's age is given as twenty-five, an inscription practice commonly used by Prior. Mrs. Rockefeller purchased and owned briefly a companion portrait of a child identified as Mrs. Trow's daughter Serina, also clearly painted by Prior. Serina Trow is said to have lived in Lynn and Danvers, Massachusetts. Her portrait, now privately owned, shows a view out a window and features personalizing accessories such as a rattle on the floor at her feet. Mrs. Trow's portrait is plain by comparison, its most interesting feature being the manner in which Prior has rendered her silk or taffeta dress in lustrous, almost iridescent colors.

Inscriptions/Marks: None found, but see *Commentary.*
Condition: In 1954 Hans E. Gassman lined the canvas, replaced

152 George Washington 32.500.2

Attributed to William Matthew Prior
Probably Massachusetts, ca. 1865
Reverse oil painting on glass
21½″ x 17″ (54.6 cm. x 43.2 cm.)

William Matthew Prior was a long-time admirer of Gilbert Stuart and even named his eldest son Gilbert Stuart Prior after the famous American artist. Probably inspired by Stuart's famous portrait of George Washington sold by Mrs. Stuart to the Boston Athenaeum in 1828, Prior painted an oil portrait on panel of the first President as early as 1830.[1] During his lifetime, Stuart retained the unfinished bust-length portrait of Washington as a model for his own copies, having remarked to a friend that he had come to America "to realize a fortune" by making "a plurality of his [Washington] portraits."[2] In 1850, reportedly after three years of persistent effort, Prior was given permission to make a direct copy of the Athenaeum Washington; this version, which now resides in the Watertown, Massachusetts, Public Library, is inscribed on the back "Copy from G. Stuart/By Wm. M. Prior/1850." That oil or another copy

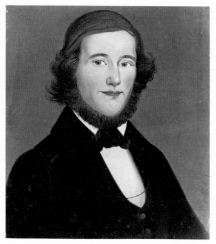

150

151

152

like it evidently served as a model for the numerous likenesses that Prior reverse-painted on glass mostly in the 1860s and continued to produce until his death in 1873.

Other popular famous persons that Prior painted on glass include Martha Washington, Benjamin Franklin, Napoleon (two versions), Daniel Webster, Abraham Lincoln, Ulysses S. Grant, General George D. McClellan, and the noted theologian Theodore Parker. Several of the surviving Prior glass portraits are signed, and some have a stamped signature and address on the back.[3] One pair of the George and Martha Washington portraits bears a verso inscription indicating that in 1868 the artist charged $8 for a single glass painting and $15 for the Washington pair.[4] According to one account, Prior used to peddle his glass portraits in the Boston shipyards on Saturday paydays.[5]

Condition: No evidence of previous conservation. Period replacement 2¾-inch cove-molded and gilded frame.
Provenance: Found in Hanover, N.H.
Published: AARFAC, 1957, p. 375, no. 362.

[1]The earliest recorded dated portrait of Washington by Prior is inscribed "Geo Washington/Painted by/Prior/July 3 1830." It is in the collection of A. D. Pottinger.
[2]John Hill Morgan and Mantle Fielding, *The Life Portraits of Washington and Their Replicas* (Philadelphia, 1931), p. 219.
[3]"Queries and Opinions," *Antiques*, XXV (February 1934), p. 78.
[4]Edith Gaines, ed., "Collectors' Notes," *Antiques*, CI (March 1972), p. 505.
[5]Lyman, p. 180. Although not so stated by the author, this information was evidently obtained from an interview with Matthew Prior, the artist's son, who joined his father in the painting business for a time.

treatment here is most suggestive of either Prior himself or William Kennedy. Yet the clumsiness and lack of skill in rendering the body, particularly the arms and hands, are uncharacteristic of any of the artists now associated with the group. At least one other painting does seem to be related, but nothing in its documentation or style offers a solution to the problem of attribution.[3] Undoubtedly the influence exerted in the popular art market by Prior, Hamblin, and other followers encouraged imitators who perhaps lacked the proficiency to succeed.

Condition: Treatment presumed to have been done by Russell J. Quandt in 1955 included cleaning, lining with a Masonite secondary support, and inpainting scattered areas of paint loss throughout. Probably original 3-inch cove-molded gilded frame with quarter-round outer edge.
Provenance: Robert Laurent, Ogunquit, Me.; Edith Gregor Halpert, Downtown Gallery, New York, N.Y.
Exhibited: AARFAC, April 22, 1959-December 31, 1961; American Folk Art; "American Primitives: An Exhibit of the Paintings of Nineteenth-Century Folk Artists," Newark Museum, Newark, N.J., November 4, 1930-February 1, 1931; William Penn Museum.
Published: AARFAC, 1940, p. 18, no.12; AARFAC, 1947, p. 14, no. 12; AARFAC, 1957, p. 114, no. 60, illus. on p. 115; AARFAC, 1959, p. 32, no. 30, illus. as no. 30 on p. 33; Cahill, p. 30, no. 7; Elinor B. Robinson, "American Primitive Paintings," *Antiques*, XIX (January 1931), p. 35, illus. as frontispiece on p. 10.

[1]The five are William M. Prior, Sturtevant J. Hamblin, William W. Kennedy, George Hartwell, and E. W. Blake.
[2]Three portraits within the stylistically related group are in the AARFAC collection, nos. 154-156.
[3]The portrait, *Young Girl in Blue Dress*, was advertised by Palmiter & Shoemaker, Inc., in the *Newtown Bee* (Conn.), February 3, 1978, p. 47.

153 Girl Seated on Bench 31.100.6

Style of William Matthew Prior
Probably New England, ca. 1845
Oil on canvas
26″ x 22″ (66.0 cm. x 55.9 cm.)
(Reproduced in color on p. 10)

Although most Prior-style portraits that have been recorded through recent research can be assigned to one of the five artists who worked in this manner based on signed or documented examples,[1] a small group of stylistically related portraits and a few individual likenesses elude a specific attribution.[2] One such isolated specimen is *Girl Seated on Bench*. The compositional device of swagged drapery in the background was popular with all the Prior-style artists, although its

154 Woman in Pink Bow and Brooch 58.100.53

Style of William Matthew Prior
Probably New England, ca. 1845
Oil on academy board
13⅞″ x 10⅛″ (35.2 cm. x 25.7 cm.)

Although there are over two dozen portraits by this same unidentified hand recorded in the Folk Art Center's research files, no signed portraits have been located that would make a firm or fully satisfactory attribution to one of the Prior-style artists possible at this time. The modeling and shading in the portraits may be as sketchy as Prior's, but they lack the degree of full facial structure and rendering skill that is evident even in Prior's most economically realized works, such as no. 150. Furthermore, the portraits in the variant style group do not

154

155

156

possess the characteristics associated with Sturtevant J. Hamblin's documented or related works. Since documented specimens of portraiture by Joseph G. Hamblin, who for a time is listed in the Boston business directory as a portrait painter, have not been located to date, perhaps his name should be kept in mind as research proceeds. See also nos. 155 and 156.

Condition: Treatment, presumably by Russell J. Quandt about 1961, included cleaning and mounting on a secondary support of heavy cardboard. Probably original 2⅛-inch splayed mahogany-veneered frame with flat outer edge. The outer edge has an inlaid border of alternating light and dark woods.
 Provenance: J. Stuart Halladay and Herrel George Thomas, Sheffield, Mass.
 Exhibited: AARFAC, American Museum in Britain; AARFAC, June 4, 1962-March 31, 1965.

155 Possibly Joseph E. Johnson 78.100.1

Style of William Matthew Prior
Possibly Havre de Grace, Maryland, ca. 1850
Oil on academy board
14⅛" x 10½" (35.9 cm. x 26.7 cm.)

The previous owner's identification of this subject as Joseph E. Johnson of Havre de Grace, Maryland, has not been verified. Although William M. Prior and William W. Kennedy are known to have worked in nearby Baltimore, the portrait does not bear the distinguishing characteristics of either artist. The extent of travel southward from New England by other artists in

the Prior-style group—Sturtevant J. Hamblin or his brothers, for instance—has not been documented to date. For *Commentary* on the style group in which the painting does seem to fit, see nos. 154 and 156.

Condition: In 1978 E. Hollyday removed buckles in the primary support, lined it with Japanese mulberry paper, and mounted it on a honeycomb aluminum support lined with ragboard and Japanese mulberry paper. The painting was cleaned and small losses in the dress and background were inpainted. Modern replacement 1-inch cyma recta frame, painted flat black.
 Provenance: Gift of Miss Mary Ethel Lynch.

156 Baby with Whip 36.100.6

Style of William Matthew Prior
Probably New England, ca. 1850
Oil on academy board
14⅝" x 10⅜" (37.1 cm. x 26.4 cm.)

Several portraits of small children with whips in their hands and in this same pose form a style group that cannot be immediately assigned to William M. Prior, Sturtevant J. Hamblin, William W. Kennedy, E. W. Blake, or George Hartwell.[1] Although the rendering of facial structure in this portrait approaches the work of Prior himself, the delineation of hands is quite unlike the formulas developed by Prior and Hamblin: in such a pose Prior usually described hands as an elliptical mass, each finger resembling a puffy cigar; Hamblin usually drew a hard, dark line around fingers and hand in cartoonlike fashion (see, for example, no. 85). The

157 Attributed to David Ryder, *Arabella Sparrow*

hands and face of the baby in this portrait have a vague-ness of modeling that easily sets it apart from the documented work of identified artists in the Prior-style group. See also the *Commentary* for no. 154.

Inscriptions/Marks: A penciled inscription on the reverse of the support, not in Prior's handwriting, appears to read "Mis Macmejter Mulbury 1 year 9/Hencieele/Gill pt."

Condition: The painting was cleaned by Russell J. Quandt in 1955 and lined with a Masonite secondary support. Period replacement 3-inch splayed mahogany-veneered frame with flat outer edge.

Provenance: Katrina Kipper, Accord, Mass.

Exhibited: AARFAC, September 15, 1974-July 25, 1976; Philbrook Art Center.

Published: AARFAC, 1957, p. 353, no. 201; AARFAC, 1974, p. 19, no. 1, illus. as no. 1 on p. 10.

[1]Of these artists, only Hartwell and Blake are not represented in this collection. See no. 155 for a similarly posed portrait of a child.

David Ryder
(active 1848)

157 Arabella Sparrow 61.100.1

Attributed to David Ryder
Probably Middleboro, Massachusetts, 1848
Oil on canvas
41½" x 35¼" (105.4 cm. x 89.5 cm.)
(Reproduced in color on p. 181)

Many years after this engaging portrait of a child's world was completed, the subject attached a note to the back of the painting that reads, "Portrait of/Arabella 'Lois' Sparrow Southworth./At 3 years of age—Painted by/Mr. David Ryder/of Rochester, Mass. my father's/old home—I was sitting in/the front room on a cricket/with—strawberries in my hand/to keep me quiet—at the/Sparrow home on/Wareham St.—1848."

The fidgety child was painted in her parents' parlor, while the vine-covered pillar and colorful summer garden overlooking a field and farmhouse were apparently added later, probably from memory or from a sketch.

David Ryder remains an elusive figure. Except for Mrs. Southworth's notation, nothing is known about him or about the extent and nature of his career as an artist. In this painting, the facile handling of foliage, flowers, and landscape details contrasts sharply with the flat, wooden treatment of the child and suggests the hand of someone more accustomed to creating wall

murals or other forms of ornamental painting than with portraiture.

Arabella Sparrow, daughter of Jacob Y. and Lois Macomber Sparrow, was born in Middleboro, Massachusetts, in 1845 and lived there throughout her life. She married Rodney J. Southworth in 1866, became a popular local vocalist, and died in 1928 at the family home on Wareham Street.

Inscriptions/Marks: See *Commentary.*

Condition: In 1961 Russell J. Quandt cleaned the painting and inpainted a small area in the sky. Original 2¾-inch board frame, painted red brown.

Provenance: Miss Sara Andrews, Ashaway, R.I.

Exhibited: AARFAC, September 15, 1974-July 25, 1976; Philbrook Art Center.

Published: AARFAC, 1974, p. 28, no. 21, illus. on p. 29; *Middleborough Antiquarian,* XVIII (April 1978), p. 3.

Ruth Whittier Shute
(1803-1882) and
Dr. Samuel Addison Shute
(1803-1836)

Paintings and drawings bearing the Shute name have been known for many years, but only recently has Helen Kellogg's systematic research revealed any of the significant facts of the lives and the respective styles of the itinerant artists heretofore known only as R. W. and S. A. Shute.[1]

The complex problem of determining the two artists' individual contributions to their collaborative efforts has been resolved to some extent by the discovery of several works known to have been done by Ruth alone; three inscriptions reading, in part, "Drawn by R. W. Shute/and/Painted by S. A. Shute" have also provided a useful clue to their division of labor. Although a number of works—primarily watercolors—have been speculatively attributed to Samuel's hand alone, to date no signed or otherwise documented specimens have been found to verify the attributions. Ascriptions to Samuel have thus far been based on his personal style, derived in part by deleting visually Ruth's contributions from their joint efforts. Moreover, attribution to Samuel provides logical authorship for a well-known body of works that has long puzzled Shute students by its curious mixture of similarities and differences with respect

to documented joint works. If the group of boldly abstract, brightly colored, and unshaded likenesses is indeed the work of Samuel alone, then some of the implications of the inscriptions quoted above take on concrete meaning, for the extensive penciled definition of facial features would clearly denote Ruth's "drawing," while vivid, largely flat coloration would certainly constitute at least one facet of Samuel's "painting." Recent studies indicate that Samuel may also have been responsible for a number of subdued, almost monochromatic likenesses in browns and blacks, and a marked proclivity for patterned backgrounds may reflect his influence.

Ruth Whittier was born in Dover, New Hampshire, October 28, 1803, the eighth of nine children of Obadiah and Sarah Austin Whittier.[2] The son of Aaron and Betsey Poore Shute, Samuel Addison Shute was born in Byfield, Massachusetts, on September 24, 1803. Samuel and Ruth were married on October 16, 1827, and initially settled in Weare, New Hampshire. Presumably marriage coincided with the beginning of their joint artistic endeavors, because no paintings or drawings that conclusively predate their union are known. Samuel was a physician and is thought to have practiced medicine along with portrait painting. A large "M. D." on his tombstone implies that his profession was a source of considerable pride to the family. Ruth gave birth to two girls by Samuel Shute: Adelaide Montgomery (born March 4, 1829), who was described as an invalid and who never married, and Maria Antoinette, who died on February 4, 1831, at the age of only nine days. These births and tragedies accord with a hiatus in Ruth's work and may also explain a new sensitivity in her portraits beginning in 1831.

Sitters' residences and surviving documentary evidence such as newspaper advertisements indicate that the Shutes traveled throughout New England and upper New York state in search of portrait commissions. Samuel may have been ill for some time before his death because Ruth worked largely alone during this period. He died January 30, 1836, in Champlain, New York, and was buried in Concord, New Hampshire. In 1840 the widowed Ruth married Alpha Tarbell in Concord, and Whittier genealogies state that the couple went to live in Kentucky. The date of their departure south is unknown, but their two daughters are noted as having been born in Louisville. Ruth died September 26, 1882.

[1] The initial results of Mrs. Kellogg's research were published in Helen Kellogg, "Found: Two Lost American Painters," *Antiques World*, I

(December 1978), pp. 36-47. Mrs. Kellogg has since considerably expanded our knowledge of the Shutes, and at present she is still engaged in active research on the pair. Factual information in this entry is from conversations with Mrs. Kellogg and from her article.
[2] The Quaker poet and abolitionist John Greenleaf Whittier was a first cousin of Ruth's on her father's side of the family and a second cousin on her mother's.

158 Lady in Blue 35.300.3

Attributed to Ruth Whittier Shute
and Dr. Samuel Addison Shute
New York state or New England, possibly
New Hampshire, possibly 1832-1833
Watercolor, gouache, pencil, and gold foil collage
on wove paper
5⅞" x 4⅝" (14.9 cm. x 11.7 cm.)
(Reproduced in color on p. 184)

This miniature portrait attributed to the Shutes bears all of the characteristics of their jointly executed full-scale watercolors, including a streaked background, distinctive pencil draftsmanship of facial features, the use of gouache in describing lace details, and collage elements—in this instance, the sitter's gold foil buckle and drop earrings.

Stephen Van Rensselaer, from whom *Lady in Blue* was purchased, maintained a shop in Peterborough, New Hampshire, locating in Williamsburg only during the winter months. He probably acquired this portrait in New England, possibly in Peterborough itself. An oil portrait inscribed "No. 15/Painted by S. A. and R. W. Shute/January 11, 1833/for/Elizabeth Piper Peterborough N. H." confirms the fact that the Shutes were working there during the period when this unidentified young woman sat for her portrait.[1]

Inscriptions/Marks: Penciled on the reverse of the frame along one side in what appears to be modern handwriting is "Margaret Grimes." No watermark found.
Condition: Torn corners were mended and the entire support was backed with Japanese mulberry paper by E. Hollyday in 1974. Period replacement ⅝-inch gilt frame.
Provenance: Stephen Van Rensselaer, Williamsburg, Va.
Exhibited: "Arthur Dove: The Years of Collage," University of Maryland Fine Arts Gallery, College Park, March 13-April 19, 1967; "Collector's Choice," Museum of American Folk Art, New York, N.Y., September 7-November 30, 1969.
Published: AARFAC, 1940, p. 26, no. 63; AARFAC, 1947, p. 24, no. 63; AARFAC, 1957, p. 146, no. 73, illus. on p. 147; Helen Kellogg, "Found: Two Lost American Painters," *Antiques World*, I (December 1978), p. 43, no. 31; Walters, Pt. 3, p. 2C, illus. as fig. 8 on p. 3C.

[1] The portrait is at Old Sturbridge Village, Sturbridge, Mass.

159 Portrait of a Young Man 58.200.3

Attributed to Ruth Whittier Shute
and Dr. Samuel Addison Shute
New England or New York state, possibly
1833-1836
Pastel, watercolor, and pencil on wove paper
27⅜" x 20¾" (69.5 cm. x 52.7 cm.)

This example combines a pastel image with a water-color background. Watercolor backgrounds streaked with long brushstrokes in the manner seen here have long been associated with the Shutes, but no. 159 is the only one of nine large pastel likenesses ascribed to either or both artists that incorporates this distinctive feature. This portrait is also one of only two known Shute portraits in any medium in which the streaking is verti-cal rather than horizontal or diagonal.[1] The retention of watercolor for the background rendering is supportive of a Shute attribution, and the penciled definition of facial features closely resembles that seen in a broad range of the Shutes' work.

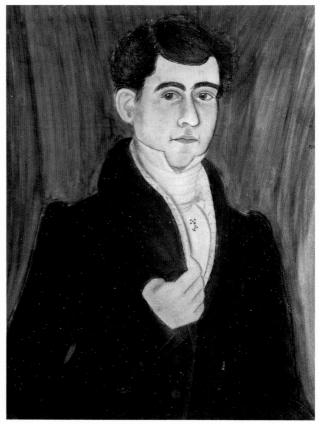

159

Inscriptions/Marks: Watermark in the primary support reads "J WHATMAN/TURKEY MILL/1831" for the Maidstone, Kent, Eng-land firm operated by the Hollingworth brothers between 1806 and 1859.
Condition: No evidence of previous conservation. Original 2¾-inch cove-molded mahogany-veneered frame with relief-carved raised corner blocks.
Provenance: J. Stuart Halladay and Herrel George Thomas, Sheffield, Mass.
Exhibited: "Collector's Choice," Museum of American Folk Art, New York, N.Y., September 7-November 30, 1969.

[1]The second portrait with a vertically streaked background is in pencil, watercolor, and gouache and is privately owned.

Joseph Whiting Stock
(1815-1855)

Thanks to newspaper advertisements and a personal *Journal* that covers his first fourteen years as a prolific itinerant portrait painter, a good bit is known about the

158 Attributed to the Shutes, *Lady in Blue*

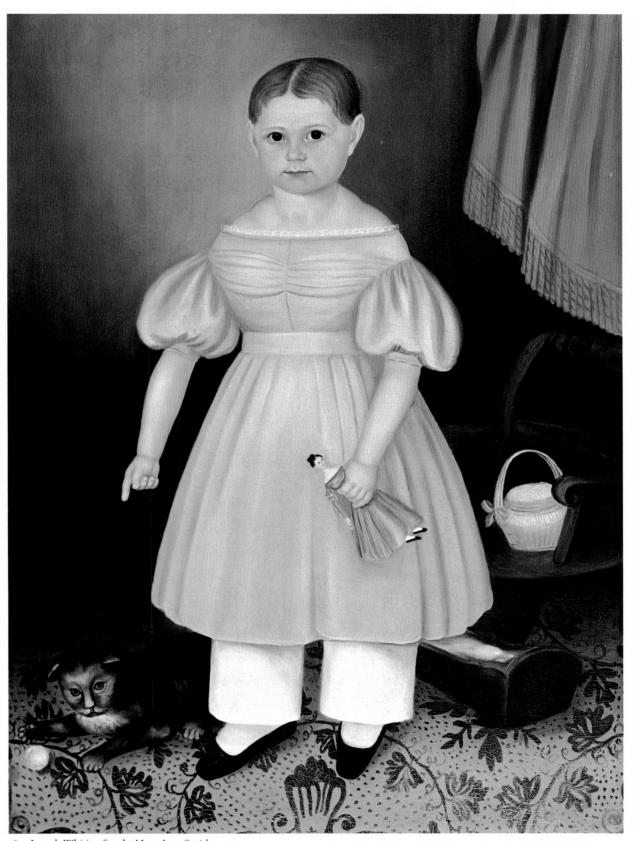

160 Joseph Whiting Stock, *Mary Jane Smith*

career of Joseph Whiting Stock, whose decorative and colorful full-length portraits of children are greatly admired today.

Stock was born in Springfield, Massachusetts, on January 30, 1815, and lived there most of his life. An injury when he was eleven left him crippled, but Joseph, the third of twelve children born to parents of modest means, was determined to support himself. At the suggestion of his physician, he began to study painting and learned how to prepare canvases and set up a palette from Franklin White, a former pupil of Chester Harding. Stock's early likeness of his sister was so convincing that friends and relatives offered him other commissions for portraits. His poor health improved somewhat and a specially designed wheelchair enabled him to travel about.

He maintained a studio in Springfield for several years and made trips to the nearby towns of Chicopee and Westfield. During the 1840s he traveled east to Bristol and New Haven, Connecticut, New Bedford, Massachusetts, and Warren, Rhode Island. Later he ventured as far west as Orange County, New York, painting miniatures and portraits in Middletown, Goshen, and Port Jervis, where he entered into a brief partnership with an elusive young artist named S. W. Corwin (see nos. 43 and 44). Stock succumbed to tuberculosis at the age of forty, dying in Springfield in 1855.

Besides portraits, Stock's *Journal* indicates that he painted landscapes, genre scenes, anatomical drawings, and window shades, although no examples of any of them are currently attributed to him. On several occasions Stock and his brother-in-law, Otis Cooley, maintained a business that produced daguerreotypes and portraits.

Although his portraits appear to lack depth and his subjects seem rather rigid, Joseph Whiting Stock had the ability to record acceptable likenesses whether from life or from a daguerreotype, or posthumously. His output was prodigious. *Journal* entries reveal that he earned $740 during a nine-month period in 1842-1843, having "painted to order 37 portraits and 18 miniatures, besides several landscapes, etc."[1] Stock's prices for oil portraits varied depending on the size of the canvas and the number of subjects; 30 inches by 25 inches seems to have been the most popular size and generally cost $6. Of the 912 works Stock is known to have painted during a fourteen-year career, only about a tenth have been identified as his.

[1]Tomlinson, p. 37.

160 **Mary Jane Smith** 41.100.9

161 **William Howard Smith** 41.100.8

Joseph Whiting Stock
Springfield, Massachusetts, 1838
Oil on canvas, with engraving glued onto canvas
41⅞" x 30³/₁₆" (106.3 cm. x 76.7 cm.)
52¼" x 35⅞" (132.7 cm. x 91.2 cm.)
(No. 160 is reproduced in color on p. 185)

According to an entry in his handwritten seventy-three-page *Journal* that covers the period 1832-1846, Stock painted David Smith's son and daughter in his Springfield studio in 1838 and charged their father $12 for each portrait.[1] The painter made no effort to link the two compositions and the only shared element is a curiously tilted beige carpet patterned in green with foliate medallions and a meandering vine.

The Smith children are shown almost life-size in identical wooden stances. The boy's black coat and

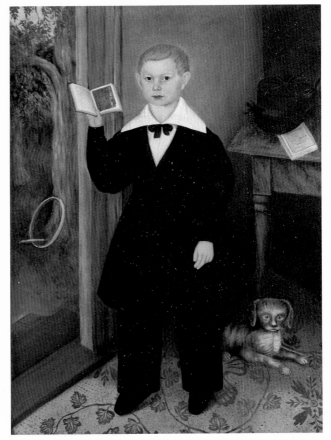

161

pants and his sister's stylish pink dress were painted quickly, with creases and folds outlined rather than shaded. Both children have square hands with stubby fingers, prominent, elongated ears, and short, flattened noses with round ends. Slight dimples at the corners of their mouths create pleasant expressions. In both portraits the area behind the heads is painted a lighter shade than the rest of the background.

Stock's characteristic use of props to indicate the interests and personalities of his subjects is abundantly evident in these portraits. The hoop visible through the open door to William Howard's right suggests the child's outdoor activities. He holds a schoolbook open to an engraving of a battle between the British and Indians glued by Stock to the surface of the canvas, perhaps reflecting the boy's interest in soldiers or military campaigns. Other books and a black cap rest on the grained brown table behind him, and an alert little dog lies near his feet. Mary Jane points at her playful cat with one hand while she nonchalantly grips a fragile jointed doll in the other. The doll's cradle and a child's chair with a ribbon-trimmed wicker sewing basket on it appear just behind her.[2]

William Howard Smith (1832-1911) and his sister, Mary Jane (1836-1854), were the children of David and Harriet Griffin Smith of Springfield, Massachusetts. David Smith was a strong Methodist, and Mary Jane inherited some of her father's religious fervor. She died at the age of eighteen from an illness contracted while working at a Methodist revival at the Pynchon Street Church in Springfield. William Howard eventually succeeded his father as a successful manufacturer of carriages and stagecoaches, which were shipped as far away as Virginia. In 1892 Charles Duryea, a mechanic working in Springfield, bought a secondhand carriage from the younger Smith. Duryea put a motor in the carriage, and a week later he drove it to Smith's shop without the horse! This first horseless carriage is in the Smithsonian Institution. William Howard Smith died in Springfield on March 12, 1911, at the age of seventy-nine.[3]

Inscriptions/Marks: Written on the backs of the original canvas supports are "Wm. Howard Smith. aged 5 years 7 months/Painted June 1838 by J. W. Stock," and "Mary Jane Smith, aged 7 yrs. 4 months/Painted June 1838 by J. W. Stock."
Condition: M. Knoedler & Co. cleaned, lined, and restretched the paintings in 1943. Russell J. Quandt relined and cleaned them and did some inpainting in 1955. Period replacement 3¾-inch mahogany-veneered splayed frames.
Provenance: Descended in the family; Mr. Richmond, Springfield, Mass.; Edith Gregor Halpert, Downtown Gallery, New York, N.Y.

Exhibited: AARFAC, April 22, 1959-December 31, 1961; AARFAC, September 15, 1974-July 25, 1976; "Joseph Whiting Stock," Smith College Museum of Art, Northampton, Mass., February 4-March 20, 1977, and exhibition catalog, no. 160 only, p. 50, no. 1, illus. on p. 9.
Published: AARFAC, 1947, p. 12, no. 3, p. 13, no. 4; AARFAC, 1957, p. 6, no. 1, p. 8, no. 2, illus. on pp. 7 and 9; AARFAC, 1959, p. 34, nos. 31 and 32, illus. on p. 35; AARFAC, 1974, pp. 32 and 33, no. 27, no. 160 only, illus. on p. 7; McClinton, no. 160 only, illus. on p. 292; Tomlinson, p. 64, nos. 8 and 9, illus. on pp. 90 and 93.

[1]Tomlinson, p. 21.
[2]See nos. 69 and 70 for similar compositions also painted about 1838 by Erastus Salisbury Field, a contemporary of Joseph Whiting Stock, who was working in the same area.
[3]William Smith Fowler to AARFAC, November 30, 1948.

Cephas Thompson
(1775-1856)

Cephas Thompson was born on July 1, 1775, in Middleboro, Massachusetts, where he married Olivia Leonard in 1802.[1] Their two sons, Cephas Giovanni and Jerome Thompson, became artists like their father.

The elder Cephas painted extensively both in his native New England and throughout the southeastern states from about 1804 until his death in Middleboro on November 6, 1856.[2] His advertisements were published in newspapers in Alexandria, Richmond, and Norfolk, Virginia, and Charleston, South Carolina.[3] The artist's surviving *Memorandum of Portraits* lists a number of commissions for these cities as well as others in Bristol, Rhode Island, Middleboro, Massachusetts, and Savannah, Georgia.[4]

From his advertisements, surviving paintings, and the *Memorandum* it is known that Thompson executed full-sized canvases as well as likenesses in "demi and small sizes" and mourning pieces.[5] Thompson advertised in an 1804 Charleston newspaper that he "cuts PROFILES, with his machine, which is on a new principle, and more accurate than any in use . . . will likewise paint Profiles, and execute them in gold."[6] None of the artist's profiles have been identified, although the design of his "deliniating machine," which he patented in 1806, is known through a drawing of 1845.[7]

Thompson's artistic development, which spans nearly five decades, has never been treated in publication. The large number of surviving portraits that he painted in Virginia, such as the two of Mr. and Mrs.

James Cuthbert (nos. 163 and 164), document the consistency of his style from about 1805 to 1815. These likenesses are usually well composed and finely modeled, illustrating Thompson's ability to render a variety of textures and forms in nearly perfect perspective. The muted colors and simple neoclassical poses and backgrounds are additional evidence that the artist had some formal training.

[1]AARFAC, 1957, p. 108.
[2]*Ibid.* Thompson's last trip to the South, to Charleston, appears to have occurred in 1822. Thereafter he worked in Middleboro and nearby areas.
[3]Research files, Museum of Early Southern Decorative Arts, Winston-Salem, N.C.
[4]*Cephas Thompson's Memorandum of Portraits*, published privately by Madeleine Thompson Edmonds, great-granddaughter of the artist (Northampton, 1965), unpaginated.
[5]*Ibid.*; *Charleston Times*, December 12, 1804.
[6]*Charleston Times*, December 12, 1804.
[7]AARFAC, 1957, p. 108; *Smithsonian*, VI (September 1975), p. 78.

162 Girl with Dove 33.100.3

> *Cephas Thompson*
> Possibly Rhode Island, ca. 1805
> Oil on wood panel
> 31⅝" x 26¹¹/₁₆" (80.3 cm. x 67.8 cm.)

The identity of the girl in this portrait has never been adequately resolved, a matter that complicates precise dating and provenance;[1] the painting's early ownership in Rhode Island is the only available documented clue.

The incidence of boldly stamped signatures on early nineteenth-century panel paintings of any type is rare, yet Thompson seems to have done it with some frequency.[2] This type of mark is not commonly seen on his southern portraits, most of which were executed on canvas rather than wood panels.

There are a number of stylistic nuances in the picture that suggest the early date assigned here. When compared with the Cuthbert portraits from Virginia (nos. 163 and 164), this likeness seems more ambitious in composition but less sophisticated in rendering. The modeling of the girl's face, while convincing, is devoid of the strong shadows and the smooth blending of middle tones that characterize the treatment of the Cuthberts. The overall quality of this portrait is technically sound, however, and was undoubtedly inspired by academic methods. In this respect Thompson's work falls outside the purview of folk painting, representing

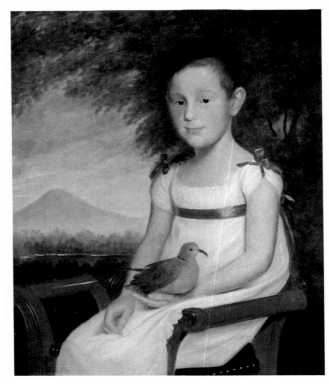

162

instead the skillful accomplishments of those native artists who must have had considerable studio training.

Inscriptions/Marks: Stamped beneath the paint in the lower left corner is the artist's name, "C. THOMPSON."
Condition: David Rosen cleaned the painting in 1933. Russell J. Quandt recleaned the painting and reduced a warp in the support in 1955. Possibly original 4-inch molded gold leaf frame.
Provenance: Elizabeth Church, Newport, R.I.; Rhode Island School of Design, Providence, R.I.
Published: AARFAC, 1957, p.108, no. 57, illus. on p. 109; Robert Bishop, *Centuries and Styles of the American Chair, 1640-1970* (New York, 1972), p. 239, illus. as fig. 351.

[1]Madeleine Thompson Edmonds, great-granddaughter of the artist, suggests that the subject is Marianne De Woolf (1795-1834), daughter of James De Woolf (1764-1837), and his wife, Nancy Bradford De Woolf, of Bristol, R.I. An entry in *Thompson's Memorandum of Portraits* indicates that he painted Miss De Woolf "with hands" about 1805.
[2]Hannah Howell, Frick Art Reference Library, to AARFAC, January 23, 1950.

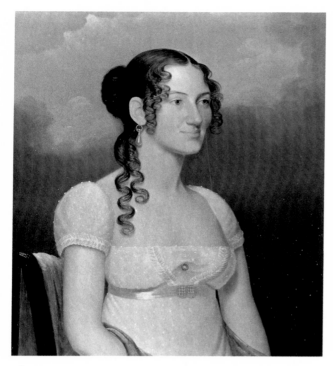

163

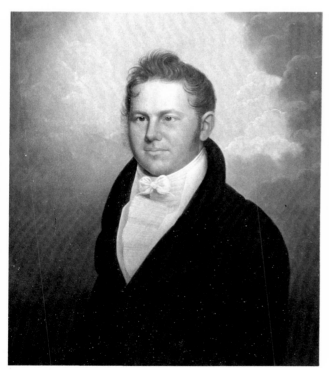

164

163	**Mrs. James Cuthbert**	G1956-271
	(Frances Bragg)	
164	**James Cuthbert**	G1956-272

Attributed to Cephas Thompson
Norfolk, Virginia, probably 1812
Oil on canvas
36⅛" x 27½" (91.8 cm. x 69.9 cm.)

Frances Bragg was the daughter of Henry Bragg and his wife, Diana Wythe Talbot Bragg, of Norfolk, Virginia, and was a grandniece of George Wythe of Williamsburg. She married James Cuthbert of Norfolk, and their daughter Henrietta (no. 220) was born on July 3, 1813.[1] Both subjects are listed separately as "Miss Frances Bragg" and "James Cuthbert" in the Norfolk section of *Thompson's Memorandum of Portraits*, which probably indicates that the portraits were executed just before, and perhaps to commemorate, the sitters' marriage about 1812. That Thompson's advertisements for Norfolk date from December 23, 1811, through January 31, 1812, substantiates this theory.

The Cuthbert likenesses are typical of the waist-length canvases that Thompson painted in Virginia in quantity. His portraits often feature dramatic skies in the backgrounds, similar poses, and chairs with draped scarves like the one in Mrs. Cuthbert's picture.

Condition: Hans E. Gassman cleaned and lined both paintings in 1957. Probably original 4-inch molded gilt frames with inner borders of egg-and-dart design.
Provenance: Gift of Mrs. Grace E. Powell.

[1]Mrs. Francis T. S. Powell to Colonial Williamsburg, 1941.

"Mr. Thompson" (active 1814-1819)

165	**Sally Vreeland**	58.300.19

Attributed to "Mr. Thompson"
Probably New Jersey, ca. 1815
Watercolor on wove paper
8⅞" x 7" (22.5 cm. x 17.8 cm.)

This simple likeness is one of twelve recorded subjects attributed to an artist whose last name is believed to have been Thompson.[1] Painted between 1814 and 1819,

the group of portraits depicts members of the Vreeland, Raub, Ackerman, Berry, Bogert, Brinkerhoff, and Outwater families. Numerous links between the families occur in marriage and estate records and tie nine of the recorded portraits to the communities of Schraalenburgh, Polifly, and other Dutch settlements in the area that now encompasses Hackensack in Bergen County, New Jersey.[2]

Characteristic of the unidentified artist's style are the inscription panels appearing below the images, the striped block letters in the inscriptions, and the format of the texts themselves, which, in most examples, give enough information to calculate the year when the portraits were executed. The artist's palette is quite pale, and his figures have sloping shoulders, clawlike hands, and puckered lips. Several types of chairs and floor coverings are depicted in his full-length and three-quarter-length portraits of standing and seated subjects. He used a cloudlike background for three subjects, and swagged drapery appears in the background of one.

Inscriptions/Marks: Printed in block letters in watercolor in the margin below the portrait is "SALLY VREELAND." Printed below this in watercolor, "Aged 3 years 7 months." Watermark in the primary support "T G & C⁰" for Thomas Gilpin, who operated a paper mill with his brother Joshua on the Brandywine River two miles above Wilmington, Del., between 1787 and 1838.[3]

Condition: Restoration by Christa Gaehde in 1958 included cleaning, unspecified repairs, and mounting on Japanese mulberry paper. Original ⅞-inch molded frame, painted black.

Provenance: J. Stuart Halladay and Herrel George Thomas, Sheffield, Mass.

Exhibited: Halladay-Thomas, Albany, and exhibition catalog, no. 85; Halladay-Thomas, Hudson Park; Halladay-Thomas, New Britain, and exhibition catalog, no. 155; Halladay-Thomas, Pittsburgh, and exhibition catalog, no. 78; Halladay-Thomas, Syracuse, and exhibition catalog, included in nos. 66-97; Halladay-Thomas, Whitney, and exhibition catalog, p. 35, no. 77; Washington County Museum.

[1] The name Thompson was obtained from a partial inscription on an original backing paper for one of a pair of stylistically related, privately owned, miniature portraits. The fragmentary inscription, "Thompson/ . . . the Painter/Has gone into the Country/ . . . few days," appears above an ink-sketched miniature profile portrait of a man.

[2] See James S. Brown, "Antiquing," *Asbury Park Press,* October 10, 1976, p. B10.

[3] Weeks, pp. 92, 157, and 175. Thomas's initials were used in the mill's watermarks only after 1800. Thomas L. Gravell to AARFAC, September 18, 1978.

SALLY ✦ VREELAND.
Aged 3 years 7 months.

165

Henry Walton
(1804-1865)

Henry Walton is believed to have been the son of Judge Henry Walton (1768-1844), a wealthy and well-educated man who owned properties at Ballston Spa, Saratoga Springs, and in New York City.[1] He was born in 1804 and, like his father, was probably educated in England; young Henry may have received some training there in architectural drawing, a skill evidenced in his views of towns in upstate New York, done about 1830.

Walton moved to the Finger Lakes area and lived for a time in Ithaca during the late 1830s. He may have worked as an engraver and letterer in the firm of Stone and Clark. He also produced townscapes and portraits in other New York towns—Elmira, Big Flats, Addison, and Painted Post. In 1851 Walton left New York for California with a gold-rush party. Information about the rest of his life is sparse; only two of his California works are known. He and his wife, Jane Orr Walton, apparently moved to Michigan, where he died in 1865 and she in 1890.

By profession Walton was both a painter and a lithographer who occasionally produced works in other printing techniques, such as mezzotint. His earliest documented views were done in the 1820s and 1830s as small illustrations for books. The artist's most active period seems to have been during the years he worked in upstate New York when he also began to paint portraits, almost exclusively in watercolor until the late 1830s. These small likenesses are quite similar to English miniature painting of the period. The sound painterly quality of Walton's watercolors and of his later oil likenesses suggests that he had some training in portrait painting.

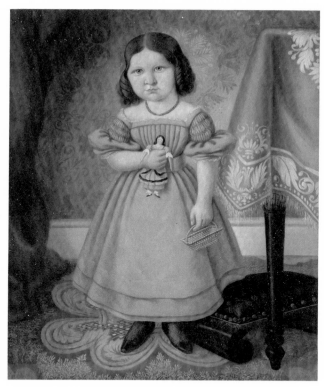

166

¹The information in this entry is from the exhibition catalog, "Henry Walton, 19th Century American Artist," Ithaca College Museum of Art, Ithaca, N.Y., December 9, 1968-January 4, 1969, pp. 9-13.

166 Sarah Louise Spencer 36.100.8

Henry Walton
Possibly New York state, 1842
Oil on canvas
33½" x 27" (85.1 cm. x 68.6 cm.)

In 1838 the editor of the *Ithaca Journal* noted that "all who wish to get portrait, miniature, landscape, or other painting, executed in oil or watercolors, can have it done in a superior style by Mr. Walton."¹ This is the earliest specific reference to oil painting by Walton, although no examples dated in that year have been found; most of his portraits, like young Miss Spencer's likeness, were executed in the 1840s.²

Walton used the same formula for Sarah Louise as he did in his numerous watercolor portraits of children—the sitter holds toys or flowers and stands in a full-length frontal pose in a fashionable interior replete with a colorful ingrain carpet.³ The artist employed vibrant pink tones for her dress and coral necklace, bright reds and greens for the carpet, and gray and yellow for the figured wallpaper behind his subject. He seems to have experienced some problems with proportion since one-year-old Sarah is dwarfed by the large Empire table covered with a gray blue cloth on the right. The peculiar, heavy-lidded eyes and chubby, stylized hands appear in other oil portraits by Walton.⁴

Inscriptions/Marks: A painted inscription on the back of the original canvas reads "Sarah Louise Spencer/Aged 1 yr 1 m/Painted by H. Walton, 1842."

Condition: Sidney S. Kopp cleaned, lined, and did minor inpainting in the upper left corner and along both lower sides in 1936. Russell J. Quandt recleaned the painting in 1956. Modern replacement 3⅛-inch gilt molded frame.

Provenance: Katrina Kipper, Accord, Mass.

Exhibited: AARFAC, New York, and exhibition catalog, no. 12; "Henry Walton, 19th Century American Artist," Ithaca College Museum of Art, Ithaca, N.Y., December 9, 1968-January 4, 1969, and exhibition catalog, illus. as no. 69 on p. 66; New York State Masterpieces, and exhibition catalog, illus. as no. 5 on p. 12.

Published: AARFAC, 1957, p. 64, no. 33, illus. on p. 65; Albert W. Force, "H. Walton—limner, lithographer, and map maker," *Antiques,* LXXXII (September 1962), illus. as fig. 4 on p. 285.

¹See the exhibition catalog, "Henry Walton, 19th Century American Artist," Ithaca College Museum of Art, Ithaca, N.Y., December 9, 1968-January 4, 1969, p. 9.

²*Ibid.,* p. 12.

³*Ibid.,* portraits illus. as nos. 37 and 39 on pp. 37 and 38.

⁴*Ibid.,* portraits illus. as no. 70 on p. 67 and as nos. 75 and 76 on pp. 72 and 73.

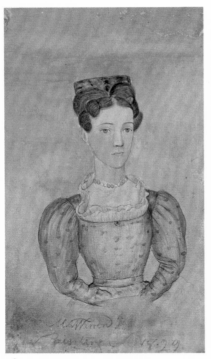
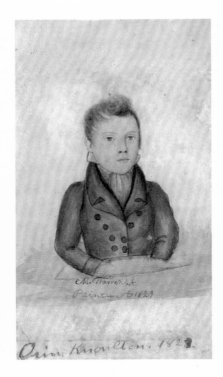
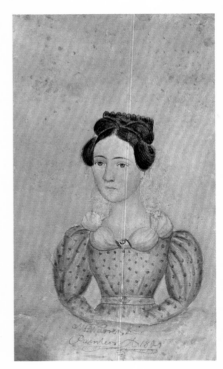

167

M. Warren, Jr.
(active 1829-1830)

167 Probably the Knowlton 58.300.7, 1-3
Children

M. Warren, Jr.
Possibly New York state, 1829
Watercolor and pencil on wove paper
LEFT: 5⁹/₁₆″ x 3¹/₁₆″ (14.1 cm. x 7.8 cm.)
CENTER: 5½″ x 3¹/₁₆″ (14.0 cm. x 7.8 cm.)
RIGHT: 5½″ x 3³/₁₆″ (14.0 cm. x 8.1 cm.)

In 1941 and 1942 Halladay and Thomas published these miniatures as *Orin Knoulton [sic] and His Sisters,* and in 1947 as *The Knowlton Children* (see *Exhibited*) — titles that would not contradict the postcard notations transcribed below except that the unidentified writer, evidently a grandchild of Orin Knowlton, might have more correctly identified the two women as "great-aunt" rather than simply "aunt." The dates following the names on the postcards are puzzling; although the

"1823" beneath the portrait of Orin Knowlton could indicate the year of his birth, the two women are obviously older than seven and three respectively if the portraits were painted in 1829, as the upper obverse date indicates.

M. Warren, Jr., has been identified as a portrait painter working in White Plains, New York, in 1830, although the location of documents or works supporting this assertion is now unknown.[1] By obscuring these figures with a blue cloudlike wash at waist height, Warren has not very cleverly or successfully disguised a reluctance to portray his subjects' hands.

Inscriptions/Marks: In ink in script below each of the three separate miniatures is "M. Warren, Jr./Painter A 1829." In ink in script in a different hand below the above inscription on the center miniature is "Orin Knowlton, 1823."[2] The "3" in this date has been nearly obliterated, and an attempt to correct or change it was unsuccessful. Three late-nineteenth-century postcards on which these portraits had been mounted bear the notations "Aunt Lydia An [sic] Knowlton/ 1822," "Grandpa Orin Knowlton/1823," and "Aunt Roxy Rundle/ 1826" in apparently the same hand as the obverse "Orin Knowlton" inscription. The reverse of the left portrait bears the faint inscription "Lydia Ann."

Condition: Unspecified restoration, possibly prior to 1958. Restoration by Christa Gaehde in 1958 included separation of primary

supports from postcards, removal of glue and oil stains, unspecified repairs, minor inpainting, and remounting on Japanese mulberry paper. In 1974 E. Hollyday removed an acidic support. Period replacement ¾-inch gilt frame.

Provenance: J. Stuart Halladay and Herrel George Thomas, Sheffield, Mass.

Exhibited: Halladay-Thomas, New Britain, and exhibition catalog, no. 120 (titled *The Knowlton Children*); Halladay-Thomas, Pittsburgh, and exhibition catalog, no. 74 (titled *Orin Knoulton [sic] and His Sisters*); Halladay-Thomas, Whitney, and exhibition catalog, p. 35, no. 73 (titled *Orin Knoulton and His Sisters*); Washington County Museum.

[1]Lipman and Winchester, Primitive Painters, p. 181.

[2]There is some question whether this name and date were written by one hand or two different hands.

Micah Williams
(1782-1837)

The work of Williams was at one time attributed to a painter named Henry Conover, an erroneous association based on a portrait inscribed "H. C." It was later discovered that the initials referred to the sitter, not the artist, and that other portraits by the same hand had inscriptions on the verso giving the name "Williams." This discovery and subsequent research by Irwin F. Cortelyou have yielded all that is known of the artist and his career in central New Jersey.[1]

An inscription on Williams's tombstone in Van Lieu cemetery in North Brunswick Township gives a death date of November 21, 1837, at age fifty-five, and is the only clue to his birth in 1782. The records of the First Presbyterian Church in New Brunswick reveal that he married Margaret H. Priestly, daughter of John and Catherine Voorhees Priestly, on December 24, 1806. The only other documented references to Williams's personal life are for the births of his six children.

Micah and his family apparently spent most of their lives in New Brunswick except for a brief three- or four-year sojourn in New York City from about 1829 to 1833. Most of his known works are pastels dating between 1818 and 1830 with provenances in the vicinity of Monmouth County, New Jersey. According to a descendant of the artist, Micah made his own pastels. His oil portraits are less well known, but no. 170 proves that he was familiar with that medium.

Evidently Williams's work was well received by his clientele. One admirer was so moved by seeing his portraits that he published a note of praise in the April 16,

1823, edition of the *Paterson Chronicle and Essex and Bergen Advertiser,* writing that Williams was self-taught, "a native of this country," and "we ... cheerfully express our opinion of his correctness of design and execution, as well worth the patronage of an enlightened public." Another interesting contemporary reference documents the length of time it took Williams to complete a likeness: Gerard Rutgers of Belleville recorded in his diary on March 19, 1823, that "this morning my Son Anthony went to Newark, and M.Williams Portrait Painter took my likeness, he began in The Morning and finished by Sundown."

Williams's work has been noted for its brilliant colors, stylized figures and hands, bold patterns, and its distinctive yet realistic effect, although he tended to use standard poses and costumes for his sitters. The artist's method of mounting the completed picture was an important feature of his work. He applied pieces of newspaper to the back of the picture and then attached it to a simple wooden frame; an additional covering of newspaper was glued to the back of the frame.

[1]Biographical information in this entry is from Cortelyou, pp. 4-15.

168	**Mrs. John G. Vanderveer** (Jane Herbert)	31.200.4
169	**John G. Vanderveer**	31.200.3

Micah Williams
Probably Freehold, New Jersey, 1819
Pastel on paper
24″ x 20¼″ (61.0 cm. x 51.4 cm.)

The companion likenesses of Mr. and Mrs. Vanderveer are typical of the highly stylized, impressive pastel likenesses that Williams produced throughout his career in New Jersey. The bright blue coat that Mr. Vanderveer wears and the position of his right hand are features seen consistently in Williams's portraits of men. Similarly, Mrs. Vanderveer's cap, gray and black dress with white ruffles at the neck and gathered sleeves, and the book she holds are elements seen in a standard pose used repeatedly by the artist.[1] The faces are carefully drawn, with the lips and modeling picked out in pink and burnt sienna tones that complement the backgrounds. These are strong likenesses, and considering the delicacy of the materials used, they have survived in fine condition.

John G. Vanderveer, the son of Garret and Jane Griggs Vanderveer of Freehold, New Jersey, was born on November 26, 1799. He married Jane Herbert sometime before 1823, the year their first child was born.[2] Williams is known to have painted other likenesses in the Freehold area, where it is presumed he executed these in 1819, the date that appears on the artist's label for Mr. Vanderveer.

Inscriptions/Marks: Williams's handwritten label was attached to the original newspaper backing of Mr. Vanderveer's picture. The label, although nearly illegible through deterioration, has been studied carefully and its reconstructed wording is "John Vanderveer/ [was b]orn November 26th 179[9] Age [d] 19 y[ears]/ [Like]ness was taken January 13, [1819]/By Micah Williams [illeg.] Monmouth."
Condition: No evidence of previous conservation on no. 169. Hans E. Gassman cleaned and presumably touched up areas of loss on no. 168 in 1954. The original newspaper backing is still intact on no. 169. Mid-nineteenth-century rebuilt 2½-inch molded frames, painted black, with gilt inner borders.
Provenance: Edith Gregor Halpert, Downtown Gallery, New York, N.Y.
Exhibited: American Folk Art; "Portraits by Americans," Monmouth Museum Gallery, Holmdel, N.J., September 9-October 3, 1967, and exhibition catalog, nos. 43 and 44, no. 169 only, illus.

Published: AARFAC, 1957, no. 169, p. 126, no. 63, illus. on p. 127, and no. 168, p. 128, no. 64, illus. on p. 129; Cahill, p. 35, nos. 35 and 34, illus. on pp. 75 and 74.

[1]Cortelyou, pp. 9-10.
[2]AARFAC, 1957, p. 126.

170 Solomon Avery 58.100.24

Micah Williams
America, 1820-1825
Oil on canvas
26" x 22" (66.0 cm. x 55.9 cm.)

Presumably found in New London, Connecticut, the portrait is thought to represent Solomon Avery. Three men with that name, none of whom can be specifically related to the portrait, lived in New London during the early 1800s. Since Micah Williams is not documented as working in that area, a Connecticut provenance cannot be verified.

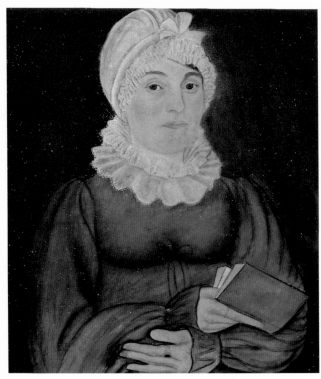

168 Micah Williams, *Mrs. John G. Vanderveer*

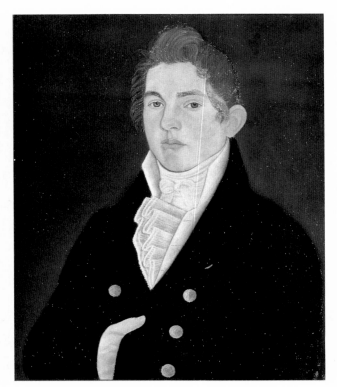

169 Micah Williams, *John G. Vanderveer*

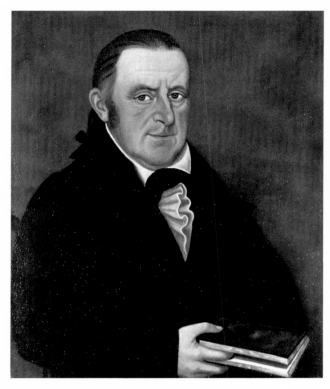

170

Inscriptions/Marks: Inscribed in paint on the back of the original canvas is "Micah Williams/Painter."

Condition: In 1971 Bruce Etchison lined the portrait, cleaned it, and inpainted minor areas of loss. Modern replacement 3½-inch molded frame, painted black, with inner and outer gilt borders.

Provenance: J. Stuart Halladay and Herrel George Thomas, Sheffield, Mass.

Exhibited: Halladay-Thomas, New Britain, and exhibition catalog, no. 117; Halladay-Thomas, Pittsburgh, and exhibition catalog, no. 12; Halladay-Thomas, Whitney, and exhibition catalog, p. 30, no. 12.

Published: Cortelyou, pp. 4-16; Irwin F. Cortelyou, "Notes on Micah Williams, native of New Jersey," *Antiques,* LXXIV (December 1958), pp. 540-541, illus. on p. 540.

Avery's likeness is the only known signed oil painting by the artist, although at least one other portrait by him in this medium survives in a private collection; Williams's best-known and most typical work is in pastel, of which a number are known, including those of Mr. and Mrs. Vanderveer (nos. 169 and 168). Except for the almond-shaped eyes, chubby fingers, and the brown background, the Avery likeness exhibits few characteristics of the artist's pastels. Its rarity as an oil on canvas suggests that the artist was far more comfortable working in pastels. Although Avery's likeness is very confidently drawn, it is undistinguished in color, definition, and decorative interest.

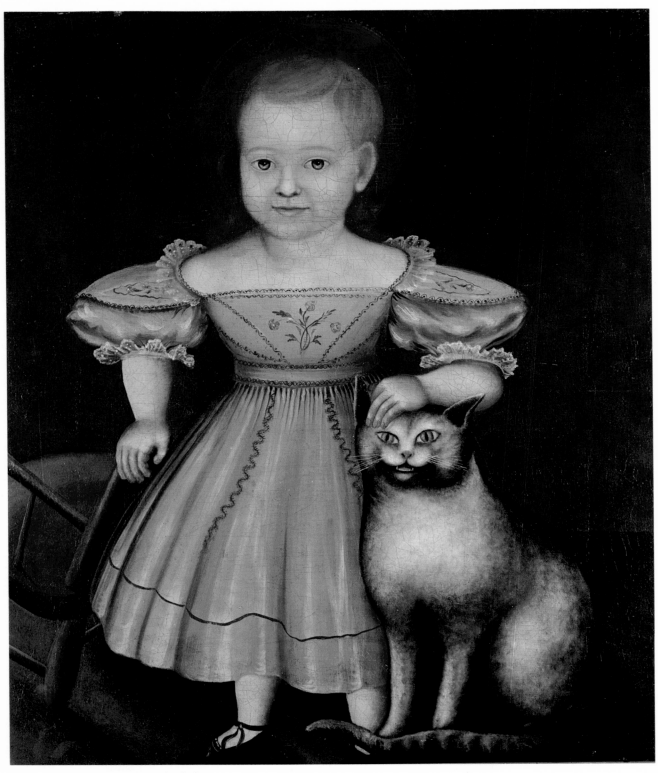

261 Unidentified artist, *Lydia and Tabitha*

UNIDENTIFIED ARTISTS

171 Johannes Lawyer 58.100.19

New York state, 1700-1725
Oil on canvas
41⅜" x 34⅜" (105.1 cm. x 87.3 cm.)

The likeness of Johannes Lawyer shares some characteristics with the large group of early eighteenth-century portraits executed in upstate New York for prosperous merchant and planter families of primarily Germanic and Dutch origin. The subject's three-quarter-length pose in front of an architectural setting and his costume are standard features seen in other New York patroon family portraits. Lawyer's likeness appears flatter and simpler by comparison, however. The artist also tended to use very heavy dark outlines around the figure and throughout the costume to describe the shape and overlapping of forms in space. More attention was given to the drawing of Lawyer's face, and some of the flatness was relieved by the detailed rendering of wrinkles around the eyes, the bushy eyebrows, and the subject's nose.

Johannes Lawyer was born in Durlash, Germany, in 1684. A surveyor and merchant, in 1709 he moved with his wife and children to Brunnendorf (now Schoharie), New York, where he opened a store and carried on an extensive trade with the Indians. The region, which was near the frontier, had been settled by large numbers of Palatinate Germans. Lawyer helped to resolve many land disputes between the settlers and the Indians and was a founder of the first Lutheran church in the area. He died in 1762.

Inscriptions/Marks: Upside down in mirror writing below the subject's right hand is what appears to be the Latin inscription "vive[s bene]" (live so that you live well).
Condition: Russell J. Quandt's treatment in 1958 included lining, cleaning, and inpainting minor areas of loss throughout. Period replacement 3⅛-inch molded frame, painted black, with gilt inner border.
Provenance: Charles W. Grant, New York state, a descendant of the sitter; J. Stuart Halladay and Herrel George Thomas, Sheffield, Mass.
Exhibited: AARFAC, New York, and exhibition catalog, no. 2; Halladay-Thomas, Albany, and exhibition catalog, no. 3; Halladay-Thomas, New Britain, and exhibition catalog, no. 17; Halladay-Thomas, Pittsburgh, and exhibition catalog, no. 33; Halladay-Thomas, Syracuse, and exhibition catalog, no. 38; Halladay-Thomas, Whitney, and exhibition catalog, p. 31, no. 33.
Published: Schoharie County Historical Review, XXIX (Spring-Summer 1965), illus. on cover.

172 Pieter Waldron 66.100.1

Albany, New York, area, 1720
Oil on canvas
39⅛" x 33⅜" (99.4 cm. x 84.8 cm.)

Pieter Waldron was the son of William and Engelita Stoutenburgh Waldron of New York City and was bap-

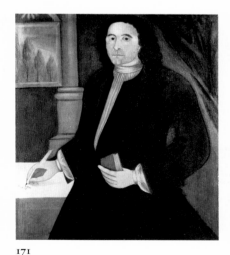

171

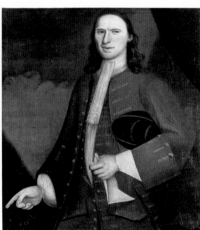

172

173

tized there in June 1675. He married Tryntie Cornelia Danburgh on September 6, 1698, and in 1700 they moved to Albany, where he died on May 3, 1725.[1]

Like the Sanders pictures (nos. 173 and 174), this portrait is attributed to the Schuyler Limner on the basis of its close stylistic relationship to other works assigned to the artist.[2] Waldron's pose and costume are quite similar to Robert Sanders's, although the brown tones used here in no. 172 are far more subdued and therefore perhaps less appealing. The artist's characteristic use of lively pinks and siennas for flesh tones is very evident in Waldron's face and right hand. For additional commentary on stylistic characteristics associated with the Schuyler Limner, see no. 173.

Inscriptions/Marks: A painted inscription in the lower left corner reads "Etas Sue/46/1720" (in the 46th year of his life).
Condition: The painting was lined and cleaned and minor areas were inpainted by an unidentified conservator prior to acquisition. Modern replacement 3-inch molded frame, painted black.
Provenance: Found in Rensselaer, N.Y., and purchased by Edith Gregor Halpert, New York, N.Y.; The Old Print Shop, New York, N.Y.; Mr. and Mrs. Holger Cahill, New York, N.Y.; M. Knoedler & Co., New York, N.Y.
Exhibited: AARFAC, Merchants and Planters, and exhibition checklist; American Ancestors, and exhibition catalog, no. 1; "Smith College 75th Anniversary Commencement Exhibitions," Smith College Museum of Art, Poughkeepsie, N.Y., June 1950, and exhibition catalog, p. 17, no. 1.
Published: Belknap, p. 265, no. 2, illus. as no. 2 in pl. LIV.

[1]All biographical information in this entry is from AARFAC archives.
[2]This artist is also frequently referred to as the *Aetatis Sue* Limner because a number of the portraits bear the inscription "*Aetatis Sue.*"

173 John Sanders 64.100.2

Albany, New York, area, ca. 1724
Oil on canvas
37⅛" x 31⅜" (94.3 cm. x 79.7 cm.)

John Sanders was born July 12, 1714, the son of Barent and Maria Wendell Sanders and the brother of Robert Sanders (no. 174), all from the Albany, New York, area. John married Deborah Glen (no. 180) on December 6, 1739, and the couple eventually bought Scotia, the Glen family home near Schenectady. This portrait, the one of John's older brother, Robert, and Deborah's likeness all hung at Scotia until their acquisition. John is mentioned in family papers as a merchant in Albany; his death date is recorded as September 13, 1782.[1]

The Sanders pictures and the portrait of Pieter Waldron (no. 172) have many similarities and are charac-

teristic of the English-inspired baroque style of an unknown New York painter now called the Schuyler Limner. His work is noteworthy for its rich coloration and dramatic contrasts of light and dark areas, no doubt a reaction to the courtly poses and opulence of portraits associated with academic painters abroad. The Schuyler painter borrowed heavily from these prototypes, but given the limitations of his talent and colonial circumstances, he altered, refined, and simplified their complex poses, swirls of fabric, and elaborate settings into a style he could practice with assurance and facility. His work thus has a decisive, crisp quality that is balanced by judicious placement of smaller details.

Another distinctive feature of the unidentified artist's style is the manner in which he drew faces, particularly the eyes. The whites of the eyes are usually painted in heavy shadow, making the eyes seem dark and set deeply into the head. The sitter's lips are generally full, boldly drawn, and nicely colored in pinks and reds. The modeling of the nose and other aspects of the face is strong, with heavy shadows adjacent to areas of intense brightness. The smooth and simple depiction of costumes and the use of balustrades, curtain swags, and rows of trees in the backgrounds are additional features of this painter's work.

Although the Schuyler Limner faithfully repeated poses, backgrounds, and other devices, it would be unfair to say that his style was totally standardized because he varied some of the hand gestures and backgrounds and incorporated a number of decorative props in his paintings. A comparison of the collection's three likenesses by the artist illustrates this point quite well. John Sanders holds a colorful parakeet on his finger, while his brother has a hat under one arm, wears one glove and holds the other, and has a flower in his left hand. Pieter Waldron's pose is nearly identical to Robert's, but reversed.

Inscriptions/Marks: Before the painting was lined, an inscription on the back of the original canvas was partially legible and is thought to have read "John Sanders."
Condition: Russell J. Quandt lined, cleaned, and inpainted minor losses throughout in 1965. Original 3-inch molded frame, painted black.
Provenance: Descended in the Glen-Sanders family of Scotia, N.Y.
Exhibited: AARFAC, Glen-Sanders, and exhibition catalog, p. 10, no. 2, illus. on p. 10; AARFAC, Merchants and Planters, and exhibition checklist; New York State Masterpieces, and exhibition catalog, p. 12, no. 1.
Published: Belknap, p. 253, illus. as no. 3 in pl. LIII; Curran, illus.; Etchison, illus. on p. 246.

[1]All biographical information in this entry is from AARFAC archives.

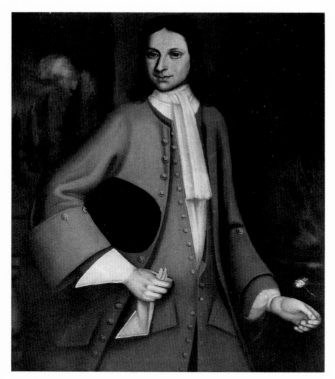

174

checklist; New York State Masterpieces, and exhibition catalog, p. 12, no. 2.

Published: Belknap, p. 254, illus. as no. 1 in pl. LIII; Curran, illus.; Etchison, illus. on p. 245.

[1]All biographical information in this entry is from AARFAC archives.

175 Miss Gibbs 58.100.37

Probably New York state, ca. 1725
Oil on canvas
30¼" x 25" (76.8 cm. x 63.5 cm.)

The pose and composition of this picture are nearly identical to, and were probably derived from, a 1720 mezzotint of Sir Godfrey Kneller's portrait of Queen Anne of England (1702-1714).[1] The colonial American painter simplified his version by using a conventional plain background with a feigned oval format and by diminishing the exuberant dress folds to simple overlaps and broadly painted areas of color. This simplification also appears in the artist's treatment of Miss Gibbs's arm, neck, and the right side of her head, which are

174 Robert Sanders 64.100.3

Albany, New York, area, ca. 1724
Oil on canvas
37⅛" x 30½" (94.3 cm. x 77.5 cm.)
(Reproduced in color on p. 20)

Robert, brother of John Sanders (no. 173), was born in 1705. He married Maria Lansing in 1740; after her death, he married Elizabeth Schuyler in 1747. Robert served as the second mayor of Albany, where he died in 1765.[1] His long peach colored coat and vest are similar in design to those worn by his brother, and he also stands in an identical interior setting with a landscape vista in the far background. (See no. 173 for additional comments on style and for this portrait's attribution to the Schuyler Limner.)

Condition: The painting was lined and cleaned, and minor areas of loss were inpainted, by Russell J. Quandt in 1965. A small puncture at the center right edge was also repaired then. Original 3-inch molded frame, painted black.
Provenance: Descended in the Glen-Sanders family of Scotia, N.Y.
Exhibited: AARFAC, Glen-Sanders, and exhibition catalog, p. 10, no. 1, illus. on p. 10; AARFAC, Merchants and Planters, and exhibition

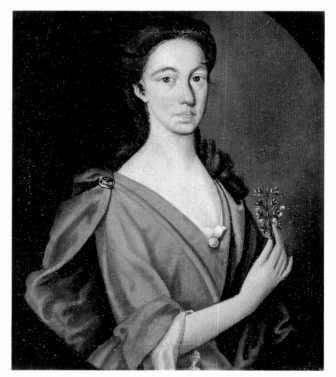

175

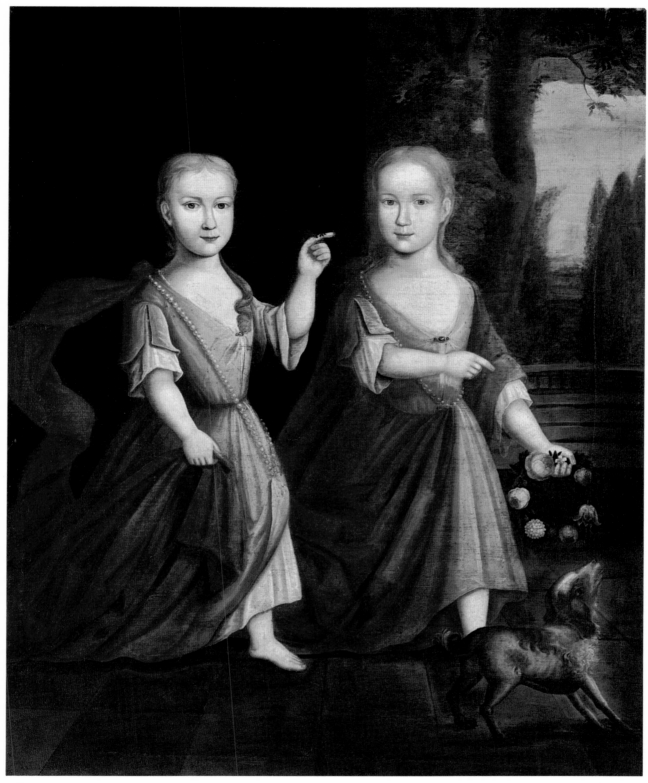

strongly highlighted but are flat and limited in modeling.

It is not possible to identify the sitter with a specific New York family, but the general style of her likeness is similar to the many extant paintings that were painted in the area about the same time. It shares a tendency toward highly stylized facial features and the use of standardized English academic poses and gestures.

Condition: The painting was cleaned and lined, and early overpainting of the mouth and nose was removed, by Russell J. Quandt in 1962 to reveal the artist's first rendering of the same features. Minor areas of loss were also inpainted. Possibly original 2½-inch molded frame, painted black.
Provenance: J. Stuart Halladay and Herrel George Thomas, Sheffield, Mass.
Exhibited: AARFAC, New York, and exhibition catalog, no.1; Halladay-Thomas, Albany, and exhibition catalog, no. 14 (attributed to John Smibert); Halladay-Thomas, New Britain, and exhibition catalog, no. 86 (attributed to John Smibert); Halladay-Thomas, Pittsburgh, and exhibition catalog, no. 27; Halladay-Thomas, Syracuse, and exhibition catalog, no. 24 (attributed to John Smibert); Halladay-Thomas, Whitney, and exhibition catalog, p. 31, no. 27.

[1]Belknap, p. xxxi, no. 31.

176 The De Peyster Twins, Eva and Catherina

65.100.1

New York state, ca. 1728
Oil on canvas
50¼" x 40¼" (127.6 cm. x 102.2 cm.)
(Reproduced in color on p. 201)

This double portrait has been linked with various stylistically associated portrait groups executed in early New York; it seems to relate most closely to *De Peyster Boy with Deer* in the New-York Historical Society and to a portrait of John Van Cortlandt in the Brooklyn Museum. All of them share similarities in painting technique and the use of elaborate settings derived from English mezzotints, and the artist was formerly referred to as the De Peyster Limner. James Flexner changed the attribution to Pieter Vanderlyn (1680-1778) in his 1959 article in *Antiques*.[1] *The De Peyster Twins* was subsequently shown in the New-York Historical Society exhibition "The Duyckincks—Merchants, Chiefs and Painters" as attributed to Gerardus Duyckinck (1695-1742). There remains considerable debate, however, about this portrait's correct assignment within the many similar styles and hands identified in early New York painting.

The De Peyster Twins is a striking portrait. Despite the slightly wooden stance of the children, it displays movement and animation through the sitters' gestures and by the fabrics swirling around them. All areas of the painting were carefully executed with the ease and graceful brushwork of one trained and experienced in portraiture. The coloration is typically baroque in the use of deep crimsons and golds for the costumes. One child is posed in front of a dark, undefined interior space, while the other stands more against the landscape vista of trees and a bright blue and pink-clouded sky. The black bird perched on the left child's finger is barely discernible through the discoloration of aged varnish; the lively little dog at lower right is more prominent and is typical of pets seen in English paintings and prints during this period. The child's wreath of greens and flowers is a decorative motif that appears almost exclusively in early New York portraits (see no. 180).

Condition: This painting has never received any major conservation treatment and remains in stable original condition except for some slight surface cleaning and minor retouching done at an unknown date prior to acquisition. Possibly original 3¾-inch gilt, carved, and molded frame.
Provenance: Descended in the family to Colonel Anastasio C. M. Azoy, Ardsley-on-the-Hudson, N.Y., and placed on loan to the Metropolitan Museum of Art from 1938 to 1965; Kennedy Galleries, Inc., New York, N.Y.
Exhibited: AARFAC, Merchants and Planters, and exhibition checklist; "The Duyckincks—Merchants, Chiefs and Painters," New-York Historical Society, New York, N.Y., October 1, 1973-March 18, 1974.
Published: Belknap, p. 303, no. 31A, illus. as no. 31A in pl. xxi; Helen Comstock, "Some Hudson Valley Portraits," *Antiques*, XLVI (September 1944), illus. on p. 40; Ruth Davidson, "In the Museums," *Antiques*, LXXXVIII (November 1965), illus. on p. 700; Alice Morse Earle, *Child Life in Colonial Days* (New York, 1899), illus. opposite p. 26; James Thomas Flexner, "Pieter Vanderlyn, come home," *Antiques*, LXXV (June 1959), p. 580, no. 7, illus. on p. 547; *Kennedy Quarterly*, IV (April 1964), illus. as no. 148 on p. 139.

[1]James Thomas Flexner, "Pieter Vanderlyn, come home," *Antiques*, LXXV (June 1959), pp. 546-549, and 580.

177 Girl with Dog

31.100.11

178 Girl Holding Flower

31.100.10

Probably Europe, 1730-1740
Oil on canvas
28¼" x 24" (71.8 cm. x 61.0 cm.)

These portraits share the same twentieth-century history and appear to be by the same unidentified artist. Their origins remain unknown, and the lack of stylisti-

cally related eighteenth-century American examples supports the tentative European provenance given here. The elaborately embroidered dresses are not typical of costumes seen in American pictures of this period but relate closely to European examples. The prominent wreath of clouds surrounding each child and the painted oval framing both compositions seem to be distinguishing characteristics of this artist's work. Both paintings, except for the faces, give the appearance of a rapid, loosely brushed technique. The earring in no. 177 was picked out in thick impasto with no attempt to depict detail. The little dog the child in this painting holds may represent a toy spaniel, a breed popularized by eighteenth-century European royalty.

Condition: Unspecified restoration by David Rosen prior to 1940. Both were cleaned, possibly relined, and had stretchers replaced by an unidentified conservator after 1940. Modern replacement 3-inch molded gilt frames.
Provenance: Found in Lancaster County, Pa., and purchased from Edith Gregor Halpert, Downtown Gallery, New York, N.Y.
Published: AARFAC, 1957, p. 354, nos. 208 and 209.

179

177 178

179 Miss Van Alen of Kinderhook, New York

66.100.2

New York state, ca. 1735
Oil on canvas
33¼" x 26" (79.4 cm. x 66.0 cm.)

This portrait was formerly attributed to Pieter Vanderlyn, but subsequent study indicates a closer stylistic relationship with paintings now attributed to an artist known only as the Gansevoort Limner.[1] Numerous paintings by his hand have been traced to the merchant and planter families who lived in the Hudson River Valley, including the likeness of Deborah Glen (no. 180) in this collection. Most have inscriptions in Dutch and thus indicate that the limner was either of Dutch descent or was famiiar with that language. His dates of activity have been narrowed to circa 1730-1740, following almost immediately after the Schuyler Limner (ca. 1715-1725), who worked in the same vicinity. In fact, some of the poses and gestures observed in the Gansevoort Limner's oeuvre were probably derived from the more refined likenesses of his predecessor.

Although the Van Alen name was prominent in the Albany, New York, area, the relationship of this sitter to members of the various branches of that family is still unclear. A portrait by the same artist whose subject has a similar costume and pose (in the National Gallery of Art) represents another Miss Van Alen. The two girls were once thought to be twins or at least sisters, but research has failed to provide any firm connection between them.

The aesthetic interest and enduring appeal of the Gansevoort Limner's work derives almost totally from naiveté; no real understanding of academic portraiture

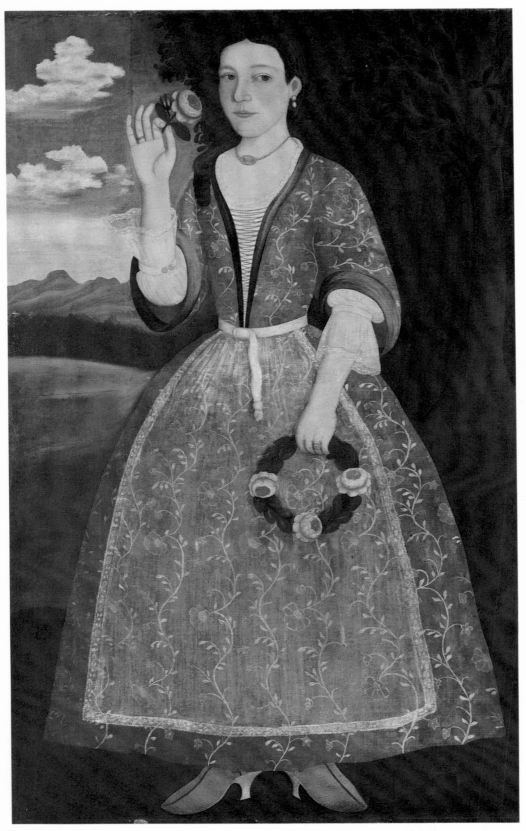

180

or its principles is shown. Large areas of fabric, torsos, faces, hands, and arms were sometimes abstracted to the point of being flat. The modeling in Miss Van Alen's face was held to a minimum, and the brushstrokes throughout were crisply ordered in linear patterns, contributing further to the overall stiff simplicity of the likeness. It is this simplicity of form, accentuated by bold outlines and the deep blues and reds of the girl's costume, which makes the portrait so attractive. Unlike *Deborah Glen* and the richly decorative passages of her dress and background, Miss Van Alen's portrait represents perhaps the purest and most fundamental aspects of this artist's style and vision.

Condition: Unspecified treatment by an unidentified conservator before its acquisition. Russell J. Quandt lined and cleaned the painting and inpainted areas of minor loss in 1967. Nineteenth-century 3-inch cove-molded frame, painted brown.

Provenance: M. Knoedler & Co., New York, N.Y.

Exhibited: AARFAC, Merchants and Planters, and exhibition checklist; American Ancestors, and exhibition catalog, no. 3; Children in American Folk Art, and exhibition catalog, p. 13, no. 53; New York State Masterpieces, and exhibition catalog, p. 12, no. 3, illus. on p. 4.

Published: Virgil Barker, "The Painting of the Middle Range," *American Magazine of Art,* XXVII (May 1934), p. 233; Mary Black, "The Gansevoort limner," *Antiques,* XCVI (November 1969), p. 783, no. 13, illus. as fig. 9 on p. 742.

[1]The attribution of this portrait to the Gansevoort Limner was first made by Mary Black, "The Gansevoort limner," *Antiques,* XCVI (November 1969), pp. 738-744, and information for this entry was taken from this article.

180 Deborah Glen 64.100.1

Albany, New York, area, ca. 1739
Oil on canvas
57½" x 35⅜" (146.1 cm. x 89.9 cm.)

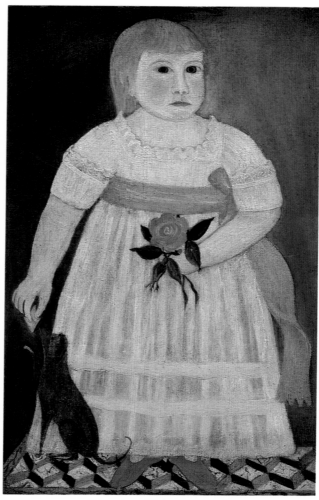

181 Unidentified artist, *Child with Dog*

Deborah Glen's portrait, like those of her husband, John Sanders (no. 173), and her brother-in-law, Robert Sanders (no. 174), descended in the Glen-Sanders family and shares with them an impressively documented history. She was born in 1721, the only child of Colonel Jacob Glen and Sara Wendell Glen of Glenville, New York.[1] The prominence of the Glen family is evident in early records, which identify Deborah's father as commander of all colonial military forces west of Albany and often mention his large landholdings and estate, Scotia, near what is now Schenectady. Deborah belonged to a family of wealth that could and did patronize several portrait painters at an early date. Portraits of Deborah's parents are in the New-York Histori-

cal Society, her father's likeness being attributed to the well-known Schuyler Limner.

Deborah married John Sanders of nearby Albany on December 6, 1739, and they had four children, who ultimately married into New York's Beekman, Ten Eyck, Ten Broeck, and Van Rensselaer families. Family history indicates that Deborah's likeness was painted at the time of her wedding, a suggestion that might account for her elaborate dress. Whatever the occasion may have been, it is clear that this picture was meant to impress and record for posterity the formal aspects of lifestyle and material wealth that the Glens enjoyed.

Deborah Glen has long been attributed to the Gansevoort Limner, and it represents the very finest of his

achievements. Many of the characteristics noted in Miss Van Alen's portrait (no. 179) by the same artist also apply here. But this is obviously a more ambitious picture and it required considerable dexterity and care in execution. The expanse of floral dress fabric and the meticulous rendering of delicate laces on her sleeves and apron surpass anything in the Van Alen picture. The artist seems to have delighted in these passages, remaining totally faithful to the evenness of the patterns and the distinctiveness of each small element. Although the dress is typically flat and devoid of modeling, allusions to three-dimensional form are seen in the floral motifs at the edges of the skirt, which gradually diminish as they approach Deborah's waist.

It is not known whether the artist's successful use of color was born out of the reality of what he was asked to paint, his own imagination, or, more likely, a happy coincidence of both, but it carries this painting and accounts for its freshness and vitality. One has only to see this picture in a black and white illustration to appreciate how crucial the balance of both muted and brilliant colors is to its appeal. This is especially true of Deborah's dress, where two muted shades of brown are overlaid with white vines and bright red flowers outlined in white. The same red was used for her shoes, mixed with white lead to produce the pinks in the roses she holds and in the sky, and her flesh tones. The deep blue trim on her dress was also used in preparing the lighter shades of the sky and was combined with white lead and red for the violet mountains in the background. Greens and yellows were used sparingly. The range of color and its variety were thus restricted to a few basic hues used effectively in patterns of detail against broad, flat areas of subdued but complementary tones. In this respect *Deborah Glen* is a reflection of the best achievements of America's folk artists.

Condition: The canvas was lined by an unidentified person between 1810 and 1850. Subsequently it was removed from its stretcher and rolled up, which caused considerable cracking and some paint loss. In 1966 Russell J. Quandt replaced the old lining, mounted the canvas on new stretchers, cleaned it, and inpainted the areas of loss. Quandt's treatment of *Deborah Glen* is documented in the Colonial Williamsburg film *The Art of the Conservator*. Modern replacement 3¾-inch molded frame, painted black.
Provenance: Descended in the Glen-Sanders family of Scotia, N.Y.
Exhibited: AARFAC, Glen-Sanders, and exhibition catalog, p. 10, no. 3, illus. on p. 10 and on cover; AARFAC, Merchants and Planters, and exhibition checklist; AARFAC, September 15, 1974-July 25, 1976; American Folk Painters.
Published: AARFAC, 1974, p. 31, no. 22, illus. on p. 30; Mary C. Black, "The Gansevoort limner," *Antiques,* XCVI (November 1969), p. 738, no. 13, illus. on p. 743; Black and Lipman, p. 3, no. 11, illus. on

p. 11; Curran, illus.; Etchison, p. 246, illus. on p. 247; Lipman and Armstrong, pp. 43-45, illus. on p. 44; Mary C. Black, "Pieter Vanderlyn and Other Limners of the Upper Hudson," in Ian M. G. Quimby, ed., *American Painting to 1776: A Reappraisal*, Winterthur Conference Report, 1971 (Charlottesville, 1971), p. 237; Beatrix T. Rumford, "Williamsburg's Folk Art Center: An Illustrated Summary of Its Growth," *The Clarion* (Winter 1978), pp. 56-66, illus. on p. 60.

[1]All biographical information in this entry is from the exhibition catalog, AARFAC, Glen-Sanders.

181 Child with Dog 31.100.2

America, probably 1770-1790
Oil on canvas
24" x 15" (61.0 cm. x 38.1 cm.)
(Reproduced in color on p. 205)

There is a timeless appeal to this abstract image of a young girl who stares intently at the viewer while she slips a morsel of food to an eager puppy at her side. The untutored artist seems to have had more experience with decorative painting than with portraiture, because the cubed floor design has a spatial quality not achieved in the flat representation of the child. Only the depiction of a red underskirt, barely visible through the transparent dress, marks an attempt to lend depth and texture to the figure. The unidentified limner's naive approach to rendering form as well as perspective and anatomy is compensated by effective accents of bright color—a moss rose, pink sash and cheeks, and vibrant red shoes.[1]

Condition: Restored by the Fogg Art Museum before 1931; unspecified treatment provided by Russell J. Quandt in 1955. Modern replacement 2-inch mahogany frame.
Provenance: Found in Massachusetts by Isabel Carleton Wilde and purchased from Edith Gregor Halpert, Downtown Gallery, New York, N.Y.; given to the Museum of Modern Art in 1939 by Abby Aldrich Rockefeller; transferred to the Metropolitan Museum in 1949; turned over to Colonial Williamsburg in April 1955.
Exhibited: AARFAC, April 22, 1959-December 31, 1961; American Folk Art; American Primitive Painting, and exhibition catalog, no. 9.
Published: AARFAC, 1957, p. 56, no. 26; AARFAC, 1959, p. 15, no. 1; Cahill, p. 29, no. 2, illus. on p. 54; Nina Fletcher Little, *Floor Coverings in New England Before 1850* (Sturbridge, Mass.,1967), p. 17, no. 15, illus. on p. 53.

[1]An anonymous portrait titled *M. Olmstead, Aged 2* in the Garbisch Collection, National Gallery of Art, Washington, D.C., acc. no. GAR 538, appears to be related stylistically to this example.

182 183

182 Israel Israel 56.100.1

183 Mrs. Israel Israel (Hannah Erwin) 56.100.2

Delaware or Pennsylvania, ca. 1775
Oil on canvas
30″ x 26″ (76.2 cm. x 66.0 cm.)

Israel Israel was born in Pennsylvania in 1743, the son of Michael and Mary J. Paxton Israel. As a young man he spent ten years in Barbados, where he acquired a considerable fortune. He returned to America before 1775, when he married Hannah Erwin in the Holy Trinity Church (Old Swede's Church) in Wilmington, Delaware. Hannah, born June 24, 1756, was the daughter of John and Letitia Erwin of Wilmington.

The young couple settled near New Castle, Delaware, shortly after their marriage and maintained close ties with the Israel family in Philadelphia during the ensuing years. Israel Israel was a member of the Committee of Safety during the Revolutionary War. The British briefly jailed him as a spy in 1777.[1] After the Revolution he served as high sheriff of Philadelphia from 1800 to 1804 and as grand master of the Masonic Order of Pennsylvania in 1802 and 1804. Israel died in 1821; his wife predeceased him in 1813.[2]

The identification of the sitters is based on a resemblance between this portrait of Israel and a likeness of him as an old man.[3] Furthermore, the ornate silver buttons on Israel's coat sleeves and lapels are still owned by his descendants.[4]

Israel Israel is seated on a Chippendale side chair that stands on a tile floor simulated by green and black paint. The artist clearly did not understand the rules of perspective since the front legs of Israel's chair are too short, causing both the sitter and chair to appear suspended in space. Mrs. Israel's high-crowned transparent white lace bonnet is similar to those seen in portraits of eighteenth- and nineteenth-century Quaker women, and the absence of sleeve ruffles on her dark green dress also suggests a Quaker background. However, such a religious affiliation has not yet been documented.

These portraits are highly stylized, although the unknown artist attempted realism both in the sitters' costumes and features. Both figures are placed so close to the foreground that their feet were left out of the compositions. The unusual ankle-length poses and the under-life-size of the subjects suggest that the painter may have been foreign, possibly a member of the large Scandinavian community that populated northern Delaware. The style of nos. 182 and 183, although clearly less polished, is reminiscent of the academic portraits created some years earlier in Philadelphia by Gustavus Hesselius, a Swedish immigrant whose brother once served as minister to the Swedish community in Delaware.[5]

Condition: Russell J. Quandt cleaned and lined the paintings and inpainted minor areas of paint loss throughout both portraits in 1956. The prominent light shadow, shaped like a bent arm to the left of Mrs. Israel, appears to be a preliminary pose that the artist adjusted before completing the portrait. Mid-nineteenth-century replacement 2-inch stained bolection molded frames with gilt inner and outer borders.

Provenance: The Old Print Shop, New York, N.Y.

Published: AARFAC, 1957, p. 354, nos. 213 and 214.

[1] Elizabeth F. Ellet, *The Women of the American Revolution,* I, 6th ed. (New York, 1856), pp. 155-167.

[2] Hannah R. London, *Portraits of Jews by Gilbert Stuart and Other Early American Artists* (New York, 1927), pp. 26-28. See also John W. Jordan, *Colonial and Revolutionary Families of Pennsylvania: Genealogical and Personal Memoirs,* I (New York, 1911), pp. 248-249.

[3] London, *Portraits of Jews,* p. 26, illus. on p. 111.

[4] Hannah London Siegal to AARFAC, January 6, 1956.

[5] E. P. Richardson, *Painting in America: From 1502 to the Present,* rev. ed. (New York, 1965), pp. 30-31.

184 Mrs. Moses Lester 58.100.27

Probably Preston, Connecticut, 1780-1800
Oil on panel
9″ x 6½″ (22.9 cm. x 16.5 cm.)
(Reproduced on p. 210)

This small likeness is related to four slightly larger oil-on-canvas bust-length portraits of Mr. and Mrs. John Avery and Wheeler and Sybil Coit.[1] All of the sitters, including Mrs. Moses Lester, are believed to have been

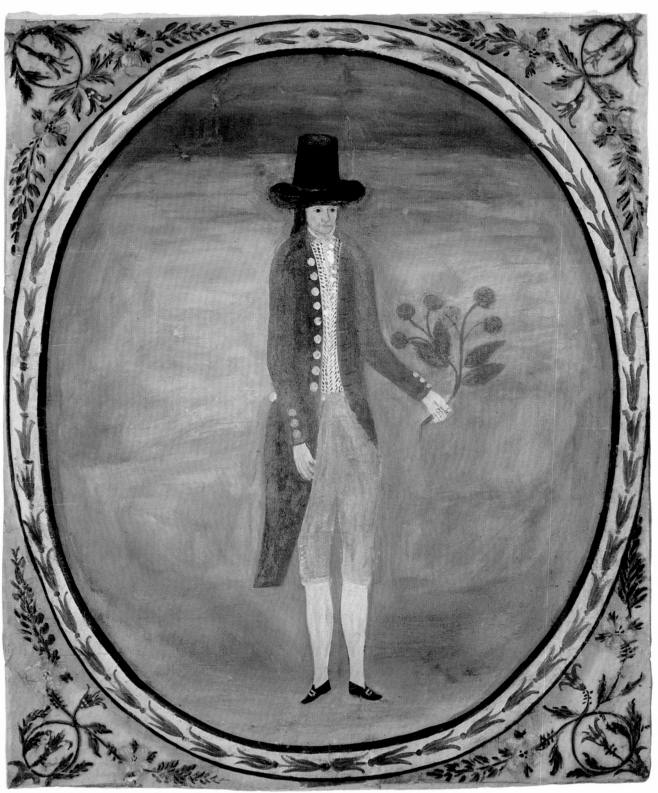

186 Unidentified artist, *Mr. Jacob Edwards*

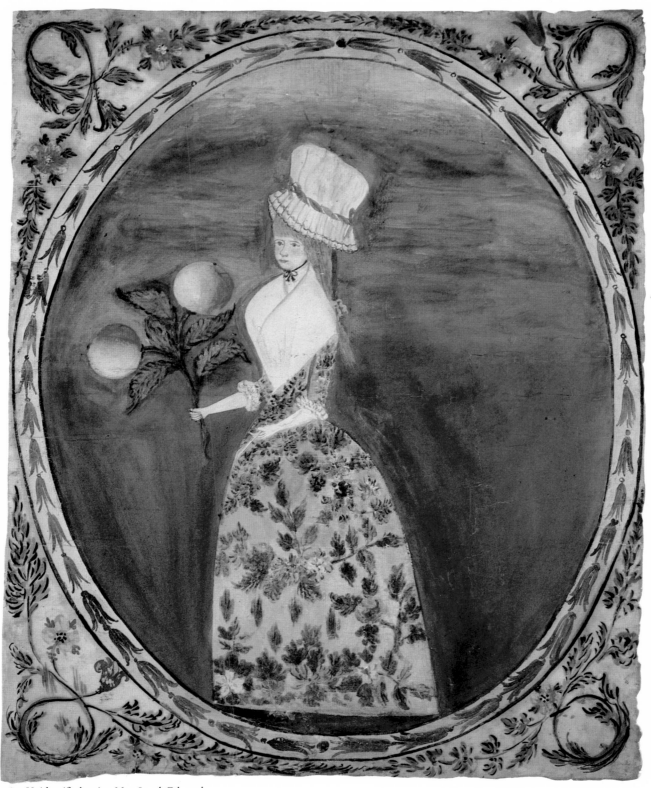

187 Unidentified artist, *Mrs. Jacob Edwards*

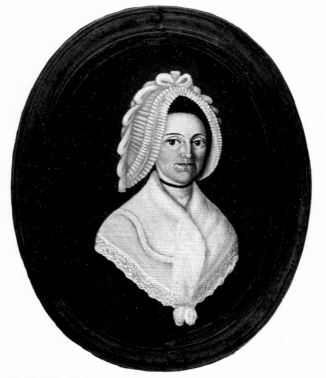

184 Unidentified artist, *Mrs. Moses Lester*

Possibly Boston, Massachusetts, 1781
Oil on canvas
41¼" x 33" (104.8 cm. x 83.8 cm.)

Elegantly dressed in a blue coat with matching cloth-covered buttons, a brown vest with pewter buttons, and a conventional white shirt, Farrington poses with one hand on the keyboard of the organ. The instrument's pipes were precisely drawn, with highlights in warm ochres and yellows. The overall success of this portrait is due to the artist's strong reliance on line to give convincing weight and form and on the jewel-like articulation of details. The figure is modeled throughout, but the flatness of the face, hands, and vest betray either a craft background or minimal training for this artist. The sitter's formal pose, with the body turned three-quarters to the left, and the lightened background behind his head and left shoulder suggest, however, knowledge of eighteenth-century academic portraiture.

from Preston, Connecticut. The women's portraits share similar dresses, nearly identical ruffled bonnets, and stylistically similar treatment of their faces.

Mrs. Lester is depicted against a light brown background and sits in a Chippendale side chair. She wears a conservative brown dress with a white lace-trimmed scarf. The portrait is crisply drawn, with details of the bonnet, face, and lace successfully suggested by quick, sure strokes of paint. The same economical techniques are present in the four other portraits attributed to this unidentified artist.

Inscriptions/Marks: Written in pencil in nineteenth-century script on the reverse of the panel is "Mrs. Moses Lester/of Griswold/ The home of Grandmother John Johnson/(Lydia Morgan Johnson)."
Condition: No evidence of previous conservation. Small areas of paint loss in lower right corner. Original 2-inch molded gilt oval frame.
Provenance: J. Stuart Halladay and Herrel George Thomas, Sheffield, Mass.
Exhibited: Halladay-Thomas, Albany, and exhibition catalog, no. 68; Halladay-Thomas, New Britain, and exhibition catalog, no. 157; Halladay-Thomas, Syracuse, and exhibition catalog, included in nos. 67-97.

[1]The portraits of Mr. and Mrs. Avery are at Old Sturbridge Village, Sturbridge, Mass.; the Coit portraits are privately owned.

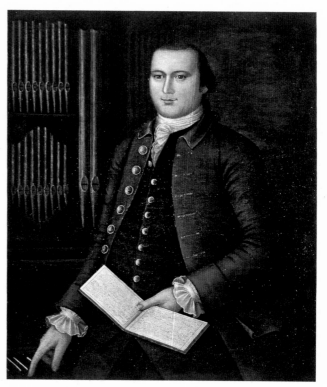

185

Inscriptions/Marks: The music-book inscription on the left page reads "All ye that pass by/Jesus My Hope, For me of . . . with Clamour purified the to Calvary for . . . /[undecipherable] . . . let it . . . [undecipherable] . . . " On the right page are the words "S. Brockiner/ Still may I walk as in the Sight My prior Observer see,/Thou by reverent love unite my Child like Heart to thee. Still let me till my Days are past . . . /Jesus feet . . . at last my features by his side." An inscription within a painted oval on the original canvas support of the painting reads "AE 33y/PF/Dec. 12,/1781."

Condition: In 1953 M. Knoedler & Co. lined and placed the painting on new stretchers and inpainted numerous small cracks throughout. Russell J. Quandt relined and cleaned the painting and inpainted minor losses in 1956. Modern replacement 3¾-inch stained molded frame with gilt inner border.

Provenance: The Old Print Shop, New York, N.Y.

Exhibited: "American Music," Smithsonian Institution, Washington, D.C., May 1, 1966-July 4, 1967; "Music in Colonial Massachusetts," Museum of Fine Arts, Boston, May 16-September 2, 1973.

Published: AARFAC, 1947, p. 14, no. 7; AARFAC, 1957, p. 100, no. 53, illus. on p. 101.

186 Mr. Jacob Edwards 58.300.1
187 Mrs. Jacob Edwards 58.300.2

Probably Connecticut, probably 1788
Watercolor (with casein?) on wove paper
16¼" x 13⅛" (41.3 cm. x 33.3 cm.)
(Reproduced in color on pp. 208-209)

No Jacob Edwards has been found in the first U.S. Census records for Danbury, Connecticut, taken two years after nos. 186 and 187 were said to have been painted there, and no other record of this couple has been found in that vicinity. However, the names and date ascribed to these subjects in 1941 (see *Inscriptions/Marks*) will be retained until more conclusive evidence can be found.

The intricate border and spandrel elements that frame these highly stylized portraits add a degree of formality to likenesses which, while decorative, visually playful, and interesting, are at best only symbolic of individual human forms in terms of realistic representation.

Inscriptions/Marks: According to information supplied in 1941, presumably by Halladay and Thomas (see *Provenance*), "the original backing[s] on . . . [these] portrait[s] carried both the name and date."[1] The backings were not intact when the portraits were acquired in 1958.

Condition: Restoration before 1957 included inpainting and backing with a pulp paper. In 1957 Christa Gaehde removed the earlier acidic backings and replaced them, removed the modern inpainting, retouched some areas, and made "extensive repairs and replacements," probably mending tears and filling in areas of support loss. In 1974 E. Hollyday dry-cleaned the verso and mended numerous tears. Period replacement 1½-inch frames, painted red.

Provenance: J. Stuart Halladay and Herrel George Thomas, Sheffield, Mass.

Exhibited: AARFAC, March 9, 1961-March 20, 1966; American Primitive Painting, and exhibition catalog, nos. 5 and 6; Halladay-Thomas, Albany, and exhibition catalog, nos. 96 and 97; Halladay-Thomas, Hudson Park; Halladay-Thomas, New Britain, and exhibition catalog, nos. 106 and 108; Halladay-Thomas, Pittsburgh, and exhibition catalog, nos. 23 and 24; Halladay-Thomas, Whitney, and exhibition catalog, p. 30, no. 23, p. 31, no. 24.

Published: Black and Lipman, no. 187 only, p. 193, illus. as fig. 182 on p. 203.

[1]See exhibition catalog entries for nos. 23 and 24, Halladay-Thomas, Pittsburgh.

188 John Mix 40.100.2
189 Mrs. John Mix (Ruth Stanley) 40.100.1

Connecticut, probably 1788
Oil on canvas
32½" x 25½" (82.6 cm. x 64.8 cm.)
(Reproduced in color on pp. 212-213)

The identity of the artist responsible for these compelling portraits of John and Ruth Mix is a subject of continuing debate. The paintings were attributed first to an artist named McKay because of superficial similarities between Mrs. Mix's pose and that of Mrs. John Bush in McKay's signed portrait.[1] In a subsequent article in *Art in America*, Susan Sawitzky further discussed the authorship of the Mix portraits and their relationship to paintings by Abraham Delanoy and Reuben Moulthrop,[2] both of whom are known to have worked in the New Haven area. Mrs. Sawitzky ascribed the painting of the faces to Delanoy and the execution of the figures to Moulthrop, who may have served briefly as Delanoy's assistant. While some aspects of the Mix portraits do compare closely with works by those artists, dissimiliarities exist, particularly in the manner of drawing and rendering the subtle volume and planes of the faces, that cannot be disregarded.

Part of the controversy over attribution arises from the differences observed in the painting techniques used to delineate the sitters' faces and their costumes. The edges of their costumes are neatly outlined in darker tones, modeling and shading being used sparingly to achieve depth. The anatomical drawing of the hands is adequate at best, and in no way approaches the subtle, correctly rendered structure achieved in the faces. Unlike the costumes, the faces are powerful in both form and coloration and were painted swiftly with assurance

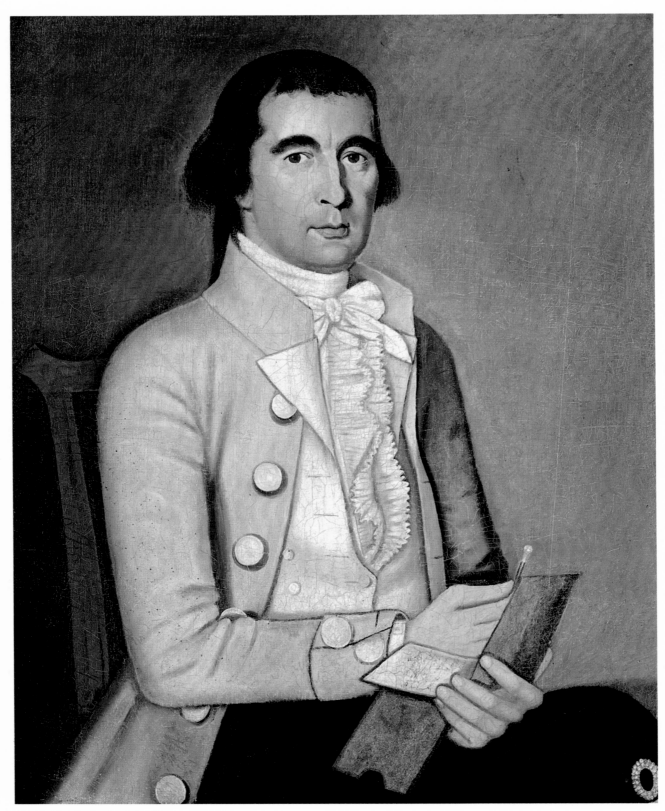

188 Unidentified artist, *John Mix*

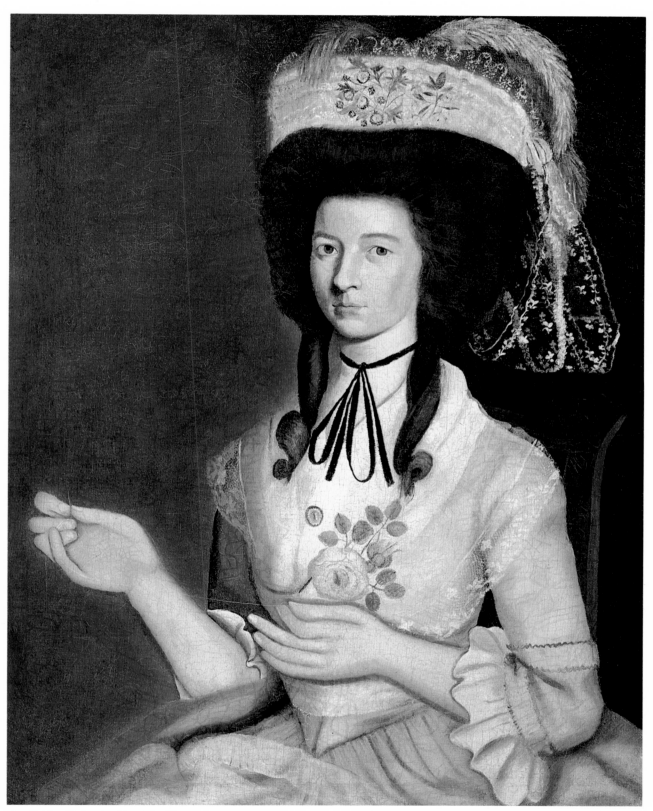

189 Unidentified artist, *Mrs. John Mix*

and facility. The costumes and hands may very well represent another artist's efforts or they may simply indicate restraint or disinterest on the part of someone more concerned with realistic faces than with the intricacies of fabrics, a not uncommon attitude among America's early portraitists.

Very little is known about the sitters. Ruth was born in 1756, the daughter of Noah and Ruth Norton Stanley. They lived in Farmington, Connecticut, where Noah kept a local tavern. Born in 1751, John was the son of Jonathan and Mary Peck Mix, also of Connecticut. The sitters' marriage date is unknown, but they probably moved to New Britain soon thereafter. John served on the town's committee to plan a new school in 1793, and by 1796 he was grand secretary of the Grand Lodge of Masons in Connecticut. Ruth died in 1811; John's death date is unknown.[3]

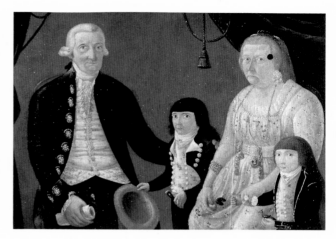

190

190 Family Group 58.100.18

Possibly Spain or South America, ca. 1795
Oil on canvas
38¾" x 53½" (98.4 cm. x 135.9 cm.)

Previous ownership records claim these sitters to be Cadwallader Colden II, his wife, Elizabeth Ellison Colden, and two of their many grandchildren, all residents of eighteenth-century Coldenham, New York. However, certain peculiarities—especially the black patch on the woman's forehead, the profusion of her elaborate jewelry, and other rather exotic costume details—have led several authorities to suggest a Spanish or South American provenance instead of the alleged New York origin. The black patch probably represents an applied beauty spot, a fashionable practice recorded in some Spanish and South American portraits of women but unknown in North American examples. The disparity in dates for these sitters' costumes further complicates the identification of provenance. The man's dress was generally popular during the second half of the eighteenth century both here and abroad, although his neckcloth and wrist ruffles were considered out of date by the 1790s. The woman and children wear costumes more typical of the period 1795-1800.

This unknown painter's love of detail and color is evident in the careful, often labored, rendering of delicate embroidery on the gentleman's and boys' vests, the lady's dress and jewelry, and in the drawing of the faces. The setting, with the enframing green curtains and tassels, was probably inspired by academic portraiture of the period.

Condition: Russell J. Quandt cleaned and lined the painting and inpainted numerous small areas of paint loss throughout in 1958. Period replacement 3½-inch molded frame, painted black, with gilt inner border.

Provenance: Ida H. Kellogg of Newburgh, N.Y., inherited the painting from her grandmother, a Mrs. Hasbrouck, whose mother is said to have acquired the portrait from a member of the Colden family; Frederick Fussenich, Torrington, Conn.; J. Stuart Halladay and Herrel George Thomas, Sheffield, Mass.

Exhibited: AARFAC, New York, and exhibition catalog, no. 3; American Primitive Painting and exhibition catalog, no. 4, illus. on cover; Halladay-Thomas, Albany, and exhibition catalog, no. 4; Halladay-Thomas, New Britain, and exhibition catalog, no. 28; Halladay-Thomas, Pittsburgh, and exhibition catalog, no. 18, illus. facing nos. 16-20; Halladay-Thomas, Syracuse, and exhibition catalog, no.37; Halladay-Thomas, Whitney, and exhibition catalog, p. 30, no. 18.

Published: Black and Lipman, p. 23, no. 50, illus. on p. 50; Ford, p. 56; Thomas Hamilton Ormsbee, "Colonial Americans and Their Jewelry," *American Collector,* X (March 1941), p. 11.

191 Deborah Richmond 74.100.3

Probably Suffield, Connecticut, probably 1797
Oil on canvas
45¾" x 34¾" (116.2 cm. x 88.3 cm.)
(Reproduced in color on p. 216)

Deborah Richmond was born in Westport, Massachusetts, on October 29, 1772, the daughter of Joshua and Eliza Cushing Richmond. Surviving family correspondence and records indicate that she had a brother, Joshua, and at least two sisters, Sally and Elizabeth. The latter married her cousin William Cushing Gay in 1796 and moved to his native Suffield, Connecticut, home shortly thereafter. Deborah, who never married, maintained close ties with Elizabeth and William Gay during her lifetime, living alternately with them, her grandmother Cushing in Scituate, Massachusetts, and her brother's family in Providence, Rhode Island, where she died in 1802.[1]

The provenance of Miss Richmond's portrait is not entirely resolved, although evidence strongly supports a Suffield, Connecticut, origin, where it may have been painted at the house of her sister Elizabeth Gay. A surviving and privately owned portrait of Elizabeth and her son, William Cushing Gay, Jr., is by the same hand, shares a similar history of descent, and is dated 1797 on the verso. In fact, Deborah's pink dress is so close in color and detail to the one Elizabeth wears that it may have been the same one. Familial ties between portrait sitters were often emphasized by similarities in costume, jewelry, and other personalizing items during the period.

Deborah's likeness and that of her sister may also be related to a portrait of Rhoda Smith of Northfield, Massachusetts, since the flower Deborah wears is nearly identical to one in Miss Smith's picture and the dresses of all three women are modeled in a similar manner.[2] A fourth portrait, only tentatively associated with this group, is that of Timothy Swan, who moved from Northfield to Suffield in 1782 and married into the Gay family in 1784.[3]

Deborah's likeness is an exceptionally thoughtful and appealing painting for many reasons. The unknown artist rendered her face and attitude with the compassion of one familiar with her sensitive nature and the lingering health problems she endured throughout her brief lifetime.[4] This effect is reinforced by her pale pink dress and the subtle pastel colors of her face, hair, and hands. The strong diagonals created by the curtain swag and the line of her body on the far side, and the horizontals and verticals formed by her back, the chair, her right arm, and the window frame seem to focus the viewer's attention on her face. The unadorned lower third of the picture escapes our vision, serving only as a compositional element of weight and stability.

The house visible through the window has not been identified, although it most likely held some significance for Deborah. The artist was rather specific in his drawing of this vista, including detailed architectural features and two lamp posts in front of the fenced yard. One suspects that the grained and decorated woodwork below the window was also a literal depiction of the interior of her home. The fan Deborah holds also descended with the painting and is in the Folk Art Center.

Inscriptions/Marks: Words on the lining probably duplicate an original inscription and read "D. RICHMOND AGE 1797."

Condition: An unidentified conservator cleaned, lined, and backed the painting with plywood before its acquisition. Minor cleaning and inpainting was done at the Cincinnati Museum of Art in 1954. Modern replacement 3¼-inch molded frame, painted black.

Provenance: The portrait descended in the family from Eliza Richmond Spencer Alling, New York, N.Y.; to Stephen Howard Alling, Toronto, Canada; to Roger Alling, Daytona Beach, Fla.

Exhibited: Little-Known Connecticut Artists.

Published: Little, p. 108, no. 9, illus. on cover.

[1]Letter from Joshua Richmond, Providence, R.I., to William Gay, Esq., Suffield, Conn., March 31, 1802, privately owned.

[2]The portrait of Rhoda Smith is owned by Pocumtuck Valley Memorial Association, Deerfield, Mass.

[3]Little, pp. 101-103.

[4]Various letters between Deborah and other members of her family, all privately owned, indicate that she suffered constantly from consumptive disorders. The letters also speak of her as a loving sister and friend to her many relatives and friends.

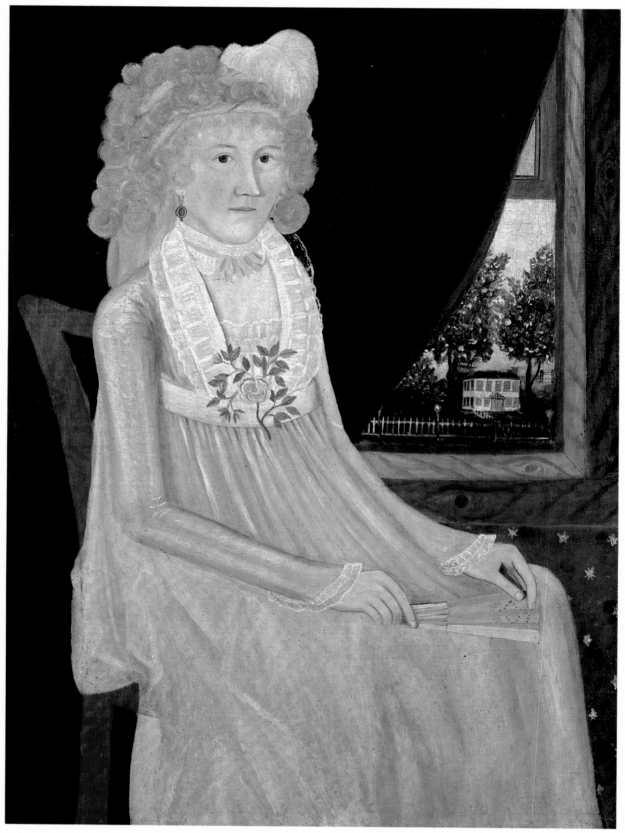

191

192 Henry Voorhees 37.200.2

193 Mrs. Henry Voorhees 37.200.1
 (Sarah Kennedy)

Probably Princeton, New Jersey, ca. 1800
Pastel on paper
20″ x 17¼″ (50.8 cm. x 43.8 cm.)
20¼″ x 18″ (51.4 cm. x 45.7 cm.)

In the past, these pastels were tentatively attributed to Micah Williams because of the sitters' origins and the medium used, but they do not relate stylistically to Williams's known work in this catalog (nos. 168-170) and in other collections. Whoever the artist was, he had a very distinctive method of drawing. The tight, thin lips of both sitters and their rather solid chins are peculiarities not seen in Williams's work. Except for the mouths, the heads have been convincingly rendered and the flesh tones are far more realistic than those used by Williams. The coloration in these portraits is otherwise unremarkable except for the blue gray tints in Mrs. Voorhees's bonnet.

Nothing conclusive has been discovered about the lives of the sitters, although the Voorhees name has been associated with a large and prominent family in the Princeton area since the eighteenth century. The circa 1800 date is based on the style of the costumes, since the authenticity of the pencil inscriptions on the backs of the portraits has never been verified.

Inscriptions/Marks: Written in pencil on the back of no. 193 is "painted in 1790"; on the back of no. 192 is "Henry Voorhees painted 1790." The dates of the inscriptions are undetermined.

Condition: Both pictures were fumigated and treated for mildew by Christa Gaehde in 1955; minor repairs of tears and cleaning were apparently done then. Period replacement 1½-inch molded frames, painted black.

Provenance: Miss Laura A. Sturdivant, Berlin Heights, Ohio.

194 Possibly Mrs. James Madison 37.300.1
 (Dolley Payne Todd)

America, ca. 1800
Watercolor on ivory
2¼″ x 2⅛″ (5.7 cm. x 5.2 cm.)

Although a precise pictorial source has not been found for this likeness of a woman thought to be Dolley Madison, other images of her seem to support the attribution.

Dorothy Payne, the second child of John and Mary Coles Payne, was born on May 20, 1768, in Guilford County, North Carolina, although the family originally came from Virginia and had returned there by April 1769. On January 7, 1790, she married John Todd, a young Philadelphia lawyer, but both he and one of their two young sons died during a yellow fever epidemic in October 1793. On September 15, 1794, Dolley married James Madison, and in 1809 she moved to the White House as the President's wife. She was beautiful, popular, and entertained with great success. She always appeared in the newest fashions, and turbans, such as she is wearing here, became noteworthy details of her cos-

192

193

194

tume. President Madison died in 1836, and Dolley died in Washington on July 12, 1849, at the age of eighty-one.

Condition: Cleaning and some inpainting of the background was done by Christa Gaehde in 1955. Probably period replacement ⅛-inch circular gold-plated metal frame.
Provenance: Bessie J. Howard, Boston, Mass.
Published: AARFAC, 1947, p. 24, no. 59 (titled *Lady with Dog*); AARFAC, 1957, p. 359, no. 236.

195 Woman Picking Flowers 31.100.26

America, ca. 1800
Oil on maple panel
24¾" x 19" (62.8 cm. x 48.2 cm.)

The scale of this figure and the pastoral setting are reminiscent of popular English portraiture of the eighteenth century and possibly were derived from an English mezzotint. The landscape background has been idealistically rendered with blue gray tree forms dissolv-

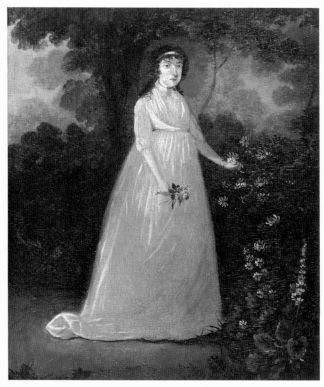

195

ing into a pale pink mist. The woman's heavy, arched brows, baggy eyes, and bulbous nose verge on caricature. She wears a white dress and white hair ribbon and a pink waistband complementing the rose she holds.

Condition: Inpainting of overall cracking losses was probably done when the painting was cleaned by David Rosen in the 1930s. Russell J. Quandt recleaned the painting in 1955. The support has been crudely beveled on the reverse with three remnants of canvas glued to it, and three beveled rectangular strips of wood have been set into it along the lower edge. Period replacement 2½-inch cove-molded frame, painted black, with gold-painted inner and outer edges.
Provenance: Found in Williamsburg, Va., and purchased from Edith Gregor Halpert, Downtown Gallery, New York, N.Y.
Published: AARFAC, 1957, p. 66, no. 34, illus. on p. 67 (titled *Picking Flowers*).

196 Man from Farmington 57.100.16
197 Woman from Farmington 57.100.17

Possibly Farmington, Connecticut, 1800-1810
Oil on cardboard
26⅞" x 21⅜" (68.3 cm. x 54.3 cm.)
(No. 197 is reproduced in color on p. 220)

Little is known about these portraits beyond their history of coming from Farmington, Connecticut. The man's double-breasted rose jacket and white ruffled shirt, the woman's Empire-style pink dress and lace-filled bodice, and the green hoop-backed Windsor chairs date these paintings to the first decade of the nineteenth century. The broad brushstrokes creating curvilinear patterns in the red curtains, the sitters' costumes, and the chair backs provide both compositional movement and abstract decorative interest. The loose, haphazard brushing throughout both pictures indicates rapid execution.

Large oil portraits on paper or cardboard are not typical of the early nineteenth century; canvas and wood panels were the most commonly used supports for oil paints. Since no other works by this hand have been found, it is not known whether the use of cardboard here represents a particular preference by this artist, or whether he simply used the only materials available to him.

Condition: Russell J. Quandt cleaned and inpainted small areas of paint loss in both portraits in 1959. Period replacement 2¾-inch veneered frames.
Provenance: Found in Farmington, Conn., and purchased from and titled by Edith Gregor Halpert, Downtown Gallery, New York, N.Y.

198 Captain Thomas Baker 58.100.17

America, 1800-1825
Oil on canvas
39⅝″ x 31½″ (100.6 cm. x 80.0 cm.)

Jauntily carrying a telescope under one arm and sporting a top hat, this rakish figure has been so heavily retouched that little of the original painting remains. Although the likeness was acquired with the history of being a portrait of Captain Thomas Baker of Kennebunkport, Maine, a master of the brigs *Sophia* and *Parker*,[1] extant records list no Bakers aboard either vessel, and the young man's identity remains unverified.

Condition: When Russell J. Quandt cleaned the painting in 1966, he found that the figure had been almost completely overpainted some years earlier. Original 1½-inch molded frame, painted black, with original brass hanging hooks.
Provenance: J. Stuart Halladay and Herrel George Thomas, Sheffield, Mass.
Exhibited: Flowering of American Folk Art; Halladay-Thomas, Albany, and exhibition catalog, no. 28; Halladay-Thomas, New Britain, and exhibition catalog, no. 25; Halladay-Thomas, Pittsburgh,

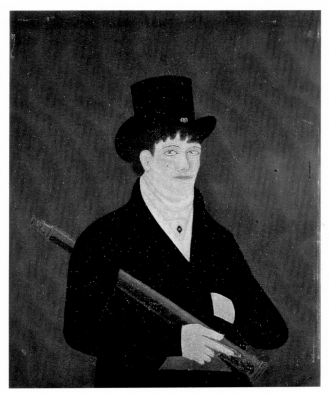

198

and exhibition catalog, no. 44, illus. facing nos. 62-65; Halladay-Thomas, Syracuse, and exhibition catalog, no. 41; Halladay-Thomas, Whitney, and exhibition catalog, p. 32, no. 44.
Published: Lipman, illus. as no. 25; Lipman and Winchester, illus. as no. 31 on p. 36.

[1]See exhibition catalog entry for no. 44, Halladay-Thomas, Pittsburgh.

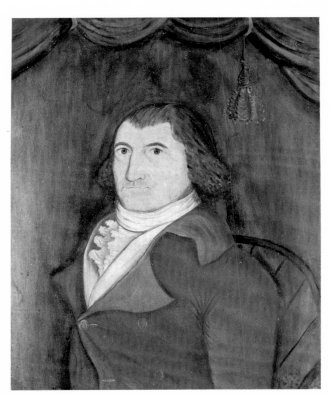

196

199 George Washington 57.300.1

America, probably 1800-1825
Watercolor on wove paper
7½″ x 6⅛″ (19.1 cm. x 15.6 cm.)

This amateurish watercolor likeness of America's first President was most likely copied from an early nineteenth-century printed image that might have been based on one of Charles Willson Peale's portraits of Washington. The deification of George Washington as a national figure is suggested by the surrounding clouds and rays of divine light from above. Other motifs fre-

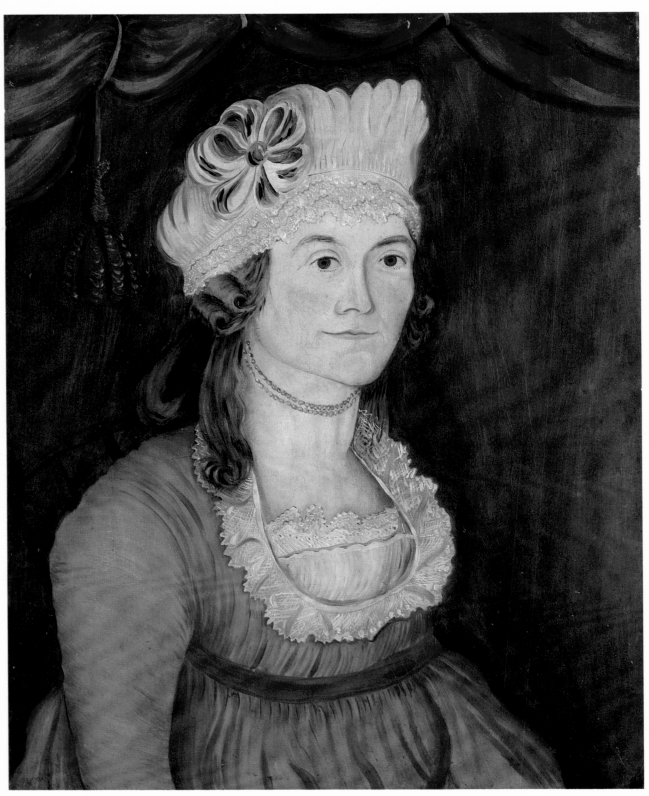

197 Unidentified artist, *Woman from Farmington*

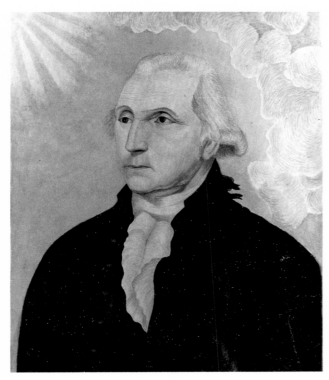

199

phasize the subject. The man's face is well modeled, although the artist's reliance on line to give form was equally strong. Heavy white impasto was used for the jeweled stickpin.

Condition: The portrait was lined by Chernoff at an unspecified date. It was cleaned and inpainted along the lower edge by David Rosen in the 1930s. Modern replacement 2½-inch gilded basswood frame.
Provenance: Edith Gregor Halpert, Downtown Gallery, New York, N.Y.
Published: AARFAC, 1957, p. 350, no. 178.

201 Ege–Galt Family 76.100.1

Virginia, 1801-1803
Oil on canvas
34⅜" x 41¼" (87.3 cm. x 104.8 cm.)

This interesting group portrait by an unidentified artist shows four generations of the Ege-Galt family of Richmond, Virginia.[1] The elderly woman at the left is Maria Dorothea Scherer Ege (1724-1803), the wife of

quently seen in Washington memorial images or apotheoses include palms, wreaths of laurel, the olive branch, flags, eagles, war emblems, the "Temple of Patriotism," and figures of America, Fame, Charity, Fortitude, and the Goddess of Liberty.

Condition: Dry surface cleaning of the verso was done by E. Hollyday in 1975. Period replacement 2-inch bird's-eye maple splayed frame attached to the front of the possibly original flat lap-joined frame.
Provenance: Edith Gregor Halpert, Downtown Gallery, New York, N.Y.

200 Man in Pink Waistcoat 32.100.1

America, 1800-1825
Oil on canvas
23½" x 22¼" (59.7 cm. x 56.5 cm.)

The semitutored artist responsible for this portrait has demonstrated his awareness of sophisticated techniques by lightening the background nearest the figure to em-

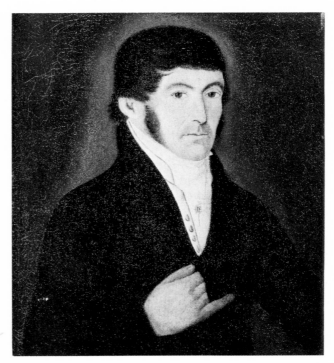

200

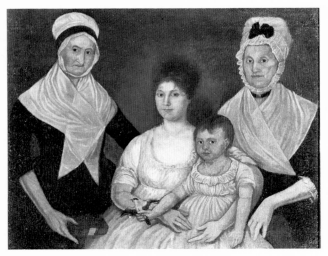

201

depict elements in angular, linear fashion with broad brushstrokes, while the academic painter who followed worked in the soft, painterly fashion of the romantic style. Seldom does one encounter such different approaches at about the same date in the same painting.

Condition: In 1976 Theodor Siegl began conservation treatment of the painting, which included some cleaning. Charles H. Olin completed cleaning and inpainting of numerous losses of paint throughout and mounted it on a solid support in 1978. Original 1½-inch cove-molded frame, painted black.
Provenance: Descended in the Galt family to Mrs. V. Lee Kirby, Williamsburg, Va.

[1]All biographical information in this entry is from AARFAC archives.

202 Gentleman Farmer 34.100.3

Probably Alabama, 1805-1825
Oil on canvas
26⅝" x 21½" (67.6 cm. x 54.6 cm.)

This gentleman may have been one of the numerous wealthy farmers living in the Tennessee River Valley in northern Alabama.[1] His dress and the style of his black hair certainly suggest a man of some means and fashion awareness. Although simple in concept, this is a very strong likeness, crisply drawn with substantial shading in the face and tied neckcloth. It is probably the work of one of the many itinerant painters who traveled throughout the South during the early nineteenth century.

Jacob Ege. Her daughter Elizabeth, the wife of Gabriel Galt (1748-1822), stands at the far right wearing similar attire. The younger woman in the center is the Galts' daughter, also named Elizabeth (1779-1807), who married Thomas Williamson of Henrico County, Virginia. The Williamsons had one son, Frederick (1801-1803), who is shown in his mother's lap holding a bird. Family history indicates that the painting was executed in Richmond, since all of the sitters were residing there during the period 1801-1803.

One of the intriguing aspects of the picture is its format. Group portraiture was certainly produced in the early nineteenth century, but examples like this one from Virginia are exceedingly rare. Even though the quality of modeling and drawing is far below that of some semitrained or trained artists, the composition is quite successful. The artist used the two elderly women's standing poses and diagonally placed arms to frame and unify the picture space. The focal point is the mother and child, drawing the viewer's attention to another feature yet unexplained.

For some reason the face and neck of Elizabeth Williamson were repainted soon after the original portrait was completed, presumably before her death in 1807. The artist who did this obviously possessed greater skill and practiced a polished academic style. The contrast between her face and those of her relatives is evident not only in modeling but in the shape and definition of all features. The original artist tended to

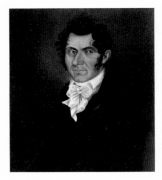

202 203

Condition: Cleaned and lined by Russell J. Quandt in 1955. Modern replacement 2-inch molded gold leaf frame.

Provenance: Found in Huntsville, Ala., and purchased from Holger Cahill.

Exhibited: AARFAC, September 15, 1974-July 25, 1976.

Published: AARFAC, 1940, p. 20, no. 29; AARFAC, 1947, p. 16, no. 29; AARFAC, 1957, p. 74, no. 39; AARFAC, 1974, p. 21, no. 4, illus. on p. 19.

[1]See the exhibition catalog, "Early Arts in the Genesee Valley: Eighteenth & Nineteenth Centuries," Geneseo, N.Y., September 29-October 20, 1974, p. 25, no. 8, for an illustration of what may be a related example.

203 Young Girl in White 31.200.2

America, ca. 1810
Pastel on paper
24″ x 19⅛″ (61.0 cm. x 48.8 cm.)

The inscription on the verso is the only clue to the portrait's previous ownership and the sitter's name, neither of which has been confirmed. No other American pastels by this hand have been discovered, partly because of the lack of published research on artists who used the medium.

This is not an extraordinary picture in terms of composition, nor is it a particularly striking likeness. It offers visual interest, however, in the use of color. The finest passage is the cluster of fruit, foliage, and an orange flower juxtaposed against the bright red sash of equal intensity and the white dress; the artist added one final punctuation of red in the girl's earring. These colors are subtly echoed in the skin tones. The drawing of the face is satisfactory, although the expression is rather bland and devoid of characterization.

The picture was folded up at some point in its history and much of the weak, indistinct quality of the girl's dress is due to flaked and missing color.

Inscriptions/Marks: Written in chalk on the reverse of the picture is "This painting of Mrs. Fletcher's/mother. Mrs. Fletcher was/[illeg.] years old when she died – /and the painting was made/when Mrs. Fletcher's mother/was 7 years old."

Condition: In 1954 Christa Gaehde fumigated the portrait and treated it for mildew. Period replacement 1¾-inch gilt and molded frame with two plaster molded and gilt inner borders of beads and running acanthus leaves.

Provenance: Found in New York state by and purchased from Edith Gregor Halpert, Downtown Gallery, New York, N.Y.

Exhibited: American Folk Art.

Published: AARFAC, 1957, p. 124, no. 62, illus. on p. 125; Cahill, p. 35, no. 36.

204

204 Lady in White Cap 31.300.11

Probably America, ca. 1810
Watercolor and gouache on wove paper
10⅜″ x 8½″ (26.4 cm. x 21.6 cm.)

The flesh tones of *Lady in White Cap*[1] are delicately stippled with pink, gray, and green tints to suggest shadows and contours, a fairly sophisticated watercolor technique that distinguishes it from the majority of items illustrated in this volume.

Condition: Possibly restored by Christa Gaehde in 1955. Period replacement 1¼-inch gilt frame.

Provenance: Found in Bridgeport, Conn., and purchased from Edith Gregor Halpert, Downtown Gallery, New York, N.Y.

Exhibited: Washington County Museum.

Published: AARFAC, 1940, p. 26, no. 54; AARFAC, 1947, p. 24, no. 54; AARFAC, 1957, p. 208, no. 106, illus. on p. 209 (titled *Martha*).

[1]This portrait was titled *Martha* in AARFAC, 1957, through an error in examination and cataloging.

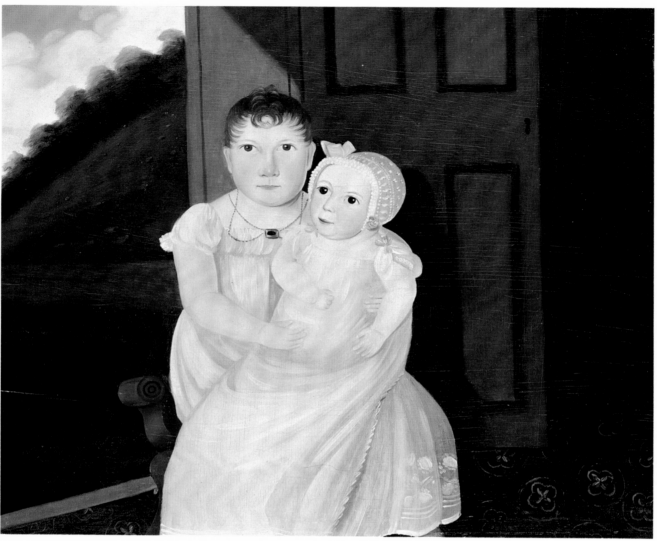

205

205 Two Children

54.100.2

America, ca. 1810
Oil on pine panel
18⅝″ x 22″ (47.3 cm. x 55.9 cm.)

By cleverly placing his chunky, almond-eyed little subjects at the intersection of two strong diagonals and bathing them in sunshine, an unidentified artist succeeded in creating a compelling portrait despite some obvious difficulties with anatomy, perspective, and natural light. The children's bright white dresses and rosy flesh tones dominate the composition, de-emphasizing the nebulous landscape beyond an open door and the patterned floor at their feet. The brushwork is broad and fluid; dress folds, chain necklace, and lace patterns are defined with thick white impasto. The sheer, high-waisted dresses indicate a date of about 1810.

Condition: William Suhr cleaned the painting in 1933 and did some minor inpainting. Russell J. Quandt recleaned it in 1955. Original 2¼-inch molded mahogany-veneered frame with molded inner edges and square corner blocks.
Provenance: Found in Bucks County, Pa., and purchased from

207

Exhibited: "American Ancestors," Downtown Gallery, New York, N.Y., October 3-14, 1933, and exhibition catalog, no. 6.

Published: AARFAC, 1957, p. 104, no. 55, illus. on p. 105.

206 The Dandy 36.100.4

America, ca. 1810
Oil on panel
30⅛″ x 20¼″ (76.5 cm. x 51.4 cm.)

This dapper young man's hair is dressed in the fashionable "French" mode that was popular in America during the early nineteenth century. The notched lapels of his black jacket, the high-buttoned white vest, and the crisply starched white collar reflect the standard dress for men during those years. The subject is viewed against a beige background in a conventional oval format. His face and clothes are boldly delineated and minimally modeled, creating a pleasing, rhythmic pattern of shapes and lines.

Inscriptions/Marks: Penciled on the reverse in a modern hand is the name "Gen. Knox."[1]

Condition: Cleaned in 1936 by William Suhr and recleaned by Russell J. Quandt in 1955. Original frame of 1½-inch molded strips painted brown and nailed directly to front of the panel with sides flush to the panel's edges.

Provenance: Katrina Kipper, Accord, Mass.

Published: AARFAC, 1957, p. 16, no. 6, illus. on p. 17.

[1]It is unlikely that this painting is actually a portrait of the Revolutionary general since Henry Knox was born in 1750 and would have been an elderly man at the time it was done. The style of the portrait indicates a date closer to 1810 than to 1806, the year of Knox's death.

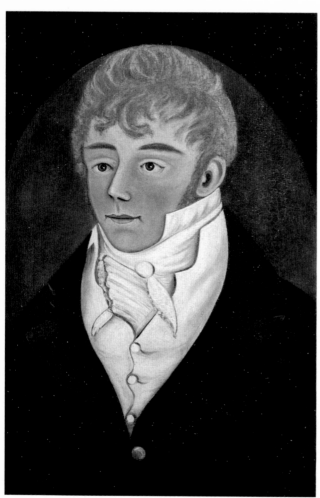

206

207 Baby in Red Chair 31.100.1

Possibly Pennsylvania, ca. 1810-1830
Oil on canvas
22″ x 15″ (55.9 cm. x 38.1 cm.)
(Reproduced in color on p. 225)

This captivating and unique image of a sleeping infant is one of the acknowledged favorites of visitors to the Folk Art Center. Although long believed to be from Pennsylvania, no other works by this unknown artist have been discovered there or in Boston, where the picture was found.

The painting is particularly difficult to date since the child's chair and costume could easily represent eighteenth-century prototypes and the unusual pose and format have no period precedent. The date put forward here is very tentative and is based on the general observation that naive portraiture of the early nineteenth century tends to allow for greater freedom in design and interpretation of subject than do the styles that precede it. Thus far the physical aspects of the canvas and the pigments used have not been helpful in determining its date.

Several aspects of this painting seem somewhat atypical of portrait painting techniques and the usual approach folk artists took in painting likenesses. There is no evidence that the design surface was ever altered or trimmed, yet the picture's composition appears

cropped, with the lower front legs and part of one arm of the chair left out. The billowing white pillow behind the infant also seems to extend beyond the painting and the child is positioned off center. The arrangement is basically asymmetrical, but the child figures very prominently in a nearly symmetrical seated pose. The chair legs and child's feet seem to press against the picture's frontal plane; the baby's legs are convincingly foreshortened but the chair is not, and the whole presents an interesting pattern of forms moving in and out of space.

The coloration of *Baby in Red Chair* is limited but nicely handled in tones of white, pale yellow, rich red, dark brown, and a hint of green in the patterned floor. The brushwork is controlled and seems to flow in uniform thickness throughout, with no particular effort to develop one area more than the next. The subtlety of the child's features and transitions among forms is probably as much the result of the artist's handling of paint as it is of the coloration.

Condition: Unspecified treatment by David Rosen in 1931 probably included cleaning and some inpainting. In 1956 Russell J. Quandt lined, cleaned, remounted the painting on new stretchers, and inpainted areas of paint loss throughout. Probably period replacement 1½-inch molded frame, painted black.
Provenance: Found in Boston, Mass., and purchased from Edith Gregor Halpert, Downtown Gallery, New York, N.Y.; given to the Museum of Modern Art in 1939 by Abby Aldrich Rockefeller; transferred to the Metropolitan Museum in 1949; turned over to Colonial Williamsburg in April 1955.
Exhibited: AARFAC, April 22, 1959-December 31, 1961; "American Art, Four Exhibitions," Brussels Universal and International Exhibition, April 17-October 18, 1958, and exhibition catalog, p. 44, no. 72; American Folk Art; "Art in Our Time," Museum of Modern Art, New York, N.Y., 1939, and exhibition catalog, illus. as no. 4, p. 19; "Survey of American Painting," Carnegie Institute, Pittsburgh, October 24-December 15, 1940, and exhibition catalog, no. 32, illus. as pl. 4.
Published: AARFAC, 1957, p. 96, no. 51, illus. on p. 97; AARFAC, 1959, p. 25, no. 15, illus. on cover and on p. 24; AARFAC, 1975, illus. on p. 4; Oto Bihalji-Merin, *Masters of Naive Art: A History and Worldwide Survey,* trans. Russell M. Stockman (New York, 1971), illus. on p. 41; Black and Lipman, p. 52, illus. as fig. 54 on p. 72; Cahill, p. 29, no. 1, illus. on p. 53; Cahill, *Early Folk Art,* illus. on p. 259.

208 Mrs. Oakley and Her Son, Robert G. 70.300.1

Possibly Hudson River Valley, 1813
Watercolor, pencil, and ink on wove paper
9¼" x 7⅛" (23.5 cm. x 18.1 cm.)
(Reproduced in color on p. 228)

Although no. 208 has not yet been associated with a specific locality, the word "Vrowtye" (or "vrouwtye,"

Dutch for little woman or wife) in its verso inscription lends credence to the later penciled reference to the Hudson River Valley, an area of heavy Dutch settlement. The New-York Historical Society owns a stylistically related portrait of Henry H. Hamsted, depicted half-length in a similarly decorated chair.

Inscriptions/Marks: Handwritten in ink below Mrs. Oakley's chair seat is "1813." On the verso, handwritten in ink in script in the upper right corner, is "Vrowtye Oakley/Robert G. Oakley/1 yr old." In modern script in pencil on a card taped to the cardboard backing of the frame appears "Oakley Family/*Hudson River Valley.*" No watermark found.
Condition: Unspecified restoration before acquisition included repairing various tears, abrasions in the upper left corner, and two small losses in the floor at the left, and backing with a sheet of Japanese mulberry paper. Period replacement 2½-inch simulated crotch-mahogany grained cyma recta frame.
Provenance: Hirschl & Adler Galleries, Inc., New York, N.Y.
Exhibited: "Plain and Fancy: A Survey of American Folk Art," Hirschl & Adler Galleries, Inc., New York, N.Y., April 30-May 23, 1970, and exhibition catalog, illus. as no. 78 on p. 62.

209 Commodore O. H. Perry 33.300.3

America, probably 1813-1819
Watercolor and ink on wove paper
8¾" x 7" (22.2 cm. x 17.8 cm.)

Oliver Hazard Perry was born in Kingston, Rhode Island, in 1785. He entered the navy as a midshipman, served against the Barbary pirates, and fought in the War of 1812; his decisive action in the Battle of Lake Erie brought him instant and enduring fame. He triumphed there despite heavy odds and such severe damage to his flagship, the *Lawrence,* that he had to abandon her, succinctly conveying his success in the now famous message, "We have met the enemy, and they are ours." Perry's victory was considered the single most important naval engagement of the war, and patriotic Americans were enthralled, immediately elevating him to hero status. Perry died only six years later, having contracted yellow fever on a mission to Venezuela. He was buried in Port of Spain, Trinidad, in 1819, but his body was reinterred in Newport in 1826.

American political leaders and military heroes have traditionally been popular subjects for both amateur and professional artists, and numerous portraits of Perry and articles about him appeared after the Battle of Lake Erie. Like no. 210, this watercolor represents a diligent attempt to copy an engraving by Samuel Lovett Waldo accompanying a description of Perry's victory

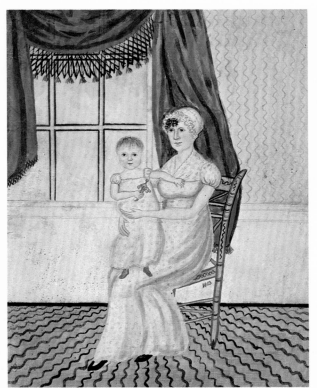

208 Unidentified artist, *Mrs. Oakley and Her Son, Robert G.*

that appeared in the December 1813 issue of *Analectic Magazine.*[1]

Inscriptions/Marks: Printed in ink in the margin below the portrait is "Comm^re O. H. PERRY." No watermark found.

Condition: Restoration between 1954 and 1971, probably by Christa Gaehde, included mending several edge tears, inpainting on the right side of the chin, removal from acidic mounting, cleaning, and backing with wove paper. Original 2-inch splayed frame, painted black, with flat inner lip and outer edge.

Provenance: Rhode Island School of Design; Edith Gregor Halpert, Downtown Gallery, New York, N.Y.

Exhibited: Arkansas Artmobile; "Great Ideas of Western Man," Denver Art Museum, March 18-May 16, 1958; Washington County Museum.

Published: AARFAC, 1940, p. 26, no. 59; AARFAC, 1957, p. 361, no. 254.

[1]"Biographical Memoir of Commodore Perry," *Analectic Magazine,* II (December 1813), p. 494.

210 Commodore Oliver Hazard Perry 35.100.5

Possibly Georgia, probably 1813-1819
Oil on canvas
26" x 22¼" (66.0 cm. x 56.5 cm.)

Like no. 209, this portrait was copied from Samuel Lovett Waldo's engraved likeness that accompanied a biographical article on Commodore Perry in the December 1813 issue of *Analectic Magazine.*[1] Copying Waldo's likeness certainly solved the mechanical problems involved in translating a three-dimensional figure into a two-dimensional one, but the unidentified artist's skillful use of his medium suggests that he would have been capable of a creditable portrayal from life. Transitions of tonality have been handled with considerable subtlety, and color has been advantageously used to enliven the composition. Perry's dark blue uniform contrasts pleasingly with the florid hues of his face and with the gold of his buttons and epaulette. Some knowledge of professional studio techniques of the period is also reflected in the soft, nebulous treatment of Perry's hair.

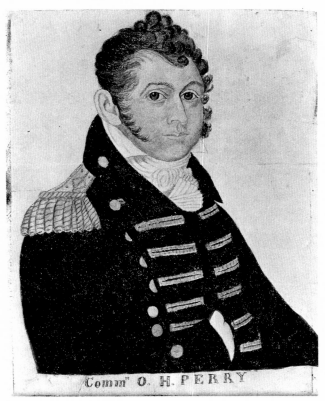

209

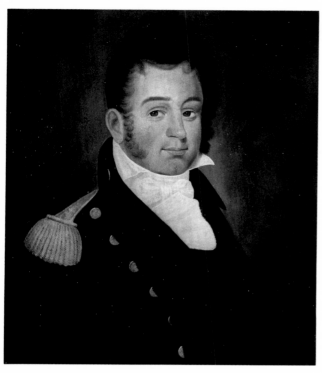

210

Condition: In the 1930s Borwin Anthon cleaned, lined, and remounted the painting, trimmed the primary support flush with the new stretchers, inpainted numerous areas of loss, and repaired a tear in the upper right corner. Period replacement 2½-inch cove-molded gilded frame with quarter-round outer edge.

Provenance: Found by Holger Cahill and purchased from Stoddard & Roche, Savannah, Ga.[2]

Published: AARFAC, 1940, p. 20, no. 28; AARFAC, 1947, p. 16, no. 28; AARFAC, 1957, p. 352, no. 193.

[1]"Biographical Memoir of Commodore Perry," Analectic Magazine, II (December 1813), p. 494.

[2]Early records for this painting state that it had been in the possession of a Savannah family "for many years."

211 Sally Ann Bond and Her Brother 68.300.1

Possibly Massachusetts, ca. 1815
Watercolor and ink on wove paper
8⅞" x 7¾" (22.5 cm. x 19.7 cm.)

Sally Ann Bond and Her Brother is the most elaborate of five recorded works by the same unidentified artist, who is presumed to have been working in Massachusetts about 1815. Two of the other four subjects are young

girls depicted full-length, seated in bamboo-turned Windsor side chairs and holding dolls in their laps, similar in both manner and pose to Sally Ann Bond. These portraits are said to depict Isabella Everset Williams of Roxbury and her twin sister Eliza.[1] The other two works attributed to this hand are half-length portraits of young women seated in Windsor armchairs; one is identified only as "Sarah," and the other is believed to have been a member of the Greene family of Sunderland, Massachusetts.[2] All four portraits have plain backgrounds.

Inscriptions/Marks: Handwritten in ink in script below the image of Sally is "Sally Ann Bond/Born Sept 13 1810." Watermark in the paper, "J WHATMAN/1811" for the Maidstone, Kent, England firm operated by the Hollingworth brothers between 1806 and 1859.

Condition: Unspecified restoration prior to acquisition included mending an edge tear in the middle of the left side, mending a tear in the toy wagon, filling in and inpainting the missing lower left corner, and hinging the support to cardboard with brown paper tabs. Restoration by E. Hollyday in 1974 included replacing previous hinges with Japanese mulberry paper ones. Period replacement 1⅜-inch molded frame, painted black.

Provenance: Mrs. Julian Fehr, Palmyra, N.Y.

Exhibited: AARFAC, September 15, 1974-July 25, 1976.

Published: AARFAC, 1974, p. 32, no. 26, illus. as no. 26 on p. 34.

[1]The portrait of Isabella Everset Williams was sold at Sotheby Parke Bernet, sale no. 3981, lot no. 386, April 29, 1977; the portrait of Eliza

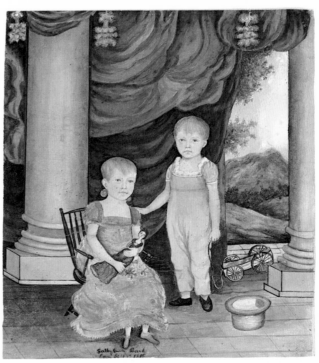

211

is in the Philadelphia Museum of Art and is titled *Eliza Roxberry,* probably a mistake resulting from confusion with Roxbury, Mass., where the twins are believed to have lived.

[2]The portrait of Miss Greene was sold at Sotheby Parke Bernet, sale no. 3947, lot no. 563, January 27, 1977; the portrait of Sarah is privately owned.

212 Mr. Carpenter of Schodack, New York 58.300.4

Probably Rensselaer County, New York, ca. 1815
Watercolor on wove paper
13¹⁵/₁₆″ x 10¾″ (35.4 cm. x 27.3 cm.)

In 1941 and 1942 Halladay and Thomas referred to the subject as "Mr. Carpenter of Schodack, New York," although by 1947 and 1949 they had—for reasons now unknown—begun to refer to him as "Mr. Carpenter of

212

Schodack Landing, New York" (see *Exhibited*). The frame notation (see *Inscriptions/Marks*) offers still another alternative, South Schodack, New York.

It may well prove impossible to establish this sitter's exact identity without further, more specific, information. However, within the scope of the tentative data provided and judging by the subject's approximate age and the conjectural date of the portrait based on costume style, one can consider some potential candidates and eliminate others altogether. The likeliest identification found to date is one Isaac Carpenter, born in 1797, one of the two sons of Walter Carpenter (1740-1816) and his first wife, Maria Huyck Carpenter. Although Walter and Maria were married in Kinderhook in 1774, the family had moved to the town of Schodack by 1800, and it was there that Isaac married Madeline Schermerhorn in 1817. Seven children were born to the couple between 1817 and 1834, and the family was included in the 1850 census for the area. Isaac and Madeline are not buried in Schodack, however, possibly because he was the same Isaac Carpenter who had moved to Washington County, Virginia, by 1874.[1]

This portrait was executed in unusually large scale for a watercolor profile of the period, and the possibility that it may have been copied from a miniature should be considered.

Inscriptions/Marks: In pencil in backhand script and printed letters along one side of the back of the frame, probably added in the twentieth century, is "One of the Carpenters—South Schodack, New York." No watermark found.

Condition: Restoration by Christa Gaehde in 1958 included removal from a pulpboard backing and cleaning. At some time before 1959, the outlines of the coat folds were extensively repainted and a ¼-inch loss in the hair over the upper forehead was inpainted. In 1974 E. Hollyday removed a modern acidic backing. Period replacement 1⅞-inch painted and grained molded frame.

Provenance: J. Stuart Halladay and Herrel George Thomas, Sheffield, Mass.

Exhibited: AARFAC, New York, and exhibition catalog, no. 17; Halladay-Thomas, Albany, and exhibition catalog, no. 79 (titled *Mr. Carpenter of Schodack Landing, New York);* Halladay-Thomas, New Britain, and exhibition catalog, no. 67 (titled *Mr. Carpenter of Schodack Landing, New York);* Halladay-Thomas, Pittsburgh, and exhibition catalog, no. 28; Halladay-Thomas, Whitney, and exhibition catalog, p. 31, no. 28; Washington County Museum.

[1]Lauretta P. Harris to AARFAC, September 12, 1978.

213 Phillip Rainor 58.300.10

214 Master Sidney Rainor 58.300.13

Possibly New York state, ca. 1815
Watercolor on wove paper
7¹/₁₆″ x 5⅜″ (17.9 cm. x 13.7 cm.)
5⅛″ x 3¹⁵/₁₆″ (13.0 cm. x 10.0 cm.)

The identification of nos. 213 and 214 is based on the records of the previous owners,[1] has not been verified, and has been confused by the typed label noted below, which is no longer attached to the portrait or available for examination.

There is, however, a noteworthy resemblance between these portraits and full-scale works in oil by Ammi Phillips, particularly in the treatment and rendering of the stock and tie area of the costumes. Few attempts to isolate miniatures by Phillips have been made,[2] and future studies may result in affirming or refuting this speculation.

Inscriptions/Marks: A typed label affixed to the back of no. 213 when it was acquired read, "Supposed to be the portrait of Sir Langhorn Burton Rainor, first Sherriff of New York City after it received its charter";[3] watermark in the primary support, "T STAIN[S]," the mark used by Thomas Stains, Foots Cray Mill, Kent, England, from 1796 until after 1803.[4] None found for no. 214.

Condition: Restoration by Christa Gaehde in 1958 included removing no. 213 from an old mounting, cleaning, filling in a wedge-shaped area of support loss from the top of the subject's head to the top of the sheet, and backing with Japanese mulberry paper; no. 214 was cleaned and an old diagonal fold was flattened. Period replacement 1-inch convex-molded oval gilt frame for no. 213; probably

214

period replacement 1⅛-inch molded walnut frame with brass inner liner for no. 214.

Provenance: J. Stuart Halladay and Herrel George Thomas, Sheffield, Mass.

Exhibited: Halladay-Thomas, Albany, and exhibition catalog, nos. 54 (titled *Phillip Rainor of New York City*) and 55 (titled *Sidney Rainor of New York City*); Halladay-Thomas, Hudson Park; Halladay-Thomas, New Britain, and exhibition catalog, nos. 165 and 166; Halladay-Thomas, Pittsburgh, and exhibition catalog, nos. 71 and 72; Halladay-Thomas, Syracuse, and exhibition catalog, included in nos. 66-97; Halladay-Thomas, Whitney, and exhibition catalog, p. 34, no. 70, p. 35, no. 71.

[1]All Halladay-Thomas exhibition catalogs that list no. 213 individually identify it as *Phillip Rainor;* it was not so listed in the catalog printed for the 1949 Syracuse show and is known to have been included in that exhibition only through a manuscript list now in AARFAC files. This manuscript list marks the only known instance when Halladay and Thomas identified the sitter as Langhorn Burton Rainor.

[2]A miniature on ivory attributed to Phillips that depicts the Reverend Jonas Coe, the subject of one of his full-scale portraits, is owned by Bertram K. and Nina Fletcher Little.

[3]This information is from AARFAC records; the label itself is now missing.

[4]Thomas L. Gravell to AARFAC, June 22, 1978.

213

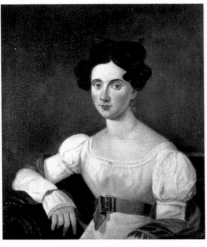

215

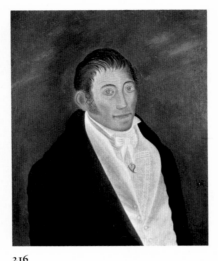

216

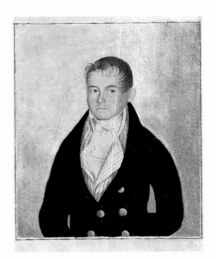

217

215 Lady with Green Belt 31.100.25

> America, ca. 1815
> Oil on canvas
> 29" x 24¾" (73.7 cm. x 62.9 cm.)

The relaxed pose of this lady and the broad, fluid brushstrokes used to define her hair, costume, and the sofa suggest an artist of some ability who had more than a passing acquaintance with academic techniques. The subject's face is carefully articulated and contrasts with the economical brushing of other areas, an uneven treatment often seen in less sophisticated portraiture. The occasional accents of color and detail in the rose colored shawl with green border, the green belt, and the woman's jewelry provide both compositional unity and interest to what is otherwise a very modest painting.

> *Condition:* In the 1930s David Rosen cleaned, lined, and inpainted the area to the right of the sitter's left shoulder. Period replacement 1¼-inch gilt frame with rounded outer and recessed inner edges.
> *Provenance:* Found in Bucks County, Pa., by and purchased from Edith Gregor Halpert, Downtown Gallery, New York, N.Y.
> *Published:* AARFAC, 1957, p. 354, no. 212.

216 Man with Heart-Shaped Pin 35.100.7

> America, ca. 1815
> Oil on canvas
> 27⅝" x 21¾" (70.2 cm. x 55.2 cm.)

The sitter's bug-eyed expression is clearly the most ar-

resting feature of this otherwise unremarkable half-length portrait. Although it seems unlikely that such an expression was assumed for the painting session, the arrangement of several of the subject's features suggests deliberate posturing: the full circles of the irises, the wrinkled forehead, and the decidedly upraised eyebrows. If these resulted from the unidentified artist's perception of his client, then other works by this obviously inexperienced hand should be easy to recognize; as yet only one possibly related likeness has been recorded.[1]

The black-coated figure with a heart-shaped stickpin is posed against a medium brown background whose monotony is slightly relieved by lighter passages suggestive of cloud forms. The depiction of the wrinkles in the far cheek, the indentation of the chin, and the corners of the mouth are subtle and contrast oddly with the harsh linear treatment of the ear, hair, and eyes.

> *Condition:* In 1936 David Rosen cleaned the painting, lined it, and inpainted scattered areas of loss, the largest occurring in the background to the right of the sitter's head and in the lower right corner. Modern replacement 2½-inch stained cyma recta frame.
> *Provenance:* Found by Holger Cahill and purchased from Hollywood Antique Shop, Providence, R.I.
> *Published:* AARFAC, 1957, p. 350, no. 174.

[1]A portrait of an unidentified man that sold as lot no. 149 in the Robert Skinner auction at Bolton, Mass., October 26, 1979, bears several notable similarities to no. 216, among them the treatment of the hair and side whiskers and a wide-eyed expression. See the *Newtown Bee* (Conn.), October 19, 1979, p. 115.

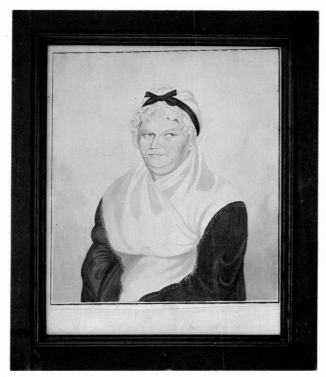

218

218 Woman with a Mole on Her Chin 58.300.27

Probably New Jersey, ca. 1815
Watercolor and gouache on wove paper,
with laid paper and thread
8 15/16 " x 7 5/8" (22.7 cm. x 19.5 cm.)

For *Commentary*, see no. 217.

Inscriptions/Marks: Watermark in the primary support, "H &
W/THIRD RIVER" for Hopkins and Whiting of the Third River Mill,
Passaic, N.J. A second watermark in a separate piece of paper sewn to
the image support is cut off so that only about the upper third is
visible; the design appears to be a crown atop a bordered ellipse
enclosing a figure of Liberty or Justice. On the back of the frame, in
the middle of the left side, the Roman numeral "V" is incised.
 Condition: Unspecified restoration by Christa Gaehde in 1958
probably included backing with Japanese mulberry paper. Dry-
cleaning by E. Hollyday in 1975. Original 1⅛-inch molded cherry
frame.
 Provenance: J. Stuart Halladay and Herrel George Thomas,
Sheffield, Mass.

217 Portrait of a Man 58.300.18

Probably New Jersey, ca. 1815
Watercolor on wove paper
10" x 7 11/16 " (25.4 cm. x 19.5 cm.)

See also no. 218. These likenesses of two unidentified
individuals have been attributed to the artist also re-
sponsible for a pair of half-length portraits of members
of the Ten Broeck family from the Bayonne, New Jersey,
area. The watermarked paper used for the Folk Art
Center's portraits partially confirms a New Jersey area
of activity for the unidentified artist.

 It is interesting to note that the frames of nos. 217
and 218 bear stamped Roman numerals, suggesting that
possibly they formed part of a larger set.

Inscriptions/Marks: Watermark in the primary support, "H &
W/THIRD RIVER" for Hopkins and Whiting of the Third River Mill,
Passaic, N.J. The Roman numeral "III" is incised on the back of the
frame in the middle of the left side.
 Condition: Restoration by Christa Gaehde in 1958 included
cleaning, removal from old backing, and remounting on Japanese
mulberry paper. Original 1⅛-inch molded cherry frame.
 Provenance: J. Stuart Halladay and Herrel George Thomas,
Sheffield, Mass.

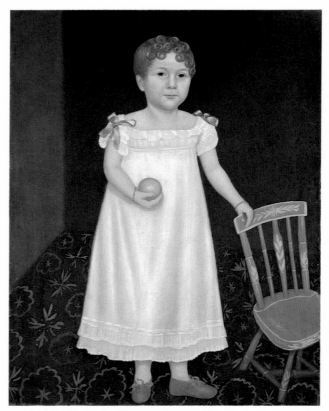

220 Unidentified artist, *Henrietta Frances Cuthbert*

219 Woman in Profile 58.300.30

Probably Pennsylvania, ca. 1815
Oil on yellow poplar panel
9″ x 7″ (22.9 cm. x 17.8 cm.)

Five of the seven other small-scale, half-length profiles
on wood panels that have been attributed to this un-
identified artist are of Pennsylvania origin.[1] Typically,
the faces are thinly and very precisely painted, while lace
edgings and highlights of the sitters' costumes are ren-
dered by distinctive squiggles of thick paint. These fre-
quently suggest fabric folds, but here even the un-
gathered lower portion of the subject's sleeve is given
this nervous surface treatment. In several of the profiles,
as in no. 219, the pupils of the eyes are painted as full
circles, giving the sitters a startled or frightened appear-
ance. Others also show the carefully depicted vertical
ridge between upper lip and nose, which would not
actually be seen in profile.

Some type of spandreled frame or églomisé mat was

221

219

obviously intended for this likeness because the corners
of the panel support are covered only by a greenish buff
ground coat, and the painted oval has a ragged, irregu-
lar edge. The upper right corner bears test patches of
red, pink, white, black, and gray pigment now hidden
by the painted glass.

Condition: There is no evidence of previous conservation. The
sitter's pink bonnet ribbon has been partially obliterated. The 1¼-
inch molded frame, probably a period replacement, has been finished
with gold paint textured with sand and touched up with gold paint; it
has a wire hanging ring clinched into the center top, and its glass has
reverse black-painted spandrels with a gold vinelike design framing
the oval aperture.
Provenance: J. Stuart Halladay and Herrel George Thomas,
Sheffield, Mass.

[1]Related paintings include depictions of three members of the Thomas
George family, illustrated in Tillou, nos. 18, 19, and 20. Portraits of an
unidentified man and woman are in the National Gallery of Art,
Washington, D.C., the gift of Edgar William and Bernice Chrysler
Garbisch. A privately owned portrait of an unidentified woman may
also be of Pennsylvania origin, while a portrait of Mary P. Dakin in the
New York State Historical Association at Cooperstown is of unde-
termined origin.

222

220 Henrietta Frances Cuthbert 41.100.7

Probably Norfolk, Virginia, ca. 1816
Oil on canvas
36¼" x 27¾" (92.1 cm. x 70.5 cm.)
(Reproduced in color on p. 233)

Untrained portraitists frequently experienced difficulty in placing their figures in an interior setting. Here the child is viewed head-on, while the oddly slanted floor and the small stenciled chair are depicted from an altogether different perspective. Whereas nineteenth-century academicians would have labeled this artist's technique "crude" or "primitive," to those conditioned by looking at twentieth-century painting the naive arrangement adds to the portrait's appeal.

Portrayed at about age three, Henrietta Frances Cuthbert was born in Norfolk, Virginia, on July 3, 1813, the daughter of James and Frances Bragg Cuthbert. Henrietta was their only child.[1] She married Dr. Francis Taliaferro Stribling of Staunton, Virginia, and died on February 28, 1889.

Silhouetted against a brightly patterned floor and dark wall, Henrietta cradles an orange in one hand and steadies herself with the other on a red chair. Her sheer muslin dress with its Empire waist and ruffled sleeves cinched with blue bows imitates adult fashions of the early nineteenth century. Girls' hair was generally cut very short and curled during this period, and coral bead bracelets were believed to bring good health to the wearer.

Condition: In 1954 Russell J. Quandt relined and cleaned the painting and replaced old inpainting in minor areas throughout. Period replacement 2¾-inch molded gilt frame with applied rope twist molding.
Provenance: Gift of the subject's grandchildren, Miss Louise Powell, Miss Lucy Lee Powell, Francis Powell, and Frank S. Foster.
Exhibited: AARFAC, September 15, 1974-July 25, 1976; Philbrook Art Center.
Published: AARFAC, 1947, p. 15, no. 15; AARFAC, 1957, p. 12, no. 4, illus. on p. 13; AARFAC, 1974, pp. 22 and 23, no. 9, illus. on p. 9; Mary C. Black, "Folk Painting," *Arts in Virginia*, XII (Fall 1971), p. 11, no. 5, illus. on p. 10.

[1]See nos. 163 and 164 for portraits of Frances Bragg Cuthbert and James Cuthbert, which were painted in Norfolk, Va., about 1812 and have been attributed to Cephas Thompson.

221 Elizabeth Lott (probably 59.300.9
 Mrs. George Lott)

222 Mr. George Lott 59.300.8

America, 1819
Watercolor and ink on wove paper
4⁷⁄₁₆" x 3½" (11.3 cm. x 8.9 cm.)

Although no histories accompany these delightful profiles of a couple known only by name, the ruler depicted in George Lott's outstretched hand provides a clue to his profession. The combination of half-length and full-length poses and the imaginative framing of this pair give them a degree of individuality not often shared by comparable inexpensive likenesses created by professionals in the early nineteenth century.

Inscriptions/Marks: In ink in script in the lower margin of the primary supports are "Elizabeth Lott 1819" and "Geo Lott 1819." No watermark found.
Condition: In 1974 E. Hollyday removed these pieces from cardboard secondary supports and repaired a small top edge tear on no. 222. Original ⅞-inch bird's-eye maple–veneered flat frames with cutout "fish-tail" designs at top and an inlaid heart, mortised and tenoned joints, and brass wire hanging rings at the top.
Provenance: Arthur J. Sussel, Philadelphia, Pa.; Robert Carlen, Philadelphia, Pa.
Exhibited: Washington County Museum.
Published: Parke-Bernet, Sussel, p. 38, no. 245 (both portraits).

223 Woman in Landscape 31.300.2

Probably New York state or New England,
ca. 1820
Watercolor and gold foil on double fold of
wove paper with supplementary pinpricking
5″ x 4³/₁₆″ (12.7 cm. x 10.6 cm.)

Two special techniques have been used that may some-
day help to identify the hand responsible for this half-
length portrait and several other miniature portraits in
private collections. The back of the sitter's ornamented
chair bears bits of gold foil apparently intended to simu-
late gold leaf decoration and pin-striping. Such a collage
element is not unique in stylistically naive forms of
portraiture; it was used occasionally by certain other
artists, among whom the best-documented practition-
ers to date are Ruth W. and Dr. Samuel Shute (no. 158)
and Ruth Henshaw Bascom. However, the artist who
created *Woman in Landscape* has elaborated the foil
areas with supplementary pinpricking. The subject's
cap and collar are also delicately pinpricked, effectively
simulating the appearance of lace. At least four other
examples related in technique, pose, drawing, and the
use of a formula-style landscape backdrop have been
recorded; two of the sitters have been identified as
Ebenezer Clark (1792-1850) and his wife, Delia Colton
Clark (1796-1842), of Longmeadow, Massachusetts.[1]

Condition: Restoration between 1954 and 1971, probably by
Christa Gaehde, included stabilization of flaking paint surface and
inpainting along old vertical fold ½ inch from right edge and in other
areas of the lower half of the painting, particularly to the right of the
near arm. Original 1¾-inch cove-molded gilt frame with applied
rope-twist molding and foliate trim on inner lip.
Provenance: Found in New York state and purchased from Edith
Gregor Halpert, Downtown Gallery, New York, N.Y.
Exhibited: American Folk Art.
Published: AARFAC, 1940, p. 26, no. 55; AARFAC, 1947, p. 24,
no. 55; AARFAC, 1957, p. 361, no. 255; Cahill, p. 35, no. 39; Walters,
Pt. 3, p. 2C, illus. as fig. 9 on p. 3C.

[1]The Clark portraits are owned by a descendant; Mrs. William A.
Godfrey to AARFAC, September 25, 1978. The other two related
portraits depict unidentified men and are privately owned.

224 Girl in Ruffled Collar 32.300.5

Possibly New England, ca. 1820
Watercolor and pencil on wove paper
4³/₁₆″ x 3⁹/₁₆″ (10.6 cm. x 9.0 cm.)

Several artists have been suggested as the author of this
sensitive miniature, but research has proved inconclu-
sive thus far. The delicate use of pale blue gray shading
in the face may eventually help to isolate the hand
responsible for this and other related examples.[1]

Condition: No evidence of previous conservation. Probably
period replacement ¾-inch cove-molded gilt frame and églomisé
glass.
Provenance: Brooks Reed Gallery, Inc., Boston, Mass.
Exhibited: Washington County Museum.
Published: AARFAC, 1940, p. 26, no. 60 (titled *Young Woman*);
AARFAC, 1947, p. 24, no. 60 (titled *Young Woman*); AARFAC, 1957,
p. 216, no. 111, illus. on p. 217.

[1]This portrait was formerly attributed to F. Mayhew.

223

224

226

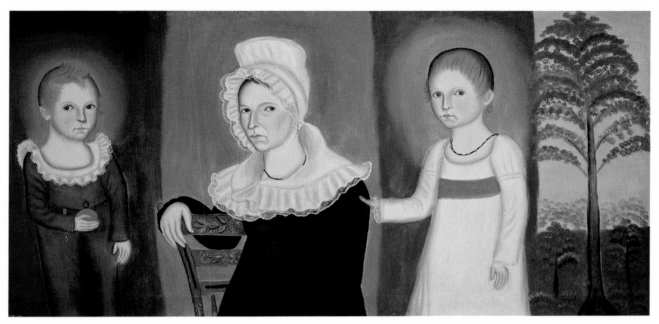

225

225 Maryland Family 34.100.2

Possibly Maryland, ca. 1820
Oil on canvas
29^{5}/$_{16}$" x 59^{1}/$_{4}$" (76.0 cm. x 150.5 cm.)

The identity of this family group and the significance of the peculiar composition are unknown,[1] although certain aspects suggest that it may be a memorial. The tall tree flanked by two smaller ones on the extreme right might indicate a deceased father and two children, while the woman's black dress and jet beads could be construed as mourning attire. The halo effect around the children's heads may also symbolize their recent deaths. Interpreted in this context, the artist's bold four-part division of the composition has greater meaning.

The untrained and unknown hand responsible for this painting worked in a traditional limner manner, picking out the important details of the faces, costumes, and the chair with care and clarity. He knew something of fashionable poses and modeling, but his understanding of perspective and anatomy was limited. Even so, the visual effect of the painting is noteworthy in terms of imaginative design, compositional balance, and, more generally, for the smooth stylization of the faces.

Condition: David Rosen cleaned the painting in 1935. Russell J. Quandt recleaned, lined, and inpainted minor losses along the edges in 1955. Modern replacement 2¾-inch molded frame, painted black.

Provenance: Found by Holger Cahill and purchased from Katherine Turner, Lexington, Ky.

Exhibited: AARFAC, September 15, 1974-July 25, 1976; Arkansas Artmobile.

Published: AARFAC, 1940, p. 18, no. 16 (titled *Kentucky Family*); AARFAC, 1947, p. 15, no. 16 (titled *Mother and Two Children*); AARFAC, 1957, p. 54, no. 25, illus. on p. 55; AARFAC, 1974, p. 18, no. 3, illus. on p. 18.

[1]The former owner of the portrait stated that the painting originally came from Maryland.

226 Lady with Feathers on Bonnet 36.100.1

America, ca. 1820
Oil on canvas
27" x 22½" (68.6 cm. x 57.2 cm.)

The unknown woman in this portrait boasts an impressive array of finery that includes a festooned hat, Indian shawl, and frilled collar. She also wears false corkscrew curls, no doubt a sign of youthful pretensions. The most intriguing aspect of the likeness is the sitter's comical expression, which seems to reflect, apparently intentionally, unabashed self-esteem. Representations of this

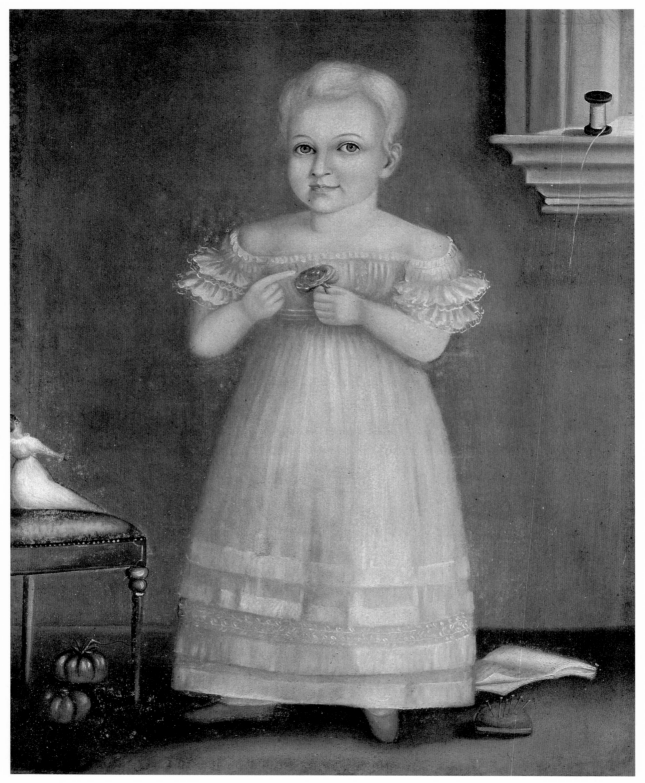

227

kind are as rare in American folk and semiacademic portraiture as they are in academic depictions.

The pose and painting technique are related to those employed by formally trained artists and those with some knowledge of academic conventions, although the overall execution of the portrait lacks the careful delineation and attention to detail that characterize the best examples by artists of comparable proficiency.

Condition: Cleaned and lined by Sidney S. Kopp in 1936. Period replacement 3-inch molded gilt frame.
Provenance: Katrina Kipper, Accord, Mass.
Published: AARFAC, 1957, p. 352, no. 195.

227 Girl in White Dress 58.100.48

America, ca. 1820
Oil on canvas
34⅛″ x 26¼″ (86.7 cm. x 66.7 cm.)

Black outlining of her bright blue irises and upper eyelids make this child's eyes stand out sharply in a figure otherwise treated subtly by soft delineation and modeling of form combined with a predominantly pastel palette.

The rose is by far the most common identifiable flower found in nineteenth-century paintings; traditionally it has represented such desirable attributes as youth, beauty, and love. The full-blown pink rose in this painting was clearly intended to be an important accessory since it is centrally placed and the child is pointing it out with great care.

Playthings like dolls were frequently incorporated into children's portraits, but any symbolism intended by the inclusion of a pincushion, a spool of thread, and two tomatoes has now been lost. These inexplicable props, the unexpected intrusion of the windowsill, and the strong shadows cast by the pincushion and spool all lend the composition a surrealistic air, as does the doll's precarious position—with her back to the viewer, the toy seems to lean against an invisible support.

Inscriptions/Marks: The markings in the book at the subject's feet are largely illegible, but the two words at the top of the left page appear to be "MORNG/HIMN."
Condition: In 1979 Bruce Etchinson lined and cleaned the painting, repaired a small backward L-shaped tear in the lower left side of the dress, and inpainted minor areas of paint loss throughout. Modern replacement 4½-inch cove-molded stained oak frame with rope twist carving along the outer edge and a gilded liner.
Provenance: J. Stuart Halladay and Herrel George Thomas, Sheffield, Mass.

Exhibited: "American Freedom Train," traveling bicentennial exhibition, April 1975-December 1976.

228 Man Holding Quill 58.300.31

Perhaps Connecticut, ca. 1820
Watercolor on wove paper
7⁹/₁₆″ x 6½″ (19.2 cm. x 16.5 cm.)

The loss of shading tones in the drapery caused by fugitive pigments and/or light damage has given the background a false, two-dimensional appearance that contrasts with the fairly convincing and delicately rendered features of the subject's head and body.

Condition: Restoration by Christa Gaehde in 1958 included cleaning, replacing, and inpainting small areas of support loss in the right margin. Original 1-inch gilded frame with applied bead molding.
Provenance: Found in New Haven, Conn.; Mr. and Mrs. Arthur G. Camp, Litchfield, Conn.;[1] J. Stuart Halladay and Herrel George Thomas, Sheffield, Mass.
Exhibited: Halladay-Thomas, New Britain, and exhibition catalog, no. 94; Washington County Museum.

[1]"Living with Antiques: The Connecticut Home of Mr. and Mrs. Arthur G. Camp," *Antiques,* XLIV (December 1943), p. 291, fig. 8.

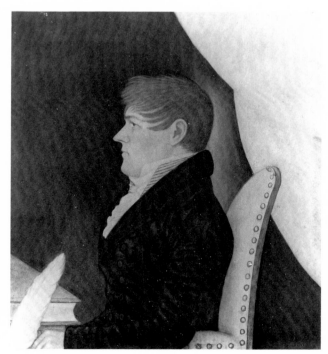

228

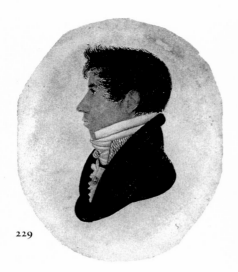

229

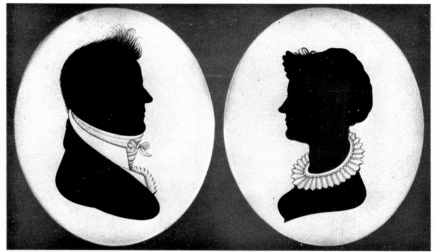

230

229 Man in Black Jacket 63.300.2

America, ca. 1820
Watercolor and pencil on wove paper
3⅞" x 3⅛" (9.8 cm. x 7.9 cm.)

An interesting detail of this simple bust-length profile is the minuscule second profile of a man that appears on the stickpin worn by the unidentified but dapper subject.

Inscriptions/Marks: Printed in ink on a small rectangular scrap of what is probably a twentieth-century paper label affixed to the frame's wood backing is "GOLDSMITH." Printed in pencil in the same hand on the inside of the frame's wood backing is "GOLDSMITH." The primary support bears no watermark or other inscriptions.
Condition: Unspecified restoration prior to acquisition included backing a ¼-inch area of support loss just above the subject's head with Japanese mulberry paper. Original ¾-inch oval wood frame with an embossed brass face and brass hanging ring at center top.
Provenance: Mary Allis, Fairfield, Conn.

230 Captain and Mrs. Henry Crary 76.306.1

New England, possibly 1822
Watercolor or ink on cut wove paper
with reverse-painted glass backing
Left: 4¼" x 3¼" (10.8 cm. x 8.3 cm.)
Right: 4¼" x 3⅝" (10.8 cm. x 9.2 cm.)

Number 230 illustrates an interesting combination of painting and cutting, since the shoulder and bust sec-tions below the sitters' collar or ruff are hollow-cut, as are the heads. The man's coat collar is painted dark blue, making a subtle but effective tonal contrast against the darker backing that shows through his hollow-cut shoulder.

An accomplished hand is evident in the refinement of freehand detail and in the precision and control of the cutting. The collar, stock, and ruff, however, were probably standard finishing touches of the artist's, be-cause he portrayed two young women of Mount Ver-non, New Hampshire, in ruffs identical to this woman's. These two related profiles, identified only as "the Clif-ford sisters," provide the sole link to a specific locale yet found.[1] Unfortunately, no Crarys appear in New Hampshire census reports for 1820 or 1830.

Inscriptions/Marks: Penciled script probably added in the twen-tieth century to the frame's wood backing states "2ⁿᵈ wife/Mary Ann/Grandma Crary/About 1822/Capt Henry/Granpa Crary." No watermark found.
Condition: These two profiles were originally backed with sepa-rate pieces of black-painted glass that had been glued to a tertiary support of paper. In 1976 E. Hollyday replaced both secondary and tertiary supports with a single piece of black-painted glass and re-duced discoloration of the primary support. Original ¹⁵/₁₆-inch molded red- and black-painted frame with wire hanging ring at center top.
Provenance: George E. Schoellkopf, New York, N.Y.
Published: Walters, Pt. 2, p. 1C, illus. as fig. 9 on p. 3C.

[1]These profiles, now unlocated, were illustrated in the *Maine Antique Digest,* V (July 1977), p. 21A.

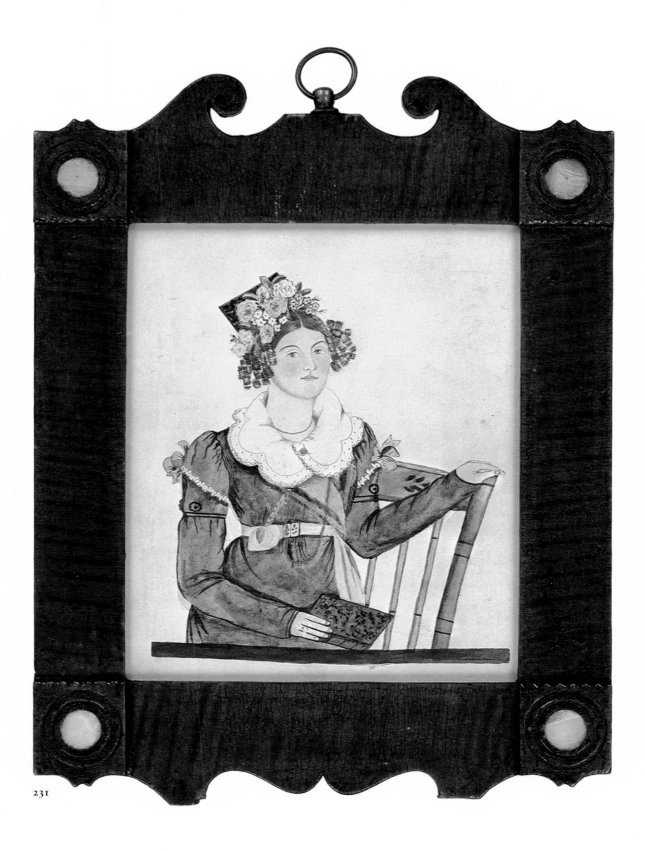

231

231 Possibly Miss Huston: Young Lady in Windsor Chair

77.300.2

Probably Pennsylvania, ca. 1825
Watercolor, pencil, and gouache on wove paper
7³⁄₁₆" x 6" (18.3 cm. x 15.2 cm.)
(Reproduced in color on p. 241)

When purchased, this watercolor portrait was identified as a Miss Huston, "granddaughter of John Huston, founder of the Bank of Union Town, Pennsylvania."[1] Firm substantiation for this identification has not yet been made, but its plausibility is strengthened by the fact that Thomas Vanhook of nearby Perryopolis had his portrait painted by the same artist.[2] Three of the five additional stylistically related watercolor likenesses that have been recorded may represent members of Miss Huston's family, for their frames are virtually identical to hers.[3]

The subject is posed somewhat awkwardly in her green-painted Windsor chair; the abundance of ribbons, bows, flowers, sashes, and laces indicates that she dressed in her most elegant finery to have her picture "taken" by the artist.

Inscriptions/Marks: In pencil in modern script on Japanese mulberry paper backing the primary support, at the top, is "Just as it is 1-16 x 20 W. Color," and at bottom, also on the backing paper, "1-16 x 20 Water Color Haw . . . [illeg., Hawtyns?] Studio, Fairchance, Pa." No watermark found.

Condition: Unspecified restoration before acquisition included backing with Japanese mulberry paper. Probably original 1¼-inch, lap-joined frame painted to resemble curly maple and cut out with scrolls at the top and cyma curves at the bottom, with raised, applied corner blocks resembling shields and inlaid with a circle of mother-of-pearl.

Provenance: Edgar William and Bernice Chrysler Garbisch, New York, N.Y.; gift of Mr. William T. Earls, Sr.

Published: "Americana is Strong: Two Records Set at Sotheby Parke Bernet Sale on January 29," *Newtown Bee* (Conn.), February 4, 1977, p. 38; Bert and Gail Savage, "January Americana Sale: Watercolors at Sotheby Parke Bernet," *Maine Antique Digest,* V (April 1977), p. 3B; Sotheby Parke Bernet, Fine Americana, lot no. 580 (titled *Miss Huston of Union Town, Pa.*); Walters, Pt. 2, p. 2C, illus. as fig. 20 on p. 4C.

[1]Sotheby Parke Bernet, Fine Americana, lot no. 580 and illus.

[2]The privately owned portrait of Thomas Vanhook is attributed to the same artist on a stylistic basis.

[3]The three similarly framed portraits are now privately owned; they were illustrated in Garth's Auction Barn, Inc., *Important Auction of Early American Antiques: Liquidation of George C. Samaha Antiques, Inc.,* lot no. 367 in catalog for sale of October 8-9, 1971. The remaining two likenesses attributable to the same artist are said to depict Benjamin and Catherine Roberts; these are owned by the Chrysler Museum, the gift of Edgar William and Bernice Chrysler Garbisch, 1975.

232 William Malsbury

58.305.16

Possibly Pennsylvania, probably 1825
Watercolor and ink on cut paper
with black silk backing
7⁵⁄₈" x 6⁷⁄₈" (19.4 cm. x 17.5 cm.)

It seems likely that two different hands were involved in the creation of this piece – the profile cutter and the person who devised its present elaborate setting. Hollow-cut heads, some carrying the "Peale Museum" blind stamp, were turned out in great numbers with the aid of the physiognotrace at Charles Willson Peale's museum in Philadelphia and also at his son Rembrandt Peale's Museum and Gallery of Fine Arts in Baltimore. The mechanical image-taking aid was in use in both places in 1825, and this head might have come from either one,[1] although it is not likely to have been cut personally by one of the Peales; the extraordinary popularity of these simple likenesses necessitated their employing help. In 1803, the first year the physiognotrace was used in the Philadelphia museum, Peale's mulatto slave, Moses Williams, cut 8,880 of them.[2]

The overall design format and decorative elaboration of the lettering are typical of hand-drawn family records from the early nineteenth century, but no. 232 is unusual in its inclusion of a hollow-cut profile. The bust-length head has been fashioned from a separate piece of paper, the outer edges cut in a coffin shape and held in place within the similarly cut larger sheet by tapes on the reverse. A double watercolor border gives the impression of a frame and helps to obscure the cut edges.

Another unusual aspect is that the piece serves as a memorial. The first two lines of the enclosed lower margin inscription are personal and are written in the first person, possibly indicating that Malsbury himself fashioned the decorative setting or added the lower inscriptions during a final illness. The last two lines are taken from chapter fourteen of the Book of Job, as the writer has indicated. The missing lower left corner of this work is particularly unfortunate in view of the fragmentary inscription there. Probably the torn word that preceded "Sept 3ʳᵈ=1825" was "Painted."

Discoloration resulting from the use of acidic inks has obscured the artist's original design to some extent, but the diversity of his decorative lettering is still apparent. Some of the open block characters are filled in with cross-hatching and some with diagonal striping, and in "WILLIAM MALSBURY" black semicircles with black

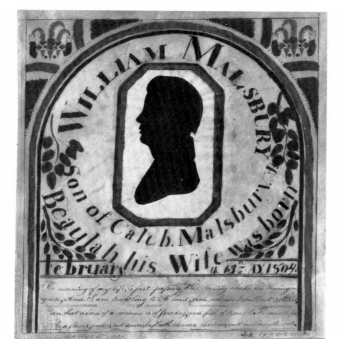

232

Probably eastern New York state, ca. 1825-1830
Oil on yellow poplar panel
30″ x 25½″ (76.2 cm. x 59.7 cm.)

In terms of composition, design, color, and characterization, this formal image of Mrs. Seth Wilkinson is a masterpiece of nonacademic portraiture. It is also the most successful of seventeen likenesses currently ascribed to an unidentifed artist whose affinity for glowing colors, use of thick impasto to create texture, and consistently sharp delineation of lace, jewelry, and small details indicate that he was trained in the techniques of ornamental painting.[1]

Mrs. Wilkinson's steady gaze, sensuous mouth, and strong chin line suggest a willful, self-reliant personality. She is seated at one end of a sofa upholstered in red with a decorative brass rosette applied to the arm. The precise, stylized arrangement of boldly swagged, gilt-edged vermilion drapery effectively frames the young woman's pretty face and creates an impression of elegance and wealth. The diagonal posture of the spaniel, clearly a cherished pet, directs the viewer's eye to the subject's realistically modeled face and her neatly coiffed full black curls, which are secured with a plain tortoiseshell comb.

The artist characteristically depicted his female subjects in high-waisted black gowns with belts buckled at one side. Here the dark dress conveniently obscures anatomical structure and serves as a foil for the exquisite treatment of Mrs. Wilkinson's gold filigree jewelry and lace-trimmed starched dimity collar, where each design element is minutely described with varying amounts of impasto.

According to a previous owner, Mrs. Seth Wilkinson was the wife of a captain of the New York Fire Brigade.[2] Although a check of New York City directories and fire lists has not verified this tradition, several related likenesses of members of the Martling family of Tarrytown have been recorded and would seem to substantiate an eastern New York provenance for this extraordinarily handsome portrait.

dots between them line the edges of the letters. The novel effect, akin to a leopard or snakeskin design, may reappear in other examples of the artist's work, helping to identify him, as may the unusual decorative elements in the upper corners.

Inscriptions/Marks: Partial blind stamp in the primary support immediately below the head reads "——useum," probably for "Peale Museum." In ink and watercolor surrounding the hollow-cut head are the words "WILLIAM MALSBURY/Son of, Caleb. Malsbury. &/ Beaulah. his Wife, was born/February, th, 13th AD: 1804." Inked script in the lower margin reads "The morning of my life, is fast passing away. The evening shades are coming on/apace, And I am travling to A land, from whence I shall not return/Man that is born of a woman is of few day[s], and full of trouble. He cometh for-/[th li]ke a flower, and is cut down: he fleeth also as a shadow, and continueth not." Below, in the lower left corner, is "——ted Sept 3rd=1825," and in the lower right corner, "Job 14=1=2 verses."

Condition: The primary support was cleaned, the missing lower left corner was filled in and inpainted, and the sheet was backed with Japanese mulberry paper by Christa Gaehde in 1959. Modern replacement 15/16-inch flat mahogany-veneered frame with lighter wood banding and half-round outer edge.

Provenance: Arthur J. Sussel, Philadelphia, Pa.

Published: Parke-Bernet, Sussel, lot no. 343; Walters, Pt. 2, illus. as fig. 8 on p. 2C.

[1]Wilbur Hunter, Peale Museum, to AARFAC, October 16, 1974.
[2]Sellers, II, p. 159.

Condition: In 1961 Russell J. Quandt cleaned the portrait and did minor inpainting. Replacement Dutch-style 5¼-inch convex mahogany frame with applied bands of gilded guilloche molding.

Provenance: Found in New York state and purchased from an unidentified dealer by the uncle of W. V. Hope-Johnstone, London, England; M. Knoedler & Co., New York, N.Y.

Published: Advertisement in *Antiques,* LXXVI (October 1959), illus. on p. 297; Black and Lipman, p. 84, illus. as no. 83 on p. 90; *The*

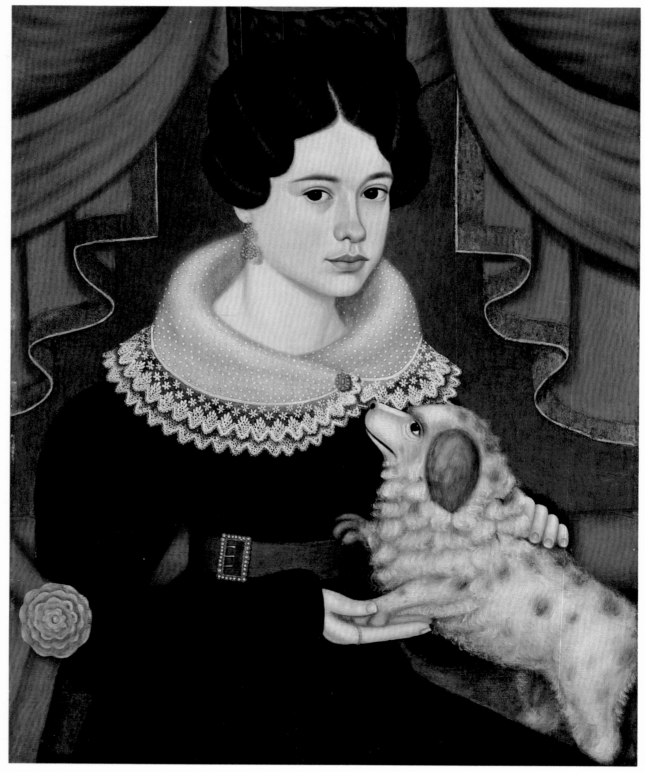

233

Williamsburg Collection of Antique Furnishings (Williamsburg, Va., 1973), p. 108.

[1]Portraits by this artist in museum collections include: (1) Mrs. Abraham Acker (Bella Becker) and her daughter and (2) Elizabeth Acker (Mrs. Squire Stephen Martling), Staten Island Historical Society; (3) Sarah A. Going, Fruitlands Museum, Harvard, Mass.; and (4 and 5) portraits of an unidentified man and woman given to the Art Institute of Chicago by Robert Allerton.

For illustrations of other examples sold on the art market, see exhibition catalog, "Plain and Fancy: A Survey of American Folk Art," Hirschl & Adler Galleries, April 30-May 23, 1970, (6 and 7) portraits of an unidentified man and woman illus. as nos. 73 and 74 on pp. 58 and 59; Skinner Auction Catalog, lot no. 70, February 12, 1972, (8) portrait of an unidentified man misattributed to Z. Belknap; catalog, 1972 Philadelphia Antiques Show, (9-12) one side of a pair of double-sided portraits of two unidentified men and women illustrated in the advertisement of Avis and Rockwell Gardiner, pp. 20 and 21; *Newtown Bee* (Conn.), December 16, 1977, (13) portrait of an unidentified man illustrated in the advertisement for Litchfield Hills Antiques, p. 7; *Kennedy Quarterly*, XVI (January 1978), (14) portrait of a lady misattributed to Noah North, illus. as no. 32 on p. 35; Sotheby Parke Bernet, Inc., *Fine Americana,* catalog for sale no. 4211, lot no. 577, January 31-February 1, 1979, (15 and 16) pair of portraits of Mr. and Mrs. Abraham D. Martling of Tarrytown, illus. as no. 577.

[2]M. Knoedler & Co. to AARFAC, April 27, 1960.

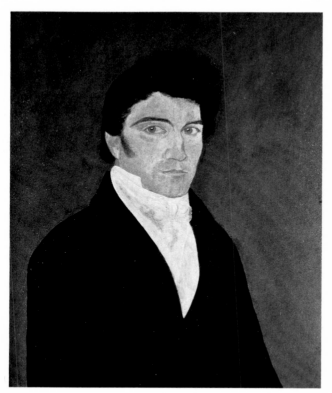

234

234 Man in Dark Blue Coat 32.100.2

America, ca. 1825
Oil on maple panel
24″ x 18¼″ (60.9 cm. x 46.3 cm.)

Minimal modeling and linear treatment of the facial features suggest that the unidentified artist was more familiar with pencil and watercolor than with oil painting; his handling has done little to soften the jagged angles of what must have been a broken nose. The painter basically has ignored the capabilities of his medium in this unremarkable portrait, but the figure does acquire a rather interesting glow from the brick red ground coat that shows through the subsequent layer, particularly noticeable at the perimeter of the body. This was probably the unintended result of hastily adding the dark olive background around the figure rather than the artist's conscious effort to achieve an effect, however. The sitter's black collar is barely discernible against the dark blue of his coat.

Condition: David Rosen cleaned the painting in the 1930s and probably did the retouching evident in the nose and around the left eye. Possibly original 2½-inch cove-molded gilded frame with quarter-round outer edge.
Provenance: Brooks Reed Gallery, Boston, Mass.
Published: AARFAC, 1940, p. 20, no. 30 (titled *Man in Blue*); AARFAC, 1947, p. 16, no. 30 (titled *Man in Blue*); AARFAC, 1957, p. 351, no. 184.

235 Profile of a Woman 75.306.2
236 Profile of a Man 75.306.1

New England, ca. 1825
Woodblock printing on cut wove paper
over wool felt backing
4¾″ x 3¾″ (12.1 cm. x 9.5 cm.)

Both hollow-cut and cut-and-paste profiles were frequently given personalizing touches of freehand decoration or definition, but the use of a woodblock to print such additions was relatively unusual, although it was a logical method of speeding production. The artist responsible for coupling these hollow-cut heads with woodblock-printed bodies is also known for a sample book that has a Westminster, Massachusetts, history and is illustrated both by fully cut profiles and by examples like this pair, which combine cutting with woodblock printing.[1] Presumably these were duplicate im-

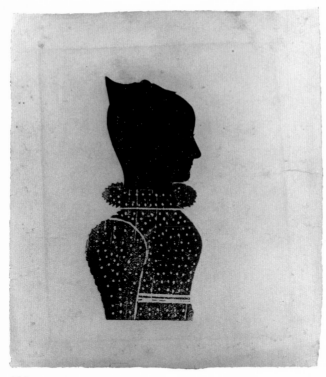

235

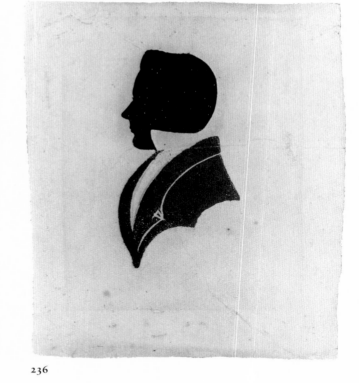

236

ages that the artist retained in order to offer clients a preview of his capabilities, but of course they also provided him with an accurate personal record of his work. The fully cut, bust-length profiles included among these samples are typified by scalloping of the lower edges, while those that are partially printed show that the artist offered two different stock bodies to both men and women. Both standard women's bodies have such similar outlines forming front and back that an error was perhaps inevitable: one sample shows the sitter's head on backward.

In addition to the Westminster examples, two women with bodies identical to no. 235 have been recorded, one of which is inscribed with the sitter's name and "Roxbery, Vermont, 1831."[2]

Inscriptions/Marks: Watermark in the paper support of no. 235 reads "GIBSON" and a partial penciled inscription on the wood backing of the frame reads "Silouttes/Mr. & Mrs. Sow——."
Condition: In 1975 E. Hollyday mended various edge tears and reduced stains in the support resulting from foxing and an acidic mat. Period replacement 1-inch molded and gilded splayed frames.
Provenance: Robert J. Riesberg, St. Paul, Minn.
Published: Walters, Pt. 3, no. 236, p. 3C, illus. as fig. 12 on p. 4C, and no. 235, p. 2C, illus. as fig. 7 on p. 4C.

[1]The sample book is privately owned.
[2]The inscribed example is privately owned; the other is at Old Sturbridge Village, Sturbridge, Mass.

237 Man with Sideburns 77.300.3

America, ca. 1825
Watercolor and pencil on wove paper
10″ x 8¹/₁₆″ (25.4 cm. x 20.5 cm.)

This profile portrait of an unidentified man is particularly interesting because of the variety of techniques the artist employed. The outermost background seems to have been produced by sponging or rag-dabbing the paint, while the fine "combed" lines at the bottom may have been made by dragging stiff brush bristles or other implements through the wet paint. The border immediately below the figure has been shaded with a dry brush and seems to suggest a marbleized surface.

Condition: Unspecified restoration prior to acquisition included backing the primary support with Japanese mulberry paper and

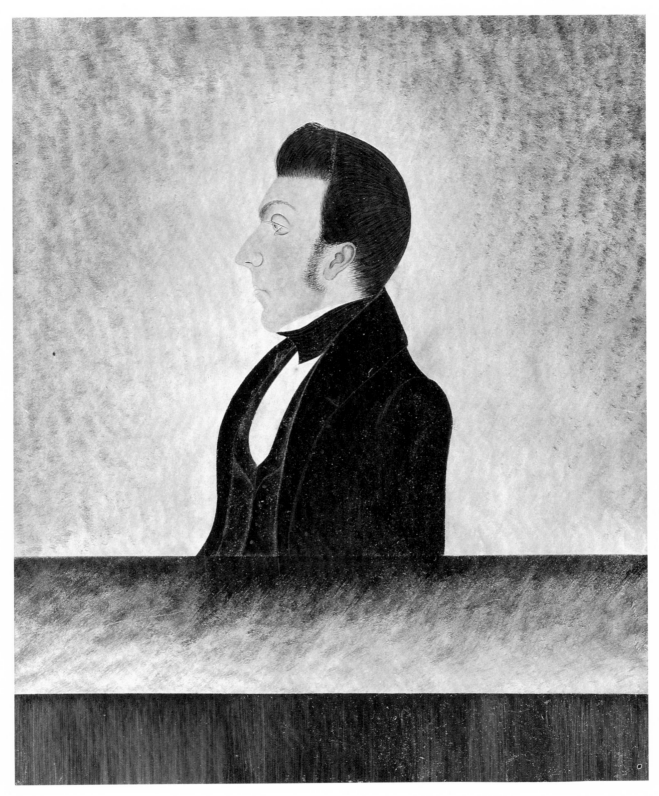

237

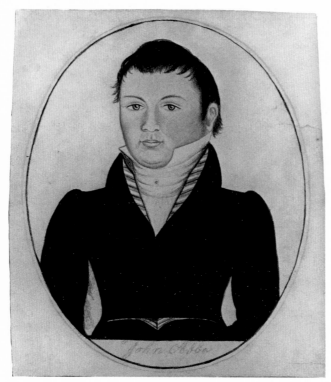

238

been suggested that nos. 252 and 253 are products of the same hand.

Inscriptions/Marks: In pencil in script below the image is "John Abbe." No watermark found.
Condition: Unspecified restoration was done by Christa Gaehde in 1958. Probably period replacement 9/16-inch reed-molded frame, painted black.
Provenance: J. Stuart Halladay and Herrel George Thomas, Sheffield, Mass.
Exhibited: Halladay-Thomas, Albany, and exhibition catalog, no. 57; Halladay-Thomas, Hudson Park; Halladay-Thomas, New Britain, and exhibition catalog, no. 153; Halladay-Thomas, Syracuse, and exhibition catalog, included in nos. 66-97; Washington County Museum.

239 John Kelsey 36.100.3

America, possibly 1826
Oil on canvas
26¾" x 22" (67.9 cm. x 55.8 cm.)

Joel Kelsey, a previous owner of no. 239, is said to have been the sitter's grandson, but efforts to locate him in

mending a 2-inch-long vertical tear at the top center extending into the head and several smaller tears to the right of this and on the right side. Restoration by E. Hollyday in 1977 included re-adhering the edge tear at the right, re-adhering flaking black paint in the coat and bottom border, and replacing the previous hinges with Japanese mulberry paper ones. Probably period replacement 2¾-inch gilded splayed frame with half-round moldings.
Provenance: Edgar William and Bernice Chrysler Garbisch, New York, N.Y.
Published: Sotheby Parke Bernet, Inc., *Americana*, catalog for sale no. 3981, lot no. 346, and illus., April 27-30, 1977 (titled *Portrait of a Young Gentleman*).

238 John Abbe 58.300.26

America, ca. 1825-1830
Watercolor and pencil on wove paper
4⁷/₁₆" x 3⁹/₁₆" (11.3 cm. x 9.0 cm.)

The hard-edged quality of the subject's body and the distorted shape of his head with its somewhat flattened features and ill-placed ear suggest that this unidentified artist felt more at ease with — and perhaps worked more often in — a profile rather than a full-face format. It has

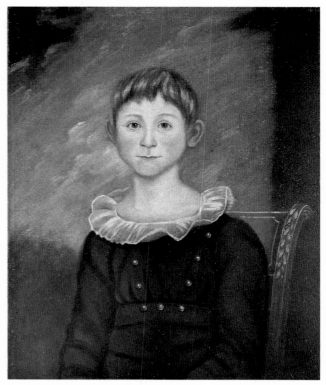

239

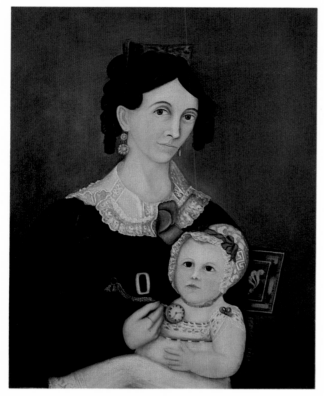

240

Aged 5 years" is recorded as having been written in pencil along the top stretcher.

Condition: Sidney S. Kopp cleaned the painting in 1936 and lined it at a later date. Bruce Etchison cleaned it, relined it, and inpainted scattered, relatively minor, areas of paint loss in 1978. Period replacement 2½-inch cove-molded white pine frame with quarter-round outer edge, painted black, with gold inner edge.

Provenance: Joel Kelsey, Attleboro, Mass.; Katrina Kipper, Accord, Mass.

Published: AARFAC, 1957, p. 350, no. 177.

[1]Virginia Bonner, Attleboro Public Library, to AARFAC, August 13, 1976.

240 Mary C. Richardson Bull and Daughter, Rebecca 64.100.6

Maryland, probably 1827
Oil on wood panel
26" x 22" (66.0 cm. x 55.9 cm.)

Ticking timepieces have long been employed to amuse restless babies, and the unidentified artist has painted his two subjects in this delightfully informal pose. Although young Rebecca shows little fascination with the pocket-watch, its heavy gold chain adds an interesting note of texture. The line of her mother's arm helps to unite the pair visually, thereby emphasizing the painting's statement of maternal devotion.

The artist's palette is rather somber. An olive green background darkens considerably through the lower half of the painting, and the subjects' gray-toned complexions are not enlivened by their black and white costumes or by Mrs. Bull's heavy black curls. Only pale blue ribbons and trim and the baby's coral beads offer touches of color.

Mrs. Bull's upturned lips contrast disconcertingly with her gaunt face and neck and her sunken eyes, which are emphasized by the thin arching lines of her eyebrows. Such rendering and also the soft gray shadowing of the woman's facial features and her tapering fingers offer clues that may prove useful in stylistically linking this likeness with others. No related paintings have been recorded to date.

The sitters' identities were provided by the former owner, a granddaughter of the baby depicted, as was the recollection that the artist was from Philadelphia and was named "Mann." Research to date has not verified this authorship. Rebecca Richardson Bull is said to have been born December 12, 1826, and to have been ten months old at the time the double portrait was painted. The Bulls lived on a plantation known as Nancy's

Attleboro, Massachusetts, city directories between 1925 and 1940 have failed. It also appears that John never lived there because no one with that surname appears in Attleboro vital records before 1850.[1]

The wistful boy's pointed chin and long neck make him appear to be several years older than five. He wears a high-waisted, very dark blue suit trimmed with rows of silver buttons and sits in a brown side chair decorated with gold. The pink-tinged clouds in the background create an atmospheric effect rarely achieved by untutored artists, and the sheen and softness of his hair are fairly convincingly handled. Yet the boy's face and neck are clumsily modeled, the red rimming of his projecting ears only sketchily suggests those features, and his delicate lace collar is given such heavy-handed treatment that the artist's amateur status is unquestionable. The dark vertical strip along the right side of the canvas is ground coat that inexplicably was not completed with the rest of the composition. The chair is merely outlined over it in this section.

Inscriptions/Marks: Now obscured by the lining canvas, "1826

Choice in Kent County, Maryland, a provenance supported by the Baltimore-type decorated side chair in which the pair sit. At age eighteen, Rebecca married James L. Bowers, and they reared eight children.

Condition: The painting was cleaned and relatively minor in-painting was done by Howard Pyle about 1912. Modern replacement 1¾-inch molded stained frame.
Provenance: Descended in the family to Mrs. John M. Emerson, Wilmington, Del.

241 Emma Clark 58.300.5

New England, possibly Massachusetts, 1829
Watercolor, pencil, and ink on heavy wove paper
5 9/16″ x 4 7/16″ (14.1 cm. x 11.3 cm.)

Six portraits stylistically related to this one have been recorded.[1] Characteristics they share include stippled mat and glossy black backgrounds, a palette of primary colors, high contrast in the drawing and coloring, and a minute stippling or hatching technique employed in the rendering of facial features. Two of the other six recorded portraits were done in 1829, the same year that Emma Clark's was executed, and have a history of having been in a Wellesley, Massachusetts, estate.

The six other likenesses attributed to this unidentified hand are half- or three-quarter-length portraits of adults seated in Empire-style chairs with tasseled drapery in the background. Three of the four female subjects hold a single rose in one hand. The portrait of Emma Clark, a little girl identified only by name, has a somewhat surreal quality, the figure being isolated on a vibrant patterned floor that recedes into seemingly infinite darkness behind her. The doll on her lap is endowed with almost human attributes and looks more like a miniature adult than the porcelain-headed toy intended by the artist.

Inscriptions/Marks: Inscribed in ink in script on the reverse of the primary support is "Emma Clark/Aged 3 Years/1829." No watermark found.
Condition: The portrait was cleaned by Christa Gaehde in 1958; in 1975 E. Hollyday removed glassine paper glued to the verso and set down flaking paint. Period replacement 1½-inch gold leaf splayed frame.
Provenance: J. Stuart Halladay and Herrel George Thomas, Sheffield, Mass.
Exhibited: AARFAC, April 22, 1959-December 31, 1961; Flowering of American Folk Art; Halladay-Thomas, Albany, and exhibition catalog, no. 86; Halladay-Thomas, Hudson Park; Halladay-Thomas, New Britain, and exhibition catalog, no. 162; Halladay-Thomas, Pittsburgh, and exhibition catalog, no. 77; Halladay-Thomas, Syra-

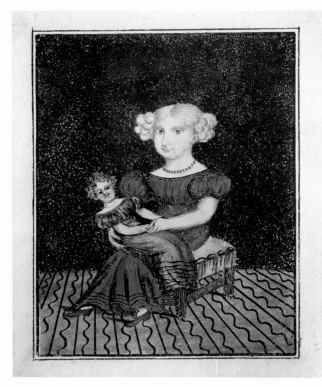

241

cuse, and exhibition catalog, included in nos. 66-97; Halladay-Thomas, Whitney, and exhibition catalog, p. 35, no. 76.
Published: AARFAC, 1959, p. 31, no. 26; Black and Lipman, p. 206, illus. as fig. 185 on p. 208; Mary Cable et al., eds., *American Manners & Morals: A Picture History of How We Behaved and Misbehaved* (New York, 1969), illus. on p. 179; Lipman, illus. as fig. 36 (titled *Edna Clark*); Lipman and Winchester, p. 44, illus. as no. 48; "Toys: A Parade from the American Past," *American Heritage*, XI (December 1959), p. 86, illus. on p. 87.

[1]All six are privately owned.

242 Frank Bottomly 58.300.21
243 Jane Bottomly 58.300.22

Probably New England, ca. 1830
Watercolor and pencil on wove paper
6″ x 7⅞″ (15.2 cm. x 20.0 cm.)
(Reproduced in color on p. 252)

Numbers 242 and 243 exhibit a loose, sketchy quality and an economy of line that suggests the artist was more at ease with his materials and more confident of his drawing abilities than most portrait painters now

classified as folk artists. Nevertheless, the large over-sized roses at either side of Jane Bottomly's likeness place her portrait in a rather stylized and abstract frame of reference, especially in comparison with her companion's portrait, in which the figure is properly scaled to the landscape setting.

Only one other work by this unidentified artist, a large illuminated family record for the Bottomly-Livermore family, has been recorded. Frank and Jane Bottomly are not on the register, but on the basis of style, there is no question that the family record is by the same hand. When it was sold at auction,[1] the register was cataloged as dated 1829 and being of probable Massachusetts origin. However, the last entry on the record, from which the date 1829 presumably was taken, is not necessarily in the artist's hand and may not represent the year of execution.

Inscriptions/Marks: In red and black watercolor letters in a penciled swag at the bottom center of the primary support is "FRANK.BOTTOMLY./AGED 7. Years." Penciled outlines for some of these painted letters are visible behind and beside them. The companion portrait is similarly inscribed "JANE.BOTTOMLY./AGED. 5. Years." Watermarks in the primary supports, "E BURBANK," for Elijah Burbank, Worcester, Mass., active ca. 1811-1834.[2]

Condition: Restoration by Christa Gaehde in 1958 included removal from backing, cleaning, remounting on Japanese mulberry paper, and filling and inpainting several large areas of support loss in the background of Jane Bottomly's portrait. Possibly original 1⅛-inch reed-molded cherry frames.

Provenance: J. Stuart Halladay and Herrel George Thomas, Sheffield, Mass.

Exhibited: Halladay-Thomas, Albany, and exhibition catalog, nos. 87 and 88; Halladay-Thomas, New Britain, and exhibition catalog, nos. 160 and 164; Halladay-Thomas, Pittsburgh, and exhibition catalog, nos. 79 and 80; Halladay-Thomas, Syracuse, and exhibition catalog, included in nos. 66-97; Halladay-Thomas, Whitney, and exhibition catalog, p. 35, nos. 78 and 79.

[1]Sotheby Parke Bernet, sale no. 3637, lot no. 55, May 8-9, 1974.
[2]Weeks, pp. 137-138.

244 Mrs. Sarah Cushman 32.300.6

Probably Bernardston, Massachusetts, ca. 1830
Watercolor and pencil on wove paper
6⅛" x 4⅛" (15.6 cm. x 10.5 cm.)

Sally Wyles, the subject of this portrait, was the daughter of David Wyles of Colchester, Connecticut. She was born there on April 8, 1782, and married Polycarpus Loring Cushman of Bernardston, Massachusetts, on November 27, 1804. Mrs. Cushman died in Saratoga Springs, New York, August 13, 1845.[1]

Inscriptions/Marks: Printed in ink on wood backing of frame, "Mrs. Sarah Cushman/Bernardston, Mass./Taken when about 50 years/of age/See Cushman Genealogy/page 245" (the inscription obviously postdates the book's 1855 publication date; see n. 1). No watermark found.

Condition: Restoration by E. Hollyday in 1974 included reduction of discoloration and acidity in the primary support and dry surface cleaning of unpainted areas. Probably period replacement ¾-inch molded frame, painted black.

Provenance: Isabel Carleton Wilde, Cambridge, Mass.; John Becker, New York, N.Y.

Exhibited: "Exhibition of American Folk Painting in Connection with the Massachusetts Tercentenary Celebration," Harvard Society for Contemporary Art, Cambridge, Mass., October 15-31, 1930, and exhibition catalog, no. 33.

Published: AARFAC, 1940, p. 26, no. 62; AARFAC, 1947, p. 24, no. 62; AARFAC, 1957, p. 360, no. 250; Homer Eaton Keyes, "Title-Hunting Americana," *Antiques,* XXIII (February 1933), illus. as fig. 5 on p. 60.

[1]This information is from Henry Wyles Cushman, *A Historical and Biographical Genealogy of the Cushmans: The Descendants of Robert Cushman, the Puritan, from the Year 1617 to 1855* (Boston, 1855), p. 245.

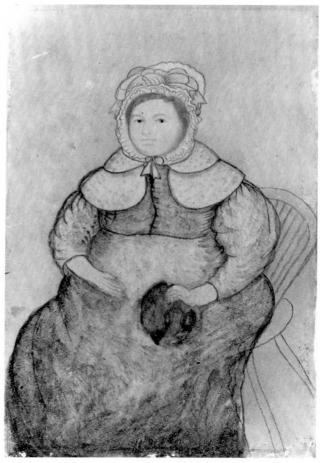

244

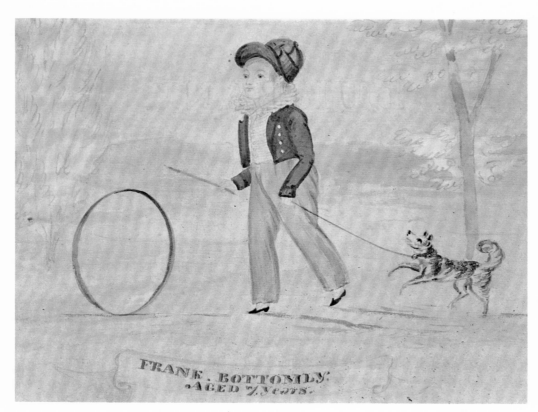

242

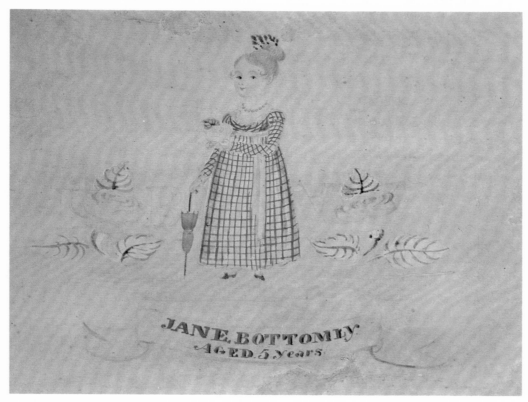

243

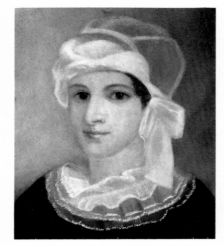

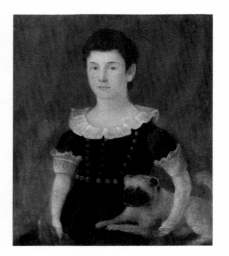

245

246

247

245 John Smith Preston 31.200.5

246 Mrs. John Smith Preston 31.200.6
 (Caroline Hampton)

> America, ca. 1830
> Pastel on paper
> 17″ x 14″ (43.2 cm. x 35.6 cm.)
> 16½″ x 13½″ (41.9 cm. x 34.3 cm.)

Little is known about the Prestons except for the information found on a nineteenth-century note and envelope that accompanied the portraits when they were acquired. It identified the sitters and mentioned that Caroline was the daughter of General Wade Hampton and that John, the son of General Francis Preston, was born in Virginia in 1809 and died there in 1881.

Both of the Prestons' likenesses are skillfully rendered, with expert highlighting and modeling of facial features. Their small size, with the backgrounds cropped close to the tops of the sitters' heads, are unusual but probably are indicative of the unknown artist's inexpensive formats. In quality and technique they represent the kind of watered-down romantic style offered by numerous itinerant semitrained artists of the 1820s and 1830s.

> *Condition:* Both pictures were fumigated and treated for mildew by Christa Gaehde in 1955. Possibly original 1¼-inch molded frames, painted black, with gilt inner liners.
> *Provenance:* Found in Pennsylvania and purchased from Edith Gregor Halpert, Downtown Gallery, New York, N.Y.

247 Boy with Pug Dog 26.100.1

> America, ca. 1830
> Oil on canvas
> 26¼″ x 22¼″ (66.7 cm. x 56.5 cm.)

The subject's quiet, romantic pose, the deliberately shaded neutral background, and the soft outlines and tonal graduations, particularly in the face, lend an air of academic proficiency to this portrait. However, the child's shapeless body, strangely foreshortened arms, and concealed hands indicate that it was the work of an untrained artist who was trying to emulate professionally rendered, fashionable portraits of the period.

> *Condition:* Sidney S. Kopp cleaned the painting, lined it, stabilized cracking, and replaced the auxiliary support in 1936. Period replacement 2¼-inch molded black walnut frame, painted black, with gilt inner liner.
> *Provenance:* Found in Boston and purchased from Katrina Kipper, Accord, Mass.
> *Published:* AARFAC, 1957, p. 352, no. 197 (titled *Boy with Puppy*).

248 Man with White Stock 31.300.1

> Possibly New York state or Connecticut, ca. 1830
> Watercolor, pencil, and charcoal on wove paper
> 20⅛″ x 16⅛″ (51.1 cm. x 40.9 cm.)

Four related examples by this unidentified hand have been recorded, including a pair whose history indicates

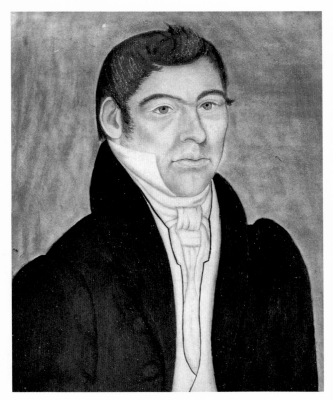

248

no. 61; AARFAC, 1957, p. 361, no. 258; Cahill, p. 35, no. 38, illus. on p. 77.

[1]The Cross River pair are privately owned. The other two related examples were recorded in the collection of Edgar William and Bernice Chrysler Garbisch in 1974; one of the Garbisch portraits was sold in Sotheby Parke Bernet, sale no. 4116, lot no. 498, April 27-29, 1978.

249 Silhouettes on Velvet 31.400.1

America, ca. 1830
Watercolor on velvet
3¹³/₁₆″ x 5½″ (9.7 cm. x 14.0 cm.)

This double portrait was probably created by using typical hollow-cut profiles as stencils, placing them over a piece of velvet, and dabbing paint through the apertures. Although this technique and the velvet support are commonly found in nineteenth-century still-life painting, it is quite unusual to find portraits created in such a manner.

Inscriptions/Marks: None found. The backing that fit an earlier frame for this piece has been preserved, and also a circular label on which is printed "F. HUBBARD & CO."

Condition: Unspecified restoration, probably by Christa Gaehde, included stitching the primary support to a larger oval of linen. Most likely this is what necessitated replacement of the gilded oval frame that had been on the piece from the time it was acquired until at least 1954, according to AARFAC file photographs. Period replacement 1-inch molded oval frame with gold paint over gilding and a gold-painted paper mat.

Provenance: Isabel Carleton Wilde, Cambridge, Mass.; Edith Gregor Halpert, Downtown Gallery, New York, N.Y.[1]

that the subjects were living in Cross River, Westchester County, New York, at the time their portraits were taken.[1] *Man with White Stock* was found not far from there, thus providing a likely general area of activity for the presumably professional portrait painter. Characteristics of the artist's style include a streaked blue watercolor background, the use of pencil and/or charcoal in the modeling of the figure, a slightly elevated placement of the sitters' eyes, and the use of highlights, which result in a glistening quality in skin representation and overly pronounced features such as cheekbones.

Inscriptions/Marks: Primary support bears a three-masted ship with two flags, the watermark of John Butler of Hartford, Conn.

Condition: Restoration by Christa Gaehde in 1959 included reduction of water stains and removal of mildew. Period replacement 2-inch cyma reversa frame of black-painted pine with gold-painted liner.

Provenance: Found in Bridgeport, Conn., and purchased from Edith Gregor Halpert, Downtown Gallery, New York, N.Y.

Exhibited: American Folk Art; Smithsonian, American Primitive Watercolors, and exhibition catalog, p. 4, no. 4.

Published: AARFAC, 1940, p. 26, no. 61; AARFAC, 1947, p. 24,

249

Exhibited: American Folk Art.
Published: AARFAC, 1957, p. 369, no. 314; Cahill, p. 41, no. 111; Walters, Pt. 3, p. 2C, illus. as fig. 10 on p. 4C.

[1] An inventory label of Edith Gregor Halpert's slightly overlaps the Hubbard label mentioned under *Inscriptions/Marks;* Hubbard therefore may be an earlier owner.

250 Man in Yellow Waistcoat 35.100.8

Probably Kentucky, ca. 1830
Oil on basswood panel
33″ x 26″ (83.8 cm. x 66.0 cm.)

The many paintings that have survived in the area from Kentucky southward along the Mississippi River indicate that a number of artists were active there early in the nineteenth century. Some are known by name and by their distinctive styles while others, such as the creator of this picture, have left no clues except their paintings. Working perhaps a step or two behind academics like Matthew Harris Jouett and Joseph Henry Bush, this artist sought to emulate their polished styles and thereby satisfy a public well aware of fashion and equally discerning in its taste. The face is commendably rendered and very likely indicates that the artist was experienced and had learned something of his trade from academic painters.

The gentleman in this portrait wears a traditional high-collared black jacket with white shirt, neckcloth, and an elegant embroidered yellow vest. The painting's richly decorated frame may also have been made by the artist.

Condition: Cleaned and inpainted in small areas throughout by an unidentified conservator. Original 3⅜-inch flat frame with square corner blocks. The frame is grained reddish black to imitate mahogany; all edges are outlined with black and yellow stripes and each corner block is decorated with an eight-pointed star stenciled in gold.
Provenance: Purchased by Holger Cahill from Mrs. Offut, Frankfort, Ky.
Published: AARFAC, 1940, p. 20, no. 31 (titled *Man with High Stock);* AARFAC, 1947, p. 16, no. 31 (titled *Man with High Stock);* AARFAC, 1957, p. 354, no. 207.

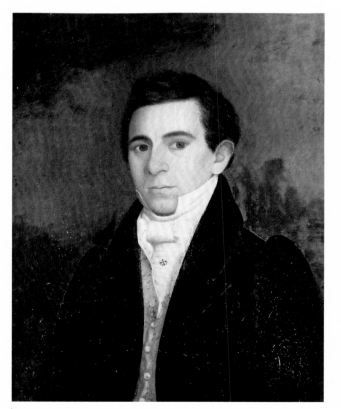

250

251 Mr. P. K. 58.300.36

America, ca. 1830
Watercolor and ink on wove paper
6½″ x 5¹¹/₁₆″ (16.5 cm. x 14.5 cm.)

The combination of a rigidly symmetrical frontal image, exaggerated stylizations, and patterned details with a schematic use of flat, unshaded color has produced a likeness of a human figure that is far more symbolic and iconographic than representational. In associating the image with a particular individual, the initials "P. K." are probably more effective than the drawing itself, which has become more a diagram of a man than a portrait.

Inscriptions/Marks: In watercolor and ink in the upper corners are the initials "P." and "K." No watermark found.
Condition: Restoration by Christa Gaehde in 1959 included cleaning and mounting on Japanese mulberry paper. Original 1-inch flat pine frame, painted red.
Provenance: Arthur J. Sussel, Philadelphia, Pa.
Published: Parke-Bernet, Sussel, p. 60, lot no. 343; Walters, Pt. 2, p. 2C, illus. as fig. 21 on p. 4C.

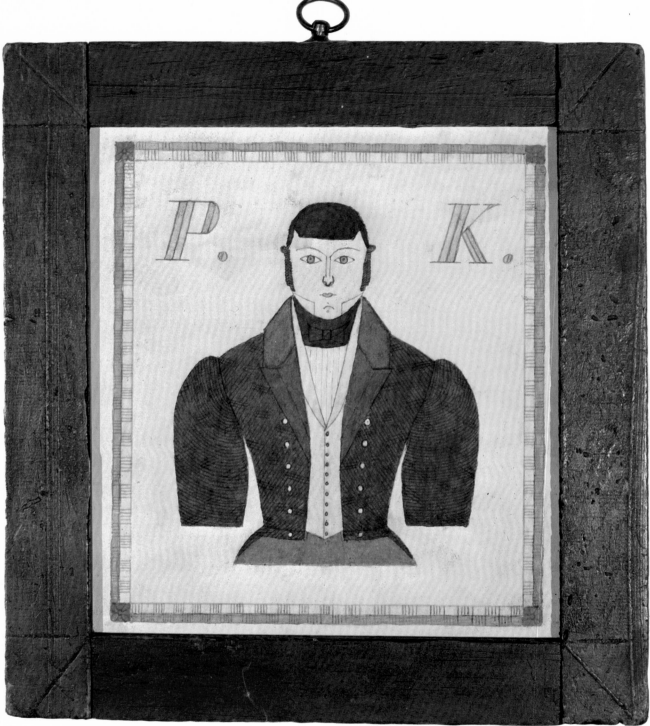

251

252

253

252 Cut Profile of a Woman 76.306.4

253 Cut Profile of a Man 76.306.3

Probably New England, 1830-1835
Watercolor on cut wove paper with black
pulpboard backing
4″ x 3⅛″ (10.2 cm. x 7.9 cm.)

The intriguing abstract shapes of the sitters' bodies make these an especially appealing pair of profiles. The rapid brushstrokes suggesting the elaborate folds and curves of the woman's dress add a decorative touch, while the bold, simplified designs and largely monochromatic coloring produce greater visual impact than many similar but more realistically rendered small-scale likenesses. Consequently, the relatively inept hollow-cutting of the heads becomes less noticeable and less objectionable. Pale red stripes alternate with gray in the man's waistcoat, and his hands are a warm flesh tone. Otherwise, different tonalities have been produced by dilutions of the artist's basic black watercolor.

At least four other half-length profiles have been attributed to the artist responsible for this pair, but only one of them represents the same combination of painting and hollow-cutting seen here. The other three are fully painted side views that do not incorporate cut shapes.[1] A full-face, half-length miniature (no. 238) has also been suggested as a product of this hand, but additional examples will be needed to substantiate the theory.

Inscriptions/Marks: None found. Part of a printed card for the Cortland, N.Y., Business Institute has been used as backing for both.
Condition: In 1977 E. Hollyday dry-cleaned unpainted areas of the primary support, reduced discoloration, mended several minor losses, and inpainted minor losses in the man's coat. The original ½-inch wood frames have brass foil covers with oval apertures clinched into grooves worked into all four members.
Provenance: Hillary Underwood, Woodstock, Vt.
Published: Walters, Pt. 2, no. 253, illus. as fig. 10 on p. 3C, and no. 252, illus. as fig. 5 on p. 2C.

[1] A painted and hollow-cut profile of a woman quite similar to no. 252 was sold at a Robert Skinner auction in Bolton, Mass., on January 16, 1971. The fully painted examples include *Young Man in Striped Waistcoat* in the Karolik Collection, Museum of Fine Arts, Boston, acc. no. 60.836, and the profiles of A. B. Cutler and Mary P. Lane Cutler in the Smithsonian Institution, Washington, D.C.

254 Boy Holding Bird
35.100.2

America, 1830-1850
Oil on canvas
38¼″ x 29⅛″ (97.2 cm. x 74.0 cm.)

When acquired, this portrait was said to represent François Gabriel "Valcour" Aimé (1797-1867), the scion of a wealthy Louisiana family, who became a planter and was noted for his experimentation with sugar refining. This identification is probably erroneous since the boy's costume was in vogue long after Aimé's childhood.

The soft, scumbled modeling apparent throughout this painting accounts for the indistinct passages from middle tones to dark color areas. The artist was aware of, if not actually tutored in, academic methods since the general position of the figure, the interior setting with carpet and partially draped background, and the juxtaposition of lights and darks were standard conventions of formal studio painting.

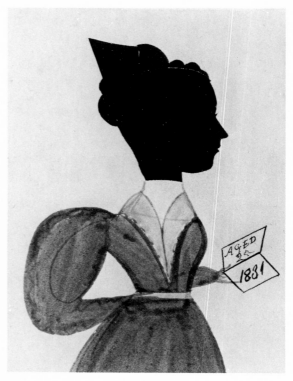

255

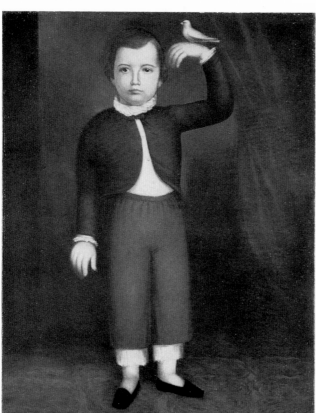

254

Condition: The painting was cleaned and lined at an unspecified date early in this century. Original 4-inch cove-molded gilt frame with a foliate plaster motif applied to the inner edge and fitted with a plain gilt liner.
Provenance: Mr. Lieutaud, New Orleans, La.
Published: AARFAC, 1957, p. 351, no. 188.

255 Aged 25
32.300.4

Probably New England, 1831
Watercolor, ink, and pencil on cut wove paper with inked cut wove paper backing
4″ x 3″ (10.2 cm. x 7.6 cm.)

A number of highly stylized, easily recognized combination watercolor and hollow-cut profiles apparently by the same hand have been found in the New England states. One that employs the same device of age and year inscription was attributed by an early writer to a Massachusetts profile cutter, Ezra Wood, although the attribution now seems untenable.[1] The bodies of these figures are quite abstract and colorful; likewise, the

cutting of the profile heads tends toward caricature. Other half-length works by this unidentified hand show figures holding floral sprigs, a pocketbook, a cane, a ledger book, a sword, or similar, somewhat personalizing props.

Inscriptions/Marks: In ink on a folded card in the sitter's hand is "AGED/25/1831." No watermark found.
Condition: Restoration between 1954 and 1971, probably by Christa Gaehde, included reduction of a water stain in the upper left corner. Probably original ⅝-inch cove-molded gilt frame.
Provenance: Found in Hanover, N.H., and purchased from Edith Gregor Halpert, Downtown Gallery, New York, N.Y.
Exhibited: Washington County Museum.
Published: AARFAC, 1940, p. 26, no. 65 (titled *Silhouette Portrait of a Woman*); AARFAC, 1947, p. 24, no. 65 (titled *Silhouette Portrait of a Woman*); AARFAC, 1957, p. 360, no. 247; Walters, Pt. 2, pp. 1C-2C, illus. as fig. 6 on p. 2C.

[1]See Olive Crittenden Robinson, "Ezra Wood, Profile Cutter," *Antiques,* XLII (August 1942), fig. 1, p. 69.

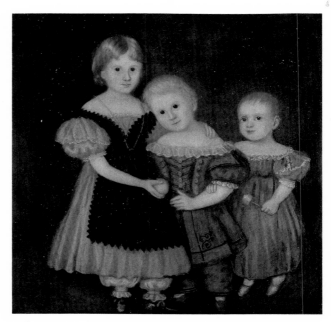

256

256 The Hayward Children 31.100.14

Possibly South Acton, Massachusetts,
possibly 1834
Oil on yellow poplar panel
37¾″ x 37″ (95.9 cm. x 94.0 cm.)

Through strategic design of his composition, the unidentified artist of this group portrait has effectively conveyed an impression of sibling loyalty and devotion; the children's interlocked arms, the inward movement of their near arms, their overlapped bodies, their graduated heights, and the boy's inclined head all contribute to a feeling of tender closeness.

According to information supplied by a descendant, the portrait shows Eben Scott Hayward (1829?-1929) flanked by his sisters, Sarah and Augusta, and was painted in South Acton, Massachusetts, about 1834.[1] Such a date is consistent with the period suggested by the children's costumes. Rickrack-edged aprons like the black one worn by the older girl became popular in the 1830s. The elaborate black soutache braiding and flanking rows of buttons on the boy's brown dress give it a semimilitary appearance that was deemed suitable for young boys of the period.

Condition: Cleaning and extensive inpainting was done by David Rosen in 1932. Possibly original 3½-inch molded and gilded white pine frame.
Provenance: Found in Syracuse, N.Y., and purchased from Edith Gregor Halpert, Downtown Gallery, New York, N.Y.

Exhibited: American Folk Art.
Published: AARFAC, 1940, p. 18, no. 10; AARFAC, 1947, p. 14, no. 10; AARFAC, 1957, p. 352, no. 198; Cahill, p. 30, no. 10, illus. on p. 59.

[1]Hayward Kiniston to AARFAC, March 26, 1937.

257 Possibly Hepzibah Carpenter 74.100.1

Possibly Vermont, ca. 1835
Oil on canvas
29¾″ x 24⅞″ (75.6 cm. x 63.2 cm.)

Despite obvious inexperience in dealing with technical problems, the creator of this intriguing likeness has conveyed some awareness of contemporary conventions of portraiture. Romantic academic painters and their imitators frequently posed women with heads slightly tilted; this emphasized the graceful curves of their necks and was also thought to reflect some of the sweet, yielding qualities of the feminine nature. In this painting, the cliché pose has unfortunately been so exaggerated that the lady's neck seems to be broken.

The sitter's red fringed paisley shawl was a popular and fashionable costume accessory from the early 1820s

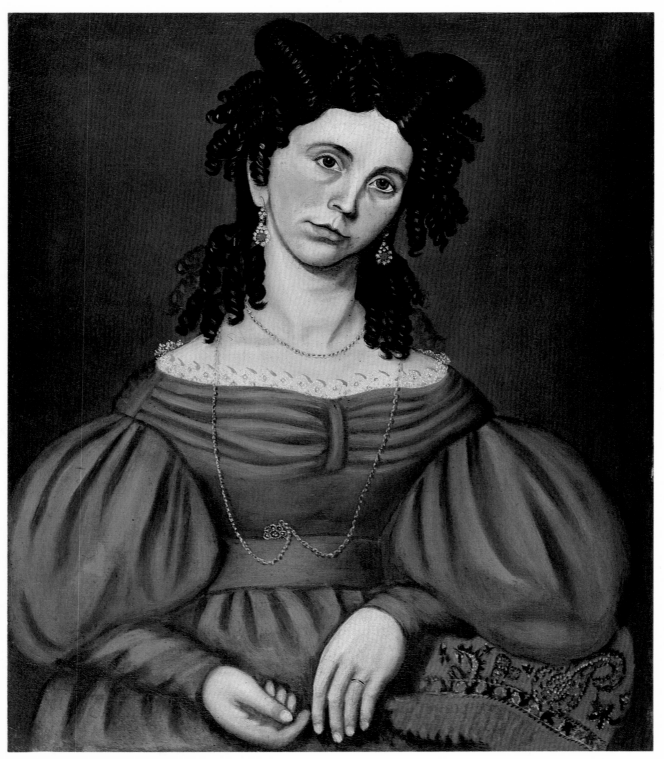

257

into the 1830s. It appeared in the broadest range of portraiture, crossing all lines of economic status of the sitter and professional training of the artist, although it was usually draped over the subject's arm or shoulder in a more graceful manner than its contrived inclusion here.

An overly simplified attempt at modeling has resulted in an extreme contrast range, with facial features being harshly defined in black on very pale skin. The subject's orange-tinted cheeks and lips add a garish note instead of softening the effect. The three-dimensional effect produced by the shadows of the embroidered edging across the top of the dress was probably just the result of an effort to distinguish between the sitter's pale body and the white trim.

A modern label affixed to the reverse of this portrait at the time of acquisition stated that the sitter was Hepzibah Carpenter of Fair Haven, Vermont. The likeness was later found to have been published as early as 1942 as "Hepzibah Carpenter of North Haven, Vermont."[1] Vital records confirm that a Hepsibah Carpenter was born to Wilson and Hepsibah Robinson Carpenter of Ira, Vermont (only a few miles from Fair Haven), on November 1, 1807. She married Dexter Gould on April 12, 1840, lived in Pittsford, Vermont, and died March 11, 1852.[2] The Works Progress Administration's index of portraits found in Vermont indicates that likenesses of Hepzibah's two sisters, Mahala (1804-1836) and Relief Robinson (1794-1842), existed in the 1930s. The two oils, recorded as having been purchased by a dealer from the sitters' descendants, have since disappeared, but both were listed as inscribed paintings by Mahala. An 1898 Carpenter genealogy describes Mahala as a "portrait painter,"[3] so circumstantial evidence points to the possibility that this sitter thought to be Hepzibah Carpenter may have been painted by her sister. Rediscovery of the two missing Carpenter likenesses would assist in substantiating or refuting such a theory.

Condition: In 1956 Russell J. Quandt cleaned, lined, and remounted the painting and inpainted scattered areas of loss, all minor except for a rectangular section 2 inches x 5½ inches in the background at middle left. Possibly original 3-inch cove-molded gilded frame with matching flat liner.
Provenance: Bequest of Grace H. Westerfield.
Published: Carl W. Dreppard, *American Pioneer Arts & Artists* (Springfield, Mass., 1942), illus. on p. 111.

[1]Carl W. Dreppard, *American Pioneer Arts & Artists* (Springfield, Mass., 1942), p. 111.
[2]Laura P. Abbott, Vermont Historical Society, to AARFAC, August 6, 1974; Amos B. Carpenter, *A Genealogical History of the Rehoboth*

Branch of the Carpenter Family in America (Amherst, Mass., 1898), pp. 244 and 408.
[3]Carpenter, *Genealogical History*, p. 408.

258 Mary Williams — 74.300.1
259 Master Williams — 74.300.2

Possibly New Jersey or Massachusetts, ca. 1835
Watercolor, gouache, and pencil on wove paper
8 9/16" x 6 9/16" (21.7 cm. x 16.7 cm.)

These portraits are said to represent Mary Williams, who was eleven in 1840, and her unidentified brother, both of Freehold, New Jersey. This information, which was provided by the previous owner, has not been confirmed to date. Two other watercolor portraits by the same artist have been recorded, at least one of which depicts an Amesbury, Massachusetts, subject.[1] The four portraits are of children, each of whom is standing on a

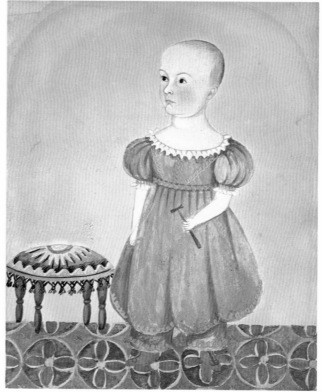

258

floor or carpet that has a colorful figured pattern. The decorative setting and the distinctive and awkwardly handled use of white gouache in the modeling of the faces may help in attributing other works by this same artist.

Condition: Restoration by E. Hollyday in 1975 included filling in the missing upper left corner of no. 258, filling in all four previously trimmed corners of no. 259, sizing the primary support, and mending tears with Japanese mulberry paper strips; and, for both, removing acidic pulpboard secondary supports and gold-painted window mats and backing the primary supports with Japanese mulberry paper. Modern reproduction 1-inch molded frames, painted black.
Provenance: Raymond Dey, Wayne, N.J.
Published: Walters, Pt. 2, no. 259 only, p. 2C, illus. as fig. 19 on p. 4C.

[1]The two are *Portrait of a Boy,* which is inscribed on its wooden backboard "James McMitchell/Amesbury, Massachusetts," and is privately owned; and *Little Girl in Red Dress,* in the Chrysler Museum, Norfolk, Va.

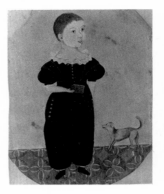

259 260

260 Girl in Blue 31.100.12

America, ca. 1835
Oil on canvas
20¾" x 16½" (52.7 cm. x 41.9 cm.)

This is a quickly painted portrait of a rosy-cheeked, fair-haired girl, wearing a dark blue dress with leg-of-mutton sleeves, who is awkwardly posed against a dull gray ground.

Condition: Borwin Anthon treated this painting in 1935, and it was probably he who replaced the auxiliary support. David Rosen restored it before 1940, and Hans E. Gassman cleaned and lined it in 1954. Period replacement 3-inch molded and gilded white pine frame.
Provenance: Found in Salem, Mass., and purchased from Edith Gregor Halpert, Downtown Gallery, New York, N.Y.
Published: AARFAC, 1957, p. 350, no. 180; Carol Ruth Berkin and Mary Beth Norton, *Women of America: A History* (Boston, 1979), illus. opposite p. 69.

picted the child, the cat, and the chair as line and outline and flat color rather than as three-dimensional forms in space. He experienced difficulty in painting arms and hands, and the oddly positioned chair shows no understanding of perspective. But the exaggerated proportions of the bright yellow dress, enlivened with quickly painted vertical highlights and strategically placed zigzag embroidery, as well as the triangular mass of the powerful gray cat with its long, supple tail all serve to draw attention to the child's pleasing smooth round face.[1]

Condition: Unspecified treatment by William Suhr in 1936. In 1955 Russell J. Quandt mounted the canvas on a rigid support and cleaned it. The peculiar halo effect is actually the outline of a head from an earlier portrait that grows more visible as the background paint in the present portrait becomes increasingly transparent with age. Period replacement 3-inch molded gilt frame.
Provenance: Edith Gregor Halpert, Downtown Gallery, New York, N.Y.
Published: AARFAC, 1957, p. 22, no. 9, illus. on p. 23.

[1]The picture was originally titled *Child in Yellow Dress with Grey Cat;* there is no information about the origin of the present title, which dates from 1956-1957.

261 Lydia and Tabitha 36.100.12

America, ca. 1835
Oil on canvas
28½" x 24" (72.4 cm. x 61.0 cm.)
(Reproduced in color on p. 196)

Directness . . . simplicity . . . strong design: these words best describe this extraordinarily successful non-academic portrait. The unschooled artist saw and de-

262 Girl in Black Pinafore 39.100.1

America, ca. 1835
Oil on poplar panel
42" x 24⅝" (106.7 cm. x 62.5 cm.)

Several factors make it difficult to envision the original appearance of this full-length portrait of a girl. The paint was initially thinly applied to its wood support, and an early abrasive cleaning with strong solvents both

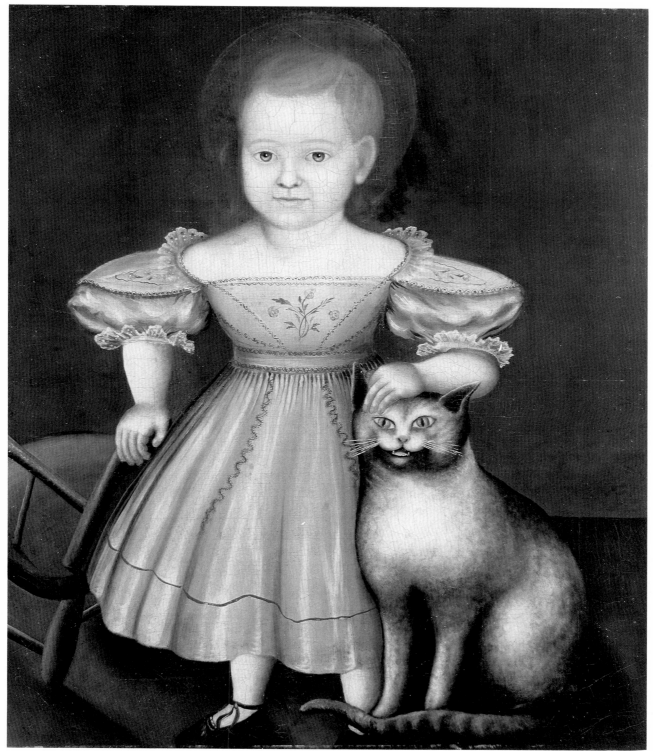

261

discolored and removed a good deal of the original surface. Distracting bloom in the varnish layer further obscures the artist's intent.

The likeness still possesses undeniable charm, however. The child's direct gaze, sweetly smiling lips, and dainty grasp of a stem of cherries all give her an air of appealing innocence. Her wide-rimmed, open-worked basket of fruit retains much of its earlier crispness of detail, as does the bowl of raspberries displayed so invitingly on the carved and upholstered footstool at her feet. Blue feather edging on the white Staffordshire bowl complements the blue of her slippers, and color touches such as these and the red fruit appeal to the eye as well

263

as soften the harshness of a scheme that is otherwise largely black and white.

Unquestionably the painting's greatest visual impact derives from the sharp contrast created by the girl's black apron against her white dress and from the boldness of the apron's trim. This zigzag or sawtooth trim was probably fashioned by folding a ribbon and tacking it back and forth between the body of the apron and its outer border, thereby creating an open fretwork or fagoting that allowed the dress to show through it.

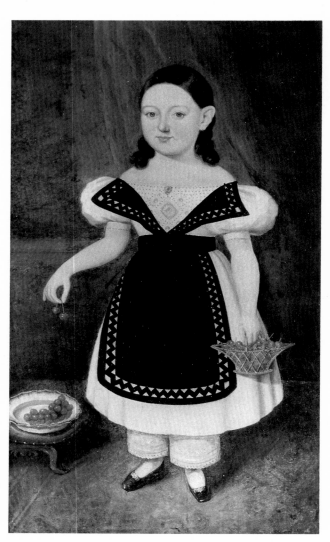

262

Condition: The painting was treated by an unidentified conservator prior to acquisition. Russell J. Quandt cleaned it and inpainted scattered areas of loss in 1955. Period replacement 2-inch molded and gilded frame.

Provenance: Found in Boston, Mass.,[1] and purchased from Edith Gregor Halpert, Downtown Gallery, New York, N.Y.

Published: AARFAC, 1940, p. 17, no. 9; AARFAC, 1947, p. 14, no. 9; AARFAC, 1957, p. 46, no. 21, illus. on p. 47; "Native Primitives Complement the Williamsburg Restoration," *Art News,* XXXVII (April 15, 1939), p. 12; "Nineteenth-Century Americana," *Newsweek,* XLIX (February 25, 1957), illus. on p. 110.

[1]File references make no allusion to the painting's history before Halpert's ownership. AARFAC, 1940, and AARFAC, 1947, both give its origin as "Massachusetts," however, and a 1939 *Art News* article states that "the anonymous artist [was] probably from Boston." ("Native Primitives Complement the Williamsburg Restoration," XXXVII, April 15, 1939, p. 12.) All of these assertions undoubtedly were based on facts known to Halpert.

264

protruding, rounded eye sockets, tight, pursed lips, and flatly folded fingers.

Inscriptions/Marks: None found. The lettering on the spine of the book in the lady's hand is illegible.

Condition: Hans E. Gassman cleaned and lined both canvases in 1952. Russell J. Quandt recleaned them in 1955. Significant areas of inpainting appear below the man's hand and in his stock. The 3¾-inch orange and brown grain-painted splayed frames are period replacements that were cut down and altered to fit these canvases.

Provenance: Undetermined.

Published: AARFAC, 1957, no. 264, p. 110, no. 58, illus. on p. 111, and no. 263, p. 354, no. 211.

265 Woman in Large White Cap 58.100.50

America, ca. 1835
Oil on canvas
25½″ x 22″ (64.8 cm. x 55.9 cm.)

A frenzied atmosphere is created by continual movement in this painting of an unidentified woman. The large folds in her dress follow no logical pattern, and the highlights on it seem to writhe with a life of their own.

263 Man with Folded Arms 41.100.3

264 Lady with Lavender Ribbons 41.100.2

America, ca. 1835
Oil on canvas
32½″ x 28¼″ (82.6 cm. x 71.8 cm.)
32¾″ x 27⅝″ (83.2 cm. x 70.2 cm.)

A level of competence not usually found in folk painting is exhibited in these unidentified companion portraits. The articulate definition of features, skillful modeling, convincing rendering of fabric folds and varied textures, and dramatic shadowing of the woman's far cheek all reflect a hand that had some proficiency in studio techniques.

Posing companion sitters slightly turned toward one another was a graceful, complementary, and common solution to the problem of visually linking two separate likenesses. Here the artist has further emphasized the subjects' connection by incorporating opposite ends of a sofa and a central drape in the two paintings.

Peculiarities of the artist's style that may help to identify others of his portraits include heavy eyelids,

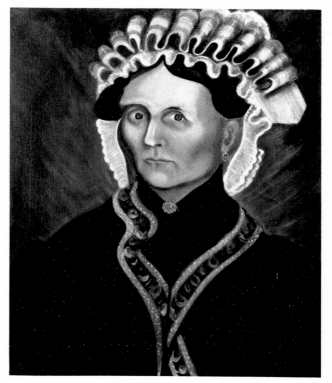

265

The trim around her neck falls according to the same irrational dictates, one side lying relatively flat and smooth, the other contorted and awry. The oversized rendering of her cap emphasizes the rippling ribbon across the crown of her head, and shooting streaks of highlighting in the brown background behind her contribute to the overall feeling of unrest. The sitter's sunken eyes, hollowed cheeks, and gray flesh tones are equally disquieting.

Condition: In 1974 Morton Bradley lined the canvas, cleaned it, and inpainted extensive cracking losses overall. Possibly original 2⅛-inch cove-molded frame, painted black, with gold-painted inner and outer edges; the latter is flat.
Provenance: J. Stuart Halladay and Herrel George Thomas, Sheffield, Mass.

266 Profile of a Woman 79.306.1

America, ca. 1835
Cut wove paper, watercolor, and printer's ink
on wove paper
4½″ x 3¼″ (11.4 cm. x 8.3 cm.)

Several methods of speeding the production of miniature likenesses, particularly of cut profiles, were used to produce examples illustrated in this collection. Like nos. 235 and 236, this profile combines a hollow-cut head with a printed body, but there the similarities end. The bodies of nos. 235 and 236 were woodblock-printed directly onto the primary support, while here a lithographed torso has been cut out and pasted onto the sheet from which the outline of the head was snipped. In this manner, a fairly sophisticated and complex body was integrated into the artist's design in seconds. Color was easy to add, too; the dress and two bows on the white collar are tinted with blue watercolor.

The hollow-cut head is backed with a sheet of paper covered with black watercolor on the obverse of which appears a second lithographed torso—a legless and headless man's trunk—in a dark blue watercolored coat (see fig. 21 in the Introduction). Apparently the artist produced or acquired a number of stock bodies printed expressly for the purpose of adding heads.

An upside-down, indented outline of part of a woman's head in the primary support, probably an abandoned earlier attempt, indicates that the artist proceeded by first defining the silhouette with a fairly sharp pointed instrument and then used the indentations as guidelines for cutting.

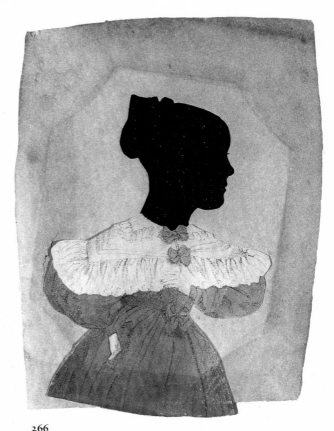

266

Condition: No evidence of previous conservation. Possibly original ¾-inch cyma recta gilded frame with églomisé glass mat.
Provenance: Pottinger-Walters Antiques, Goshen, Ind.

267 Miss Rebecca Freese of 58.300.6
Cairo Forge, New York

Possibly New York state, ca. 1835-1840
Watercolor and ink on laid paper
6⅜″ x 5″ (16.2 cm. x 12.7 cm.)

This extremely delicate and finely detailed likeness is one of the most sensitive specimens of profile portraiture in the Folk Art Center's collection, possessing a degree of refinement and subtlety lacking in many folk portraits. The identity of the subject and the New York state association, neither of which has been verified to date, are based on information published in the 1940s by the previous owners (see *Provenance* and *Exhibited*).

Condition: To judge by a comparison of various Halladay-Thomas photographs (see *Provenance* and *Exhibited*), this portrait was cleaned at some point during their ownership, with evidence of scattered foxing and support discoloration being removed or reduced. In 1958 it was cleaned by Christa Gaehde and mounted on Japanese mulberry paper. Probably original 1⅛-inch flat frame, painted black.

Provenance: J. Stuart Halladay and Herrel George Thomas, Sheffield, Mass.

Exhibited: AARFAC, New York, and exhibition catalog, no. 15; American Primitive Painting, and exhibition catalog, no. 10; Halladay-Thomas, Albany, and exhibition catalog, no. 56; Halladay-Thomas, Hudson Park; Halladay-Thomas, New Britain, and exhibition catalog, no. 146; Halladay-Thomas, Pittsburgh, and exhibition catalog, no. 66, illus. facing nos. 49-50; Halladay-Thomas, Syracuse, and exhibition catalog, included in nos. 66-97; Halladay-Thomas, Whitney, and exhibition catalog, p. 34, no. 65; Washington County Museum.

268 Sportsman with Dog 38.100.1

America or England, probably 1835-1840
Oil on canvas
72" x 47½" (182.8 cm. x 120.7 cm.)

Although many aesthetically pleasing portraits incorporate stock settings or studio backgrounds, those in-

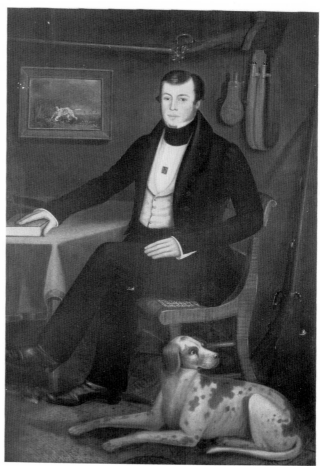

268

267

cluding personal articles that reflect the sitter's tastes and interests have far more to offer the social historian. The hunting paraphernalia, the dog, and the portrait of a dog on point make this man's favorite pastime immediately evident. Books scattered on the table hint at an interest in reading and learning.

In 1946 Laurence Halleran identified the painting as a portrait of English statesman Sir Robert Peel (1788-1850),[1] but the sitter seems somewhat younger than the forty-seven to fifty-two years of age Peel would have been circa 1835-1840. Might the portrait represent some other English gentleman, rather than an American?

No clear-cut nationality asserts itself. The powder flask, belt, and guns appear to be English types, as does the red, green, and beige patterned carpet, but such articles were so widely imported here as to render them

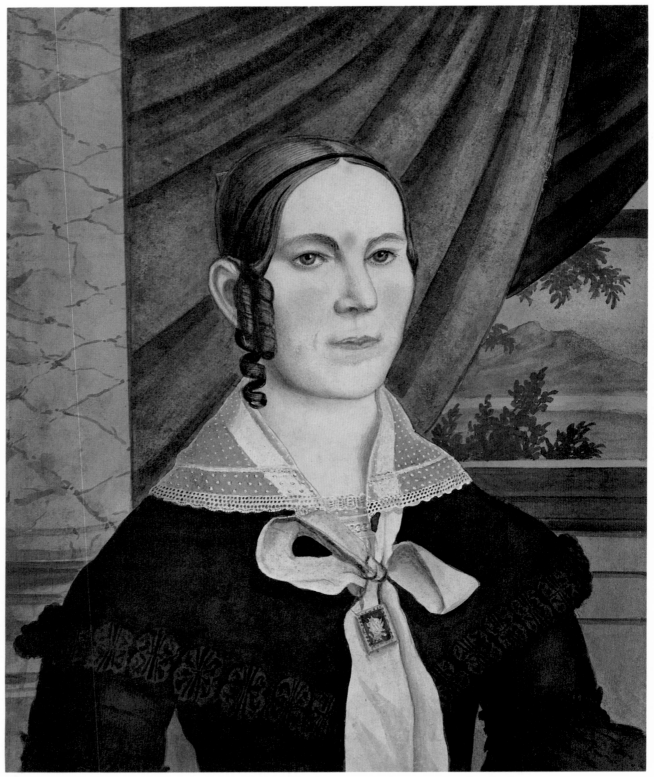

270

relatively useless as indications. The scale of this imposing likeness is rare in American folk painting, and certainly dog portraiture per se was far more popular in England than in the United States during the nineteenth century. The mourning symbols on the stickpin are more often associated with American iconography, however, and tiger-maple chairs such as the one illustrated were more common in American homes.

Condition: An unidentified conservator cleaned and remounted the painting before 1938. In 1956 Russell J. Quandt cleaned and lined it and inpainted scattered areas of loss. Modern replacement 4½-inch splayed mahogany-veneered frame with flat inner and outer edges.
Provenance: Laurence B. Halleran, Flushing, N.Y.; Joseph Oberwalder, New York, N.Y.; J. A. Lloyd Hyde, New York, N.Y.[2]
Published: AARFAC, 1957, p. 351, no. 189.

[1]Laurence B. Halleran to Colonial Williamsburg, September 25, 1946, in which Halleran claims that his father owned the portrait before his death in 1898.
[2]Mrs. Rockefeller noted that this painting had been "found in western New York state" which, although possible, was probably inferred from Hyde's statement that it "was painted, as far as I can make out, in western New York state about 1830." J. A. Lloyd Hyde to Mrs. Rockefeller, September 8, 1937. The basis for Hyde's assertion is undetermined.

271

269

269	**Mr. Briggs**	36.300.1
270	**Mrs. Briggs**	36.300.2
271	**Mary Briggs**	36.300.3

Probably Richmond, Virginia, ca. 1840
Watercolor and pencil on wove paper
10¼" x 8⅛" (26.0 cm. x 20.6 cm.)
10⅛" x 8⅛" (25.7 cm. x 20.6 cm.)
9¾" x 7½" (24.8 cm. x 19.1 cm.)

The exact identities of these three subjects remain open to speculation. Maude Pollard Hull (see *Provenance*) described the trio as "Mr. and Mrs. Briggs" and "Mary Briggs" and indicated that the last was "from the same collection and . . . the same family" as the adults' portraits in correspondence of 1935-1936 on file at the Folk Art Center. It has been generally assumed that Mr. and Mrs. Briggs were husband and wife and that Mary was their daughter, but this has not yet been verified. It should be noted that the adults' portraits were acquired

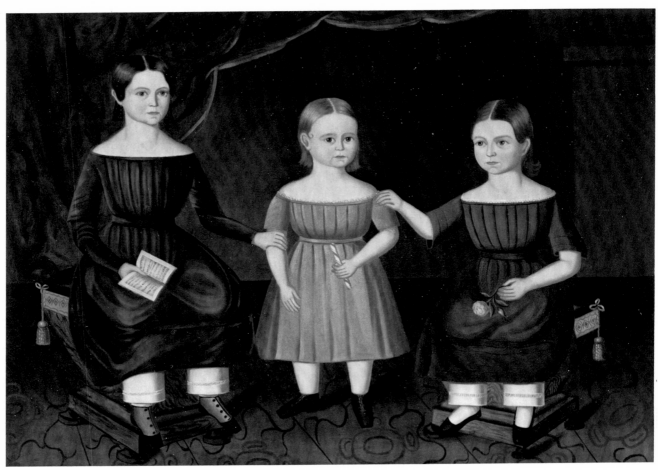

272

by Mrs. Hull and then sold to Mrs. Rockefeller nearly a year before the child's, the latter was not framed to match the adults' portraits at the time of purchase, and other than the comment quoted above, Mrs. Hull gave no indication of Mary's relationship to Mr. and Mrs. Briggs.

Although the portraits' known history originally provided only an extremely tenuous association with the Richmond, Virginia, area, this link has been largely substantiated by the discovery of eighteen additional likenesses attributable to the same hand, seventeen of which are believed to have been painted in Richmond about 1840. Sixteen of the seventeen additional portraits represent members of the related Sinton and Clarke families, Irish Quakers who emigrated from County Armagh and County Antrim early in the century. Interestingly, Mrs. Briggs's portrait is the only

nonprofile that has been discovered to date in this group; the artist's difficulty in rendering her nose and particularly her mouth may account for his preference for the more easily depicted side view.

The backgrounds in this group of portraits represent variations on a formula, most of them incorporating some combination of draped window, paneled wainscoting, and a romanticized landscape view of mountains and water. Eight also include the marbleized column seen in nos. 269 and 270. Anatomical difficulties, such as Mary's impossibly attenuated arm, contrast sharply with the subjects' precisely drawn and finely detailed heads. Possibly the disparity can be traced to the artist's use of an optical or mechanical device for transcribing outlines, such as the physiognotrace or the camera obscura.

Condition: Restoration by Christa Gaehde in 1954 included unspecified repairs and removal of acidic secondary supports of thin cardboard. In 1974 E. Hollyday removed remnants of the secondary support from the verso of no. 269 and mended minor tears and brad holes in the primary support edges. Small areas of loss, primarily in the edges, were inpainted in no. 270. Possibly original 2-inch mahogany-veneered splayed frames on nos. 269 and 270; the frame on no. 271 is a modern replacement that matches those on nos. 269 and 270.

Provenance: Maude Pollard Hull, Richmond, Va.

Exhibited: AARFAC, Minneapolis; AARFAC, April 22, 1959-December 31, 1961; AARFAC, May 10, 1964-December 31, 1966; Smithsonian, American Primitive Paintings; "A Virginia Sampler: 18th, 19th, and 20th Century Folk Art," Roanoke Fine Arts Center, March 14-April 11, 1976, and exhibition catalog, nos. 19, 20, and 21, no. 271 illus. as no. 21 on p. 23.

Published: AARFAC, 1940, p. 26, nos. 72, 73, and 74; AARFAC, 1947, no. 269, p. 24, no. 72, no. 270, p. 25, no. 73, and no. 271, p. 25, no. 74; AARFAC, 1957, no. 269, p. 178, no. 89, illus. on p. 179, no. 270, p. 180, no. 90, illus. on p. 181, and no. 271, p. 182, no. 91, illus. on p. 183; AARFAC, 1959, p. 36, no. 34; Dorothy E. Ellesin, ed., "Collectors' notes," *Antiques,* CIV (December 1973), no. 269, p. 1055 and illus.

272 Hansbury Sisters — 57.100.8

Possibly Pennsylvania, ca. 1840
Oil on canvas
47¾" x 65½" (121.3 cm. x 166.5 cm.)

The unidentified artist responsible for this unusually large group portrait was sufficiently experienced to be able to provide his middle-class clients with decorative, impressive-looking pictures produced quickly and with an economy of effort. This composition is simple and uncomplicated: the rather wooden figure of the youngest child is flanked by her taller sisters, who sit on stools with square bases positioned on converging diagonals. Familial ties and visual unity are established by the older girls' arms extended to restrain their restless sister, who does not appear to have been placated by the peppermint stick she holds. Although the children's hands are clumsily rendered, the artist made a conscious effort to use the shadows from a single light source and minimal modeling to define and soften the facial features and give the arms and bodies an illusion of roundness.

The girls' dresses were rapidly painted and simply styled, creating bold splashes of red, gold, and blue that are complemented by the patterned green carpet and a swag of brown drapery accented with red. These furnishings, together with the handsomely upholstered rosewood stools and the curious pilaster at right, were probably studio props the artist employed to suggest a fashionably decorated Victorian interior. The identity of the children as members of the Hansbury family cannot be documented.

Condition: In the 1930s William Suhr cleaned and lined the portrait, which was again cleaned and lined by Bruce Etchison in 1971. Possibly original 5-inch molded gilt frame.

Provenance: Found in Philadelphia and purchased from the granddaughter of one of the sitters by Edith Gregor Halpert; Holger Cahill, New York, N.Y.; M. Knoedler & Co., New York, N.Y.

Exhibited: Children in American Folk Art, and exhibition catalog, p.13, illus. as no. 61 on p. 12.

273 Rosa Heywood — 57.100.3

Possibly Massachusetts, ca. 1840
Oil on canvas
44¼" x 29¼" (112.4 cm. x 74.3 cm.)

This extraordinarily lifelike portrait of pretty Rosa Heywood exhibits a level of competence and sophistication that was seldom achieved without some training in the techniques and theories of studio art. The child's figure is drawn with remarkable clarity of detail and her features are realistically modeled to convey a natural, pleasant expression. A variety of textures are convincingly rendered, the placement of shadows indicates a single source of light, and the coloration is unusually rich and well balanced. Indeed, the only naive aspects of the likeness are the rigid frontality of the girl's pose and the faulty perspective apparent in the distorted relationship of the painted Victorian planter to the adjacent wainscoting.

The luxuriant blossom in the little girl's hand was apparently plucked from the rosebush behind her and may be a symbol for her name. Rosa Heywood was born in 1834, the only child of Walter and Nancy Foster Heywood of Gardner, Massachusetts. Her father founded the Walter Heywood Chair Manufacturing Company. In 1870 Rosa became the second wife of the firm's treasurer, William Otis Brown.

According to a family tradition that cannot be substantiated, the portrait was believed to be by Thomas Hill, a young man who worked at the Heywood furniture factory decorating chairs and is said also to have painted portraits.[1] No portraits signed by Hill have been located, however. Rosa's likeness shares certain stylistic similarities with four considerably more elaborate group portraits of Massachusetts children that Dale T. Johnson has credited to the hand of Deacon Robert Peckham (1785-1877) of Westminster, an attribution

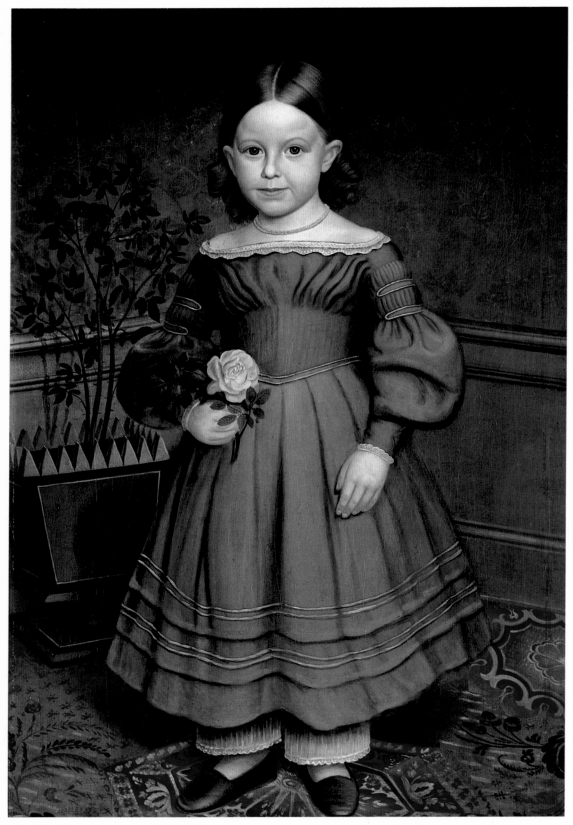

273

that needs further documentation.[2] Rosa Heywood's painter may also have been responsible for a colorful group of meticulously painted portraits of seated children, including *Boy in Plaid* (no. 288), which are characterized by convincing three-dimensional facial modeling and precise attention to details of dress and setting.

Condition: Treated by an unidentified conservator before 1966, when Russell J. Quandt lined and cleaned the canvas and mounted it on modern stretchers. Period replacement 3-inch molded gilt frame.

Provenance: The portrait descended in the family to Mrs. Ralph W. Page, Brookline, Mass.; Vose Galleries, Boston, Mass.; Harvey Additon, Boston, Mass.; Edith Gregor Halpert, Downtown Gallery, New York, N.Y.

Published: Dale T. Johnson, "Deacon Robert Peckham: 'Delineator of the Human Face Divine,'" *American Art Journal*, XI (January 1979), pp. 27-36, illus. on p. 32; Peterson, illus. as no. 59.

[1]Robert C. Vose, Jr., to AARFAC, May 16, 1963.

[2]See Dale T. Johnson, "Deacon Robert Peckham: 'Delineator of the Human Face Divine,'" *American Art Journal*, XI (January 1979), pp. 27-36. Of the portraits discussed and illustrated in Johnson's article, the two that seem most closely related to *Rosa Heywood* are *Charles L. Eaton and His Sister*, in the Fruitlands Museum, Harvard, Mass., and *The Raymond Children*, in the Metropolitan Museum of Art, New York, N.Y.

274 Portrait of a Young Man 31.100.23

America, ca. 1840
Oil on canvas
29″ x 24¾″ (73.7 cm. x 62.8 cm.)

The stark quality of this portrait typifies much of the inexpensive portraiture produced throughout America during the second and third quarters of the nineteenth century. The unidentified artist avoided the difficulties of drawing the man's hand by placing it inside the white vest, a gesture also common in modestly priced bust-length likenesses of this and earlier periods. The man's head is given spatial form by strong delineation with only minimal modeling. He wears a white oval stickpin created with heavy impasto.[1]

Condition: Cleaned in the 1930s by David Rosen; subsequently recleaned and lined by an unidentified conservator. Probably period replacement 3½-inch molded gold leaf frame with a border of alternating fleur-de-lis and laurel wreath designs.

Provenance: Found in Chambersburg, Pa., and purchased from Edith Gregor Halpert, Downtown Gallery, New York, N.Y.

Published: AARFAC, 1957, p. 349, no. 167.

[1]There is a stylistically related portrait of a Mr. A. Huggins in the New York State Historical Association, Cooperstown. The sitter holds a note in his hand bearing the inscription "A. Huggins, 1839," and the reverse is signed "Drawn by/Albertus D. Whitney/Dec. 1839." Nothing is known about Whitney and no other portraits attributable to him have been located.

275 Boy with Whip 31.100.8

America, ca. 1840
Oil on basswood panel
21¾″ x 17⅝″ (55.3 cm. x 44.8 cm.)

Dark, liquid eyes set in a pale, winsome face give the unidentified boy great appeal, and his red suit with its decorative array of buttons adds other visually attractive elements. He hunches forward, slightly off-center on the panel, and his ear, painted in a line with his jawbone, seems almost an afterthought. Shading and modeling are minimized overall, making the dark outlining of the far side of his head distractingly prominent by contrast. The thinly painted background has acquired a mottled appearance that also diverts attention from the young child's face.

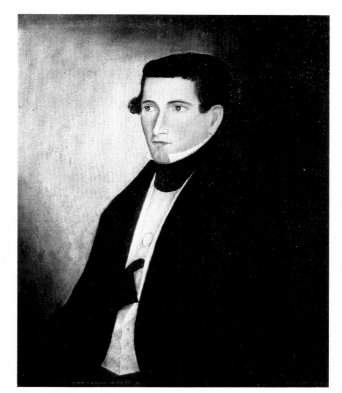

274

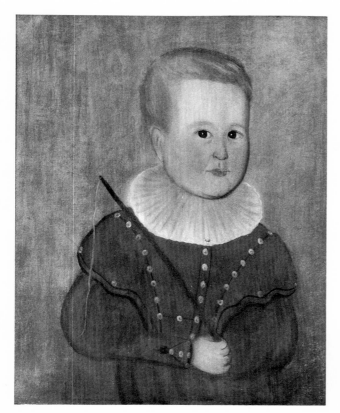

275

Condition: Unspecified treatment was undertaken by David Rosen either before acquisition or in the early 1930s. In 1935 Borwin Anthon cleaned the panel. In 1977-1978 F. Koszewnik cleaned the panel, inpainted scattered areas of loss, and built up layers of varnish over the right collar to minimize visually an old burn in that part of the painting. Modern replacement 2¾-inch gilded splayed frame with recessed outer edge.

Provenance: Found in Bridgeport, Conn., and purchased from Edith Gregor Halpert, Downtown Gallery, New York, N.Y.

Exhibited: American Folk Art.

Published: AARFAC, 1940, p. 17, no. 5; AARFAC, 1947, p. 13, no. 5; AARFAC, 1957, p. 349, no. 171; Cahill, p. 30, no. 9.

276 Girl by the Waterfall 35.100.3

277 Boy with Gold Locket 35.100.4

Possibly England, ca. 1840
Oil on canvas
38⁵⁄₁₆″ x 28¼″ (97.3 cm. x 71.8 cm.)

Establishing the origin of these portraits is particularly difficult because their known histories extend only to the 1930s, when they were purchased together in Charleston, South Carolina, with a tentative Ball family association.[1] No other works by this hand are known to survive in Charleston or elsewhere in America. The dramatic coloration of the skies and various details of the children's costumes compare closely with vernacular English painting of the same period. The figures lack both the spontaneity and decorative interest in dress usually seen in contemporaneous American folk pictures. In fact, a close study of the foliage, flowers, and atmospheric backgrounds suggests that this artist was more comfortable with and probably was trained in landscape painting.

Condition: Both portraits were cleaned and lined by Russell J. Quandt in 1956. Modern replacement 3-inch molded gilt basswood frames.

Provenance: Found in Charleston, S.C., by Holger Cahill and purchased from L. N. Burgess.

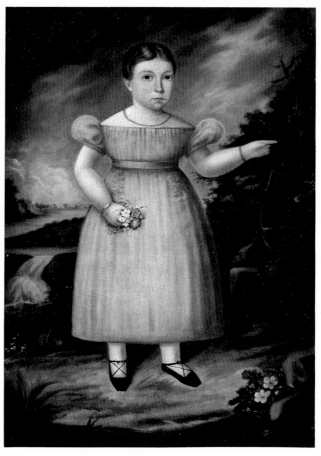

276

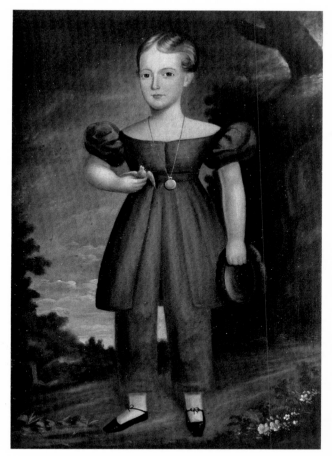

277

part of which is seen through the back of the chair. This area is painted olive green, a lighter tone of the color used for his dark, almost black, rolled-collar coat. The exaggeratedly pointed thumb folded over the musical score may eventually provide a clue in relating this portrait stylistically to others by the same hand.

Condition: Unspecified conservation prior to acquisition included inpainting of scattered areas of paint loss. Period replacement 3-inch cyma recta frame with traces of gold and black paint.
Provenance: Isabel Carleton Wilde, Cambridge, Mass.; John Becker, New York, N.Y.
Published: AARFAC, 1957, p. 351, no. 187.

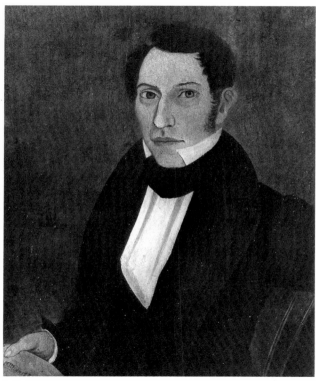

278

Published: AARFAC, 1940, p. 16, nos. 3 and 4 (titled *Girl in Pink* and *Boy in Blue*); AARFAC, 1957, no. 276, p. 34, no. 15, illus. on p. 35, and no. 277, p. 352, no. 192.

[1]Holger Cahill noted that they might depict members of the Ball family of Charleston.

278 The Composer 33.100.2

America, ca. 1840
Oil on cardboard
20″ x 15¾″ (50.8 cm. x 40.0 cm.)

The sitter's head is so oversized, his ear so misshapen, and his eyes so disparately formed as to seem a modern interpretation of folk art. The background is a warm, rich tone of brown except for the lower right corner,

279 Girl in Garden 39.100.2

America, ca. 1840
Oil on canvas
39⅞″ x 27¼″ (101.3 cm. x 69.2 cm.)

Nonacademic artists tended to combine curious distortions in scale and perspective with simplification of

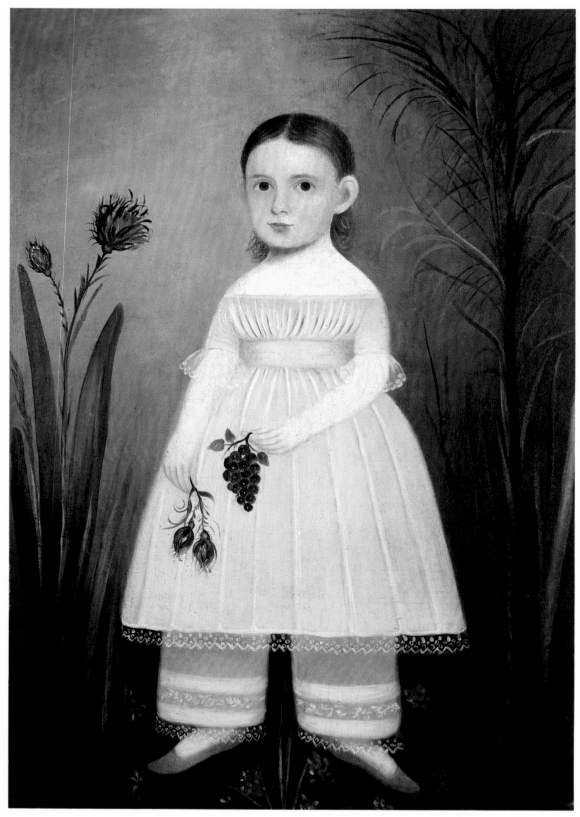

form, occasionally producing strikingly original and interesting paintings. In no. 279, an unidentified artist centered the two-dimensional representation of his subject close to the picture plane and flanked the figure with exotic, elongated plants. The result is an ethereal image of a diminutive child who appears to hover above a grassy field strewn with small red flowers.

The weak draftsmanship evident in the finlike hands and flat unmodeled features is compensated by the unusual and effective use of rich shades of apricot in the sky and muted greens in the foliage, punctuated by the red flowers and purple grapes. The exaggerated proportions of the little girl's precisely pleated skirt and her wide pantalettes with their bands of gossamer lace make an attractive decorative pattern that contributes to the aura of fragility which envelops this child.

Condition: The painting was overpainted prior to acquisition. When Russell J. Quandt treated the portrait in 1955, he discovered that the signature "Antony Drexel" was a later addition and removed it. At that time, Quandt relined and cleaned the painting and did some inpainting. Probably original 4½-inch gilded splayed frame with quarter-round moldings.
Provenance: Part of the Juliana Force collection, the painting was purchased as lot no. 356 in the Parke-Bernet sale, February 18, 1939.[1]
Exhibited: AARFAC, American Museum in Britain; AARFAC, September 15, 1974-July 25, 1976.
Published: AARFAC, 1940, p. 17, no. 6; AARFAC, 1947, p. 13, no. 6; AARFAC, 1957, p. 72, no. 38, illus. on p. 73; AARFAC, 1974, p. 21, no. 5, illus. as no. 38 on p. 73.

[1]A companion portrait by the same hand titled *Girl in Red* was sold as lot no. 357 in the February 18, 1939, sale. A photograph of the painting is on file at the Frick Art Reference Library, but its present location is unknown.

280 Woman with Sewing Box 36.100.16

America, ca. 1840
Oil on canvas
51½" x 42⅜" (130.8 cm. x 107.6 cm.)

The size of the canvas, the large scale of the figure, and the sitter's forthright gaze are factors that immediately attract the viewer's attention. The young woman's head is inclined slightly against her upraised hand, suggesting a pensive mood. Her near hand rests on an open book, one finger marking the page as if her reading had been interrupted. The unidentified artist made an admirable attempt to render the lines of the floral patterned carpet in perspective, but the absence of shadows beneath both subject and furniture leaves them unsecured visually to the floor, and they seem to hover slightly above it.

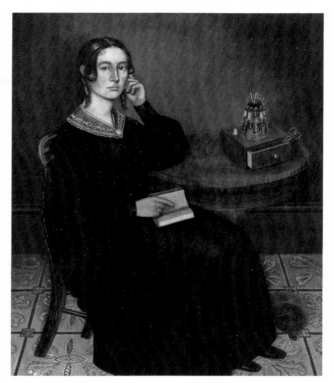

280

Many artists adopted the convention of highlighting the background behind a sitter's head in order to emphasize it, but in this instance the highlighted area is centered horizontally in the picture plane and only peripherally coincides with the woman's head. Part of the highlighted background area falls behind the sitter's sewing box, thus imparting unusual significance to a portrait prop. This may have been unintentional, or needlework may have played an important part in the sitter's life.

The artist's careful depiction of both natural and simulated wood grains adds an important element of pattern to the painting and also documents the taste for such furniture finishes prevailing in the second quarter of the nineteenth century. The young lady's grain-painted sewing box sits atop a flamboyantly figured mahogany pedestal table on casters, while her side chair is decorated in random red and black striping that suggests rosewood graining; its crest is accented by gold.

The large scale of the figure ensures that her plain black dress plays a dominant role in the viewer's overall

perception of the composition, but patterning and color in other areas visually balance this somber mass. The eye is quickly diverted from it to the bright yellow, green, and white figured carpet at her feet. The green-painted baseboard behind her complements the floor covering and the variously colored spools of thread on her sewing box add their own vivid note.

At the time of acquisition the portrait was identified as *Miss Appleton of Ipswich, Massachusetts,* but research has failed to verify the title.

Condition: David Rosen cleaned, lined, and remounted the painting in 1936. Original 4-inch grain-painted molded frame with gilt liner and outer edge.
Provenance: Katrina Kipper, Accord, Mass.
Exhibited: "Victoriana," Brooklyn Museum, April 6–June 5, 1960.
Published: AARFAC, 1940, p. 18, no. 15 (titled *Miss Appleton of Ipswich*); AARFAC, 1957, p. 90, no. 47, illus. on p. 91; C. Kurt Dewhurst, Betty MacDowell, and Marsha MacDowell, *Artists in Aprons: Folk Art by American Women* (New York, 1979), illus. as fig. 23 on p. 44.

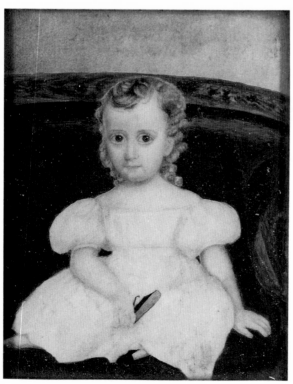

281

281 Child on Green Sofa 79.300.2

New England, ca. 1840
Watercolor on ivory
3⅞″ x 3″ (9.8 cm. x 7.6 cm.)

While the execution of this miniature of a youngster coyly posed with one shoe off is uneven in quality, it is typical of scores of small likenesses commissioned from itinerant portraitists in the decade before the camera put them out of business. The mass of blond curls and the features in the child's long face are sensitively drawn and colored, particularly the deep-set eyes with their heavy lids and projecting lashes. The rest of the pale figure is poorly articulated and appears to have been superimposed on the green upholstery of a scroll-arm mahogany sofa.

Condition: There is no evidence of previous conservation. The ivory panel curves slightly inward and there are insignificant paint losses along all edges. Period replacement 1-inch molded gold leaf frame with modern hanging ring screwed into the top edge.
Provenance: Found in Hampton, N.H., and purchased October 19, 1937, from Bessie J. Howard, Boston, Mass., for use at Bassett Hall, Mr. and Mrs. John D. Rockefeller, Jr.'s Williamsburg home.
Exhibited: Previously unrecorded.
Published: Previously unrecorded.

282 George Washington 33.100.1

America, 1840–1860
Oil on canvas
24″ x 24¼″ (61.0 cm. x 51.4 cm.)

Military heroes and national leaders were popular subjects for artists of all ranks, especially following the American Revolution. George Washington clearly led the list of celebrated public figures, and after his death in 1799 expressions of overwhelming respect for him approached deification. Paul Svinin commented on the prevalence of Washington portraits in *Picturesque United States of America* (1815):

It is noteworthy that every American considers it his sacred duty to have a portrait of Washington in his home, just as we have the images of God's saints. . . . Washington's portrait is the finest and sometimes the sole decoration of American homes.

This attitude continued well into the first half of the nineteenth century, and painters frequently relied on prints as copy sources for producing heroic likenesses.

282

For this example, the artist used a stipple engraving published by Edward Savage in 1792 and inscribed "George Washington Esqr./President of the United States of America/from the Original Pictures Painted in 1790 for the Philosophical Chamber, at the University of Cambridge/In Massachusetts."

Although minimized in detail and stylized by the artist's limited expertise in modeling and foreshortening, this painting remains a remarkably strong portrait of Washington. He is shown in military attire with buff colored collar and lapels, a dark blue coat, and gold epaulettes. The decoration on the lapel shown in Savage's print was omitted in favor of three gold buttons.

Condition: Lined before acquisition; cleaned by William Suhr in 1933 under the supervision of Dr. Wilhelm Valentiner; relined, re-stretched, and cleaned by M. Knoedler & Co. in 1943; cleaned and relined in 1954 by Russell J. Quandt. Modern replacement 2½-inch molded frame, painted black, with gold-painted inner molding.

Provenance: Mr. and Mrs. Elie Nadelman, New York, N.Y.; Edith Gregor Halpert, Downtown Gallery, New York, N.Y.

Published: AARFAC, 1940, p. 20, no. 27, illus. on p. 19; AARFAC, 1947, p. 16, no. 27, illus. on p. 14; AARFAC, 1957, p. 350, no. 179.

283 Roxanne Corinth Ray and Charles Carroll Ray 72.100.1

Probably Connecticut, ca. 1844
Oil on canvas
46″ x 36″ (116.8 cm. x 76.2 cm.)

Occasionally the line between folk and academic art becomes rather thin. Such is the case in this formal likeness of a demure brother and sister posed in a romantic landscape setting with indistinct hills and a pinkish sky in the distance. This portrait of Roxanne Corinth Ray (1836-1856) and her younger brother, Charles Carroll Ray (1841-1844), the children of Benjamin and Roxanne Smith Ray of Bristol, Connecticut, was probably painted before Charles's early death at the age of three.

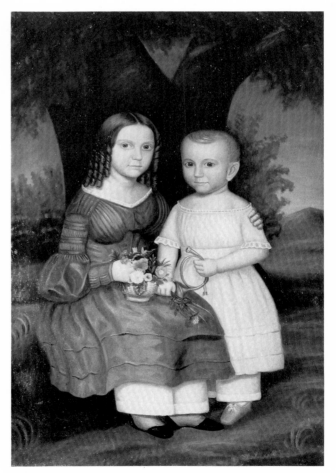

283

By strategically placing a massive tree trunk immediately behind his subjects, the artist has created an effective foil for the children's heads and continues the vertical thrust of his well-balanced composition. The facial features are unusually well modeled and particular attention has been given to the heavy-lidded, deep-set eyes, which glisten and give the children a vacant, almost tearful expression. The hands are also drawn with confidence, and the colorful arrangement of clover, a wicker basket brimming with common summer flowers, and the boy's circular brass horn make a charming decorative passage.

The creator of the portrait remains unidentified.[1] The convincing spatial arrangement, well-articulated figures, and competent brushwork indicate a professional portraitist of some skill and experience.

Condition: There is evidence of routine surface cleaning at an unspecified time prior to acquisition, but the canvas support is unlined and retains its original white pine stretchers. Period replacement 5-inch gilded frame with applied moldings.
Provenance: Hirschl & Adler Galleries, Inc., New York, N.Y.; gift of Wilson Douglas, Jr.
Exhibited: "Plain and Fancy: A Survey of American Folk Art," Hirschl & Adler Galleries, Inc., April 30-May 23, 1970, and exhibition catalog, p. 61, no. 77, illus. on p. 61.
Published: Tomlinson, p. 74, illus. as fig. II, 40 on p. 154.

[1]Although Tomlinson attributed the picture to Joseph Whiting Stock, this attribution is rejected for stylistic reasons and for lack of documentation. See also nos. 160 and 161.

284 Girl by Balustrade 31.100.9

America, ca. 1845
Oil on canvas
38" x 29½" (96.5 cm. x 74.9 cm.)

The dull coloration of this portrait may be partially due to harsh cleaning in the late nineteenth century. Much of it also results from the artist's inexperience in modeling and his preparation of a basically unremarkable palette. There is no explanation for the sad expression on this little girl's face unless the likeness was painted posthumously for bereaved parents who wanted a tangible reminder of their deceased child. In all other aspects of the girl's pose and the decorative addition of the landscape setting with balustrade, the portrait betrays a strong reliance on formats favored by mid-nineteenth-century academic painters.

Condition: Probably in 1931 David Rosen cleaned and lined the painting and repaired a small canvas tear to the left of the girl's hem. In 1956 Russell J. Quandt cleaned and relined the painting. Modern replacement 2½-inch gold leaf basswood frame.
Provenance: Found near Bethlehem, Pa., with a tradition of coming from the Shenandoah Valley of Virginia, and purchased from Edith Gregor Halpert, Downtown Gallery, New York, N.Y.
Exhibited: American Folk Art.
Published: AARFAC, 1940, p. 18, no. 14; AARFAC, 1947, p. 14, no. 14; AARFAC, 1957, p. 38, no. 17, illus. on p. 39; Cahill, p. 30, no. 11, illus. on p. 60; Henry Kauffman, *Pennsylvania Dutch American Folk Art* (New York, 1946), p. 46.

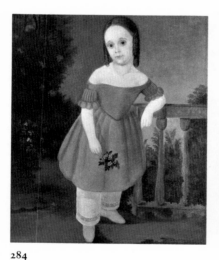

284

285

286

285 Lady with Hair Necklace 31.100.22

286 Man with Black Tie 31.100.21

America, ca. 1845
Oil on canvas
29½" x 24½" (74.9 cm. x 62.2 cm.)
29¼" x 24¼" (74.3 cm. x 61.6 cm.)

Some degree of proficiency is evident in the soft grada-
tions of shadow that model the facial features of these
sitters; although unrealistically exaggerated, the planes
of the noses demonstrate a consciousness of anatomy
that might have been gleaned from instruction books or
from another painter familiar with such studies. Overly
narrow shoulders and attenuated arms, however, reveal
this unidentified artist's incomplete understanding of
such matters. His dramatic, high-contrast treatment of
the fringed and tasseled blue draperies that visually link
these paintings is more typical of a craft background
and perhaps hints at another source of his instruction.

Both figures are clothed in black and posed against
dark olive green backdrops, their somberness relieved
somewhat by playful linear patterns in the woman's
curls, lace, and jewelry. The strands of her necklace are
composed of hair and illustrate a popular fad among
sentimental Victorians.

Inscriptions/Marks: An Edith Gregor Halpert label on the top
stretcher of no. 286 identifies the artist as "Gouldings," but other
entries in her files do not mention this name.
 Condition: David Rosen cleaned both paintings prior to 1940;
he later recleaned them and, in the case of the woman's portrait only,
replaced the auxiliary support and lined the canvas. Possibly original
2-inch molded black walnut frames.
 Provenance: Found in Maine and purchased from Edith Gregor
Halpert, Downtown Gallery, New York, N.Y.
 Published: AARFAC, 1957, p. 351, nos. 190 and 191.

287 Boy in Plaid 36.100.14

New England, ca. 1845
Oil on canvas
30⅞" x 25½" (78.4 cm. x 64.8 cm.)

The Victorian taste for strong colors and bold decora-
tive patterns is evident in this accomplished likeness of
an auburn-haired boy. Wearing a stylish plaid frock over
white trousers and gazing directly at the viewer, he sits
on an upholstered stool, a gray carpet patterned with
striped mustard yellow diagonals beneath his feet. The
lively composition is further brightened by a swag of red
drapery and the touches of red on the child's braided

287

whip and on the blanket and harness of his rocking
horse.

An identical stool, carpet, and drapery appear in a
companion portrait of a little girl who is presumed to be
the boy's sister.[1] Three other quite similar portraits of
Concord, New Hampshire, youngsters thought to date
from the 1840s have also been recorded.[2] Each of the
subjects is seated in an attractive setting that usually
features a Brussels carpet and the conventional bit of red
drapery. The children, whose clothes and accessories are
carefully painted, hold a flower, a Bible, or a pet.

Although their alert little faces are realistically
modeled and have individualized features, the children
have certain physical similarities that include overlarge
heads and feet, short necks and crisply outlined chins,
rosebud mouths that turn up at the corners, a tiny
triangular brown fleck consistently used to define the tip
of a rounded nose above one nostril, and deep-set eyes
with slightly indented temples.[3] Although his identity
has not been determined, the artist was unusually suc-
cessful at creating personable likenesses of young chil-
dren whose sparkling eyes and slight smiles exude
vitality.

Condition: Russell J. Quandt lined and cleaned the portrait in 1955. Period replacement 3½-inch molded gilt frame.

Provenance: Found in Charlestown, Mass., by and purchased from Bessie J. Howard, Melrose, Mass.

Exhibited: AARFAC, American Museum in Britain; AARFAC, June 4, 1962-November 20, 1965; Picture Gallery at Fruitlands Museum, Harvard, Mass., June 1-September 15, 1979.

Published: AARFAC, 1957, p. 30, no. 13, illus. on p. 31; Clara Endicott Sears, *Some American Primitives: A Study of New England Faces and Folk Portraits* (Boston, 1941), p. 88, illus. on p. 73.

[1] In 1936 Clara Endicott Sears purchased this portrait, which is now exhibited with her collection at Fruitlands Museum, Harvard, Mass.

[2] The Concord children depicted in the three portraits, all of which are privately owned, are May E. Hill, Charles Odlin, and Elizabeth Odlin.

[3] Many of these stylistic qualities are also evident in the portrait of Rosa Heywood (see no. 273).

288 Gentleman at a Table

32.300.3

America or England, ca. 1845
Watercolor on wove paper
6⅝″ x 5½″ (16.8 cm. x 14.0 cm.)

The facial features of this subject have been executed in a fine stippling technique similar to that often used by

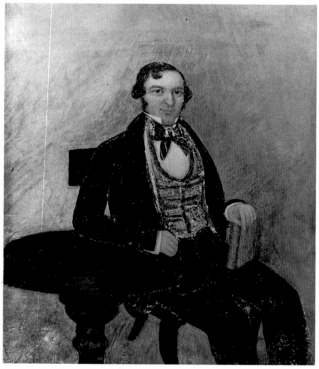

288

portraitists of miniatures on ivory, a refinement that is inconsistent with the somewhat immature development of the remainder of the composition.

Condition: Restoration between 1954 and 1971, probably by Christa Gaehde, included consolidation of flaking paint in hair and vest. Treatment by E. Hollyday in 1975 included repair of the broken upper right corner. Period replacement 1½-inch cove-molded gilt frame.

Provenance: Found in Massachusetts and purchased from Edith Gregor Halpert, Downtown Gallery, New York, N.Y.

Exhibited: Washington County Museum.

Published: AARFAC, 1940, p. 26, no. 71 (titled *New England Gentleman*); AARFAC, 1947, p. 24, no. 71 (titled *New England Gentleman*); AARFAC, 1957, p. 360, no. 246.

289 Portrait of a Young Gentleman

70.100.1

America, ca. 1845
Oil on canvas
30⅛″ x 25⅜″ (76.5 cm. x 64.5 cm.)

An overwhelming sense of drama is created in this portrait. Almost no passages have been flatly painted, and as a result, the eye is kept busy wandering over the entire canvas. While such a treatment unquestionably distracts attention from the face, a portrait's normal focal point, it does unify the composition, and unusual vitality is achieved through the repetition of swirling shapes. The painter used lines and folds everywhere, complicating the jacket and waistcoat creases. Fleshy folds in the hands are certainly exaggerated in a sitter so young and slim, and the grained surfaces of the table, chair, and book add their own note of nervous energy. Many people claim to see a tiny smiling face in the graining pattern on the chair's scroll back.

The unidentified artist has made a rather fantastic transition between the conventional red swagged drapery at upper right and top and a stormy blue sky at middle left. There is no delineation per se between the two; choppy strokes of red and blue intermingle, contributing to the background confusion. While oversimplified and rather garish sunbeams stream down at left below the dark clouds, an area of sky bordering the sitter's collar is rendered equally bright, curiously suggesting that light also emanates from the earth beyond his shoulder. Posing a portrait subject in front of a diagonally draped window had been an extremely popular convention earlier, but the formula had fallen from general favor by 1845. This may account for the artist's confusion in rendering the cliché.

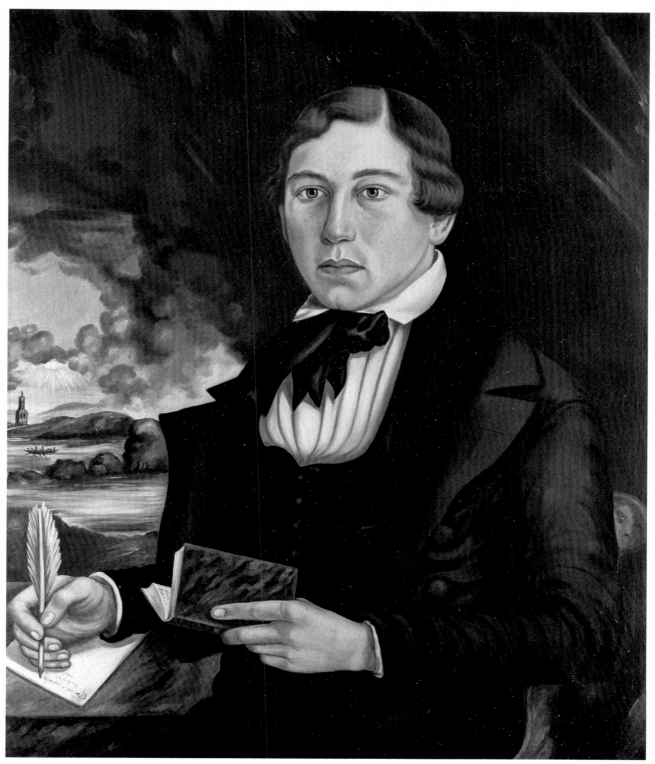

289

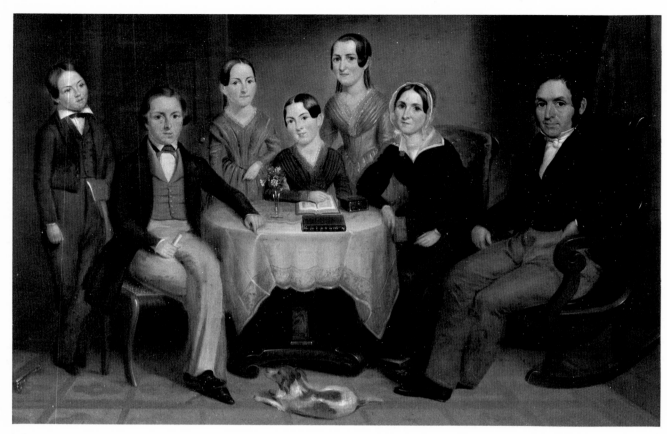

290

Condition: In 1971 Bruce Etchison cleaned the painting, removed canvas patches from the verso, lined it, and inpainted scattered areas of paint loss, particularly along the upper and lower edges and in the sleeve of the coat. Modern replacement 3½-inch cove-molded frame, painted black, with reeded liner.

Provenance: Paul Hopkins, Deltaville, Va.

Exhibited: "Perspective Folk Art," Hollins College and the Roanoke Valley Historical Society, Roanoke, Va., May 7-30, 1975, and exhibition catalog, no. 1.

290 The Adams Family 36.100.5

Possibly New England, ca. 1845-1850
Oil on canvas
28″ x 41¾″ (71.1 cm. x 106.0 cm.)

Although the paint handling throughout this portrait shows considerable proficiency and decided academic influence, the subjects themselves have disproportionately large heads for the diminutive bodies supporting them. The unidentified artist may have been more accustomed to miniature or half-length depictions, which were certainly more popular – and cheaper – than full-length oils such as this.

Insufficient individualization of the subjects' faces shifts attention from them to their setting, where middle-class tastes are reflected in the furnishings that were considered suitable in a well-equipped parlor at mid-century. A mahogany pedestal-based "center table" was often the focal point in such rooms. In 1850 the taste-setter A. J. Downing wrote that it was "the emblem of the family circle,"[1] as it obviously is here. Household members gathered around the table daily to read, converse, sew, and nourish the family ties deemed essential in Victorian life. The oldest son sits in a cane-bottomed adaptation of the Grecian *klismos,* while his parents occupy a black upholstered rocker and a tufted green side chair. The ornate gold footstools at left and center illustrate one of the numerous historical revival

styles adopted with enthusiasm by Victorians. The figured carpet was another parlor essential. The family spaniel reclining on the geometrically patterned green and cream colored floor covering gives it a note of easy informality. Fashionable conservatism in clothing is evident in the somber tones of black, gray, brown, and mauve in which the family is attired.

Condition: William Suhr cleaned the painting in 1936. Hans E. Gassman mounted the canvas on Masonite, trimmed the edges flush, and inpainted numerous scattered areas of paint loss in 1954. Period replacement 4-inch gilded cyma recta frame with black-painted inner edge.
Provenance: Katrina Kipper, Accord, Mass.
Exhibited: "Victoriana," Brooklyn Museum, April 6-June 5, 1960.
Published: AARFAC, 1957, p. 18, no. 7, illus. on p. 19.

[1]William Seale, *The Tasteful Interlude: American Interiors Through the Camera's Eye, 1860-1917* (New York, 1975), p. 32.

291 Boy and Girl in Mountain Landscape

79.100.4

Probably Delaware, ca. 1850
Oil on canvas
48" x 38" (121.9 cm. x 96.5 cm.)

Number 291 is a large and puzzling picture of two stylishly dressed children, a boy and girl, and an improbable combination of pets posed at the edge of a rocky path. A dramatic mountainous landscape looms abruptly behind them. The paint has been quickly and knowingly applied to achieve maximum effect with minimum effort. Except for a sprig pattern in the boy's shirt, particularized details, including shoelaces, are omitted. Even the children's faces are schematized and expressionless, and their bodies are so ill defined that the boy appears to be sitting on his dog's back. From the evidence it appears that the unidentified artist had some training in ornamental painting but little experience with portraiture.

Condition: Lined and mounted on new strainers by David Rosen in 1936. Probably original 2½-inch refinished mahogany-veneered cyma recta frame with square corner blocks and beveled inner edge.
Provenance: Joseph E. Holland, Milford, Del.; purchased from Miss Blanche Irvine, Downingtown, Pa., June 9, 1936, for use at Bassett Hall, Mr. and Mrs. John D. Rockefeller, Jr.'s Williamsburg home.
Exhibited: Previously unrecorded.
Published: Samuel T. Freeman & Co., *Antiques at Auction: The Joseph E. Holland Collection* (catalog for sale June 30, 1930, listed as lot no. 627).

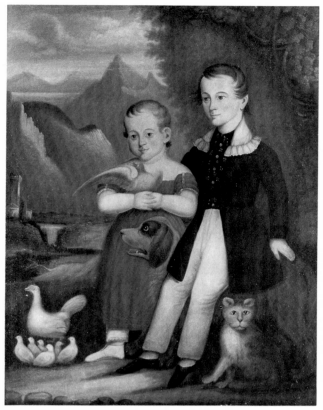

291

292 Possibly Jean Macdonald Lee Myers

31.100.5

Possibly Pennsylvania, ca. 1850
Oil on canvas
30" x 26¾" (76.2 cm. x 68.0 cm.)

An attribution to John James Trumbull Arnold (1812-ca. 1865) has been considered for this painting and is based on the soft gray to reddish brown shading around the eyes, the soft brown lips divided by a thin, dark line, the single finger sticking upward, the arms jutting out stiffly from the body, and the rendering of waves over the top of the head and the ropelike curls behind the child's ears. However, the gross anatomical distortion evidenced here by the oversized head, fat arms, and extremely short, knock-kneed legs does not seem commensurate with Arnold's admittedly inaccurate but still more believable figural depictions. The discovery of

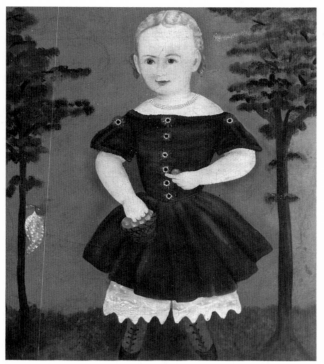

292

Condition: Treatment by an unidentified conservator included cleaning, lining, remounting, and inpainting scattered areas of loss, particularly in a small circular section of the upper edge of the dress. Period replacement 3¾-inch cove-molded gilded frame with quarter-round outer edge.

Provenance: Found in New York state and purchased from Edith Gregor Halpert, Downtown Gallery, New York, N.Y.

Exhibited: AARFAC, September 15, 1974-July 25, 1976; American Folk Art; "Birds in American Art," Heritage Plantation of Sandwich, Sandwich, Mass., April 28-October 15, 1978, and exhibition catalog, p. 49, no. 93, illus. as no. 93 on p. 48.

Published: AARFAC, 1940, p. 18, no. 11 (titled *Child with Woodpecker*); AARFAC, 1947, p. 14, no. 11 (titled *Child with Woodpecker*); AARFAC, 1957, p. 28, no. 12, illus. on p. 29; AARFAC, 1974, p. 19, no. 2, illus. as no. 2 on p. 18; Cahill, p. 30, no. 6, illus. on p. 58; Cahill, Early Folk Art, illus. on p. 262; Henry Kauffman, *Pennsylvania Dutch American Folk Art* (New York, 1946), illus. on p. 49.

[1]A full-length Arnold portrait of a girl in pantalettes reportedly exists in a private collection. Milton Flower to AARFAC, July 10, 1979. With regard to an Arnold attribution, it should be noted that although Halpert recorded this painting as having been "found in New York," she also described it in her records as "Pennsylvania German," raising the possibility of its having come to New York out of Arnold's territory, that is, Pennsylvania.

[2]A portrait of Mary Holmes of Stonington, Conn., was advertised by Timothy J. Stevenson in the *Maine Antique Digest,* VII (April 1979), p. 30B. A privately owned portrait of a *Girl with a Rose* was illustrated in the exhibition catalog, "Early Arts in the Genesee Valley, Eighteenth & Nineteenth Centuries," Geneseo, N.Y., September 29-October 20, 1974, p. 29, no. 12. A Spanish artist named Freda produced unauthorized imitations of *Jean Macdonald Lee Myers* in the 1960s.

other examples of Arnold's portraiture, particularly full-length likenesses that have landscape backgrounds, will help to settle the attribution of no. 292.[1] Two other very similar portraits exist, one having a Connecticut history and the other with a tentative Cambridge, New York, association.[2]

The girl holds a basket filled with cherrylike fruits, and a plump redheaded woodpecker at left is pecking a piece of fruit. The technique used to describe the curious bushlike trees flanking the child as well as the rendering of the sitter's face and figure provide important clues toward ultimately identifying the artist. The leaves have been thickly painted with dabs from a spongelike tool, shades of green being overlaid with darker greens, yellow, and rust.

Edith Gregor Halpert's notes state that the former, unidentified, owner of the painting believed it represented Jean Macdonald Lee Myers, a daughter of Ramsey Macdonald Lee, who was related to Sir John Macdonald, prime minister of Canada, and to Ramsay MacDonald, a British prime minister. To date, all efforts to verify this information have failed.

293 Member of the Whitney Family 31.100.24

Possibly Binghamton, New York, ca. 1850
Oil on canvas
27⅛" x 21¼" (68.9 cm. x 54.0 cm.)

Edith Gregor Halpert's notes state that the sitter was a "woman of the Whitney family, prominent in the history of Binghamton, New York," but this general identification has not been documented.

The artist has depicted his subject in a straightforward and uninspired fashion, the composition lacking those touches of bright color and decorative linear design that might have relieved the monotony of the woman's plain features. The slight tilt of her head imparts a certain wistfulness to her expression. She wears a dark green dress trimmed with white eyelet-embroidered collar and cuffs and a gold and onyx necklace and ring.

Condition: The painting was cut down before cleaning, lining, inpainting of losses, and replacement of the auxiliary support by Ralph Mayer in 1930. Hans E. Gassman cleaned and relined the canvas in 1954. Period replacement 1⅜-inch molded and gilded frame.

Provenance: Found in Binghamton, N.Y., by and purchased from Edith Gregor Halpert, Downtown Gallery, New York, N.Y.
Published: AARFAC, 1957, p. 349, no. 172.

294 Girl with Hat

31.100.13

America, ca. 1850
Oil on canvas
42⅛" x 32⅞" (107.0 cm. x 83.5 cm.)

Children's portraits of the mid-nineteenth century are often rich in compositional elements and iconographical details, as seen in this likeness of an unidentified little girl. The landscape setting and the atmospheric vista parallel and were undoubtedly borrowed from more elaborate formats used by academic painters. In a similar way, the skillful drawing and modeling of the girl's face evidence some formal training on the part of the artist. The subject's fancy straw hat trimmed with a blue ribbon and the large peach she holds are typical of the everyday objects illustrated in children's portraits during this era. She wears a fashionable blue-dotted white dress and a coral necklace.

Condition: Repaired and restored by David Rosen before 1940. It was subsequently lined, restretched, and inpainted by an unidentified conservator. Bruce Etchison relined, cleaned, and replaced old inpainting in 1978. Modern replacement 2⅝-inch molded gilt frame.
Provenance: Found in Connecticut by and purchased from Edith Gregor Halpert, Downtown Gallery, New York, N.Y.
Published: AARFAC, 1957, p. 349, no. 173.

295 Man Holding Spectacles

31.300.12

Probably America or England, ca. 1850
Watercolor and gilt on wove paper with metal and foil collage elements
5½" x 4⅞" (14.0 cm. x 12.4 cm.)

The buttons on this subject's suit and the tack heads running along the edge of the red upholstered seat of the mahogany armchair are actually small dots of thick paper, painted and gilt, respectively, and adhered to the primary support. The sitter's watch fob is suggested by an applied bit of embossed metal. The use of such collage elements to give a three-dimensional effect rather than mere simulation of materials is rare and is evidence of one of the more naive concepts encountered in less sophisticated varieties of portraiture. The tiny dots of watercolor at the corners of both eyes and above and below the sitter's right eye perhaps represent the artist's attempt to locate those features properly in the facial plane.

Condition: No evidence of previous conservation. Period replacement 1-inch molded walnut frame with gilt liner.
Provenance: Found near Ephrata, Pa., and purchased from Edith Gregor Halpert, Downtown Gallery, New York, N.Y.
Published: AARFAC, 1940, p. 27, no. 77; AARFAC, 1947, p. 25, no. 77; AARFAC, 1957, p. 359, no. 237.

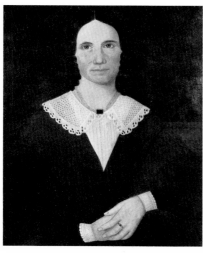

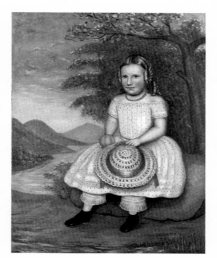

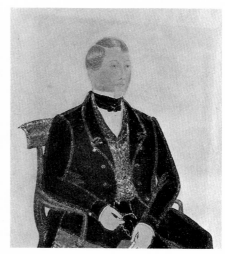

293

294

295

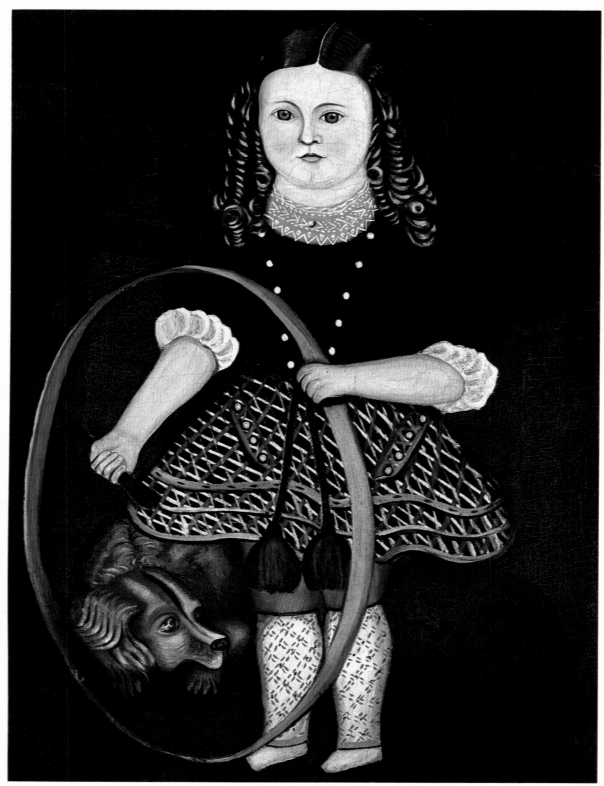

296 Girl with Hoop
36.100.2

America, ca. 1850
Oil on canvas
36″ x 26½″ (91.4 cm. x 67.3 cm.)

Elements originally appearing in the background of this portrait were painted over at an unknown date and for unknown reasons. Some of them – those comprising a complex architectural setting – conceivably could have been intended as a backdrop for the girl and dog, particularly since x-radiography reveals no conflicting overlapping between the architectural elements and the girl's and dog's figures. However, other painted-over designs – such as a suggestion of a face at the upper left – appear to be unrelated to either architecture or figures, indicating that a canvas supporting a study or abandoned effort was recycled in creating the present portrait. X-radiography also shows a bowl of circular forms, probably fruit, to the right of the child's legs and reveals numerous curving shapes in the foreground that must have represented foliage. Other minor changes were made in the girl's curls and the plaid of her skirt.

The unmodeled drab olive background is unusual in a full-length nineteenth-century portrait; most similar likenesses incorporated some kind of interior or exterior view, whether idealized or realistic. Possibly the earlier architectural background offered too much competition with the child's busy costume to suit a previous owner's taste.[1] The bright green, yellow, and white plaid skirt, large blue tassels, and red-on-white embroidered stockings combine with the dog's wavy fur and the highlights on the girl's ringlets to form an overwhelming display of pattern. The decorative quality thus achieved becomes the painting's focal point, for the child's simplified figure and extremely stylized face can hardly be reckoned a "good likeness." The figure is a symbol of a girl rather than a portrait.

The painting also illustrates two popular fads of the time. Wooden hoops were favored playthings of both boys and girls throughout the second half of the nineteenth century, and they were featured as props in portraits and in illustrations of juvenile fashions in contemporary ladies' magazines. "Scotch plaids" enjoyed a similar rage, their popularity burgeoning with Queen Victoria's personal endorsement of the handsome woven fabrics brought back to England from Balmoral, her vacation home in the Scottish Highlands.

Inscriptions/Marks: The name "Morse" is recorded as having been written in ink on the original top stretcher and on the reverse of the canvas. "N Becket" is lettered in chalk along the right side of the back of the frame.

Condition: Sidney S. Kopp cleaned the painting in 1936. Russell J. Quandt replaced the auxiliary support and recleaned and lined the canvas in 1955. Period replacement 4⅛-inch mahogany-veneered cyma reversa frame with a flat outer edge terminating in quarter-round molding.

Provenance: Early records of Mrs. Rockefeller's state that the painting came "from the Browne family of Watertown, Mass."; Katrina Kipper, Accord, Mass.

Exhibited: "Toys and Tots," Gunston Hall, Lorton, Va., March 3-31, 1972.

Published: AARFAC, 1957, p. 52, no. 24, illus. on p. 53.

[1] The overall olive coat may have been applied with the canvas held in an easel, since strips ½ to ⅝ of an inch long at the top and bottom were not covered and still exhibit the underpainting.

297 Woman in White Bonnet
61.300.2
298 Man in Sprigged Waistcoat
61.300.1

Possibly New England, ca. 1850
Watercolor on wove paper
3¼″ x 2¾″ (8.3 cm. x 7.0 cm.)
3⅛″ x 2⁵⁄₁₆″ (7.9 cm. x 5.9 cm.)

This pair of anonymously painted profile portraits, which are among the latest executed in the collection, are housed in what is presumed to be the original composition case with embossed metal matting. The use of an early photographer's standard framing materials testifies to the interchange, competition, and peculiar relationship between photographers and painters, particularly miniature painters, at an interesting point of transition in the processes of image-making. At mid-century the Scovill Company was America's sole supplier of daguerreotype plates and also produced cameras, cases, brass mats, and other components. The Peck Company,

297 298

a New Haven subsidiary of the Scovill Company, was primarily involved in the manufacture of daguerreotype cases like this one. Made by the thousands, such cases were marketed in New York City and were distributed all over the world. It is thus difficult to draw any conclusions about the origin of the watercolors from the case in which they are displayed.

Inscriptions/Marks: The brass foil mat in the frame of no. 298 bears the embossed inscription "CONSTITUTION AND UNION/JULY 4/1776" incorporated into its design; embossed at the top of the same mat, beneath a separate foil surround, is the inscription "SCOVILL MGF CO SUPERIOR." Embossed at the bottom of the same mat, again beneath the separate foil surround, is the inscription "WATERBURY CONN. No 824." Behind the foil-encased support, a loose piece of paper is laid in the back of the case on which appears the printed inscription "GENUINE/UNION CASE/IMPROVED./Fine Gilt and Burnished/Hinge./S. PECK & CO.,/MANUFACTURERS." There are no inscriptions or marks on the half of the case that houses no. 297. No watermarks found.

Condition: No evidence of previous conservation. Probably original 3⅝-inch x 6½-inch (overall opened measurements) hinged composition case with brass foil spandrels and surrounds on either side to hold a pair of portraits.

Provenance: Gift of Mrs. George Schlobach.

Exhibited: Washington County Museum.

Published: Walters, Pt. 3, no. 297 only, p. 3C, illus. as fig. 13 on p. 4C.

EXHIBITIONS SHORT TITLE LIST

AARFAC, AMERICAN MUSEUM IN BRITAIN
"American Folk Art from the Abby Aldrich Rockefeller Folk Art Collection," American Museum in Britain, Claverton Manor, Bath, England, March 9-November 1, 1961.

AARFAC, BEARDSLEY LIMNER
"The Beardsley Limner and Some Contemporaries: Postrevolutionary Portraiture in New England, 1785-1805," Abby Aldrich Rockefeller Folk Art Collection, October 15-December 3, 1972, and exhibition catalog.

AARFAC, BELKNAP
"Portraits of Zedekiah Belknap," Abby Aldrich Rockefeller Folk Art Collection, May 8-June 26, 1977.

AARFAC, ELLSWORTH
"The Paintings of James Sanford Ellsworth: Itinerant Folk Artist, 1802-1873," Abby Aldrich Rockefeller Folk Art Collection, October 13-December 1, 1974, and exhibition catalog.

AARFAC, FIELD
"Erastus Salisbury Field 1805-1900: A Special Exhibition Devoted to His Life and Work," Abby Aldrich Rockefeller Folk Art Collection, January 20-March 17, 1963, and exhibition catalog.

AARFAC, GLEN-SANDERS
"The Glen-Sanders Collection from Scotia, New York," Abby Aldrich Rockefeller Folk Art Collection, January 23-28 and January 30-February 4, 1966, and exhibition catalog.

AARFAC, MERCHANTS AND PLANTERS
"Merchants and Planters of the Upper Hudson Valley 1700-1750," Abby Aldrich Rockefeller Folk Art Collection, January 15-February 26, 1967, and exhibition checklist.

AARFAC, MINNEAPOLIS
"American Folk Art from the Abby Aldrich Rockefeller Folk Art Collection," Minneapolis Institute of Arts, May 19-July 1, 1964.

AARFAC, NEW CANAAN
"Folk Art from the Abby Aldrich Rockefeller Folk Art Collection," New Canaan Library, New Canaan, Conn., January 2-31, 1962.

AARFAC, NEW JERSEY
"Selections from the Abby Aldrich Rockefeller Folk Art Collection," New Jersey State Museum, Trenton, January 15-March 12, 1972.

AARFAC, NEW YORK
"The Folk Art of New York State," Abby Aldrich Rockefeller Folk Art Collection, March 15-May 20, 1959, and exhibition catalog.

AARFAC, POWERS
"Asahel Powers: Painter of Vermont Faces," Abby Aldrich Rockefeller Folk Art Collection, October 14-December 2, 1973, and exhibition catalog.

AARFAC, APRIL 22, 1959-DECEMBER 31, 1961
Traveling exhibition organized by AARFAC in cooperation with the American Federation of Arts, April 22, 1959-December 31, 1961.

AARFAC, MARCH 9, 1961-MARCH 20, 1966
Traveling exhibition organized by AARFAC, March 9, 1961-March 20, 1966.

AARFAC, JUNE 4, 1962-APRIL 17, 1963
Traveling exhibition organized by AARFAC, June 4, 1962-April 17, 1963.

AARFAC, JUNE 4, 1962-MARCH 31, 1965
Traveling exhibition organized by AARFAC, June 4, 1962-March 31, 1965.

AARFAC, JUNE 4, 1962-NOVEMBER 20, 1965
Traveling exhibition organized by AARFAC, June 4, 1962-November 20, 1965.

AARFAC, MAY 10, 1964-DECEMBER 31, 1966
Traveling exhibition organized by AARFAC, May 10, 1964-December 31, 1966.

AARFAC, SEPTEMBER 1968-MAY 1970
Traveling exhibition organized by AARFAC in cooperation with the Virginia Museum of Fine Arts, September 1968-May 1970.

AARFAC, SEPTEMBER 15, 1974-JULY 25, 1976
Traveling exhibition organized by AARFAC, September 15, 1974-July 25, 1976.

AMERICAN ANCESTORS
"American Ancestors," Downtown Gallery, New York, N.Y., December 14-31, 1931.

AMERICAN FOLK ART
"American Folk Art: The Art of the Common Man in America, 1750-1900," Museum of Modern Art, New York, N.Y., November 30, 1932-January 15, 1933; Pennsylvania Museum of Art, Philadelphia, Pa., February 4-March 4, 1933; Rhode Island School of Design, Providence, R.I., April 1-April 30, 1933; Museum of Fine Arts, Boston, Mass., October 10-November 5, 1933; William Rockhill Nelson Gallery of Art, Kansas City, Mo., March 1-March 30, 1934; Greenwich Society of Artists, Greenwich, Conn., May 26-June 11, 1934; Westchester Community Center, White Plains, N.Y., June 20-July 9, 1934.

AMERICAN FOLK PAINTERS
"American Folk Painters of Three Centuries," Whitney Museum of American Art, New York, N.Y., February 26-May 13, 1980.

AMERICAN PRIMITIVE PAINTING
"American Primitive Painting of Four Centuries," Arts Club of Chicago, November 2-27, 1943, and exhibition catalog.

AMMI PHILLIPS IN COLUMBIA COUNTY
"Ammi Phillips in Columbia County," Columbia County Historical Society, Kinderhook, N.Y., August 15-September 30, 1975, and exhibition catalog.

AMMI PHILLIPS PORTRAIT PAINTER
"Ammi Phillips Portrait Painter," Museum of Early American Folk Art, New York, N.Y., October 14, 1968-January 7, 1969.

AMMI PHILLIPS 1788-1865
"Ammi Phillips 1788-1865," Connecticut Historical Society, October 31, 1965-February 1, 1966.

ARKANSAS ARTMOBILE
Arkansas Arts Center Artmobile, traveling exhibition organized by the Arkansas Arts Center, Little Rock, September 1, 1976-September 1, 1977.

BORDEN LIMNER
"The Borden Limner and His Contemporaries," University of Michigan Museum of Art, Ann Arbor, November 14, 1976-January 16, 1977, and exhibition catalog.

CHILDREN IN AMERICAN FOLK ART
"Children in American Folk Art," Downtown Gallery, New York, N.Y., April 13-May 1, 1937, and exhibition catalog.

CORNÈ
"Michele Felice Cornè, 1752-1845: Versatile Neapolitan Painter of Salem, Boston, & Newport," Peabody Museum, Salem, Mass., Summer 1972, and exhibition catalog.

FLOWERING OF AMERICAN FOLK ART
"The Flowering of American Folk Art, 1776-1876," traveling exhibition organized by the Whitney Museum of American Art, New York, N.Y., February 1-September 15, 1974.

FRYMIRE
"Jacob Frymire, American Limner," Corcoran Gallery of Art, Washington, D.C., October 4-November 16, 1975, and exhibition catalog.

GOETHEAN GALLERY
Goethean Gallery of Art, Franklin and Marshall College, Lancaster, Pa., January 3-February 10, 1969.

GOODELL
"Painted by Ira C. Goodell," Columbia County Historical Society, Kinderhook, N.Y., July 20-September 30, 1977, and exhibition catalog.

HALLADAY-THOMAS, ALBANY
"American Provincial Paintings, 1700 to 1860: The Halladay-Thomas Collection," Albany Institute of History and Art, October 1-31, 1949, and exhibition catalog.

HALLADAY-THOMAS, HUDSON PARK
"Early American Painting: The Collection of J. Stuart Halladay and Herrel George Thomas," Hudson Park Library, New York, N.Y., March 1-April 30, 1946.

HALLADAY-THOMAS, NEW BRITAIN
"American Provincial Paintings, 1680 to 1880: The Halladay-Thomas Collection," The Art Museum, New Britain, Conn., November 1-31, 1947, and exhibition catalog.

HALLADAY-THOMAS, PITTSBURGH
"American Provincial Paintings, 1680-1860, From the Collection of J. Stuart Halladay and Herrel George Thomas," Department of Fine Arts, Carnegie Institute, Pittsburgh, April 17-June 1, 1941, and exhibition catalog.

HALLADAY-THOMAS, SYRACUSE
"American Provincial Paintings, 1680 to 1880: The Halladay-Thomas Collection," Syracuse Museum of Fine Arts, January 23-February 22, 1949, and exhibition catalog.

HALLADAY-THOMAS, WHITNEY
"American Provincial Paintings, 1680-1860, From the Collection of J. Stuart Halladay and Herrel George Thomas," Whitney Museum of American Art, New York, N.Y., October 27-November 19, 1942, and exhibition catalog.

LITTLE-KNOWN CONNECTICUT ARTISTS
"Little-Known Connecticut Artists, 1790-1810," Connecticut Historical Society, Hartford, November 3, 1957-February 1, 1958.

NEW YORK STATE MASTERPIECES
"Selected Masterpieces of New York State Folk Paintings," Museum of American Folk Art, New York, N.Y., February 23-May 22, 1977.

PHILBROOK ART CENTER
"Arts Festival," Philbrook Art Center, Tulsa, April 6-June 6, 1965.

SMITHSONIAN, AMERICAN PRIMITIVE WATERCOLORS
"American Primitive Watercolors," traveling exhibition organized by the Smithsonian Institution Traveling Exhibition Service in cooperation with AARFAC, October 31, 1964-October 10, 1965, and exhibition catalog.

THREE NEW ENGLAND WATERCOLOR PAINTERS
"Three New England Watercolor Painters," traveling exhibition organized by the Art Institute of Chicago, November 16, 1974-September 1, 1975, and exhibition catalog.

TILLOU
"Nineteenth-Century Folk Painting: Our Spirited National Heritage, Works of Art from the Collection of Mr. and Mrs. Peter Tillou," William Benton Museum of Art, University of Connecticut, Storrs, April 23-June 3, 1973, and exhibition catalog.

WASHINGTON COUNTY MUSEUM
Washington County Museum of Fine Arts, Hagerstown, Md., July 15-September 15, 1965.

WILLIAM PENN MUSEUM
William Penn Memorial Museum, Harrisburg, Pa., July 7-September 30, 1966.

PUBLICATIONS SHORT TITLE LIST

AARFAC, 1940
Edith Gregor Halpert, comp., *American Folk Art: A Collection of Paintings and Sculpture Produced by Little-Known and Anonymous American Artists of the Eighteenth and Nineteenth Centuries.* Williamsburg: Colonial Williamsburg, Inc., 1940.

AARFAC, 1947
Edith Gregor Halpert, comp., *A Catalogue of the American Folk Art Collection of Colonial Williamsburg.* Williamsburg: Colonial Williamsburg, Inc., 1947.

AARFAC, 1957
Nina Fletcher Little, *The Abby Aldrich Rockefeller Folk Art Collection.* Williamsburg: Colonial Williamsburg, Inc., 1957.

AARFAC, 1959
American Folk Art from the Abby Aldrich Rockefeller Folk Art Collection. Williamsburg: Colonial Williamsburg, Inc., 1959.

AARFAC, 1965
The Abby Aldrich Rockefeller Folk Art Collection: Gallery Book. Williamsburg: Colonial Williamsburg, Inc. [1965].

AARFAC, 1969
Nina Fletcher Little, *Land and Seascape as Observed by the Folk Artist.* Williamsburg: Colonial Williamsburg, Inc., 1969.

AARFAC, 1974
Folk Art in America, A Living Tradition: Selections from the Abby Aldrich Rockefeller Folk Art Collection, Williamsburg, Virginia. Atlanta: High Museum of Art and AARFAC, 1974.

AARFAC, 1975
Beatrix T. Rumford, *The Abby Aldrich Rockefeller Folk Art Collection: A Gallery Guide.* Williamsburg: Colonial Williamsburg Foundation, 1975.

BELKNAP
Waldron Phoenix Belknap, Jr., *American Colonial Paintings.* Cambridge, Mass.: Harvard University Press, 1959.

BLACK
Mary C. Black, "A Folk Art Whodunit," *Art in America,* LIII (June 1965).

BLACK, FIELD
Mary Black, "Rediscovery: Erastus Salisbury Field," *Art in America,* LIV (January-February 1966).

BLACK AND FELD
Mary Childs Black and Stuart P. Feld, "Drawn by I. Bradley from Great Britton," *Antiques,* XC (October 1966).

BLACK AND LIPMAN
Mary Black and Jean Lipman, *American Folk Painting.* New York: Clarkson N. Potter, 1966.

BURDICK AND MULLER
Virginia M. Burdick and Nancy C. Muller, "Aaron Dean Fletcher, portrait painter," *Antiques,* CXV (January 1979).

CAHILL
Holger Cahill, *American Folk Art: The Art of the Common Man in America, 1750-1900.* New York: Museum of Modern Art, 1932.

CAHILL, EARLY FOLK ART
Holger Cahill, "Early Folk Art in America," *Creative Art,* XI (December 1932).

CARRICK
Alice Van Leer Carrick, *Shades of Our Ancestors: American Profiles and Profilists.* Boston: Little, Brown, 1928.

CORTELYOU
Irwin F. Cortelyou, "Micah Williams: New Jersey Primitive Portrait Artist," *Monmouth Historian,* II (Spring 1974).

CURRAN
Ona Curran, "Schenectady Ancestral Portraits Early 18th Century," *Schenectady County Historical Society,* X (September 1966).

ETCHISON
Bruce Etchison, "The Glen-Sanders portraits of Scotia, New York," *Antiques,* LXXXIX (February 1966).

FORD
Alice Ford, *Pictorial Folk Art: New England to California.* New York: Studio Publications, 1949.

FRENCH
Reginald F. French, "Erastus Salisbury Field, 1805-1900," *Connecticut Historical Society Bulletin,* XXVIII (October 1963).

GROCE AND WALLACE
George C. Groce and David H. Wallace, *The New-York Historical Society's Dictionary of Artists in America, 1564-1860.* New Haven: Yale University Press, 1957.

HOLDRIDGE AND HOLDRIDGE, *Ammi Phillips*
Barbara C. and Lawrence B. Holdridge, *Ammi Phillips: Portrait Painter 1788-1865.* New York: Clarkson N. Potter, 1969.

HOLDRIDGE AND HOLDRIDGE, "AMMI PHILLIPS"
Barbara and Lawrence B. Holdridge, "Ammi Phillips 1788-1865," *Connecticut Historical Society Bulletin,* XXX (October 1965).

HOOD
Graham Hood, *Charles Bridges and William Dering: Two Virginia Painters, 1735-1750*. Williamsburg: Colonial Williamsburg Foundation, 1978.

LIPMAN
Jean Lipman, *American Primitive Painting*. London: Oxford University Press, 1942.

LIPMAN, BRADLEY
Jean Lipman, "I. J. H. Bradley, Portrait Painter," *Art in America*, XXXIII (July 1945).

LIPMAN AND ARMSTRONG
Jean Lipman and Tom Armstrong, eds., *American Folk Painters of Three Centuries*. New York: Hudson Hills Press, 1980.

LIPMAN AND WINCHESTER
Jean Lipman and Alice Winchester, *The Flowering of American Folk Art, 1776-1876*. New York: Viking Press, 1974.

LIPMAN AND WINCHESTER, PRIMITIVE PAINTERS
Jean Lipman and Alice Winchester, eds., *Primitive Painters in America, 1750-1950*. New York: Dodd, Mead, 1950.

LITTLE
Nina Fletcher Little, "Little-Known Connecticut Artists, 1790-1810," *Connecticut Historical Society Bulletin*, XXII (October 1957).

LITTLE, BREWSTER
Nina Fletcher Little, "John Brewster, Jr., 1766-1854: Deaf-Mute Portrait Painter of Connecticut and Maine," *Connecticut Historical Society Bulletin*, XXV (October 1960).

LITTLE, HATHAWAY
Nina Fletcher Little, "Doctor Rufus Hathaway, Physician and Painter of Duxbury, Massachusetts, 1770-1822," *Art in America*, XLI (Summer 1953).

LITTLE, PRIOR
Nina Fletcher Little, "William M. Prior, Traveling Artist, and His In-Laws, the Painting Hamblens," *Antiques*, LIII (January 1948).

LYMAN
Grace Adams Lyman, "William M. Prior, The 'Painting Garret' Artist," *Antiques*, XXVI (November 1934).

MCCLINTON
Katharine Morrison McClinton, *Antiques of American Childhood*. New York: Clarkson N. Potter, 1970.

MANKIN
Elizabeth Mankin, "Zedekiah Belknap," *Antiques*, CX (November 1976).

MITCHELL
Lucy B. Mitchell, "James Sanford Ellsworth: American Miniature Painter," *Art in America*, XLI (Autumn 1953).

MULLER AND OAK
Nancy C. Muller and Jacquelyn Oak, "Noah North (1809-1880)," *Antiques*, CXII (November 1977).

PARKE-BERNET, SUSSEL
Arts and Crafts of Pennsylvania and Other Notable Americana: Part One of the Collection of the Late Arthur J. Sussel, Philadelphia, catalog for sale no. 1847, October 23-25, 1958. New York: Parke-Bernet Galleries, Inc., 1958.

PEAT
Wilbur D. Peat, *Pioneer Painters of Indiana*. Indianapolis: Art Association of Indianapolis, 1954.

PETERSON
Harold L. Peterson, *Americans at Home: From the Colonists to the Late Victorians*. New York: Charles Scribner's Sons, 1971.

PLEASANTS
J. Hall Pleasants, "William Dering, A Mid-Eighteenth Century Williamsburg Portrait Painter," *Virginia Magazine of History and Biography*, LX (January 1952).

SAVAGE AND SAVAGE
Norbert and Gail Savage, "J. A. Davis," *Antiques*, CIV (November 1973).

SELLERS, I
Charles Coleman Sellers, *The Artist of the Revolution: The Early Life of Charles Willson Peale*. Vol. I. Hebron, Conn.: Feather and Good, 1939.

SELLERS, II
Charles Coleman Sellers, *Charles Willson Peale: Later Life (1790-1827)*. Vol. II. Philadelphia: American Philosophical Society, 1947.

SHAFFER
Sandra C. Shaffer, "Deborah Goldsmith, 1808-1836: A Naive Artist in Upstate New York." M.A. thesis, State University of New York College at Oneonta, 1968.

SOTHEBY PARKE BERNET, FINE AMERICANA
Fine Americana, catalog for sale no. 3947, January 26-29, 1977. New York: Sotheby Parke Bernet, Inc., 1977.

SPINNEY
Frank O. Spinney, "Joseph H. Davis: New Hampshire Artist of the 1830's," *Antiques*, XLIV (October 1943).

TOMLINSON
Juliette Tomlinson, ed., *The Paintings and the Journal of Joseph Whiting Stock*. Middletown, Conn.: Wesleyan University Press, 1976.

WALTERS, FINCH
Donald R. Walters, "Out of Anonymity: Ruby Devol Finch (1804-1866)," *Maine Antique Digest*, VI (June 1978).

WALTERS, PT. 2
Donald R. Walters, "Making Faces: Aspects of American Portraiture," *Maine Antique Digest*, V, Pt. 2 (December 1977).

WALTERS, PT. 3
Donald R. Walters, "Making Faces: Aspects of American Portraiture," *Maine Antique Digest*, VI, Pt. 3 (January-February 1978).

WARREN, BROADBENT
William Lamson Warren, "Doctor Samuel Broadbent (1759-1828) Itinerant Limner," *Connecticut Historical Society Bulletin,* XXXVIII (October 1973).

WARREN, CHECKLIST
William Lamson Warren, "A Checklist of Jennys' Portraits," *Connecticut Historical Society Bulletin,* XXI (April 1956).

WARREN, JENNYS
William Lamson Warren, "The Jennys Portraits," *Connecticut Historical Society Bulletin,* XX (October 1955).

WEEKLEY
Carolyn J. Weekley, "Further Notes on William Dering, Colonial Virginia Portrait Painter," *Journal of Early Southern Decorative Arts,* I (May 1975).

WEEKS
Lyman Horace Weeks, *A History of Paper-Manufacturing in the United States, 1690-1916.* New York: Lockwood Trade Journal Co., 1916.

INDEX